FUTURISM

Original title
Le Futurisme à Paris. Une avant-garde explosive produced by the Éditions du Centre Pompidou, Paris
and 5 Continents Editions, Milan, 2008.
Revised and enlarged Italian and English editions first published by Éditions du Centre Pompidou
and 5 Continents Editions, 2009.

© 2009 Éditions du Centre Pompidou, Paris/5 Continents Editions s.r.l., Milan
ISBN: 978-2-84426-403-9 (Éditions du Centre Pompidou)
ISBN: 978-88-7439-496-8 (5 Continents Editions)

Copyright deposit: January 2009

Cover:
Umberto Boccioni, *Le forze di una strada*, 1911
[The Forces of the Street]
Oil on canvas, 99.5 x 80.5 cm
Osaka City Museum of Modern Art, Osaka

FUTURISM

Edited by Didier Ottinger

The original exhibition
Le Futurisme à Paris. Une avant-garde explosive
was conceived by Centre Pompidou, Paris
in collaboration with Scuderie del Quirinale, Rome
and Tate Modern, London.

Centre Pompidou, Paris
15 October 2008–26 January 2009

Scuderie del Quirinale, Rome
20 February–24 May 2009

Tate Modern, London
12 June–20 September 2009

EXHIBITION CURATORS
Didier Ottinger, Centre Pompidou
Ester Coen, Scuderie del Quirinale
Matthew Gale, Tate Modern

ACKNOWLEDGEMENTS

We would like to pay tribute to Anne d'Harnoncourt, Director of the Philadelphia Museum of Art and an early and enthusiastic supporter of this project, who died on 1 June 2008.

The exhibition would not have been possible without the generosity of all the lenders. We are enormously grateful to all of those private collectors who, while preferring to remain anonymous, have so willingly endorsed this celebration of the centenary of Futurism. We would also like to acknowledge the generosity of the following institutions and colleagues around the world who have contributed such crucial works. We would like to thank them all for their support at every stage of this project.

Stedelijk Museum, Amsterdam
Gijs van Tuyl, Director

Albright-Knox Art Gallery, Buffalo (NY)
Louis Grachos, Director
Douglas Dreishpoon, Chief Curator

Harvard Art Museum, Cambridge (MA)
Thomas W. Lentz, Elizabeth and John Moors Cabot Director
Harry Cooper, former Curator of Modern Art

Möbel Transport SA, Chiasso
Silvana Pasquin

Musée de Grenoble, Grenoble
Guy Tosatto, Director
Isabelle Varloteaux, Collections Registrar

Gemeentemuseum Den Haag, The Hague
Dr Wim Van Krimpen, Director

Estorick Collection of Modern Italian Art, London
Roberta Cremoncini, Director
Christopher Adams, Curator

Government Art Collection, London
Penny Johnson, Director
Julia Toffolo, Senior Registrar and Deputy Director
Jules Breeze, Registrar

Museo Thyssen-Bornemisza, Madrid
Guillermo Solana, Chief Curator

Civiche Raccolte d'Arte, Milan
Lucia Matino, Director
Maria Teresa Fiorio, former Director

Galleria d'Arte Moderna, Milan
Sandrino Schiffini, Director
Maria Fratelli, Curator

Tretiakov Gallery, Moscow
Valentin Rodionov, Director
Lidia Iovleva, First Deputy Director
Katerina Semenova, Head of Coordination, Department of International Exhibitions

Bayerische Staatsgemäldesammlungen, Pinakothek der Moderne, Munich
Prof. Dr Reinhold Baumstark, Director
Prof. Dr Carla Schulz-Hoffmann, Deputy Director of Bavarian Collections and Chief Curator of the Pinakothek der Moderne

Solomon R. Guggenheim Museum, New York
Marc Steglitz, interim Director
Lisa Dennison, former Director
Susan Davidson, Senior Curator

The Metropolitan Museum of Art, New York
Philippe de Montebello, Director
Gary Tinterow, Engelhard Curator in Charge, Department of Nineteenth-Century, Modern and Contemporary Art

The Museum of Modern Art, New York
Glenn D. Lowry, Director
John Elderfield, former Chief Curator, Department of Painting and Sculpture
Ann Temkin, The Marie-Josée and Henry Kravis Chief Curator, Department of Painting and Sculpture
Anne Umland, Curator, Painting and Sculpture Collections
Cora Rosevear, Curator, Painting and Sculpture
Jodi Hauptman, Curator, Drawings
Jennifer Russell, Senior Deputy Director for Exhibitions, Collections and Programs

Osaka City Museum of Modern Art, Osaka
Katsuaki Fukahori, General Director, Osaka Tourist Office
Tsukada Kumada, Chief Curator
Tomoko Ogawa, Curator

Kröller-Müller Museum, Otterlo
Dr Evert J. Van Straaten, Director

Centre Pompidou, Paris
Alain Seban, Chairman
Agnès Saal, General Director
Alfred Pacquement, Director, musée national d'art moderne

Musée d'Art moderne de la Ville de Paris
Fabrice Hergott, Director
Gérard Audinet, Curator

Philadelphia Museum of Art
Anne d'Harnoncourt (†), former Director
Michael Taylor, The Muriel and Philip Berman Curator of Modern Art

Carnegie Museum of Art, Pittsburgh
Richard Armstrong, Henry J. Heinz II Director

Fonds national d'art contemporain, Puteaux
Claude Allemand-Cosneau, Chief Curator, Director

Galleria Nazionale d'Arte Moderna, Rome
Maria Vittoria Marini Clarelli, Director

Musée d'Art moderne de Saint-Étienne, Saint-Étienne
Lorand Hegyi, Director
Jacques Beauffet, Chief Curator

State Russian Museum, St. Petersburg
Vladimir Gussev, Director
Evgenia Petrova, Scientific Deputy Director
Ivan Karlov, Deputy Director of Registry and Conservation

Staatsgalerie Stuttgart, Stuttgart
Sean Rainbird, Director
Prof. Dr Christian von Holst, former Director

State Museum of Contemporary Art – The George Costakis Collection, Thessaloniki
Maria Tsantsanoglou, Director
Prof. Miltiades Papanikolaou, former Director

Museo di Arte Moderna e Contemporanea di Trento e Rovereto
Gabriella Belli, Director
Clarenza Catullo, Registrar of Exhibitions

Munson-Williams-Proctor Art Institute, Utica
Dr Paul D. Schweizer, Director

Musée des Beaux-Arts de Valenciennes, Valenciennes
Emmanuelle Delapierre, Chief Curator
Patrick Roussiès, Municipal Councillor for Culture, Tourism and Heritage

Peggy Guggenheim Collection, Venice
Philip Rylands, Director

Galleria dello Scudo, Verona
Massimo Di Carlo

Hirshhorn Museum and Sculpture Garden, Smithsonian Institution, Washington DC
Olga V. Viso, Director
Kristen Hileman, Assistant Curator

Von-der-Heydt Museum, Wuppertal
Dr Gerhard Finckh, Director
Brigitte Müller, Head of Exhibitions

Kunsthaus, Zürich
Dr Christoph Becker, Director
Dr Christian Klemm, Director of Collections
Dr Tobia Bezzola, Curator

And the many others who wished to remain anonymous.

We would like to add our sincere thanks to all those whose help and advice enriched both the exhibition and this volume in so many ways:

Lynne Addison, Cristina Agostinelli, Noëlle Albert, Ezzio Amuro, Sergei Androsov, Marián Aparicio, Élodie Aparicio-Bentz, Maria Aprile, Jean-Paul Avice, Xavier Baert, Pierangelo Bellettini, Bibliothèque littéraire Jacques Doucet, Bibliothèque Kandinsky, Delphine Bishop, Beatriz Blanco, Peggy Bodemski, Emily Braun, British Library, Cécile Brunner, Claudia-Rosa Brusin, Françoise Cabioch, Françoise Cagli, Vicki Cain, Ashley Carey, Lucia Cassol, Francesco Federico Cerruti, Jean-Claude Charton, Ludovic Chauvin, Annick Chemama, Judith L. Cline, Alexis Constantin, Helen Cooper, Antoine Coron, James Cuno, Maria De Marco-Beardsley, Jean Derens, Christelle Desclouds, Olivier Donat, Douglas Druick, Dietmar Elger, Dino Facchini, Savine Faupin, Pauline Faure-Vergne, Annalisa Ferrari, Moira Fitzgerald, Laura Fleischmann, Eliza Frecon, Peter Frei, Ilaria Galgaro, Patricia Garland, Jean-Claude Gebleux, Marie-Jeanne Geyer, David Gordon, Marc Goutierre, Holcombe T. Green, Thierry Grillet, Jennifer Gross, Géraldine Guillaume-Chavannes, Joan U. Halperin, Atty Heijting, Anthony G. Hirschel, Jacques Hourrière, Erin Hyde, Maria Iacoveli, Sacha Ilic, Laurent Juillard, Joe Ketner, Simone Kober, Ulrich Krempel, Agnès de la Beaumelle, Marina Lambraki-Plaka, Angéline Lavigne, Brigitte Leal, Antoinette Le Normand-Romain, Peter Loorij, Émilie Lormée, Lori Mahaney, Rebecca Marshall, Karin Marti, Eloise W. Martin, Ursula Martin-Malburet, Paul Matisse, Jacqueline Matisse Monnier, Vladimir Matveev, Ceridwen Maycock, Margaret Mazzullo, Dr Bernhard Mendes Bürgi, Philippe-Alain Michaud, Anastasia Mikliaeva, Dominique Morelon, Nathalie Muller, Anna Müller-Härlin, Jodi Myers, Brigitte Nandingna, Ingrid Novion, Anna Orsini, Nicolas Petit, Estelle Pietrzyk, Joëlle Pijaudier-Cabot, Mikhail Piotrovsky, Christine Poggi, Martine Poulain, Earl A. Powell III, Anne-Catherine Prud'hom, Nicolas Pujol, Bruno Racine, Allison Revello, Jock Reynolds, Véronique Roca, James E. Rondeau, Julia Samulyonok, Jacqueline Sanson, Shannon N. Schuler, Françoise Simeray, Adrien Sina, Barbara Slifka, Mary Solt, Sophie Spalek, Gregory Spurgeon, Jonas Storsve, Elena Suriani, Nicolas Surlapierre, Rebecca Tarello, Pierre Théberge, Nicole Thébert, Alicia B. Thomas, Monika Tomko, Keri A. Towler, Elena Tyun, Evert J. Van Straaten, Magali Vène.

We are immensely grateful to all those whose dedication in each of the venues brought this exhibition to fruition.

In Paris, where the exhibition at the Centre Pompidou was sponsored by the Devoteam Group, thanks are due to:

Alain Seban, Chairman
Agnès Saal, General Director
Alfred Pacquement, Director, musée national d'art moderne
d'art moderne – Centre de création industrielle
Bernard Stiegler, Director Département du développement culturel
François Trèves, President Société des Amis du Musée National
d'art moderne
Isabelle Monod-Fontaine, Deputy Director
Frédéric Migayrou, Deputy Director
Didier Ottinger, Deputy Director
Sylvie Perras, Administrator
Didier Schulmann, Bibliothèque Kandinsky
Catherine Duruel, Head of the Collections Unit
Jacques Hourrière, Conservator
Catherine Sentis-Maillac, Director of Production
Laure Rolland, Deputy to the Director of Production
Martine Silie, Head of the Events and Programmes Unit
Annie Boucher, Head Registrar, the Artworks Management Unit

The project team comprised:
Curator: Didier Ottinger
Assistants: Nicole Ouvrard, Mai Lise Bénédic
Production Manager: Armelle de Girval
Design: Laurence Le Bris
Registrar: Viviane Faret
Interns: Valentina Cefalù, Anke Daemgen, Suzanna Muston,
Violeta Tirado Mendoza, Francesca Zappia, Chiara Zippilli

In Rome, where the exhibition was at Scuderie del Quirinale, Azienda Speciale Palaexpo, thanks are due to:

Giorgio Van Straten, former President
Antonio Paolucci, President of the Scientific Board, Scuderie del Quirinale
Mario De Simoni, General Director
Rossana Rummo, former General Director
Caterina Cardona, Head of Scientific and Cultural Activities, Scuderie del Quirinale
Daniela Picconi, Director of Operations
Andrea Landolina, Head of Legal Affairs
Fabio Merosi, Head of Administration and Management
Alexandra Andresen, Exhibition Co-ordinator

The project team at Scuderie del Quirinale comprised:
Guest Curator: Ester Coen
Registrar: Eva Francaviglia
Catalogue Coordinator: Graziella Gnozzi

In London, where the exhibition is at Tate Modern, thanks are due to:

Sir Nicholas Serota, Director, Tate
Vicente Todolí, Director, Tate Modern
Sheena Wagstaff, Chief Curator, Tate Modern
Stephen Mellor, Exhibitions and Displays Coordinator, Tate Modern
Helen Sainsbury, Curatorial Programme Manager, Tate Modern
Dr Stephen Deuchar, Director, Tate Britain
Celia Clear, Chief Executive, Tate Enterprises
Roger Thorp, Publishing Director, Tate Publishing
James Attlee, Sales and Rights Director, Tate Publishing
Rebecca Williams, Director of Development and Tate Foundation
Sarah Robinson, Head of Corporate Development
Charlotte Web, Deputy Head of Corporate Development
Will Gompertz, Director, Tate Media
Helen Beeckmans, Head of Press
Caroline Collier, Director, Tate National
Catherine Clement, Loans Registrar
Nicole Simoës da Silva, Loans Registrar

The project team at Tate Modern comprised:
Curator: Matthew Gale
Assistant Curator: Amy Dickson
Interns: Ana Luiza Teixeira de Freitas, Maria Ana Pimento
Registrar: Stephanie Bush
Film Curator: Stuart Comer
Public Programmes Curator: Marko Daniel
Interpretation Curator: Simon Bolitho
Press Officer: Bomi Odufunade
Catalogue Project Editor: Alice Chasey
Art Installation Manager: Phil Monk
Art Installation Administrator: Marcia Ceppo
Senior Art Handling Technician: Gary McDonald
Conservators: Rachel Barker, Pilar Caballe Valls, Rachel Crome, Charity Fox,
Annette King, Katharine Lockett, Alice Powell, Rachel Scott

And colleagues in Archive and Library, Art Handling, Communications,
External Relations, Media and Front House

CATALOGUE

Editor
Didier Ottinger

Editorial Coordination
Marion Diez

Iconographic Research
Mai Lise Bénédic
Marion Diez
Nicole Ouvrard

Lay-out
Robaglia Design, Paris: Antoine Robaglia
assisted by Nathalie Bigard

Production
Martial Lhuillery

Éditions du Centre Pompidou

Managing Director
Annie Pérez

Publishing Unit
Françoise Marquet

Commercial Unit
Benoît Collier

Rights Unit
Claudine Guillon
Matthias Battestini

Administration Unit
Nicole Parmentier

Stocks
Josiane Peperty

For the present edition

Editorial Coordination
Laura Maggioni

Graphic Designer
Annarita De Sanctis

Translations
Daniel Katz
for Giovanni Lista's essays
Chris Miller
for Jean-Claude Marcadé's essay
Simon Pleasance & Fronza Woods
for Didier Ottinger's essay, the catalogue entries
and the annexes
David George Smith
for Ester Coen's essay and catalogue entries

Copy editing
Caroline Taylor-Bouché

5 Continents Editions

Publisher
Eric Ghysels

Sales & Marketing Director
Debbie Bibo

Production Director
Enzo Porcino

Editor in Chief
Laura Maggioni

Art Director
Lara Gariboldi

Graphic Designer
Annarita De Sanctis

TABLE OF CONTENTS

DIRECTOR'S FOREWORD

It is now a century since Filippo Tommaso Marinetti wrote of overturning his expensive car in a Milanese ditch in the preamble to the *Manifesto of Futurism*. If he, thereby, slyly undermined his own boundless enthusiasm for modern technology, Marinetti also struck a chord across Europe in launching a movement that would shake the past out of the hair of the present and place its faith in the future: "We intend to sing the love of danger, the habit of energy and fearlessness." In this light, the future looked endlessly exciting. Technological developments had transformed the everyday life of the city: from a wider urbanisation arose electric street lighting, telephones and radios, cinemas and sound recording, trams, trains and underground systems, liners and aeroplanes. And although the energy of the urban centres relied, above all, on the strivings of the workers, they were not excluded, as it was to the crowds of industrialised workers and idealistic students that Marinetti addressed Futurism as a means of social—anarchistic—change.

A century on, all of this looks very different. The lens of the Great War that cut short the first phase of Futurism, and the ensuing bastardisation of technology to terrible ends naturally makes the urgency of the movement seem, at best, naïve. This said, the ferment that Marinetti and his artist colleagues—Giacomo Balla, Umberto Boccioni, Carlo Carrà, Luigi Russolo and Gino Severini—generated in the period 1909–15 remains astonishing on many levels and merits revisiting and reassessment. In the wake of the *Manifesto of Futurism* of 20 February 1909, famously published in Paris from Marinetti's Milanese headquarters (though, as Giovanni Lista's essay in this volume shows, it was tested in Italy first), the five painters gathered to transform Italian painting and formulate their wider ambition to be "placed … at the head of the European movement in painting", as they would claim in 1912. Though there was bravado in this assertion, there was also more than a grain of truth. While breaking with the past (what Marinetti called "passatista"), Futurism's cultural heritage was complex: from the perceptual theories of nineteenth-century Italian Divisionist painters to the social consciousness of international Anarchism, and from the awareness of the psychological charge associated with Symbolism to the formal experimentation found in Parisian Cubism. In embodying Futurism, Marinetti did not privilege any experience or aspect of life, believing that the movement should encompass them all. This resulted in manifestos on politics, painting and prose, on lust, on cinema and the art of noises, on theatre, on sculpture and on weights and measures. These reached a mass audience through the audacity and inventiveness of Marinetti's innate instinct for promotion: manifestos in multiple languages poured through the newspapers, through the Futurist publishing house and appeared as wall posters and flyers. Tracts "Against Venice" were thrown into the Piazza San Marco, exhibition leaflets fluttered in the wake of Berlin taxis; above all, Marinetti, the master-of-ceremonies of a fervent band of collaborators, spoke, recited and provoked from stages and at *soirées* across Europe. In this welter of activity, there were profound errors of judgement that continue to mark the historical position of Futurism: the tragic fascination and celebration of war, the pathetic misogyny and the eventual transformation in the 1920s of radical Anarchism into Fascism, chaos into order, individualism into conformity.

Looking back now, all these issues and more colour a reassessment of Futurism. The evidence is clear that it represented a cultural transformation of modern life. For an intense period the term 'Futurism' was used synonymously in place of 'modernism' and 'avant-gardism'; anything new was seen as Futurist. This acceptance speaks for Futurism's success in bringing together in an original and energetic synthesis many aspects of contemporary thought and artistic practice in a way that indelibly changed their acceptance by the public at large. Complex theories and discoveries in science (Einstein, Riemann) came to be married to those in philosophy and politics (Bergson, Sorel) in an explosive combination that generated responses around the world.

Although the Futurist painters' first exhibition may have been held in Paris in 1912 (at the Galerie Bernheim-Jeune), it immediately travelled to London (the Sackville Gallery), to Berlin, Brussels, Amsterdam and onwards. This European tour epitomised the ambition that Marinetti personified but also the welcome extended internationally to the radicalism they embodied. Within two years, Futurist painting had been seen in cities as far apart as Moscow and San Francisco.

In Italy Futurism remains a key stage in a national engagement with the modern world, the first avant-garde. To a great extent this is replicated across Europe, where Futurism elicited responses from young artists and poets—some sympathetic, some resistant—that constituted a much wider, looser network of avant-garde action. In London, Vorticism as coined by Wyndham Lewis (with support from Ezra Pound and T. E. Hulme) reacted against Futurism, to become a self-defining and *more* radical response to the movement. In Paris, the disparate groups of modernists were galvanised into action by the energy of the Italians. While some sought to clarify the means, meaning and path of Cubism in the light of Futurist propaganda, others were seduced to bring their cool formal analysis towards the concerns and emotional energy of Futurism. The conjunction of these concerns, found in many ways and in many places, gave rise to a complex and variegated 'Cubo-Futurism' (explored here by the originating curator of the exhibition, Didier Ottinger), able to encompass divergent ideas of abstraction and 'the subject', of sound poetry and symbolism in Italy, France, Britain and Russia.

Just as with the original 1912 exhibition that trumpeted Futurism abroad, so this reassessment has taken different forms in three capitals. In Paris, the original emphasis has been upon the impact of that exhibition and the dialogue with Cubist and Orphist artists working there. Picasso, Braque, Léger, Delaunay, Duchamp, Picabia all provide key points of engagement. This remains a crucial aspect of the project as it has been reconfigured for Rome and London, with the 1912 exhibition still at its heart, but the opportunity has been taken to bring about a slight shift in emphasis back to the Futurist artists themselves, and to afford a glimpse of the consequences of their plunge towards conflict in the First World War.

No exhibition of this magnitude is possible without the understanding and generosity of the lenders, both private and institutional, and I should like to add my thanks to those expressed in the curators' acknowledgements. We are grateful to all those who have offered their advice, knowledge and support, and especially our colleagues in Paris and Rome, and the authors of the catalogue essays. The ambition of such projects would not be possible without the support of enlightened benefactors, and I should like to thank them for their commitment in supporting our work.

Futurism has been a remarkable project appropriate to the challenge laid down when the Futurist painters positioned themselves as "the primitives of a new sensitiveness". While it is no longer possible to share their unrestrained enthusiasms, the position of Futurism as the epitome and blueprint of the radical avant-garde is clear. The exhibition and this accompanying volume justify Marinetti's claim one hundred years ago: "Courage, audacity and revolt will be essential elements of our poetry."

Vicente Todolí
Director Tate Modern

LES
PEINTRES
FUTURISTES
ITALIENS

EXPOSITION
du lundi 5 au samedi 24 février 1912
(sauf les dimanches)

PARIS
15, RUE RICHEPANCE, 15
MM. BERNHEIM-JEUNE & C^{ie}
EXPERTS PRÈS LA COUR D'APPEL

Cubism + Futurism = Cubofuturism

Didier Ottinger

On 20 February 1909, *Le Figaro* published on its front page the ground-breaking manifesto of a new literary movement: Futurism. There was nothing exceptional about this launch, *per se*. The Faubourg Saint-Antoine's daily paper had already twice published pieces by Jean Moréas—first in 1886 with the *Manifeste du symbolisme*, and five years later with the programme of the *École romane française*. In 1902, in those same columns, Fernand Gregh had announced the birth of *Humanism*. In tone, however, Filippo Tommaso Marinetti's *Manifeste du futurisme*—known as the *Manifesto of Futurism* in English—stood out from previous manifestos. Its virulence was such that the paper's editorial board deemed it necessary to introduce it by way of a warning for their readers: "M. Marinetti … has just founded the School of 'Futurism' whose theories surpass in daring all those expounded by other schools, earlier and contemporary alike… Need we add that we ascribe to the signatory all responsibility for his unusually bold ideas, often unjustly immoderate with regard to ideas at once signally respectable and, happily, duly respected in all quarters?"[1]

The *Manifesto of Futurism* was definitely something novel. Its publication was part and parcel of a communications plan. Its public promotion made the most of the modern media by espousing a hitherto unseen method. This advertising strategy, along with this totally new sense of provocation, its radical denial of the past and its legacy—as asserted by its very name—would make Futurism the first of the Twentieth Century's avant-garde movements.

Cubism born of parents unknown

Paris had to be Marinetti's base for launching his Futurism. The Italian poet, steeped in French culture,[2] had cut his literary teeth in the French capital. Paris was a sounding board, and one that was all the more effective because the city offered no contrasting noise, not even a dull hubbub capable of interfering with the spread of his vehement statements. Ever since the Fauves and their much talked-about exhibition at the 1905 Salon d'Automne, Paris seemed prey to a gentle torpor. Certainly, in 1907, Pablo Picasso painted his remarkable *Les Demoiselles d'Avignon*, but his picture, which was as indigestible as tow, was only seen by the rare visitors to his studio at the Bateau-Lavoir. It had to wait quite some time before being acknowledged as the introduction of a new aesthetics. *Les Demoiselles…* was the harbinger of a 'Cubism' which, in 1909, was only found in the satirical columns, and enlivened by those witticisms that art-column hacks were so crazy about. An art critic applied it for the very first time in 1908 to the six pictures submitted by Georges Braque to the Salon d'Automne jury. Most of them were rejected, so the painter decided to boycott the show. This was a break heralding a new departure.

At the previous Salon d'Automne, Braque had been struck by the retrospective show devoted to Cézanne's work. He had interpreted his paintings as a clear invitation to go beyond Impressionism and its sensualist, lyrical legacy. At L'Estaque, Braque had radicalised the constructive lessons imparted by Cézanne by intensifying the latter's determination to scale nature down pictorially to the forms of an elementary geometry. He had submitted the paintings that he brought back from Provence to the Salon d'Automne jury, presided over by the 'old Fauves': Matisse, Marquet and Rouault. The critic André Salmon spread Matisse's justifications for rejecting them all over Paris: "Braque has just sent here a picture made up of small cubes."[3] Salmon then added: "An ingenuous or ingenious art critic was with him [Matisse]. He hurried to the paper, wrote an off-the-cuff gospel article, and the very next day readers learned that Cubism had been born."[4] The 'ingenious critic' was none other than Charles Morice.

Some months later, during the exhibition of Braque's selfsame Provençal canvases at the Galerie Kahnweiler,[5] the 'small cubes' reappeared in the pages of a Parisian newspaper.

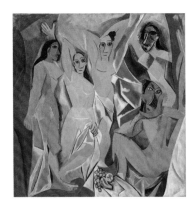

Pablo Picasso
Les Demoiselles d'Avignon, 1907
Oil on canvas, 243.9 x 233.7 cm
The Museum of Modern Art, New York

Georges Braque, *Road near L'Estaque*, 1908
Oil on canvas, 46 x 38 cm
Centre Pompidou-Musée national d'art moderne, Paris
Gift of the Société des Amis du Musée d'art moderne in 1951

Previous page:
Cover of the catalogue for the exhibition
Les Peintres futuristes italiens, Paris, Galerie Bernheim-Jeune & Cie, 5–24 February 1912

This time it was Louis Vauxcelles who, in the *Gil Blas* of 14 November 1908, was outraged at seeing that the painter "despises form, reduces everything, places and figures and houses, to geometrical schemes, to cubes".[6] The 'ingenious critic' who, a year before, had popularised 'Cubism', got back to work once more. In an article in the *Mercure de France*, dated 16 April 1909, Charles Morice wrote: "M. Braque is on the whole a victim—setting 'Cubism' aside—of an admiration for Cézanne that is too exclusive or ill considered."[7]

In 1909, Braque's 'small cubes' did not as yet represent 'Cubism'. It was not until three years later that the term referred to a school, before being associated with an initial theoretical definition. Braque's canvases may not have created Cubism, but they did mark a major stylistic turning-point in the development of Parisian painting. In the year they were produced, Henri Le Fauconnier made a prescient diagnosis of the situation: "The clash between painters and men-of-letters hails, in my view, from the fact that the customary art critics are people from a generation before ours. Their conception of an aesthetics very often based on sensibility and suggestion tallied wonderfully with the research carried out by the Impressionists and the Neo-Impressionists, very little with the work of Cézanne and Gauguin, but a lot with Van Gogh's. At the present time, our pictorial research is leading us to an aesthetics that is less changeable, more stable, and more theoretical, seeking to find synthetic expression through cerebral concepts based on argument and a preordained, rigorously espoused logic… In the last resort, painters are withdrawing more and more towards pure plastic art, doing away with all literature."[8] The stylistic turning-point analysed here had to do with artists who barely knew one another, and who, for the most part, had not yet even met. The sole painters whose works might illustrate this evolution of Parisian art towards 'theory' and 'synthesis'—Braque and Picasso—had decided, in 1909, no longer to exhibit their works at Salons.[9] For a few years this was matched by the intentional concealment of Cubism itself. This latent effect was exploited by Futurism as it established itself as the first historical avant-garde, the first movement endowed with a manifesto, a concerted promotional approach, and a collective exhibition strategy. One example from the moment of its public birth, in 1911, Cubism could peruse at its leisure, as witnessed by Roger Allard in 1913: "With the help of press articles, shrewdly organised exhibitions, provocative lectures, controversies, manifestoes, proclamations, prospectuses and other forms of Futurist publicity, a painter or group of painters is launched. From Boston to Kiev and Copenhagen, this fuss creates an illusion and the outsider gives a few orders."[10]

The *Manifesto of Futurism* (20 February 1909)

Filippo Tommaso Marinetti reported the invention of the form of Futurism which he himself founded, to borrow his own words, to inject a breath of fresh air into his plan for poetic reform: "On 11 October 1908, having worked for six years at my international magazine *Poesia* in an attempt to free the Italian lyrical genius that was under sentence of death from its traditional and commercial fetters, I suddenly felt that articles, poetry and controversies were no longer enough. It was absolutely crucial to switch methods, get out into the streets, lay siege to theatres, and introduce the fisticuff into the artistic struggle. My friends, the poets Paolo Buzzi, Corrado Govoni, Enrico Cavacchioli, Armando Mazza and Luciano Folgore, sought out the slogan and watchword with me. For a moment I hesitated between the words *dynamism* and *futurism*. My Italian blood raced faster when my lips coined out loud the word *futurism*. It was the new formula of Action-Art and a code of mental health. It was a youthful and innovative banner, anti-traditional, optimistic, heroic and dynamic, that had to be hoisted over the ruins of all attachment to the past."[11]

Before its publication on the front page of *Le Figaro*, the manifesto had an Italian proto-history. In December 1908, Marinetti read the manifesto to his closest friends, as part of a literary salon he held at his Corso Venezia home in Milan.[12] In mid-January 1909, he wrote a first draft in the form of a tract printed in blue ink. He sent it to poets (in particular to Gian Pietro Lucini) and intellectuals whom he hoped to win over to his cause. In the first week of February, several reports on the *Manifesto of Futurism* appeared in the Italian press. The Bolognese paper *La Gazzetta dell'Emilia* reproduced it in its entirety in its 5 February 1909 issue. The manifesto was also distributed abroad. On 20 February, it was published in the magazine *Democratia* in Krakow.

1 Quoted in G. Lista, *Futurisme. Manifestes, proclamations, documents*, (Lausanne: L'Âge d'homme, 1973), p. 83. See p. 77.

2 In his childhood in Alexandria, Marinetti attended a college run by French-speaking Jesuits.

3 Apollinaire would borrow the terms of this tale which he popularised in his 1913 book about Cubist painters: "The new school is called Cubism; this name was given to it mockingly, in the autumn of 1908, by Henri Matisse, who had just seen a picture depicting houses whose cubic look greatly struck him". *Les Peintres cubistes, méditations esthétiques*, (Paris: Hermann, 1980), p. 66.

4 A. Salmon, *La Jeune Peinture française*, (Paris: Société des Trente, Albert Messein, 1912), pp. 53–4.

5 Exhibition held in Paris 9–28 Nov. 1908.

6 L. Vauxcelles, "Exposition Braque", *Gil Blas* (Paris), 14 Nov. 1908; trans. in E. F. Fry, *Cubism*, (London: Thames and Hudson, 1966), p. 50.

7 C. Morice, "La Vingt-Cinquième Exposition des Indépendants", *Mercure de France*, 16 April 1909, p. 727; trans. J. Cousins, "Documentary Chronology", in W. Rubin (ed.) *Picasso and Braque: Pioneering Cubism*, exh. cat., Museum of Modern Art, New York, 1989, p. 360.

8 Letter to Alexandre Mercereau , Nov. 1908, quoted by G. Fabre, "Albert Gleizes et l'Abbaye de Créteil", in *Albert Gleizes : Le cubisme en majesté*, exh. cat., Museu Picasso, Barcelona, and Musée des Beaux-Arts, Lyons 2001, (Paris: Réunion des musées nationaux) pp. 139-140.

9 Following the advice of their dealer Daniel-Henry Kahnweiler.

10 R. Allard, "Les arts plastiques", *Les Écrits français* (Paris), no. 1, [5 Dec. 1913], p. 64.

11 F. T. Marinetti, *Guerra sola igiene del mondo*, (Milan: Edizioni futuriste di *Poesia*, 1915), p. 6, quoted in Lista, *F.T. Marinetti. L'anarchiste du futurisme. Biographie*, (Paris: Séguier, 1995), p. 77.

12 See Lista *Futurisme*, op. cit., p. 43 and also his essay *Genesis and Analysis of Marinetti's Manifesto of Futurism, 1908–1909* in this volume.

The prime target of the *Manifesto of Futurism* was an Italian culture which its author deemed to be in the clutches of archaeologists and antique dealers—a culture he reckoned was suffocating under the weight of an ever-present past. The Italian context, which Marinetti was reacting to first and foremost, explained the manifesto's pivotal principle: his total and irreversible rejection of all artistic heritage, and his encouragement to "spit every day on the Altar of Art."[13] The iconoclasm and violence of the manifesto owed a great deal to this Italian setting, but its poetic, philosophical, and political content issued for the most part from Marinetti's contacts with the Parisian circles he had been assiduously frequenting since 1893. The clean slate that he advocated echoed the thesis of an anarchism prevalent in the literary circles in which he moved in Paris. He borrowed the aspect of a "religion-of-the-future"[14] from the theories expounded by Proudhon, Bakunin, Kropotkin and Georges Sorel—whose *Réflexions sur la violence* were translated into Italian as early as 1908, the same year as their French publication. Anarchist activism inspired him to use tracts with varied and expressive typographies, printed on coloured paper.[15] Marinetti's anarchist persuasions impressed the artistic director of the Galerie Bernheim-Jeune, Félix Fénéon. As one who had himself planted bombs which, for their part, had nothing to do with aesthetics, it was Fénéon who organised the first exhibition of the Futurist painters in Paris in February 1912. "We affirm that the world's magnificence has been enriched by a new beauty: the beauty of speed. A racing car whose hood is adorned with great pipes, like serpents of explosive breath—a roaring car that seems to run on grapeshot is more beautiful than *The Victory of Samothrace*."[16] In its celebration of machines, the *Manifesto of Futurism* echoed a craze which, since the early 1900s, in France and Italy alike, had given rise to a new lyrical poetry. Back in 1904, in *La Beauté rationnelle* [Rational beauty], Paul Souriau had already asserted that "[in] a locomotive, an electric bus, a steamship, pending the first aircraft, it is human genius that is showing through". Adding: "In this weighty mass so scorned by aesthetes, an apparent triumph of brute force, there is as much thought, intelligence, purpose and, to sum it all up in a word, genuine art, as in an old master's painting or in a statue."[17] One year after Souriau, it was the turn of Mario Morasso, a contributor to the magazine *Poesia*, who, in *La Nuova Arma: La macchina* [The New Weapon: the machine], used the same terms as the *Manifesto of Futurism*: "It has been said about the *Victory of Samothrace*, winged and headless, set imposingly at the top of the grand staircase in the Louvre, that it sweeps up the wind within the pleats of its robe, and that the attitude of the body reveals the momentum of an easy, joyous run; well, and there is nothing irreverent about the comparison, when the iron monster shakes and stamps under the effect of the angry throb of its engine, it represents, in the very same way, a magnificent revelation of virtual power and, in an obvious way, shows the crazy speed of which it is capable."[18]

Marinetti was in touch with the Symbolist poets in Paris, through magazines such as *La Vogue, La Plume,* and *La Revue blanche*, to which he contributed, and duly brought to a head his passion for progress, and the spectacle of the modern city. In 1901, he had been introduced to these literary circles by Gustave Kahn, who was the author of *Esthétique de la rue* [Aesthetics of the Street], in which he extolled the 'fairylike glow' of illuminated signs which, from Giacomo Balla to Natalia Goncharova, would inspire Futurist painters. If there is a philosophical foundation for the *Manifesto of Futurism*, it lies somewhere in relation to Bergsonism. The doctrine of an *élan vital* [life force] ran like a thread through the *Manifesto*, just as it would permeate ensuing writings: "To the conception of the imperishable, the immortal, we oppose, in art, that of becoming, the perishable, the transitory, and the ephemeral."[19] It was from Henri Bergson that Marinetti borrowed his vitalist poetics, his conception of a perpetually changing ego, and his lyricism which culminated in a dream of cosmic fusion. After Marinetti, Umberto Boccioni, the main author of the *Manifesto of Futurist Painters*, would be the most 'Bergsonian' of the Futurists. His programme involving a pictorial "simultaneism", advocating the compenetration of bodies and objects, the fusion of space and time, aiming at the expression of a 'time-frame' fashioned by memory, owes everything to the French philosopher's theories. Boccioni would give one of his works the title *The Laugh* (1911, cat. 27), making reference to the book of the same title published by Bergson in 1900. Bergsonism came across to such a degree as the Futurists' own birthright that, in 1911, Ardengo Soffici deemed it necessary to reply to an article by André Salmon[20] that likened Cubist paintings and the theses of the theoretician of the life force: "It [Cubist theory] was in

U. Boccioni, C. Carrà, L. Russolo, G. Balla, G. Severini, *Manifeste des Peintres Futuristes* [the title under which *The Technical Manifesto of Futurist Painting* was published in French], 11 April 1910, p. 1

stark contradiction with the conclusions of his [Bergson's] philosophy."[21] The inventory of French sources in the *Manifesto of Futurism* would be incomplete if it left out Alfred Jarry and, thereby, disregarded the witty ingredient that is aptly associated with Marinetti's hyperboles and other braggartly boastings.

In March 1909, the Toulouse-based magazine *Poésie* responded to the *Manifesto of Futurism* with a *Manifeste du primitivisme*. It conducted a survey when it received Marinetti's text. Seen from Toulouse, there was an element of *déjà-vu* about Futurist iconoclasm: "We don't want to 'demolish Museums and Libraries, and fight moralism, etc.' We find that there are already more than enough politicians, MPs, senators, and even councillors, to deal with these tasks…"[22]

Devised as shock treatment, the *Manifesto of Futurism* had the anticipated effect in French literary circles. Writing in *La Nouvelle Revue française*, Jacques Copeau set the tone: "Those of our readers who have read *Le Figaro* of 20 February and, since then, the raft of futile banter about Mr. F.T. Marinetti's manifesto, cannot imagine that we should pay heed to this declamatory, incoherent and farcical prose… Mr. F.T. Marinetti's agitation merely illustrates a great paucity of reflection or a great thirst for advertisement. It can only be one of two things: either this young poet is sincere and deserves our smiling compassion or he is mocking himself and we feel something akin to a duty to say nothing about his indecent mystification."[23] "He should have called his manifesto not one of *Futurism*, but one of *Vandalism*", ranted Frédéric Mistral.[24] Parisian reactions resembled Cyrano-style tirades of Rostand. In the Circassian mode: "I persist in thinking that the *Manifesto* of our charming colleague Marinetti is a pure high-wire fantasy";[25] in the Darwinian genre: "Futurism is just another primitive, gorilla prejudice, since it presupposes some kind of fragment of art and poetry in Modern Life";[26] peremptory: "nothing more than a quip or, in words of one syllable, a *sham*";[27] mnemonic: "The surest future guarantee for a nation is *knowledge* of and respect for its past."[28]

Once the manifesto had been launched in Paris, Marinetti started Futurism's international promotion. He wrote a "Futurist Proclamation to the Spanish", a "Futurist Speech to the English" and gave lectures in London, Moscow, St. Petersburg, and Berlin. The German capital was snowed under by a cloud of tracts fluttering out of the taxi hired by Marinetti to crisscross the city.

The Futurist Painters

In Milan, one year after the publication of the *Manifesto of Futurism*, Marinetti contacted the painters Umberto Boccioni, Carlo Carrà and Luigi Russolo (in late January and early February 1910),[29] then he got in touch with Gino Severini who had been living in Paris since 1906. A new manifesto, launched in late February 1910, then backdated to the 11th of the month,[30] endowed Futurism with a pictorial component. "Boccioni, Russolo and I all met in the Porta Vittoria café, close to where we all lived, and we enthusiastically outlined a draft of our appeal. The final version was somewhat laborious; we worked on it all day, all three of us, and finished it that evening with Marinetti and the help of Decio Cinti, the group's secretary."[31] The painters Aroldo Bonzagni and Romolo Romani, who both signed the manifesto, actually left the movement right away; they were replaced by Giacomo Balla and then Severini.[32] On 18 May the text was published in its entirety in *Comœdia*. The version distributed in France was a combination of the *Manifesto of Futurist Painters*, dated 11 February, and the *Technical Manifesto of Futurist Painters* dated 11 April of that same year.

Its chief editor, Boccioni, gave the new manifesto a decidedly 'Bergsonian' tone: "The gesture which we would reproduce on canvas shall no longer be a fixed *moment* in universal dynamism. It shall simply be the *dynamic sensation* itself. Indeed, all things move, all things run, all things are rapidly changing."[33] Contradicting the analytical aim peculiar to Cubist painting, at the distance it assumes from its object, the Futurists demanded and insisted on a fusional form of communication, and invited people to plunge into the whirlwind of 'universal dynamism': "We would at any price re-enter into life."[34]

The *Technical Manifesto* advocated a "colourist's perception", laying claim to the legacy of Impressionism, and proclaiming: "painting cannot exist today without Divisionism."[35]

13 Marinetti quoted in Lista, *L'anarchiste*, op. cit., p. 98.

14 "Le devenir, voilà la seule religion!" See *Le Roi Bombance* (Paris: Mercure de France, 1905), quoted in Lista ibid., p. 46.

15 "The poster, the manifesto, the flyer—large, small, red, blue, orange, green—this is the kind of propaganda the anarchists like best!" See F. Dubois, *Le Péril anarchiste* (Paris: Flammarion, 1894), quoted in F. Roche-Pézard, *L'Aventure futuriste 1909–1916*, (Rome: École française de Rome, 1983), p. 44.

16 Marinetti, *Founding and Manifesto of Futurism*, trans. in U. Apollonio (ed.), *Futurist Manifestos* (London: Thames and Hudson,1973), p. 21.

17 P. Souriau, *La Beauté rationnelle* (Paris: F. Alcan, 1904).

18 Lista (ed.), *Marinetti et le futurisme. Études, documents, iconographie*, (Lausanne: L'Âge d'homme, 1977), p. 15.

19 Marinetti, *Nous renions nos maîtres les symbolistes, derniers amants de la lune*, trans. by R. W. Flint and A. A. Coppotelli as "We Abjure Our Symbolist Masters, the Last Lovers of the Moon", in Flint (ed.), *Marinetti: Selected Writings*. (London: Secker & Warburg, 1972), p. 67.

20 A. Salmon, "Bergson et le cubisme", *Paris-Journal*, 30 Nov. 1911, quoted in Boccioni, *Dynamisme plastique. Peinture et sculpture futuristes*, Lista (pref.), (Lausanne: L'Âge d'homme, 1975), p.120. Soffici's text describes, it is true, the Cubism of Braque and Picasso with which he was familiar. It conspicuously ignores the positions and writings of Albert Gleizes and Jean Metzinger, who, for their part show a real attachment to the philosophy of Bergson. In France, Tancrède de Visan had just published "La philosophie de M. Bergson et le lyrisme contemporain" (*Vers et prose*, Paris, vol. 21, April–May 1910, pp.125-40), whose formulae "dynamism of consciousness" and "perpetual development of the integral ego" would be taken up by Marinetti. Bergson was studied in Italy by Giovanni Papini and Giuseppe Prezzolini, gravitating around the magazine *La Voce*. In 1908, Papini translated Bergson's *Introduction à la métaphysique*, and, in 1909, a selection of writings under the title *La Filosofia dell'intuizione*, which greatly influenced Boccioni. In 1910, Soffici published *Le Due Perspective*, an essay devoted to Bergson. In Bologna, in April 1911, the French philosopher took part in the International Philosophical Congress, with great success.

21 A. Soffici, "Bulletin bibliographique", *La Voce* (Florence), 3rd year, no. 52, [Dec.] 1911, p. 726.

22 *Manifeste du primitivisme*, quoted in Lista *Futurisme. Manifestos…*, op. cit., p. 71.

23 J. C. [Jacques Copeau], "*Poesia* et le futurisme", *La Nouvelle Revue française*, Paris, no. 7, 1 Aug. 1909, pp. 82–3; Lista, *Marinetti. L'anarchiste…*, op. cit., p. 106.

24 Ibid.

25 J.Perdiel-Vaissière, ibid., p. 197; Lista *Futurisme. Manifestos…*, op. cit., p. 74.

26 A.-M. Gossez, ibid.

27 P. Vierge, ibid.

28 J. Reboul, ibid.

29 In his memoirs, *La mia vita*, 1945, Massimo Carrà (ed.), (Milano: Abscondita, 2002), p. 81, Carrà dates this meeting in February 1910: "It was in February that Boccioni, Russolo and I met Marinetti."

30 See Lista's essay *Genesis and Analysis of Marinetti's Manifesto of Futurism, 1908–1909* in this volume, p. 78.

31 Carrà, *La mia vita*, op. cit., p. 81.

32 A report on the manifesto was published in *L'Intransigeant* of 17 May 1910.

33 *Manifeste des peintres futuristes*, in *Les Peintres futuristes italiens*, exh. cat. Paris, Galerie Bernheim-Jeune & Cie, 5–24 Feb. 1912, p.16; *Futurist Painting: Technical Manifesto*, in *Exhibition of Works by the Italian Futurist Painters*, Sackville Gallery, London March 1912, republished in U. Apollonio, *Futurist Manifestos*, op. cit, p. 27.

34 Ibid., p. 28.

35 Ibid., p. 29.

This claimed connection distinguished it from a Cubism which, faithful to Cézanne's intellectualism, favoured formal analysis, paying for this effort at abstraction in the drastic scaling-back of the palette to shades of greys and browns. While with Picasso's *Les Demoiselles d'Avignon*, along with Braque's *Large Nude*, (1907–08, cat. 6), Cubism had been genetically linked with the study of the nude, the *Technical Manifesto* ended up with a conclusive: "We demand, for ten years, the total suppression of the nude in painting."[36]

Territorial Matters

The Futurist manifestos defined a theoretical space leading Cubism to shift the boundaries of its doctrine. In laying claim to the legacy of Post-Impressionism, and declaring themselves to be "Bergsonians", the Futurist painters stripped the "Cubist camp"—that occupied by the "Salon Cubists" (Albert Gleizes, Jean Metzinger, Fernand Léger, and Robert Delaunay) and their spokesman, Roger Allard—of two major components of their plastic and theoretical inheritance. Bergson and his philosophy were regularly quoted in the first writings which Gleizes, Metzinger and Allard devoted to Cubism. The philosopher was the mentor of the Abbaye de Créteil circle and that around *Vers et prose* magazine which they frequented. In the column devoted by Allard to the 1910 Salon d'Automne, he observed: "Thus is born, at the antithesis of Impressionism, an art which, with little concern for copying some incidental cosmic episode, offers to the viewer's intelligence, in their full painterly quality, the elements of a synthesis situated in the passage of time."[37] Writing further on that Gleizes' painting was aimed at "directly touching the viewer's memory", he gave a new example of the Bergsonism applied by the Cubist painters. Seen from this angle, the *Nude* exhibited by Metzinger that same year appears as a hommage to Bergson. With a clock close by, it becomes the allegory of the Bergsonian "time-frame", consubstantial with Cubism (the sum of visions staggered in time contrasted with 'mechanical' and linear time). A year later, Metzinger published "Cubisme et tradition", in which he declared: "Formerly a picture took possession of space, now it reigns also in time."[38] "Intuition",[39] "duration"[40] or "lived time" and other Bergsonian terms peppered the first theoretical formulations of Cubism.

Forced to reply to the theses of a conquering Futurism, the theoreticians of Cubism gradually rid their writings of all reference to Bergson's ideas (up until 1913, at least, the year which saw the birth of Orphism, also known as Orphic Cubism). The Post-Impressionist theory of colour, another theoretical reference 'confiscated' by the Futurist painters' *Technical Manifesto*, was also whisked away without trace, among writings devoted to Cubism (and this in spite of the divisionist past of Delaunay and Metzinger). The Futurist appropriation of Bergson and Post-Impressionism was compounded by the indifference of Braque and Picasso, who preferred the new mathematics and multi-dimensional spaces—opened up in the works of Henri Poincaré and popularised in the studios of Montmartre by the "mathematician Princet".[41] In deserting Bergsonian territory, and renouncing all immersion in the flow of time, as in that of sensations, Cubist theory took off towards the arenas of pure reason. In 1915, Daniel-Henry Kahnweiler embarked on the writing of *Weg zum Kubismus*, which lent Cubism its Kant-inspired catechism. From Carl Einstein to Alfred Barr, from Clement Greenberg to William Rubin, it was possible to develop the *doxa* of a Cubism obsessed with "purity", whose inner movement merged with that of the emancipation of reason. In his "Note sur la peinture,"[42] published in October 1910, Metzinger paid tribute to the work of Braque and Picasso. He was familiar both with the Montmartre studios and with "Salon Cubist" circles, and worked on the formulation of a compromise. He "cobbled together" a theory, reconciling Bergsonism and the new mathematics popularised by Princet: "With visual perceptions [Picasso] combines tactile perceptions."[43] For informed readers, this "tactility" referred to the analyses of Henri Poincaré who, in *La Science et l'hypothèse* (published in 1902), turned space into the outcome of a perceptive, visual and motor complex.[44] By specifying that Cubism gives rise to a "shrewd confusion of the successive and the simultaneous", Metzinger outlined a second line of thought anchored, this time unambiguously, in Bergsonism. This impulsive attempt at theorisation of a "Cubism" imbued with Bergsonian metaphysics angered Apollinaire, who came up with his own critique of the Salon as a call to order. "There has been some talk of a bizarre manifestation of Cubism. Badly informed journalists have gone so far as to speak of 'plastic metaphysics'. But the Cubism they had in mind is not

Pablo Picasso,
Portrait of Guillaume Apollinaire in Picasso's Studio at 11, boulevard de Clichy, Autumn 1910
Musée Picasso, Paris

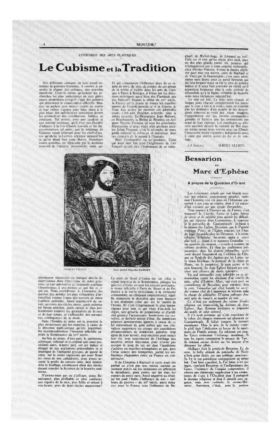

A. Gleizes, "Le Cubisme et la Tradition, Montjoie !"
(Paris), no. 1, 10 February 1913, p. 4

even that; it is simply a listless and servile imitation of certain works that were not included in the Salon and that were painted by an artist who is endowed with a strong personality, who, furthermore, has revealed his secrets to no one. The name of this great artist is Pablo Picasso. The Cubism at the Salon d'Automne was a jay in peacock feathers."[45]

Towards the end of 1910, Le Fauconnier's studio and the *Closerie des Lilas* café became meeting-places for painters and poets. "Le Fauconnier 'received' his friends and people interested in his works. On those evenings, you might meet Metzinger, Delaunay and his wife Sonia, Léger and Jean Marchand; some poets, Paul Fort, Jules Romains, Castiaux, P. Jean Jouve, Arcos, Mercereau, G. Apollinaire, Roger Allard, André Salmon", Gleizes recalled.[46] Those meetings brought to the fore the idea of a collective and public event: "It was at *La Closerie*, a few months later, that we and a few poet friends, Guillaume Apollinaire, André Salmon, Roger Allard, worked out the plan of action that was to bring to the organisation of the placement and hanging of the Indépendants a minor modification which, unbeknownst to us, would turn into a revolution."[47] The grouping of Cubist Young Turks in the same Salon room proceeded by way of the hanging committee. Le Fauconnier was promptly and unanimously elected chairman by those artists with a vote.[48] As pastmasters when it came to hanging, the "Cubists" were able to gather their works in one room, which would become the Salon's centre of attraction. For Salmon: "The great coup was made. It was no longer possible to ignore Cubism."[49]

In the report he wrote for the *Marches du Sud-Ouest* in June 1911, Allard emphasised the stylistic kinship among the works brought together in room 41 of the Salon des Indépendants: "The lingering adherents of individualism will be greatly shocked … to see a *group* firmly constituting itself, under the domination of a shared ideal, which is this: *To react with violence against the notation of the instant, the insidious anecdotalism and all the other surrogates that pass under the name of Impressionism.*"[50] The Cubism that the 1911 Salon des Indépendants saw emerge was to a great extent negatively defined in relation to the theoretical stances of Futurism. Allard had the Italian movement in mind when he ranted about "a certain composite Mallarmism [which] cannot keep up the illusion for very long and all the research geared in this direction is limited by the most restricted horizon."[51] When the critic noted the faithfulness of the painters in room 41 to the lessons of Poussin, Claude, Ingres and Corot, it was the *tradition* in which Cubist painting was incorporated that he cannily contrasted with Futurist *anti-tradition*. In that period when Cubism was attempting to come up with an initial theoretical definition, it was not good to express the slightest complacency with regard to Futurist values. Allard pointed to Delaunay's works: "Dissociating objects that form an aspect to the point of causing between them a moving interpenetration calls strangely to mind [a] certain Futurist manifesto which caused much mirth."[52] He spoke out against the ambition to place the viewer "at the centre of the visual fact"; a "Futurist conception" that Allard deemed "very hazardous". The fairies leaning over the cradle of Cubism were clearly keen to remove any Futurist spells.

The 1911 Salon des Indépendants held in Brussels was the occasion for a new event staged by the Cubist 'group'. Apollinaire, who a year earlier had denounced the "credit-taking" of the Cubism of the Salon des Indépendants, suddenly changed his tune:[53] "The new painters who jointly proclaimed their artistic ideal at this year's Indépendants in Paris accept the appellation of Cubists which has been bestowed on them."[54] When, a few months later, these same painters, along with a few others, gathered in room 8 of the Salon d'Automne, the poet, this time without any reservations, observed that "it does, however, constitute a school".[55] He added: "Cubism is the most noble undertaking in French art today."

A Red, White and Blue Cubism

For *Paris-Journal*, Metzinger wrote "Cubisme et tradition"[56] in which he declared that the new painting stemmed from an "exemplary discipline",[57] and in no way whatsoever denied the legacy of the past: "How could they break with tradition, an uninterrupted sequence of innovations in itself, those who, through their innovations, actually perpetuate it?"[58] To give a new pledge of the "nationalism" of his art, Metzinger reaffirmed that Cubism paid allegiance to the thinking of the most famous of French philosophers, Bergson: "Formerly a picture took possession of space, now it reigns also in time."[59]

36 Ibid., p. 31.
37 R. Allard, "Au Salon d'automne de Paris", *L'Art libre* (Lyons), no. 12, Nov. 1910, p. 442; trans. in Fry, *Cubism*, op. cit., p. 62.
38 J. Metzinger, "Cubisme et tradition", *Paris-Journal*, 16 Aug. 1911, p. 5; trans. in Fry, p. 67.
39 In "La sensibilité moderne et le tableau", which he wrote in 1912, Le Fauconnier gave the painter the task of "making available to intuition this power of suggestive astonishment and this inner life that painting can contain in its brilliance".
40 Gleizes and Metzinger, *Du "cubisme"*, 1912, (Saint-Vincent-sur-Jabron, Sisteron: Éd. Présence, 1980), p. 44: " … today, oil painting helps to express notions of depth, density, duration, all deemed inexpressible … "
41 Born in 1875, Maurice Princet had a science degree; he had prepared for the Polytechnique before becoming an insurance actuary and external consultant for the L'Abeille company. Fernande Olivier, Picasso's partner in the Bateau-Lavoir days, records in her memoirs (*Picasso et ses amis*, Paris: Librairie Stock, 1933, p. 138) that Princet paid daily visits to Picasso's studio. On Princet, see Décimo, *Maurice Princet, Le mathématicien du cubisme*, (Paris: L'Échoppe, 2007).
42-43 Metzinger, "Note sur la peinture" (September 1910), *Pan* (Paris), 3rd year , no. 10, Oct.–Nov. 1910, pp. 649–52; excerpts trans. in Fry op. cit, pp. 59–60.
44 H. Poincaré, *La Science et l'hypothèse* [1902], (Paris: Flammarion, 1968), p. 80: "Outside the data of sight and touch, there are other sensations which contribute as much as and more than them to the genesis of the notion of space. These are the ones everyone knows about, which accompany all our movements and which we usually call muscular".
45 Apollinaire, "À propos du Salon d'automne", *Poésie* (Toulouse), autumn 1910, p. 74, and *Écrits sur l'art*, in *Œuvres complètes (OC)*, P. Caizergues and M. Décaudin (eds.), (Paris: Gallimard, coll. "Bibliothèque de la Pléiade", vol. 2, 1991), p. 229; trans. in L. C. Breunig (ed.) *Apollinaire on Art: Essays and Reviews 1902-1918*, (New York: Da Capo Press, 1972), p. 114.
46-47 Gleizes, *Souvenirs*, op. cit., pp. 9-10.
48 Ibid., p. 11: "We had a list of candidates printed, among whom we featured … And then we thought that a few posters unrolled during the meeting … might strike a major blow. The writing of these posters was done by common agreement with our literary friends: 'Jeunes peintres vous êtes trahis.' Article 13 was denounced. Vote for the hanging committee whose names follow and the Salon will be organised in your interests."
49 Salmon, op. cit., p. 58. On view in room 41 were works by Delaunay, Gleizes, Le Fauconnier, Laurencin, Léger, and Metzinger.
50-52 Allard, "Sur quelques peintures", *Les Marches du'Sud-Ouest*, no. 2, June 1911, pp. 60-2.
53 Gleizes, *Souvenirs*, op. cit., pp.14–15: "Apollinaire himself was reticent at first about the term and it was only some time after the opening of the Indépendants, at the exhibition we held in Brussels, that he finally accepted for himself and for us the word Cubism, whereby we were described ironically by one and all."
54 Apollinaire, preface to the catalogue of the 8th Salon annuel des indépendants (Musée d'art moderne de Bruxelles, 10 June–3 July 1911, n.p.); trans. in Breunig, *Apollinaire on Art*, op. cit., p. 172.
55 Apollinaire, "Le Salon d'automne", *L'Intransigeant* (Paris), 10 Oct. 1911; Breunig, ibid., p.183. For Gleizes, the Cubism that triumphed in room 8 of the Salon d'Automne was an adulterated, distorted Cubism: "The whole lacked the homogeneity of room 41 [at the Salon des Indépendants]. The representatives of orthodox Cubism, Le Fauconnier, Léger, Metzinger and myself were side by side with artists who resembled us only remotely." (Gleizes, *Souvenirs*, op. cit., p. 21; trans. Fry, op. cit., p. 174).
56-59 Metzinger, "Cubisme et tradition", *Paris-Journal*, 16 Aug. 1911, p. 5; trans. Fry, *Cubism*, op. cit, pp. 66-7.

The conservative press was far from sharing the patriotic enthusiasm of the first champions of Cubism. After mocking painters whom it described as "*fumistes*" [layabouts] and "*farceurs*" [pranksters], it embarked on a campaign described by Apollinaire as 'hateful'.[60] Cubism was the talk of the town and became a national issue. The dean of Paris' City Council, Mr. Lampué, wrote an open letter to the Under-Secretary of State for Fine Arts, Léon Bérard, who, on 3 December 1912, summoned the Chamber of Deputies to warn the Nation against the Cubist peril. One Socialist deputy, Jules-Louis Breton, demanded that vigorous steps be taken: "It is absolutely inadmissible that our national palaces should be used for demonstrations of a character so clearly anti-artistic and anti-national."[61] The well-meaning declarations of another deputy from the Socialist ranks, Marcel Sembat, temporarily calmed tempers.

Apollinaire also rushed to the rescue of these artists suspected of anti-patriotism. Mindful of attacks from the conservative camp, and of threats of Futurist assimilation, he invented a 'Gothic Cubism': "Today's art is linked with Gothic art through all the genuinely French characteristics of the intervening schools, from Poussin to Ingres, from Delacroix to Manet, from Cézanne to Seurat, and from Renoir to the Douanier Rousseau, that humble but so very expressive and poetic expression of French art."[62] Some Cubists hastened to illustrate these ideas. Pierre Dumont painted a *Cathédrale*, Gleizes the *Cathédrale de Chartres* (1912, cat. 9), Luc-Albert Moreau painted Gisors cathedral, and Delaunay set up his easel opposite the towers of Laon.

On "Cubism"

For Apollinaire, for the press and for the general public, ever since the Salon des Indépendants, a Cubist manner of painting had undoubtedly existed, but this painting still had neither manifesto nor doctrine. To fill this gap, in late 1911 Gleizes and Metzinger wrote *On "Cubism"*, which would be published the following year by Eugène Figuière. To dissociate themselves from the Futurists, both artists had to flaunt their distance from that part of the Impressionist and Symbolist past which they had hitherto shared with Italian painters.

In 1906, Gleizes had been one of the founders of the Abbaye de Créteil, a select group of artists sharing Dreyfusard persuasions, libertarian ideals, and aesthetic values rooted in Symbolism. Writers and painters in this group shared their research into a new poetics, fuelled by the energy peculiar to the modern world, its metropolises, and its mass movements. Their literary heroes were Jules Romains (whose poems *La Vie unanime* had been published by the Abbaye in 1908, Emile Verhaeren[63] and Henri-Martin Barzun.[64] "Unanimism", which posterity would associate with the spirit of Créteil, owed much to the ideas of Bergson.[65] The aesthetics that claimed to espouse those ideas wanted to capture the pace peculiar to modern cities, aimed at the transcription of collective energies. According to Marinetti's conception, Futurism was one of the possible variants of this Unanimism. The Italian writer, like the Futurist poet Valentine de Saint-Point, had been among the Abbaye's adherents. Apollinaire would not forget that connection, when, in the margin of the catalogue for the Parisian exhibition of the Italian Futurist painters, he emitted a furious "Jules Romains!"

In the very first pages of their book, Gleizes and Metzinger were keen to remove any trace of (Bergsonian) "metaphysics", which Apollinaire in turn suspected in Salon Cubism. To demonstrate that their art had indeed left the mists of metaphysics behind it, Gleizes and Metzinger drew up a genealogy of Cubism rooted in realism: "To assess the importance of Cubism, we must go back to Gustave Courbet … who would usher in a realist aspiration involving every manner of modern effort."[66] After Courbet came Manet, from whom "the realist aspiration turned into superficial realism and profound realism. The latter belonged to the Impressionists: Monet, Sisley, etc., and the former to Cézanne."[67] Gleizes and Metzinger declared further: "To understand Cézanne is to foresee Cubism."[68] By thus repudiating any linkage with Impressionism, the authors responded to the Futurist painters' *Technical Manifesto*, which observed "painting cannot exist today without Divisionism".[69] *On "Cubism"* opposed this assertion with a mordant riposte: "After the Impressionists had consumed the last paths of Romanticism, people believed in a rebirth if not the advent of a new art: the art of colour. They were delirious."[70]

Cover of the book by A. Gleizes and J. Metzinger, *Du "cubisme"*, Paris, Eugène Figuière, 1912

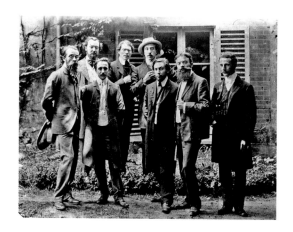

Members of the Abbaye de Créteil, 1909
First row, from left to right: Charles Vildrac,
René Arcos, Albert Gleizes, Henri-Martin Barzun,
Alexandre Mercereau; second row, left to right:
Georges Duhamel, Berthold Mahn, Jacques d'Otémar

It was in displaying its indifference to the subject that Cubism, as defined by Gleizes and Metzinger, kept its greatest distance from Futurism (a distinction to which Apollinaire would ultimately and insistently return). On "Cubism" challenged the legacy of Manet, who had diminished the value of the anecdote to the point of painting "any old thing."[71] "We recognise a forerunner of this, we for whom the beauty of a work resides expressly in the work and not in what is merely its pretext."[72] When the two painters started questioning "those who muddle plastic dynamism with the hubbub of the street",[73] they revealed the extent to which one of the issues of their essay was to thwart Futurist Painting: Technical Manifesto. At the precise moment when Gleizes and Metzinger were dotting the 'i's and crossing the 't's of their text illustrating the existence of a Cubist painting and theory, the Futurist painters were preparing a new attack in the very heart of Paris. Boccioni announced it in a letter written in December: "We Futurist painters are working relentlessly to complete our preparations for our show at Bernheim-Jeune, the battlefield where, in two months' time, we shall array our canons."[74]

The Trip to Paris

While they were writing their manifesto, in early 1910, the Milan Futurists could only get a rudimentary idea about Cubist painting, whose existence remained discreet. It was by way of the reproductions to an article by Allard published in June 1911[75] that Boccioni discovered the works of Le Fauconnier (Village), Gleizes (Nude), Léger (Nudes in the Forest, cat. 18) and Delaunay (Eiffel Tower, 1910).[76] This lack of knowledge deeply shocked Soffici when, in June 1911 at Milan, he came upon the first exhibition of Futurist painters.[77] He described himself as flabbergasted because he reckoned they were "silly, ugly braggarts."[78] Like Severini, he was a regular visitor to Picasso's studio and was thoroughly acquainted with the situation of Parisian painting. Both artists urged the Milanese artists to find out about the developments of Cubism, and go to Paris to visit Salons, galleries and studios. Boccioni paid heed to these recommendations, and wrote to Severini in the summer of 1911: "Get all the information you can about the Cubists, and about Braque and Picasso. Go to Kahnweiler's. And if he's got photos of recent works (produced after I left), buy one or two. Bring us back all the information you can."[79] His documentation on Cubism was enhanced by the article that Soffici wrote, in August, about the painting of Picasso and Braque in his magazine La Voce.[80] At that time, Soffici was one of the best-informed connoisseurs of Cubism. He had been spending time with Picasso since 1901, enjoying special access to his studio in the period when Picasso invented Cubism. As a painter and art theoretician, he was among the very few people to defend Les Demoiselles d'Avignon, at a time when that picture was systematically offending its rare viewers. Soffici, along with Apollinaire, advocated the idea of a methodical (analytical) Cubism, opening the way to a "pure painting". In his article he wrote that Picasso "no longer cared to depict nature in its appearances in his paintings, choosing instead to show in them a tissue of pure pictorial values". His text vigorously distinguished between the art of Picasso and Braque and the art of their followers who fail to understand "even one of the profound aesthetic reasons that guide the investigations of Picasso and Braque". These followers, he wrote, "have nonetheless taken to distorting, geometrising and cubing, aimlessly and haphazardly, perhaps in the hope of hiding behind triangles and other figures their innate, inextricable and fatal banality and academicism!"

"Boccioni and I were swiftly persuaded that with this show in Paris we were staking our all; for a flop would have meant kissing our fine aspirations goodbye. This is why we decided to go to Paris, to see what the art situation there was like."[81] In September 1911, at the Galerie Kahnweiler, they saw pictures by Braque and Picasso, met Apollinaire and visited the Salon d'Automne, in particular room 8, which housed the canvases of Gleizes, Léger, and Metzinger.[82]

Back in Milan, Boccioni's discovery of Cubism prompted him to paint a second version of his States of Mind (1911, cat. 20-25). A comparison between the two triptychs showed a development of more than stylistic issues. From the initial studies, imbued with the sinuous qualities of Symbolist art, to the second, which incorporated Cubist crystallography, it was possible to read a transfer in Boccioni's art, proceeding from a model marked by the art of Central Europe (Vienna, Munich) to another model, newly aware of

60 "Now they are stirring up hatred", wrote Apollinaire ("Demain a lieu le vernissage du Salon d'automne", L'Intransigeant (Paris), 30 Sept. 1912; Breunig, Apollinaire on Art, op. cit, p. 247).
61 Quoted in P. F. Barrer, Quand l'art du xxᵉ siècle était conçu par des inconnus : L'histoire du Salon d'automne de 1903 à nos jours, (Paris: Arts et Images du monde, 1992), p. 95, trans. by J. M. Todd, in M. Antiff and P. Leighten (eds.), A Cubism Reader: Documents and Criticism, 1906–1914 (Chicago and London: University of Chicago Press, 2008), p. 396.
62 Apollinaire, "La peinture nouvelle. Notes d'art", Les Soirées de Paris, no. 4, May 1912, pp. 114–15; Breunig, op. cit., p. 225.
63 Author of Les Villes tentaculaires (1895), and Les Forces tumultueuses (1902).
64 Author of La Terrestre Tragédie (1907).
65 The story of the birth of Unanimism has been handed down to posterity. One evening in October 1903, walking down the rue d'Amsterdam, Jules Romains suddenly had "an intuition about a vast and elementary being, in which the street, the vehicles and the passers-by formed the body, and whose rhythm surpassed or covered the rhythms of individual consciences" (quoted in F. Azouvi, La Gloire de Bergson. Essai sur le magistère philosophique, (Paris: Gallimard, 2007), p. 108. One of Jules Romains' poems, published in La Phalange (Paris, no. 1, 15 July 1906, p. 175), was titled "Intuitions".
66 Gleizes and Metzinger, Du "Cubisme", op. cit., p. 38.
67 Ibid., p. 39.
68 Ibid., p. 41; trans. Fry, op. cit., p. 105.
69 Futurist Painting: Technical Manifesto; Apollonio Futurist Manifestos, op. cit., p. 28.
70 Gleizes and Metzinger Du "Cubisme", op. cit., p. 54.
71 Ibid., p. 39.
72 Ibid.
73 Ibid., p. 68.
74 Boccioni, letter 1, Dec. 1911, former Apollinaire collection, cat. 87.
75 Allard, "Sur quelques peintres", Les Marches du Sud-Ouest, no. 2, June 1911, pp. 57–64.
76 See M. Calvesi, Il Futurismo. La fusione della vita nell'arte, (Milan: Fratelli Fabri Editore, 1975), pp. 82–3.
77 The exhibition was held in the Padiglione Ricordi.
78 Soffici, "Arte libera e pittura futurista", La Voce (Florence), vol. 3, no. 25, 22 June 1911, p. 597.
79 Letter from Boccioni to Severini datable summer 1911, Museo di Arte moderna e contemporanea di Trento e Rovereto, Severini Archives, Sev. 1.3.2.8.
80 Soffici, "Picasso e Braque", La Voce (Florence), 3, no. 34, 24 August 1911, pp. 635–6, trans. in Antiff and Leighten, op. cit., pp. 137, 140.
81 Carrà, L'Éclat des choses ordinaires (Paris: Images modernes, 2005), p. 104.
82 Carrà, La mia vita, op. cit., p. 94: "The Salon d'Automne had just opened and in it the Cubists showed their works for the first time in their own room. Present were Léger, Gleizes, Le Fauconnier, Metzinger: Picasso and Braque, who were missing, would probably have been the most interesting twosome. But we saw their works at Kahnweiler's, who had been their dealer for some time by then."

the progress made by the Paris avant-garde. A Cubist-inspired drawing, conceived in Paris, was the sketch for *The Forces of the Street* (1911, cat. 31).[83] Another of his canvases, *The Street Enters the House* (1911, cat. 26), was inspired by a Delaunay picture (an Eiffel Tower), that Severini probably showed him during his stay in France.[84]

During their trip to Paris, the Futurist painters and the Galerie Bernheim-Jeune finalised the arrangements for an exhibition of their works in early 1912. In the gallery's director, Fénéon, lay a particularly well-meaning interlocutor. He introduced himself as a "Turin Burgundian"—he was actually born in Italy— and had, since 1906, been running a new section at Bernheim-Jeune, dedicated to contemporary art. A year after being appointed, he was promoted to the position of artistic director of the new gallery. Fénéon had been one of the pioneers of Parisian Symbolism. In 1886, with Gustave Kahn, Charles Henry, and Jules Laforgue, he had founded the magazine *La Vogue*. His rationalist art criticism drew inspiration from Henry's theories. Fénéon, a convinced anarchist, had been linked to the wave of terrorism that struck France in the 1890s.[85] Suspected of having placed a bomb in the Hotel Foyot's restaurant, he had been at the centre of a famous trial. His intelligence, wit and literary relations—Mallarmé had stood in the witness box to give evidence in his favour—had all contributed to his acquittal. Fénéon's past as a critic and activist meant that he was keen to extend a favourable welcome to the Futurists. Were they not, after all, updating the values that he himself had keenly championed in the days of Symbolism? The Italian painters took up the torch of Post-Impressionism which he had historically promoted. Their pictures also attested to their sympathy for the anarchist cause.[86]

The Futurism which invited people to "destroy museums" echoed Fénéon's youthful dream of seeing the Luxembourg museum consumed by fire: "We would applaud a fire cleansing the Luxembourg shed, if it weren't for the fact that in it are piles of documents crucial for future monographs on the follies of the nineteenth century."[87] The "total art" project, with Marinetti as its self-appointed promoter, echoed the programme of Paul Fort's multi-sensory Théâtre d'art hailed by Fénéon in his time: "Sprays … spread about the room aromas of incense, white violets, hyacinths, lilies, acacia, lilies-of-the-valley, syringa, orange blossom and jasmine, while the music of Flamen de Labrély played. And under the coalition of these chromatic, auditory and sweet-smelling forces, released by M. P.N. Roinard, the onlooker abandoned himself to the words of Solomon."[88] In 1913, Fénéon's fidelity to the Symbolist project of fusing arts would lead him to offer the walls of the Galerie Bernheim-Jeune to the 'Orphic' paintings of Morgan Russell and Stanton Macdonald-Wright.[89]

Portrait of the Artist as a Tycoon

In early February 1912, the Futurist artists were in Paris for the opening of their exhibition. Standing on either side of Marinetti, looking at a camera, they duly posed for posterity. Their clothes were befitting of new society tycoons. Apollinaire was up in arms over their prosperity, which he saw as ostentatious: "I met two Futurist painters: Messrs. Boccioni and Severini. … These gentlemen wear very comfortable English-cut clothes. Mr. Severini, a Tuscan, is shod in open-toed shoes and his socks are different colours."[90] The poet lost no time in proceeding from observation to intent: "The Futurist artists, supported by the ample funds of the *Futurist movement*, whose headquarters are in Milan, are doing very nicely financially. At the same time, most of the young Cubists, whose art is the most noble and most lofty existing today, are abandoned by all, ridiculed by practically every art critic, and living at best in semi-poverty, at worst in the most abject penury."[91]

On 5 February, the day of the opening, neon letters cleaved the Paris night: *Galerie Bernheim-Jeune–Exposition des peintres futuristes–Boccioni–Carrà–Russolo–Severini*.[92] Even though Balla was the first of the Futurist painters to have extolled electric lighting, his name did not feature on the gallery's façade, because Boccioni had decided to remove his *Street Lamp* from the exhibition.[93]

The 'Symbolist old guard' greeted the show enthusiastically. Gustave Kahn noted with satisfaction that Charles Henry's dynamogenic theories, implemented in their day by both Seurat and Signac, were conscientiously applied by Italian painters who found in them a method capable of expressing the dynamism of the modern city.[94] Carlo Carrà was surprised at the reverberations from the Parisian press: "I was walking along the Boulevard des Italiens, when, as I passed in front of a newspaper stand, I had the pleasant surprise of seeing on the front page of the *Journal*[95] the reproduction of my picture

Cartoon of the *Exhibition of Italian Futurist Painters*, *Gil Blas* (Paris), 13 February 1912, p. 3

From left to right: Russolo, Carrà, Marinetti, Boccioni, Severini in Paris in February 1912 for the opening of the *Exhibition of Italian Futurist Painters*, Galerie Bernheim-Jeune & Cie, Paris, 5-24 February 1912

The Funeral of the Anarchist Galli (1910–11, cat. 32)."[96] Pathé Brothers films did a reportage that Carrà would later see in Italian cinemas.

L'Intransigeant observed that the public, for its part, turned up at the appointed time set by the Bernheim gallery: "There are no two ways about it, the Salon des Futuristes is always full. A new throng ceaselessly moves along looking at the canvases—there are thirty-six![97]—being exhibited by Marinetti's disciples. Elegant cars, limousines and coupés, purr in front of the door. Plumed women come and go; … they will talk only about this… And this is what success and glory are! The Cubists and the pupils of Mr. Matisse are starting to make a song and dance about it."[98] Louis Vauxcelles took mischievous pleasure in emphasising this success: "So let's talk about the Cubists again… They're not as 'tough' as they were a year ago. Just think! Futurism suddenly arrived and has ousted them. … One of them—a frank follower of all the formulae risked in the past fifteen years—was saying the other morning: 'It's true, yes! We're outmoded—yesterday's news. *We are now classics*'. Savour the word, I beg you; it's as beautiful as Homer."[99]

The Cubists were irked by this Futurist fuss and success. In the report he gave to *Le Petit Bleu*, the future artilleryman Apollinaire arrayed his big guns: "The Futurists … are scarcely interested at all in plastic problems. Nature does not interest them. Their chief concern is the 'subject'. They want to paint 'states of mind' [a direct allusion to Boccioni's triptych]. That is the most dangerous kind of painting imaginable. It will inevitably lead the Futurist painters to become mere illustrators."[100] Another critic, close to the Cubists, André Salmon, joined in this counter-attack: "Futurism… *Opera buffa* claiming to be 'seriosa'."[101] His attacks were justified in the name of self-defence. They answered the provocations of the Futurists who, in the introductory essay in their catalogue, railed against Cubist painters who, in their view, "continue to paint objects motionless, frozen, and all the static aspects of Nature; they worship the traditionalism of Poussin, of Ingres, of Corot, ageing and petrifying their art with an obstinate attachment to the past, which to our eyes remains totally incomprehensible." The Futurist accusation did not stop there, either: "Is it indisputable that several aesthetic declarations of our French comrades display a sort of masked academicism. Is it not, indeed, a return to the Academy to declare that the subject, in painting, has a perfectly insignificant value?" The text continues: "To paint from the posing model is an absurdity, and an act of mental cowardice, even if the model be translated upon the picture in linear, spherical and cubic forms."[102] As if these provocations were not enough, the catalogue stated that the Futurist painters were henceforth "placed … at the head of the European movement in painting".[103]

Cubist Futurisations

The 1912 Paris Salons (Salon des Indépendants, d'Automne, de la Section d'or) which came in the wake of the show at the Galerie Bernheim-Jeune attested to the ambiguity of the answer—somewhere between rejection and assimilation—of the Parisian artists to the principles of Futurist painting.

The Salon des Indépendants which opened on 20 March, that is a month after the opening of the exhibition of Futurist paintings, brought an answer to both their proposals and their provocations. The works shown by the Cubists were of two sorts. Some seemed directly to appropriate Futurist declarations inviting people to reject tradition, and to ban the nude in painting "for ten years". Through their monumentality, which likened them to academic works, through their subjects, inspired from classical models, and through the importance they attached to the nude, Delaunay's *The City of Paris* (1910–12, cat. 54) and Gleizes' *Bathers*[104] responded to these categorical proscriptions. By placing his figures in a context conjuring up the golden age of classical culture, Gleizes' work was a denial of "Futurist anti-tradition". By coming up with a modern interpretation of the motif from a Pompeiian fresco, the Three Graces, which he set in the centre of his composition, Delaunay replied explicitly to the Futurists' attacks against "antique dealers" and "archaeologists". Not without mischief, Apollinaire wrote that with that picture Delaunay was once more making a link with an art that had been "lost with the great Italian painters".[105] In spite of his borrowings from the 'classical' iconographic repertory, *The City of Paris* displayed above all his quest for synthesis, by its stylistic treatment, and his inclusion of the most 'modern' features of the urban landscape. Such an ambition was underscored by the critic Albert Croquez when he wrote: "An enormous canvas by Robert Delaunay titled *The City of Paris* seemed to me to stem from Cubism and from Futurism".[106] The Cubo-Futurist tone of the 1912 Salon was not

83 Study for *The Forces of the Street*, 1911, pencil on paper, 43.8 x 37 cm, Civiche Raccolte d'Arte, Milan.

84 See M. Kozlov, *Cubism-Futurism*, (New York: Charterhouse, 1973), p. 156.

85 The period 1890 to 1894 was an active one in French anarchist circles.

86 See the riot that took place during the burial of the anarchist Galli, killed in Milan during the general strike of 1904, which became the subject of a monumental painting by Carrà *The Funeral of the Anarchist Galli*, 1911 (cat. 32). In his memoirs, Carrà described his anarchist past: "I fell in with the anarchists when I was barely 18, and I, too, started to dream about the 'inevitable changes of human society, free love, etc." (Carrà, *La mia vita*, op. cit., p. 31).

87 F. Fénéon, "Le Musée du Luxembourg", *Le Symboliste*, 15 Oct. 1884, quoted in J. J. Halperin, *Félix Fénéon. Art et anarchie dans le Paris fin de siècle*, (Paris: Gallimard, 1991), p. 181.

88 Report in December 1891, quoted in Halperin, ibid., p. 222.

89 Orphic in their conception, even though theirauthors, in the preface to the exh. cat. (*Les Synchromistes. Morgan Russell et S. Macdonald-Wright*, Paris, Galerie Bernheim-Jeune & Cie., 27 Oct.–8 Nov. 1913), refute this connection.

90 Apollinaire, *Anecdotiques* (November 1911), (Paris: Librairie Stock, 1926), p. 45.

91 Apollinaire, "Futurisme", *L'Intermédiaire des chercheurs et des curieux* (Paris), no. 1342, 10 Oct. 1912, pp. 477–8; in Breunig, *Apollinaire on Art*, op. cit., p. 256.

92 Carrà, *La mia vita*, op. cit., p. 97.

93 This episode is recounted by Boccioni, in a letter to Carrà, in early January 1913: "Balla flabbergasted us, for, not content with launching a Futurist campaign as you well imagined him capable of, he is hell-bent on a complete change. He is rejecting all his works and all his working methods. … He admires us and shares our ideas about everything. … He said to Pallazzeschi: 'They didn't want me in Paris and they were quite right; they are much more advanced than I am but I'll work on it and I'll also improve!'" (quoted in Lista, *Giacomo Balla futuriste*. Lausanne: L'Âge d'homme, 1984, p. 44.)

94 "I met Gustave Kahn, a most affable person, who, before leaving us, invited us all to dine at his home the day after [the opening]." (Carrà, *La mia vita*, op. cit., p. 97).

95 In French in the Italian text.

96 Carrà, *La mia vita*, op. cit., p. 97.

97 According to the *Archivi del Futurismo*, put together by Drudi Gambillo and Fiori (Rome: De Luca, 1958), vol. 1, p. 477, just 32 pictures were exhibited. In fact 34 were put on view.

98 Le Wattman, "On dit que…", *L'Intransigeant* (Paris), 14 Feb. 1912, p. 2; quoted in Lista, *Futurisme. Manifestes*, op. cit., p. 49.

99 Vauxcelles, "Au Salon des indépendants", *Gil Blas* (Paris), 19 March 1912, p. 2; Apollinaire, *Les peintres cubistes*, op. cit., p. 216.

100 Apollinaire, "Les Futuristes", *Le Petit Bleu* (Paris), 9 Feb. 1912; Breunig, *Apollinaire on Art*, op. cit., p. 203.

101 Salmon, *Souvenirs sans fin*, (Paris: Gallimard, 1956), p. 227.

102 Boccioni et al., "Les exposants au public", in *Les Peintres futuristes italiens*, exh. cat. Paris, Galerie Bernheim-Jeune & Cie, Feb. 1912, pp. 2–3; as "The Exhibitors to the Public", in *Exhibition of Works by the Italian Futurist Painters*, London, Sackville Gallery, Mar. 1912, republished in Apollonio, *Futurist Manifestos*, op. cit., p. 46.

103 Ibid., p. 1; ibid., p. 45.

104 Gleizes, *Bathers*, 1912, oil on canvas, 105 x 171 cm, Musée d'Art moderne de la Ville de Paris.

105 G. Apollinaire, "Le Salon des indépendants", *L'Intransigeant* (Paris), 19 Mar. 1912; Breunig. *Apollinaire on Art*, op. cit., p. 212.

106 A. Croquez, "Le Salon des indépendants", *L'Autorité*, 19 March 1912; quoted in *Robert Delaunay*,

lost on Severini, who noted in his memoirs: "The Salon des Indépendants of that year, as well as the Salon d'Automne which followed, revealed not only the influence of Futurist ideas on several significant artists, but also a veritable switch in artistic atmosphere in general: the museum hues of the early Cubist canvases had vanished, giving way to the brighter colours of the prism."[107] As a champion of the use of these "brighter colours", Delaunay showed one of his *Eiffel Tower* paintings, as well as *The City of Paris*. In the context immediately following the exhibition of Futurist painters, this hanging of a work whose formal principles dated back to 1909 seemed like a clarifying statement. Delaunay declared that his own research had anticipated that of the Futurists. He confessed to sharing a number of values with them: "What they say is good", he confided in February 1912 to Sam Halpert.[108]

Léger was also among the Cubists whose canvases shown at the Salon des Indépendants suggested that "what the Futurists are saying is good." In his study of Léger and the avant-garde, Christopher Green puts forward the hypothesis that, between the opening of the exhibition at the Galerie Bernheim-Jeune and that of the Salon des Indépendants, Léger managed to 'futurise' *The Wedding* (1911–12, cat. 55).[109] Actually, the two pictures he submitted to the Indépendants contain a number of features that recur in the works of the Italian painters. *The Wedding* is formally organised with two zigzagging axes from which a series of acute angles fan out. This dynamic structure, give or take its orientation, corresponds to the introductory essay in the catalogue for the Futurist painters' exhibition, which refers to the "horizontal lines, fleeting, rapid and jerky, brutally cutting into half-lost profiles of faces or crumbling and rebounding fragments of landscape".[110] Fitted into this dynamic grid, Léger's figures seem driven by the swaying, lopsided motions of a dance, or else caught in different phases of their descent of a staircase.[111] In 1912, the painter developed a colour scheme which drew him nearer to Futurist works than to Braque and Picasso, works about which he related Delaunay's comment declaring that they were painted "with spiders' webs".[112] Even more so than by their use of colour, it was by their renewed definition of form that Léger's 1912 pictures marked their proximity to Futurist ideas.

The Smokers and *The Wedding* saw their forms dissolved in plumes of white smoke, partly hidden by the covering of bulbous clouds. The Futurists' *Technical Manifesto* had announced this formal instability: "Our bodies penetrate the sofas upon which we sit, and the sofas penetrate our bodies. The bus rushes into the houses which it passes, and in their turn the houses throw themselves upon the bus and are blended with it."[113] In the name of the 'simultaneity of ambiances', the preface to the catalogue for the show at the Galerie Bernheim encouraged painters to "the dislocation and dismemberment of objects, the scattering and fusion of details, freed from accepted logic and independent of one another."[114] In his *States of Mind* (in the panel *The Farewells* [1911, cat. 21, 24]), Boccioni had illustrated this blending by a vaporisation of forms, caused by the plume of smoke from a locomotive. This '*nuagisme*' [cloudism] enjoyed an unexpected good fortune in the Cubist pictures of 1912 and 1913. It helped to dissolve the 'Cubist grid', and opened forms up to Futurist 'compenetrations'. In the *Hunter* which he showed at the 1912 Salon des Indépendants, Le Fauconnier used the smoke wafting from a gun to merge the features of his composition.

From *Aesthetic Meditations* to *Cubist Painters*

The upheaval caused by the Parisian exhibition of Futurist painters generated a shock wave that reverberated as far as the desk upon which Apollinaire was writing his "Aesthetic Meditations". The poet initially intended to illustrate the kinship between his own research and that of the most advanced painters of his day and age. Like *Alcools*, which was a compilation of his various poems, this collection was an anthology. (It borrowed almost verbatim an introduction prepared for the catalogue of the 3rd Exhibition of the "Cercle d'art moderne" presented at Le Havre's city hall in June 1908, which essentially featured Fauve works). Under the pressure of circumstances, the book turned into a study of Cubism. Not without some resistance, Apollinaire rallied to the opinions of his publisher Eugène Figuière, who had the words *Les Peintres cubistes* [Cubist Painters] printed in large letters on the book's cover. In a letter dated 30 July 1915 written to Madeleine Pagès, the poet observed: "The second part of the title which ought to have been a sub-title has been printed in much larger letters than the first, and has thus become the title."[115]

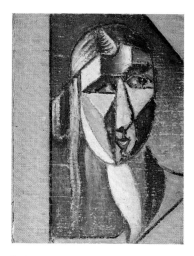

Binding painted by J. Metzinger for *Les Peintres cubistes* by G. Apollinaire

Cover of the book by G. Apollinaire, *Les Peintres cubistes*, Paris, Eugène Figuière, 1913

Annoyed by the provocations of the Italian painters, Apollinaire counter-attacked. In the chapter devoted to Léger, Futurist dynamism became "a grotesque frenzy, the frenzy of ignorance"[116] At the exhibition in the Galerie Bernheim-Jeune, he had already railed at the 'silliest' of the declarations uttered by the Italian painters demanding "for ten years, the total elimination of the Nude in painting".[117] This "silliness" was still uppermost in his mind when, in *Cubist Painters*, he pointed out that "Duchamp is the only painter in the modern school who is nowadays (autumn 1912) concerned with the nude".[118]

So it was in the name of a sudden defensive reflex that the *Aesthetic Meditations* were turned into *Cubist Painters*. This Cubism, supported by Apollinaire for its first public showing, and to which his name was thenceforth linked, found itself in the crossfire of the conservative press and the Futurist avant-garde alike. This pressure prompted him to turn his new magazine, *Les Soirées de Paris*, into the militant organ of the Cubist cause. "Du sujet dans la peinture moderne" [On the Subject in Modern Painting], which he published in February 1912 (the article would become chapter two of *Cubist Painters*) was an address to the Futurist painters. For Apollinaire, the clash between Cubism and Futurism could be summed up in the dialectics of formalism and iconicity. To single out the Italian painters' attachment to the subject, he described the recent evolution of Picasso's art towards a "pure painting", extolling a Cubism which would be "pure painting, just as music is to pure literature."[119]

Braque's and Picasso's *papiers collés* , and the evolution of Cubism in its 'synthetic' phase had been, for Apollinaire, the first manifestations of this "pure painting". This 'purity' was only relative, however. In April 1912, Delaunay painted his first *Windows*. To describe these canvases, Apollinaire came up with the term "Orphism". This new art, for which colour played a vital role, reinvented Charles Henry's laws of "dynamogenics", and Michel Eugène Chevreul's law of 'simultaneous contrasts'. It reconciled French avant-garde painting with the legacy of Impressionism and Post-Impressionism, for a moment confiscated by the Futurists. With the chapter in his *Cubist Painters* devoted to Orphism, Apollinaire, reluctantly, invented the first form of Cubo-Futurism. No sooner was it out in the open than the Parisian 'duel' between Cubism and Futurism was settled by a synthesis of the two movements.

A French Convert to Futurism

The majority of Parisian artists may have vigorously rejected any links with Futurism, but some of them were not afraid to enrol amid their ranks. Félix Del Marle was one such. He contacted Severini early in 1913. On 10 July, he launched his *Futurist Manifesto Against Montmartre*, which was first plastered over the city's walls, then published in the 13 July issue of *Paris-Journal* and, two days later, in *Comœdia*. In August the text received its Futurist blessing: it was reproduced in French in the magazine *Lacerba*.[120] After paying tribute to Futurist iconoclasm—"INTREPID WRECKERS!!! / GET OUT THE PICKS!!! / MONTMARTRE MUST BE DESTROYED!!!"[121]—Del Marle described the philosophical foundations of the movement he had just joined: "Everything is moving, everything is changing fast. As the philosopher Bergson puts it, 'Everything is change and flight.' Nothing is static. The gesture we wish to reproduce on canvas shall no longer be a fixed split-second of universal dynamism (which, in a word, becomes a symbol), it will simply be the dynamic *sensation* of itself, and not the cinematographic reconstruction of movement."[122] Driven by the fervour of the Futurist convert, Del Marle had to cross swords with the Cubists: "Over and above the Synthesists and the Cubists, whose aesthetics, through the negation of colour and subject, reveals a masked academicism, we shall seek out a style of movement, something which has never been attempted before us."[123]

His most ambitious Futurist work, *The Port* (1913, cat. 53, begun in the winter of 1913-14), illustrates the complexity and the serried interweaving of the links between Cubism and Futurism. The picture echoes Picasso's *Souvenir du Havre* (1910–11), itself a work created in response to Severini's *Memories of a Journey* (cat. 46), inspired by a reading of Bergson.

Valentine de Saint-Point was another leading figure of French Futurism. The echo given by Futurism to her declarations, which anticipated those of women's liberation movements, sufficed to remove all suspicion of 'machismo' with regard to Marinetti's

1906–1914. De l'impressionnisme à l'abstraction, exh. cat., Musée national d'art moderne, Paris, 1999 (Paris: Éd. du Centre Pompidou, 1999), p. 243.
107 Severini, quoted in "Apollinaire et le futurisme", *XXᵉ Siècle* (Paris), no. 3, June 1952, p. 14.
108 Letter from Delaunay to Halpert, February 1912 (BnF, Delaunay collection); quoted in *Robert Delaunay, 1906–1914* op. cit., p. 156.
109 C. Green, *Léger and the Avant-Garde*. (New Haven and London: Yale University Press, 1976), p. 44: "The temptation is strong to conclude that during the month or so between the opening of the Futurist exhibition and the opening of the Indépendants, Léger made a conscious and clear-cut attempt to turn *La Noce* into a more up-to-date, a more emphatically Futurist image and to apply the lessons taught by the catalogue preface and the paintings he had seen at Bernheim-Jeune."
110 "Les exposants au public", in *Les Peintres futuristes italiens*, 1912, p. 10; Apollonio, *Futurist Manifestos*, op. cit., p. 49.
111 The staircase was a motif which attracted the attention of Parisian painters. Duchamp's *Nude Descending a Staircase No. 2* would popularise the Cubo-Futurist formula. Léger planned on devoting to the motif a work synthesising his research undertaken in 1913–14: "They were quite abstract research projects (contrasts of forms and colours) that I was trying to carry out on a large canvas that would have had the title *The Staircase*. I got caught up in the war, and that stopped me carrying out what I wanted to do" (Léger, letter to the Swedish painter Nils de Dardel, 14 Nov. 1915; quoted in *Fernand Léger*, exh. cat., Musée national d'art moderne, Paris 1997 (Paris: Éd. du Centre Pompidou, 1997), p. 302.
112 "If Apollinaire and Max Jacob had not come to see us, we wouldn't even have known what was going on in Montmartre. They told us to go to Kahnweiler's, and there, along with the large Delaunay, we saw what the Cubists were up to. Then, surprised at seeing their grey canvases, Delaunay exclaimed: 'But they're painting with spiders' webs, these guys !'" (D. Vallier [interview], "La vie fait l'œuvre de Fernand Léger", *Cahiers d'art* (Paris), no. 1, Oct. 1954, p. 149).
113 *Manifeste des peintres futuristes*, in *Les Peintres futuristes italiens*, 1912, pp. 17-18; *Futurist Painting: Technical Manifesto*, in Apollonio, *Futurist Manifestos*, op. cit., p. 28.
114 "Les exposants au public", in *Les Peintres futuristes italiens*, 1912, p. 6; Apollonio, op. cit., p. 47.
115 Apollinaire, *Lettres à Madeleine. Tendre comme le souvenir*, edited, revised and expanded by Campa, (Paris: Gallimard, 2005), p. 92. *Méditations esthétiques*, the title at the top of Apollinaire's manuscript in 1912, actually became the sub-title of the finished book.
116 Id., *Les Peintres cubistes*, op. cit., p. 102.
117 Id., "Les Futuristes", *Le Petit Bleu* (Paris), 9 Feb. 1912; Breunig, *Apollinaire on Art*, op. cit., p. 203.
118 Id., 1980, p. 10.
119 Id., "Du sujet dans la peinture moderne", *Les Soirées de Paris*, no. 1, Feb. 1912, p. 2 (reprint Geneva: Slatkine, 1971); Apollinaire, *Les Peintres cubistes*, op. cit., p. 59; trans. in Breunig, op. cit., p. 197.
120 *Lacerba* (Florence), vol. 1, no. 16, 15 Aug. 1913, pp. 173–4, as *Manifeste futuriste contre Montmartre*; in Prague, in *Umělécký Měsíčnik* [Monthly Arts Magazine], 9 Aug. 1913.
121 See Lista, *Futurisme. Manifestes*, op. cit., p.119.
122 F. Del Marle, "Un peintre futuriste à Lille", *Le Nord illustré* (Lille), no. 5, 15 April 1913, p.122; Lista, op. cit., p. 178.
123 Ibid.

movement. On 25 March 1912, her *Manifesto of the Futurist Woman* was published.[124] The public reading she gave of it on 27 June, in the Salle Gaveau, forced Marinetti, Boccioni and Severini to turn into bodyguards. "An elderly gent asked from an upper gallery: 'At what age, Madam, should we teach lust to our daughters?' He received several carefully considered answers. First among them, this: 'Not yours, of course!' And this, somewhat irreverent: 'Bring them anyway, we'll give you the answer afterwards!'"[125] Her *Futurist Manifesto of Lust* (11 January 1913) declared that: "Lust, when viewed without moral preconceptions and as an essential part of life's dynamism, is a force. …*Lust excites Energy and releases Strength*", and that it was high time to destroy "*ill-omened debris of romanticism*".[126]

Montjoie !

Early in 1913, the French opposition to Futurism already seemed like a rearguard struggle. Just one periodical, which declared itself to be the mouthpiece of "French cultural imperialism" was still able to muster a last stand. This review, *Montjoie !*, borrowed its title from the war cry of those Capetian knights who went to the basilica of St. Denis to seize the standard of St. Louis in order to fight France's enemies. In memory of this bellicose custom, Gleizes published "Le cubisme et la tradition" in the first two issues.[127] The title of this article was, in itself, a response to Futurist 'anti-tradition'. In it, Gleizes traced the genealogy of a French art through artists who almost all had in common the fact that they reacted to Italian influences. To begin with there was François Clouet, who "had no interest in falling into clumsy imitation of the Italians", who "knew how to interest us through the plastic values he discovered in his models, and through the profound and faithful study of faces and objects", and who "avoided the puerile psychology that was very much the in favour".[128] A century after him, it was Philippe de Champaigne who "in turn and with all his might reacted against the Renaissance".[129] He was followed by Claude le Lorrain, who "bears few outwards signs of the time he spent in Italy".[130]

As he had already had a chance to say in *On "Cubism"*, Gleizes hammered home his conviction that the French genius was realist by nature. He wrote that the Le Nain brothers "who barely inaugurated a popular art from which all realist audacity would emerge".[131] Because the historical legacy of this tradition was taken on by Cubism, this realism had to be shifted by the assertion of pure plastic virtues. It befell Chardin to confirm the "quality of painting itself".[132] At the dawn of the Twentieth Century, Cézanne was the person who "introduce[d] new concepts, … saw that the study of primordial volumes would open up unprecedented horizons, … he sensed that plastic dynamism ha[d] nothing to do with the motion animating our streets, our machines, and our factories".[133] Here again we can detect the shadow cast by Futurism.

At the moment when Gleizes penned those lines, the issue of 'plastic dynamism' was once again on people's lips. One part of French painting was by now won over to the Futurist principle of dynamism, but this latter was not interpreted in the same way on both sides of the Alps. The debate offered the pretext for a new variation on the theme of the clash between Cubist 'pure painting' and Futurist 'subject'. Delaunay resorted to Chevreul's scientific principles to suggest the movement of his *Circular Forms* (see cat. 70). Léger believed in the energy of his graphic structures to drive his *Contrast of forms* (see cat. 72). Writing that "plastic dynamism comes into being through the pattern of relationships among objects, even among the different aspects of a single object, *juxtaposed* and not superimposed as some delight in making people believe",[134] Gleizes introduced his own arguments into the debate.

"Le cubisme et la tradition" ends with a pictorial programme defined with regard to Futurist options: "Painting must not in itself live off foreign elements, it must know how to avoid any compromise, whether literary, musical, philosophical or scientific; it would bea grave error to believe it could express its age solely by depicting everyday episodes, anecdotes, picturesqueness, any more than by painting flywheels, tie rods and pistons it could evoke the lyricism of the machine."[135]

Hybridisations

In 1917, Severini took note of the symbiosis being carried out by the international avant-gardes between Cubism and Futurism: "The truth lies somewhere between these two aesthetics. The 'pure form' of Ingres led inevitably to a life-less Platonism; the lyricism

F. Del Marle, "Manifeste futuriste à Montmartre" with caricatures by André Warnod, *Comœdia*, 15 July 1913, p. 1

Cover of the catalogue for the exhibition *La Section d'or*, Galerie La Boëtie, Paris, 10-30 October 1912

and romanticism of Delacroix no longer tallied with our cerebral and geometric age …
as in all great ages, today's artwork must be the synthesis of these two things."[136]
Boccioni had already imagined in 1912, both on his own behalf and that of Futurism,
an initial Cubo-Futurist-type synthesis. In *Dynamisme plastique. Peinture et sculpture
futuristes* [Plastic dynamism. Futurist painting and sculpture], which he published in
1914—but for which the first drafts date back to 1912—he wrote: "We wanted a
complementarity of form and colour. So we made a synthesis of analyses of colour (the
divisionism of Seurat, Signac and Cross) and analyses of form (the divisionism of
Picasso and Braque)."[137] The polemic engaged in by Gleizes in 1913 contradicted a
context, French and international alike, globally focusing on the quest for a compro-
mise between Cubist formalism and Futurist modernism.

Marcel Duchamp and Francis Picabia had voiced their agreement with the matter of this
conciliatory programme. As assiduous visitors to the exhibition of Futurist painters at the
Galerie Bernheim-Jeune, they were among the first to go in search of this synthesis.
This was an objective that had been condemned by both Gleizes and Le Fauconnier,
who deemed Duchamp's *Nude Descending a Staircase No. 2* (completed in January
1912, cat. 59) too indulgent of 'Futurist' values and had forced him to remove it from
the picture rails of the 1912 Salon des Indépendants. They were not the only ones to
identify Duchamp's "drift to Futurism". His mind focused on writing his *Cubist Painters*,
Apollinaire was angry about the blatant seduction worked by the values of Futurism on
the works of Duchamp and Picabia. On the book's proofs he wrote a conclusion that
was not included in the final edition: "Let us add, if truth is to be told, that at the point
where the art of Duchamp and Picabia (instinctive Cubism) stands today, where these
painters provide merely the simulacrum of movement, which might be regarded as tend-
ing towards the symbolism of mobility, there has not yet been a clearly defined plastic
significance."[138] Years later, in 1966, Duchamp would return to his Futurist pull of the
early 1910s. He would tell Pierre Cabanne that his *Sad Young Man in a Train* (1911)
was indeed a "Cubist interpretation of the Futurist formula".[139]

Puteaux Reinvents Créteil

On the heights of Puteaux, in the rue Lemaître, Jacques Villon and František Kupka
had a studio where, every Sunday, Léger, Delaunay, Metzinger, Severini, Duchamp, and
Raymond Duchamp-Villon would meet. Between chess, games and picnics, Gleizes
reactivated the discussions of the now defunct Abbaye de Créteil. As in the heyday of
the 'Abbey', Tancrède de Visan offered commentary on Bergson's thinking.[140] After
descending from the Montmartre studios, 'Princet the mathematician' continued with his
popularisation of the mathematics of Riemann and Poincaré.

Puteaux saw the germination of the idea of a Salon capable of conducting the synthe-
sis of research into the Cubist movement. This idea would be the Salon de la Section d'or
—the 'Golden Section'. For a while Bergson was announced as the catalogue's preface
writer. In her memoirs, Gabrielle Buffet—then living with Picabia, one of the show's organ-
isers—pointed out that the Salon de la Section d'or had "as dominant themes philo-
sophical and scientific research".[141] This observation alone illustrated the projected
synthesis between Bergson's lessons (philosophy) and those of Princet (science) which
informed the Salon's organisers. The canvases shown by Duchamp and Picabia were
enough to turn it into the first Cubo-Futurist exhibition. After Gleizes it was Picabia who,
with thirteen works, hung the most canvases in the Galerie de la Boëtie, which housed
the Salon. Some of his pictures showed his assimilation of subjects and stylistic formu-
lae peculiar to the Futurist works exhibited eight months earlier at Bernheim-Jeune. The
comparison between Picabia's landscapes of 1909–10 and his recent pictures showed
the impact of Futurist models. The *Dance at the Spring 1* (1912, cat. 62) echoes the
works of Severini, whose *Dance of the Pan-Pan at the Monico* [1909–11/1959–60,
cat. 45] was seen as the masterpiece. Among the paintings shown by Picabia, *Sad Figure*
(1912) alluded to a Futurist 'psychologism', totally alien to '[Cubist]-conceived art'.[142]
It was at the Salon de la Section d'or that Duchamp's *Nude Descending a Staircase No. 2*
made its appearance, a work which posterity would consecrate as the icon of Cubo-
Futurism. After being rejected by the 'Cubists' of the Salon des Indépendants, here the
canvas had its first public showing in Paris. It was accompanied by recent Duchamp paint-
ings, showing his early assimilation of Futurist principles. Arturo Schwarz has suggested
that one of the pictures presented at the Section d'or might have been the *Sad Young Man*

124 Published in German in *Der Sturm* (Berlin),
no. 108, May 1912, pp. 26–7.
125 Quoted in Lista, *Futurisme. Manifestes*, op. cit.,
p. 55.
126 Ibid., pp. 332–3 (original emphasis); trans.
in Apollonio, *Futurist Manifestos*, op. cit., pp. 70-2.
127 *Montjoie !* (Paris), no. 1, 10 Feb. 1913, p. 4
and no. 2, 25 Feb. 1913, pp. 2–3.
128 Ibid., no. 2, p. 2; trans. Antliff and Leighton,
op. cit., p. 462.
129 Ibid.; ibid. p. 463.
130-135 Ibid., p. 3; ibid., pp. 462, 464–5, 465.
136 Severini, "Preface", in *Drawings, Pastels,
Watercolours and Oils of Severini*, Photo Secession
Gallery, New York, March 1917, quoted in *Severini
futurista: 1912–1917*, exh. cat., Yale University
Art Gallery, New Haven 1995, p. 127.
137 Boccioni, *Dynamisme plastique*, op. cit., p. 83.
See also Coen's essay *Simultaneity, Simultaneism,
Simultanium* in this volume.
138 Apollinaire *Les Peintres cubistes*, op. cit., p. 140,
note 7.
139 P. Cabanne *Entretiens avec Marcel Duchamp*,
(Paris: Somogy Éditions d'art, 1967 & 1995) p. 43;
trans. as *Dialogues with Marcel Duchamp*, trans.
Padgett, London, p. 35.
140 Tancrède de Visan, christened Vincent Biétrix,
was the first to transpose the ideas of Bergson
into the field of aesthetics. In 1900–01, he attended
the philosopher's courses at the Collège de France.
Alongside Paul Fort and his magazine *Vers et prose*
he was involved in the Symbolist revival of the period
1904–14.
141 G. Buffet-Picabia, *Rencontres avec Picabia,
Apollinaire, Cravan, Duchamp, Arp, Calder*, (Paris:
Pierre Belfond, 1977,) p. 67.
142 This "psychologisme", attacked by Apollinaire,
was illustrated by the triptych of Boccioni's *States
of Mind*.

4

MANIFESTES
du Mouvement futuriste

Envoi franco de ces Manifestes contre mandat de 1 fr.

DIRECTION DU MOUVEMENT FUTURISTE: Corso Venezia, 61 - MILAN

1

L'ANTITRADITION FUTURISTE

Manifeste=synthèse

ABAS LEP*ominir* A *liminé* SS *korsusu*

otalo EIS *cramlr* ME *nigme*

ce moteur à toutes tendances impressionnisme fauvisme cubisme expressionnisme pathétisme dramatisme orphisme paroxysme **DYNAMISME PLASTIQUE MOTS EN LIBERTÉ INVENTION DE MOTS**

DESTRUCTION

	Suppression	
	de la douleur poétique	
	des exotismes snobs	
	de la copie en art	
	des syntaxes *déjà condamnées par l'usage dans toutes les langues*	
SUPPRESSION DE L'HISTOIRE	de l'adjectif	INFINITIF
Pas de regrets	de la ponctuation	
	de l'harmonie typographique	
	des temps et personnes des verbes	
	de l'orchestre	
	de la forme théâtrale	
	du sublime artiste	
	du vers et de la strophe	
	des maisons	
	de la critique et de la satire	
	de l'intrigue dans les récits	
	de l'ennui	

2

CONSTRUCTION

1 Techniques sans cesse renouvelées ou rythmes

Continuité simultanéité en opposition au particularisme et à la division — **LA PURETÉ**

- Littérature pure **Mots en liberté Invention de mots**
- Plastique pure (5 sens)
- Création invention prophétie
- **Description onomatopéïque**
- Musique totale et **Art des bruits**
- Mimique universelle et Art des lumières
- **Machinisme** Tour Eiffel Brooklyn et gratte-ciels
- Polyglottisme
- Civilisation pure
- Nomadisme épique exploratorisme urbain **Art des voyages** et des promenades
- Antigrâce
- Frémissements directs à grands spectacles libres cirques music-halls etc.

LA VARIÉTÉ

2 Intuition vitesse ubiquité

Coups et blessures

- Livre ou vie captivée ou phonocinematographie ou **Imagination sans fils**
- Trémolisme continu ou onomatopées plus inventées qu'imitées
- Danse travail ou chorégraphie pure
- Langage véloce caractéristique impressionnant chanté sifflé mimé dansé marché couru
- Droit des gens et guerre continuelle
- Féminisme intégral ou différenciation innombrable des sexes
- Humanité et appel à l'outr'homme
- Matière ou **trascendentalisme physique**
- **Analogies et calembours** tremplin lyrique et seule science des langues calicot Calicut Calcutta tafia Sophia le Sophi suffisant Uffizi officier officiel ô ficelles Aficionado Dona-Sol Donatello Donateur donne à tort torpilleur

ou ou ou flûte crapaud naissance des perles apremine

3

MER DE

ROSE

aux

Critiques	Essayistes	Les frères siamois D'Annunzio et Rostand
Pédagogues	*Néo* et *post*	Dante Shakespeare Tolstoï Goethe
Professeurs	Bayreuth Florence Montmartre et Munich	Dilettantismes merdoyants
Musées		
Quatrocentistes	Lexiques	Eschyle et théâtre d'Orange
Dixseptièmesièclistes	Bongoûtismes	Inde Egypte Fiesole et la théosophie
Ruines	Orientalismes	
Patines	Dandysmes	Scientisme
Historiens	Spiritualistes ou réalistes (sans sentiment de la réalité et de l'esprit)	Montaigne Wagner Beethoven Edgard Poe Walt Whitman et Baudelaire
Venise Versailles Pompei Bruges Oxford Nuremberg Tolède Bénarès etc.		
Défenseurs de paysages	Académismes	
Philologues		

ROSE

aux

Marinetti Picasso Boccioni Apollinaire Paul Fort Mercereau Max Jacob Carrà Delaunay Henri-Matisse Braque Depaquit Séverine Severini Derain Russolo Archipenko Pratella Balla F. Divoire N. Beauduin T. Varlet Buzzi Palazzeschi Maquaire Papini Soffici Folgore Govoni Montfort R. Fry Cavacchioli D'Alba Altomare Tridon Metzinger Gleizes Jastrebzoff Royère Canudo Salmon Castiaux Laurencin Aurel Agero Léger Valentine de Saint-Point Delmarle Kandinsky Strawinsky Herbin A. Billy G. Sauvebois Picabia Marcel Duchamp B. Cendrars Jouve H. M. Barzun G. Polti Mac Orlan F. Fleuret Jaudon Mandin R. Dalize M. Brésil F. Carco Rubiner Bétuda Manzella-Frontini A. Mazza T. Derême Giannattasio Tavolato De Gonzagues-Friek C. Larronde etc.

PARIS, le 20 Juin 1913, jour du Grand Prix, à 65 mètres au-dessus du Boul. S.-Germain

GUILLAUME APOLLINAIRE.

(*202, BOULEVARD SAINT-GERMAIN - PARIS*)

DIRECTION DU MOUVEMENT FUTURISTE
Corso Venezia, 61 - MILAN

in a Train, a 'state of mind' echoing Boccioni's triptych. The very Bergsonian Chess Players (1911) and The King and Queen Surrounded by Swift Nudes (1912), which were definitely in the show, also demonstrated Duchamp's closeness to the Futurists.

After showing The Wedding (cat. 55) at the Indépendants, Léger presented it at the Salon de la Section d'or. The Air around the Sawyers (1912) shown there by Henry Valensi was like a zealous application of the Futurists' principle of 'interpenetration'. It was an assimilation much lamented by Maurice Raynal: "He possibly attaches a bit too much importance to the subject, and it even seems to me to put a bit too much into that superficial observation dear to the Futurists."[143]

Villon's paintings on view at the Salon de la Section d'or may have had nothing Cubo-Futurist about them, but 1912 was nevertheless the year in which he came up with his first studies for his Marching Soldiers (for the 1913 painting, cat. 65) which applied the palette of Cubism and its crystalline structure to a subject, to a dynamic Futurist expression.The third Duchamp brother, Raymond Duchamp-Villon, also gave an account of the susceptibility of the artists in the Puteaux group to Futurist ideas. The concern for formal synthesis and the quest for a movement inspired by mechanisation peculiar to his Large Horse (1914/1931, cat. 67) make this work undeniably Cubo-Futurist. The Section d'or exhibition also revealed the existence of the 'pure' abstract painting of Kupka,[144] which Apollinaire would soon liken to Delaunay's research. On 11 October 1912, in the same Salon setting, the poet gave a lecture about the latest developments of Cubism. The public duly learnt from his lips about the birth of 'Orphism'.

Orphism

"The Cubists and the other avant-garde painters can see the danger of being called Futurists. They are attracted by research involving the movement and the complexity of subjects. To avoid this kind of threat, they invented Orphism", Severini wrote to Marinetti in 1913.[145]

In March of that same year, the report on the Salon des Indépendants written by Apollinaire for the magazine Montjoie ! gave the poet a chance to celebrate his prophetic powers: "Room 45. Here is Orphism. This is the first time that this new tendency, which I foresaw and proclaimed, has manifested itself."[146] One week later, this time in L'Intransigeant, he specified the nature of the new movement: "this tendency … is the result of a slow and logical evolution from Impressionism, Divisionism, Fauvism, and Cubism."[147] Orphism, "pure painting, simultaneity",[148] reconciled two notions that had hitherto seemed irreconcilable: "pure painting" was —precisely in accordance with the norms drawn up by Apollinaire— the exclusive prerogative of Cubism: "simultaneity" belonged to Futurism, the self-proclaimed heir of Post-Impressionism. Orphism, Apollinaire pointed out, was an art "which not only vibrates with the contrast of complementary colours discovered by Seurat, but in which every shade calls forth and is illuminated by all the other colours of the prism. This is simultaneity."[149] It already seemed some time since that the opposition to Impressionism appeared as the common denominator of research conducted by artists in the Cubist movement. Aware of the risk of 'futurisation' presupposed by the claim of the Impressionist legacy, on the eve of the lecture at which he announced the birth of Orphism, Apollinaire published a fictional dialogue: "But to my mind, these young French painters are the natural heirs of the Impressionists, and it would be a mistake to confuse them with the Futurists."[150] Olivier Hourcade, Cubism's unconditional champion, struggled to follow Apollinaire in his conflicting theoretical musings. On 23 October 1912, he responded to an attack by Vauxcelles aimed at the Section d'or Cubists, recalling one of the founding dogmas—that had in the meantime become obsolete—of the movement: "All the Section d'or painters and others, scattered in the Salon d'Automne, have between them a single common principle, the desire to react against the negligent decadence of Impressionism."[151]

Simultaneity was just the first of the borrowings made by Orphism from Futurist theory. Apollinaire, who was not ready to make a retraction, proclaimed a little later on: "The subject has come back into painting, and I am more than a little proud to have foreseen the return of what constitutes the very basis of pictorial art."[152] Ever more of a Futurist, he ended up, a year later, by paraphrasing Boccioni to describe an Orphism which puts "the poet at the centre of life [who] in some sense records the ambient lyricism".[153] When Boccioni realised that Orphism was taking all the credit from Futurism, he had no

143 M. Raynal, "L'exposition de la Section d'or", La Section d'or, 1st year, no. 1, 9 Oct. 1912, pp. 2–5, quoted in La Section d'or 1925, 1920, 1912, exh. cat., Musées de Châteauroux, Châteauroux and Musée Fabre, Montpellier, 2000 (Paris: Éd. Cercle d'art, 2000), p. 304; trans in Fry, Cubism, op. cit., pp. 97-100.

144 On the matter of Kupka's presence at the Salon de la Section d'or, see the article by Brullé, "La création de Kupka et le cubisme 'écartelé' de la Section d'or : un rapprochement problématique", in La Section d'Or, op. cit., pp. 85–96.

145 Letter from Severini to Marinetti, 31 March 1913, quoted in Severini futurista, op. cit., p. 146.

146 Apollinaire, "À travers le Salon des indépendants", Montjoie ! (Paris, supplement to no. 3, a special issue devoted to the 29th Salon des artistes indépendants), 18 Mar. 1913, p. 4; trans. Breunig, Apollinaire on Art, op. cit., p. 292.

147 Id., "Le Salon des indépendants", L'Intransigeant (Paris), 25 Mar. 1913; trans. Breunig, op. cit., p. 284.

148 Id., "À travers le Salon des indépendants", p.1; trans. Breunig, op. cit., p. 286.

149 Ibid., p. 4; ibid., p. 291.

150 Id., "À la Section d'or, c'est ce soir que les cubistes inaugurent leur exposition", L'Intransigeant (Paris), 10 Oct. 1912; trans. Breunig, op. cit., p. 254.

151 Olivier-Hourcade, "Courrier des arts. Discussions. A.M. Vauxcelles", Paris-Journal, 53rd year, no.1478, 23 Oct. 1912; La Section d'or, op. cit., p. 309.

152 Apollinaire, "À travers le Salon des indépendants", p. 4; trans. Breunig, op. cit., p. 292.

153 Apollinaire, "Simultanéisme–Librettisme", Les Soirées de Paris, 25 June 1914, p. 323. See also the letter Severini wrote to Marinetti, 31st March 1913, quoted in Severini Futurista: 1912-1917, p. 146.

Page 34:
Guillaume Apollinaire, L'Antitradition futuriste: Manifeste synthèse, June 1913

option but to react vigorously: "And here we have so many obvious plagiarisms of what, based on its first manifestations, formed the essence of Futurist painting and sculpture … Orphism—let us say straightaway—is just an elegant masquerade of the basic principles of Futurist painting."[154] And it was Boccioni who wound up his article by recalling that one day, in Severini's studio, Apollinaire had said "that we [Futurists] were Orphic-Cubists and that under the name of 'Orphism' he wanted to devote a specific study to the Futurists".[155]

The degree of assimilation of Futurist values by painters who, only recently, were fiercely laying claim to their Cubist identity was such that the polemic between the two camps turned into a hair-splitting debate. In the magazine *Montjoie !*, Léger took up his pen to reply to Boccioni. His "Origines de la peinture et sa valeur représentative" [The Origins of Painting and its Representational Value] attacked a Futurism which he reproached as being no more than the sum of Impressionist principles and Cézanne's doctrine.[156] Through two new articles, "Il dinamismo futurista e la pittura francese" [Futurist Dynamism and French Painting][157] and "Simultanéité futuriste" [Futurist Simultaniety],[158] Boccioni laid claim, on the one hand, to the Futurist priority over the notions of "plastic dynamism" and "innate complementarism" in the use of colour, and, on the other hand, over "simultaneity". It was Delaunay who in January 1914, replied to him in the Berlin magazine *Der Sturm*.[159] The debate became a Parisian one over the article that was jointly signed by Carrà, Papini and Soffici, "Une querelle artistique", published in *L'Intransigeant* on 8 March 1914.[160]

That "quarrel over simultaneity" revealed the symbiosis at work, around 1913, between Cubist and Futurist values. Under the pressure of Futurist writings, but also under the influence of the 'Montmartre Cubists' and their critic friends, Gleizes, Metzinger, Léger and Delaunay had been prompted to purge their writings of the term "simultaneous", which nevertheless belonged to their theoretical heritage (that of a scientific analysis of colour, inherited from Seurat). *Futurist Painting: Technical Manifesto*, which made the claim loud and clear, had made "simultaneity" the rightful possession, as it were, of the Italian painters. In 1913, "simultaneous" once again became a 'French' word. In November, Sonia Delaunay and Blaise Cendrars jointly signed the first "simultaneous" book, *Prose of the Trans-Siberian and the Little Jehanne of France* (1913, cat. 58). In an additional sign of this assimilation, Gleizes encircled his *Portrait of Eugène Figuière* (1913) with halo-like inscriptions referring to Henri-Martin Barzun's "simultaneism" (he depicted his book *Poème et Drame* above the inscription "Rythmes simultanés" [Simultaneous Rhythms]) and the symbolism of Gustave Kahn, one of the writers closest to Marinetti and the Futurists.

Apollinaire was not to be outdone. After reading Marinetti's words-in-freedom manifestos, he did away with punctuation in his poems. His first ideogram, *Lettre-Océan*, appeared three months after he had received a dedicated copy of Marinetti's *Zang Tumb Tumb*. The 'Futurist conversion' of Apollinaire became public when he published, in *Gil Blas* of 3 August 1913, his manifesto *L'Antitradition futuriste*.[161] Only Salmon still wanted to see irony in this change: "Futurism has survived! It's M. Guillaume Apollinaire … who dealt it the final blow. … It had to be found: a way of being more of a Futurist than Marinetti! … We'll keep the rose awarded us … in memory of the biggest buffoonery of the century. Futurism has lived, and it's right to be glad of it."[162]

The 1914 Salon des Indépendants marked the high point of the dialogue introduced, in Paris, between Cubism and Futurism: "This year," noted Apollinaire, "Futurism has begun to invade the Salon and while the Italian Futurists, to judge by the reproductions published, seem to be more influenced by the innovators of Paris (Picasso, Braque), it appears that a certain number of Parisian artists have permitted themselves be influenced by the theories of the Futurists."[163]

The Russian Cubo-Futurists

Certain poets and historians of Russian literature, who were fiercely attached to the principle of an 'Oriental' genius distinct from European models, were keen to make Futurism a native invention.[164] If it is a fact that Victor Khlebnikov's early writings dating back to 1908 made massive use of neologisms, these could not lay any legitimate claim to the invention of Futurism as it would be defined by Marinetti a year later. The facts are stubborn, and the dates even more so. The birth of Italian Futurism was announced by the Moscow press on 8 March 1909 in the daily *Večer* [Evening].

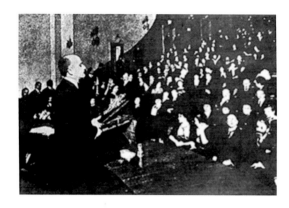

Marinetti's lecture in St. Petersburg in February 1914
Giovanni Lista Archives, Paris

Copy of *Zang Tumb Tumb* by F.T. Marinetti
(Milan: Edizioni futuriste di *Poesia*, 1915),
sent to G. Apollinaire, with the author's dedication on
page one

Cover *A Slap in the Face of Public Taste*
(Moscow: Kuzmin and Dolinski), 1913

A few weeks later, an article by R. Rabov, "Futurism: a new literary school",[165] presented a detailed examination of the movement. After various newspapers and magazines had had their say, the literary reviews, in their turn, informed the Russian public about the nature and developments of Futurism.[166]

In the latter half of April 1910, the St Petersburg publication *Sadok sudei* [A Trap for Judges],[167] to which painters and poets alike contributed, seemed the very first manifestation of a Russian Futurism. Khlebnikov, David Burliuk, his two brothers, Vladimir and Nikolai, Mikhail Matiushin and Vassily Kamiensky, formed the editorial board of the new review. From the outset, Russian Futurism was conspicuously marked by the imprint of Cubism. David Burliuk had just discovered Picasso's work, whose Cubist principles he conveyed into his own canvases. In 1913, Matiushin would publish a translation of Gleizes and Metzinger's book *On "Cubism"* (1912), in which he included passages from Piotr Uspensky's *Tertium Organum* (1911).[168]

At the Moscow Academy of Painting, Sculpture and Architecture, David Burliuk met Vladimir Mayakovsky, who introduced him to avant-garde poetry circles. The Burliuk brothers' vacation at the family estate on the shores of the Black Sea gave rise to the formation of a new group from which would emerge Russian Cubo-Futurism. Referring to the name given by the Greek historian Herodotus to this region, the group was called Hylaea. The three Burliuk brothers and Benedikt Livshits were soon joined by Khlebnikov, Mayakovsky, Aleksei Kruchenykh and Kamiensky. Well removed from the cities lyrically celebrated by the Italian Futurists, the members of Hylaea sang the praises of country life. (In November 1910, Kamensky published *Zemlyanka* [The Mud Hut], a romantic story about getting back to the earth, the tale of a fashionable writer turning his back on his life in the big city, and setting up home in an abandoned hut.) The Russians pitted their primitivist passion against the cult of the machine, and the modernism of Italian Futurism. For his poems, Khlebnikov drew inspiration from child-like expressions; Kamensky collected children's drawings. Like the Burliuk brothers, newly converted to Cubism, Hylaea's eyes were on Paris rather than Milan. Mayakovsky, composing hymns to the modern city, and extolling speed, turned out to be the most Futurist of the poets in the group.

Invited to take part in the debates organised for the first "Bubnovyj Valet" [Jack of Diamonds] exhibition (Moscow, December 1910–January 1911), Vladimir Burliuk gave a lecture on Cubism in the lecture-hall of the Moscow Polytechnic Museum on 12 February 1911. Borrowing from Apollinaire's arguments, he asserted that the issue of the subject was marginal for modern artistic expression. In a second lecture in the same hall, he clarified his attack, aimed explicitly at Futurism, which he rebuked for sacrificing painting for literature. Still, towards the end of 1912, for the most famous manifesto put out by the Hylaea group, *Poščёčina obščestvennomu vkusu* [A Slap in the Face of Public Taste],[169] Burliuk contributed a text in which he declared that Cézanne, father of Cubism, lay at the root of the sole aesthetics capable of being claimed by the painterly and poetic avant-garde.

In October 1911, in St. Petersburg, a new poetic movement came into being, Ego-Futurism, openly claiming links with Italian Futurism.[170] Two publications of its magazine, including the *Petersburg Herald*, set forth the programme exalting speed and the future, in a decidedly Marinettian tone. In it we can read that "the goal of each Ego-Futurist is the self-affirmation of the future".[171] Vadim Shershenevich was so directly inspired by the ideas of Italian Futurism that a critic wrote that he was "the first to really read Marinetti".[172] The imprint of the Italian poet on Ego-Futurism was such that his collaboration was announced in a publication by the movement.

While in Russia the epithet 'Futurist' became generally used for describing any avant-garde group or event, Hylaea changed names. In 1913, it adopted the term "Cubo-Futurism". For David Burliuk and his friends, the prefix Cubo- had a twofold meaning. It was aimed both at singling out the new movement from its Italian antecedent, and from Ego-Futurism. In addition, it confirmed its group members' attachment to the lessons of Cubism.

The year 1913 was the great moment of Russian Futurism. Vladimir Burliuk, Mayakovsky and Kamensky travelled to seventeen cities around the country to spread propaganda in favour of their movement. In Moscow, Mayakovsky gave a lecture on "Cubism and Futurism", in which he declared the independence of Russian Futurism from the Italian

154 Boccioni, "I Futuristi plagiati in Francia", *Lacerba* (Florence), 1, no. 7, 1st April 1913, pp. 66-7.
155 Ibid., p. 68.
156 F. Léger, "Les origines de la peinture et sa valeur représentative", *Montjoie !* (Paris), no. 8, 29 May 1913, p. 7 and nos. 9–10, 14–29 June 1913, pp. 9–10; excerpts trans. in Fry, *Cubism*, op. cit., pp.121–6.
157 Boccioni, "Il dinamismo futurista e la pittura francese", *Lacerba* (Florence), vol.1, no. 15, 1 Aug. 1913, pp.169–71.
158 Boccioni, "Simultanéité futuriste" (25 Nov. 1913), *Der Sturm* (Berlin), nos.190–1, 2 Dec. 1913, p. 151.
159 R. Delaunay, "Lettre ouverte au Sturm" (written, in French, to Walden on 17 Dec. 1913), *Der Sturm* (Berlin), nos.194–5, Jan. 1914. p.167 (Reprint Nendeln/Liechtenstein–Kraus Reprint, 1970).
160 Carrà, Papini and Soffici, "Une querelle artistique", *L'Intransigeant*, 8 Mar. 1914; trans. as "An Aesthetic Controversy", in Breunig, *Apollinaire on Art*, op. cit., p. 505.
161 Published in Italian, *Lacerba* (Florence), vol.1, no.18, 15 Sept. 1913, pp. 202–3.
162 Salmon, "La fin du futurisme", *Gil Blas* (Paris), 3 Aug. 1913, pp. 3–4; Lista, *Futurisme. Manifestes*, op. cit., p.125.
163 Apollinaire, "Le 30e Salon des Indépendants", *Les Soirées de Paris*, no. 22, Mar. 1914, pp. 184–5; trans. Breunig, op. cit., p. 365.
164 See V. Markov, *Russian Futurism: A History*, (London: Macgibbon & Kee, 1968), p. 26 : "... Italian futurism remains almost a year older, despite all the later efforts of some of the Russians to prove their seniority. However, it is true that in its origins the Russian group was quite independent of the Italians."
165 In *Vestnik literatury tovariščestva Vol'f* [The Literary Bulletin of Vol'f] (Moscow), note 5, [1909], pp. 120–1, quoted in Markov, ibid, n. 55 p. 400.
166 On this reception of Italian Futurism in Russia, see ibid., p. 148.
167 *Sadok sudei* [A Trap for Judges], May 1910, St Petersburg. A second eponymous almanac-collection would be published in Feb.-Mar.1913.
168 Matiushin's translation was published in the 3rd issue of the Union of Youth's magazine. In addition to the excerpts from Uspensky's book, the author added certain comments, did not always comply with the order of the paragraphs in the original text and even left passages out. An unabridged version of *Du "Cubisme"* was published in 1913 in St Petersburg in a translation by Nizen and, in Moscow, in a translation by Vološin.
169 This manifesto was only published in January 1913.
170 Its creator was Igor Severyanin, the pseudonym of Igor Vassilievich Lotarev.
171 In Ignatiev's *Eagles over Abysses*, quoted in Markov, op. cit., p. 73.
172 Ibid., p. 105.

movement. Mikhail Larionov's manifesto *Lučizm* [Rayism], and that of the Futurians *Oslinyj Hvost' i Mišen* [Donkey's Tail and Target]) smacked of Futurist emphases: "We exclaim: the whole brilliant style of our day and age resides in our trousers, our jackets, our shoes, our trams, buses, airplanes, trains, steamboats; what enchantment; what a great age, unparalleled in the world's history."[173] For a collection of Kruchenykh's poems, *Utinoe gnezdyshko … durnykh slov* [The Duck's Nest of … Bad Words] (1913), Olga Rozanova mixed painting and writing, a hybridisation reinterpreted by Sonia Delaunay and Blaise Cendrars for *Prose of the Trans-Siberian and the Little Jehanne of France*.

Marinetti was invited to Russia early in 1914 by Genrikh Edmundovich Tasteven, the Russian delegate of the Society of Great Lectures. During an evening organised for the Italian poet, Khlebnikov and Livshits penned a tract which they tried to hand out: "Today, one or two natives and the Italian colony on the banks of the Neva … are prostrating themselves at the feet of Marinetti, thus betraying the first steps of Russian art on the path of honour and freedom, and putting Asia's proud neck beneath the European yoke."[174] Later on, at a dinner organised by Nikolai Kulbin, Livshits got involved in a polemical dialogue with Marinetti. It may have ushered in the end of Russian literary Futurism, but Marinetti's visit to Russia encouraged a better knowledge of Italian Futurism in all its various parts. A lengthy article by Mikhail Ossorguin, written in Rome for *Vestnik Evropy* [The Messenger of Europe] provided a precise and detailed background of the movement, and pointed out the challenges involved. In Moscow, Shershenevich compiled and translated in a book, *Manifesty italânskogo futurizma*, most of the manifestos on Italian Futurism.

At first literary and poetic, Russian Futurism and then Cubo-Futurism were not long in discovering the paths of a new plastic expression. In 1913, Malevich designed the cover for a 'Futurist' book, *Troe* [The Three], by Matiushin, Elena Guro and Kruchenykh, in which the poems of Guro (Eleonora Genrikhovna von Notenberg) were inspired by the guitars painted by Picasso. In the text written by Kruchenykh , he mocked the childishness of Italian poets, and ironically derided their "ra-ta-ta-ra-ta-ta". That same year, a pamphlet written by Khlebnikov and Kruchenykh was illustrated by Malevich and Rozanova. (In 1912, the latter, in the second issue of the Youth Union magazine, translated two Futurist manifestos.) This complicity between the poets and painters of Russian Futurism and Cubo-Futurism was once again illustrated by the opera *Pobeda nad solntsem* [Victory over the Sun], the product of a joint effort involving Matiushin (for the music), Khlebnikov (for the prologue), Malevich (for the sets), and Pavel Filonov (for the costumes). In 1913, Malevich became the theoretician of a pictorial 'Cubo-Futurism',[175] which he saw as one of the three phases of Futurism's development: kinetic, Cubo-Futurist, and dynamic.

The movement of Russian artists between Paris and Moscow encouraged the emergence of Russian Cubo-Futurism. Thanks to Mikhail Larionov, Natalia Goncharova, Vladimir Baranov-Rossiné and Alexandra Exter, who all lived in Paris in the early 1910s, the artists of the Russian avant-garde had almost instant information at their fingertips in relation to the developments of Parisian Cubism and its links with Futurism. Nadezhda Udaltsova and Liubov Popova spent time in 1912–13 in the Atelier de la Palette, where Le Fauconnier and Metzinger both taught, before introducing into their pictures features peculiar to Futurist iconography. Exter shared Soffici's Paris studio and adopted the Futurist idiom after going through a Cubist phase.

The *Self-Portrait with Saw* painted by Ivan Kliun in 1914 sums up quite well the meaning and challenges of Russian Cubo-Futurism. In compliance with the programme of *Futurist Painting: Technical Manifesto*, the work resulted from the dynamic interpenetration of fragments of space. Its palette and its general structure are those of Picasso's *Portrait of Ambroise Vollard* (1910–11), which Kliun saw in the home of the Moscow-based collector Ivan Morozov. The 'Russian' character of the work lies in its 'rusticity', and the literalness claimed by Kliun, who painted the saw with which the space of reality is 'cut' into slivers. Like the Russian peasant splitting the logs needed for making log cabins—*isbas*—the painter 'sawed' space in order to subject it to the Futurist principle of compenetration.

Vorticism

With Vorticism, Britain saw the emergence of an original form of Cubo-Futurism. The movement's leader, the painter Wyndham Lewis, was in contact in Paris with the ideas

Cover of the magazine *Blast* (London), no. 1, dated 20 June 1914 (published on 2 July)

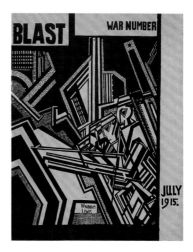

Cover of the magazine *Blast* (London), no. 2, July 1915

and works which would enable him to conceive of this synthesis. His compatriot Augustus John had kept him abreast of the latest developments of Cubism. (John was among the fortunate visitors who saw *Les Demoiselles d'Avignon* in Picasso's studio.) Lewis attended Bergson's courses at the Collège de France, and became friends with Prince Kropotkin, the theoretician of Anarchism. Back in London, he witnessed the first public Futurist events in England. The philosopher T.E. Hulme, who became the leading theoretician of Vorticism, also followed the intellectual itinerary that saw the intermingling of Anarchism and Bergsonism. As an admirer of Georges Sorel, in 1913 he translated Bergson's *Introduction à la métaphysique* as *Introduction to Metaphysics*.

In April 1910, Futurism landed in Britain. At the Lyceum Club, Marinetti gave his "Discours futuriste aux Anglais"—his "Futurist Speech to the English". Two years later, Cubism and Futurism were the talk of the town in London's art press. In March 1912, the exhibition of Italian Futurist painters, which had just rocked Paris art circles, opened at the Sackville Gallery. In October, the critic Roger Fry presented at the Grafton Galleries the *Second Post-Impressionist Exhibition* devoted to the French legacy of Impressionism. Among the Cubist paintings by Picasso and Braque, he introduced Wyndham Lewis's wash drawings (illustrations for Shakespeare's *Timon of Athens*, published the following year by Max Goschen at the Éditions du Cube). By their Cubist structure and their cinematic sense, these wash drawings were akin to certain works by Léger (in particular *The Wedding*), and also illustrated the impact of Boccioni's *States of Mind* seen a few months earlier at the Sackville Gallery.

As in Paris, the exhibition of Futurist painters enjoyed a considerable *succès de scandale*. (Marinetti, who reported the way it was received in the English press, counted some 350 articles devoted to it). As in Russia, 'Futurism' became synonymous with avant-garde. It was this broadly accepted sense of the term that the critic and curator Frank Rutter used when, in October 1913, he titled his selection devoted to the latest developments in British art the *Post-Impressionist and Futurist Exhibition*. In it, C.R.W. Nevinson showed *The Departure of the Train de Luxe* (c. 1913 lost), which directly echoed Severini's *Train Nord-Sud* (1912), exhibited in April at the Marlborough Gallery. The 'futurisation' of the British avant-garde was not to Lewis's liking. He strove to gather it under an independent banner. His first attempt to do so occurred when, with Edward Wadsworth, Frederick Etchells and Cuthbert Hamilton, he decided to break away from Roger Fry's Omega Workshop (a workshop at the interface of art and the decorative arts) to create, in April 1914, the Rebel Art Centre (promoting an aesthetics originating from Cubism).

The spring of 1914 saw Marinetti back in London again. In tandem with the exhibition of Futurist paintings and sculptures on view at the Doré Galleries, he gave a series of lectures. On 30 April, he gave a reading of *The Siege of Adrianople,* accompanied on a bass drum by Nevinson, who had become his first English disciple. Once again, Futurism filled the front pages of England's daily papers, submerging everything in its wake. The decor designed by Lewis for Countess Drogheda's apartment had been described by the press as a "Futurist dining-room". In July 1914, Lewis was introduced as "one of the leading Futurists" by *T.P.'s Weekly* of 11 July.

Marinetti's missionary zeal led him to commit the error which was immediately used by Lewis to coalesce the individualists of the Rebel Art Centre. On 7 June 1914, the Italian poet and Nevinson published a manifesto in English and Italian, "Futurist Manifesto: Vital English Art", in which they enrolled Lewis, Lawrence Atkinson, David Bomberg, Jacob Epstein, Frederick Etchells, Cuthbert Hamilton, William Roberts, and Edward Wadsworth, without even alerting them. The manifesto was published on 7 June in the *Observer* and then in the *Times* and *Daily Mail*.[176] The 'in-spite-of-us' brigade of English Futurism gathered for a reading of Marinetti's manifesto at the Doré Galleries, with the express intention of giving vent to their indignation.

Already in mid December 1913, Lewis had seized the occasion of the exhibition in Brighton *English Post-Impressionists, Cubists and Others* (16 December 1913–14 January 1914) to organise a pooling of future Vorticists (and future members of the Rebel Art Centre). The room where their works were brought together has gone down in history as the "Cubist Room" (it included works by Lewis, Nevinson, Etchells, Hamilton and Wadsworth). To avoid being labelled a "Futurist", Lewis temporarily had no other choice but to agree to be described as a "Cubist". In the preface he wrote for the catalogue, he expressed his reservations about a form of Cubism, which was

173 Translated in Marcadé, *Le Futurisme russe*, (Paris: Dessain et Tolra, 1989), p. 49. M. Larionov, *Lučizm* [Rayism], Apr. 1913; *Oslinyj Hvost' I Mišen* [Donkey's Tail and Target], July 1913
174 Quoted in Markov, op. cit., p. 151. See also Marcadé's essay *Russian Cubofuturism* in this volume.
175 The term Cubo-Futurism was used by Malevich in the catalogue of the last exhibition of the Youth Union, late December 1913. See Marcadé, *L'Avant-garde russe 1907–1927*, (Paris: Flammarion, 1995), p. 86.
176 It was published in *Lacerba* (Florence), vol. 2, no. 14, 15 July 1914, pp. 209–11. See Walsh, *C. R. W. Nevinson: the Cult of Violence*, (New Haven and London: Yale University Press, 2002), pp. 76-7.

"chiefly, the art, superbly austere and so far morose, of those who have taken the genius of Cézanne as a starting point", then admitted the Futurist sympathies of the artists in the "Cubist Room" who, "for the most part underlines such geometric bases and the structure of life".[177]

When Nevinson had the idea of creating a new magazine aimed at spreading the ideas of the 'English Cubists', he gave it the very Futurist name of *Blast*. Later on, the poet Ezra Pound, who was at work in a concrete way on the preparation of this new publication, affixed the term "vortex" to it—a term that had been several times claimed by Futurist writings. From late 1913 on, Pound had associated this word with the English literary scene. One year later, he also used it to describe Lewis's works and those of the 'English Cubists'. When the new magazine came out in July 1914, a sub-title—*Review of the Great English Vortex*—had been added to the title *Blast*. The programme of Vorticism, as defined by the articles in the first issue of *Blast*, was that of Cubo-Futurism. In it Pound drew up a list of the movement's supposed parents. He mentioned Picasso and Kandinsky, whom he introduced as the "father and mother" of Vorticism.[178] Vorticist painting, which he thought abstract, rejected the "facts, ideas, truths" and everything relating to an arena foreign to that of painting itself. Such declarations echoed the principle of a "pure art", which appeared during the French argument over Futurism. In the texts he wrote for the first issue of *Blast*, Lewis was at pains to keep his distance from a Futurism to which the British press kept linking him. He quoted Baudelaire, and his hatred of "movement that shifts lines". In the second issue, published in 1915, he considerably toned down this apology of Cubist formalism: "By Vorticism we mean (a) ACTIVITY as opposed to the tasteful PASSIVITY of Picasso; (b) SIGNIFICANCE as opposed to the dull or anecdotal character to which the Naturalist is condemned; (c) ESSENTIAL MOVE-MENT and ACTIVITY (such as the energy of a mind), as opposed to the imitative cinematography, the fuss and hysterics of the Futurists."[179]

This 'theoretical zigzag' between Cubist and Futurist stances had the effect of blurring the categories to which those witnessing the development of the Vorticists attempted to refer. *The Times*' critic with the task of reporting on the first Vorticist exhibition, organised in June and July 1915 at the Doré Galleries, had no choice but to describe the exhibitors as 'Cubist–Futurist–Vorticist Artists.'

From Luna Park to Coney Island

The Armory Show, which opened on 17 February 1913 in New York, revealed to the American public the diversity of modern European art. In that show, Meyer Schapiro saw "the great event, the turning-point in American art".[180] The absence of Futurist works on the walls at that time seemed to be a new demonstration of the coherence of the public action of the movement founded by Marinetti. Invited to take part in the American show, the Italian painters demanded that their works be grouped together and presented with an explicit notice, so they were turned away by the organisers. Despite their absence, it was the direct legacy of Futurism that triumphed in New York, then in every American venue visited by the exhibition.[181] Here again, for press and public alike, 'Futurist' soon encompassed every manner of avant-garde expression. In the critical reviews of the Armory Show, and in the educational publications accompanying it, Cubism was "futurized", and became a "static Futurism", or alternatively a 'subset of Futurism'. Cubism was all the more misunderstood because its presence was marginal in the New York show: "Picasso and Braque were poorly represented, and their invention, Cubism, the most important new art trend of the time, which was to determine much of the painting and sculpture of the next decades, was fixed in the public mind through the pictures of Picabia and Duchamp,"[182] in the words of Meyer Schapiro.[183]

Because of the place accorded it by the American media, Duchamp's *Nude Descending a Staircase No. 2* seemed like the embodiment of the audacities of the European avant-garde. The work became widely famous, as attested to by the numerous cartoons the popular press heaped on it. A competition, complete with prize, was even held to explain its meaning and iconography.[184] The triumph of Duchamp's 'nude' was the triumph of Cubo-Futurism. In his review of the Armory Show, the critic Frank Jewett Mather Jr. emphasised the synthesis worked by the picture: "Often the Futurists use geometric devices akin to those of the Cubists. Such an effect we see depicted here in Duchamp's *Nude Descending a Staircase*. It should be noted that this technique, though not connected with the Futurists' group, combines something of their ideas

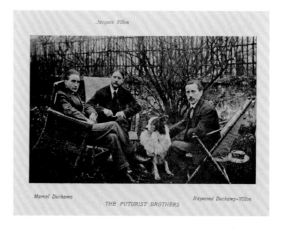

"The Futurist Brothers".
From left to right: Duchamp, Villon, Duchamp-Villon
Photograph reproduced in J. Nilsen Laurvik,
Is it Art?: Post-Impressionism, Futurism, Cubism,
(New York: International Press, 1913)

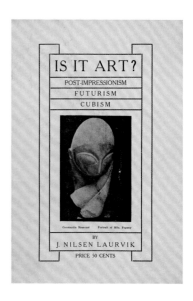

Cover of the book by J. Nilsen Laurvik, *Is it Art?
Post-Impressionism, Futurism, Cubism*, (New York:
International Press, 1913)

with those of Cubism."[185] This 'futurisation' of Cubism was made explicit with the group portrait of the Duchamp brothers which wound up the essay by J. Nilsen Laurvick, *Is it art? Post-Impressionism – Futurism – Cubism*, published in 1913. The image was accompanied by the caption: "The Futurist Brothers".

Cubo-Futurism, which made Duchamp's painting a triumph, was commented upon and brought into general use by Picabia, who was in New York the week before the exhibition opening. Picabia, who became the darling of the American media, appeared in the *New York Times* as the person who had "recubed" the Cubists, and "refuturized" the Futurists.[186] The painter, who introduced himself as a "post-Cubist", extolled the modern city with a lyricism that not even Marinetti could repudiate. He laid claim to an art responding to the programme outlined in detail by the Italian Futurist painters in the preface of their Paris exhibition catalogue of 1912. "Art deals with profound and simple moods. … Let us suppose that the artist—in this instance Picabia—gets a certain impression by looking at our skyscrapers, our city, our way of life, and that he tries to reproduce it …, he will convey it in a plastic way on the canvas, even though we see neither skyscrapers nor city on it."[187]

The exhibition "American Cubists and Post-Impressionists", organised by Arthur B. Davies at the Carnegie Institute in Pittsburgh in December 1913, was an initial confirmation of the impact of the Armory Show on American art. In February 1914, the same exhibition held in New York at the Montross Gallery, was further enhanced by a painting by Joseph Stella, reinterpreting his *Battle of Lights* which was on view in Pittsburgh. The new picture was acclaimed in the American press, with commentators comparing its success to that accorded Duchamp's *Nude Descending a Staircase* the year before. *Battle of Lights* (in its version at the Montross Gallery show, 1913–14, cat. 75) illustrated the assimilation of Cubo-Futurism by the American avant-garde. In its initial phases, the work had the formal characteristics peculiar to early Futurism. A 1913 tondo (*Battle of Lights*) made use of the pointillist technique. The painting of the same subject, which featured in the Pittsburgh show, adopted a structure consisting of swaying curves evoking the first version of Boccioni's *States of Mind*, and their rootedness in symbolism. *Battle of Lights* which the New York public discovered, had assimilated the lessons of Cubism, with its crystalline structures, and its breakdown of light into homogeneous expanses of colour. In 1900, in Paris, Balla painted a night view of Luna Park adjoining the Electricity Pavilion at the World Fair (cat. 1). From the Luna Park at the Trocadero to the one at Coney Island, Stella's picture brought into the United States the plastic and poetic values of that Cubo-Futurism born from the dialogue of the French and Italian avant-gardes in Paris. *Battle of Lights* ratified the "murder of moonlight" long perpetrated by New York's electric lights.

177 P. W. Lewis in Cork, *Vorticism and Abstract Art in the First Machine Age*. Vol. I: *Origins and Development.* (London: Gordon Frazer, 1976), p. 137.

178 E. Pound, "Vortex", *Blast* (London), no. 1, 20 June 1914, p. 154 (reprint New York: Kraus Reprint Co, 1974).

179 Lewis, "Note", *Vorticism Exhibition*. London, Doré Galleries, June-July 1915, in Cork, *Vorticism and Abstract Art…*, op. cit., p. 280. See Gale's essay *A Short Flight*, in this volume.

180 M. Schapiro, "Rebellion in Art", *America in Crisis*, 1952; *Armory Show–International Exhibition of Modern Art*, exh. cat, New York, (equipment storehouse of the 69th artillery regiment), 17 Feb.-15 March 1913, vol. 3: "Contemporary and Retrospective Documents", p. 203 (reprint New York: Arno Press, 1972).

181 After New York, the exhibition was presented at the Art Institute of Chicago (24 March–16 April 1913), and the Copley Society, Boston (28 April–19 May 1913).

182 Duchamp exhibited: *Nude Descending a Staircase No. 2* (1912); *The Chess Players* (1911); *The King and Queen Surrounded by Swift Nudes* (1912); *Sad Young Man in a Train* (1911). Picabia exhibited: *Dance at the Spring* (1912); *Paris* (1912); *Memory of Grimaldi, Italy* (1912); *Procession, Seville* (1912).

183 Schapiro, "Rebellion in Art", *America in crisis*, op. cit., p. 208.

184 "By all odds the most publicised work exhibited at the Armory Show was 'Nude descending a staircase'. For most people the painting has become a kind of symbol of the show and what it stood for." (Entry for Duchamp's *Nu* in *The 1913 Armory Show in Retrospect*, exh. cat, Amherst College, 17 Feb.–17 March 1958; cat. of the Armory Show exhibition, vol. 3, op. cit., p. [17].

185 F. J. Mather, "Newest Tendencies in Art", *Independent*, 6 March 1913; cat. of the Armory Show, vol. 3, op. cit., p. 512.

186 See "Picabia, Art Rebel, Here to Teach New Movement", *New York Times*, Section 5, 16 Feb. 1913, p. 9; M. L. Borràs, *Picabia*, (Paris: Albin Michel, 1985), p.105.

187 H. Hapgood, "A Paris painter" (interview), *Globe and Commercial Advertiser*, 20 Feb. 1913, p. 8; Borràs, ibid., p. 107.

The Italian Sources of Futurism

Giovanni Lista

Futurism is linked to French culture through its founder, the writer and poet Filippo Tommaso Marinetti. Born in Egypt to Italian parents, Marinetti received a Franco-Italian education in a secondary school in Alexandria which was run by Jesuits from the Lyons diocese. One might say his heart was Italian while his head was French: his thinking drew deeply on a formative culture shaped largely by French writers of the end of the Nineteenth Century, while his passionate sense of action, his vigorous social activism and his sense of vocation as Futurism's missionary were all profoundly Italian.

Of course, Marinetti's Franco-Italian education does not justify, in itself, the positing of a strong causative relationship between French culture and Italian Futurism. First of all, to think of Futurism as an historical fact that sprang fully formed from Marinetti's head, like an armed Minerva from Jupiter's brow, is to adopt an outmoded historical approach that glorifies the heroic individual as history's sole protagonist. Second, to affirm that Futurism was based on Marinetti's desire to introduce into Italy the innovations of French culture—one of the clichés of this approach—is both superficial and erroneous.[1] If Marinetti's intervention was crucial and decisive, it was only within the process of completing a development which Italian culture had been undergoing for over half a century. To be exact, Marinetti's role consisted in producing a short-circuit between two cultures, French and Italian, each one with its own conception of modernity.[2] Still, we must examine the very unusual nature of Marinetti's education and early background, along with his particular sensibility as a Franco-Italian intellectual. For, though Italian, the poet first encountered Italy only at the age of eighteen. Thus, for many years his vision of the country was both abstract and highly charged emotionally, consisting largely of an image built around the literary culture of his mother, Amalia Grolli, who regularly read to him from Dante's *Divine Comedy* or canonical poets like Giacomo Leopardi. These readings prepared the way for the mythology of an idealised Italy, inheriting the mentality of the Risorgimento.[3] Marinetti's father Enrico, a lawyer, had moved to Alexandria with his wife in 1873, only three years after Rome was declared the capital of unified Italy.

Marinetti's relationship to France is similar. He also discovered Paris at the age of eighteen, when he went there to sit an examination to validate his secondary studies, but he never lived in the city long enough to become really familiar with it. His frequent but short stays could only reinforce his sense of Paris as the city of modernity. The intellectual curiosity which Marinetti always felt for French culture was, therefore, also nourished by an idealised image, which, in this case, would never confront ordinary reality.

Thus, the young Marinetti found himself facing two fictive, even caricatural and antithetical images, one of Italy, one of France. This Manichean opposition triggered a conflict in him, which partially explains his iconoclastic fury and the rage of his Futurist engagement. On the one hand, he saw an Italy marked by its past: the Italy of archaeologists, tour guides and antique dealers, as he would tirelessly repeat. On the other, he fantasised about a France of innovation, turned entirely towards modernity—the stereotyped country of the French Revolution. The contrast inherent in this divided experience certainly explains the most radical statements of the 1909 *Manifesto of Futurism*.

When he began his career as a writer in Milan, the most modern city of the Italian peninsula, the young Marinetti knew nothing of the Italian culture which had developed since the Risorgimento. His initial sense of disappointment thus long remained anchored in his vision of Italy. His rejection of a country still subdued by the rhetoric of the Risorgimento and by the myth of past splendour was expressed in his very first book of poetry, an epic titled *The Conquest of the Stars*, written in French and published in Paris, and dealing with the attack of the ocean waves on the starry sky.[4] The death of the stars represents the destruction of the old sentimental, idealised world which his mother had taught him, and which no longer bore the least correspondence to reality. The book already put forth the principal challenges and questions of Futurism, whose founding manifesto would end, seven years later, with a new "challenge to the stars". With this book, the poet definitively joined an Italian intelligentsia aware that the project of the Risorgimento had not

Marinetti at home, in Milan, in 1907
Giovanni Lista Archives, Paris

been taken to its conclusion. In response to this problem, Futurism would be conceived precisely as a global ideology of art, called on to play a political role within a more encompassing social transformation.

Marinetti's biography thus explains the radicalism of his revolutionary mythology.[5] As a Futurist, he would at once construct and attack an image of Italy as mired in the past (passatista) in order to make his call for the future all the more radical. Like an authentic political activist, he identified an enemy to be fought, and coined slogans which, in order to exhort to action, excessively simplified a complex situation in Italy, where forces of modernity were already playing a more than productive role. Read literally, the battle slogans with which Futurism's manifestos were strewn have greatly contributed to the historiographical framework still seen today, of a provincial Italy wishing to assimilate the innovations that come from Paris.

In reality, an Italian modernity had been taking a clear shape since the middle of the Nineteenth Century in an effort to give substance to the young nation born of the Risorgimento. Not only did Italy participate fully in the various stages of European artistic and literary change at this time but, in certain cases, Italian culture clearly anticipated subsequent developments: for example, the Macchiaioli prefigured Impressionist painting.[6] But the emergence of post-unification culture was accompanied by the contradictions pertaining to the historical moment. Once the political unity of the country had been achieved, Italian art found no other issue but that of suggesting, elaborating and figuring an 'Italian identity' and this orientation led it constantly to refer to the artistic glories of the past. Post-unification exigencies dominated artistic life on the peninsula, notably the need to define a cultural tradition, and to construct a pantheon of artistic and literary ancestors for an Italy at last unified and free.

Giuseppe Mazzini, the apostle of the struggles of the Risorgimento, had not been able to imagine a new liberty for art which would allow it to brandish a revolutionary torch as bright as that of political struggle. For him, simply to mention the "history of the Fatherland" was to confer an edifying role, giving Italians the sense that they were a single people, and awakening in them the moral and ethical virtues and creative powers of their ancestors. Thus, the Risorgimento spirit led only to a mode of History painting based on the portrayal of the great figures and glorious episodes of Italy's past. An entire rhetoric took shape, in art as well as literature, for the lauding of Roman grandeur, Dante's poetry, the imperial glory of Venice, the artistic dominance of Florence, the Sicilian Vespers etc. This attempt to idealise Italy's past and to formulate an edifying art capable of forging national feeling among Italians would extend all the way to D'Annunzio. For their part, the Futurists would virulently reject this celebration of the past. Their target would be none other than that Italy of museums which the French Romantics had already called the "land of the dead". Yet while rejecting all mythologising of Italy's past, they would nevertheless show themselves extremely attentive to anything capable of writing the quest for Italian identity in a new symbolic language.[7]

Nonetheless, the main characteristic of this still gestating modernity was the desire to reconcile the past and the new. Immediately following unification, the new Italian state set up an entire system of national exhibitions which celebrated both the ancient and the modern. In 1870, the very year Rome was proclaimed capital of the Italian kingdom, a National Exhibition of Fine Arts, gathering together various contemporary artists, was held in Parma. It was inaugurated at the same time as a monument was dedicated to Correggio. Two years later, a similar show was held in Milan and a statue of Leonardo da Vinci simultaneously unveiled. In other words, the unified State pursued a strategy for encouraging the creation of a national art, but only while placing such an art under the authority of an artistic past which would henceforth be placed within a discourse of national heritage and identity. Thus, the entirety of post-unification Italian art vacillated between the desire to contextualise itself within the historical present of modernity and the need to connect with the peninsula's artistic past.

The creative period of the post-Risorgimento, then, oscillated between two opposed poles, one based on compromise, the other on rupture, but both partaking of a dynamic which already heralded the modes of behaviour which would characterise the avant-garde. The first pole was represented by the Macchiaioli, who, reviving the proportions and geometries of Renaissance painting, offered a synthesis between ancient and modern. Their goal was to reconstruct the impression of reality through the juxtaposition of coloured spots or blotches (macchia = blotch), yet even while developing a truly

1 Most of the key ideas and principles of Futurism were elaborated from specifically Italian cultural or artistic elements. Neither the art of noise nor words in freedom, to give just two examples, have French precedents.

2 It is worth noting that Marinetti first addressed Italians: his Manifesto of Futurism was first published in Italy, where it appeared in various newspapers, including Bologna's La Gazzetta dell'Emilia, on 5 Feb. 1909. Only two weeks later did Marinetti have it published in France, accompanied by a prologue, in Le Figaro in Paris. See G. Lista, F. T. Marinetti, (Paris: Éditions Seghers, 1976).

3 The survival in Marinetti of a culture that was over half a century old—that is, the Romanticism of the Risorgimento—appears in several places. For example, when founding the revue Poesia in Milan in 1905, Marinetti affirms his wish to resurrect "dead poetry", citing a famous formula from The Divine Comedy. Mazzini had already cited Dante in this manner to elaborate "the special mission of art", which was to be born again in order to "push men to translate their thoughts into actions". This is exactly Marinetti's hope for Futurism.

4 F. T. Marinetti, La Conquête des étoiles, poème épique, (Paris: Éditions de la Plume, 1902), reissued (Paris: Sansot, 1904).

5 See G. Lista, F. T. Marinetti, l'anarchiste du futurisme. Biographie, (Paris: Nouvelles Éditions Séguier, 1995).

6 Perhaps translatable as the "blotchists", the group's painting was characterised by its deployment of the macchia ("blotch" or "spot"). The movement evolved between 1860 and 1870. See G. Picon, La Naissance de l'art moderne, (Geneva: Skira, 1974) and Lista, "An Italian Modernity", in De Fattori à Morandi: Macchiaioli et modernes, exh. cat., Caen, Musée des Beaux-Arts, 25 July–27 Sept. 1998.

7 See Lista, "Symboles futuristes et identité nationale", in Actes du Colloque International, "Le Futurisme et les avant-gardes littéraires et artistiques au début du xxᵉ siècle", (Nantes: Université de Nantes-Centre international des Langues, 2002).

innovative style of painting, they allowed the works of the great Italian masters to inspire the structure of their compositions, taking up their formal solutions in the search of an artistic tradition that could be considered 'national'. Nevertheless, their theoretician, the art critic Diego Martelli, managed to imagine a new role for art, which would appropriate the revolutionary *élan* of Garibaldi or the militancy of Mazzini and transfer them into the realm of artistic production. In fact, to define the attitude of the Macchiaioli in their fight "against academicism", he referred to the struggles of the Risorgimento, in which, it so happens, some of the painters in question had directly participated. In 1867, in the *Gazzettino delle arti del disegno*—house organ of the group—Martelli attributed to the Macchiaioli the desire to "seek each other out, to band together, to form a column and to launch the attack".[8] This determination to occupy the terrain prior to any formal claim would also be seen in Futurism, which would in fact be based on a total identification of the spirit of the avant-garde with activism. At the origin of this typical trait of modern Italian culture lay the historical experience of the Risorgimento, that is, romanticism lived as political action. A half-century after the Macchiaioli, even as he took his inspiration from revolutionary syndicalism, Marinetti founded and directed the Futurist movement on the model of a "society" like Mazzini's Giovane Italia, the Futurists being "agitators" who diffused new ideas and led them to victory in every city in Italy.[9]

The other pole of post-unification Italian art is represented by the *Scapigliatura*, whose members, in the same period, demonstrated a deliberate refusal as they contested the culture of the new bourgeoisie and refused all celebrations of the past.[10] Provocative and oppositional, the *Scapigliati* prefigured Futurism's performances and 'evenings' in their urban spectacles, costume parties and derisive parodies of stuffy and humourless official Italy, as it attempted to assume the dignity befitting a newly fashioned nation. *Scapigliatura* preached the complementarity of the arts, analysis of sense impressions and experimentation. Its most important painters, Tranquillo Cremona and Daniele Ranzoni, tended to fuse the subject with its surrounding environment. Their work was based on luminous and chromatic vibration which led to the loss of the sense of volumetric solidity and the disappearance of contour under the fluid, dynamic action of light. In sculpture, these formal innovations were introduced by Giuseppe Grandi, whose work on the relation between body and space made use of rough edges and uneven contours, fragmenting the sculptural surface through painterly touches and rhythmic breaks well-suited to capturing and animating light.

Over the last two decades of the nineteenth century, the sculptor Medardo Rosso emerged as the *Scapigliatura*'s direct successor. His work aimed to translate the transience of form, and its immersion in the surrounding space. Working in wax, he reconstructed an 'impression' through faces which seem to be emerging from changes in the light. Form takes shape in the visible but clings to the surface of the magma that is the matrix of the world. The discovery of Rosso's works and ideas proved decisive for Umberto Boccioni, who in painting and above all sculpture, put them to a new and more intensive use. Boccioni would translate the interdependence of body and space into a symbiotic exchange of energy: the Futurist principle of 'compenetration' was based on a dynamic and contrasting integration of the figure and the surrounding environment.[11] Whereas Rosso strove to suggest movement by blurring the definition of his forms, the Futurists attempted to make as explicit as possible each kinetic movement, not to provide a simple mechanical representation but to make it emblematic of modern life, that is, to make movement as such an absolute value, no less lyrical than ideological.[12] Towards the end of the nineteenth century, the rapid urbanisation of the cities of the industrial north made itself felt in socially conscious art, which dealt with themes like the worker, strikes, and labour. The spectacle of the modern city inspired in particular Giuseppe De Nittis and Giovanni Boldini, both of whom lived in Paris. Boldini, who painted boulevards alive with the silhouettes of fashionably-dressed women, owed his fame to his edgy, virtuoso brush strokes, which created the feeling of motion through a kinetic rendering of form.

Modernity was constructing its first myths while new ideas enlivened literary and artistic debate. In Ancona in 1875, in order to oppose the rhetoric of the historical dramas of the day, but also to parody Vittorio Alfieri's tragedies, Ugo Cori put on his *Rosmunda*, an ultra-synthetic tragedy of seven scenes, each one consisting of a single line followed by the fall of the curtain.[13] It was as a tribute to Cori that forty years later Marinetti chose the same theatre in Ancona for the first performances of his "Futurist

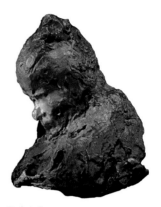

Medardo Rosso
The Concierge, 1883-84
Wax on plaster, 37.3 x 29 x 16.8 cm
Private collection

Gino Severini
Via di Porta Pinciana at Sunset, 1903
Oil on canvas, 91 x 51 cm
Private collection

Giuseppe Pellizza Da Volpedo
Sun, 1904
Oil on canvas, 155 x 155 cm
Galleria Nazionale d'Arte Moderna, Rome

synthetic theatre". In 1880, the sculptor Adriano Cecioni wrote his pamphlet *I Critici profani all'Esposizione nazionale di Torino* [The Profane Critics at the National Exhibition in Turin], which attacked literary modes of art criticism and provoked a great polemic.[14] He insisted on the necessity of a language specific to the visual arts for the analysis of modern art and it was in this spirit that Carlo Carrà was later to launch his Futurist attacks "against art critics". In 1881, Milan's Teatro alla Scala enjoyed a great popular success with its *Bal Excelsior*, by Luigi Manzotti and Romualdo Marenco—an allegory pitting the forces of technological progress against those of reactionary obscurantism. In 1887, Corrado Ricci published an illustrated edition of *L'Arte dei bambini* [The Art of Children], in which children's drawings were considered for the first time as 'art'.[15] Although Boccioni would later dismiss Ricci as *passatista*, due to his role in preserving Italy's artistic heritage as a civil servant working for the Ministry of Art and Culture, he would also be won over by this idea: in 1911 Boccioni suggested showing "children's drawings" in the first Mostra d'Arte libera, organised by the Futurist group in Milan. Quickly translated into German and Russian, Ricci's book launched the vogue for "child primitivism" within the European avant-garde—a notion which also left its mark on the Futurist art of Fortunato Depero.

It was only in 1895, with the first Venice Biennale, that Italy was able to offer an art exhibition of international importance. This event also brought with it the first scandal: Giacomo Grosso, instructor of the young Giacomo Balla at the Fine Arts Academy of Turin, provoked controversy with his *Supreme Meeting*, a large painting depicting five naked women gathered around a coffin in a church. The Biennales around the turn of the century played a major role for the Futurists, above all by showing art from Berlin, Munich, and Vienna, along with works of Russian and Flemish Symbolism, and thereby largely determining the direction of Russolo's painting and even Boccioni's investigations.

Divisionism, which derived from the principle of dividing the brush stroke in order to evoke light and colour, developed in a particular fashion.[16] The originality of the Italian Divisionists came, above all, from their refusal of all system. This attitude, seen again among the Futurists, implied that technique must not be subjected to any scientific or ideological precept. Rather, it should serve to liberate individual creativity, even to glorify the lyric content of subjects, be they naturalistic or oneiric. Giovanni Segantini, Divisionism's leading figure, most often created an atmosphere of inner spirituality. His rural scenes feature strong contrasts between light and shadow, lengthy horizons, and figures in meditative postures that seem almost religious. Angelo Morbelli, on the contrary, portrayed urban modernity as often as peasant labour, while the works of Pellizza Da Volpedo evoked a certain climate of interiority even when treating subjects derived from popular everyday life. Very often the theme was constructed through the contrast of light and dark, with a strongly lit central zone which seems to radiate outwards, or on the other hand, pull light inwards. Brush strokes are applied on top of each other rather than next to each other , allowing underlying strokes to be seen. Pellizza developed an art associated with Symbolism, socially conscious art and Naturalism all at once. His *Car on the Penice Pass* already introduces the Futurist principle that "motion and light destroy the materiality of bodies", while the epic scope of his *Fourth Estate* would be seen again, now adapted to the theme of urban transformation, in Boccioni's *The City Rises* (1910–11, cat. 28).

Gaetano Previati's critique of positivist realism took the form of painting images of a refined spirituality. He created dream-like atmospheres, and composed his heavily symbolic paintings musically. The sinuous inflections of his slender, extended brush strokes almost always followed the fluid expansion of light. His book, *I Principi scientifici del divisionismo: La tecnica della pittura* [The Scientific Principles of Divisionism: Painting Technique],[17] which was also translated into French, met with great success. Boccioni, who borrowed from him the idea of publishing 'technical' manifestoes in the context of Futurist art, saw in Previati the painter who had brought awareness of the medium into the pictorial image. For Boccioni, he was "the greatest Italian artist since Tiepolo".

Before undertaking a critical analysis of this aesthetic position in the elaboration of their own poetics of dynamic values, the Futurists took part in Divisionism. At the beginning of the Twentieth Century, Balla became one of its key figures. Influenced by photography, framing effects and unusual poses proliferated in his painting, while constantly displaying a rigorous objectivism. Balla initiated his two young pupils, Severini and Boccioni, into Divisionist techniques. The former then emigrated to Paris, where he

8 Cited by Giuliano Matteucci, "Genesi della macchia, espressione della realtà moderna", *Il Secondo Ottocento italiano: Le postiche poetiche del vero*, exh. cat, Milan, Palazzo Reale, 26 May–11 Sept. 1988 (Milan: Mazzotta, 1988), p. 124.

9 See Lista, "The Activist Model or The Avant-Garde as Italian Invention", *South Central Review*, vol. 13, no. 2-3 (summer-fall 1996).

10 "Scapigliatura" and "Scapigliati" (youths recognisable by their "wild" hair), are terms that were launched by the novel, *La Scapigliatura e il 6 febbraio*, [La Scapigliatura and February 6] by Cletto Arrighi, pseudonym of the writer Carlo Righetti (Milan, 1828–1906). In 1857, the author published a theoretical text in the almanac of the revue *Il Pungolo* (Milan) to explain the choice of the word "Scapigliatura" and the socio-artistic definition of the avant-garde group which he attributed to it.

11 Boccioni also addressed the sculpture of Rodin and Canova, but more in terms of representational themes. His *Unique Forms of Continuity in Space* referred to Rodin's *Walking Man*, while his *Speeding Muscles* found inspiration in Canova's *Damozenos*.

12 See Lista, "Medardo Rosso e i futuristi", *Medardo Rosso: Le origini della scultura moderna*, exh. cat., Trento and Rovereto, 28 May–22 Aug. 2004 (Milan: Skira, 2004).

13 See Lista, "Il Teatro di Marinetti tra simbolismo e futurismo", *Primafila* (Rome), no. 7, May 1995.

14 A. Cecioni, *I Critici profani all'Esposizione nazionale de Torino*, (Florence: Tipografia del Vocabolario, 1880). Cecioni published the pamphlet under the pseudonym Ippolito Castiglioni.

15 C. Ricci, *L'Arte dei bambini*, (Bologna: Nicola Zanichelli Editore, 1887).

16 Italian Divisionism was born with Segantini's painting *Ave Maria*, the second version of which was painted in 1886, the same year Seurat showed his *Grande Jatte*, which allowed Félix Fénéon to launch Neo-Impressionism. See G. Belli, "Néo-impressionisme français et divisionnisme italien. Brève histoire d'une convergence culturelle", *La Revue du musée d'Orsay*, no. 12 (spring 2001).

17 G. Previati, *I Principi scientifici del divisionismo: La tecnica della pittura*, (Milan–Turin–Rome: Fratelli Bocca Editori, 1906). French translation by V. Rossi-Sacchetti : *Les Principes scientifiques du divisionnisme (la technique de la peinture)*, (Paris: A. Grubicy, 1910).

painted the streets of Montmartre in brush strokes that approached Pointillism, while Boccioni brought into his canvases subjects such as trains cutting through fields, or the city sprawling into the suburbs, while experimenting with chromatic contrast. Boccioni's Divisionist painting, through its exploration of themes like that of a figure placed before a window or in its use of highly saturated colour that intensifies the image, prefigured some of the major elements he would explore as a Futurist. By contrast, Carrà's later Divisionist experiment was conducted almost entirely under the aegis of Futurism. Some of his paintings would transform the figurative data of the subject into a large-scale liberation of pigment itself. For his part, Russolo explained that the Futurist painters, instituting the poetics of Divisionism, had transformed it into an instinctive approach: "Above all, we continue and develop the Divisionist principle, but we are not engaged in Divisionism. We apply an instinctive complementarism which is not, for us, an acquired technique, but rather a *way of seeing* things."[18] It was in fact through the formal principle of the divided brush stroke that the Futurists first strove to render the transparency of bodies and the interpenetration of the object and its surrounding environment, both of which drew upon dynamism.

Giacomo Balla
The Workman's Day, 1904
Polyptych, oil on paper glued on canvas,
100 x 135 cm, frame painted by the artist
Private collection

On the threshold of the Twentieth Century, Symbolism found its most meaningful expression through artists such as Alberto Martini, Raul Dal Molin Ferenzona, Romolo Romani and Galileo Chini, while for others it was only one element in their work. The period was marked by parascientific literature, the investigation of psychic mysteries, esoterism, and occult knowledge. Among others, the famous intellectual Cesare Lombroso, anthropologist and psychiatrist, participated in the activities of the Società degli Studi psichici, in Milan. Marinetti was a devoted follower of the spiritualist séances held at the home of his friend, the writer Enrico Annibale Butti. Immersed in esoterism, Dal Molin Ferenzona was a friend of Boccioni, while Martini and Romani were Marinetti's favourite artists until the founding of Futurism. More draughtsman than painter, Martini developed a dark and surreal style, referring or explicitly depicting fantasies. He designed a Liberty style (as Art Nouveau was called in Italy) cover for Marinetti's review *Poesia*, with a half allegorical, half fantastic content. Romani, who was later involved in the founding of Futurism, searched for an elementary definition of the psychical forces that dominate the individual. He examined states of mind, moods, and feelings as *Gesamstimmung*, the emotional environment of the subject's experience of being in the world. It was through the symbolic and abstract networks of his designs that Boccioni would develop the Futurist poetics of the *Stimmung*, that is, the state of mind inherent to the lived experiences of the senses. In his famous triptych, *States of Mind* (1911, cat. 20-25), which deals with psychic energy, Boccioni used networks of lines to transcribe the sensation that comes to upset the Bergsonian *élan vital* and break apart the organisation of the individual's inner dynamism.

Umberto Boccioni
Signora Massimino, 1908
Oil on canvas
Private collection

For his *Portrait of Zanardelli*, Romani used chrono-photographic repetitions of forms, within a surreal evocation of dimensionality. He has the figure's profile repeat itself as if within an imaginary space. This work deeply impressed Russolo, who also used repetition of forms within an oneiric dimension, and in paintings like *Music* and *The Solidity of Fog*, he strove to give material form to expanding mediumistic powers, articulated in space. Russolo would also produce works which figure among the extensions of visionary symbolism, like his *Self-Portrait with Skulls* and *Self-Portrait with Ethereal Double*. Cominetti and Dal Molin Ferenzona often used repetitions of the subject within their paintings. The latter, in his *Amorous Nocturne*, makes the image loom up, doubled and divided between memory and fantasy, between the representation of inner life and the simple persistence of visual memory traces in consciousness. Boccioni adopted the same iconographic solution for his *Mourning*, in which the intensity of the scene of grief subjugated the gaze, and led to the differentiated repetitions of the same female figure. The impact of visionary symbolism on the first phase of Futurist painting was visible even in Severini's *Dynamic Hieroglyphic of the Bal Tabarin*, where the erotic charge of the dancer brings forth images from the unconscious: a black African on horseback and a naked woman straddling a parted pair of scissors.

During this time, technological modernity was making itself felt in Italy. Several hydroelectric power plants were built, and, seen as signs of progress, they were both monumental and designed according to a Liberty style aesthetic.[19] The Futurist architect Antonio Sant'Elia called them "cathedrals of modernity", and would make use of their principles in his Futurist projects. In the first decade of the new century, metallurgical

Romolo Romani
Lust, 1906
Pencil on paper, 62.5 x 47.5 cm
Private collection

production increased tremendously, going from 19,000 to 250,000 tons per year. The automobile industry grew in similar proportions, as factories sprouted throughout the north. The *Prima esposizione internazionale d'arte decorativa moderna* [First International Exhibition of Modern Decorative Art], held in Turin from April to November 1902, displayed the international extension of Art Nouveau, through the works of artists like Peter Behrens, Victor Horta, Joseph Olbrich, Hector Guimard and Henry Van de Velde. This exhibition, the first of its kind ever organised,[20] launched an artistic trend in Italy dedicated to the rejuvenation of the applied arts through the goal of "bringing art closer to life". After seeing the show, Balla joined the review *Novissima*, which defended this new aesthetic programme, and would become the instigator of a Futurism articulated around the everyday object. Leonetto Cappiello took up the technique of chronophotographic formal repetition, to give the impression of movement and gesture in his posters.[21] Meanwhile, the painter Marius (the alias of Mario Stroppa) provided an example of the visionary Futurism of the time: he drew aerial perspectives of Italian cities with strange "flying machines" soaring above them. In 1906, the opening of the Simplon tunnel was hailed as a "triumph of progress", and the *Esposizione internazionale del Sempione* [Simplon International Exhibition], was held from April to November in Milan. If Turin was the city of the automobile, Milan symbolised the urban, industrial and financial modernity which was starting to express itself in a new culture and way of life, whose previously unknown parameters demanded to be thought through.

For this reason, among the precursors of Futurism the essayist and theorist Mario Morasso occupied a central position. Between the end of the nineteenth and the beginning of the Twentieth Century, he published a series of books with strikingly evocative titles: *Uomini e idee di domani: L'egoarchia* [Men and Ideas of Tomorrow: Egoarchy], *L'Imperialismo artistico* [Artistic Imperialism], *La Nuova Arma: La macchina* [The New Weapon: The Machine], *Il Nuovo Aspetto meccanico del mondo* [The New Mechanical Aspect of the World]. Extremely well-known in Italy, Morasso's works were also read in France, where he was grouped with the "young Italian aestheticians", alongside Benedetto Croce and Angelo Conti. According to Morasso, with the modern movement, art was now tied to life and to the most powerful possible expressions of grandeur and pleasure. Therefore, artworks must be either representations of energy, pleasure, and conquest, or instigations to them. A fervent reader of Nietzsche, Stirner and Gumplowicz, Morasso wrote of the "philosophy of strength" and advocated the deployment of "national energy", while announcing the advent of an "egoarchy" which, through its dissolution of social structures, would lead to the total empowerment and liberation of the individual.

Morasso saw the modern metropolis as the space of the spirit of conquest which was structuring "the new dynamism of human will and desire". Boulevards swarming with the crowd were "immense accumulators of differing excitations." He celebrated electric signs and department stores and insisted, above all, on the theme of the energy found in the machine as a manifestation of power. He often returned to the "feeling of speed" and the spectacle of energy embodied in the machine. In 1902, in the Florentine review *Il Marzocco*, he published a text which, going beyond any functionalist concern to link the beautiful to the useful, stressed the pure beauty of the locomotive and the automobile. When at speed, they evoke "a deep and grave feeling of admiration and satisfaction within my soul before this bridled energy, and a joyous excitement before this ardent rush forwards, this wonderfully rapid motion".[22] Morasso affirmed that "in works which inspire racing or speed is found an element particular to them, open to aesthetic appreciation, because the feelings of which I have just spoken are in fact aesthetic or at least close to the aesthetic feeling".[23] The following year he called the automobile a "modern monument", which substituted "iron for stone" and which was "without any precedent in the past".[24]

In fact, Morasso was a great admirer of Gabriele D'Annunzio, the leading figure of decadent, Symbolist culture, but this did not prevent him from developing a vitalist interpretation of the machine, conceived in opposition to the functionalist principles of industrial art. Defining the machine as an image of virtual energy and proposing an aesthetic of speed, he formulated a foundational concept on which Marinetti would build his Futurism, and Marinetti would also borrow other ideas, including Morasso's polemic against Ruskin. In terms of politics, there was a total continuity between Morasso's thought and those excesses of Futurism which would come to be called 'Marinettism',

18 L. Russolo, cited in Lista, *Le Futurisme : Création et avant-garde*, (Paris: L'Amateur, 2001), pp. 55–6.
19 One of the most famous is the Centrale Taccani de Trezzo sull'Adda, near Milan, designed by Gaetano Moretti, and made operational in 1906. Today only in partial use, it has been officially recognised as a national monument.
20 The Belgian art historian Paul Fierens often stressed that the Exposition internationale des arts décoratifs et industriels modernes, organised in Paris in 1925, simply repeated the idea behind the Turin exhibition of 1902.
21 See U. Ojetti, "Le caricature di Cappiello," *Lettura* (Milan), no. 2, Feb. 1901.
22 M. Morasso, "L'Estetica della velocità", *Il Marzocco* (Florence), 14 Sept. 1902, p. 13.
23 Ibid., p. 14.
24 M. Morasso, *L'Imperialismo artistico*, (Milan–Turin–Rome: Fratelli Bocca Editori, 1903), p. 210.

to wit, the kind of overblown Heraclitanism mixed with Social Darwinism that led Marinetti to consider war as aesthetics in action and the apogee of industrial society. Boccioni also took in Morasso's ideas. The journal he kept in the years before Futurism shows that he read not only *L'Imperialismo artistico* [Artistic Imperialism] but also *La Vita moderna nell'arte* [Modern Life in Art], Morasso's study of the *Fifth Venice International Exhibition*.[25] Morasso was Italy's first theorist of urban culture and of "modernolatry", to use the expression Boccioni was to coin later, in opposition to Baudelaire's "modernity". In 1907, without ever having met, Boccioni and Marinetti both went to the new motor racing *Circuito* in Brescia, watched the race, and derived the same vitalist exaltation, which they described in terms similar to Morasso's. The theme of energy, of which the political value was first glorified in the French Revolution, was very prominent in the culture of the period. The young Italian nationalism orchestrated this theme, celebrating the aggressive and militarist but also the ethical energy thought necessary to restore to Italy her lost splendour. Nietzscheanism, very widespread at the time, suggested that it was art itself which must instigate the vitalist surge.[26] Nevertheless, the debate around modern art continued to be marked by the search for a national identity, that is Italian art still found itself unable to break with references to the past. Moreover, with a few exceptions, Italian art was unable to respond to different cultures such as seen in Japanese or African art. Thus, in Futurist art there is no echo of the verticality of the *kakemono* or the formal syntheses of African masks. Instead, it was mostly modernist images of sport, locomotives, automobiles and the city which found their way into the paintings of artists like Giuseppe Cominetti or Aroldo Bonzagni. Also, during this period a mechanic of genius who had been educated in the Fine Arts Academy, Ettore Bugatti, built his first car in Milan, that would give birth to automotive design. He thus became the first interpreter of the Marinettian idea that hailed the advent of a new aesthetic linked to the machine: according to the *Manifesto of Futurism*, an automobile was more beautiful than the *Victory of Samothrace*.

The new technological media, photography and film, whose innovations would open the path to Futurism, became very popular at this time. The wide-spread enthusiasm for film gave rise to the first production companies, and among them, the Cines of Rome made *Le Farfalle* in 1908—a film showing a cloud of butterfly-women dancing the Serpentine, Loïe Fuller's famous dance, in which gestural patterns materialised in space through the rippling of moving veils in their wake.[27] The sons of the production director of the Cines, Anton Giulio and Arturo Bragaglia, often visited the studio during filming, and four years later they would be the creators of Futurist "photodynamics", by which, as distinct from the chrono-photographs of Etienne Jules Marey, they strove to map the precise trajectory of gestures in space. Meanwhile, the quick-change artist and impersonator Leopoldo Fregoli explored the medium of cinema on the stage of the variety theatre, notably by projecting films backwards. Marinetti would later praise these multimedia shows based on "the simultaneity of speed + transformations". For the Ambrosio Film production company of Turin, the writer Arrigo Frusta directed *La Storia di Lulù*, a popular success depicting the life of a woman only through images of her feet.[28] Marinetti took inspiration from this when he launched his revolution of the theatrical stage, by performing "Futurist syntheses" with the curtain almost entirely lowered, so as to hide the actors' faces.[29]

The revolution of the gaze instigated by the new advances in photography played a major role at this time in a culture marked both by scientific progress and the crisis of positivism. Enrico Imoda was one of the Italian photographers engaged in "transcendental photography", that is, pictures meant to document parascientific experiments with spiritualism.[30] Boccioni and Russolo were very receptive to these kinds of images, thinking them capable of providing suggestions for the visual content of their paintings on the theme of psychic energy considered in terms of "states of mind".[31] Experimental photography documenting work in physics and physiology was obtaining sensational results, which were disseminated in popular reviews aimed at wide audiences.

Increasingly powerful instruments were accelerating scientific observation of the nature of phenomena which make up part of humanity's immediate environment. Going beyond what the human eye could see, new technology allowed the secret movements of matter to be explained, and registered objectively. Étienne-Jules Marey was well known in Italy[32], where his work recalled the analyses of birds in flight or the turbulence of air that Leonardo Da Vinci had undertaken centuries earlier.[33] Some of his writings were even published in Italy before they appeared in France.[34] The French physiologist conducted

A façade of the Fine Arts Gallery designed in Liberty style by Raimondo D'Aronco, at the *Esposizione internazionale d'arte decorativa*, Turin, 1902
Giovanni Lista Archives, Paris

A façade reproducing the entrance of the Simplon tunnel, at the *Esposizione internazionale del Sempione*, Milan, 1906
Giovanni Lista Archives, Paris

most of his experiments in his villa in Naples, where he would normally spend more than half the year. In fact, he commissioned Neapolitan artists to execute the sculpted studies of birds in flight, which he used in his laboratory work. The Futurists would be the first to propose a new aesthetic language based on the direct transposition into art of the scientific signs of chronophotography. Eadweard Muybridge's photographic plates on animal kinetics, along with Ernst Mach's microphotographs of atmospheric phenomena provoked by a body in motion, were also known in Italy.[35] In order to paint the sensory experience of reality, the Futurists made use of the rhythmical notations, conceptual diagrams and abstract formalisations of the scientific investigations conducted through photography. But they never engaged in an academic application aimed simply at elaborating a "scientific aesthetic". These representations of the infravisible would always be used freely and intuitively, with the goal of intensifying vital feeling rather than transcribing phenomena. Futurism developed a vision of the world anchored in the first stage of sensory experience, a sort of materialism of the sensory pleasure inherent in the experience of modern life.

In the early years of the Twentieth Century, scientific and philosophical manuals, appearing with specialist publishers like Fratelli Bocca in Turin or Libreria Hoepli in Milan, introduced Italy to the emerging ideas of the time. Notable among them were the different theories of "psychophysics", the scientific movement founded by Gustave Theodor Fechner, devoted to the analysis of "sensations" as the relational element fundamental to all psychic life and therefore all conceptual systems. Although he never cited them directly, Boccioni made it clear that he read works like Ernst Mach's *Die Analyse der Empfindingen* [The Analysis of Sensations][36], or Herbert Spencer's *First Principles* and *The Principles of Psychology*, which posit sensation as the raw material of consciousness.[37] Thanks to the work of Giovanni Papini and Giuseppe Prezzolini, who ran the journal *La Voce* from Florence, the Italian intelligentsia was able to form a critical view of William James' pragmatism, analysed as a "will to act", the operational principle of practical truth. Under the title *La Filosofia dell'intuizione* [The Philosophy of Intuition], and guided by his own particular reading of the philosopher, Papini also published his selection and translation of Bergson's writings, in a volume which offered a clear interpretation of Bergsonian philosophy.[38] Boccioni's thinking was profoundly marked by it.

Anton Giulio Bragaglia also had recourse to the theories of Spencer, James and Bergson in his arguments for the aesthetic validity of his Futurist photodynamics. In a similar spirit, Russolo used the work of Hermann Ludwig von Helmholtz in his development of the "art of noise". Although Helmholtz was known in Italy as far back as the 1870s, due to the intellectual and philosophical debate he provoked in the work of scientists like Mario Panizza[39] and Pietro Blaserna[40], his work *Die Lehre von den Tonempfindungen als physiologische Grundlage für die Theorie der Musik* [On the Sensations of Tone as a Physiological Basis for the Theory of Music] was never translated into Italian.[41] Russolo thus relied on the French edition in order to define the musical quality of noise in terms of the duration and amplitude of the vibrations perceived by the auditory nerve.

Marinetti's Futurism was also born of the social contrasts and tensions of the first decade of the Twentieth Century. All social stability underpinning a traditionalist, conservative equilibrium—like the programme of the old bourgeoisie, tied to agricultural production and textiles—was being violently thrown into question by the rapid growth of Italy's young industrial capitalism. Social upheaval and political turbulence only increased the widespread impression that the Risorgimento had failed to bring about any kind of spiritual or moral renewal. Fear of decadence and dreams of heroism fed the minds of many Italian intellectuals. Anarchism sustained the spirit of revolutionary radicalism. Political assassinations and violence in Europe at this time were often the work of Italian anarchists, seeking to make an exemplary gesture. This attitude only gained in intensity when the ideas of Mikhail Bakunin and Errico Malatesta, both very popular in Italian anarchist circles, came to be replaced by those of Georges Sorel, theorist of revolutionary syndicalism and new ideological mentor for extremist movements.[42] It was in the aftermath of the general strike of 1904, which ended in crushing defeat for the working class, that Marinetti finished writing his play *Le Roi Bombance* [The Feast King], a ferocious satire of political discourse of every stripe. To this status quo he opposes the figure of the Poet, starving for the Ideal, spokesman for the frustration engendered by the failure of the hopes to which the Risorgimento gave rise, and thus, spokesman of a specifically Italian context.

25 M. Morasso, *La Vita moderna nell'arte*, (Milan–Turin–Rome: Fratelli Bocca Editori, 1904).

26 See M. A. Stefani, *Nietzsche in Italia, rassegna bibliografica, 1893-1970*, (Rome: Biblioteca Nazionale, 1975), and G. Michelini, *Nietzsche nell'Italia di D'Annunzio*, (Palermo: S. F. Flaccovio, 1978).

27 See Lista, *Loïe Fuller, danseuse de la Belle Epoque*, (Paris: Stock/Somogy, 1994). For more on film and filmic representations of the Serpentine Dance, see in particular the revised and augmented 2nd edition, (Paris: Hermann, 2007).

28 See Lista, *Cinema e fotografia futurista*, exh. cat., Trento-Rovereto, Museo di arte moderna e contemporanea, 18 May–15 July 2001 (Milan–Paris: Skira, 2001).

29 See Lista, *La Scène futuriste*, (Paris: Ed. du CNRS, 1989).

30 E. Imoda, *Fotografie di fantasmi*, (Milan–Turin–Rome: Fratelli Bocca Editori, 1912).

31 See Lista, *Futurismo e fotografia*, (Milan: Multhipla, 1979).

32 Marey's chronophotographs were shown for the first time in Italy in 1887, at an international exhibition in Florence; see L. Gioppi, "La Cronofotografia," *Rivista scientifico-artistica di fotografia* (Milan), vol. 2, no. 9, March 1984. By the following year Marey was collaborating with Italian scientific journals; see Marey, "Studio della locomozione animale colla cronofotografia" and E. J. Marey and G. Demeny, "Parallelo fra il passo e la corsa", *Annali universali di medicina e chirurgia* (Milan), vol. 283, no. 8, August 1888. It was only twenty years later, thanks to the Futurist poetics of dynamism, that chronophotographic repetitions of the human form into the domain of art were daringly introduced for the first time.

33 This is why when Balla heard of Marey's kineticised images of hummingbirds, he answered ironically, "In the sixteenth century, my name was Leonardo."

34 See, for example, Marey, "La Cronofotografia," *Il Dilettante di fotografia* (Milan), 3rd year, 23 (March)–32 (Dec.) 1892.

35 See, for example, (anon.), "Cinematografia: Muybridge", *La Fotografia artistica* (Turin), 8th year, no. 1, Jan. 1911. In his abstract paintings on the "speed of a car," Balla was to use the Mach cone, in other words the sign of the acute angle obtained by "the photographic fixing of the phenomena to which the projectile's passage through the air gives rise". See Barco, "La Fotografia dei proietilli durante la loro traiettoria," *Il Dilettante di fotografia* (Milan), 3rd year, no. 24, April 1892.

36 E. Mach, *Analisi delle sensazioni*, (Milan–Turin–Rome: Fratelli Bocca Editori, 1903).

37 Spencer's *The Principles of Psychology* (1855) was translated into Italian under the title *Le Basi del pensiero*, (Milan–Turin–Rome: Fratelli Bocca Editori, 1907), and republished by the same house in 1909 under the title *L'Evoluzione del pensiero*.

38 H. Bergson, *La Filosofia dell'intuizione*, Papini (ed.), (Lanciano: Carabba, 1909).

39 See M. Panizza, *Il Positivismo filosofico e il positivismo scientifico: Lettere ad Hermann Helmholtz*, (Florence: Bencini, 1871).

40 See P. Blaserna, *La Teoria del suono nei suoi rapporti con la musica: Dieci conferenze*, (Milan: Fratelli Dumolard, 1875). The book was translated into French and published two years later by the Librairie Germer Baillière & Co., Paris, with an appendix including Helmholtz's text, "The Physiological Causes of Musical Harmony."

41 See Russolo, *L'Art des bruits*, edited and with an introduction by Lista, (Lausanne: L'Âge d'homme, 1975). Russolo cites the French edition of Helmholtz's essay, which was published by Victor Masson et fils in 1868.

42 See G. Sorel, *Lo Sciopero generale e la violenza*, (Rome: Edizioni Industria e Lavoro, 1906).

The birth of Futurism really dates from 1905, although the 'Futurist Movement' was only founded four years later. It was in 1905 that Marinetti launched his review *Poesia*, open to poets and writers throughout Europe, and engaged in a cultural production aimed at surpassing symbolist values. It was also in 1905 that he published his first poems on the automobile, intensified his dynamisation of free verse, and published *Le Roi Bombance*, his play inspired by Nietzsche and Schopenhauer, which already proclaimed the "religion of becoming" which was to be the basis of Futurism. At this time, a group of poets was forming the initial core of the Futurist Movement around Marinetti, and among them was Gian Pietro Lucini, the theoretician of an 'Italian Symbolism' built on Renaissance philosophers like Ficino, Pico della Mirandola, and Giordano Bruno, and an Italian literary tradition running from Dante to the *Scapigliatura*.

With *Poesia*, Marinetti made extensive contacts while engaging in a cultural combat which, in his words, would liberate Italian literature from its "traditionalist and mercantilist chains".[43] He expressed his desire to attack the "cult of the past" along with the aestheticism bereft of ideals of post-Risorgimento Italy. By this time, the naturalist novel and the experimentalism of the *Scapigliati* had already introduced the forms and themes of modernity into Italian literature, and in terms of poetry, Futurism was prefigured in various guises, formal and thematic. One should mention the insistent use of onomatopoeia by Giovanni Pascoli, Giosué Carducci's celebration of the locomotive as symbol of progress, Luigi Capuana's rather moderate experiments with free verse, and finally, Augusto J. Sinadino's small vellum paper volumes featuring playful typography in different colours. In fact, Marinetti's undertaking was directed as much against the nostalgic and suggestive poetry of symbolism as it was against the Italy of antique dealers. In the Futurist manifesto, *We Renounce our Symbolist Masters, Last Lovers of the Moon*, he rejected both Italian and French symbolists, like Mallarmé. He dreamt of a militant poetry, fully engaged in the contemporary world, modern because belonging to life and following the forward march of human progress.

A short time later Marinetti would write *Les Poupées électriques* [The Electric Dolls], a play marked by Ibsen's drama and by the theories on the relationship between hysteria and hypnosis developed at the Salpêtrière by Jean-Martin Charcot and his followers.[44] The theme of the Double appears in the form of two automatons which, through their presence alone, act on the working of the psychical apparatus in such a way as to release a couple's unconscious desires. At issue are body-machines which reveal an anthropological fact inherent to industrial civilization, to wit, the need to redefine the human in the face of the world of technology and major industry. Philosophers like Marx and Bergson had already attempted to capture the advent of the "mechanised being", the former by studying "mechanisation" in *Capital*, the latter by evoking the disappearance of the tragic in *Laughter*. Marinetti, on the contrary, proposed the rediscovery of the human who finds himself or herself confronted with the mechanical, this new dimension of existence imposed by modernity. If Marinetti's theatre staged human figures likened to machines, it was because Italy was the ancestral home of humanism and the great tradition of Italian art always celebrated the splendours of the human body. Thus, Marinetti's response was culturally specific, which paradoxically bore witness to the Italian sources of Futurism. Only in Italy could one produce such an image of the automaton, grasped by Marinetti in a dialectical relationship of fascination and anxiety to human nature: the machine is the Other inside ourselves.[45]

The largely endogenous characteristics of Futurism can be found in many other places, reflecting the mechanics of reaction engendered by Italian culture itself in its most typical forms of expression. For example, the art of noise was born in opposition to *bel canto* melodies, just as the telegraphic style of words-in-freedom was conceived in opposition to a rhetorical tradition stretching from the Accademia dell'Arcadia poets all the way to D'Annunzio. Later, the experiments in "aeropainting" would aim at a re-elaboration of the rules of perspective, whose invention was the founding event of Italian art. Indeed, as glorification of the future, Futurism could only be born in Italy as, ever since the fashion for the Grand Tour, the country had been seen as the land of the past *par excellence*.

With his review *Poesia*, Marinetti managed a voyage through and beyond Symbolism. When he launched his "inquest on free verse", meant to renew poetic form in Italy, his friend Lucini developed an ideological interpretation of metric freedom invoking anarchism. He celebrated in free verse the concrete expression of a rebellion "against the

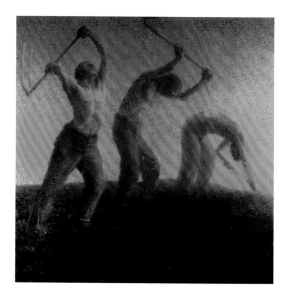

Giuseppe Cominetti
Conquerors of the Sun, 1907
Oil on canvas, 291 x 290 cm
Private collection

principle of authority". Marinetti also conceived of this literary technique as the ideological model for social, cultural, and political change: art, through a formal revolution of its own, could inaugurate a true ethics of the new, and thus contribute to human progress. But if Lucini thought of anarchy, Marinetti referred rather to revolutionary syndicalism, which, beyond the recourse to direct action, also contributed the theory of the workers' syndicate as an autonomous force, free from the authority of any political institution or party. Arturo Labriola, the leading figure of Italian revolutionary syndicalism, was developing in his review L'Avanguardia socialista a theory of minority action which led him to imagine a federation of all the syndicates, which could then take power.[46] Marinetti would make this strategy his own by founding the Futurist movement on the basis of the self-organisation of artists, poets and creators of all kinds, gathered together as "workers of the mind", engaged in "activating" the impending arrival of the "man of the future". He went on to propose a united front of Futurists and revolutionary syndicalists.[47]

Thus, Futurism inaugurated the militantism and activism of the avant-garde, calling on the artist to play his or her role fully as a catalyst within the cultural and political dynamic of the time. Following the ideological model implied by free verse, the Futurist programme was based on the refusal of all closed and predetermined forms, on the exigency of a constant renewal of the arts, and the affirmation of the individual's creative freedom over and above all social hierarchy. Futurist art strove to express the new values of the Twentieth Century, like speed, multiplicity, simultaneity, and "mechanical beauty".[48] According to Boccioni's formulation, its task was to explore and represent "relative motion" and "absolute motion", in other words kinesis (active energy) and dynamis (potential energy). Taking energy as its true subject matter, Futurism practised disfiguration through motion. It destroyed representation in the name of the forces that shaped matter, and the subsequent discovery and integration of the analytic syntax of Cubism would not alter this formal and ideological orientation. Boccioni's painting transformed the interpenetration of planes into an articulation of large plastic cadences that knew no equivalent among the Cubists. Through its work on the immaterial transitions of energy, Futurism paved the way for painting's autonomy. It practised abstraction, while avoiding the impasse of an art that means nothing but itself.

With his manifesto of 1909, Marinetti opened the activist phase of Futurism. Above all, within an Italian modernity constantly conditioned by reference to the past, he contributed a declaration of refusal, proclaiming that culture and art did not belong to the museum, but were embodied by life in its action. Affirming the normative concept of the anti-tradition, he allowed the Italian artist to identify with the operational model of the avant-garde and situate himself or herself as someone creating within the perspective of the future. By founding the Futurist movement, Marinetti established the fundamental notion of the break with the past, promulgating an ideology of rupture capable of lending a different visibility to the new.[49] Futurism thus led Italian artists to open their eyes to a world in the making. It was through this fundamental gesture that modernity could become effectively present, and, by that token, was able to prefigure the future.

43 Marinetti, Guerra sola igiene del mondo, (Milan: Edizioni futuristi di Poesia, 1915), p. 5.
44 See Lista, La Scène futuriste, op. cit. The play was written in French; its title could make one think—erroneously, as it happens—of Villiers de l'Isle-Adam's L'Ève future. Marinetti was to cite the Italian title, I Fantocci, when he announced its completion in the review Il Teatro illustrato, in June 1907.
45 In short, through the figure of the automaton Marinetti seizes the destitution of Man, formerly placed at the centre of an iconographical tradition running from Vitruvius to Leonardo da Vinci and made master of both himself and reality through the invention of perspective. Many years later, the Czech writer Karel Čapek, Marinetti's friend and translator, would make use of a far more banal idea in his play R.U.R., from which the word "robot" originates.
46 See Lista, "Marinetti et les anarcho-syndicalistes", Présence de F. T. Marinetti, (Lausanne: L'Âge d'homme, 1982). Sorel himself noted the originality of Italian revolutionary syndicalism on more than one occasion. In fact, he contributed to several Italian journals, like Benedetto Croce's La Critica and La Voce of Giuseppe Prezzolini and Giovanni Papini.
47 See Lista, "Medardo Rosso e i futuristi", Medardo Rosso: Le origini della scultura moderna, exh. cat., Trento-Rovereto, Museo d'Arte Moderna e Contemporanea, 28 May–22 Aug. 2004 (Milan: Skira Editore, 2004).
48 Marinetti, Le Futurisme [1911], (Lausanne: L'Âge d'homme, 1980).
49 Structuring itself through opposition to Futurism, Dada would insist on the abolition of the future. See Lista, Dada libertin et libertaire, (Paris: L'Insolite, 2006).

Simultaneity, Simultaneism, Simultanism

Ester Coen

A controversy involving the most interesting artistic schools in one particular year (1913) that was decisive and fundamental to the history of culture and socio-political-economic doctrines in the western world and north-east America, brought together propositions dominated by thorough inquiry into a thought which, in previous decades, had undergone limitless metamorphoses. It was a thought of extraordinary value, and perhaps for this reason even more tremendous. If, on the one hand, the impetus of evolution could foster feelings of marvel and amazement, on the other, the awareness of a rush towards the unknown, and, above all, the loss of a reality principle that was tried and tested, or at least not wholly without luminosity, gave rise to unexpected states of concern and singular apprehension.

It was the eve of the greatest war the world had seen, a war that would head in the most ferocious direction, unpredictable in extent and consequences. And it was right in the middle of that race towards progress and modern civilisation which only *a posteriori* would show the signs of absolute and harsh loss of any sense of humanity. Many artists had promptly grasped the threatening and sinister aspect of that modern civilisation and withdrawn into the irrational intuition that uncontaminated worlds existed somewhere in their work, worlds whose autonomy and freedom could only be expressed through the work of art and its language. But work that bore witness to an anxious tension with regard to colour or form, without tackling social or political themes, concealed something behind an apparent obsession with tone or object: the effort to avoid revealing, if not through transcendence of model or inspiration, a direct relationship with the everyday, punctuated by news and newspaper articles. That relationship, as in the Cubism of 1912-14, could be set simply on the surface, with the insertion of fragments, information or even letters which would circumscribe the plane of the work with that of reality, idealising and ennobling the object of pure phenomenological speculation. With the signs of daily life themselves, art could emphasise its own autonomy, thus keeping its own distance from the everyday. But if many took refuge in an individual universe and withdrew from the concrete world, already a source of restrictions and miseries, there were other artists and intellectuals who vindicated, through art, the need to absorb those ideas from outside and use them as a pure source of inspiration.

The supremacy of fascinating mechanistic technologies, the loss of values, the projection of the images of a reality manipulated by the effect of great and prodigious inventions, this epoch memorised and transcribed the crumbling of positivist ideologies that underpinned a middle class who, contrarily, struggled and fought to consolidate them. An epoch in which a malaise of doubt and uncertainty lay behind the marvels of science and all the epistemological categories that remoulded the very perception of the universe. Almost the end of an era, in which illusions of past moments were rife, veiled and hidden to the eyes of a world celebrating new urban spectacles with easy-going lightness.

It is hard to know just how aware of this dramatic opposition was the young generation of artists, full of energy and inventive power. Nonetheless the liveliness of the inventions, polemics, discussions and controversies that followed in succession in the space of so very few years—astounding and shaken by events—is the sure sign of an exuberant desire for comparison and individualistic predominance.

In the striking and radical transformation brought about by the visual and plastic arts, miraculous mirror of a revolutionary civilisation with increasingly modern urban contexts, the desire to construct or implement a stylistic and formal overturning took on the strength of a superior will. Dominated by a dialectical vitalism, though not always expressed through direct confrontation, was an expression of the natural urge to go beyond empiricism and give images the concreteness of new sensations or the immateriality of purely spiritual impressions.

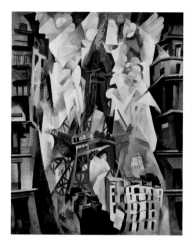

Robert Delaunay
Champ de Mars. The Red Tower, 1911
[reworked c. 1923]
Oil on canvas, 162 x 130.8 cm
The Art Institute of Chicago
Joseph Winterbotham Collection

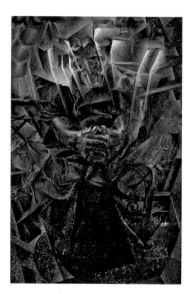

Umberto Boccioni
Matter, 1912 [reworked in 1913]
Oil on canvas, 226 x 150 cm
Gianni Mattioli Collection, on long-term loan
to the Peggy Guggenheim Collection, Venice

The inflamed and burning minds of the various factions concentrated the combative aspirations of their conflicting spirits in the tough polemic which, precisely in 1913, saw various opposing fronts and positions in the Italian, French and German art worlds. The animosity of their missives and correspondence, their violent tones, the passion of their impulses may be read today as emotional and ardent expressions of a thought whose motivations, as well as being mainly spontaneous and sincere, were either similar or at least shared the same ideal or intellectual awareness.

The battle which broke out in that famous 1913 between Futurism and Orphism laid bare the dramatic tension of the whole generation and the pretext around which the various currents of opinion became radicalised. Captious reasons, sometimes excessively subtle, sometimes exceedingly confused, marked those months that were tinged with the grim shades of a clash which went far beyond the limits of simple controversy. A polemic that emerged around the term "simultaneity" and the desire to vaunt its primogeniture, or rather to subdivide the term into all its special facets, burnished to build up the authentic, original system of contemporaneity.

If the intensity of the resulting conflict summed up the animosity with which the Futurists had invaded French soil the previous year—arousing hostility and dissent among numerous intellectuals[1]—it was actually the sign of trench warfare and of a virulent expansionism aimed at extending the boundaries of their own credos and hard artistic truths.

The salient points of that "battle" were summarised with considerable precision in an eight-point letter written by Sonia Delaunay in November 1956[2]. The controversy was triggered by Umberto Boccioni's letter published on 15 December in no. 190-91 of the magazine Der Sturm in which the artist "directly attacks R. Delaunay"[3]. The second point reports Delaunay's reply, printed in the same magazine (no. 194-195, 15 January 1914)[4]. The third and fourth points deal with two articles by Apollinaire to which Delaunay's previous text refers ("Chronique mensuelle", in no. 18 of Soirées de Paris, 15 November, and "Le Salon d'Automne" in the same magazine, no. 19 of 15 December). The fifth point quotes Apollinaire's review in the column "La vie artistique" in L'Intransigeant, 5 March 1914, where the poet speaks of Delaunay's painting Disque solaire simultané forme; au grand constructeur Blériot [Solar Disk Simultaneous Form; To the Great Constructor Blériot] as a work fired by a character of "futurisme tournoyant" [swirling futurism]. At the sixth point is Delaunay's immediate reaction against use of the term Futurist for his painting (L'Intransigeant, 6 March 1914[5], "refuting the two articles in 'Les Soirées de Paris' [sic]")[6]. Point seven deals with the response from Carrà, Papini and Soffici[7], while the eighth consists of parts of a manuscript by Delaunay[8] in which he points out certain ideas intended to define his position with regard to artistic research in those years.

The polemic therefore centred around the dating of simultaneist research by Boccioni or Delaunay respectively and to what extent the term "simultaneity" belonged to a strictly Futurist lexicon. Rereading these documents today, and the innumerable pages published or still unpublished in the meantime, written by the participants in the literary-artistic disputes of those years, one catches the slight ingenuousness of a heroic debate in the name of boundless theoretical and abstract ideals.

Simultaneity, simultaneism, simultanism were terms already somehow resonant, though in far from strictly artistic contexts, terms already in use long before the violent fury that struck the narrow literary and artistic world in 1913. Around the subtle variety and divergence of these designations the flames blazed up and became an inextinguishable hotbed of greater and more concrete battles. These words, with their different colouring of linguistic resemblance and all possible declensions of meaning, were in the sights of all those who aimed to assert themselves, to maintain autonomy and to establish superiority and paternity with regard to logics or mechanisms deeply rooted in the art world. The word "simultaneity" in its various accepted meanings is found in numberless Futurist texts, but indubitably its appearance in the catalogue introduction signed by young Italian artists at the Galerie Bernheim-Jeune in Paris in 1912[9] may be identified as the departure point for a situation which, through that exhibition, began at once as an actual declaration of war. The vehement tone of the five artists and their chief, Filippo Tommaso Marinetti, the clear divide that set "the immobile, the frozen and all the static aspects of nature" of the Cubists against their own "futuristic" poetics,

1 The Futurist painters' exhibition at the Galerie Bernheim-Jeune (February 1912) was accompanied by a lot of debate in the French press.
2 Letter from Sonia Delaunay to Maria Drudi Gambillo which attempts to piece together the tesserae of the polemic, of which she found traces in a letter signed by Carrà, Papini and Soffici (12 March 1914, to the editor of L'Intransigeant). The draft of the letter is in the Bibliothèque nationale de France in Paris (Fonds Delaunay–donation 36054/280). At the end of her letter Sonia Delaunay names the research author as Guy Weelen. But the letter was sent to Drudi Gambillo only in 1959 (dated 27 February) accompanied by another letter in which Sonia Delaunay pointed out that her reply had been considerably delayed because at the time of the Italian scholar's request (13 September 1956) Gualtieri di San Lazzaro had wished to publish a text on the same subject in his magazine XXe siècle. These notes were also used by Pierre Francastel for his book on Robert Delaunay, Du cubisme à l'art abstrait/Robert Delaunay; Documents inédits publiés par Pierre Francastel et suivis d'un catalogue de l'œuvre de R. Delaunay par Guy Habasque (Paris: SEVPEN, 1957).
3 This text by Boccioni, which appeared in the December 1913 number of the magazine Der Sturm and was written in Milan on 25 November, is an article and not a letter as described by Sonia Delaunay.
4 Lettre ouverte au Sturm, 17 December 1913, addressed to the magazine's editor Herwarth Walden.
5 Sonia Delaunay in her letter of November 1956 mistakenly writes 4 March.
6 Apollinaire's article "Au Salon des Indépendants. Réponse à une critique" was printed in the column "La vie artistique" in L'Intransigeant on 5 March 1914, trans. in Breuning (ed.), Apollinaire on Art: Essays and Reviews 1902–1918 (New York: Da Capo Press, 1972), p. 358; and Delaunay's protest, ibid., p. 504.
7 "Une querelle artistique" was published in L'Intransigeant on 7 March 1914.
8 Sonia refers to a manuscript by Delaunay, transcribed and published in Francastel, op. cit., (October 1913, 11 bis, pp. 109-112) in which, as will be explained subsequently, Delaunay accuses Futurism of being a "machiniste et non vivant" movement. The part she quotes is the following (p. 111): "The need for a new subject has inspired the poets, launching them onto a fresh path and bringing to their attention the poetry of la Tour, which communicates mysteriously with the whole world. Rays of light, waves of symphonic sound. Factories, bridges, iron structures, airships, the numberless gyrations of [sic] aeroplanes, windows seen by crowds simultaneously. Cendrars (April 1912) spent Easter in New York—strolling around the precincts of New York on Easter night, under the suspension bridges, in the Chinese districts, among the skyscrapers, in the subway (inaugurated in 1912). Returning to Paris, he went to see Apollinaire to discuss art in all sincerity, and in so doing threw him into a frenzy of elation [Sonia transcribes: emulation]; Apollinaire, who published Zône [sic] (November 1912) in Les Soirées de Paris, republished in Sturm and subsequently again in Alcools."
9 Boccioni et al., Les exposants au public, in Les Peintres futuristes italiens, exh. cat., Paris, Galerie Bernheim-Jeune & Cie 5–24 Feb. 1912, p. 2; trans. as The Exhibitors to the public, in Apollonio (ed.), Futurist Manifestos, (London: Thames and Hudson, 1973), p. 47.

built on an idea of speed, was the most offensive and provocative accusation by the Italians with regard to the cultural entourage of their host country. Even if Marinetti did feel more at home in France than in Italy, being bound to the latter almost exclusively by the thread of a lineage often evoked but never experienced with total identification. Born and bred in Alexandria, but in an atmosphere of French culture and mentality—albeit reflected in the sun of the Mediterranean coast—Marinetti had emotional and intellectual affinities with France. So it was not only for propaganda and publicity purposes that he chose Paris for publication of his first manifesto in 1909. The positive or negative echo in the literary world of that page in *Le Figaro* was such as to thrust the cultural difference and distance of Italy—unified for only a few decades and still so fragmented—into the centre of an international controversy which from that moment on could only be combated with new and more energetic means. The Futurist painters' exhibition therefore lent itself as a jemmy whose force was used by Marinetti and the Futurists to unhinge an order of inoffensive and surprised stability and to raise aesthetic controversies among various currents and factions which theretofore had not felt the need of such a head-on collision.

Gino Severini
Dynamic Hieroglyph of the Bal Tabarin, 1912
Oil on canvas, 161.6 x 156.2 cm
The Museum of Modern Art, New York
Acquired through the Lillie P. Bliss bequest, 1948

"Simultaneity of states of mind in the work of art: that is the intoxicating aim of our art," wrote the Futurists in the text for the Paris exhibition, adding: "Let us explain again by examples. In painting a person on a balcony, seen from inside the room do not limit the scene to what the square of the window renders visible: we try to render the sum total of visual sensations which the person on the balcony has experienced: the sun-baked throng in the street, the double row of houses which stretch to right and left, the beflowered balconies etc. This implies the simultaneity of the ambient, and, therefore, the dislocation and dismemberment of objects, the scattering and fusion of details, freed from accepted logic, and independent from one another. In order to make the spectator live in the centre of the picture, as we express it in our manifesto, the picture must be the synthesis of *what one remembers* and *what one sees*. You must render the invisible which stirs lives beyond intervening obstacles, what we have on the right, or the left and behind us, and not merely the small square of life artificially compressed, as it were, by the wings of a stage set. We have declared in our manifesto that what must be rendered is the *dynamic sensation*, that is to say, the particular rhythm of each object, its inclination, its movement, or more exactly, its interior force."[10]
It was within the framework of the French culture in which the Futurists now moved that style of text and artistic expressions of pictorial language were enriched by subtleties and problems that were new with respect to the declarations of just a few months earlier. From the intuitive concept of a "painting of states of mind" as pure translation of feelings in lines and colours Boccioni, supported and surrounded by his companions, developed a theory of psychophysical simultaneism. A theory which, perhaps all too hurriedly, appropriated newly spread philosophical and scientific ideas, with a view to reflecting an extraordinary contemporaneity with the mutations of life and the processes of the alteration of reality.
In brief, it was a revolutionary theory as regards the hypothesis of a space-time crossing of the image with a view to opening up horizons to the incommensurable dimension of consciousness. How to represent reality in continuous becoming by painting in one and the same space the dynamic concreteness of being and the intangible truth of interior worlds and feelings? Convulsive writings and restless behaviour from the Futurists re-echoed new scientific theories, such as Einstein's idea of simultaneity, put forward in his Special Theory of Relativity in relation to two events occurring in the same space. And if modern physics—and in parallel philosophical speculation—altered the very system of thought and its coordinates, the Futurists pursued the illusion of redesigning the landscape of aesthetic doctrines at the rhythm of denial of what had been, the rhythm of refusal of an obsolete historical past lacking all vitality. To the *élan* of creative energy, to temporal abstraction, to time and duration experienced in consciousness, in accordance with the new Bergsonian principle, the Futurists and especially Boccioni reacted by pursuing a visual synthesis of reciprocally dissonant fragments, yet without discrediting the plane of a sensorial perception deeply rooted in the objectivity of things. But in this complex fusion of elements there remained nonetheless the idea that an absolute reality existed to which the artist appealed in order to find a metaphysical explanation for phenomena of a universal nature: "if it is true that Relativity governs the world",

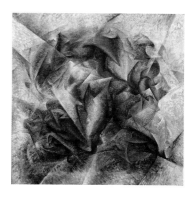

Umberto Boccioni
Dynamism of a Soccer Player, 1913
Oil on canvas, 192.3 x 201 cm
The Museum of Modern Art, New York
Sidney and Harriet Janis Collection

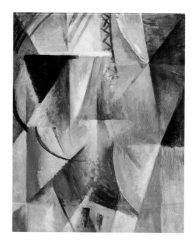

Robert Delaunay
A Window (Study for The Three Windows), 1912-13
Oil on canvas, 111 x 90 cm
Centre Pompidou-Musée national
d'art moderne, Paris
Purchased from Sonia Delaunay in 1950

Boccioni stated in 1911, "it is also true that without flashes of the absolute, which are granted to only a few, humanity would proceed in the dark, indeed it would not exist because it would not acknowledge itself to itself! And as far as I know the flash is never preceded by explanations or preambles, and only a very small mind … could fail to understand that *eternal aspiration* is the *absolute* and that the work is the *relative*; that to create is already to circumscribe; that to comment is to circumscribe the circumscribed, is to subdivide the divided, is to reduce to minimum terms, is to annihilate!"[11] With the visionary quality of a man fired by a titanic design, Boccioni set himself the task of finding a way of mediation between the relativity of the work and the absolute dimension of the universe, and a space-time perception whose physical coordinates altered with the variation of the boundaries that had been shifted by the new sciences: "A time will come when the picture will no longer be enough. Its immobility will become an archaism with the vertiginous movement of human life. The eye of man will perceive colours as feelings within itself. Multiplied colours will not need form to be understood and paintings will be swirling musical compositions of great coloured gases which, on the scene of a free horizon, will move and electrify the complex soul of a crowd that we cannot yet conceive of."[12] With these premises and with a breathless search for a material capable of absorbing all the attributes of the new sensitivity, mixed with the sensorial planes of the memory, as would happen above all in Severini, the passage from the notion of physical transcendentalism—expressed by the Futurists in the *Technical Manifesto*—to the concept of simultaneity would be the logical conclusion to ideas and principles concerning dynamism.

Theoretical elaboration would follow in the book *Pittura Scultura Futuriste* [Futurist Painting Sculpture], published in 1914,[13] where the polemic on the concept of simultaneity was brought up once more and defined as the last defence of a supremacy which the Italians now felt was escaping them: "Simultaneity for us is lyrical exaltation, the plastic manifestation of a new absolute: speed; of a new and marvellous spectacle: modern life; of a new fever: scientific discovery … Simultaneity is the condition under which the various constituent elements of DYNAMISM appear. And is therefore the effect of that great cause which is *universal dynamism*. It is the lyrical exponent of the modern conception of life, based on rapidity and contemporaneity of knowledge and communications. If we consider the various manifestations of Futurist art we see simultaneity violently asserted in all of them."[14]

But for a better understanding of the controversy that arose over the term 'simultaneity', it is indispensable to recall the irritation the Futurists had aroused with their statements and declamatory tone, to re-examine the important role of Apollinaire and, in a minor key, all the other leading figures in the debate.[15] And to see how the heart of the whole matter lay fatally in Apollinaire's reasoning on Cubism and Orphism. And in his definition of Robert Delaunay—who was highly displeased with the designation—as an artist of the new Cubist current of Orphism, persistently bound to an idea of reality and with an ambiguous manner of handling that material. And, again, to recall the inclusion of the Futurists in Apollinaire's text, a fact immediately communicated by Severini to his Italian friends and interpreted as a sign of dependence on French art: "Apollinaire told me about a book of his on the Cubists that's about to come out. He divides the Cubists into *Physical Cubists,* (Gleize) [*sic*], who add some dramatic elements to their expression of external realities; *Scientific Cubists*, (Picasso, Metzinger) and "Orphiques" [*sic*] (I give you this last classification in French because I don't know how to translate it); in Apollinaire's opinion the "Orphiques" [*sic*] seek new elements of expressing abstract realities; and we Futurists belong with the latter."[16] Other extremely important episodes could be added to these: the involvement of Herwarth Walden and artists in Germany (from Kandinsky to Marc and Macke),[17] taking the part of the Italians or the French, and the Futurists' attempt once more to shift the axis of alliances by launching a new manifesto that grew out of an understanding between Marinetti and Apollinaire, the *Antitradition Futuriste*.[18]

By what terms, however far from the poetics of the Italian artists, did Delaunay lay claim to simultaneous painting which, though assonances and correspondences were discernible, had nothing to do with Boccioni's painting of states of mind or Kandinsky's spiritual sensitivity?[19]

"Heretic of Cubism," as he liked to call himself, an artist whose painting, like Severini's, followed in the wake of the French Post-Impressionist tradition, Delaunay upheld an idea of plastic art constructed on colour and light. Factors which distanced him from

10 Ibid. pp. 5-6, trans. in Apollonio, op. cit., p. 47.
11 In "La Pittura Futurista", a lecture held in Rome at the Associazione Artistica Internazionale, via Margutta 54, in May 1911, in *U.Boccioni—Altri inediti e apparati critici*, Birolli (ed.), (Milan: Feltrinelli, 1972), p. 13.
12 Ibid. p. 11.
13 Edizioni Futuriste di "Poesia", Milan 1914.
14 Ibid., pp. 263 and 265–6. The 1913 Armory Show in New York, in which the Futurists decided not to take part, was instrumental, though there was confusion between Cubist and Futurist terminology, in introducing and spreading awareness of the French artists' research, whereas the Futurist contingent not present in America aroused far less interest.
15 For an in-depth view from the French side, see "Entre cubisme et futurisme: Le simultanéisme, un malentendu", in Fauchereau, *Hommes et mouvements esthétiques du XXe siècle*, (Paris: Éditions Cercle d'Art, 2005), pp. 421–52. This recent essay emphasises the French situation and its antecedents. I cannot summarise here all the positions extensively dealt with in this text, which supplies a more detailed analysis of the various figures, from the Delaunays to Apollinaire, Cendrars, Barzun and Léger.
16 Severini to Boccioni, 29 Oct. 1912, coll. Calmarini, Milan, reproduced and in part transcribed in *Apollinaire e l'Avanguardia*, exh. cat., Galleria Nazionale d'Arte Moderna di Roma (Rome: De Luca Editore, 1980), pp.141-2. In this letter Severini tells his friend his impressions of the Salon d'Automne and his meeting with Apollinaire. To reconstruct the entire series of events would require quoting Severini's letters to Marinetti and Boccioni, the exchange of letters between Apollinaire, Marinetti, Papini and Soffici, the Papini-Soffici correspondence and the letters between the Florence group and Marinetti. This note, however, can only anticipate a future work of far wider reconnaissance.
17 See correspondence with Delaunay (Fonds Delaunay, BnF, Paris) and letters between Walden, the Futurists and Kandinsky (Staatsbibliothek: Sturm-Archiv, Berlin).
18 See Apollinaire, *Lettere a F.T.Marinetti con il manoscritto Antitradizione Futurista*, edited by Iannini, (Milan: All'Insegna del Pesce d'Oro, 1978). It contains all the documents covering the history of this manifesto and relations between Apollinaire and Marinetti. Iannini quotes a sentence of Marinetti's from *Una sensibilità nata in Egitto* (ed. by L. De Maria, Milan: Mondadori 1969, pp. 288-9): "The movement known as Orphism or Sensitive Cubism or Futurist Cubism came into being at the Closerie des Lilas, and we baptised it with plenty of Burgundy at the restaurant *Lapérouse*. While savouring a delightful goose Apollinaire wrote the Futurist Antitradition Manifesto, with his explicit support of the Italian Futurist Movement". He also quotes a letter from Carrà (30 Nov. 1958) in reply to a request for clarification about the genesis of the manifesto: "Marinetti told me: 'you know, Apollinaire's going to write a manifesto which will be very important for our movement because of the repercussions it will certainly have'. In fact Apollinaire's manuscript arrived a few days later. I was there by chance, because I didn't go to Marinetti's every day. The Futurism secretary Decio Cinti was also present. Marinetti read the manuscript with great enthusiasm and after a brief pause added: 'the ideas expressed are very interesting, but we must give the manuscript the form of a manifesto'. He grabbed a large sheet of paper and transcribed Apollinaire's words, lingering over the spacing as in the previous manifestos. Having altered a few words he took it to the printers, enjoining urgency, and the proof arrived towards evening the next day. It was immediately sent to Apollinaire in Paris. After three or four days the author sent his permission, highly pleased with the typographical form Marinetti had given his manuscript. Printed in many thousands of copies, Apollinaire's manuscript had great influence in artistic and literary circles". Iannini suggests that the manuscript version of the manifesto he published may have been drafted "in the Paris restaurant" mentioned by Marinetti, while he

L'Antitradition futuriste

Manifeste ~~universel~~ = synthèse

P Omini, Aiminéss Koesusnotale Eï
S = crumie ME

Futuristement ce moteur à toutes
tendances *Impressionisme* Fauvisme cubisme expressionis
abstractionisme dramatisme orphisme fantaisisme
paroxysme DYNAMISME = ~~FINIDD~~ Plastique

Rose

Aux

..... Marinetti Picasso ~~Paul Dermé~~ Boccioni
Guillaume Apollinaire Max Jacob ~~Séverini~~
Corra Braque *Depaquit* Séverine Séverini
Derain Russolo Archipenko Pratella, Henry
Delaunay Balla Fernand Divoire Théo Varlet Buzzi
Palazzeschi Alexandre Mercereau *A. Mazza* Papini Soffici
Folgore govoni ~~Théo~~ *Carrà Tridon* Metzinger Gleizes Castiaux
marie Laurencin Aydo Fernand Léger Valentine Hist
~~H~~ W Kandinsky Herwath Walden Herbin Frank han
André Billy Picabia Marcel Duchamp Blaise
~~Français~~ Tavre A. M. Barzun J. Polti Fernand Fleur

analyses tending to the monochromatism and volumetry of certain Cubists, and from the studies of form that led other artists to develop a decorativism without foundation. But his studies of chromatic elements, and consequently of light and the mobility of bodies, in some ways linked his research to that of the Futurists, and he noted the danger in this.[20]

"Simultaneousness (Delaunay wrote in 1913) was discovered in 1912 in the *Windows* for which Apollinaire wrote his famous poem. It was just taking shape or was in a state of transition in *La Ville de Paris* [1910–12, cat. 54], *Les Tours* [1910] and *Les Villes* [1909], which influenced Cendrars in his poem (*Poèmes Élastiques*, published by Sans Pareil).

"In G. Apollinaire's *Les Méditations Esthétiques*, the first book on Cubism, these paintings are described as representing Cubism's second style. This was the reaction of colour to the chiaroscuro juxtaposition of Cubism. It was the first appearance in the group of colour for colour's sake, which Cendrars dubbed simultaneous—a specifically painterly notion indicating a sensibility that will not countenance any attempt to turn the clock back in art or imitate nature and past styles in any way. In this regard, he writes: 'Our eyes look straight into the sun…'.

Contrast is not black set against white (dissimilarity); on the contrary, contrast is similarity: today's art is the art of depth. The word simultaneous is a technical term. Delaunay employs it when he works with everything: harbour, house, man, woman, plaything, eye, window, book; when he is in Paris, New York, Moscow, in bed or in the air.

"'Simultaneousness' is a technique. Simultaneous contrast is the most up-to-date honing of this technique in this field. Simultaneous contrast is visible depth—Reality, Form, construction, representation. Depth is the new inspiration. We live in depth, we travel in depth. I'm in it. The senses are in it. And the mind is too!"[21]

Simultaneity was understood by Delaunay as pure pictorial sensibility of a chromatic dynamism, where a balance of the parts opens up to the attainment of a "pure reality", a "unity": a reality as pure "expression of beauty". Wholly visual formal constructions set in contrast with a Futurist sensibility inspired, according to Delaunay, by the simple movement of appositions in succession. To the clarity of a spatial vision he opposes the logic of a temporal conception where the object, in order to manifest itself in its mobility, must assume the guise of "simulacrum of movement".

If the terminology could have led to confusion, it certainly was not a comparison between the works that added disorder to the unbridled hostile currents. But maybe it was also the themes that widened a now unbridgeable gap. The city with its glittering atmospheres, radiant and spherical lights, its reflections, its primary colours, the swarming confusion of the metropolises, modern architecture, the vital energy of the athlete, were all figures of that contemporaneity in synchrony with the ideals of an extreme and still bellicose generation.

and Boccioni were in Paris for the latter's sculpture exhibition which opened on 20 June. On 21 June Marinetti held a lecture and on 29 June he left. The manuscript bears the date 29 June but appears to have been altered: "beneath the definitive number we seem to read 20 or 21 (or even an impossible 31)". Iannini adds: "The hypothesis that the first draft of the manifesto may have been done on one of those two days appears to be borne out by Marinetti's words: 'I accept and rush to the aid of Boccioni, binding with an improvisation plastic dynamism with words in freedom, essential and surprising, and I announce that Apollinaire has declared himself a Futurist (…).'"
19 A subject impossible to go into here but one which, in view of all the papers published to date, deserves a separate essay and far more meticulous analysis.
20 An interesting role was played by Félix Fénéon, art critic and director of the Galerie Bernheim-Jeune, a great supporter of impressionist and Post-Impressionist painting who invited the Futurists to exhibit in Paris and later, in October 1913, collected Delaunay's notes on "simultanism" found among the artist's papers (see Francastel, *Du Cubisme*, op. cit, pp. 108-09).
21 Ibid.

Russian Cubofuturism

Jean-Claude Marcadé

Futurism as a whole no longer enjoys the esteem it once did and the connections between Parisian Cubism and Italian Futurism or between Futurism and Dada have consequently been largely ignored.[1] The movement has been discredited on two fronts: the ideological and the aesthetic. The ideological discrediting of Futurism began with Walter Benjamin, who saw in Marinetti's Futurism—notably in the aestheticisation of politics and war—a kind of perversity in which the prescription of art for art's sake reached its apogee. "*Fiat ars, pereat mundus*"[2] says Fascism, and, as Marinetti admits, expects war to supply the artistic gratification of a sense perception modified by technology. This is evidently the consummation of "*l'art pour l'art*".[3]

Marinetti was not, of course, a visual artist but his personality was so strong that for Kasimir Malevich, for example, Marinetti represented the entire *prism* of Futurism. In his celebrated letter to Alexandre Benois of May 1916, Malevich wrote: "Boors continue to follow on one after the other [the Symbolist writer Dmitry Merezhkovsky had defined Futurists of any ilk as 'boors'] and I've lost count of how many there have been in our time! Monet, Courbet, Gauguin, Van Gogh, Millet, that boor Cézanne and the even more boorish Picasso and Marinetti (not to mention our own selves, the local boors)."[4] Picasso and Marinetti thus appear side by side; for Malevich, they were the two pillars of the new twentieth century art, the most prestigious exponents of Cubism and Futurism respectively.

The ideological discrediting begun by Benjamin was exacerbated by a form of aesthetic slighting. This has taken the form of exaggerating—at the expense of Futurism—the contribution made by Cubism to the revolution that had taken place in the visual arts over the early Twentieth Century. The thunderous triumphalism of the Italian Futurists raised hackles and resulted in a denial of the fundamental contribution made by the movement.

Futurism flowered in Russia to an extraordinary degree. Italian Futurism had given the initial impulse to the movement and triggered its principal creative ideas but the local variant rivalled its achievements. Indeed its success was such that the protagonists of left-wing art around 1910 and many subsequent Russian artists and critics denied that Italian Futurism had exerted any significant influence at all over its Russian counterpart. Three eminent Soviet specialists of the Russian avant-garde, Nikolai Khardzhiev, Evgeny Kovtun and Dmitry Sarabianov, all argued that Futurism had made no substantial contribution to Russian visual art. Khardzhiev wrote: "In Russia there was no Futurist painting as such, if we except the isolated efforts of K. Malevich (*Sharpener—The principle of flight*[5]) Natalia Goncharova (*Aeroplane on a Train*[6] and *Cyclism—Dynamo*[7]), M. Larionov (*Town-Promenade*[8]) and Olga Rozanova (*Urban Fire*[9]). By contrast, Cubism had no sooner appeared than it directly influenced the young Russian painters."[10] Evgeny Kovtun contrasted the "machinism" of Italian Futurism with the "organicism" of the Russian variant.[11] Dmitry Sarabianov similarly tended to minimise the influence of Futurism on Russian art.[12]

It should be said from the outset that the term 'Russian Futurism' covers a wide variety of aesthetic and stylistically divergent realities.[13] In early twentieth century Russia, 'Futurism' was the insult hurled by the enemies of modernity at anything in the visual arts discordant with the conventions born of the Renaissance, whether it was Symbolist, Naturalist or Realist. Around 1913, when avant-garde modernity was at its height, the Russian word 'Futurism' referred to what we now call 'the Russian avant-garde'. Consequently, 'Russian Futurism' does not designate a corpus as stylistically and aesthetically specific as that of Italian Futurism. The poet and theoretician Benedikt Livshits observed: "The term 'Futurism' was of bastard birth here: the movement was a torrent of *heterogeneous ambitions with no single orientation*; its principal characteristic was *its shared negative goal*."[14]

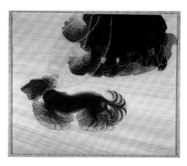

Giacomo Balla
Dynamism of a Dog on a Leash
Oil on canvas, 89.85 x 109.85 cm
Albright-Knox Art Gallery, Buffalo (NY)
Conger Goodyear Bequest and Gift of
George F. Goodyear, 1964

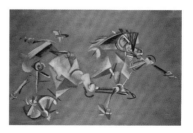

Georgy Yakulov
Sulky, 1918 c.
Oil on plywood, 102.5 x 150 cm
Centre Pompidou–Musée national d'art moderne, Paris
Gift of Raphaël Khérumian, 1971

Let us for now confine ourselves to pictorial Futurism, as invented by Boccioni and Balla around 1912–1913. In its origination of unprecedented forms and actions, it was quite as important as Parisian Cubism and its ramifications can still be felt today. Italian Futurism's analysis of movement by multiplication—exemplified by Giacomo Balla's notorious *Dynamism of a Dog on a Leash* (1912, Albright-Knox Art Gallery, Buffalo)—directly influenced only a small number of paintings by Mikhail Larionov, Natalia Goncharova, Nikolai Kulbin,[15] Vladimir Baranov-Rossiné,[16] Alexander Shevchenko[17] and Ivan Kliun (for example, *Landscape Running By*, 1914-15, Vasnetsov Museum, Kirov/Vyatka). During the 1920s, Malevich analysed for his Leningrad and Kiev students another Balla painting similarly paradigmatic of multiplied movement, *Young Girl Running on a Balcony* (1912, cat. 88).[18] He placed this kind of work in the category of "Kinetic Futurism"[19] and contrasted it with the "Dynamic Futurism" he detected in Balla's astonishing series of 1913–14 and Boccioni's work of the same period. In Malevich's opinion, the structure of *Young Girl Running on a Balcony* is "dull and monotonous, without any great tension".[20] In this picture, Balla had used "the kinetic method of fixing moments, whilst preserving the academic appearance of all the forms of the moving figure".[21] Similarly the painter and theoretician Georgy Yakulov, author of the Cubo-Futurist masterpiece *Sulky* (1918, Centre Pompidou, Paris), declared: "The Futurists' efforts to bestow forty legs on a running dog is naïve and does nothing to make the dog move."[22]

In Larionov's *Promenade. Venus of the Boulevard* (1912–13, cat. 94) and in Goncharova's *Cyclist* (1913, cat. 91) we find Primitivism combined with one application of the visual principle of the Italian Futurists, that is, the repetitive juxtaposition of the various stages of the movement of a form (such as body, wheel, or leg). But these works remain isolated examples in the œuvres of both Larionov and Goncharova and in Russian leftist art generally. We might say the same of Malevich's *The Knife Grinder* (1913), which takes the multiplication of movement to such an extreme that it no longer functions as a mimetic representation of the movement of a form in space. By contrast, the real index of Cubofuturism is the setting in motion of the planes of Cubist architectonics by the scintillation of the coloured planes and by 'shifts' or 'dislocations' (*sdvig*). Malevich later said: "Dynamism is also the forming formula for Futurist works, i.e. dynamism is the additional element that transforms the perception of one state of phenomena to another, for example, from a static to a dynamic perception."[23] *The Knife Grinder* is a step towards the total dynamism in which figurative elements vanish to become pictorial masses in movement. This also occurs with Balla's paintings on the theme of *Velocità* and Boccioni's *Unique Form of Continuity in Space* (plaster 1913, bronze, Tate, cat. 80) and *Dynamism of a Cyclist* (1913, private collection).

As we have seen, Malevich contrasts "Kinetic Futurism" ('naturalistic' multiplication of movement) with "Dynamic Futurism". He took the latter to be the true form of Futurism and the quintessence of Italian Futurism, a movement whose role in the foundation of the new art of the Twentieth Century was, in his view, equalled only by that of Cubism. "The art of *Futurism* … achieved great momentum in the first quarter of the Twentieth Century and remains a basic stimulus in the following forms of new art: *Suprematism*, *Simultaneism*, *Purism*, *Odorism*[24], *Pankinetism*, *Tactilism*[25], *Haptism*,[26] *Expressionism* and *Lég[er]ism*[27].[28] He insists that the dynamic principle was the novelty contributed by the Futurists and one which could only be compared with that of Cubism. But this dynamic principle was not, let us remind ourselves, reducible to mimetic reproduction of movement: "There is movement and movement. There are movements of small tension and movements of great tension and there is also a movement which our eyes cannot catch although it can be felt. In art this state is called dynamic movement. This special movement was discovered by the Futurists as a new and hitherto unknown phenomenon in art, a phenomenon which some Futurists were delighted to reflect."[29]

Malevich's detailed and very subtle analysis of Boccioni and Balla is openly admiring; he describes them as "the central figures of Dynamic Futurism."[30] And he points out the distinctive trait of Boccioni's Futurism: "With Boccioni the structure of the surface and of the dynamic sensation portrayed is a mass, bubbling like lava in volcanic craters or in a cauldron."[31] As to Balla, he "advanced Dynamic Futurism … drawing closer, not to the human body but to the machine, as contemporary muscles of a man of today.

1 On the rejection of Futurism, see my article, "Les rapports du futurisme italien et du futurisme russe vus par Livchits et Malévitch" in *De Russie et d'ailleurs. Feux croisés sur l'histoire. Pour Marc Ferro* (Paris: IES, 1995), pp. 477–85.

2 "Art should be made even if it brings the world down".

3 W. Benjamin, *Illuminations,* trans. Harry Zohn (London: Fontana/Collins, 1982), p. 244.

4 K. Malevich, 'A letter from Malevich to Benois', in Malevich, *Essays on Art* 1915–33, Troels Andersen (ed.), (London: Rapp & Whiting, 1969), vol. 1, p. 42.

5-9 Respectively: *The Knife-Grinder (Principle of Glittering),* 1913, Yale University Art Gallery, New Haven, C.T.; *Aeroplane Over a City* (1913), State Museum of the Visual Arts of Tatarstan, Kazan; *Cyclist* (1913); *Promenade. Venus of the Boulevard* (1912–1913); *Fire in the City* (1913–14), Art Museum, Samara, reproduced in *Amazons of the Avant-Garde: Exter, Goncharova, Popova, Stepanova, Udaltsova,* J. E. Bowlt and M. Drutt (eds.) (New York: Solomon S. Guggenheim Foundation, 1999), plate 43.

10 N. Khardjiev, *Formirovanie kubofuturizma* [The Forming of Cubofuturism], in *Stat'i ob avangarde* [Articles on the avantgarde], Moscow: 1997, vol. I, p. 31.

11 See *Présence de Marinetti*, Proceedings of the international symposium "F.T. Marinetti", held at UNESCO 15–17 June 1976 (Lausanne: L'Âge d'homme, 1982); E. Kovtun, A. Povélikhina, "La ville futuriste de Sant'Elia et les idées architecturales de Khlebnikov", p. 267, and Kovtoune, "Les 'mots en liberté' de Marinetti et la *transmentalité [zaum]* des futuristes russes", pp. 234–38.

12 See D. V. Sarabianov, *Istoriâ russkogo iskusstva konca 19-načala 20 veka* [History of Russian Art from the Late Nineteenth Century to the Early Twentieth Century] (Moscow: 1993), p. 223.

13 See J.-C.Marcadé, *Le Futurisme russe. 1907–1917: Aux sources de l'art du xxᵉ siècle* (Paris: Dessain & Tolra, 1989).

14 B. Livshits, *L'Archer à un oeil et demi* (Lausanne: L'Âge d'homme, 1971), p. 269. (Livshits, *One and a Half-Eyed Archer,* trans. and ed. J. E. Bowlt (Newtonville, Mass.: Oriental Research Partners, 1977).

15 For a reproduction of Kulbin's Futurist work *Sappho* (1914), see K. Umansky, *Neue Kunst in Russland 1914–1919* (Potsdam: Kiepenheuer/Munich: Golz, 1920), plate1.

16 Baranov-Rossiné painted many fine works in both the Futurist style—notably *Maternity* (private collection)—and in Cubofuturist style, for example, the superlative *Norwegian Rhapsody. Winter Motif from Trondheim,* (1915–16) in the State Russian Museum of St. Petersburg (reproduced in *Russian Futurism,* Yevgenia Petrova (ed.) (St. Petersburg: Palace Editions, 2000), p. 45.

17 See for example Shevchenko's *Circus* (1913) in the Nizhni-Novgorod Museum, reproduced in the catalogue of *The avant-garde before and after,* (Saint-Petersburg: Palace Editions, 2005), p. 157.

18 Malevich attributed this work to Luigi Russolo, referring to it as *Plastic Synthesis of a Woman in Motion.*

19-21 Malevich, "Dynamic and Kinetic Futurism" in *Essays on Art,* op. cit., vol. 2, p. 106.

22 G. Yakulov, "Bloc-Notes d'un peintre" [1924], *Notes et Documents édités par la Société des amis de Georges Yakoulov* (Paris), November 1975, nos. 4 and 6.

23 Malevich, "Cubofuturism" in *Essays on Art,* op. cit., , vol. 2, p. 86.

24 See Carrà's manifesto, "La Pittura dei suoni, rumori, odori. Manifesto futurista" (11 Aug. 1913), *Lacerba* (Florence), vol. I, no. 17, 1 Sept. 1913, pp. 185–87. English translation ("The Painting of Sounds, Noises and Smells") in U. Apollonio (ed.), *Futurist Manifestos,* trans. R. Brain, R. W. Flint, J. C. Higgitt, C. Tisdall (London: Thames and Hudson, 1973), pp. 111-5.

25 See Marinetti's manifesto, "Tactilism", published in French in *Comoedia,* 16 Jan. 1921; see also *Marinetti: Selected Writings,* ed. R.W. Flint (London: Secker and Warburg, 1972), pp. 109–12.

26 See R. Hausmann, "Presentismus gegen

… The actual structure of each of Balla's works tells us that the dynamic power sensed by the artist is incomparably greater than the actual bodies of the machines, and the content of each machine is only a small part of this dynamic power, since each machine is a mere unit from the sum total of the forces of contemporary life."[32]

Note that Malevich, who in his published lectures speaks only of Italian Futurism, gave his first lecture on Cubofuturism and followed it with one on "Dynamic and Kinetic Futurism". Clearly for Malevich, Cubofuturism is an intermediary state between Cubism (its basis) and the introduction of movement into the Cubist architectonic. In Soffici's works of 1912–13, *Synthesis of the City of Prato* (1912, destroyed), *Synthesis of an Autumnal Landscape* (Estorick Collection of Modern Italian Art, London), *Dance of the Pederasts* (*Plastic Dynamism*), (1913, destroyed) Malevich perceives a Cubism marked by "a certain nuance of unrest … Therefore, I think that we should single out such works from the Cubist system and create an intermediate 'Cubofuturist' category, which has at the basis of its formation only the sickle-shaped formula, and according to which law the artists strive to form dynamic sensations".[33] In this Cubofuturist category Malevich also places Carrà's *Centrifugal Forces* (1912) and *Woman + Bottle + House* and Severini's *North-South* (1912, Pinacoteca di Brera, Milan) and *Boulevard* (1911, cat. 51).

However, these analyses of the Italian artists were made later in Malevich's life. He himself had used this term for a whole series of his own works, which he grouped under the title 'Cubofuturist realism' at the last *Soyuz Molodyozhi* [Union of Youth] exhibition in St. Petersburg in 1913.[34] The only oil from this series that we know is a version of *Samovar* (1913, Museum of Modern Art, New York), no doubt the one shown at the 1914 Salon des Indépendants and described in Xenia Boguslavskaia-Pugny's letter of submission as 'Cubo-foutouristique'.[35] The basic structure of *Samovar* is clearly Cubist but the painting is traversed by spherical movements—the same system of setting the work in motion by circles and semi-circles is found in Malevich's *Sewing Machine* (1913, former Khardzhiev Collection).[36] Of the other works presented as Cubofuturist by Malevich in the 1913 exhibition in St. Petersburg, the only ones we know are drawings and lithographs such as those on the theme of 'Woman Harvesting'[37] and a pencil sketch on paper preparatory to *Portrait of a Landowner* (1913, Kunstmuseum Bochum). There too we find a geometrical structure mobilised by curves and fan-shapes in syncopated rhythm.

The synthesis of Parisian Cubism and Italian Futurism called Cubofuturism quickly made an impression on the new Russian art. The term designates the new interpretation of Futurism and Cubism—protocubism (*Cézannisme géométrique*) and Analytical and Synthetic Cubism— made by Russian artists between 1912 and 1920. Malevich had quickly perceived that the dynamic principle was already present in embryonic form in the work of Cézanne and subsequently in the geometrical *Cézanniste* paintings by Georges Braque and Pablo Picasso, such as the latter's *Harlequin and His Family* (1908, Van der Heydt-Museum, Wuppertal). He added: "The ideal of Futurism rests with Van Gogh … who … conveyed the idea of the Universal Movement of the World."[38] Prior to the 1917 Revolution, then, a profusion of paintings of great visual power was produced on Russian soil. They combined the methods of several pictorial cultures (this is one of the identifying characteristics of the Russian school); their figurative elements were geometrised by various methods of dislocating the planes (the famous *svdig* again); and they incorporated the metallic colours and forms of the new industrial civilization. All this was underpinned by a basic Primitivist structure. Almost all the great painters of the Russian left-wing—Natalia Goncharova, David and Vladimir Burliuk, Alexandra Exter, Alexander Shevchenko, Mikhail Le-Dantiu, Kasimir Malevich, Ivan Kliun, Olga Rozanova, Liubov Popova, Vera Pestel, Nadezhda Udaltsova—went through a Cubofuturist stage. The notable exceptions were Kandinsky and Larionov, who both eschewed the discipline of Cubism; Larionov's *Promenade. Venus of the Boulevard* is essentially Futuro-Primitivist. And the sculptures and pictorial reliefs by the Ukrainians Alexander Archipenko, Vladimir Baranov-Rossiné (his pre-Dada *Symphony no. 1*—1913, Museum of Modern Art, New York—is very characteristic of the Cubofuturist spirit) and Liubov Popova (for example, her *Portrait of a Woman*, 1915, Museum Ludwig, Cologne) are among the major works of the Twentieth Century.

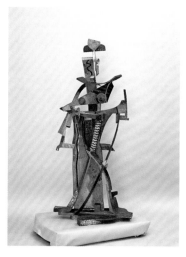

Vladimir Baranov-Rossiné
Symphony No.1, 1913
Polychrome wood, cardboard and crushed eggshells,
161 x 72 cm
The Museum of Modern Art, New York

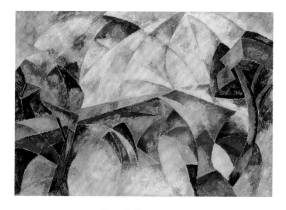

Alexandra Exter
Landscape with Bridge, c.1912
Oil on canvas, 51 x 73 cm
Private collection

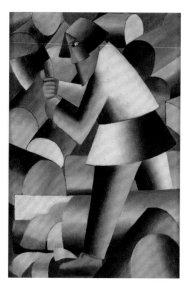

Kasimir Malevich
Woodcutter, 1912
Oil on canvas, 94 x 71.5 cm
Stedelijk Museum, Amsterdam

Something quite specific to Russian Cubofuturism (as distinct from Italian Futurism) is landscape painting. The Kiev artist Alexandra Exter is a particularly striking example of this tendency but Liubov Popova also painted landscapes and her *Cubist Urban Landscape* (1914, private collection)[39] has features in common with Exter's landscape work. These include their love of intense, glittering colour and their 'futurisation' of Cubism. In both, play is made with buildings and arches construed as quadrilaterals and triangles. In Exter's *Landscape with Bridge* (c. 1912, private collection), the Cubist structure has been set in motion; objects are dissected into facets, following a 'crystalline' procedure typical of Exter, while the curves multiply and intersect in pointed arches. In 1914, Exter shared the studio of the Italian poet and painter Ardengo Soffici. She frankly integrates Futurist principles with a (typically Ukrainian) baroque dynamism and her paintings are covered in a profusion of figurative elements and fragmentary objects; this results in a harmony of curves, spirals, straight lines and surfaces tending toward the geometrical. This is how her biographer, Georgy Kovalenko, described Exter's *City by Night* (c. 1913, cat. 90): "One can consider this landscape not as a landscape but as a conventionally dynamic composition. The artist is pursuing purely experimental objectives, striving to create a certain coloured structure charged with the energy of movement and endowed with a transformative capacity—or at least with the capacity to convince the spectator of the inevitability of its movement and transformations."[40]

These observations apply to all of Exter's work on the city between 1912 and 1924. Her immense painting *Venice* (268 x 639 cm, The State Tretyakov Gallery, Moscow)[41] was painted for the 1924 Venice Biennale and is a summation of Cubofuturist techniques. Her urban paintings are perhaps the most significant works of 'Russian Cubofuturism' in that Cubist and Futurist structures combine in them to perfectly organic effect. Were it not for her powerful Ukrainian palette, these would be the most 'Western' works of leftist Russian art, since the 'barbarian' Neo-Primitivist component characteristic of Russian Cubofuturism is less prominent in Exter's work.

Her generous deployment of forms and her joy in yellow-red-mauve-black-white and sky-blue harmonies are particularly resonant in one of her absolute masterpieces, *Florence* (1914–15, cat. 89). Here Exter dislocates the architectural movement of the arches, streets and buildings into rhythms of straight lines (horizontal black and white bands), zigzags and fan-shapes. Colours reflected in light and water shimmer through the whole painting. One figurative element, the Italian flag, appears lower right, its rectangular tricolour melding into the composition as a whole. Exter had a particular penchant for the colour-rhythms of the French, Russian, Ukrainian and Italian national flags, and used them as components in many of her *Colour Dynamics* series.

Malevich pointed out that Cubism and Futurism were essentially urban arts.[42] His Cubofuturist works demonstrate the originality attained on Russian soil by the synthesis of the static and the dynamic. The pictorial space was reconstructed by deconstruction of the object; this was combined with the representation of movement in an urban or industrial thematic and grafted onto Neo-Primitivist themes and forms. Popular kinds of structure such as the icon, *lubok* (popular print) and signboards were in the blood of Russian artists and their sense of the opposition of town and country was very strong. This is particularly clear in Goncharova's work prior to 1914. Marina Tsvetaeva devotes a chapter of her brilliant essay to "Natalia Goncharova and the Machine", declaring that Goncharova was—in works like *Electric Machine, Dynamo-Machine, Electricity* and *Electric Lamp* (cat. 92)—"the first woman to introduce machines into painting".[43] For Tsvetayeva there is a contrast in Goncharova's work between "nature …, the ancestral …, trees" and the modern machine, the latter being presented as menacing and even deadly. She nevertheless states that for Goncharova the clock is a "horse … galloping on the edge of the world"[44] and goes on to quote the artist as saying "The principle of movement is the same in the machine and in the living being. The great joy of my work is to reveal the equilibrium of movement."[45]

By contrast, Malevich—in a 'peasant' cycle painted around 1912 that includes the *Mower* (Nizhniy Novgorod Museum), the *Woman Harvester* (Astrakhan Museum), and the *Woodcutter* and *Rye Harvest* (Stedelijk Museum, Amsterdam) —breaks the subject up into cylinders, cones and spheres. This geometrical *Cézannisme* is inscribed into an icon-like and Primitivist base influenced by signboards;[46] it combines these with

den Puffkeismus der teutschen Seele", *De Stijl*, vol. 4, no. 9, 1921, p. 141.

27 Malevich generally referred to Léger's pictorial system as "Légerism"; here he refers to it as "Légerism", which the English translation corrects to "Légism" with a note to that effect.

28 Malevich, "Cubofuturism" in *Essays on Art* (n. 3), op. cit., vol. 2, p. 85.

29 Ibid., p. 86.

30 Ibid., p. 103.

31 Ibid., p. 99.

32 Ibid., pp. 100–101.

33 Ibid., p. 89.

34 See T. Andersen, *Malevich. Catalogue raisonné of the Berlin Exhibition 1927* (Amsterdam: Stedelijk Museum, 1970), p. 162 (nos. 67–72).

35 See the facsimile of the letter dated 22 January 1913 from Xenia Pugny to Vladimir Lebedev in Marcadé, "L'Avant-garde russe et Paris. Quelques faits méconnus ou inédits sur les rapports artistiques franco-russes avant 1914", *Les Cahiers du Musée national d'art moderne*, no. 2, 1979, p. 183. A photo of the Salon des Indépendants (reproduced in Marcadé, *Le Futurisme russe*, op. cit., pp. 10-11) shows *Samovar* upside down relative to the way in which it is reproduced (without comment) in A. Nakov, *Kasimir Malewicz. Catalogue raisonné* (Paris: Adam Biro, 2002), p. 140.

36 *Sewing Machine* is reproduced in *Kasimir Malevich*, exh. cat. (Barcelona: Fondació Caixa Catalunya), 21 March–25 June 2006, p. 135.

37 See Nakov, *Kasimir Malevich. Catalogue raisonné*, op. cit, pp. 131-132.

38 "On New Systems in Art" in Malevich, *Essays on Art*, op. cit., p. 101.

39 This work is reproduced in Marcadé, *L'Avant-garde russe 1907-1927*, (Paris: Flammarion 2007), plate 29.

40 Kovalenko, *Alexandra Exter* (Moscow: Galart, 1993), p. 58.

41 Exter's *Venice* is reproduced in Kovalenko, *Alexandra Exter – Cvetovye ritmy/Farbrhythmen* (Saint-Petersburg: Palace Editions, 2001), p. 102s.

42 "An Introduction to the Theory of the Additional element in Painting" in Malevich, *The World as Non-Objectivity; Unpublished Writings1922-25*, vol. 3 tr. Glowacki-Prus and Little, ed. Andersen (Copenaghen: Borgen, 1976), pp. 147–195).

43-44 M. Tsvetaeva, *Natalie Gontcharova, sa vie, son œuvre* [1929], trans. V. Lossky (Paris: Clémence Hiver, 1990), p. 53.

45 Ibid, pp. 157–158.

46 See the indispensable work by Povelikhina and Kovtun, *The Painted Signboard of Russia: Tradition and the Avant-Garde* (New York: Harry N. Abrams, Incl. / Leningrad: Aurora, 1990).

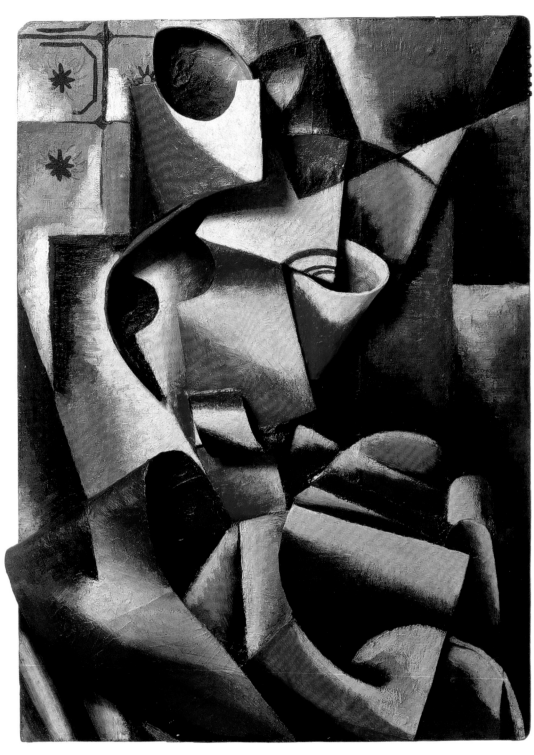

Liubov Popova
Portrait of a Woman (Plastic Drawing), 1915
Oil on paper and cardboard on wood, 63.3 x 48.5 cm
Museum Ludwig, Cologne

Futuristic metallic surfaces. No trace here of any Parisian influence. The same collision/synthesis between a peasant civilization (wood-based) and an urban civilization (metallic) is evident in the *Perfected Portrait of Ivan Vasilyevich Kliunkov* (1914, cat. 95). We have already seen that, at the last *Soyuz Molodyozhi* exhibition in St. Petersburg in 1913, *Samovar* was one of the works categorised as "Cubofuturist realism". The *Perfected Portrait,* by contrast, was categorised as "*zaumny realizm*" [transrational realism] like *The Knife Grinder* and *Morning in the Village after Snowstorm* (Solomon R. Guggenheim Museum, New York). Transrational Realism clearly covers a multitude of different styles. Malevich pictures are invariably canny combinations of several kinds of pictorial structure and the category to which they are assigned gives only a partial idea of their formal attributes.

In the context of the new art of the early Twentieth Century, the word 'Realism' is particularly associated with Albert Gleizes and Jean Metzinger, whose work *Du "cubisme"* (1913) enjoyed considerable success in Russia and had a huge impact on the evolution of the avant-garde there.[47] And here a parenthesis is necessary: partly because of Apollinaire's unfavourable judgement, Gleizes and Metzinger are rather looked down on by Western critics. But on both visual and theoretical levels, they had a significant impact on Russian leftist art. A structure borrowed directly from Metzinger (in particular from his *Woman on Horseback*, 1911, Statens Museum for Kunst, Copenhagen) is apparent in Popova's paintings *Figure + Air + Space* (c. 1913, cat. 98) and her *Seated Nude* (1913–1914, Museum Ludwig, Cologne). We might say the same of Udaltsova's *Red Figure (Seated Model)* (1915, Kremlin Museum, Rostov). This is not surprising; Popova, Udaltsova and Vera Pestel spent some of 1912–1913 at 'La Palette', the Parisian studios of Le Fauconnier, Segonzac and Metzinger. And no doubt they also saw the major show of the Italian Futurist artists at Bernheim-Jeune & Cie and read their manifestos. Popova's title—*Figure + Air + Space*—clearly echoes the title of one of the Boccioni sculptures exhibited at the Galerie La Boëtie (20 June–16 July 1913): *Head + Houses + Light.*

Between 1913 and 1915, Popova produced an impressive set of works in her own inimitable style. They consist almost exclusively of portraits and still lifes. The familiar undulating and multilinear forms of the violins, guitars and cellos of Cubism are traversed by seismic upheavals; the deconstructed object of Cubism is invaded by the visual principles of Italian Futurism. Large format letters in Latin or Cyrillic form an integral part of these compositions, for example the 'CUBOFUTURISM' featured in *Portrait of a Philosopher* (1915, Tula Museum) and *Study for a Portrait* (1914–1915, cat. 100). Malevich's *Morning in the Village after Snowstorm* could not have existed without Gleizes' *Meudon Landscape* (1911, Centre Pompidou-Musée national d'art moderne, Paris). In 1915, Marcel Duchamp expressed what was then a dissident opinion: "People talk of Picasso as the leader of the Cubists but, strictly speaking, he is no longer a Cubist. Today he is a Cubist, tomorrow he will be something else. The only true Cubists today are Gleizes and Metzinger."[48]

In *Du "cubisme"*, Gleizes and Metzinger write about universal realism and "regions in which profound realism gradually and insensibly becomes luminous spiritualism".[49] A similar view was expressed by Fernand Léger in his famous lecture "The Origin of Painting and Its Representative Value", given at the Académie Marie Vassilieff in Paris and therefore to a predominantly Russian public. Léger stated that "the realistic value of a work of art is wholly independent of any imitative character".[50] The combination of the word "realism" with "transrational" in Malevich's category refers to the practice of his friends the Cubofuturist poets Khlebnikov and Kruchenykh.[51] In 1914, Malevich dubbed this transrational quality "alogism" and grouped under it works such as *An Englishman in Moscow* (1914, Stedelijk Museum, Amsterdam), *Partial Eclipse (Composition with Mona Lisa)* (1914-1915, State Russian Museum, St. Petersburg) and *Aviator* (1914, cat. 96). In the "transrational realism" of the *Perfected Portrait of Ivan Vasilyevich Kliunkov*, the outline of the face remains visible but references to the motif of the head are reduced to a minimum. The *Portrait of Mikhail Vasilevich Matiushin* (1913, cat. 97) is all but illegible as a portrait. True, figurative elements appear here and there—a portion of the skull, a keyboard, parts of a piano—but a scattering of such elements, even when reduced to their outlines, does not amount to figuration. The Futurist component here is the interpenetration of the human and

47 There were two Russian editions of *Du "cubisme"*: one translated by Elena Guro's sister Ekaterina Nizen, edited by Matiushin (St. Petersburg: Žuravl, 1913), the other by M.V. (Moscow: Sovremennye probliemy, 1913). See the article by Babin, *"Kniga A. Gléza i Ž. Metsenžé 'O kubizme' v vospriâtii russkih hudožnikov i kritikov"* [The reception by Russian artists and critics of Gleizes' and Metzinger's *Du "cubisme"*], in Kovalenko (re-ed.), *Russkij kubo-futurizm* [Russian Cubofuturism] (St.-Petersburg: Dmitri Bulanin, 2002), pp. 37-57.

48 M. Duchamp, "A complete reversal of opinions on art", *Art and Decoration* (New York), 1 Sept. 1915.

49 Gleizes and Metzinger, *Du "cubisme"*, 1912 (Sisteron: Éditions Présence, 1980), p. 41, trans. *Cubism*, unknown translator, (London: T. Fisher Unwin, 1913), p. 15.

50 F. Léger, "The Origin of Painting and its Representative Value" in *Functions of Painting*, Fry (ed.), trans. A. Anderson (London: Thames and Hudson, 1993), p. 3.

51 On poetic Cubofuturism, see Markov's pioneering volume *Russian Futurism: A History* (Berkeley: University of California, 1968), pp. 117–163; N. Khardjiev, *La Culture Poétique de Maiakovski*, op. cit.; A. Sola, *Le Futurisme russe. Pratique révolutionnaire et discours politique*, typescript of thesis for State doctorate, Sorbonne-Paris 3, 1982; J-C. Lanne, *Vélimir Khlebnikov, poète futurien* (Paris: IES, 1983, 2 vols.); Marcadé, "Peinture et poésie futuristes", *Les Avant-gardes littéraires au XXᵉ siècle* (Budapest: Akademiai Kiado, 1984) vol. 2, pp. 963–979; G. Janacek, *The Look of Russian Literature. Avant-Garde. Visual Experiments 1900–1930* (Princeton, NJ: Princeton University Press, 1984); M Rowell, D. Wye (re-ed.), *The Russian Avant-Garde Book. 1910-1934* (New York, The Museum of Modern Art, 2002); Kovalenko (re-ed.), *Russkij kubo-futurizm*, op. cit.

machine worlds. Boccioni, Carrà, Russolo and Severini had declared in 1910: "Our bodies penetrate the sofas upon which we sit and the sofas penetrate our bodies. The motor bus rushes into the houses which it passes, and in their turn the houses throw themselves upon the bus and are blended with it."[52]

This phenomenon also occurs in the work of Olga Rozanova. In a series of paintings of 1913–1914, she used a restrained palette and relatively dull tones. The subject is suggested by a small number of referential elements. *Man in the Street (Analysis of Volumes)* (1913, cat. 101) persists with the grey and ochre tones of Parisian Cubism. These are combined with the Futurist multiplication of planes or linear sequences, which create the dynamic aspect of the urban landscape through the movements of the walker. As in Malevich's portrait of Matiushin, objects penetrate the walker and explode him into multiple fragments: houses and vehicle-wheels become one with his body. The same Cubofuturist visual principles are at work in 'twin' works by Popova: *Travelling Man* (1915, cat. 99) and *Travelling Woman* (1915, Norton Simon Art Foundation, Pasadena). The influence of Balla's *Mercury Passing Before the Sun* is clear in the system of concentric horizontal movements traversed by triangular vertical rays, which produce quadrilaterals and trapezoids at the intersections of the straight lines and the circles. In both Popova paintings, a subject from daily life is subjected to a process of dynamic decomposition and 'simultaneisation'. Moreover, there is something odd—something unexpected and even incongruous—in these paintings. This oddity is the mark of the 'Alogist Cubofuturism' launched, as it were, by Malevich.

It is also present in the emblematic *Ozonator* (or *Ventilator*, 1914, cat. 93) by Malevich's disciple, Ivan Kliun. The construction in asymmetrical planes and the confinement of the colours to ochre-yellow-brown, with just a few strokes of green and off-grey, is combined with the reproduction of the texture of wood and of a small-scale chequered grid. All of this conforms to the conventions of Parisian Cubism. Futurism is present first and foremost in the choice of subject—an electro-mechanical device—and then in the slight multiplication of line that renders the rotation of the fan. The atmosphere of the picture, two circular elements contrasting with the quadrilaterals of the background, is more than a little unexpected.

The most emblematic image of Alogist Cubofuturism is undoubtedly Malevich's *Aviator* (1914, cat. 96), a painting directly linked to Matiushin's Cubofuturist opera-happening *Victory over the Sun* (1913). To the basically Cubist structure of the painting are appended a number of incongruous objects. An enormous white fish (also present in *An Englishman in Moscow*) crosses the body of the aviator diagonally while a fork 'crosses out' his left eye; the builder's saw from the *Perfected Portrait of Ivan Vasilevich Kliunkov* cuts vertically through the real, the extra-real and the pictorial only to find its teeth echoed in the fins of the fish. The ace of spades in the aviator's hand is similarly unexpected (a form of 'spade' is also found in the hand of the tailor in the drawing *Tailor* and in a sketch of *Victory over the Sun* that represents a *Budelânskij silach* [Futuraslav Strongman], 1920s, State Russian Museum, St. Petersburg). The other arm is reduced to a handless sleeve; this is a one-handed aviator. The overturned stool at the bottom of the painting reminds us of photographs of the energetic jokers behind the 1913 spectacles *Vladimir Mayakovsky. Tragedy* and *Victory over the Sun*: Filonov, Matiushin, Kruchenykh and Malevich.[53] The most incongruous thing of all is the aviator himself, constructed like the protagonists of Malevich's cylindrical period and wearing a black top hat like that of the *Englishman in Moscow*. On the square of the hat is placed the figure '0', which evokes the exhibition "0.01" of late December 1915. That exhibition marked the "Suprematism of Painting", in which figuration in painting was reduced to zero. In Malevich's words, "I have … dragged myself out of the *rubbish-filled pool of Academic art*."[54]

The arrows emanating from the site of the zero show that the beams of light illuminating the world in new and radical fashion emanate from the man's head. The world of objects thus illuminated is designated by a word in Cyrillic capitals: A-PTIÉKA, meaning "Pharmacy". In a text that anticipates Dadaism, "The Secret Vices of the Academicians", Malevich wrote: "A work of the highest art is written in the absence of reason. A fragment from such a work:
—'I have just eaten calves feet.

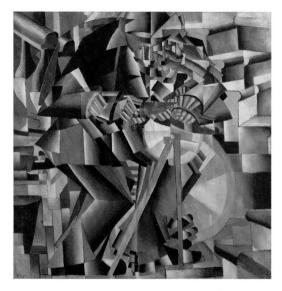

Kasimir Malevich
The Knife Grinder (Principle of Glittering), 1913.
Oil on canvas, 79.5 x 79.5 cm
Yale University Art Gallery, New Haven (CT)
Gift of Collection Société Anonyme

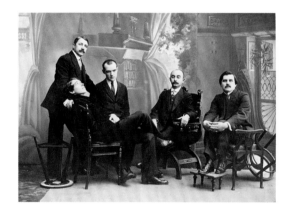

'Transrational' photo showing the protagonists
of the Cubofuturist spectacles
(*Vladimir Mayakovsky—Tragedy* and *Victory over
the Sun*) at the Luna Park Theatre, St. Petersburg,
December 1913. From left to right, seated:
Alexei Kruchenykh, Pavel Filonov, Iosif Shkolnik
and Kasimir Malevich; standing: Mikhail Matiushin.
When the protagonists have their feet on the ground,
the piano stands on the ceiling, and vice-versa.

Alexander Shevchenko
Rayonist Composition, 1914
Oil on canvas, 104 x 101 cm
Perm Art Gallery, Perm

It is surprisingly difficult to adjust oneself to happiness having travelled the length and breadth of Siberia.

I always envy the telegraph pole. [Pharmacy].'"[55]

This aviator would seem to be a symbolic self-portrait of Malevich himself as the new artist within whose skull all forms must be warehoused. As Malevich put it: "Man's skull represents the same infinity for the movement of conceptions. It is equal to the universe, for in it is contained all that it sees in it. Likewise the sun and whole starry sky of comets and the sun pass in it and shine and move as in nature … Is not the whole universe that strange skull in which meteors, suns, comets and planets rush endlessly?"[56]

The word "Pharmacy" refers to the pictorial 'cuisine' that had, in academic art, taken precedence over authenticity: "Everywhere there is craft and technique, everywhere there is artistry and form. / Art itself, technique, is ponderous and clumsy, and because of its awkwardness it obstructs that inner element … / All craft, technique and artistry, like anything beautiful, results in futility and vulgarity."[57]

One might say that, from the moment Futurism appeared, its *bacillus* (to take up Malevich's nosological metaphor of the 'additional element') penetrated all the new Russian arts. This is particularly clear in Cubofuturism with its combination of the static and the dynamic (perfectly realised in the West by Duchamp at this same period). To this combination must, of course, be added the freeing up of the palette of Cubism and the resulting explosion of colour. But the impact of Italian Futurism went well beyond this. Its influence is also felt in early Russian non-figurative art. One example is the Rayonism of Larionov and Goncharova in 1912–1913 with its vigorous lines of force rhythmically punctuating the picture surface. But this phenomenon is also evident in the paintings of Le-Dantiu and Shevchenko. The spiral is the dominant shaping principle in Vladimir Tatlin's *Monument to the Third International* (1920), which thus declares its debt to Boccioni. After 1921, Futurism is omnipresent even in Russian Constructivism. The famous movable stage-sets that Popova designed in 1922 for Fernand Crommelynck's *The Magnanimous Cuckold* are wholly imbued with Futurism: the assemblage of staircases, walkways, wheels, propellers and Latin letters was set in movement as the action of the play required. Indeed, in the theatre of this time, and in particular in the work of Vsevolod Meierhold and Nikolai Foregger, there was a *horror quietis* that, for all that it pertains to the origins of theatre, was also strangely consonant with the Futurist spirit.

Italian Futurism thus left an indelible mark on the Russian avant-garde. Few eschewed it. Among those who did were the poet Khlebnikov and the painter Filonov; Khlebnikov invented the word *budyetlianstvo* [futuraslavia] to distinguish his own work from Western Futurism.[58] Important as these two artists are, their example does nothing to change the picture that I have sketched of the convergence of Parisian Cubism and Italian Futurism on Russian soil.

52 Boccioni et al., *Manifeste des peintres futuristes*, in *Les Peintres futuristes italiens*, exh. cat. Paris, Galerie Bernheim-Jeune & Cie, 5–24 Feb. 1912; *Futurist Painting: Technical Manifesto*, in *Exhibition of Works by the Italian Futurist Painters*, Sackville Gallery, London March 1912, republished in Apollonio, *Futurist Manifestos*, op. cit., p. 28.
53 See the reproduction of one of the 'alogist' photos of 1913 in Marcadé, *Malévitch* (Paris: Casterman, 1990), p. 121.
54 Malevich, "From Cubism and Futurism to Suprematism. The New Realism in Painting", in *Essays on Art*, op. cit., vol.1, p. 19.
55 Malevich, "The Secret Vices of the Academicians", ibid., op. cit, vol. 1, p. 17–18. See also Irina Kronrod's text on the *Aviator* in this catalogue (cat. 96).
56 Malévich, "God is Not Cast Down"[1922], ibid., vol. 1, p. 193.
57 Malevich, "On Poetry", *ibid.*, p. 81.
58 See Marcadé, "La futuraslavie" in *Alfabeta/ La Quinzaine littéraire*, May 1986, no. 84, pp. 108–09.

A Short Flight:
between Futurism and Vorticism

Matthew Gale

Vorticism was born of polemic in June 1914, but barely survived a year of the First World War. In adapting combative tactics—especially those of Futurism introduced to London from 1910 onwards—to the (seemingly) genteel reticence of the British art world, it brought to public prominence the divisions that had, for some time, been conducted in private. The judgement of the press was crucial in this regard, as was its seduction and manipulation.[1] In this, the Futurist leader Filippo Tommaso Marinetti was exemplary to the point of filing reports on his own activities for the Italian news-papers.[2] News journalists and art critics helped to generate public debate and to make the controversies familiar, as is demonstrated by one jaunty summary of the artistic events of June 1914: "It is difficult to keep abreast of the various rebellious groups which have been formed this season. A movement is born on a Monday, and the following week hot-headed Secessionists emerge from it and form another."[2] The reader was thus led to see the art of such "hot-heads" as a fashionable diversion. This marginalisation was compounded by the propensity to call anything unusual 'Cubist' or 'Futurist', a tendency that was already well-established by the time that the painter and writer Wyndham Lewis, together with the poet Ezra Pound, brought Vorticism to the public.

In taking as its title "A Short Flight", from a lost painting by Edward Wadsworth illus-trated in the Vorticist publication *Blast*, this essay traces some of the episodes in the reception of Futurism in London and the explosion of Vorticism. Though the painting combined the diagrammatic and the aerial,[3] a retrospective consideration allows the title to evoke other layers of meaning. These include Wadsworth's allusion to the experience of aviators, and perhaps especially those who showed how close Britain was to the Continent (Louis Blériot flew the channel in July 1909, and Charles Rolls flew non-stop both ways a year later). Above all, the title pinpoints the brevity of Vorticism and, perhaps, helps to picture this brevity as an escape.

1910: Speaking (French) to the English

Even before founding Futurism in 1909 Marinetti had formed an international reputa-tion as a Symbolist poet and he put this to extensive use on the advent of his movement. Translations, lectures and performances were integral to its propagation, and he courted controversy across a broad political and artistic front. Just as the publication of "The Founding and Manifesto of Futurism" in *Le Figaro* on 20 February 1909 indicated a desire to conquer Paris, so awareness of Marinetti in London was confirmed by the report in the British press, two months later, of his duel over a review of his play *Le Roi Bombance*.[4] Britain became a more focused target in 1910, with lecture tours, transla-tions of key texts,[5] and, in 1912, London was the site for the second stage of the Futurist exhibition.

Marinetti's view, as "a passionate admirer of England",[6] was primarily framed through London, the metropolis at "the centre of the world", built on the legacy of the Victorian empire of commerce and industry. London's dynamism was enfolded in its strange penumbral existence. The clearing-house of world-wide riches allowed for grand houses, spacious parks and thoroughfares, but it relied upon the industrialised river and the underground railways, the round-the-clock activity and poverty of its workers, and, embracing all, what Claude Monet called its "black, brown, yellow, green and purple fogs".[7] This mysterious energy provided a frisson of danger. When visiting the Jewish theatres and opium dens of Whitechapel in 1914, Marinetti considered seeking a police escort (though these sites formed part of a tourist itinerary).[8] That such experiences of the cosmopolitan 'other' were found in the heart of the metropolis was a mark of its multivalent modernity and this permeated the political and social strata that the author-ities strove to control. Joseph Conrad based *The Secret Agent* on an anarchist plot to blow up Greenwich Observatory, with the underworld of ineffective revolutionaries enveloped in an atmosphere of "diffused light, in which neither wall, nor tree, nor beast,

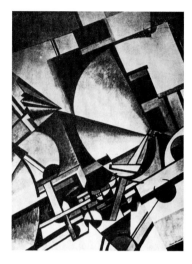

Edward Wadsworth
A Short Flight, 1914
Oil on canvas
Whereabouts unknown

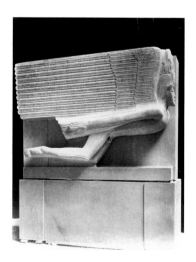

Jacob Epstein
Tomb of Oscar Wilde (before its installation
in the Père-Lachaise cemetery), 1909–12
Hoptonwood stone

nor man cast a shadow."[9] Within the energetic city, the private and the underhand could be conducted with anonymity.

The tradition of tolerance towards political radicals was one of the aspects of British life singled out for praise by Marinetti in his first public lecture—delivered in French—in London in April 1910. This was not entirely surprising, given the political nature of Futurist activity at that moment. He arrived fresh from being arrested at a riotous *serata* in Milan in February for publicly espousing the Irredentist cause, which demanded the wresting (by military means if necessary) of Italian-speaking areas from the Austro-Hungarian Empire.[10] In the same month he had sponsored the "cry of rebellion" launched by his artist colleagues—the Milanese painters Boccioni, Carrà and Russolo, with Severini and Balla as signatories—in the *Manifesto of Futurist Painters* which also provoked chaotic scenes when launched in Turin on 18 March.[11] Two days earlier, Marinetti had published "I nostri nemici comuni" [Our Common Enemies], an explicitly political text which sought to unite anarchist intellectuals and syndicalist workers by calling for the "eternal and dynamic phenomenon of rebellion".[12] It is in this context that he delivered his "Futurist Speech to the English" on 2 April, and made direct reference to his political position by admiring the British for "opening [your] arms to individualists of every land, whether libertarians or anarchists."[13] As well as his current concerns, Marinetti may also have had in mind Carrà's engagement with the city's anarchist circles a decade earlier, sympathies that the painter was explicitly working through in *The Funeral of the Anarchist Galli* (1910–11, cat. 32).[14]

Marinetti also launched into what he admitted were "discourtesies" in his "Futurist Speech to the English". Among these was his frank analysis of the nation's hypocritical sexual habits, with young men "homosexual for a time" before going on "to marry a shamelessly licentious young lady, making haste to condemn the born invert severely".[15] He prefaced these remarks by a reference to the "ridiculous condemnation of Oscar Wilde", whose trial and exile in Paris (where he died in 1901) remained a *cause célèbre*. This was again timely for a London audience, as the project for a monument to Wilde in the Père Lachaise cemetery had been announced in late 1908 together with the news that it was to be made by Jacob Epstein, an artist recently hounded by controversy over the nudes on the British Medical Association Building (1907–08).[16] In July 1910 Epstein began the massive "demon-angel" in Hoptonwood stone that would be acclaimed two years later, but whose nudity caused the Parisian cemetery authorities to impose a fig-leaf.

If Marinetti chose a topical concern, his often contradictory views on sexual politics must be seen in the light of his publication in 1910 of *Mafarka le futuriste*. A highly-sexed foundation myth of Futurism, set in a fictional Africa, the Italian version was prosecuted in Milan as an "offence to public decency" in October 1910. Marinetti publicised both the trial and the (initial) acquittal, asserting in his defence that the super-human Mafarka creates "his ideal son … a winged hero whom he transfuses with life by a supreme kiss, without the occurrence of woman".[17] This Nietzschean Parthenogenesis was deeply misogynistic, with the male violently abusive of the female, in turn consis-tently shown as weak and violated, but corrupting. Marinetti justified such gendered violence as a political metaphor, primarily framed by the anarchist ideology of the virile and revolutionary General Strike, propounded by Georges Sorel, that made an active masculinity part of the wider revolutionary aspiration for political change.[18] It is in this deliberately controversial sense that the famous ninth point of the *Futurist Manifesto* brought these anxious assertions of virility together: "We will glorify war—the world's only hygiene … and scorn for women".[19]

Given these public statements it is surprising that both Marinetti's "Futurist Speech to the English" in April and "Futurism and Woman", a lecture given in December (shortly after the *Mafarka* trial), were delivered at the Lyceum Club for Women in Piccadilly.[20] It may be assumed that his radical credentials first qualified him to address the Club whose membership was exclusively female, though it may equally be assumed (and perhaps he counted on this) that such an audience, at the height of Suffragette political activism for the vote, was potentially combustible. On the first occasion Marinetti's attack on the British was accepted with a politeness that he wittily anticipated. According to Margaret Wynne Nevinson, on the second occasion his "superlatively vigorous language" did not make up for the conservative "railery at woman" whom he condemned for being both a romantic and erotic ideal. This attitude

1 Marinetti telegrammed *Il Giornale d'Italia* on 17 June 1914 (Marinetti Libroni, Marinetti Archive, Beinecke Library, Yale University [hereafter Yale], MSS 475 / 00493-06) about the 'success' of Russolo's *intonarumori* concert in London. The Tate Gallery Archive [hereafter TGA] holds press cuttings collected by C.R.W. Nevinson (TGA 7811), Edward Wadsworth (TGA 8112) and David Bomberg (TGA 878).
2 C. Lewis Hind, "Rebel Art: Exhibits by the Philistines; From the Ordinary to the Extraordinary", *Daily Chronicle*, 25 June 1914, TGA 7811.
3 See J. Black, *Edward Wadsworth: Form, Feeling and Calculation; The Complete Paintings and Drawings*, (London: Philip Wilson Publishers, 2005), p. 23.
4 "Furious Fight with Swords: Determined duel between novelist and well-known poet", *Police Budget* (London), 24 Apr. 1909, Yale, MSS 475 / 01273-01.
5 *Against Past-Loving Venice* (27 Apr. 1910) and extracts from *The Founding and Manifesto of Futurism* in *The Tramp: An Open Air Magazine*, Aug. 1910.
6 F. T. Marinetti and C.R.W. Nevinson, "A Futurist Manifesto: Vital English Art", *Observer*, 7 June 1914 (TGA 7811).
7 From E. Bullet, "Macmonnies, the sculptor, working hard as a painter", *Eagle*, (Brooklyn), 8 Sept. 1901.
8 G. Galza Redolo, "Di notte, nei bassi fondi londinesi, in compagna di Marinetti", *Giornale d'Italia*, 31 May 1914, Yale, MSS 475 / 01266-02.
9 Joseph Conrad, *The Secret Agent*, (London, 1907), (re-ed. Harmondsworth: Penguin Books, 1963), p. 19.
10 Paolo Buzzi's *Ode* to the anti-Austrian General Asinari di Bernezzo was declaimed on 15 Feb. 1910; see G. Berghaus, *Futurism and Politics: Between Anarchist Rebellion and Fascist Reaction, 1909-1944*, (Providence, R.I. and Oxford: Berghahn Books, 1996), pp. 49–52.
11 U. Boccioni et al., *Manifesto of the Futurist Painters*, originally published in *Poesia*, (Milan) 11 Feb. 1910, trans. by R. Brain in U. Apollonio (ed.), *Futurist Manifestos*, (London: Thames and Hudson, 1973), pp. 24–27.
12 Marinetti, "I nostri nemici comuni", *La demolizione*, 16 March 1910, reprinted in Carpi, *L'estrema avanguardia del novecento*, Rome 1985, pp. 39–40, see Berghaus, op. cit., pp. 54–5.
13 See Flint (ed.), *Marinetti: Selected Writings* (London: Secker and Warburg, 1972), p. 59 and Edwards, *Wyndham Lewis: Painter and Writer*, (New Haven and London: Yale University Press, 2000), p.19, no. 15.
14 For the painter's friendship with Errico Malatesta in London in 1900 see Carrà, *La mia vita*, 1945, M. Carrà (ed.) (Milan: Abscondita, 2002), pp. 31–4. *The Funeral of the Anarchist Galli* was painted in 1911, but the preparatory drawing was made in 1910.
15 Flint 1972, p. 60.
16 See E. Silber and T. Friedman (eds.), *Jacob Epstein: Sculpture and Drawings*, exh. cat., Leeds City Art Galleries, Whitechapel Art Gallery, London, 1987, pp. 124, 127, 130.
17 Marinetti, "Il processo e l'assoluzione di Mafarka il Futurista", *Distruzione: Poema futurista*, Milan 1911, cited in C. Sartini Blum, *The Other Modernism: F.T. Marinetti's Futurist Fiction of Power*, (Berkeley, Los Angeles and London: University of California Press, 1996), p. 55. In the end, the Italian edition was banned. Sartini Blum analyses the repressed homosexual anxieties of the text, ibid. pp. 55–78.
18 For the importance of Georges Sorel's theories to Marinetti see Berghaus, op. cit., pp. 54–9. See also Hal Foster's identification of an armoured *and* threatened phallic imagery, in *Prosthetic Gods*, (Cambridge, Mass. and London: MIT Press, 2004), p. 114.
19 Marinetti, *The Founding and First Manifesto of Futurism*, 20 Feb. 1909, trans. Apollonio op. cit., p. 22.
20 See "Woman and Futurism", typescript, Marinetti's papers (Yale); see N. Locke, "Valentine de Saint-Point and the Fascist Construction of Woman", in M. Affron and M. Antliff (eds.), *Fascist Visions: Art and Ideology in France and Italy*, (Princeton: Princeton University Press, 1997), p. 73, no. 3.

was greeted, rather wearily, as "the same old story".[21] Nevinson, the Club's secretary and a long-standing campaigner for women's rights, acutely dissected the contradictions in Marinetti's situation. Astonished that he "found time to extol the Suffragette (had he an idea that among his London audience were more than one or two women who would answer proudly to that title?)", she observed: "it was not the Suffragette's desire for liberty that aroused the Signor's admiration, but merely her method of enforcing her demands".[22] This admiration for violent mass action (Suffragettes had attacked the House of Commons on 18 November) was accepted somewhat indulgently, but Marinetti's view of women was not. Nevinson argued robustly: "The erotic woman is a product of man's absolutism—a product that is declining rapidly along with man's unlimited control of things that matter."[23]

1912: Paint Run Mad

It has been suggested that Wyndham Lewis was a guest at Marinetti's April lecture, and it was certainly the case that the Futurist leader's later visit overlapped with the large exhibition that became a watershed of modernism in Britain: Roger Fry's "Manet and the Post-Impressionists" at the Grafton Galleries.[24] Even if artists who regularly visited Paris (including Lewis, who lived there periodically between 1902 and 1908) were already familiar with the work of Cézanne, Van Gogh, and Gauguin, Fry's inclusion of recent work by Matisse, Derain and Picasso under the catch-all term "Post-Impressionism" had an electrifying effect. The public was encouraged to outrage by the press: "It is paint run mad."[25] Crucially, Margaret Wynne Nevinson's son, C.R.W. Nevinson, was among the students at the Slade School—including Edward Wadsworth and David Bomberg—who ignored professorial injunctions in order to visit the exhibition.[26] Selecting the exhibition catapulted Fry to the centre of Francophile modernist activities in London, a position reinforced by the "Second Post-Impressionist Exhibition" that followed at the end of 1912.[27]

It was in the period between these exhibitions that Lewis worked hard to build his own artistic alliances. After years abroad occupied largely by writing, he exhibited with the Camden Town Group in June and December 1911. He visited the Salon d'Automne in Paris in November, where he saw the Cubist room with large-scale works by Léger, Metzinger and Gleizes (including the latter's *Portrait of Jacques Nayral* (cat. 19). Cubism was in the ascendant in Lewis's work, and his tendency towards graphic rigour is evident in his contribution of *Mother and Child* (lost) to the "Second Post-Impressionist Exhibition".[28] By that time, this interest had been reinforced by his response to the "Exhibition of Works by the Italian Futurist Painters" which arrived at the Sackville Gallery on 1 March 1912 straight from the Galerie Bernheim-Jeune in Paris.

"All London is talking of the Italian Futurist Painters", reported the modernist critic Frank Rutter a week after the opening.[29] Much of this talk described the fragmented works, which aimed to capture what Henri Bergson had called the flux of everyday experience, as redolent of madness, degeneracy and hysteria—terms that directly contradicted Futurist claims of revolutionary virility and purposeful action.[30] Even the sympathetic critic P.G. Konody, who interviewed Marinetti and Boccioni, wrote of their "overabundant imagination".[31] On his return to Paris, Boccioni summarised his experience of the British in dismissive, telegraphic style: "London, beautiful, monstrous, elegant, well-fed, well-dressed, but brains heavy like beefsteak. Interiors of magnificent houses: cleanliness, honesty, calm, order, but underneath it all an idiotic people (or partly so)."[32]

As well as illustrations of key works, the Sackville Gallery catalogue contained three major texts: the "Initial Manifesto of Futurism" from 1909, the two-year-old "Futurist Painters: Technical Manifesto" and the newly-completed "The Exhibitors to the Public". This last text—largely written by Boccioni—concentrated on expanding the concepts of the "simultaneousness of states of mind" and the "synthesis of *what one remembers* and of *what one sees*" in order to place the spectator "in the centre of the picture".[33] Even the unsympathetic read these texts with care. However, it is notable that one vociferous critic was Margaret Wynne Nevinson's husband, the war correspondent Henry Nevinson who, like fellow war correspondent Francis McCullagh,[34] saw Futurism in the light of the Italian invasion of Tripoli (now in Libya) in October 1911: "It is 'militant tactics' in paint, and 'Syndicalism' on canvas. One hears the clatter of broken glass as one gazes at it, and catches an echo of the war-cry of 'direct action' … The impulse which

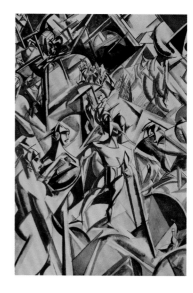

Wyndham Lewis
The Thébaïde, *Timon of Athens* portfolio, 1913
Tate Gallery Archive, London

slaughtered the Arabs of the oasis is the same frenzy which struggles to paint on canvas these fantastic 'lines of force'."[35]

Although this was deliberately dismissive, the Futurists may have welcomed the association with febrile energy. In particular, it is possible to see Boccioni's sailor-suited figures of *The Farewells* (1911, cat. 24)—the central panel of the triptych completed in the autumn of 1911—as an acknowledgement of the departure for the invasion. Together with both his Milanese colleagues, Boccioni had drawn upon related themes of street protest and he witnessed Suffragette demonstrations in London where he reported "encouraging them and acclaiming them when I saw them stop".[36] That such direct action had stepped over into war with the Libyan adventure, transformed the political fantasy of mass protest into military reality. Where Marinetti's rhetoric spoke up for such violence, *The Farewells* tells a more ambiguous story of anticipated sacrifice.

Rather than the cult of violence, it was the Italians' treatment of more festive experience that initially found a receptive audience in Britain. Writing of the Futurists in late 1913, Lewis's simple identification of Severini as "the foremost of them" exemplified the broad enthusiasm for the Paris-based painter.[37] Severini's *Dance of the Pan-Pan at the Monico* (1909–11, cat. 45) dominated the 1912 exhibition, and his appeal was reinforced by a solo exhibition for which he returned to London in April 1913. In his catalogue he wrote of abstraction as "a sign of that intensity … with which life is lived today", while in the press he explained how a painting should be "the realisation of a complex view of life or of things that live in space."[38] Severini planned this exhibition in defiance of central Futurist preference for group activity,[39] but had to report that there were no sales even if it was going well "in terms of morale and an extension of Futurism".[40] This "extension" was evidently through contact with C.R.W. Nevinson and his family.[41] Preparing Marinetti for another visit to London, Severini told him in November that Nevinson had "introduced [me] to other young artists who, with him, all became convinced Futurists … *Nevinson will, thus, introduce himself to you on my behalf; he writes to me enthusiastically about Futurism and will put himself at your service.*"[42]

Severini's influence combined with an absorption of Cubism. *Le Vieux Port* [cat. 108], with its vertical compositional structure derived from that of the massive gantry cranes, shows Nevinson adapting subjects close to those of the Salon Cubists, while *The Departure of the Train de Luxe* (now lost) developed this towards a more hermetic rendering of a subject close to Futurism. There are similarities in Wadsworth's treatment of the *Omnibus*, and Lewis identified "the cold blond of Severini's earlier painting" in Bomberg's works of 1913.[43] Lewis himself moved towards an abstracted figuration in the huge *Kermesse*, first shown in 1912 but substantially reworked in 1913. While this, like a majority of Vorticist-related works, is now lost, the robotic composition is evident from associated works including the *Timon of Athens* portfolio 1913. Such dynamic works distinguished Lewis from the more lyrical modernity of Fry's Omega Workshop, the Arts and Crafts association which offered some financial security to young artists. Though needing this support, Lewis balked at Omega's rules and, when Fry mishandled a public commission, found an excuse to secede very publicly in October 1913, taking Frederick Etchells, Cuthbert Hamilton and Edward Wadsworth with him.[44]

A shift to radical engagement with continental developments was evident in these final months of 1913. In October the "Post-Impressionist and Futurist Exhibition", selected by Rutter, opened at the Doré Galleries. Two months later, a different perspective was offered by the "Exhibition of English Post-Impressionists, Cubists and Others" held in Brighton. Although the designations 'Futurist' and 'Cubist' were largely applied to British-based artists, the critics were alert to the continental connections. Robert Delaunay's *Cardiff Team* (1912–13, cat. 57) dominated the Doré Galleries, while Severini's *Valse* and *Polka*, Wadsworth's *Omnibus*, Nevinson's *Departure of the Train de Luxe* and Lewis's reworked *Kermesse* ("some terrible battle of extermination between murderous insects"[45]) all attracted attention. For Clive Bell *Kermesse* indicated that "Lewis promises to become that rare thing, a real academic artist … that is to say he uses a formula of which he is the master and not the slave."[46] He was more direct about Severini, concluding: "Futurism is a negligible accident". However, he was swimming against the tide, as Futurism was very much in the public eye again

21 Wynne Nevinson, "Futurism and Woman", *The Vote*, 31 Dec. 1910 (TGA 7811).

22 Ibid. Most scholars have conflated the two lectures but they were given six months apart. For the family set-up, see Walsh, *C.R.W. Nevinson: The Cult of Violence* (New Haven and London: Yale University Press, 2002), pp. 3–5.

23 Ibid. On support for the Suffragettes undermining parliamentary democracy see Tisdall and Bozzolla, *Futurism*, (London: Thames and Hudson, 1977), pp. 153–163.

24 That Lewis attended the April 1910 lecture is suggested in Edwards (ed.), *Blast: Vorticism, 1914–1918*, (Aldershot: Ashgate Publishing, 2000), p. 11.

25 *Daily Express*, 9 Nov. 1910, cited in P. O'Keeffe, *Some sort of genius: a Life of Wyndham Lewis* (London: Johnathan Cape, 2000), p. 101.

26 For Tonks' warning, see Walsh, *C.R.W. Nevinson: The Cult of Violence*, op. cit., p. 21.

27 *Second Post-Impressionist Exhibition*, Grafton Galleries, Oct. 1912–Jan. 1913.

28 See A. Greutzner Robbins, *Modern Art in Britain 1910–1914* (London: Merrell Holberton Publishers/Barbican Art Gallery, 1997), pp. 96–97.

29 *Sunday Times*, 8 March 1912, cited in J. Black, "Taking Heaven by Violence: Futurism and Vorticism as seen by the British Press ca.1912-20", in *Blasting the Future! Vorticism in Britain 19101920*, exh. cat., Estorik Collection, London / Whitworth Art Gallery, University of Manchester (London: Philip Wilson publishers, 2004), p. 30.

30 Ibid., p. 30

31 *Pall Mall Gazette*, 14 Mar. 1912, cited by Robbins, op. cit., p. 57.

32 Boccioni to Vico Baer, 15 Mar. 1912, in M. Drudi Gambillo and T. Fiori, *Archivi del Futurismo*, vol. 2, (Rome: De Luca,1962) p. 43.

33 "The Exhibitors to the Public", trans. in "Exhibition of Works by the Italian Futurist Painters", (London: Sackville Gallery, 1912) and republished in Apollonio, op. cit., p. 47.

34 For Francis McCullagh's dismissal of Italian militarism, see Black, *Blasting the Future*, op. cit., p. 30. Boccioni told Vico Baer (15 Mar. 1912, in Drudi Gambillo and Fiori, op. cit., p. 43) that he and Marinetti had challenged one critic to a duel; Walsh states that it was McCullagh (Walsh, op. cit., p. 47).

35 This article is known from a cutting in Yale.

36 Boccioni to Baer, 15 Mar. 1912.

37 Wyndham Lewis, "The Cubist Room", *Exhibition of English Post-Impressionists, Cubists and Others*, Brighton, Nov. 1913–Jan. 1914, republished in W. Michel and J.-C. Fox (eds.), *Wyndham Lewis on Art: Collected Writings 1913-1956*, (London: Thames and Hudson, 1969), p. 56.

38 *The Futurist Painter Severini Exhibits his Latest Works*, Marlborough Gallery, April 1913, republished in Drudi Gambillo and Fiori, vol. 1, op. cit., pp. 113–15. Severini's "Get Inside the Picture: Futurism as the Artist Sees it", *The Daily Express*, 11 Apr. 1913, repr. ibid. p. 37.

39 Severini (in Paris) to Marinetti, 31 Mar. 1913 (Yale) reveals that his catalogue prefacehad not been vetted in Milan. See ibid. p. 146.

40 Severini (in London) to Boccioni, mistakenly, dated "[1 Mar. 1912]" in Drudi Gambillo and Fiori, op. cit., vol. 1, p. 235. It must date from 7 Apr. 1913, the opening day of his show.

41 Severini's visit has been confirmed by Henry Nevinson's journals (Bodleian Library, Oxford): he arrived on 6 April 1913; he met the Nevinsons on 13th (Walsh, op. cit., p. 54).

42 Severini (in Pienza) to Marinetti, 3 Nov. 1913, trans. in Hanson, op cit., pp. 158–59.

43 Wyndham Lewis, 'The Cubist Room', Nov. 1913, in Michel and Fox, op. cit., p. 57.

44 For the Ideal Home commission and Lewis's vitriolic "Round Robin" see Edwards, *Lewis*, op. cit., pp. 95–9.

45 Sir C. Phillips, "Post-Impressionism", *Daily Telegraph* [Oct.] 1913, TGA 7811.

46 C. Bell, "Art: The New Post-Impressionist Show",

thanks to Marinetti's return to London to deliver "peculiarly blood-thirsty concoctions with great dramatic force".[47] Lewis and Nevinson gave a celebratory dinner in Marinetti's honour at the Florence Restaurant on 18 November 1913. Reflecting a change of heart, Nevinson's father reported: "Those who have heard him in the last few days at the Cabaret, the Florence, the Poetry Shop or among the Futurist works now gathered in the Gallery know what vitality means. He overruns with it. There is no stinting or sparing."[48]

Marinetti encouraged any enthusiasm for Futurism. Fired-up by Severini's report, he actively aspired to the formation of a London 'cell' and had to be dissuaded by Nevinson from unilaterally annexing those at the Florence Restaurant dinner to the cause.[49] This followed a pattern established over the preceding months. In late June, Guillaume Apollinaire had composed his typographical *L'Antitradition futuriste*, which famously offered "merde" to enemies and "roses" to friends.[50] In August, Marinetti welcomed the French painter Félix Del Marle's *Manifeste futuriste contre Montmartre*, telling him that "to consider Futurism a monopoly … is absurd".[51] The original Futurist painters, however, directly opposed such openness and Marinetti had acted despite Severini's warning against Del Marle taking "advantage of the celebrity of the 'Futurist' name".[52] In September, Boccioni insisted on the Florentine periodical *Lacerba* refuting Anton Giulio Bragaglia's book *Fotodinamismo futurista*, that had been encouraged by Balla.[53] Two months later, Carrà urged the exclusion of Ugo Giannattasio, another associate of Severini's (and who, with Del Marle, had already featured in Apollinaire's "roses").[54] Carrà would later articulate the original painters' anxieties over the "imbeciles that, in calling themselves Futurists, cause negative publicity that yields disaster for all of us".[55] Word of Marinetti's recruitment of Nevinson—and, potentially, of others in London—does not seem to have reached Milan immediately but, on this evidence, it would have met with an equally hostile reaction from the established painters. Like Del Marle, Nevinson was never included in an exhibition of the core artists.

Beyond Nevinson's enthusiasm there is little evidence that the British were seeking anything more than the experience and reflected glory of Marinetti's presence. A nucleus was forming, but not necessarily a Futurist nucleus. This was evident in the Brighton exhibition, for which Lewis wrote the introduction to the 'Cubist Room'. He acknowledged Futurism as "one of the alternative terms for modern painting" even if "it will never mean anything else … than the art practised by five or six Italian painters".[56] He described Cubism as "superbly severe", and grouped Etchells, Hamilton, Wadsworth, Nevinson and himself together in their concern with abstract art: "All revolutionary painting today has in common the rigid reflections of steel and stone in the spirit of the artist." By including Epstein and Bomberg in the same room, Lewis identified the "volcanic matter" that was forming "a vertiginous … island in the placid and respectable archipelago of English art". In December a periodical was discussed. Nevinson's title—with its heady flavour of slang—received qualified approval from Wadsworth, who wrote to Lewis on 17 December: "I have not been able to think of another name for *Blast* and I am not convinced yet that *Blast* is bad".[57]

1914: *Blast*

The novelist H.G. Wells held a dinner in Marinetti's honour, but his appreciation was problematic as his science fiction appeared to anticipate Futurism. As one journalist asked: "Who's the Futurist: Wells or Marinetti?"[58] Certainly in *The Time Machine*, still in print after nearly twenty years, Wells had already imagined the "hysterical exhilaration" of time travel.[59] Even Lewis concurred. With a subtle deflation of both writers, he emphasised that Futurism "means the Present, with the Past vigorously excluded, and flavoured strongly with H.G. Wells' dreams of the dance of monstrous and arrogant machinery, to the frenzied clapping of men's hands".[60] Lewis belittled the obsession with machines and later recalled telling Marinetti: "You're always on about these driving belts, you are always exploding about internal combustion. We've had machines here in England for a donkey's years. They're no novelty to *us*."[61] By the time that positions were declared in *Blast* in the summer of 1914, Lewis was able to draw distinctions between a romantic 'Automobilism' based in an Impressionistic recording of sensations, on the one hand, and, on the other, the abstract (implicitly classical) experimentalism that he and his associates espoused.[62] This distinction had parallels with the

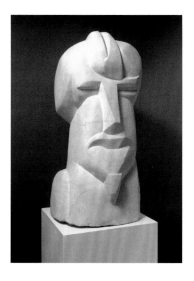

Henri Gaudier-Brzeska
Hieratic Head of Ezra Pound, 1914
Marble, 90.5 x 45.7 x 48.9 cm
The Nasher Art Collection, Dallas (TX)

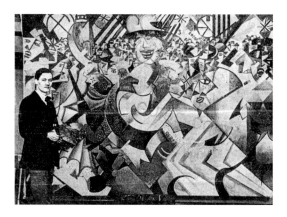

C. R. W. Nevinson in front
of *Tum-Tiddly-Um-Tum-Pom-Pom*, 1914
Oil and confetti on canvas (lost canvas reproduced
in *The Western Mail*, 15 May 1914),
Tate Gallery Archive, Nevinson Papers, London

polemic within Futurism itself earlier in the year, when Giovanni Papini had raised doubts about the artists' incorporation of reality into art, and Boccioni, whose sculptures were implicated in this criticism, responded by making a case for the synthetic creation of "new realities".[63]

The publication of *Blast* was announced in January 1914.[64] The intellectual support provided by Ezra Pound was reinforced by the critic and philosopher T.E. Hulme, who combined a Sorelian idealism with an understanding of abstract art coloured by Wilhelm Worringer's *Abstraction and Empathy*. In "Modern Art and its Philosophy" Hulme argued against Futurist naturalism (of the sort that simultaneously worried Papini) and in favour of "a certain abstract geometrical shape, which, being durable and permanent, shall be a refuge from the flux and impermanence of outside nature".[65] He equated this abstraction with a primitive instinct for stability, a notion directly derived from Worringer, who saw this desire echoed in the uncertain condition of modern life. This coincided with Hulme's championing of Epstein and of Henri Gaudier-Brzeska who were immersed in non-Western art forms. Epstein adopted forms from African art to infuse his own concern with sexual imagery, seen in the three versions of the coupled *Doves* made in 1913. He also provided crucial encouragement for Gaudier-Brzeska who made a sudden breakthrough with *Red Stone Dancer* (1913 ca., cat. 105) in January 1914. Where Boccioni's sculptures sought to exert "lines of force" on the surroundings, *Red Stone Dancer* condensed movement with weight and gravity. As such, Gaudier-Brzeska's sculpture could be said to embody "The Vortex", the term first mentioned in relation to the London artists by Pound in December 1913.[66] Indeed, their friendship was sealed at this moment by the *Hieratic Head of Ezra Pound*, a phallic portrayal of the poet (transmuted from an Easter Island figure) that would be Gaudier-Brzeska's most extraordinary work.[67]

In March 1914 Lewis tried to add organisation to the idealism of his allies by founding the Rebel Art Centre as a riposte to Omega. The short-lived organisation, supported by Kate Lechmere, failed in its aspiration as a design and teaching institution (even though Marinetti gave a fund-raising lecture in support), but it proved a further shift towards cohesion.[68] At the London Group exhibition that month, Bomberg showed *In the Hold* (cat. 103), which balanced planar structure and dynamism in a way that marked him out from Futurism and the Rebels. Fry reviewed Lewis's contribution, which included *Christopher Columbus* (lost), by acknowledging its "clear and definite organising power" but comparing the impact to "a piece of close reasoning".[69] Nevinson confirmed his connection with the Italians by showing *Tum-Tiddly-Um-Tum-Pom-Pom* (lost), depicting a public holiday on Hampstead Heath. Despite its vaguely mocking title (which onomatopoeically conveys the final phrase of a brass band march), this was his most ambitious Severinian painting to date. The relentless pace of activities was sustained with the *Exhibition of Italian Futurist Painters and Sculptors* which opened at the Doré Galleries on 27 April, and at which Nevinson played a supporting role in Marinetti's performance of *The Siege of Adrianople*.[70] This partnership—later evoked by Lewis as "the golden booming days"[71]—probably gave rise to "Vital English Art", the manifesto that Marinetti and Nevinson jointly published in the *Observer* on 7 June 1914 and subsequently in *Lacerba*.

Claiming the right "to give the signal for battle", "Vital English Art" was a call to arms that followed the pattern of other strident Marinettian manifestos. It built upon the publicity associated with "Twentieth Century Art: A Review of the Modern Movements", the Whitechapel Art Gallery exhibition (with a Jewish section selected by Bomberg) in which the Rebel artists and their allies were the most radical.[72] Marinetti and Nevinson's text condemned the philistine "English notion that art is a useless pass time, only fit for women and schoolgirls", and the outmoded "idea of genius—drunken, filthy, ragged, outcast". Instead it demanded: "a powerful advance guard, which alone can save English art … This will be an exciting stimulant, a violent incentive for creative genius, a constant inducement to keep alive the fires of invention".[73] Although not especially controversial in its incitements, the assumption that Lewis, Bomberg, Wadsworth and others named in the text shared these views, and could be publicly allied to the Italian movement without consultation—the annexation that Marinetti had attempted six months earlier—proved to be a miscalculation. Understood by Lewis as an attempt to usurp his leadership and by his friends as a presumption, it provoked an immediate public protest published on 13 June: "We, the undersigned, whose

Nation, 25 Oct. 1913, TGA 7811. Given Bell's knowledge of the schism at Omega, this seems deliberately ambivalent praise.
47 Lewis to Mrs Percy Harris, [Nov. 1913], in W. K. Rose (ed.) *The Letters of Wyndham Lewis*, Norfolk (Virginia) 1963 and London 1965, pp. 53–4.
48 H. W. Nevinson, "Marinetti: The Apostle of Futurism", *Manchester Guardian*, [Nov. 1913], in Yale MS 475 / 00581-1.
49 Nevinson to Lewis, 19 Nov. 1913, cited in Cork, *Vorticism and Abstract Art in the First Machine Age*, (London: Gordon Fraser, 1976), p. 225.
50 Apollinaire, *L'Antitradition futuriste*, 29 June 1913.
51 Marinetti to Del Marle, 15 Aug. 1913, in Drudi Gambillo and Fiori, op. cit, vol. 1, p. 25.
52 Severini to Marinetti, 17 July 1913, in Hanson. op. cit, pp. 152–3.
53 Boccioni to Sprovieri, 4 Sept. 1913, in Drudi Gambillo and Fiori, op. cit, vol. 1, p. 288. The book had been advertised in *Lacerba* in July; the disclaimer came in *Lacerba* in October.
54 Carrà to Soffici, 2 Dec. 1913, ibid., p. 307.
55 Carrà (in Paris) to Severini (discussing Arturo Ciacelli and Giannattasio), 13 Mar. 1914, in Carrà and Fagone (eds.), *Carlo Carrà - Ardengo Soffici: Lettere 1913/1929*, (Milan: Feltrinelli, 1983), p. 246.
56 Lewis, 'The Cubist Room', Nov. 1913, in Michel and Fox, op. cit., p. 56.
57 Wadsworth to Lewis, 17 Dec. 1913, quoted in O'Keeffe, op. cit., p. 142.
58 Jackson, "Who's the Futurist: Wells or Marinetti?" *TP's Weekly*, 15 May 1914, p. 633, Yale MS 475 / 00357-4.
59 Wells, *The Time Machine: An Invention*, (London: Heinemann, 1895), reprinted 1911 (twice) and 1914, pp. 28–31.
60 Lewis, 'The Cubist Room', Nov. 1913, in Michel and Fox, op. cit., p. 56.
61 Lewis, *Blasting and Bombardiering*, (London: 1937 and Calder & Boyars: 1967), pp. 37–8.
62 Lewis elided Futurism and Impressionism in "Long Live the Vortex!", *Blast*, no. 1, '20 June' [2 July] 1914, pp. 7–8. Severini had characterised "Futurism: continuation of Impressionism" in *The English Review*, as he reported (from London) to Marinetti, 19 Apr. 1913, in Hanson, op. cit., pp. 149–50.
63 G. Papini, "Il cerchio si chiude", *Lacerba*, vol. 2, op. cit., no. 4 (15 Feb. 1914), and Boccioni, "Il cerchio non si chiude", *Lacerba*, vol. 2, no. 5 (1 Mar. 1914). It is not clear how far Lewis was aware of the details of this split.
64 *The New Age*, 8 Jan. 1914, quoted in O'Keeffe, op. cit, p. 143.
65 Hulme, "Modern Art and its Philosophy", lecture, Quest Society, Kensington Town Hall, London, 22 Jan. 1914, cited by Edwards, *Lewis*, op. cit., p. 113.
66 Pound's use was ambivalent: "You may get something slogging away by yourself that you would miss in 'The Vortex'—and that we miss." Pound to William Carlos Williams, 19 Dec. 1913, quoted in O'Keeffe, op. cit., p. 142.
67 For Gaudier-Brzeska and the status of Vorticist sculpture see E. Silber, *Gaudier-Brzeska: Life and Art*, (London: Thames and Hudson, 1996).
68 Nevinson "divided equally the profits … between the five members of the 'Blast' group", Walsh, op. cit., p. 67 citing Nevinson to Lewis, 2 March 1914.
69 Fry, "Two views of the London Group", *Nation*, 19 March 1914, TGA 878.
70 "Futurist Painters", Doré Galleries, April–May 1914; the performances were on 28, 29 and 30 April according to Walsh, op. cit, p. 71.
71 Lewis, "Marinetti's Occupation", *Blast*, no. 1, p. 26.
72 See A. Greutzner Robbins, op. cit, pp. 138–51.
73 Marinetti and Nevinson, "A Futurist Manifesto: Vital English Art", *Observer*, 7 June 1914, TGA 7811, republished in Walsh, op. cit, pp. 76–7.

ideals were mentioned or implied … beg to dissociate ourselves from the 'futurist' manifesto".[74] As well as Lewis and Pound, the ten signatories included Bomberg, Etchells, Wadsworth, Gaudier-Brzeska and the young William Roberts. The night before they had taken their protest to the reading of "Vital English Art" that Marinetti and Nevinson gave at the Doré Galleries. Marinetti, an old hand at provoking opponents, may well have been disappointed, as an eye-witness reported: "The new seceders from the Marinetti group, Messrs Wyndham Lewis and Co., who now call themselves the Vorticists, who promised at the beginning to provide a belligerent opinion, dwindled into silence very early in the evening."[75] Nevinson published a response to the protest, but he now found himself isolated as the only Futurist in London.[76] The speed of events is conveyed by Severini's unembroidered (but underlined) astonished response to *Lacerba* on 22 July: "*I have read in the latest number the Marinetti-Nevinson Manifesto.*"[77]

Vorticism's sudden self-definition came in *Blast*, dated 20 June 1914 but actually published on 2 July, and much of it a tour-de-force of Lewis's writing: polemical, topical and provocative. In "Melodrama of Modernity", he slyly accepted the term Futurism: "It is picturesque and easily inclusive."[78] However, it became a consistent target and point of opposition. "Long Live the Vortex!" began: "Long live the great art vortex sprung up in the centre of this town! | We stand for the Reality of the Present—not for the sentimental Future, or the sacripant Past." More specifically: "AUTOMOBILISM (Marinettism) bores us. We don't want to go about making a hullo-bulloo [*sic*] about motor cars, anymore than about knives and forks, elephants or gas-pipes."[79] Lewis was a master of such a dismissive side-swipe. However he was also politically astute and, though the 'Blast' section (like Apollinaire's "merde" a year earlier) lined up targets, he held back from blasting Futurism, Marinetti or Nevinson.

The *Manifesto* in *Blast* is ambivalent. It lays claim to various positions without specifying much more than its own individualism. Rejecting the "abasement of the miserable 'intellectual' before anything coming from Paris" (a reference to Fry), it proclaimed that British industrialisation had ensured that "the modern world, has reared up steel trees where the green ones were lacking".[80] Despite assertions to the contrary, the *Manifesto* is chauvinistic in its national viewpoint, identifying a geographical divide: "what is actual and vital for the South is ineffectual and unactual in the North".[81] Instead, among the references to Futurism lies an allegiance to a primitive sensibility that Lewis made timeless and classless: "The artist of the modern movement is a savage (in no sense an 'advanced', perfected, democratic, Futurist individual of Mr Marinetti's limited imagination): this enormous, jangling, journalistic, fairy desert of modern life serves him as Nature did more technically primitive man." [82]

Lewis believed that the modern artist should not mimic fleeting sensations and, in so doing, he pinpointed the difference between Futurism's Bergsonianism and Vorticism's Worringerian abstraction. Such distinctions were evident in the accompanying illustrations of works by Wadsworth, Etchells and Lewis himself, and such surviving paintings as Lewis's *Workshop* (cat. 107), where rectilinear forms and an abstract structure eschew blurring dynamism or urban sensations. It was noticeable, too, that Vorticism was distinguished from Futurism by the strong presence of women. Jessica Dismorr, in particular, was notable for her abstractions, but *Blast* also reproduced works by Dorothy Shakespear and Helen Saunders.[83] This having been said, Lewis's reflection on the Suffragette Mary Richardson's famous slashing of Vélazquez's *Rokeby Venus* (in early March) failed to disguise its condescension: "IN DESTRUCTION, AS IN ALL OTHER THINGS, stick to what you know … LEAVE ART ALONE BRAVE COMRADES!"[84]

Vorticism's existence was pitifully brief and the chain of military metaphors that runs through *Blast* seems startlingly prescient. On 28 June (just days before its publication), Archduke Franz Ferdinand, the heir to the Austro-Hungarian throne, having escaped an earlier bomb, was shot in Sarajevo. By 4 August, Austria-Hungary and Germany were at war with Russia, France and Britain. Much has been written of the misplaced optimism of the war, and perhaps the conjunction of anarchism and bombing echoing between *Blast* and international events was exciting at first. However, enthusiasm rapidly gave way to disillusion, as the tenor of the response to war coloured all activities. When Epstein's *The Rock Drill* was first seen at the London Group exhibition in March 1915 it had a deeply divided and contradictory reception.

Jessica Dismorr
Abstract Composition, c.1915,
Oil on board, 41.3 x 50.8 cm,
Tate, London

Lewis identified sexual allusions in the full-height robotic figure perched on a real mining drill, "straining to one purpose … a vivid illustration of the greatest function of life".[85] Others saw it as dehumanising: "a nightmare in plaster … a cubist-futurist abortion of indescribably revolting aspect".[86] Epstein himself came to see it as malign and truncated it as the, still-threatening, *Torso in Metal from 'Rock Drill'* (1913–14, cat. 104). This exemplified the wider question of the appropriateness of modern art in meeting the demands of the war, a debate that stealthily reasserted conservative values. Gaudier-Brzeska was killed at the Front on 5 June 1915; his "Vortex Gaudier-Brzeska" appeared in *Blast* (2) in July with an obituary notice.[87] Writing in a review of the "Vorticist Exhibition" at the Doré Galleries a week later, Konody cited his death in answer to those angered by the Vorticists' continued "antics in times as serious and critical as the present".[88] A review of the earlier London Group exhibition in the *Times* had attacked Vorticism under the scandal-mongering title "Junkerism in Art", even while concluding nonchalantly: "Perhaps if the Junkers could be induced to take to art, instead of disturbing the peace of Europe, they would paint so [i.e. like Vorticists] and enjoy it."[89] However witty Lewis's riposte, he recognised that it was "done with intent to harm" by implying that modernism was unpatriotic.

In an interview given in February, Nevinson had recommended that "all artists should go to the Front" (where he had been serving as an ambulance driver). That this was a rhetorical device, perhaps for the ears of his interventionist colleagues in Italy, seems to be borne out by a less bellicose account that he drafted a fortnight earlier: "I have spent the last three months at the Front in France and Belgium amongst wounds, blood, stench, typhoid, agony and death."[90] This raw experience coloured such paintings as *Bursting Shell* (1915, cat. 111), which Nevinson made as the first painter associated with Futurism to attempt to channel the experience of the First World War trenches into his art. As such, it could be that Nevinson, in returning to the simplified fragmentation that he had learned from Severini, provided an example to the Italian as he sought to devise his own war art. On 20 November 1914, Marinetti had already urged Severini: "Try to live the war pictorially, studying it in all its mechanical forms, (military trains, fortifications, wounded men, ambulances, hospitals, parades, etc.)."[91] Whether Nevinson received similar encouragement, his output precisely matches these suggested subjects.

Nevinson appeared as a guest in the "Vorticist Exhibition" in June 1915 and was included in *Blast* (2) in July. This was an acknowledgement of the limited circle of the avant-garde acceptable to Lewis and cannot mask the divergence of their art. In contrast to Nevinson's practice of dynamic lines of force, Lewis's surviving paintings, such as *The Crowd* ([1914–15], cat. 106), show the structured abstraction that set Vorticism apart. The pictorial language is cool and restrained, a vision of order imposed upon a newly constructed reality. A similar abstraction would characterise his *Portrait of an Englishwoman* which appeared in the St Petersburg Futurist periodical *Strelets* [The Archer] in 1915 and through which Vorticism, somewhat unexpectedly, made its impact felt on Russian abstraction.[92]

Aftershock

The second number of *Blast* and the Vorticist exhibition in 1915 were followed by an exhibition in New York in 1917 organised by Pound and the collector John Quinn.[93] These events helped to maintain the illusion of vitality, but Vorticism never recovered. Among the key figures, Gaudier-Brzeska and Hulme were dead, Bomberg, Roberts and Lewis were among those selected by Konody to make monumental paintings for the Canadian War Memorial, which brought inevitable compromises with realism. While maintaining a geometric abstraction in *Vorticist Composition* (cat. 112), Wadsworth was alone in finding war-work that provided an outlet for further experiment: his work in the camouflage unit allowed him to devise monumental abstractions the purpose of which was to disguise. Despite his self-identification with the movement, even Lewis could not remain immune to the exigencies of war and *A Battery Shelled* of 1919 is a tragic image of the fruitless destruction on a grand scale. In *Blast* (1), he had meant to shock when declaring: "Killing somebody must be the greatest pleasure in existence, either like killing yourself without being interfered with by the instinct of self-preservation—or exterminating the instinct of self-preservation itself!"[94] A year later, the tone was more subdued, when he wrote

74 Letter to the editor, *News Weekly*, 13 June 1914, TGA 7811.

75 "Vorticism", *Manchester Guardian*, 13 June 1914, TGA 7811.

76 Nevinson, letter to the editor, *News Weekly*, 20 June 1914, TGA 7811. Nevinson's draft letter to Lewis, TGA 7811.2a.68, refers back to the original complaint about "Vital English Art": "I consider you are far more guilty of attributing opinions to persons beside your unbridled love of labelling them."

77 Severini, postcard (from Montepulciano) to Carrà, 22 July 1914, in Carrà and Fagone, op. cit, p. 252.

78 Lewis, "The Melodrama of Modernity", *Blast*, no. 1, p. 143.

79 Lewis, "Long Live the Vortex!", ibid., pp. 7–8.

80 "Manifesto" 3:2 and 4:4, *Blast*, no. 1, p. 34, 36.

81 Ibid. 3:3, p. 34.

82 Ibid. 2:9, p. 33.

83 For the exclusion of women Vorticists from scholarship see J. Beckett and D. Cherry, "Reconceptualizing Vorticism: Women, Modernity, Modernism", in Edwards, *Blast*, op. cit., pp. 59–72.

85 "The London Group", March 1915, republished in *Blast*, no. 2, p. 78, and in Michel and Fox, op. cit, p. 86.

86 *Evening News*, 13 March 1915, TGA 7811.

87 *Blast*, 2, July 1915, pp. 33–4.

88 P. G. Konody, "The Vorticists at the Doré Galleries", [June 1915], TGA 8112.

89 "Junkerism in Art: The London Group at the Goupil Gallery", 10 March 1915, TGA 7811.

90 Draft in response to "Sowing the Wild Oats in Art", *Times*, 11 Feb. 1915, TGA 7811. The later interview is in "Painter of Smells at the Front: A Futurist's Views on the War", *Daily Express*, 25 Feb. 1915, TGA 7811.2.92; there he claims: "All artists should go to the Front to strengthen their art by a worship of physical and moral courage and a fearless desire of adventure, risk and daring." This is a, slightly modified, echo of the second demand of "Vital English Art": that English artists strengthen their art by a recuperative optimism, a fearless desire for adventure, a heroic instinct of discovery, a worship of strength and physical and moral courage".

91 Marinetti to Severini, 20 Nov. 1914, cited in Tisdall and Bozzolla, op. cit., p. 190.

92 *Strelets* [The Archer], March 1915, see S. Compton, *The World Backwards: Russian Futurist Books 1912-16*, (London: British Library, 1978), pp. 41–2, who notes the debt to *Blast* of David Burliuk's and Vladimir Mayakovsky's *Vzâl: baraban futuristov* [Took: A Futurists' Drum] published in Dec. 1915.

93 "Exhibition of the Vorticists at the Penguin Club", New York, Jan. 1917; see Cork 1976, vol. 2, and the forthcoming analysis by Antlif and Green.

94 Lewis, "Futurism, Magic Life", *Blast*, no. 1, p. 133.

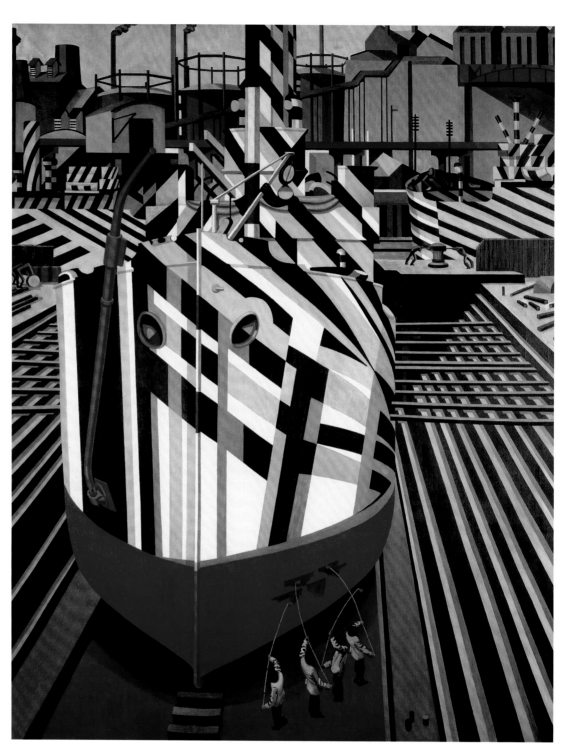

Edward Wadsworth
Dazzle-ships in Drydock at Liverpool, 1919
Oil on canvas, 302.3 x 243.5 cm
Canadian Museum of Fine Arts, Ottawa
Transfer of Canadian works commemorating
the war, 1921

of Marinetti: "The war has exhausted interest for the moment in booming and banging". However, it was the profound seriousness of their endeavour that united these artists, whatever their differences, and that Lewis captured in imagining the potential for a new art:

"It was always plain that as artists two or three of the Futurists painters were of more importance that their poet-impresario. Balla and Severini would, under any circumstances, be two of the most amusing painters of our time. And regular military War was not their theme, as it was Marinetti's, but rather very intense and vertiginous peace."[95]

95 Lewis, "Marinetti's Occupation", *Blast*, no. 2, p. 26.

Wyndham Lewis
A Battery Shelled, 1919
Oil on canvas, 182.7 x 317.7 cm
Imperial War Museum, London

55ᵉ Année — 3ᵉ Série — N° 51 Le Numéro avec le Supplément = SEINE & SEINE-ET-OISE : 15 centimes = DÉPARTEMENTS : 20 centimes Samedi 20 Février 1909

LE FIGARO

Gaston CALMETTE
Directeur-Gérant

RÉDACTION — ADMINISTRATION
26, rue Drouot, Paris (9ᵉ Arrᵗ)

POUR LA PUBLICITÉ
S'ADRESSER, 26, RUE DROUOT
A L'HÔTEL DU FIGARO

ET POUR LES ANNONCES ET RÉCLAMES
Chez MM. LAGRANGE, CERF & Cⁱᵉ
8, place de la Bourse

H. DE VILLEMESSANT
Fondateur

RÉDACTION — ADMINISTRATION
26, rue Drouot, Paris (9ᵉ Arrᵗ)

TÉLÉPHONE, Trois lignes : N°ˢ 102.46 — 102.47 — 102.48

ABONNEMENT

« Lent qui censait, blâmé qui croule, me moquant des sots, bravant les méchants, je me ficle de rire de tout... ou plus d'être obligé d'en pleurer. » (BEAUMARCHAIS).

Le Futurisme

M. Marinetti, le jeune poète italien et français, au talent remarquable et fougueux, que de retentissantes manifestations ont fait connaître dans tous les pays latins, vient d'une pléiade d'enthousiastes disciples, venu de fonder l'École du « Futurisme » dont la doctrine dépasse, en violence toutes celles des écoles antérieures ou contemporaines. Le *Figaro* qui a déjà servi de tribune à plusieurs d'entre elles, et non des moindres, offre aujourd'hui à ses lecteurs le manifeste des « Futuristes ». Est-il besoin de dire que nous laissons à leur auteur toute la responsabilité de ses singulièrement audacieuses et très souvent injustement outrancières déclarations, qui en tout sens, bien pour des choses infiniment respectables et, heureusement, partout respectées ? Mais il nous intéressait de réserver à nos lecteurs la primeur de cette manifestation, quel que puisse en être le jugement qu'on en porte sur elle...

Nous avions veillé toute la nuit, mes amis et moi, sous des lampes de mosquée dont les coupoles de cuivre aussi ajourées que notre âme avaient pourtant de leurs cœurs électriques. Et tout en piétinant notre native paresse sur d'opulents tapis persans, nous avons discuté aux frontières extrêmes de la logique et griffé le papier de démentes écritures.

[Le texte intégral du Manifeste et des articles est en grande partie illisible à cette résolution.]

Manifeste du Futurisme

1. Nous voulons chanter l'amour du danger, l'habitude de l'énergie et de la témérité.

2. Les éléments essentiels de notre poésie seront le courage, l'audace et la révolte.

3. La littérature ayant jusqu'ici magnifié l'immobilité pensive, l'extase et le sommeil, nous voulons exalter le mouvement agressif, l'insomnie fiévreuse, le pas gymnastique, le saut périlleux, la gifle et le coup de poing.

4. Nous déclarons que la splendeur du monde s'est enrichie d'une beauté nouvelle : la beauté de la vitesse. Une automobile de course avec son coffre orné de gros tuyaux, tels des serpents à l'haleine explosive... une automobile rugissante, qui a l'air de courir sur de la mitraille, est plus belle que la *Victoire de Samothrace*.

5. Nous voulons chanter l'homme qui tient le volant, dont la tige idéale traverse la Terre, lancée elle-même sur le circuit de son orbite.

6. Il faut que le poète se dépense avec chaleur, éclat et prodigalité, pour augmenter la ferveur enthousiaste des éléments primordiaux.

7. Il n'y a plus de beauté que dans la lutte. Pas de chef-d'œuvre sans un caractère agressif. La poésie doit être un assaut violent contre les forces inconnues, pour les sommer de se coucher devant l'homme.

8. Nous sommes sur le promontoire extrême des siècles !... À quoi bon regarder derrière nous, du moment qu'il nous faut défoncer les vantaux mystérieux de l'Impossible ? Le Temps et l'Espace sont morts hier. Nous vivons déjà dans l'absolu, puisque nous avons déjà créé l'éternelle vitesse omniprésente.

9. Nous voulons glorifier la guerre, — seule hygiène du monde, — le militarisme, le patriotisme, le geste destructeur des anarchistes, les belles Idées qui tuent, et le mépris de la femme.

10. Nous voulons démolir les musées, les bibliothèques, combattre le moralisme, le féminisme et toutes les lâchetés opportunistes et utilitaires.

11. Nous chanterons les grandes foules agitées par le travail, le plaisir ou la révolte ; nous chanterons les marées multicolores et polyphoniques des révolutions dans les capitales modernes ; la vibration nocturne des arsenaux et des chantiers sous leurs violentes lunes électriques ; les gares gloutonnes avaleuses de serpents qui fument ; les usines suspendues aux nuages par les ficelles de leurs fumées ; les ponts aux bonds de gymnastes lancés sur la coutellerie diabolique des fleuves ensoleillés ; les paquebots aventureux flairant l'horizon ; les locomotives au grand poitrail, qui piaffent sur les rails, tels d'énormes chevaux d'acier bridés de longs tuyaux, et le vol glissant des aéroplanes, dont l'hélice a des claquements de drapeaux et des applaudissements de foule enthousiaste.

C'est en Italie que nous lançons ce manifeste de violence culbutante et incendiaire, par lequel nous fondons aujourd'hui le Futurisme, parce que nous voulons délivrer l'Italie de sa gangrène de professeurs, d'archéologues, de cicérones et d'antiquaires.

L'Italie a été trop longtemps le marché des brocanteurs. Nous voulons la débarrasser des innombrables musées qui la couvrent d'innombrables cimetières.

Musées, cimetières !... Vraiment identiques dans leur sinistre coudoiement de corps qui ne se connaissent pas. Dortoirs publics où l'on dort à jamais côte à côte avec des êtres haïs ou inconnus. Férocité réciproque des peintres et des sculpteurs s'entre-tuant à coups de lignes et de couleurs dans le même musée.

Qu'on y fasse une visite chaque année comme on va voir ses morts une fois par an !... Nous pouvons bien l'admettre !... Qu'on dépose même des fleurs une fois par an aux pieds de la Joconde, nous le concevons !... Mais que l'on aille promener quotidiennement dans les musées nos tristesses, nos courages fragiles et notre inquiétude, nous ne l'admettons pas !...

Admirer un vieux tableau, c'est verser notre sensibilité dans une urne funéraire au lieu de la lancer en avant par jets violents de création et d'action. Vous voulez donc gâcher vos meilleures forces dans une admiration inutile du passé, dont vous sortez forcément épuisés, amoindris, piétinés ?

En vérité, la fréquentation quotidienne des musées, des bibliothèques et des académies (ces cimetières d'efforts perdus, ces calvaires de rêves crucifiés, ces registres d'élans brisés !...) est pour les artistes ce qu'est la tutelle prolongée des parents pour de jeunes gens intelligents, ivres de leur talent et de leur volonté ambitieuse.

Pour des moribonds, des invalides et des prisonniers, passe encore. C'est peut-être un baume à leurs blessures, que l'admirable passé, du moment que l'avenir leur est interdit... Mais nous n'en voulons pas, nous, les jeunes, les forts et les vivants futuristes !

Viennent donc les bons incendiaires aux doigts carbonisés !... Les voici ! Les voici !... Et boutez donc le feu aux rayons des bibliothèques ! Détournez le cours des canaux pour inonder les musées !... Oh ! qu'elles nagent à la dérive, les toiles glorieuses ! À vous les pioches et les marteaux !... Sapez les fondements des villes vénérables !

Les plus âgés d'entre nous ont trente ans : nous avons donc au moins dix ans pour accomplir notre tâche. Quand nous aurons quarante ans, que de plus jeunes et plus vaillants que nous veuillent bien nous jeter au panier comme des manuscrits inutiles !... Ils viendront contre nous de très loin, de partout, en bondissant sur le rythme léger de leurs premiers poèmes, griffant l'air de leurs doigts crochus, et flairant aux portes des académies la bonne odeur de nos esprits pourrissants déjà promis aux catacombes des bibliothèques.

Mais nous ne serons pas là. Ils nous trouveront enfin, par une nuit d'hiver, en pleine campagne, sous un triste hangar pianoté par la pluie monotone, accroupis près de nos aéroplanes trépidants, en train de chauffer nos mains à la misérable feu que font nos livres d'aujourd'hui flambant radieusement sous le vol étincelant de leurs images.

F.-T. MARINETTI

LA VIE DE PARIS

« Le Roi » à l'Elysée... Palace

[colonnes suivantes en grande partie illisibles]

Échos

La Température

À Travers Paris

Les Courses

Nouvelles à la Main

Le complot Caillaux

Genesis and Analysis of Marinetti's *Manifesto of Futurism*, 1908–1909

Giovanni Lista

The artistic and literary 'manifesto' is not an invention of Futurism—its history goes back to Romanticism, and it is fully part of the modern age. However, it was the Futurist movement that made use of the manifesto as a genre in its own right, as the privileged tool of the writer or artist striving to record in reality his or her own vision of the world, poetic intuition, dreams, or simply theoretical ideas that would, in principle, lead to the creation of a work. Futurism thus forged a model the repercussions of which were felt throughout the century, right down to the neo-avant-gardes. To give just two examples, on 14 March 1959, adopting the Futurist style, Jean Tinguely dropped copies of his manifesto *Pour le statique* from an aeroplane flying over Düsseldorf, while on 12 December 1985, in Dernburg, George Baselitz unveiled his manifesto *L'Outillage des peintres*, printed in red ink on a large leaflet. Both texts took up the Marinettian practice of using capital letters to enliven the page and transcribe the will of the artist. Baselitz, using the word "Futurism", poetically illustrated the relationship to time which is the very core of the Futurist impetus, in other words the intimate relationship between the artist and the white page of becoming.

Indeed, the deep meaning of Futurism goes well beyond a Utopian thinking which glorifies the machine and technological progress. In a manuscript draft passage of the *Manifesto of Futurism*, Marinetti defines Futurism as an existential dimension of the artist's experience as well as a projection forward: "While an artist is labouring at his work of art, nothing prevents it from surpassing Dream. As soon as it is finished, the work must be hidden or destroyed, or better still, thrown as a prey to the brutal crowd which will magnify it by killing it with its scorn, and thereby intensify its absurd uselessness. We thus condemn art as finished work, we conceive of it only in its movement, in the state of effort and draft. Art is simply a possibility for absolute conquest. For the artist, to complete is to die."[1] Futurism thus preached an aesthetic of the ephemeral and performance precisely because it privileged the manifesto, which incarnates the Dionysian moment of art as it expresses the artist's project and will, and concretises the creative drive in all its purity, before it is forced to confront the real and suffer humiliation before matter, in all its opacity and overmastering physicality.

However, that does not mean the 'manifesto' is a univocal category. For a linguist, especially one working with discourse theory, a manifesto can have different ways of meaning, and different manners of communicating. Each of them has its historical precedents. The text that announces a new literary theory, or a renewal or transgression of traditional rules, goes back at least to Alessandro Manzoni's preface to his tragedy *Il Conte di Carmagnola* of 1816, which discussed the three dramatic unities and the role of the chorus and inspired Victor Hugo's preface to *Cromwell* in 1827.[2] Likewise, an example of the visionary text that evokes in a lyrical mode the Utopia of a reality still to come, can be found in 1843 with Vincenzo Gioberti's *Augurio dell'Italia futura*,[3] a text with which Marinetti must certainly have been familiar. Indeed, Gioberti used the word "futurism" a good half century before Marinetti. As for the perlocutionary text aimed at provoking the reader's reaction through personal or ideological attacks, the most famous example remains the 1898 front page leader "J'accuse" by Émile Zola, one of Marinetti's idols as a youth and a writer whose polemical temperament was due to his Italian roots. Finally, the text that calls for radical upheaval, that proclaims the founding will of a new movement, emerges of course with Marx and Engels' *Manifesto of the Communist Party* of 1847. Marinetti adopted this model, with its rhetoric inherent in political activism, as early as 1905, with the appearance of his review, *Poesia*. In fact, he paraphrased Marx in a tract, proclaiming "Idealists, workers of thought, unite to show how inspiration and genius walk in step with the progress of the machine, of aircraft, of industry, of trade, of the sciences, of electricity." Although the large corpus of Futurist manifestos runs the full gamut of these different styles and varieties, *The Manifesto of Futurism* belongs above all to the political activist category. Recent historiographical discoveries have shed light on the circumstances of its launching.

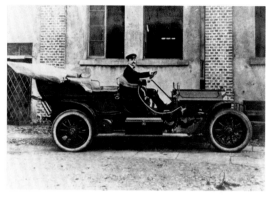

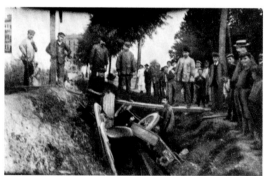

Marinetti at the wheel of his car in 1908, in Milan
Marinetti's car after the accident that occurred
on 15 October 1908, in Via Domodossola,
in the suburbs of Milan
Giovanni Lista Archives, Paris

F. T. Marinetti colla sua automobile in un fossato

Ieri poco prima di mezzogiorno F. T. Marinetti percorreva in automobile via Domodossola. Il proprietario stesso della vettura era alla sterza, e con lui si trovava il meccanico Ettore Angelini, d'anni 23. Non si sa in qual modo, ma pare per la necessità di scansare un ciclista, l'automobile andò a finire in un fossato.

Il Marinetti e il suo meccanico furono subito raccolti. Dallo stabilimento Isotta e Fraschini giunsero i corridori Trucco e Giovanzani, entrambi con automobili. Il primo condusse il Marinetti alla sua abitazione: pare che egli se la sia cavata collo spavento. Il meccanico invece fu dal Giovanzani accompagnato all'Istituto di via Paolo Sarpi, ove gli furono riscontrate contusioni leggere.

The short report on the accident, published
in *Il Corriere della Sera* (Milan) on 16 October 1908,
Giovanni Lista Archives, Paris

Previous page:
The *Manifeste du Futurisme* by Marinetti
published on the first page of «Le Figaro»,
20 February 1909, private collection

Marinetti claimed to have had his first inkling of the word "futurism" in October 1908, in the company of the young poets of his review: "On 11 October 1908, having laboured for six whole years on my international review *Poesia* in order to liberate the Italian lyric genius, in danger of death, from its traditionalist and mercantile chains, I suddenly felt that the articles, poems and polemics no longer sufficed. It was absolutely necessary to change methods, to take to the streets, to lay siege to the theatres and to make the throwing of punches part of the artistic struggle. My friends, the poets Paolo Buzzi, Corrado Govoni, Enrico Cavacchioli, Armando Mazza, Luciano Folgore and I sought the new watchword together. I hesitated a moment between the words *dynamism* and *futurism*. My Italian blood leapt higher when my lips invented out loud the word *futurism*. It was the new formula of Action-Art and a law of mental hygiene."[4] In fact, on 15 October 1908, Marinetti was the victim of a car accident in the Milan suburbs,[5] an episode he recounted himself, in dramatic mode.[6] The "emotional shock" he felt then probably freed him from his "Swinburne complex", erasing an originary trauma linked to the figure of the father.[7] In the "prologue" to his *Manifesto* he lends this event great symbolic significance.[8] It is thus reasonable to deduce that the first idea of the *Manifesto* indeed dates from October 1908.

The writing of the *Manifesto* as such, in other words the 'programme' of Futurism without the introductory 'prologue', began shortly thereafter. In November, Marinetti brought out Gian Pietro Lucini's *Poetic Reason and Free Verse Programme*, published by *Poesia*. Lucini, older than Marinetti, enjoyed an authority derived from his fame both as poet and as theorist of an "Italian version of Symbolism". A participant in the *Inquest on Free Verse* launched by Marinetti's review, Lucini developed his ideas in the theoretical work whose title alludes to Kant's "pure reason". Starting from an interpretation of free verse as an "insurrection against all principles of authority", Lucini elaborated a thinking of becoming that reconciled Spencer's evolutionism with Nietzsche's "will to power". He thus defined the "libertarian" aspect of avant-garde art, its "sociality," and the continually "provisional" status of its creations. Marinetti set about radicalising these same ideas in Futurism, writing a manifesto which goes so far as to take up the structure of Lucini's treatise: a prologue conceived as a "poetic reason", followed by a "programme."[9] In fact, in order to avoid all argument with Lucini, Marinetti only sent him the text of the *Manifesto* at the last minute, when it had already gone to press.

Enrico Cavacchioli confirmed that Marinetti, Paolo Buzzi and he established together "the canons of a school of rebels".[10] This was the eleven-point 'programme' of the *Manifesto*, undoubtedly written between October and November. Federico De Maria later said he received this 'programme' in December 1908, when Marinetti asked him to subscribe to it.[11] Writing that Marinetti read him the "proclamation of Futurism" in December,[12] Buzzi continues, "The merits of this excellent text are due entirely to Marinetti. With a modesty which honours him, when he first shared with his friends the formulation of these ideas, he seemed initially to doubt whether he could enclose these norms—so potent for the future—within the grip of peremptory codification. And he talked with some of us. But then, in one of those volcanic outbursts which were so characteristic of him, in a single night he drew up the schema alone, opening it and closing it with formulas which are to be counted among his greatest successes."[13] So it was in December, after having put together the 'programme' of Futurism, that Marinetti, apparently alone, wrote the "poetic reason" of the *Manifesto*, that is, the 'prologue.'[14] Written in the past tense and in an epic style, the 'prologue' is a poetic narrative which introduces the principles of the Futurist programme. The text as a whole was thus finished in December, but Marinetti preferred to wait until the beginning of January to launch his *Manifesto*. A former Jesuit pupil, he wanted his act to coincide with a moment of new beginnings, and have it take place in the climate of future expectations that occur in the first days of a new cycle. Very attentive to communication strategies, he also wanted to launch his Futurist movement according to a fully developed plan.

Thus, Marinetti carefully prepared the distribution of his *Manifesto*. He used the text in its entirety as a preface for two books on their way to the printer. The first, in Italian, is the collection *Le Ranocchie turchine* by Cavacchioli,[15] whose title, "The Turquoise Frogs," alludes to Aristophanes' comedy, *The Frogs*. In his book, Cavacchioli satirises poets in search of the ideal, like Giovanni Pascoli and Gabriele D'Annunzio, in the style of contestation that will become Futurism's trademark. One of the poems in the collection is already titled "La Zanzara futurista"[16] [The Futurist Mosquito], which confirms that

1 See Andréoli de Villers, *Le Premier Manifeste du futurisme*, critical edition with facsimile of Marinetti's original manifesto, (Ottawa: Editions de l'Université d'Ottawa, 1986), p. 84.
2 Hugo attacks Goethe in the preface, to distract the reader from his unavowable borrowings from Manzoni's theories. See Laisney, "On est étonné de lire dans M. Goethe…" ("A propos de la "note XI" du *Cromwell* de Victor Hugo")," *Revue d'histoire littéraire de la France* (Paris), vol. 104, no. 3, 2004, pp. 637–65.
3 This is the famous "Chapter of Total Conclusion" which brings to a close the book *Del primato morale e civile degl'Italiani*, published in 1843.
4 Marinetti, *Guerra sola igiene del mondo*, (Milan: Edizioni Futuriste di Poesia, 1915), p. 6. Marinetti evokes the 11th of the month through a superstition which made him refer systematically to this number. Futurist manifestos are always dated the 11th. As for the word "futurism," in the manuscript of the founding manifesto Marinetti also uses the term "avénirisme," later suppressed as undoubtedly recalling too strongly certain Socialist slogans or Wagner's "artwork of the future" [*avenir*]. Nevertheless, the terms "avénirisme" and "avéniriste" were to make several appearances in Futurist manifestos, to the point of being taken up later by Russian Futurists.
5 See (anon.), "F. T. Marinetti colla sua automobile in un fossato," *Il Corriere della sera* (Milan), 16 Oct. 1908, p. 5.
6 See Marinetti, *Una sensibilità italiana nata in Egitto*, (Milan: Mondadori, 1969), p. 88.
7 For a psychoanalytic reading of this episode, see Lista, *F. T. Marinetti. L'anarchiste du futurisme. Biographie*, (Paris: Séguier, 1995), pp. 80–1.
8 See Vaccari, *Vita e tumulti di Marinetti*, (Milan: Omnia Editrice, 1959), pp. 177–78.
9 This highly unusual structure, which Marinetti gave to his *Manifesto* in the wake of Lucini's model, was to reappear in other avant-garde texts of the 1920s, starting with André Breton's *Manifeste du surréalisme*.
10 Cavacchioli, "I futuristi," *Attualità, rivista settimanale di letteratura amena* (Milan), 25 June 1911, p. 1.
11 De Maria, "Contributo alla storia delle origini del futurismo e del novecentismo," *Accademia, rivista italiana di lettere arti scienze* (Palermo), vol. 7–8, no. 7-8 (July–August 1945), pp. 3–10.
12 Buzzi, "Toute la lyre," *Poesia* (Milan), 5th year, nos. 1–2, Feb.–March 1909, p. 61.
13 Buzzi, *Futurismo: Scritti, carteggi, testimonianze*, Morini and Pignatari, (eds.), (Milan: Quaderni di Palazzo Sormani, 1982), book 1, p. 14.
14 The pages of the two manuscripts of the *Manifesto* are reproduced in *Le Premier Manifeste du futurisme*, Andréoli de Villers. I think the author is mistaken, however, in the chronology he offers of the two manuscripts. The first is probably that of the 'programme', which contains corrections made in the same hand as in the second, which contains the programme completed by the 'prologue'.
15 According to the copyright records of the Biblioteca Nazionale Centrale in Florence, Cavacchioli's collection was printed in 1908, and this has been established beyond any doubt. See the *Bollettino delle Pubblicazioni italiane ricevute per diritto di stampa nell'anno 1909*, (Florence: Edizioni Tipografia Galileiana, 1910), in which the book *Le Ranocchie turchine* by Cavacchioli is attributed the number 1 426, and listed as published by *Poesia* Editions in Milan in 1909, but printed by the Officina grafica Bertieri e Vanzetti in 1908. The book is also listed as printed in 1908 by the *Catalogo cumulativo 1886-1957 delle Pubblicazioni italiane ricevute per diritto di stampa dalla Biblioteca Nazionale Centrale di Firenze*, vol. 9, Kraus-Thomson, 137 484.
16 The poem is written in opposition to Giovanni Pascoli and the poets of the Accademia dell'Arcadia; see Cavacchioli, *Le Ranocchie turchine*, (Milan: Edizioni futuriste di Poesia, 1909), pp. 195–197.

Marinetti had already enlisted the young poets of the *Poesia* circle in the coming launch of his *Manifesto*, even though he had yet to speak of it to Lucini. The second book, in French, is the anthology, *Enquête internationale sur le vers libre*, which contains all the responses *Poesia* received during the four years of the survey or "inquest" on free verse. The use of the *Manifesto* as a preface which seems to go beyond the very contents of the book being prefaced, forms part of the cultural revolutionary tactics which Marinetti quite lucidly pursued.[17]

Printed in December 1908, the two books were meant to appear early in January 1909, to coincide with the launching of the *Manifesto*. Also in December, Marinetti had printed in blue ink several thousand copies of two pamphlets, one French, the other Italian, each containing only the 'programme' of the *Manifesto*. He was also seeing to press the December 1908–January 1909 issue of his review *Poesia*, where the complete text of the *Manifesto* is followed by four pages devoted to Marinetti himself: one page advertising the imminent production of his plays *Les Poupées électriques* [The Electric Dolls] and *Le Roi Bombance,* in Turin and Paris, and three pages of favourable reviews of the young Italian poet by French writers.

However, in the middle of the night of 28 December 1908, a massive earthquake destroyed towns and villages on both sides of the Straits of Messina, causing almost 150 000 deaths. It was the largest seismic event ever recorded in Europe. This tragedy, which plunged Italy into a state of national mourning, severely disrupted the scenario for the founding of the Futurist movement. Marinetti immediately postponed the distribution of the text, and in the issue of *Poesia* that appeared in early January, the pages set aside for the *Manifesto* are instead given to a poem by Lucini dedicated to the victims of the "great national disaster". But this poem of mourning, bizarrely enough, is followed by four pages of newspaper articles singing the praises of the young poet Marinetti. Meanwhile, throughout the entire month the Italian press was given over to a violent polemic on the disorganisation of Italian aid to the devastated regions. So the founding text of twentieth century avant-garde culture only appeared quite discreetly, as the prefaces to Cavacchioli's book and to the survey on free verse.

Thus, it was only quite belatedly, near the end of January, that thousands of copies of the 'programme' of the *Manifesto* were sent to writers, poets, artists, journalists, and politicians throughout the world. It was accompanied by a circular when sent to journalists, but the copies sent to important individuals came with a handwritten letter, asking the recipients to answer with a "judgment" or with "total or partial adherence".[18] The responses from writers, above all French ones, were subsequently published in Marinetti's review.[19] Lucini, however, did not appreciate having been outflanked by Marinetti. He responded to the *Manifesto* in a long letter dated 4 February 1909, in which he refuses to join and contests the *Manifesto*'s principles point by point, above all its negation of the past and the attack on museums.[20]

In the newspapers, the first critical account of the Futurist programme appeared on 4 February in the Milan daily *L'Unione*;[21] more were published the following day in *La Sera*,[22] also in Milan, as well as in *Il Caffaro* in Genoa,[23] while Bologna's *La Gazzetta dell'Emilia* published the text itself.[24] In Naples, *Il Pungolo* published excerpts of the programme on 6 February,[25] while the satirical and humorous paper *Il Monsignor Perelli* savaged Marinetti's thinking.[26] *I Tribunali* in Milan also published the *Manifesto* on 7 February,[27] while *Il Pasquino* in Turin only offered an ironic summary.[28] The third publication of the 'programme' was in *La Gazzetta di Mantova*[29] on 8 February and the text or summaries of it also appeared in the following days in *Arena* in Verona,[30] *Il Corriere delle Puglie* in Bari[31] and *Il Momento* in Turin[32], among others. Remarks from the most visible Italian intellectuals, such as Enrico Thovez[33] and Ugo Ojetti[34], were to follow a few days later.

One reads in the papers that the *Manifesto* was sent by "registered mail" and was accompanied by a "long printed circular" in which Marinetti explained his undertaking. As this text is apparently lost,[35] in order to provide a partial reconstruction, here follows a compendium of some of the fragments which started to appear in the Italian press from 4 February 1909: "I have explained what *Futurism* is in my preface to the great poet Enrico Cavacchioli's *Ranocchie turchine*, a book which has only just been published, but which is already the object of endless discussion and commentary in intellectual circles throughout the world. … The fundamental principles of the new *Futurist* literary school were inspired by an imperious desire for struggle and renewal at any

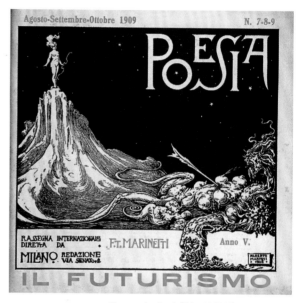

The magazine *Poesia* (Milan, 1905-09), founded and edited by Marinetti, with its cover designed by Alberto Martini
Giovanni Lista Archives, Paris

cost, a desire born of the feeling of surfeit, fatigue, and discouragement which oppresses anyone sufficiently cultivated to perceive that literature—especially in Italy— is languishing miserably. It is the slave of the past and a thousand traditions and conventions which have become unbearable, and therefore it remains blind, deaf, and dumb before the marvellous spectacles that the ceaseless ardour of contemporary life offers the artist. Thus, *Futurism* can be considered as a salutary, natural phenomenon, determined in our art by the inevitable rebellion of a chosen group of young and courageous spirits who are sensitive to all the potent, irresistible force of the *New*, and who, weary of an over-long adoration of the past, stretch forth their arms and lift their voices to the future. The tone of the manifesto launched by *Poesia* had to be and is, of necessity, extremely violent. … By Marinetti's side, grouped around *Poesia* and the flamboyant standard of *Futurism*, now raised and rippling gloriously at the forefront of Italy's most radical intellectual avant-garde, is brought together a team of fervent, battle-ready spirits. Gian Pietro Lucini, Paolo Buzzi, Corrado Govoni, Federico De Maria, Enrico Cavacchioli and others, many others, all young, all moved to action by an intense love of free art, of the life that continually accelerates its grand universal throbbing, of the new that comes from everywhere, impetuous and despotic. Italy should be deeply grateful to the poet Marinetti for this noble and audacious act. … You can join, even with a simple visiting card, at 2 via Senato, Milan."

The text of the circular confirms certain extremely important details. For example, Marinetti indicates that Cavacchioli's book, with the *Manifesto* and prologue serving as preface, has been in circulation since January.[36] He counts Lucini among Futurism's neophytes although he had not even seen the *Manifesto* at this point. He says that one must read in the prologue the explanation of Futurism's intentions. He uses the word "avant-garde" as a metaphor drawn from military terminology and refers to the "force of the *New*" in a sense that goes far beyond the desire to "plunge to the depths of the abyss" as evoked by Baudelaire. He also lists his home address, inviting all and sundry to join Futurism, which he conceives of as a party, a political movement, a syndicate, or a "society" along the lines of Mazzini's Giovane Italia.

Otherwise, the mythical aura Marinetti had wished to bestow upon his *Manifesto* by making its appearance coincide with the New Year was in the end more than magnified by the Messina earthquake. In his poem for the victims, Lucini affirmed that "to die is to be reborn" and Buzzi placed the disaster in direct relation to the founding of Futurism. Alluding to the four horsemen of the Apocalypse, he wrote: "The warriors of Futurism are born on the 200 000 corpses of the infernal cataclysm."[37] Marinetti himself evoked the catastrophe in the last chapter of his novel *Mafarka the Futurist,* which he was writing at the time, describing the birth of Futurism in terms of palingenesis, that is, a veritable regeneration of life.

The international launch of the 'programme' took place on the same date: for example, it appeared in the February issue of the *Bulletin de Instrucción pública de México*, in Mexico, in a Spanish translation and with commentary by Amado Nuevo, and also in the 20 February issue of the Romanian review *Democratia*, in Craiova, translated and introduced by Mikhail Draganescu. On the other hand, it seems that Marinetti had reserved for *Le Figaro* the premiere of the full text of the *Manifesto*, that is, the prologue followed by the programme. He went to Paris himself, and thanks to Mohamed El Rachi, a shareholder in the newspaper and also an old friend of Marinetti's father, he managed to get the *Manifesto* published on the front page on 20 February 1909. He would later tell how at four in the morning he began wandering among lorries piled high with vegetables in the marketplace neighbourhood of Les Halles, waiting for the newspaper vendors to open so he could buy the paper with his *Manifesto* in it.[38] Back in Milan, he brought out the February–March issue of *Poesia*, which also had the full text, in French and Italian.[39] He also hung from his balcony at 2 via Senato a huge white sheet with the word "Futurism" written on it in gigantic letters,[40] and had "plastered up all over Milan a three by ten-foot manifesto announcing Futurism in flame-red letters".[41] In addition, he organised "the repeated billboarding of the streets of Italy's major cities".[42] His procedure was at the antipodes of symbolism's ivory tower. Marinetti claimed he had "the art of making manifestos",[43] of which the prime principles were the violence and precision of the attack, conducted with "laconic explosiveness".[44] If the prologue to the *Manifesto of Futurism* is written in a flamboyant style reminiscent of Nietzsche's *Zarathustra*, the eleven-point programme adopts the

17 See Lista, *F. T. Marinetti. L'anarchiste du futurisme*, p. 147.

18 For a reproduction in facsimile of the form letter that Marinetti sent written by hand and signed by himself, see Lista, op.cit., p. 76.

19 See for example the responses of Paul Adam, Pierre Loti and André Ibels, among others, in *Poesia* (Milan), 5ᵗʰ year, nos. 3–6, April, May, June, July 1909, pp. 5–11.

20 See Lucini, *Marinetti, Futurismo, Futuristi*, an anthology of texts edited by M. Artioli, (Rome: Massimiliano Boni Editore, 1975), pp. 144–56.

21-24 See (Anon.), "Intermezzi: Il Futurismo", *L'Unione* (Milan), 4 Feb. 1909; Flok, "Dopo il caffé: Futurismo", *La Sera* (Milan), 4–5 Feb. 1909; Il Cintraco, "Il Futurismo", *Il Caffaro* (Genoa), 5 Feb. 1909; (Anon.), "Cronache letterarie: il 'Futurismo," *La Gazzetta dell'Emilia* (Bologna), 5 Feb. 1909.

25-28 See Spada, "Punto e taglio", *Il Pungolo* (Naples), 6 Feb. 1909; Carli, "Tieni in mano!" *Monsignor Perelli* (Naples), 6 Feb. 1909; (Anon.), "Futurismo da tribunale", *I Tribunali* (Milan–Naples), 7 Feb. 1909, with a letter from Bianchi; Il Beniamino, "Le Pasquinate della settimana", *Il Pasquino* (Turin), 7 Feb. 1909. The review subsequently published satirical drawings on Futurism by Manca, on 28 Feb, 7 and 21 March.

29-30 See (Anon.), "Il 'Futurismo", *La Gazzetta di Mantova* (Mantua), 8 Feb. 1909; (Anon.), "Il 'Futurismo", *Arena* (Verona), 9–10 Feb. 1909.

31 Paphnedo, "Una nuova scuola letteraria", *Il Corriere delle Puglie* (Bari), 11 Feb. 1909. The author would seem to be a partisan of Lucini, as he writes that Futurism has just been founded "by two young authors".

32 Snob, "I nipoti di Carneade", *Il Momento* (Turin), 13 Feb. 1909.

33 Simplicissimus (pseudonym of Enrico Thovez), "La poesia dello schiaffo e del pugno", *La Stampa* (Turin), 20 Feb. 1909. The author writes that he has received "the manifesto of Futurism conceived in eleven points and a page of supplementary instructions".

34 Ojetti, "Accanto all vita," *L'Illustrazione italiana* (Turin), 28 Feb. 1909.

35 The destruction of the Archivi di Stato in Milan during a bombing raid in World War II has made it impossible to find the circular, which apparently is also absent from the Marinetti papers held by the Beinecke Rare Books Library at Yale University.

36 On the other hand, Marinetti does not refer to the collection *International Inquest on Free Verse*, which also featured the full text of the *Manifesto*. The probable explanation is that the book was almost entirely in French, and its circulation was consequently very limited within Italy. Published as a preface, the *Manifesto* makes no mention of its publication in *Le Figaro*, unlike the re-publications after 20 Feb. 1909.

37 Buzzi, "Toute la lyre," p. 61.

38 See Marinetti, *La Grande Milano tradizionale e futurista*, (Milan: Mondadori, 1969), p. 279. Mohamed El Rachi, an Egyptian politician and lawyer, had retired from business and lived in Paris. He had a villa on the Seine where he would receive the young Marinetti during the latter's visits to the French capital. The text of the *Manifesto* published in *Le Figaro* shows several omissions and variants, probably due to editorial intervention at the paper.

39 See *Poesia* (Milan), 5ᵗʰ year, nos. 1–2, Feb.–Mar. 1909, pp. 1–8. Marinetti doesn't mention the publication of the *Manifesto* in *Le Figaro*, in Paris. This number, in which Buzzi refers to Futurism more than once, must have been ready in early February at the latest.

40 See De Angelis, *Noi Futuristi*, (Venice: Edizioni del Cavallino, 1958), p. 33.

41 Note published in the *Frankfurter Zeitung* (Frankfurt), 23 Feb. 1909.

42 L. Altomare, *Incontro con Marinetti e il futurismo*, (Rome: Corso, 1954), p. 10.

43 See Marinetti's letter to Severini in September 1913, *Archivi del Futurismo*, (Rome: De Luca, 1958), vol. 1, p. 294.

44 Letter from Marinetti to the Belgian poet Henry Maassen (1911), Lista, *Futurisme. Manifestes,*

imperative mode of slogans of cultural mobilisation and political agitation. Finally, the text ends with a long passage where Marinetti handles with irony and flair the heroic comedy style, along the lines of Edmond Rostand's *Cyrano de Bergerac*.

Promoting a veritable cultural revolution, Marinetti uses a language of striking images and sensational, provocative formulas. The peremptory character of the 'programme' leads him to occasionally equivocal affirmations, like the famous glorification of "scorn for woman", the source of many polemics. He explained himself shortly afterwards, pointing out that what he really wished to attack was idealised images of women, such as those in D'Annunzio, precisely in order to give the opposite sex the chance to participate actively in modern life.[45] On the contrary, his slogan in praise of "war [as] the world's only hygiene, militarism, patriotism, the destructive act of the anarchists" sums up his Social-Darwinist convictions, marked by the national evolutionism of Spencer, his reading of Sorel, and the political romanticism inherited from the Risorgimento, as well as his Heraclitism, which saw "war as the logical complement to nature".[46] For Marinetti, war was not only the engine of history, but also the most effective remedy for a given people against decline and death. These hateful ideas, which were part of the intellectual climate of the time, did not provoke any real indignation. The scandal the *Manifesto* caused was above all due to its rejection of the past, expressed by Marinetti with the greatest violence, and by the fact that such a discourse emanated from Italy, the country which international culture had labelled for at least two centuries as the sacred "open air museum," to use Quatremère de Quincy's expression. To declare from the peninsula that the past must be abolished and the museums burned was an act of madness, or such at least was the most common response provoked by the *Manifesto*. In fact, Marinetti was condemning the cult of the masterpiece and the museum, the veneration of Italian "cities of art", the dusty culture of libraries and anything that blunted people's reactions to the forces of life. His *Manifesto* is as much a theoretical text on art as a call to revolt: "Set the library shelves on fire! Divert the canals so that they flood museum cellars!" Marinetti wished to put an end to all narcissistic, contemplative, Saturnine, and initiatory conceptions of art. He reminded his public that art is a goal which is immanent to life itself, and proclaimed that in the face of the modern world, artistic creation could only be action and an instrument of progress. "A roaring automobile that seems to ride on a hail of bullets is more beautiful than the *Victory of Samothrace*."[47] This is the key idea on which Marinetti constructs the very principle of his Futurism: the automobile at full speed embodies the parameters of energy and dynamism against which the art of the new century must henceforth measure itself.

Marinetti deployed extraordinary formulas to sum up the loss of the stable grounding of human experience and the new feeling of vitality which both resulted from scientific and technological progress: "Time and space died yesterday. We live in the absolute, because we have created eternal, omnipresent speed." Thus, another world is born and takes shape alongside contemporary humanity. Marinetti's message takes its place within a growing general awareness that goes beyond the realms of art and literature. The advent of technological civilization cannot be understood without profound anthropological, cultural and social change. The machine as model of an unprecedented reality thus embodies the promise of a future that would break with all tradition. For Marinetti, scientific progress and the industrial revolution have not killed art, but rather given birth to new prototypes of beauty.

With the machine, it is not the feeling for beauty which vanishes, but rather its ability to occupy forms and values of the past, or to recognise itself in them. The radical act which must henceforth be accomplished consists in abolishing the traditional objects of aesthetics, such as the organic curves of the female body as seen in the *Victory of Samothrace*, in order to redefine the raw material of art. And it is precisely by taking upon itself the new aesthetic values incarnated by the machine that art can recover its link to life. Thus Marinetti designates the active, living forces of modernity as the new field of aesthetic creation. The strand of tradition being irrevocably severed, the space for art is no longer the museum but reality in its becoming which the artist lives, immersed in his or her own time.

Futurism is first of all an act of will which consists in resolutely turning towards the future, in taking stakes in a future that has ceased to need the past in order to be born. With Futurism, art becomes concrete action, a force of disturbance which no longer operates in reference to the past, but according to life. The Futurist artist, through both

The 'programme' of the Manifesto of Futurism, printed on a tract in blue ink, as it was sent to the newspapers at the end of January 1909 by Marinetti
Giovanni Lista Archives, Paris

artwork and action, will instigate an acceleration of becoming by promulgating the inclusion of the new aesthetic values of urban and technological modernity within the social body. Marinetti's main ideas, like the need for a constant evolution of the language of art, the ephemeralisation of the artwork, or the insistence on a renewal corresponding to the new conditions the machine imposes on humanity, are founded on a real faith in the regeneration that life accomplishes on its own. In the name of this imperative of renewal, Marinetti makes himself the apostle of continuous revolution: art must maintain itself in a state of permanent insurrection in order to play within society the role that Bergson's *élan vital* plays in nature. In this way, Marinetti fixed in place the laws of the avant-garde spirit which was to dominate the art of the Twentieth Century.

proclamations, documents, (Lausanne: L'Âge d'Homme, 1973), pp. 18–19.
45 See Marinetti, "D'Annunzio futuriste et le 'mépris de la femme'", *Poesia* (Milan), nos. 7–9, August–September–October 1909, pp. 38–39.
46 Marinetti, "La guerra complemento logico della natura", *L'Italia futurista* (Florence), 2nd year, no. 2, 25 Feb. 1917, p. 1.
47 Marinetti, *Manifesto of Futurism*.

Authors
Mai-Lise Bénédic (M.-L. B.)
Valentina Cefalù (V. C.)
Ester Coen (E. C.)
Juliette Combes Latour (J. C. L.)
Zelda De Lillo (Z. D. L.)
Marion Diez (M. D.)
Matthew Gale (M. G.)
Irina Kronrod (I. K.)
Doïna Lemny (D. L.)
Colin Lemoine (C. L.)
Irène Mercier (I. M.)
Camille Morando (C. M.)
Barbara Musetti (B. M.)
Didier Ottinger (D. O.)
Johan Popelard (J. P.)
Perrine Samson-Leroux (P. S.-L.)
Iveta Slavkova-Montexier (I. S.-M.)
Chiara Zippilli (C. Z.)

Catalogue of Works

1 **Giacomo Balla**
 Luna Park a Parigi, 1900
 [Luna Park in Paris]
 Oil on canvas, 65 x 81 cm
 Civiche Raccolte d'Arte, Museo del Novecento, Milan

Through the classes given by Cesare Lombroso at Turin University in the late nineteenth Century, the Piedmontese capital became the link between French and Italian followers of Positivism. Balla gave expression to this legacy by incorporating in his art the principles of photography and of scientific colour theories.

He stayed in Paris between September 1900 and March 1901, when the *Exposition Universelle* was in full swing. The "Palais de l'Electricité", erected as a monument to electric light, that symbol of technological modernity, was one of the main attractions of the Exhibition. A fairground set up behind that building became, according to Giovanni Lista,[1] the dominant theme for the picture *Luna Park in Paris*. In a letter to his fiancée Elisa Marcucci, the painter expressed the enthusiasm which these attractions kindled in him: "In the evening I study a fair …; if you could see the pomp and luxury of the merry-go-round and the stands and booths. Everything is decorated in Baroque style, all gold and silver; there are mirrors, fabrics and electric lighting. By night the whole thing is fantastic and rowdy. First of all I shall make a small picture and some drawings for illustrations."[2] *Luna Park in Paris* marked the entry of urban modernity into Balla's work. One step ahead of an iconography which would later become emblematic of Futurism, artificial light is here associated with movement and machinery, which assume the form of the merry-go-round. By endowing this work with a cosmic dimension, Balla announced the aesthetic metaphor of reality which he would express fifteen years later in the manifesto *Futurist Reconstruction of the Universe,* written with Fortunato Depero.[3]

The electric lights of *Luna Park in Paris*, whose brightness literally kills the moonlight and romanticism usually associated with it (the very same year the *Manifesto of Futurism* was published, Marinetti wrote another one entitled *Let's Murder the Moonshine!*),[4] seemed to him to be one of the most lyrical manifestations of technical and scientific modernity. It is noteworthy that when, in 1913, the Italian-American artist Joseph Stella was looking for a subject in New York capable of illustrating his Futurist sentiments, it was in another 'Luna Park' and in another riot of electric lights—those of Coney Island—that he too would find inspiration (cat. 75).

C. Z.

1 Lista, *Giacomo Balla futuriste*, (Lausanne: L'Âge d'homme, 1984), pp. 28–30.
2 Quoted in *Giacomo Balla (1871-1958)*, Fagiolo dell'Arco (ed.), exh. cat., Rome, Galleria nazionale d'arte moderna, 2 Dec. 1971–27 Feb. 1972 (Rome: De Luca Ed., 1991).

3 Balla, Depero, *Ricostruzione futurista dell'universo* (11 March 1915); trans. in Apollonio (ed.), *Futurist Manifestos*, (London: Thames and Hudson, 1973 and 2001), pp. 197-200.
4 Dated "April 1909", published in French in *Poesia* (Milan), nos. 7–9, Aug.-Oct. 1909, pp. 1–9; trans. by Flint and Coppotelli in Flint (ed.), *Marinetti: Selected Writings*, (London: Secker and Warburg, 1972), pp. 45–54.

2 **Umberto Boccioni**
Officine a Porta Romana, **1909**
[Workshops at Porta Romana]
Oil on canvas, 75 x 145 cm
Intesa Sanpaolo Collection

In 1909 Boccioni revisited and went deeper into the lexicon of Divisionism, seeking to redefine—together with the perspective layout of the painting—the material of paint in a crescendo of signs and combinations of timbres, in order to dissolve the physicality of bodies in an effort to liberate the maximum quantities of light and pictorial dynamism.

Bearing witness to an interest in social disciplines, *Workshops at Porta Romana*—together with *Mattino* [Morning] and *Crepuscolo* [Twilight]—is part of an imaginary thematic trilogy focused on the condition of workers in early twentieth century Milan, with the suburbs that were springing up around the city's new industries.

At the beginning of the century Giacomo Balla had centred his research on these themes, combining everyday subjects of ordinary simple life with a more modern technique, free of dogmatisms. And Balla was a master who had been open and rare in his generosity during Boccioni's and Severini's formative years. He had opened up an avenue to a natural world, to a painting far from all kinds of virtuosity.

In spring 1908 Boccioni wrote in his diary about the need to break away from Balla's extreme naturalism. An increasing admiration for Previati transpires, a figure in whom Boccioni appeared to have found the example of painting that was freer in the study of colour and the pictorial intonation given to a grouping. *Workshops at Porta Romana* is a painting constructed on a superabundance of lines which, with extreme mastery, define the architectural structure of the work. In particular, the street foreshortened diagonally that narrows towards the background line, almost crashing into one of the blocks of buildings that delineate the outline of the horizon. The angle compresses the distance between the planes, highlighting certain details which would otherwise be lost: figures with elongated shadows, broad areas of light contrasting with parts in shade, sudden chromatic outbursts, the opacity of the smoke from the chimneys in the distance. The size of this canvas with its extreme horizontality is unquestionably a reference to the 1908 *Self-Portrait* in the Pinacoteca di Brera where, for the first time, the background consists of a city suburb. In *Workshops at Porta Romana* Boccioni's hand is expert and rapid, the brushstroke is flowing and assured, with greater awareness of the perspective layout and an internal mechanism of the representation set in motion by strong outlines and by the staggering of colour, broken down into descending beams of light. Emphasised rays crystallise on the side of the building under construction in a blinding chromatic glittering that charges with energy the minute breakdown with its vibrant pictorial touch. A touch made of solid stuff and with an effect of extraordinary vibrant tension. The Divisionist phase, by this time at its end, took part with this work in an intellectual evolution that would lead a few months later to *The City Rises* (cat. 28), a painting which for Boccioni embodies the real shift towards a new vision of art.

E. C.

3 **Carlo Carrà**
Notturno a Piazza Beccaria, 1910
[Nocturne in Piazza Beccaria]
Oil on canvas, 60 x 45 cm
Civiche Raccolte d'Arte, Museo del Novecento, Milan

During the months of Carrà's involvement with Futurism, in search of an unprecedented lexicon, the theme of the city in its nocturnal sparkling of lights was one of the first subjects he approached. Having abandoned the late Romantic forms and Symbolist illusions of earlier painting, the artist embraced Divisionism as a different system of expressing a powerful tension towards modernity. *Nocturne in Piazza Beccaria* represents his initial mastery of the new language which, in resoluteness and shared determination, tends in a synchronous manner to approach the style of Boccioni and Russolo at the same period and of Balla's painting *Street Lamp*. Here we see the bright tones of the declarations in the *Technical Manifesto of Futurist Painting* (11 April 1910): "Your eyes, accustomed to semi-darknes, will soon open to more radiant visions of light. The shadows which we shall paint shall be more luminous than the high-lights of our predecessors, and our pictures, next to those of the museums, will shine like blinding daylight compared with deepest night. We conclude that painting cannot exist today without Divisionism. This is no process that can be learned and applied at will. Divisionism, for the modern painter, must be an innate complementariness which we declare to be essential and necessary."[1]

Congenital complementarism meant an innate and instinctive sensitivity to the perception of colour—in its primary entity and secondary correspondences—as original principle of light. In this canvas it is electric light that illuminates the nocturnal cityscape with its artificial glow, transfigured and unreal. It is electric light that creates the luminous refractions that spread in rays, lighting up the moving tram and the figures of passers-by, perfectly picked out with touches of shimmering blue, almost ghosts discoloured by the rays of light. The reds, blues and greens—colours evoked in the manifesto—together with the yellows, oranges and violets, charge the image with that first impression of vibratile aura which Carrà would soon abandon in favour of a more structural choice of representation.

E. C.

1 Reprinted in Drudi Gambillo and Fiori, *Archivi del Futurismo* (Rome: De Luca Editore, 1958), vol. 1, pp. 65–67; trans. as *Futurist Painting: Technical Manifesto*, in *Exhibition of Works by the Italian Futurist Painters*, Sackville Gallery, London Mar. 1912, republished in Apollonio (ed.), *Futurist Manifestos*, (London: Thames and Hudson, 1973 and 2001), p. 29.

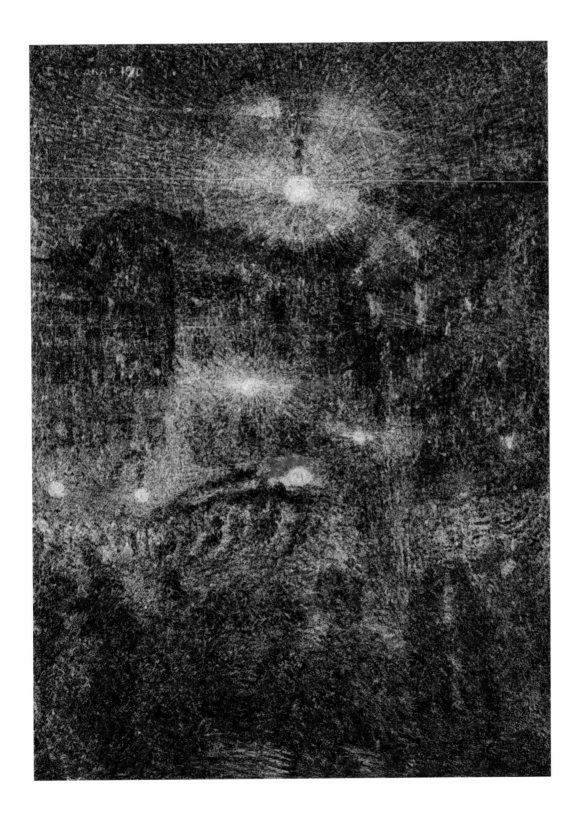

4 **Georges Braque**
 Le Viaduc à L'Estaque, 1908
 [Viaduct at L'Estaque]
 Oil on canvas, 72.5 x 59 cm
 Centre Pompidou, Musée national d'art moderne, Paris
 Accepted in lieu of tax, 1984

In the footsteps of Cézanne, the motif of the viaduct at L'Estaque inspired Braque to paint three pictures. This is the second version, which was faithfully kept by the painter for many years in his studio. It illustrates the crucial shift in his work from Fauvism to Cubism. The first canvas, *The Viaduct (Viaduct at L'Estaque)* (September–October 1907, The Minneapolis Institute of Arts), shows a pyramidal composition, curved and delimited surfaces, and a chromatic harmony of blues and greens, inspired by Cézanne's landscapes and his *Bathers*. In the third version, *Trees and Viaduct (Viaduct at L'Estaque)* (1908, private collection), the landscape is part of a sort of mandorla formed by the arabesques of the trees, anticipating the oval format of Braque's Cubist pictures of 1912. In this second canvas, painted from memory in his Paris studio early in 1908 (unlike the other two which were painted at L'Estaque), Braque simplified and economised on curves in favour of a geometrisation of forms, while combining frontal and oblique views. He carried on the deconstruction of the perspective worked on by Cézanne, so as to render volumes tangible and, as he later recalled, "bring the object closer to the viewer while keeping its beauty and real flavour".[1] From the landscape, the painter extracted the force-lines and harmonised the cubic planes through colours, creating a vibrancy made of hatching and uneven strokes, and green trees punctuating the geometric composition of the houses right up to the sky, which contribute to a feeling that the motif is unfinished. We should stress that the picture is the only one of the three where the horizontal of the viaduct stands out against the sky without being surmounted by other houses. The landscape is no longer a subject, but a pretext for painting. The re-worked light no longer accompanies the vanishing point which, moreover, the painter refused to use: "To avoid a projection towards infinity I am interposing overlaid planes a short way off. To make it understood that things are in front of each other instead of being scattered in space."[2] What is involved is no longer painting a landscape from a foreground but setting oneself at the middle of the picture by inverting the pyramid of forms in such a way that the onlooker penetrates the space of the canvas. Nevertheless, the edges and ridges of the various planes of the houses and the viaduct highlighted by blue, usher in an idea of depth between the different elements. The Cézannesque colours, limited to green, ochre and sienna, are luminous and create a vibrant musical atmosphere. Like the *Large Nude* (1907–08, cat. 6), and *Houses at L'Estaque* (1908, Musée d'Art moderne Lille Métropole, Villeneuve-d'Ascq), this canvas was refused at the 1908 Salon d'Automne and exhibited by Kahnweiler that November. Through this landscape, driven by the inexhaustible source that Cézanne's paintings represented for him, Braque affirmed all the interest he had in intermediate spaces, that he later called "the interspace that forms the subject".[3]

C. M.

1 Braque, "Entretien avec Jacques Lassaigne"
(1961), quoted in *Georges Braque*, exh. cat.,
Fondation Maeght, Saint-Paul 1980, p. xvi.
2 Ibid.
3 Charbonnier, "Entretien avec Braque",
Le Monologue du peintre, (Paris: Julliard, 1959), p. 10.

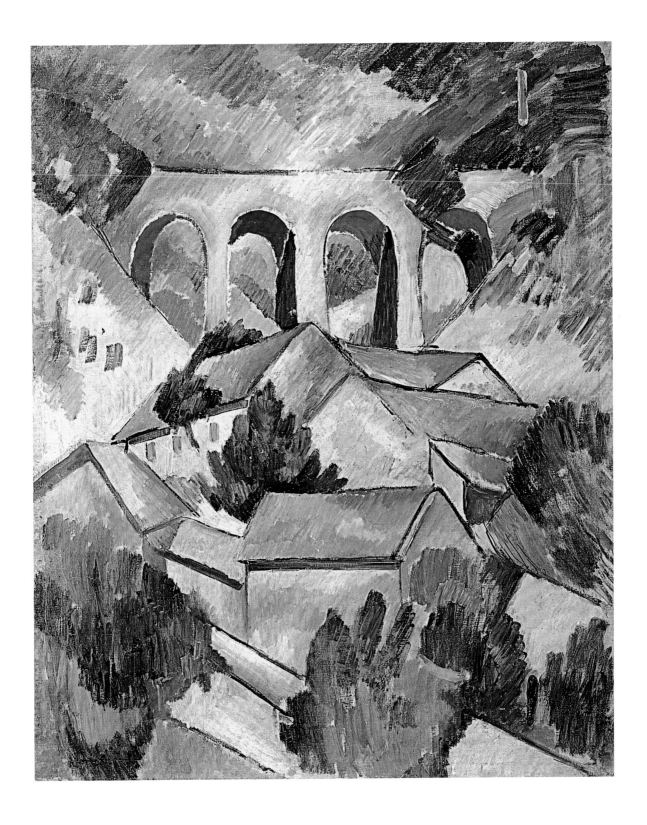

5 **Pablo Picasso**
La Dryade, 1908
[The Dryad]
Oil on canvas, 185 x 108 cm
Hermitage Museum, St. Petersburg

This large picture, known both as *The Dryad* and *Nude in the Forest*, was begun in the spring of 1908 and finished the following autumn, just as Picasso and Braque were starting to engage in rich daily dialogue. It belongs among the many figures Picasso painted in 1908 following the research carried out for *Three Women* (1907–08, Hermitage Museum, St. Petersburg). In addition to the landscapes and figures that the painter brought back from his August 1908 stay in the village of La Rue-des-Bois, near Creil (in Picardy), the analysis of the volume and frontal monumentality of the body, accentuated by the ochre colour bounded by black, made reference to the landscapes painted by Braque at L'Estaque in the summer of 1908. Like *Three Women*, *The Dryad* was the subject of a preliminary version re-worked by the painter after he had seen Braque's canvases. Between the highly compartmentalised study and the final canvas, Picasso softened the shifts between the planes; the ridges and edges are less marked, and the volume seems to move, immersed in a "tenuous and luminous atmosphere".[1] The surprising posture of the figure wavers between standing and sitting.[2] The indecisive, albeit massive and monumental body moves towards the middle of the composition, surrounded by trees which seem to draw closer to each other in the woman's wake. The claustrophobic look of the forest, because the foliage is only visible at top right, is rendered by a sculptural treatment of the trunks, identical to that of the nude, divided into many different planes with force-lines which harmoniously complement one another. The thoroughly Cézannesque colour range (green, ochre, brown, and particularly toned down here), characteristic of the 1908 canvases, makes the angular body placed in the light the more luminous and dazzling. The treatment of the face barely underscores the volumes, suggesting that Picasso had abandoned the extreme tensions and primitivist paroxysms of *Les Demoiselles d'Avignon* (1907, The Museum of Modern Art, New York) and the *Nude with Drapery* (1907, Hermitage Museum, St Petersburg). The shadow, which spreads over half the face, also tells us that the painter's preoccupation was elsewhere. This was actually the first time he gave the landscape a role around the human figure: with lines and areas of colour tending to shatter the perspective, the female nude is here incorporated within a rocky abstract decor.

The Dryad, a sylvan figure in Greek mythology, conjures up the mysteries of undergrowth and its atmosphere of strangeness, here rendered by its disconcerting effect, underscored by the outlines of the body and heightened by the surrounding shadows. There are two preparatory drawings, the most finished of which (a gouache)[3] shows another woman in the background on the left. By omitting her the painter chose to put the stress on the shape and vibrations of this figure which now alone becomes both subject and signifier. The sobriety of the colour, the round volumes of the body, and the light and shadow all produce a hesitant dynamic, breaking with the static nature of the other figures painted by Picasso in 1908. After finding its way into the Kahnweiler collection, this picture was probably purchased in 1913, along with other 1908 canvases, by the Russian collector Sergei Shchukin, whose collection was known to Russian artists before being nationalised in 1918.[4]

C. M.

1 Daix, *La Vie de peintre de Pablo Picasso,* (Paris: Éd. du Seuil, 1977), p. 102.
2 A pencil study (1908), shows the woman sitting in an armchair; see no. 191 in *Tout l'œuvre peint de Picasso, 1907–1916,* (Paris: Flammarion, 1977), p. 95.
3 Ibid. p. 95, no. 192.
4 It was subsequently transferred to the Hermitage museum in 1934, but was not put on public view until the exhibition *Fifty Years of Modern Art* in Brussels in 1958.

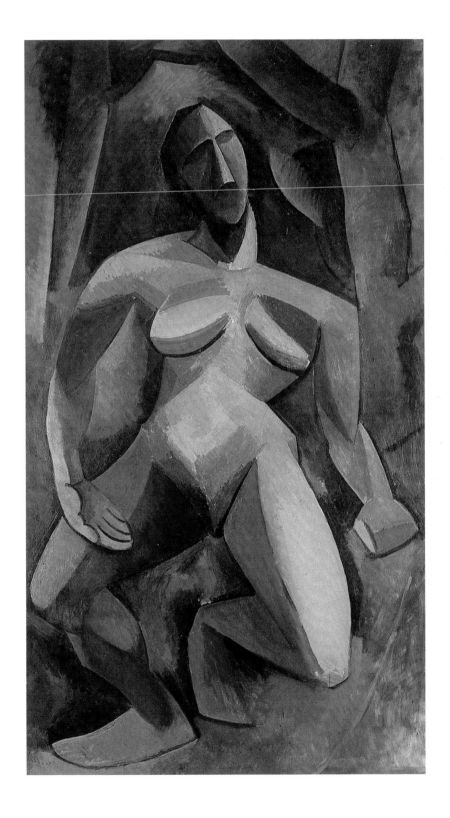

6 **Georges Braque**
Grand Nu, **1907–1908**
[Large Nude]
Oil on canvas, 140 x 100 cm
Centre Pompidou, Musée national d'art moderne, Paris
Accepted in lieu of tax from Alex Maguy-Glass, 2002

The well-known and much-studied history of this picture is of paramount importance in the burgeoning development of Picasso's and Braque's Cubism.[1] While visiting Picasso's studio in late November or early December 1907, Braque discovered *Les Demoiselles d'Avignon* (1907, The Museum of Modern Art, New York), as well as *Nude with Drapery* (1907), and a first version of *Three Women* (1907, both Hermitage Museum, St. Petersburg), which was reworked in 1908. These canvases caught Braque's full attention. Late in 1907 he embarked on a composition showing a woman seen from three different angles: *Woman* was exhibited at the Salon des Indépendants in March 1908, though it was not mentioned in the catalogue and has since been lost. He also began the *Large Nude*. The latter, which was his largest work at that time, was completed during his stay at L'Estaque in June 1908, the sole date written on the back of the painting by Braque. The work was turned down for the Salon d'Automne, but shown by Kahnweiler in the *Braque* exhibition held in November 1908. Responding to *Woman*, the canvas on view at the Salon des Indépendants, Guillaume Apollinaire and Gelett Burgess hailed Braque's "will to construct",[2] a recent undertaking that distanced him from his last Fauve canvases, painted during the summer of 1907. The *Large Nude*—something of a manifesto of this new style—related back to Braque's and Picasso's early exchanges about Cézanne's handling of paint. The three works spotted in Picasso's studio certainly sparked in Braque a desire to rethink the motif of the female nude, but the black contours of the body, the parallel strokes, the knotted, angular design and the warm harmony created by different browns were all inspired, above all, by Cézanne's *Bathers*, shown at the 1907 Salon d'Automne. Two other canvases, shown at the Salon des Indépendants in March 1907, also played a part in the genesis of the *Large Nude*: Matisse's *Blue Nude (Souvenir of Biskra)* (1907, Baltimore Museum of Art) and Derain's *Bathers* (1906–07, The Museum of Modern Art, New York). The only thing the *Large Nude* retained from the lost painting *Woman* is the figure at the left. To get the most comprehensive idea possible of the body's volumes, its twisting aspect used a rotating movement (with the right leg as the standing leg), giving the impression that the massive, angular body is turning in space. The head is offered face-on, seemingly defying the body's motion.

What is more, Braque censured the problem raised by Picasso in his *Nude with Drapery*, where the composition of the silhouette in the picture's vertical axis nevertheless prompts the viewer's eye to see the figure prone. The woman, whether lying or upright, stands out against a sheet or a bluish canopy, like a box or an aperture, where the strokes create abstract planes with bolder colours. The shadow cast by the body, like an intermediate plane, seems to obliterate the painting's very motif, and place the nude against a background which, at the bottom, covers *pentimenti* from another composition. Braque thus suggests the void existing between the woman and the surrounding space. The facial features, inspired by *Fang* masks, do not retain the violent incisions of those in Picasso's canvases; rather, they are sketched using simple black outlines, which also follow the body's forms. With this picture (shown in Moscow in January and February 1909 at the second *Golden Fleece* exhibition, before disappearing from view until 1933), Braque imposed an architectonic construction bathed in a harmonious patchwork of Cézanne-inspired colours, as well as the radiance of the monumental body in space.

C. M.

1 See in particular Parvu's study, "De l'histoire au tableau. *Grand Nu* (1907–08) de Braque", *Les Cahiers du Musée national d'art moderne* (Paris), no. 91, spring 2005, pp. 28–43) which cites, among others, Rubin ("Cézannism and the Beginnings of Cubism", *Cézanne. The Late Work*, exh. cat., The Museum of Modern Art, New York 1977, pp. 151–202) and Daix ("Le Grand Nu de Braque clé de la 'cordée en montagne' avec Picasso",

Georges Braque, exh. cat., Fondation Maeght, Saint-Paul 1994, pp. 61–3).
2 For a long time Apollinaire's response to the Salon des Indépendants (*La Revue des Lettres et des Arts*, 1 May 1908, trans. in Breunig (ed.) *Apollinaire on Art: Essays and Reviews 1902–1918*, (New York: Da Capo Press, 1972, p. 46), then those posited by Burgess ("The Wild Men of Paris", *Architectural Record*, May 1910, p. 405, extract in Fry, *Cubism*,

(London: Thames and Hudson, 1966, p. 53), were linked to the *Large Nude* (see Parvu 2005, notes 32 and 41, p. 43), when the work in question was actually *Woman*, a preliminary drawing which is reproduced by Parvu (ibid., p. 32) and Fry (ibid., p. 54).

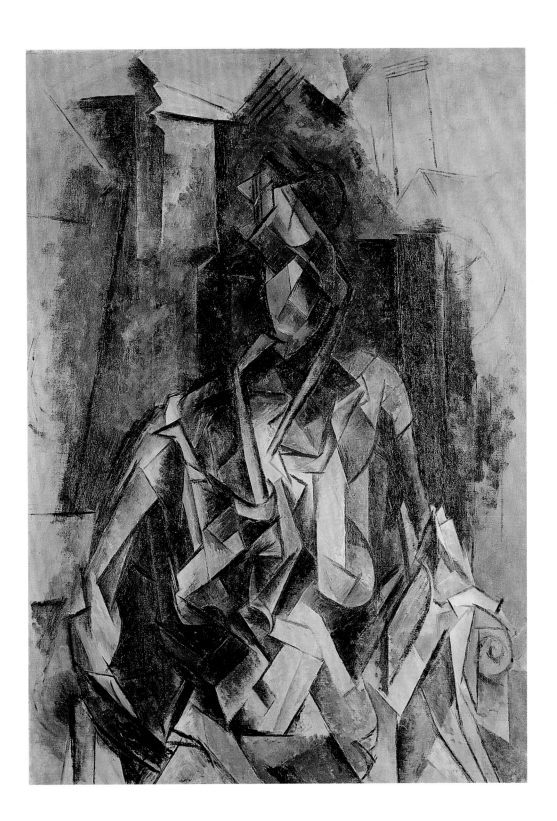

8 **Georges Braque**
Le Sacré-Cœur de Montmartre, **1909–1910**
Oil on canvas, 55 x 40.5 cm
Musée d'Art moderne Lille Métropole, Villeneuve-d'Ascq
Donated by Jean and Geneviève Masurel, 1979

Le Sacré-Cœur de Montmartre, very likely begun during the winter of 1909–10, shows the Paris church seen from below the hill, probably from a window. In it, Braque was keen to reintroduce a feeling of verticality, emphasised by the many 'tiers' of the staggered houses on the Sacré-Cœur hillside. The urban landscape is reduced to broad facets—lozenges, pyramids, rectangles. Here, Braque focused on a geometrisation of the landscape embarked upon at La Roche-Guyon, where, on several occasions, he painted the feudal castle set on top of a crag.[1] Compared to these pictures, the view of Montmartre illustrates a chromatic austerity which ushered Cubism into its most speculative phase: its 'analytical' period. While the cubes, spheres and cones of the Sacré-Cœur paved the way for a geometrisation simplified to the level of a blueprint for Braque, Delaunay drew inspiration from another Parisian church, Saint-Séverin, to inaugurate the "destructive phase" of his painting, and derive from the lines of Gothic architecture the formal resources of a dynamism and a revived lyricism[2]—a lyricism that the Futurists then laid claim to in a programmatic way. A comparison can be drawn between Braque's *Le Sacré-Cœur de Montmartre* and *The City Rises* (1910–11, cat. 28), painted by Boccioni in the same period. The latter was intended as the expression of the energy peculiar to the modern city, precisely where Braque's picture freezes it in some classical, changeless vision. In that same year, Braque did indeed paint at L'Estaque an industrial site, *The Rio-Tinto Factories* (1910),[3] but he overlooked the 'modern' features of such a building, and clung on to just its planes and volumes, the harmony of the composition. Unlike the Futurist painters, what principally concerned him were things pictorial.

I. S.-M.

1 In 1909, Braque painted five versions on this theme: musée d'Art moderne Lille Métropole, Villeneuve-d'Ascq; Stedelijk van Abbemuseum, Eindhoven; Moderna Museet, Stockholm; Pushkin Museum, Moscow; private collection.
2 Delaunay painted seven versions on this theme.
3 Braque painted two versions on this theme: musée d'Art moderne Lille Métropole, Villeneuve-d'Ascq; Centre Pompidou, Musée national d'art moderne, Paris.

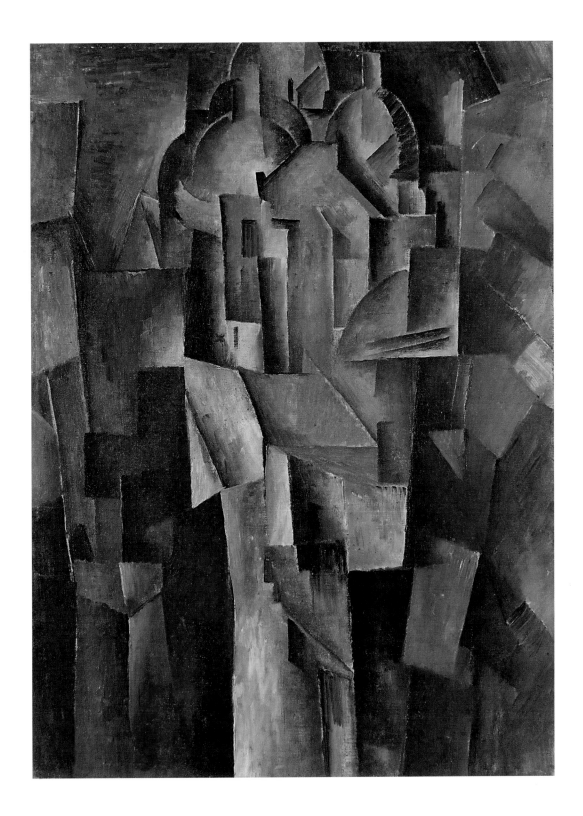

9 **Albert Gleizes**
La Cathédrale de Chartres, **1912**
[Chartres Cathedral]
Oil on canvas, 73.6 x 60.3 cm
Sprengel Museum Hannover, Hanover

In February 1912, Cubist circles welcomed the Italian Futurist painters' first show in Paris with wariness, to say the least. While the canvases of the latter left the Galerie Bernheim-Jeune to continue on their European tour, the Cubist counter-attack was being readied in many a Paris studio. It was launched barely a month later, at the opening of the Salon des Indépendants, and carried on right through the summer, taking in the Salon de la Société normande de peinture moderne [the Normandy Society of Modern Painting].[1] Alongside canvases by Metzinger, Duchamp and Picabia, Gleizes showed a *Cathedral*, the final version of which would be produced at the same time as Delaunay's *Towers of Laon* (1912, Musée national d'art moderne, Paris). *Chartres Cathedral* was exhibited right after the Futurists' show and illustrated the Cubists' desire to define their painting as a counterpoint to the proposals made by the Italian movement. Summoning up a loathing of the past, and in an attempt to rectify the cult of ruins, the Futurists called for the destruction of Venice: "We renounce the old Venice, enfeebled and undone by worldly luxury … Let us hasten to fill in its little reeking canals with the shards of its leprous, crumbling palaces … raise to the heavens the imposing geometry of big metal bridges and howitzers plumed with smoke, to abolish everywhere the falling curves of the old architecture."[2] Gleizes replied to this invective by giving pride of place to a secular iconography, symbolising a golden age of French art. Because of its monumentality and its sta-bility, the *Cathedral* embodies that French tradition whose revival Gleizes had, indeed, announced, saying "the pillars of which are grandeur, clarity, equilibrium and intelligence."[3] Through the austerity of its brown and green colour ranges, it clearly displays its distance from the chromatic conflagrations of the Futurist works presented in February 1912 in the rue Richepance. Lastly, the work helped to apply to a traditional motif the principles soon to be set out in the book written jointly by Gleizes and Metzinger, *On "Cubism"*: an increased number of perspectival viewpoints, an interpenetration of the geo-metric planes of both architecture and surrounding space and the fight against the dissolution of forms bequeathed by Impressionism. Echoing the cutting remarks Cubist critics had directed at the canvases in the Galerie Bernheim-Jeune, Gleizes refused the conception of the modernist subject as a necessary condition of pictorial modernity: his *Chartres Cathedral* unambiguously referred the Futurists to their own naivety.

When it was exhibited a few months later at the Salon de la Section d'or,[4] Gleizes' picture became topical in a different way. At the end of that year, 1912, the recent opening of the Salon d'Automne had in effect rekindled things, and the scandal which went as far as the Chamber of Deputies raised the issue of Cubism's national sympathies.[5] The unheard-of violence of the attacks made against the new painting prompted its defenders to re-assert its inclusion in an authentically French tradition, which they did both in the pages of the magazine *La Section d'or*, and on the walls of the Galerie La Boëtie. It was no coincidence that the picture by Gleizes then featured in the exhibition catalogue, alongside two other views of the cathedral.[6] Some months earlier, for the *Soirées de Paris*, Apollinaire had sketched the outlines of a "Gothic" Cubism, using as its source the period of the cathedral builders. The arrival of this new painting, in which the poet saw the heir to a Nordic artistic tradition, was to mark the end of Latin influences, thus ushering in the "rebirth of French art": "One could easily establish a parallel between this contemporary French art and the Gothic art which planted admirable monuments in the soil of France and all of Europe. Gone are the Greek and Italian influences. Here is the rebirth of French art, that is to say, of Gothic art—a rebirth wholly spontaneous, and free from pastiche."[7] This was a theme which Gleizes was quick to take up in *Montjoie !*, a magazine that proclaimed itself to be the "mouthpiece of French artistic imperialism", with its title taken straight from *The Song of Roland*.[8] From François Clouet and later from Philippe de Champaigne to Paul Cézanne, the prestigious pictorial genealogy with which the painter would then endow Cubism would have as its common denominator the fact that it incarnated France's resistance to Italian cultural hegemony.

M.-L. B.

1 Rouen, Grand Skating, 15 June–15 July 1912.
2 Futurist poets (Marinetti, Buzzi, Palazzeschi, Cavacchioli, Mazza, Altomare, Folgore, Carrieri, etc.) and painters (Boccioni, Bonzagni, Carrà, Russolo, Severini, etc.), "Venise futuriste", a tract published (with variants) in *Comœdia* (Paris) (accompanied by cartoons by A. Warnod), 17 June 1910, p. 3. The Italian version, "Contro Venezia passatista", was dated 27 April 1910; trans by Flint and Coppottelli as "Against Past-Loving Venice", in Flint (ed.) Marinetti: Selected Writings (London: Secker and Warburg, 1972), p. 55).
3 Gleizes, "L'art et ses représentants. Jean Metzinger", *Revue indépendante* (Paris), no. 4,

September 1911, p. 171; trans. in Antliff and Leighton (eds.), *A Cubism Reader: Documents and Criticism, 1906–1914* (Chicago and London: University of Chicago Press, 2008), p. 151
4 Salon de la Section d'or, Galerie La Boëtie, Paris, 10–30 Oct. 1912.
5 "I cannot accept that our administration of the fine arts should lend itself to those jokes in very poor taste, and graciously hand over our national palaces to demonstrations that run the risk of compromising our marvellous artistic legacy", declared Jules-Louis Breton in the Chamber of Deputies, on 3 Dec. 1912.; quoted in Barrer, *Quand l'art du xxᵉ siècle était conçu par des inconnus: L'histoire du Salon d'automne*

de 1906 à nos jours, (Paris: Arts et Images du monde, 1992), pp. 94–95; trans. in Antliff and Leighton, op. cit., p. 395.
6 Pierre Dumont exhibited a *Cathédrale de Rouen* (1912, Milwaukee Art Museum), and Luc-Albert Moreau, *Gisors, La Cathédrale* (present wherabouts unknown).
7 Apollinaire, "La peinture nouvelle. Notes d'art", *Les Soirées de Paris*, no. 4, May 1912, p. 114.; trans. in Breunign (ed.), Apollinaire on Art: Essays and Reviews 1902–1918 (New York: Da Capo Press, 1972), p. 225.
8 Gleizes, "Le cubisme et la tradition", *Montjoie !* (Paris), no. 1, 10 February 1913, pp. 2–3; trans. in Antliff and Leighton, op. cit., p. 460–6.

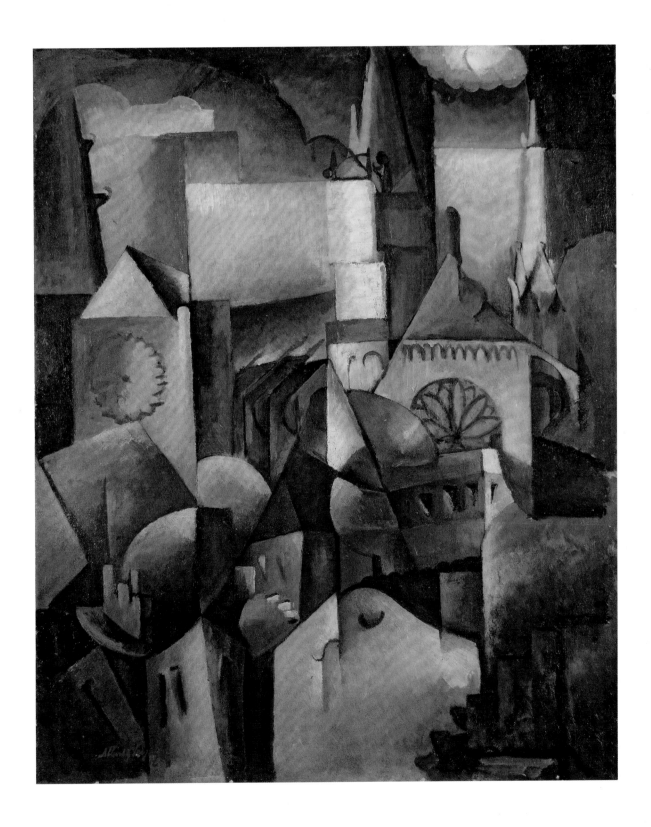

10 **Robert Delaunay**
Tour Eiffel, 1911
[Eiffel Tower]
Oil on canvas, 202 x 138.4 cm
Solomon R. Guggenheim Museum, New York / Solomon R. Guggenheim
Founding Collection / Gift of Solomon R. Guggenheim, 1937

When Delaunay showed his picture entitled *Eiffel Tower* at the 1911 Salon des Indépendants in Paris it stimulated in Guillaume Apollinaire a peremptory verdict: "The exuberance that he [Robert Delaunay] manifests assures his future."[1] The canvas in question has since been lost,[2] but this, almost identical, *Eiffel Tower* was exhibited in June 1911 at the Salon des Indépendants in Brussels (as no. 54). So it is perfectly logical that this second painting has attracted commentaries that have been all the more plentiful because they are also associated with its (defunct) twin. Although this could have aroused criticism, this painting has been the object of extremely revealing studies.[3]

The *Eiffel Tower* is part of a series produced between 1909 and 1912, begun when the series devoted to the ambulatory of St. Séverin was being finished. Delaunay thus decided to explore the metal ribs of a modernising monument whose twentieth anniversary had been a reminder of its significance within the popular imagination and imagery. By opting for this gigantic cast-iron lacework, the artist could have probed the plays of light and the voids, as well as the pure linear open-work. But in giving up any idea of transcribing the building's symmetrical verticality—that Seurat had subtly reinstated in 1889—Delaunay preferred to de-construct his composition. By increasing the number of viewpoints—head-on, sideways, overhanging, from below—he made use of the resources of a Cubism prone to dislocate forms. By manipulating the framework for which he carried out an unfolded and unfurled in-depth analysis, he bound or disembowelled the nodal elements of the tower which he a(na)tomised without failing to convey a vitalism of Futurist descent. A swift nosological examination of the *Eiffel Towers* is enough to show the extent to which this canvas is the one that offers the most advanced symptoms of alteration, such is the way that the artist—to borrow Roger Allard's words—"fragments and dismembers the Eiffel Tower to give substance to the plastic forces diverging around it."[4]

Probably painted in May 1911, and not in 1910 as Delaunay wrote on the back of the work, this *Eiffel Tower* is the largest in the series and marked a substantial break with the earlier versions. In fact, the elimination of details hampering perfect legibility and the decidedly aggressive chromatic chord chosen—purple and blood red shades contrasting with the range of neutral ochres and greys—point to the significance of the Marinettian legacy in which kaleidoscopic rigour would be a Cubist after-thought. In this respect, it fell to Metzinger to supply one of the more perceptive analyses: "Out of a repugnance for chance events, vague recollections, and ambiguities, he [Delaunay] intentionally uses mechanical techniques as Seurat did for different ends."[5] At times distinct, at others obliterated, the sky filled with soft, fluffy clouds and the salient buildings together create a vibrating alternation between a dynamic perception and a certain stasis, whose visual outcome is the tower, motionless and authoritarian. The left part of the canvas, as if issuing from a luminous blindness—already present, though less boldly, in the lost version—reinforces the impression of photographic focus which, by trying to grasp the object, fails to depict *objectively* what is around it. So the urban fabric—and do curtains not predate the buildings in the earlier Düsseldorf version (1910–11, Kunstsammlung Nordrhein-Westfalen)?—is a perspectival contraction of the rue Saint-Dominique as it appears photographed from the boulevard La Tour-Maubourg on a postcard held today in the Delaunay collection at the Bibliothèque nationale de France.

The simultaneity of the viewpoints and the Bergsonian quest for "unscrolling in space" invite us to see this Cubo-Futurist work in photographic terms, but, even more so in our view, in cinematographic and, what Élie Faure later called, *cineplastic* terms. Does not Delaunay's *Eiffel Tower*—and who has not noted as much!—embody that eloquent formula uttered in 1922 by Faure: "The notion of direction enters as a component part into the notion of space, so we can easily imagine a blooming cineplastic art that is no longer anything more than an ideal architecture…. A great artist can on his own build edifices endlessly forming and collapsing and reforming through imperceptible shifts of tones and shapes, which are themselves architecture at any given moment of the duration, though we are unable to grasp the thousandth of a second in which the transition is made."[6]

C. L.

1 Apollinaire, "Le Salon des indépendants", *L'Intransigeant*, 21 Apr. 1911; trans. in Breunig (ed.) *Apollinaire on Art: Essays and Reviews 1902-1918*, (New York: Da Capo Press, 1972), p. 151.
2 It passed into the Koehler collection and was destroyed in Berlin in 1945.
3 See especially Rousseau, "Tour Eiffel", *Robert Delaunay, 1906–1914. De l'impressionnisme à l'abstraction*, exh. cat., Musée national d'art moderne,

Paris 1999 (Paris: Éd. du Centre Pompidou, 1999), pp. 130–7.
4 Allard, "Sur quelques peintres", *Les Marches du Sud-Ouest* (Paris), no. 2, June 1911, p. 62; trans. by Jane Marie Todd in Antliff and Leighton (eds.), *A Cubism Reader: Documents and Criticism, 1906–1914*, (Chicago and London: University of Chicago Press, 2008), p.117.

5 Metzinger, "Cubisme et tradition", *Paris-Journal*, 16 Aug. 1911; trans. ibid., p. 124.
6 Faure, "De la cinéplastique", *L'Arbre d'Éden*, (Paris: G. Crès & Cie, 1922) , and *Œuvres complètes*, (Paris: Jean-Jacques Pauvert,1964), vol. 3, p. 308.

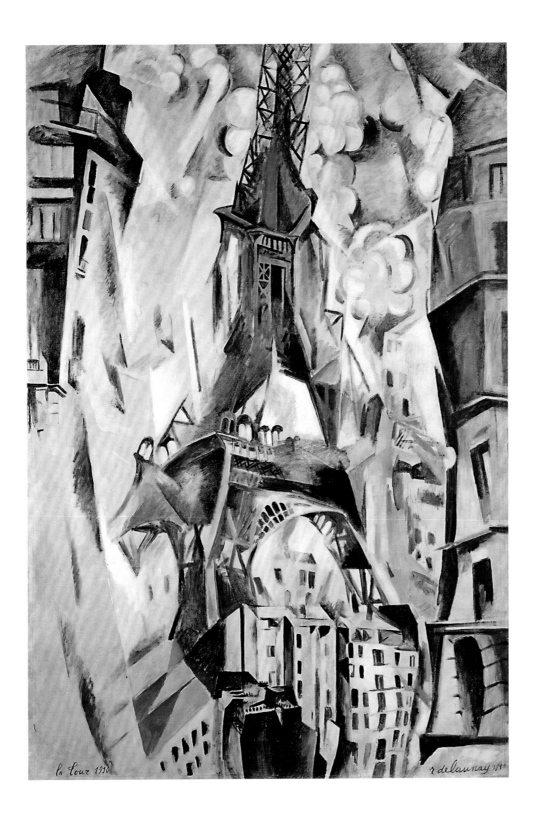

11 **Georges Braque**
 Nature morte au violon, 1911
 [Still Life with Violin]
 Oil on canvas, 130 x 89 cm
 Centre Pompidou, Musée national d'art moderne, Paris
 Donated by M^me Georges Braque, 1965

Céret, summer 1911: Braque and Picasso are in the process of scaling the heights of pictorial modernity, coordinated and mutually supportive "roped together like mountaineers", to borrow the former's words. This alchemy, with all its tentative explorations and discoveries, gave rise to the major and fertile experiments of an analytical Cubism which still did not have a name, but was developed in the joyful and carefree summer in a South of France well suited to regenerating forms and ideas, syntax and vocabulary. It was thus with the obsessiveness of a laboratory technician seeking out a new formula that Braque painted *Still Life with Violin*.

A latter-day classification might suggest that this work owes nothing to the past, despite some well-informed commentators having been swift to emphasise its topicality as much as its links with "Cézanne and Carrière, El Greco, the Venetians and certain great classical masters".[1] The canvas is actually carefully worked out, at once constructed and 'analytical'. The seeming ease, not to say frivolity, of the deconstructive process called for the gifts of a builder to put the pieces back together again. The pyramidal structure, made up of ochres blurring and dwindling in the upper part, is rendered denser by a network of sloping diagonal lines which, based on an identical angle, invariably cast brown shadows to the right. These lines, like so many strokes and crossings out and knife slashes, alter our reading of the piece and lend it a prismatic and syncopated vision. Clear, horizontal touches organise the centre of the picture and, consequently, its *subject*. This is swiftly detected: the subject may be centred—here again a legacy and/or concession to classical tradition—but it is not central, unlike a Futurist orthodoxy more concerned with appropriating the real. The contribution of decipherable elements painted in a realist manner—such as the scroll of a violin or the mouldings of a mantelpiece—is not enough for the onlooker to invest the canvas with some kind of meaning. Because the meaning is not instantly accessible, it comes *as an extra*. This resistance of the subject and this stumbling block of discernment tend to highlight the plastic means that were called upon. The orchestrated arrangement of the colours gives rise to a disruptive rhythm, and the compenetration of planes a significant material quality. Two-dimensionality is not synonymous with flatness. Resolved to go beyond traditional spatiality and the plane of the canvas, Braque was one of the first artists to cross the threshold of this "new space".

When Carrà arrived in Paris in 1911, and then stayed there again in 1912, he was not unaware of Braque's experiments with modernity, which had been at their height for a whole year. Constructive knowledge, formal decantation, the declension of light values and the chromatic structuring of analytical Cubism—of which *Still Life with Violin* and its twin *Clarinet and Bottle of Rum* (1911, Beyeler Collection, Basel) are paragons—won him over to the point of altering his work. So the dull colouring instantly made an appearance in his output before he had oriented it towards a "classical moderateness" rich in Cubist propaedeutics.

Still Life with Violin would remain in Braque's possession until his death.[2] This retention of a particular work is eloquent of the artist's affection for a period that was as intensely busy as it was brief—his stay in Céret came to an end on 19 January 1912—with this canvas probably sufficing to remind him of its existence and, above all, wealth. A relic just as much as a shroud, whence the later observation: "Picasso and I said things to each other during those particular years that nobody would say any more, things that nobody would any longer know how to say, that nobody would be able to understand any more…, things that would be incomprehensible, and which gave us so much pleasure."[3]

C. L.

1 [Anon.], "Notes d'art—Le cubisme au Salon Biderman", *Gazette de Lausanne*, 4 May 1913.
2 The work was shown at the *Exposition de peintures et sculptures contemporaines* organised by Yvonne Zervos at the Papal Palace in Avignon (27 June–30 Sept. 1947, under the title *The Violin*); in 1965 the artist verbally bequeathed it to the Musée national d'art moderne in Paris.

3 Vallier [conversations with the artist], "Braque, la peinture et nous", *Cahiers d'art* (Paris), 19^th year, 1954, p. 14.

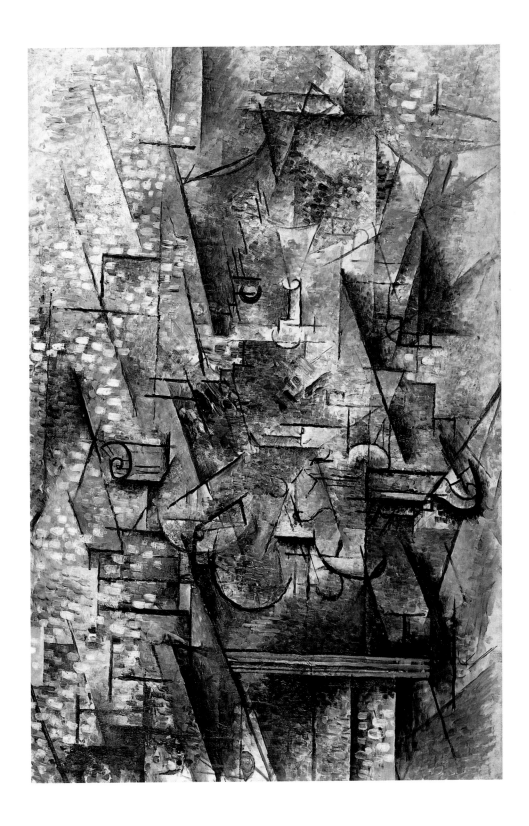

12 **Georges Braque**
Le Guéridon, **1911**
[The Guéridon; The Occasional Table]
Oil on canvas, 116.5 x 81.5 cm
Centre Pompidou, Musée national d'art moderne, Paris
Gift of Raoul La Roche, 1952

The Occasional Table followed on from a series of works which Braque started during the summer of 1911 in Céret, where he stayed with Picasso. Under the effects of mutual rivalry, the two painters greatly developed the movement of deconstruction which they applied to objects and figures alike. Painted in the autumn, after Picasso had left, this canvas borrows the pyramidal construction common to pictures from this period. The composition, at once dynamic and unstable, tips the occasional table of the title towards the viewer, using a principle applied by Cézanne in many of his still lifes (such as *The Basket of Apples*, 1895, The Art Institute of Chicago).

The evocation of a "tactile space" lay at the heart of Braque's preoccupations when he was planning *The Occasional Table*. In 1954 he confided to Dora Vallier: "I started above all by producing still-lifes because in nature there is a tactile space, I would say almost manual."[1] This interest in an art of multiple senses echoed one of the concerns of the Futurists. In his article "Picasso and Braque",[2] the first Italian study of Cubism, Ardengo Soffici emphasised the tactile quality of Cubism, reacting to the essentially optical research carried out by the Impressionists. This was also a recurrent theme in Futurist writings. In 1913, in a manifesto titled *The Painting of Sounds, Noises and Smells*, Carrà urged the creation of explosive works, capable of stirring up real sensations, calling for the "active cooperation of all the senses".[3] In 1914, the visual poem by Balla and Francesco Canguillo, *Palpavoce*, strove to recreate the "tactile space" of a stairwell. Marinetti's manifesto titled *Tactilism*, on 11 January 1921, confirmed the fundamental place of the "touch" in Futurist aesthetics; he aimed to "transform the handshake, the kiss and copulation into continuous transmissions of thought".[4]

I. S.-M.

1 Vallier [conversations with the artist], "Braque, la peinture et nous", *Cahiers d'art* (Paris), 19th year, 1954, p. 16.
2 Soffici, "Picasso e Braque", *La Voce*, vol. 3, no. 34, 24 August 1911, trans. in Mark Antliff and Patricia Leighton eds., *A Cubism Reader: Documents and Criticism, 1906–1914*, (Chicago and London: University of Chicago Press, 2008), pp.128–140.
3 Carrà, "La Pittura dei suoni, rumori, odori. Manifesto futurista" 11 Aug. 1913, *Lacerba* (Florence), vol. 1, no. 17, 1 Sept. 1913; Carrà, *Tutti gli scritti*, op. cit., p. 21; trans. in Apollonio (ed.), *Futurist Manifestos*, (London: Thames and Hudson, 1973 and 2001), p. 115.
4 Marinetti, "Le tactilisme" (11 January 1921), published in French in *Comœdia*, 16 Jan. 1921.

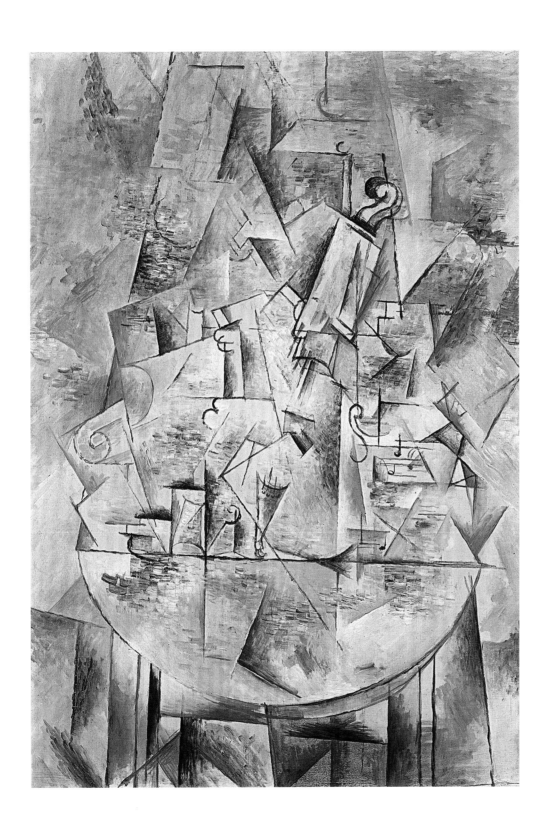

13 **Pablo Picasso**
Portrait de Daniel-Henry Kahnweiler, 1910
[Portrait of Daniel-Henry Kahnweiler]
Oil on canvas, 101.1 x 73.3 cm
The Art Institute of Chicago
Gift of Mrs. Gilbert W. Chapman in memory of Charles B. Goodspeed

Daniel-Henry Kahnweiler opened his Paris art gallery in 1907. One year later he exhibited the works inspired by Cézanne which Braque brought back from L'Estaque. In describing these pictures, the critic Louis Vauxcelles used the term "Cubism" for the first time, a word that was to have a remarkable success. The name Kahnweiler has ever since been inseparable from the history of Cubism. He was Cubism's dealer, strategist and theoretician. He organised its dissemination and turned his gallery into the exclusive venue where Braque and Picasso exhibited their new works in Paris. He enabled his painters to take advantage of his contacts (in Berlin, Alfred Flechtheim; in New York, the Washington Square Gallery), thus contributing to the international spread of Cubism. In 1915, Kahnweiler started work on his *Der Weg zum Kubismus* [The Way of Cubism][1] which conveyed his conception of a Cubism whose development overlapped with a rational exploration of the visible (a model inspired by Kant which would become the catechism of modernist historiography).

In the autumn of 1910, Picasso embarked on his portrait of Kahnweiler. It followed the portraits of his two other dealers of the day: Wilhelm Uhde (1909–10, private collection) and Ambroise Vollard (1909–10, Pushkin Museum of Fine Arts, Moscow). Between completing Vollard's portrait and Kahnweiler's, Picasso spent the summer at Cadaqués, where he took his Cubism to the borders of abstraction. Despite the anecdote recounted by Kahnweiler about the subject's identification by a four-year-old child ("That's 'Voyard'!") Picasso's work no longer showed those caricatured graphic ellipses still present in the portraits of Uhde and Vollard. Certain details, like the hair, still evoked the model but Picasso was now determinedly involved in an arbitrary approach to plastic signs which would culminate two years later in the portrait drawings of Frank Burty Haviland (1912, The Metropolitan Museum of Art, New York) and Guillaume Apollinaire (1912–13, private collection).

Did Boccioni see the *Portrait of Daniel-Henry Kahnweiler* during his stay in Paris in October 1911? The similarities noted by many art historians between the still life which appears in the lower left part of Picasso's picture and certain drawings by the Italian artist (in particular *Table + Bottle + Block of Houses,* 1912, Civiche Raccolte d'Arte, Milan) support this hypothesis. More than a slightly futile quest for any set of influences, it is worth pointing out the convergences in the *Portrait of Daniel-Henry Kahnweiler* between the Cubism of the moment and Futurist art, as defined in the *Futurist Painting: Technical Manifesto* (11 April 1910). The absence of clearly-defined outlines around the figure and the openness of the geometric facets which form it, along with the surrounding atmosphere, apply and echo—though without the dynamism—the programme of a Futurist painting asserting that: "To paint a human figure you must not paint it; you must render the whole of its surrounding atmosphere."[2] By assimilating, from 1912, some of the formal data of Cubism, with his *Horizontal Construction* (1912, cat. 77), Boccioni would reconcile the residual realism of the *Portrait of Ambroise Vollard* and the pose in the *Portrait of Daniel-Henry Kahnweiler.*

D. O.

1 Kahnweiler, *Der Weg zum Kubismus,* (Munich:
Delphin-Verlag, 1920); trans. as *The Way
of Cubism,* New York 1949.
2 Boccioni et al., *Manifeste des peintres futuristes,*
in *Les Peintres futuristes italiens,* exh. cat., Galerie
Bernheim-Jeune & Cie, Paris, 5–24 Feb. 1912, p. 16;
trans. in Apollonio (ed.), *Futurist Manifestos,* (London:
Thames and Hudson, 1973 and 2001) p. 28.

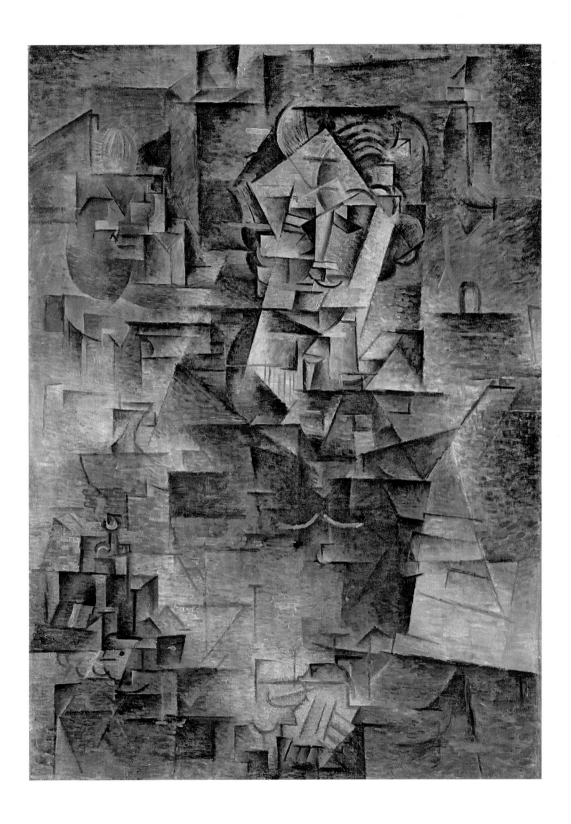

14 **Pablo Picasso**
Tête de femme (Fernande), **1909**
[Head of a Woman (Fernande)]
Plaster, 40.5 x 23 × 26 cm
Private collection on long loan to Tate, London 1994

Fernande Olivier, whom Picasso met in 1904, was his first serious partner. At Horta de Ebro, where the couple spent the summer of 1909, Picasso produced many portraits of the young woman (including *Head of a Woman with Mountain*, (Frankfurt-am-Main); *Bust of a Woman (Fernande)*, (The Art Institute of Chicago); *Portrait of Fernande*, (Kunstsammlungen Nordrhein-Westfalen, Düsseldorf). These works crowned the first phase of analytical Cubism, leading to an explosion of form. *Head of Fernande*, the first Cubist sculpture, was made in Paris that autumn, though still closely linked to the works produced at Horta. The hair is transposed into volumetric curves, the face is treated in facets underscoring its inner structure. Despite the bold deconstruction of his model, a resemblance remained.

The *Head of a Woman (Fernande)*, which opened a new path in the way volumes were treated, would influence the Cubist sculptors in Paris: Archipenko, Laurens, Lipchitz. It would also be a decisive work for Boccioni, who managed to see it on his trip to Paris in the autumn of 1911; this was either in Ambroise Vollard's collection, where the bronze (cast by Picasso himself) was on permanent view (cat. 15), or in Picasso's Montmartre studio, where the original plaster cast (cat. 14) was kept (as proved by a photograph from that autumn).Three important works by the Italian artist illustrate the impact of Picasso's sculpture. *Abstract Dimensions* (Civiche Raccolte d'Arte, Milan), a portrait of the artist's mother dated spring 1912, would appear to be a pictorial transposition of the *Head of a Woman (Fernande)*. *Antigrazioso* (1912, cat. 76)—literally 'anti-graceful'—extended the plastic research embarked upon with *Abstract Dimensions*. In it some believe that Boccioni depicted the figure of his mistress Margherita Sarfatti, an intellectual close to the Futurists, schematically broken down into rudimentary volumes. The masculine gender in the title cannot be interpreted as an allusion to Sarfatti's lack of charm or grace. Rather it refers to the wish, common among Futurists, to proffer a re-invented image of femininity: energetic, intelligent, and breaking with stereotypes of passiveness and mawkishness.

Boccioni's third work showing the impact of the *Head a Woman (Fernande)* is a sculpture—begun in June 1912 and completed in 1913—which he also called *Antigrazioso* (cat. 81) and which was a portrait of his mother. The edges are less harsh—thereby revealing the influence of Medardo Rosso's *The Concierge* (1883, Museo Medardo Rosso, Barzio), who was cited in the *Technical Manifesto of Futurist Sculpture* on 11 April 1912.[1] However the construction of the face as dynamic planes, the boldness of the voids and solids, the lack of boundary between hair and face, the fleeting smile, and the very sunken eye-sockets all attest to the influence of Picasso's sculpture, again visible in the painting *Spiral Construction* (1913–14, Galleria d'Arte Moderna, Milan).

I. S.-M.

15

Tête de femme (Fernande),
1909
[Head of a Woman (Fernande)]
Bronze, 41.3 x 24.7 x 26.6 cm
Museo Nacional Centro de Arte
Reina Sofia, Madrid

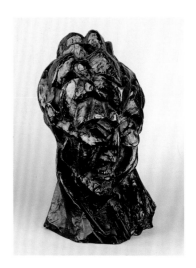

1 Boccioni, *Manifeste technique de la sculpture futuriste*, in *Première Exposition de sculpture futuriste du peintre et sculpteur futuriste Boccioni*, exh. cat., Galerie La Boëtie, Paris, 20 June–16 July 1913, pp. 17–18; trans. in Apollonio (ed.), *Futurist Manifestos*, (London: Thames and Hudson, 1973 and 2001), p. 62.

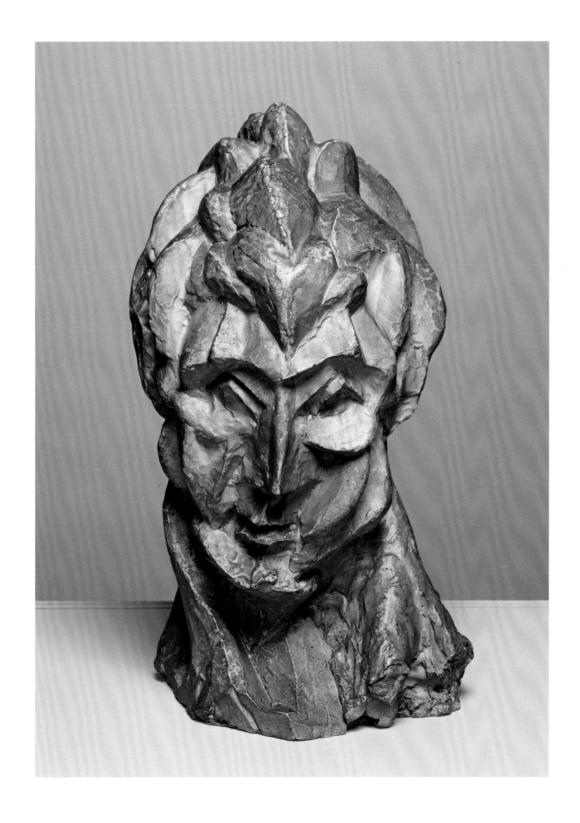

16 **Jean Metzinger**
***Le Goûter (Femme à la cuillère)*, 1911**
[Teatime (Woman with a Teaspoon)]
Oil on board, 75.9 x 70.2 cm
Philadelphia Museum of Art, Philadelphia
The Louise and Walter Arensberg Collection, 1950

In the late summer of 1911, all France was in a state of shock: Mona Lisa has disappeared! The newspapers were filled with the smile of the lovely lady who had vanished into thin air. With the Louvre wall now desperately empty, the opening of the 1911 Salon d'Automne gave Parisians a chance to discover a quite different *Mona Lisa*: Jean Metzinger's *Teatime*, immediately described by André Salmon as the 'Cubist Mona Lisa'.[1]

With her elbows akimbo on a table, a half-(un)dressed model is taking tea, in between two sittings. The stretcher of a canvas visible in the background sets the scene in the privacy of a studio. Metzinger's fascination with the "wizardry of geometric figures" dated back to his boyhood;[2] he was introduced to the delights of the new mathematics by Maurice Princet[3] and duly explored the mysteries of non-Euclidean geometry and the fourth dimension. The book titled *On "Cubism"* (1912), which Metzinger would soon co-author with Gleizes, attested to his desire to offer pictorial equivalents to the spatial theories issuing from the works of Bernhardt Riemann, Victor Schlegel and Henri Poincaré.

Teatime, which also came under the aegis of mathematical and philosophical research (Salmon would also describe it as a "metaphysical puzzle"),[4] echoes the theory of conventionalism formulated by Poincaré in *La Science et l'hypothèse* (1902 [Science and Hypothesis]), from which he would borrow the concept of representative space as the joint experience of visual, tactile and motor spaces.

Prior to the picture proper there were several studies illustrating an increased simplification (pared-down lines, shedding of props). The study held at the Musée national d'art moderne, in which triangles and rectangles link the figure to the surrounding space, has been compared by Linda Dalrymple Henderson to a diagram taken from *Mélanges de géométrie à quatre dimensions* (1903 [Mixtures in Four-dimensional Geometry]) by Esprit Pascal Jouffret.[5]

In the definitive version, facets and planes are juxtaposed, interpenetrate, and are at times informed by a transparency which breathes dynamism into the picture. In 1910, the painter had praised Picasso's use of a "free, moveable perspective".[6] The adoption of multiple viewpoints—the face is seen head on and in profile; the cup at a three-quarters angle and in profile—here gets different instants within the painting to co-exist, simultaneously.

Before the 1911 Salon d'Automne opened, Metzinger published the article "Cubisme et tradition",[7] his intention being to root the new painting in the footsteps of the great masters. A few months earlier, his *Head of a Woman*, sent to the Indépendants, had already been deemed "very eighteenth century".[8] Just when Cubism was being accused of letting tradition down, and even of being anti-national, *Teatime* displayed a disturbing kinship with a portrait of Jean François de Troy, who painted the elegant life of the Age of Enlightenment;[9] the same stability of construction, same suspension of gesture, the same work too, on light and the refinement of colour.

As a programmatic and emblematic picture of a Cubism intent on being based upon scientific foundations as well as on the pictorial legacy of past centuries, *Teatime* was once again shown in 1912 at the Salon de la Section d'or. The title of the exhibition straightaway placed geometry at the core of painters' preoccupations—a geometry whereby, well removed from the radical dislike of harking back to the past, by which the Futurists set so much store, they wished to reconcile Cubism and tradition. Twenty years or so later, it would find its way into the Arensberg collection, a transaction brokered by Marcel Duchamp.

M.-L. B.

17

***Étude pour «Le Goûter»*, 1911**
[Study for "Teatime"]
Pencil and ink on grey paper,
19 x 15 cm
Centre Pompidou, Musée national
d'art moderne, Paris
Purchased, 1960

1 La Palette [Salmon], "Courrier des ateliers, Jean Metzinger", *Paris-Journal*, 3 Oct. 1911, p. 5; trans. by Todd in Antliff and Leighton (eds.), *A Cubist Reader: Documents and Criticism, 1906–1914*, [Chicago and London: University of Chicago Press 2008] p.157.
2 Metzinger, *Le Cubisme était né. Souvenirs*, (Chambéry/Saint-Vincent-sur-Jabron: Éd. Présence, 1972), p. 20.
3 Princet's name appeared in Metzinger's writings from the autumn of 1910 in his "Note sur la peinture", *Pan* (Paris), 3, no. 10, Oct.–Nov. 1910, p. 650;

trans. in Antliff and Leighton, op. cit., p. 76. The painter would then introduce him to the artists belonging to the Puteaux group.
4 La Palette, "Courrier des ateliers", art. cit.; trans. in Antliff and Leighton, op. cit., p. 157.
5 Dalrymple Henderson, *The Artist, "The Fourth Dimension" and Non-Euclidean Geometry 1900–1930: A Romance of Many Dimensions*, Ph. D., New Haven (CT), Yale University, 1975, pp. 149–50.
6 Metzinger, "Note sur la peinture", art. cit.; trans. in Fry, *Cubism*, (London: Thames and Hudson, 1966), p. 60.

7 *Paris-Journal*, 16 August 1911, p. 5: trans. in Fry, op. cit, pp. 66–7.
8 Granié, "Salon des indépendants", "Les Arts" section, *Revue d'Europe et d'Amérique* (Paris), June 1911, p. 361; Apollinaire, *Les Peintres cubistes*, (Paris: Hermann, 1980 (1965)), pp. 193–4.
9 *Le Petit-déjeuner* [*Breakfast*] (oil on canvas, 34 x 25 cm, Berlin, Gemälde Galerie). The Ingres Museum in Montauban holds a copy, whose square format makes the "family likeness" even more striking.

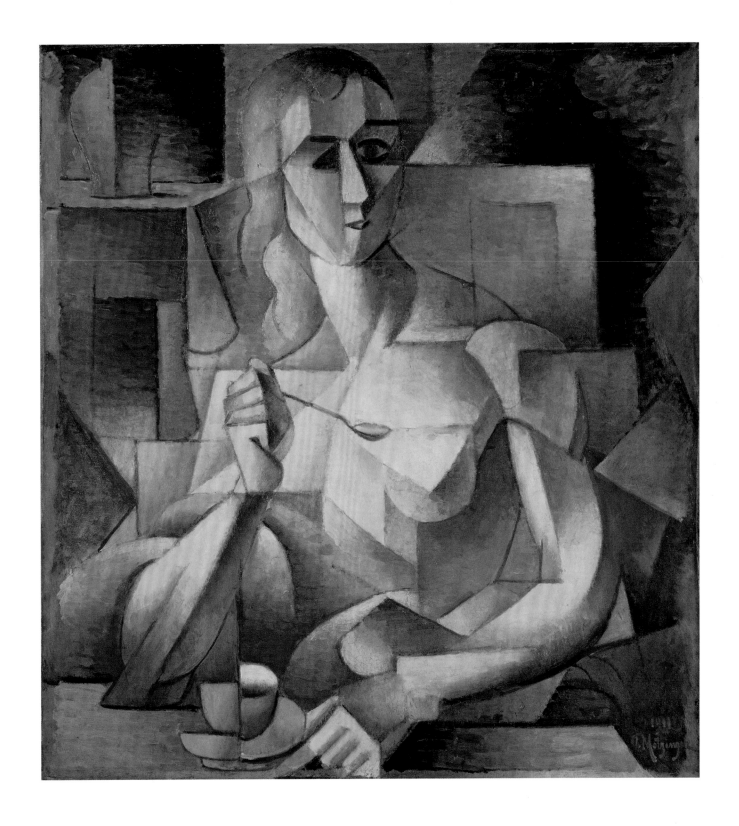

18 **Fernand Léger**
Nus dans la forêt, 1909–1911
[Nudes in the Forest]
Oil on canvas, 120.5 x 170.5 cm
Kröller-Müller Museum, Otterlo

Léger observed, after the fact, that _Nudes in the Forest_, which he completed in 1911, marked a turning-point in his artistic career. In December 1919 he wrote to his dealer Daniel-Henry Kahnweiler that this canvas confirmed his break with Impressionism and opened up a new chapter in his œuvre.[1] At the root of this development lay the retrospective exhibition of Cézanne's work, which Léger saw at the 1907 Salon d'Automne; it had a considerable impact on him, heightened by his discovery of Braque's first "Cubist" canvases, on view at the Kahnweiler gallery in November of the following year. _Nudes in the Forest_ was shown at the 1911 Salon des Indépendants, unleashing much anger among the critics.[2] Léger recalled having become the "Tubist", or, alternatively, the 'tube merchant'.[3] The radical novelty of his work was nonetheless acclaimed by Apollinaire who saw in that "wild appearance of a heap of tyres"[4] all the talent of its author. The work epitomised the Cézanne-inspired principle aimed at seeing the world like an interplay of cones, cylinders and cubes.[5] The picture heralded Léger's major pictorial project: "treating in the same way object and human figure, vaguely defined materials that the artist must model, treat, arrange, and polish".[6] In _The Cubist Painters_ Apollinaire underscored this decision taken in Léger's art: "The woodcutters bore upon them the marks of the blows that their hatchets left on trees and the general colour was part and parcel of that deep, greenish light that came down from the branches."[7]

Boccioni, who had seen _Study for Three Portraits_ (1911, Milwaukee Art Center) at the 1911 Salon d'Automne, admired Léger's work.[8] In his article "Il dinamismo futurista e la pittura francese" [Futurist Dynamism and French Painting], he directly compared Léger's work and writings with the concerns of the Futurists: "From our very first conversation in the Closerie des Lilas the day after the opening of the first exhibition of Futurist painting, I noticed that Fernand Léger was one of the most gifted and promising Cubists… Léger's article[9] is a true act of Futurist faith which gives us great satisfaction (all the more so since the author is kind enough to mention us)."[10] Along with the Futurists, Léger nursed the dream of a new and indefatigable humanity, offspring of the machine age. Describing his years at the front, he referred not only to the horrors of war but also to the advent of a new humankind, functional, efficient, the product of mechanised warfare: "I was dazzled by a 75 [mm] breech open in full sunlight, magic of light on white metal. That was all it took to get me to forget about that abstract art of 1912–13 … That 75 breech open in bright sunlight taught me more for my sculptural development than all the world's museums. Returning home from the war, I went on using what I'd felt at the front. For three years I used geometric forms, in a period that would be called the 'mechanical' period."[11] The robotised woodcutters of _Nudes in the Forest_ announce this new man, superman, radically modern, invincible, as foretold by Marinetti in his novel _Mafarka the Futurist_ (1909–10). Despite his being in ideological and plastic agreement with Futurism, there was a deep-seated difference between Léger's attitude and the Futurists. Where the former sought, in an objective way—via a new plastic technique of _Contrasting Forms_ (cat. 72)—to put order to "present-day life, more fragmented and faster-moving than in previous eras",[12] the latter aspired to an intense empathy with the frenzy and chaos peculiar to modern life.

I. S.-M.

1 Kahnweiler acquired _Nudes in the Forest_ in early 1913.
2 The work was titled _Nus dans un paysage_ [Nudes in a Landscape] in the catalogue.
3 "Peintres et sculpteurs vous racontent leur première exposition : 'la critique fut impitoyable' par Fernand Léger", _Les Lettres françaises_ (Paris), no. 532, 2–9 Sept. 1954, p. 8.
4 Apollinaire, "Les Salon des indépendants", _L'Intransigeant,_ 21 April 1911; trans. in Breunig (ed.), _Apollinaire on Art: Essays and Reviews 1902–1918_, (New York: Da Capo Press, 1972) p. 152.
5 Cézanne wrote to Émile Bernard on 15 April 1904: "Treat nature by the cylinder, the sphere, the cone, everything in proper perspective."

6 Léger, "Le spectacle–lumière–couleur–image mobile–objet-spectacle" (lecture given at the Sorbonne in May 1924), _Bulletin de l'Effort moderne_ (Paris), nos. 7, 8 and 9, July, Oct.– Nov. 1924, pp. 4–7, 5–9 and 7–9; trans. as "The Spectacle: Light, Color, Moving Image, Object Spectacle" in Fry (ed.), _Fernand Léger: Functions of Painting_ (New York: 1973), p. 35.
7 Apollinaire, _Les Peintres cubistes. Méditations esthétiques,_ (Paris: Hermann, 1980), p. 102.
8 Also called _Trois Figures_ [Three Figures].
9 Léger, "Les origines de la peinture et sa valeur représentative" (notes compiled for a lecture given at the Académie Vassilieff, 5 May 1913), _Montjoie !_ (Paris), no. 8, 29 May 1913, p. 7 and nos. 9–10,

14–29 June 1913, p. 9; trans. in Fry, _Cubism,_ (London: Thames and Hudson, 1966), pp. 121–7.
10 Boccioni, "Il dinamismo futurista e la pittura francese", _Lacerba_ (Florence), vol. 1, no. 15, 1 Aug. 1913, p. 169; trans. in Apollonio (ed.), _Futurist Manifestos,_ (London: Thames and Hudson, 1973 and 2001), p. 107.
11 Léger quoted in _Fernand Léger : Rétrospective,_ exh. cat., Fondation Maeght, Saint-Paul, 2 July–2 Oct. 1988, p. 56.
12 Léger, op. cit., p. 9; trans. Fry 1966, p. 125.

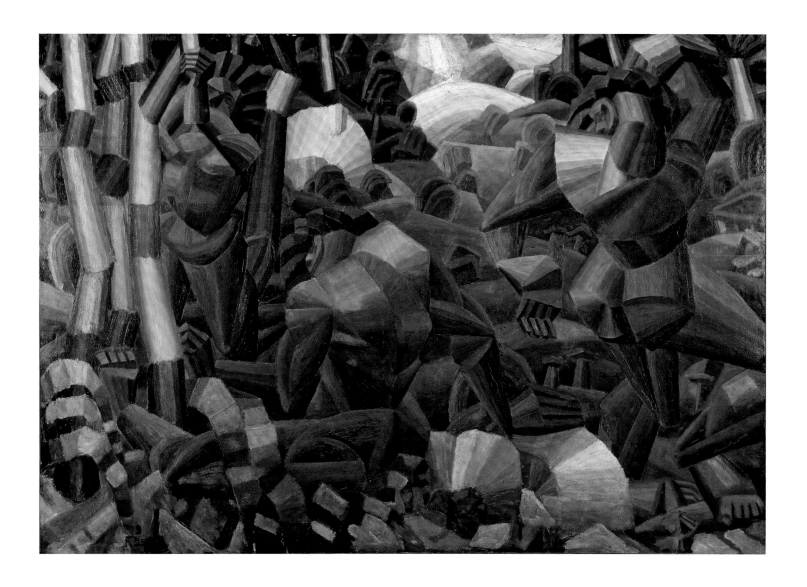

19 **Albert Gleizes**
Portrait de Jacques Nayral, 1911
[Portrait of Jacques Nayral]
Oil on canvas, 161.9 x 114 cm
Tate, London / Purchased, 1979

Just a few months after the scandal at the 1911 Salon des Indépendants, the throng pushed and jostled in front of the Cubist canvases on view at the Salon d'Automne. Among the visitors was the small group of Futurist painters, come to prepare their attack.[1] In room 8, they came face to face with Gleizes' *Portrait of Jacques Nayral*, which he had finished during the summer: "A strong-looking guy with a handsome expression, an ink-black mane, a man from the Vosges…, a naturalist tending towards the fantastic."[2] That was how André Salmon remembered Joseph Houot, better known as Jacques Nayral—a journalist, poet, and novelist, close to those who had been at the Abbaye de Créteil. It was through Alexandre Mercereau that Nayral met Gleizes. Nayral was called upon to play a major role in the development of Cubism: as literary director of the Éditions Figuière, he would publish the books *On "Cubism"* (1912), co-authored by Gleizes and Metzinger, and *The Cubist Painters* (1913), by Guillaume Apollinaire.

The *Portrait of Jacques Nayral* [3] was produced on the eve of the preparation of *On "Cubism"* (and reproduced there), and announced the principles developed in that book underpinning the movement's theoretical formulation, which served as a response to Marinetti's *Futurism*.[4] The precise moment of its publication coincided with the opening of the Salon de la Section d'or, through which the Cubists intended to respond to the attempt at annexation made by the Futurist painters. The *Portrait of Jacques Nayral* featured in the retrospective which, within the Salon, retraced the path taken by Gleizes towards Cubism. As if embedded in the soil of the artist's garden at Courbevoie, the seated figure displays a thoroughly classical stability. From the large diagonal formed by the legs to the book that the writer holds on his knees, and from the solid foundation of the arms to the head surmounting the lozenge-like shape of the torso, the eye roves, then goes astray in a network of geometric forms. The painter's palette, reduced to a harmony of greys, browns and greens, and broken here and there by a few hints of pink, supports the picture's architecture by balancing the composition and stressing the way the volumes are organised. This firm footing, as claimed within a pictorial tradition, and the "museum colours",[5] were bound not to hold out much attraction for the Futurists visiting the Salon d'Automne in 1911. The portrait nonetheless illustrates areas of research shared by both the Cubist and the Futurist painters. Like the *Memories of a Journey* painted by Gino Severini after reading Henri Bergson's *Introduction to Metaphysics* (1903),[6] it highlights the influence possibly enjoyed in Cubist and Futurist circles of works to do with the time factor. The theories formulated by the philosopher were subsequently disseminated by the writer Tancrède de Visan among the regulars at the *Closerie des Lilas*. Among these latter was Nayral, who had forged links with Bergson.[7]

This portrait evokes certain Futurist works painted from memory, such as Severini's above-mentioned *Memories of a journey* (1910–11, cat. 46), *The Funeral of the Anarchist Galli* (1910–11, cat. 32), by Carrà and Russolo's *Memories of a Night* (1911, cat. 43). Its final version was painted without the model present: the painter was happier to have lengthy discussions with him rather than long sittings. In the shadow of some chestnut trees, the painter's mind straightaway hatched a whole interplay of formal liaisons between the figure and his surroundings. By stressing these echoes, and through the exaggeration of the volumes and the interpenetration of forms, Gleizes ushered dynamism into his composition, without even resorting to multiple perspective. Apollinaire hailed these efforts: "Gleizes shows us two aspects of his great talent: invention and observation. Take, for exemple, his *Portrait of Jacques Nayral*, it is a very good likeness, yet in this impressive canvas, there is not one form or colour that was not invented by the artist. This portrait has a grandiose appearance about it that should not escape the notice of connoisseurs."[8]

Having become Gleizes' brother-in-law, Nayral pursued his career alongside the Cubists. The Section d'or catalogue mentioned him as the owner of two canvases.[9] In the preface he wrote for the catalogue for the Cubist exhibition held in Barcelona, Nayral brought the picture up again: "The portrait of the author of the present lines … attests to a profound sense of expression which has nothing in common with facile characterisations. In other words, it is both a portrait and a painting, with the likeness and the pictorial qualities in perfect balance: that is *style*."[10]

M.-L. B.

1 The "Exhibition of Italian Futurist painters" was to have been held in Paris at the Galerie Bernheim-Jeune, from 11 Nov. to 2 Dec. 1911; it was delayed because of the war between Italy and Turkey, as well as by Marinetti's departure for Tripoli as correspondent for *L'Intransigeant*.
2 Salmon, *Souvenirs sans fin* (*1903-1944*), (Paris: Gallimard, 2004), p. 232.
3 The canvas is reproduced in *Du "cubisme"*, n. p. 4 Marinetti's book was published by Sansot in Aug. 1911.
4 Marinetti's book was published by Sansot in August 1911.
5 Severini, "Apollinaire et le futurisme", *xx^e Siècle*

(Paris), no. 3, June 1952, p. 14; and also in *La Vita di un pittore* [1946] (Milan: Edizioni di Comunità, 1965), p. 82.
6 Bergson, "Introduction à la métaphysique", *Revue de métaphysique et de morale* (Paris), January 1903; Antliff, *Inventing Bergson, Cultural Politics and the Parisian Avant-Garde*, (Princeton, NJ: Princeton University Press, 1993), p. 54 and Antliff and Leighten, *Cubism and culture* (London: Thames and Hudson, 2001), p. 89.
7 Quoted in Antliff, op. cit., p. 54, and Antliff and Leighten, op. cit., p. 87.
8 Apollinaire, "Le Salon d'automne", *L'Intransigeant*

(Paris), 10 Oct. 1911, p. 2; trans. in Breuining (ed.), *Apollinaire on Art: Essays and Reviews 1902–1918* (New York: Da Capo Press, 1972), pp. 183–4.
9 His portrait painted by Gleizes in 1911 and *Femme au cheval* [Woman on Horseback] (1912, Statens Museum for Kunst, Copenhagen) by Metzinger.
10 Nayral, "Preface" *Exposició d'arte cubista*, Barcelona, Galeries Dalmau, 20 April–10 May 1912; trans. by Todd in Antliff and Leighton (eds.), *A Cubist Reader: Documents and Criticism, 1906–1914*, [Chicago and London: University of Chicago Press 2008] p. 289.

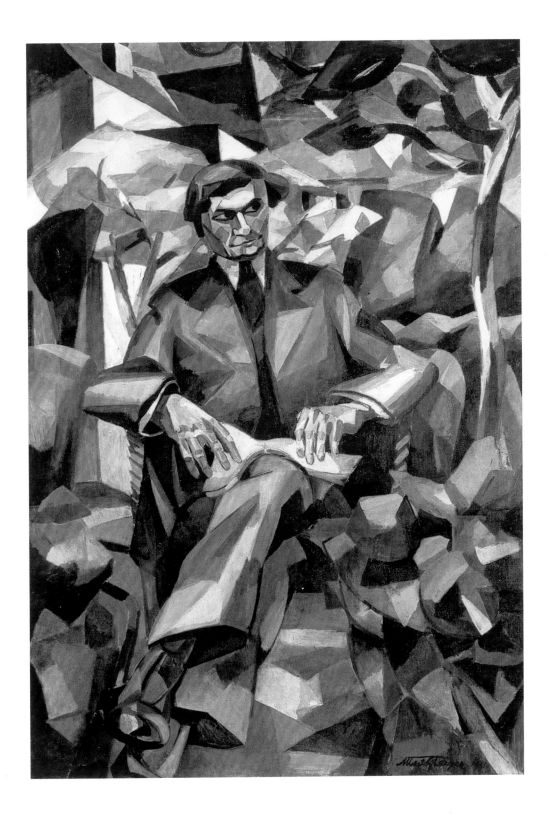

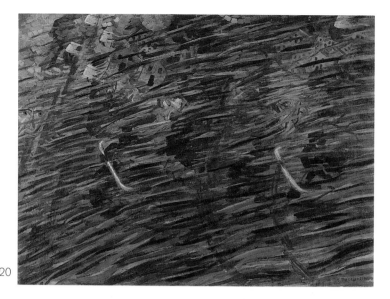

20

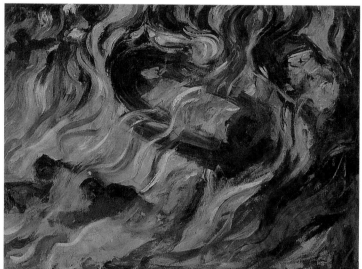

21

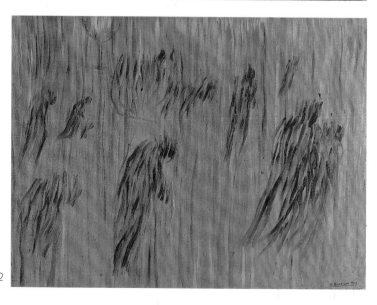

22

***Stati d'animo*, 1911**
[States of Mind]
20. ***Quelli che vanno***
[Those who go]
71 x 95.5 cm
21. ***Gli addii***
[The Farewells]
71 x 96 cm
22. ***Quelli che restano***
[Those who Stay]
71 x 96 cm
Oil on canvas
Civiche Raccolte d'Arte,
Museo del Novecento, Milan

20-25 **Umberto Boccioni**
Stati d'animo, **1911**
[States of Mind]
First triptych, Civiche Raccolte d'Arte, Museo del Novecento, Milan
Second triptych, The Museum of Modern Art, New York

Boccioni's famous *States of Mind* triptych (1911, New York, cat. 23–25) was shown at Bernheim-Jeune in February 1912, during the first Futurist exhibition in Paris, with seven other of his canvases. Painted towards the end of 1911, these three pictures follow on from a first attempt which ushered in the transcription of the feelings and movements of a crowd with de-individualised shapes. Adhering to one of Futurism's watchwords, "simultaneity", the earlier series of *States of Mind* (1911, Milan, cat. 20–22) reflected the stamp of Neo-Impressionism and an expressionist Symbolism, both in the brush-work and in the colouring. During his stay in Paris in autumn 1911, Boccioni described it to Apollinaire, who made the first mention of the *States of Mind*.[1] The painter renewed the Futurist enterprise: it was no longer a matter of merely depicting the speed of a machine or the effects of light, but of transcribing the movements of the soul at the heart of a separation punctuated by three related circumstances (*The Farewells, Those Who Go, Those Who Stay*) which are each the subject of a picture. The railway station, the train, the journey, which all refer to themes dear to the Futurists, present the meeting between man and the mechanised world, and give rise to the contradictory emotions of departure.

After his stay in Paris, Boccioni painted the second version of his *States of Mind*, influenced by the Cubist geometrisation and construction of Picasso and Braque in exploded volumes and muted colours. In fact, the composition is structured by force-lines and the dynamic compenetration of planes in which are included bodies and objects subject to the radicalisation of forms based on the lessons learnt from Cézanne. Nevertheless, the suggestion of movement is still essential. In *The Farewells*, the undulating arabesques of the first version (cat. 21) remain, but in the second version they separate the various spaces and times by surrounding the different projections of an entwined couple (cat. 24), treated with divided strokes of green and outlined in black, the whole being organised in volumes which seem to revolve upon themselves. Crossed by an undulating diagonal in the middle, the composition concentrates upon a black locomotive, impressive and steaming. The station signs show the train at a standstill, and announce its route. The figures 6943 stencilled on, a direct influence of Braque and Picasso, indicate the train's number. The green and brown hues are enlivened by yellows, blues, pinks, mauves and reds, which have an effect on the gloomy quality of the whole. Boccioni depicts the heart-rending nature of farewells: the hug and the separation. The psychological transcription is not based on interplays of physiognomy supposed to express sadness and enthusiasm, but on contrasts and linear rhythms, underscored by a chromatism which is itself subjective. As Pontus Hultén wrote, "departures in a station seem more definitive than those made in a horse-drawn carriage, for example, not because of the speed involved but because the train passengers become part and parcel of a system, while those remaining behind are outside this system".[2] The straight and wavy lines dovetailed in the planes describe the confusion of feelings through contrary movements, emphasised by the dappled stroke and the hatching.

This canvas is flanked to the left by *Those Who Go* (cat. 23) and to the right by *Those Who Stay*. These two pictures have a curtain of lines in the foreground, creating prismatic effects and disguising the characters; the dappled stroke has gone. In *Those Who Go*, the horizontal and diagonal blue lines provide the motion, from left to right, and draw the dynamics of the shift from light to shadow. Interior and exterior are overlaid: the railway carriages with their blue lampshades dimly illuminate the passengers; the city left behind, glimpsed through the train's windows as it gathers speed, is symbolised by the smoking factory chimney at top left then by different shattered yellow and red planes, indicating houses at the top of the canvas. Sleeping faces are painted from every angle, impervious to the train's movement and frozen in an expression of anonymous sadness. The most melancholy canvas of the three, *Those Who Stay*, is virtually monochrome with a blue-green hue edged in black (cat. 25). The vertical lines assure the static nature of the people on the platform. Entwined within this network, the bodies with their simplified geometric forms appear like ghosts, from the foreground at bottom left to the background, almost invisible, at top right, doing away with all imprints, rendering the depiction almost abstract. Three 1912 drawings (one held in the Museum of Modern Art in New York, the other two in private collections) describe the intermediate stages of the painting.

As a pivotal work in the 1912 Paris show, Boccioni's triptych ensured the rupture with the tendencies of Cubist painting. It met with mixed reactions. Louis Vauxcelles voiced reservations: "Mr. Boccioni's larvae are a dull plagiarism of Braque and Picasso."[3] Taking up a position in relation to Cubism, Balla, Boccioni, Carrà, Russolo and Severini wrote for the event "Les exposants au public", subsequently published in London as "The Exhibitors to the Public".[4] This was an apologia for the "dynamic sensation" transcribed according to "force-lines" and "battles of planes" which extend the object into space

and create an interaction between its forms and the ambient surroundings: "The simultaneousness of states of mind in the work of art: that is the intoxicating aim of our art. … In the pictorial description of the various states of mind of a leave-taking, perpendicular lines, undulating lines and as it were worn out, clinging here and there to silhouettes of empty bodies, may well express languidness and discouragement. Confused and trepidating lines, either straight or curved, mingled with the outlined hurried gestures of people calling to one another will express a sensation of chaotic excitement. On the other hand, horizontal lines, fleeting, rapid and jerky, brutally cutting in half lost profiles of faces or crumbling and rebounding fragments of landscape, will give the tumultuous feelings of the person going away."[5] The depiction of sentiments replaced that of the modern urban world, while at the same time providing the synthesis of that which one remembers and sees,[6] as well as a simultaneity of space-time narrative, and the formal symbolism of emotions. The attempt was a novel one: the psychological value of lines, depending on whether they are diagonal or horizontal, was used within figuration. In this triptych, Boccioni went about things in a different way; he reduced the share of representation and constructed the canvas like a "dynamic hieroglyph", as Severini termed it. Neither the Cubists, nor Carrà or Russolo, risked such introspection, which would foreshadow Abstract Expressionism insofar as this latter was based on a choreographic rhythm in the painter's gestures. Cubism was reinterpreted to express the simultaneity of the modesty of the moods and of the many different structures of the visible world. The splitting-up of the planes suggests dynamic sensation, fast or slow, the drawing becomes a vehicle, and the colour transcribes warmth and feverishness.[7]

C. M.

1 Apollinaire, "Les peintres futuristes", *Mercure de France* (Paris), no. 346, 16 Nov. 1911, pp. 436–7.
2 Hultén, in *The Machine as Seen at the End of the Mechanical Age,* exh. cat., (New York: The Museum of Modern Art, 1968), p. 61.
3 Vauxcelles, "Les futuristes", *Gil blas* (Paris), 6 Feb. 1912, p. 4.
4 "Les exposants au public", *Les Peintres futuristes italiens,* exh. cat., Galerie Bernheim-Jeune & Cie, Paris,

5–24 Feb. 1912, pp. 1–14; trans. as "The Exhibitors to the Public", exh. cat., Sackville Gallery, London, March 1912, and republished in Apollonio (ed.), *Futurist Manifestos,* (London: Thames and Hudson, 1973 and 2001), pp. 45–50.
5 Ibid., pp. 4 and 9–10; ibid., pp. 47, 49.
6 Ibid.
7 Years later the originality of Boccioni's *States of Mind* would inspire Mimmo Paladino, who revived

the experiment in his triptych *Those Who Go and Those Who Stay* (1984, private collection).

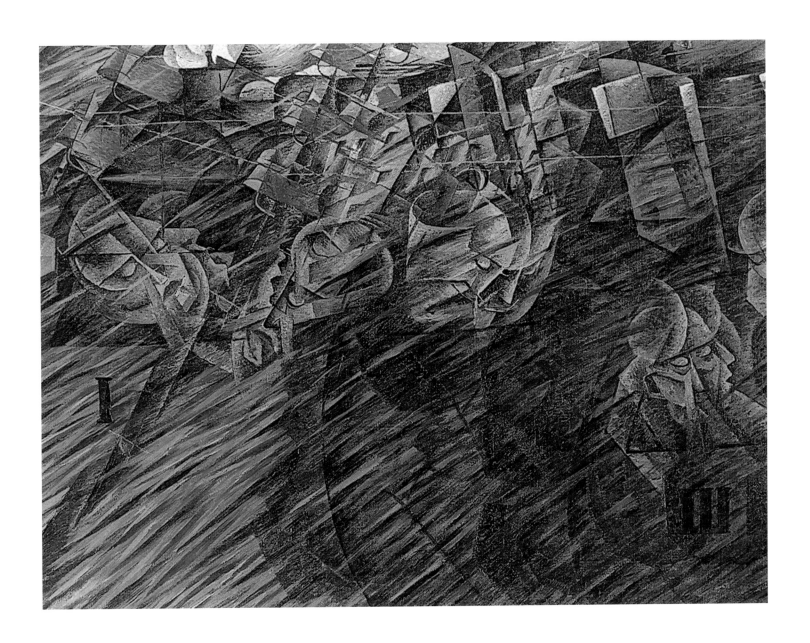

23 ***Stati d'animo: Quelli che vanno, 1911***
[States of Mind: Those who Go]
Oil on canvas, 70.8 x 95.9 cm
The Museum of Modern Art, New York
Gift of Nelson A. Rockefeller, 1979

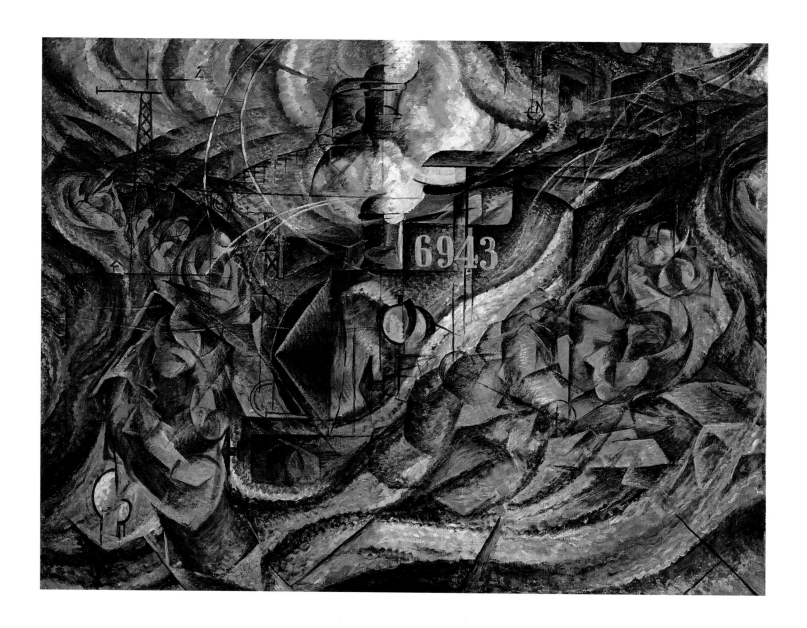

24 **Stati d'animo: Gli addii, 1911**
[States of Mind: The Farewells]
Oil on canvas, 70.5 x 96.2 cm
The Museum of Modern Art, New York
Gift of Nelson A. Rockefeller, 1979

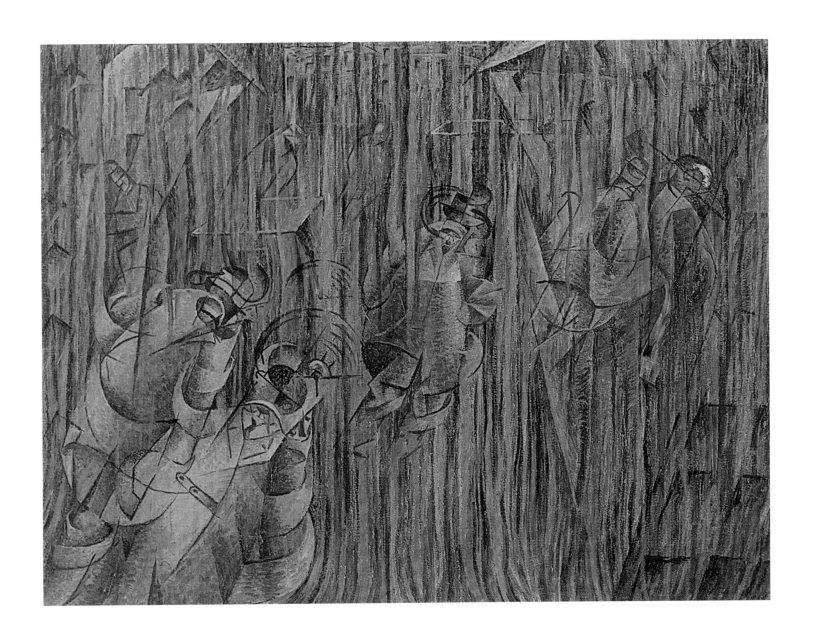

25 **Stati d'animo: Quelli che restano, 1911**
[States of Mind: Those who Stay]
Oil on canvas, 70.8 x 95.9 cm
The Museum of Modern Art, New York
Gift of Nelson A. Rockefeller, 1979

26 **Umberto Boccioni**
 La strada entra nella casa, **1911**
 [The Street Enters the House]
 Oil on canvas, 100 x 100 cm
 Sprengel Museum Hannover, Hanover

On the Balcony was the title under which Boccioni exhibited *The Street Enters the House* at the annual exhibition of the Famiglia artistica in Milan in December 1911. The new title, given to the work for the exhibition *Les Peintres futuristes italiens* held in Paris at the Galerie Bernheim-Jeune, clarified the painter's didactic emphasis on the picture's essential theme: the perception of sensations emanating from the city. "The Exhibitors to the Public", published in the catalogue for the Paris exhibition, conveyed this Futurist quest for the sensation: "In painting a person on a balcony, seen from inside the room, we do not limit the scene to what the square frame of the window renders visible; but we try to render the sum total of visual sensations which the person on the balcony has experienced".[1]

The window recurred in Futurist paintings, especially in those of Boccioni who, from his early works onward, was fascinated by this motif. It permits the co-existence of two antithetical spaces: the inner world of the home, tranquil and set apart from the surrounding world, and the city, a space favouring many temptations of the senses. When the exhibition of Futurist painters reached London, *The Street Enters the House* was described in the catalogue as: "The dominating sensation is that which one would experience on opening a window: all life, and the noises from the street rush in at the same time as the movement and reality of objects outside."[2] We are witnessing a "dissolution of boundaries".[3] The canvas challenges the traditional distinctions of painting: interior and exterior, top and bottom, foreground and background. The picture's formal components are deliberately broken up so as to describe the compenetration of spaces: in this way, the horses projected onto the foreground seem to enter the apartment.

The composition that is split up in this way is organised around a female figure with a massive silhouette, her arms resting on the balcony. This is probably the artist's mother, seen leaning out of their Milan apartment at 23, via Adige. Her head is "the centre of sensations and the melting-pot where the various impressions experienced are brought together".[4] Different elements are organised around her. They are arranged in such a way as to lend the construction a whirling, spiralling appearance; the yellow and pink colours enhance the rotating motion, forming a halo around the figure. At the heart of the circular plan Boccioni introduces us into "the moving whirlwind of modernity through its crowds, its cars, its telegraph poles, its bare, working-class neighbourhoods, its noises, its squeals, its violence, its cruelty, its cynicism, and its relentless pushiness".[5]

The hustle and bustle of the city is also lent substance by a peculiarly Futurist formal vocabulary. Acute angles underscore the interpenetration of objects, people, noises, and the city's movement, while broken forms, combined with a Cubistic breaking down of buildings into facets, lead to the vision of an urban space that is structureless. The repeated presence of workers, horses, walls being built and scaffolding, vertically punctuating the central part of the work, heightens the city's frenzied activity. This intensified number of motifs is "a sort of hymn to the expansion of the modern city",[6] a subject already tackled by the painter in *The City Rises* (1910-11, cat. 28). The image of the Futurist city in perpetual motion—a recurrent theme in the œuvre of the Italian Futurist painters—here finds a new echo.

P. S.-L.

1 Boccioni et al "Les exposants au public",
Les Peintres futuristes italiens, exh. cat., Galerie
Bernheim-Jeune & Cie, Paris, 5–24 Feb. 1912, pp. 4,
6; trans. as "The Exhibitors to the Public", in Apollonio
(ed.), *Futurist Manifestos,* (London: Thames
and Hudson, 1973 and 2001), p. 47.
2 *Exhibition of Works by the Italian Futurist Painters,*
exh. cat., The Sackville Gallery, London, Mar. 1912,
p. 21.

3 Braun, "Vulgarians at the Gate", in *Boccioni's
Materia: A Futurist Masterpiece and the Avant-Garde
in Milan and Paris,* Mattioli Rossi (ed.), (New York:
The Solomon R. Guggenheim Foundation, 2004), p. 7.
4 Martin, *Futurism,* (Cologne: Taschen, 2005), p. 30.
5 Boccioni, *Pittura scultura futuriste,* Milan 1914.
6 Roche-Pézard, *L'Aventure futuriste: 1909–1916,*
(Rome: École française de Rome, 1983), p. 239.

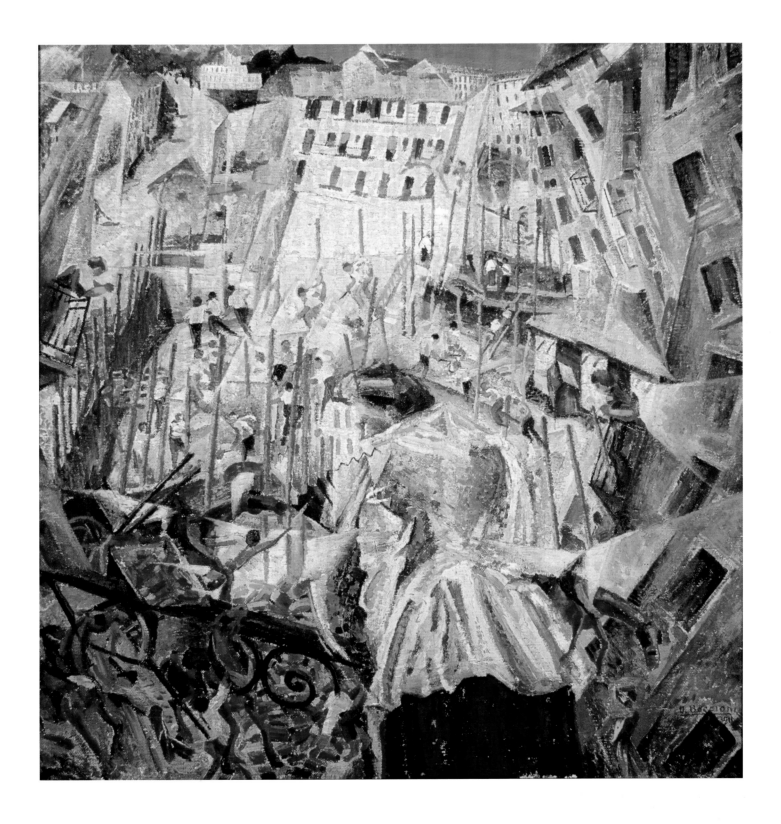

27 **Umberto Boccioni**
La Risata, 1911
[The Laugh]
Oil on canvas, 110.2 x 145.4 cm
The Museum of Modern Art, New York
Gift of Herbert and Nanette Rothschild, 1959

"Instead of stopping in the darkness of pain, you have to pass through it in a rush to enter the light of the burst of laughter."[1] Thus did Aldo Palazzeschi formulate his argument for laughter in *Against Sadness: Futurist Manifesto* of 15 January 1914. Three years earlier, Boccioni had already celebrated laughter in this monumental picture.

The setting of his work draws on the rowdy cafés and crowded dancehalls dear to his friend Severini. The painter did his utmost to recreate the uproar as well as the chaotic visual and acoustic atmosphere. The disproportionate face of the laughing woman is the focal, irradiating point of the composition, from which the 'ripples' of her laugh fan out. A "geometric crystallization of forms"[2] enables Boccioni to capture the path of an acoustic vibration that tears through the din of the café. He transposes the cackle of laughter into a range of acid hues; he allots the colour yellow to an impressive ostrich feather, affixed to a hat, in the foreground, a feather expressing nature and the intensity of the "laughter of the grotesque *cocotte*".[3] In 1911, the critics saw in this work a "strident orchestra of harmonies".[4]

Laugh was painted at a pivotal moment in Boccioni's œuvre. It marked a break, and the artist's rejection of the technique of divisionism, inspired by Symbolism. As a 'Bergsonian' work, *The Laugh* borrows the title of a book by the French philosopher.[5] It precisely applies the precepts of the Futurist programme. Just like the water in Carrà's *Women Swimmers* (1910–12, cat. 38), cafés and cheap dance halls encourage the immersion and merger of the individual in a world in motion. They are the melting-pot for a simultaneity of sensations, mixing together acoustic, visual, tactile, gustatory and motor impressions. The movement of their dancing throngs tallies with the spiral structure through which Boccioni tried to give form to the dynamic conception of the world. *The Laugh* adds Cubist geometrisation to these Futurist features. Boccioni explicitly laid claim to the spatial solutions adopted by French artists. During the presentation of the exhibition of Futurist painters at the Sackville Gallery, his picture was described as: "The scene is around the table of a restaurant where all are gay. The personages are studied from all sides, and both the objects in front and those at the back are to be seen, all these being present in the painter's memory."[6] A different echo of the Cubist analysis can be seen in Boccioni's still lifes, particularly in *Table + Bottle + Block of Houses* (1912, Civiche raccolte d'arte, Milan). The tension in *The Laugh* between Cubist and Futurist forms is such that it gives rise to the hypothesis that the work was painted in two separate stages.

The painting was damaged by a visitor at its first public showing in the spring of 1911, after which Boccioni repainted it.[7] Opinions differ as to the extent of the work's restoration. Some historians (Ragghianti, Ballo, Bruno) have suggested that the picture was totally rethought from a Cubist perspective after Boccioni's trip to Paris in the autumn of 1911, during which he discovered the pictures of Picasso and Braque.[8] The preliminary sketches for the work, very removed stylistically from the version we know today, tend to bolster this thesis. Maurizio Calvesi, however, suggested a different time-frame, dating the re-touching, which he felt was limited, to the summer of 1911.[9] For him the stay in Paris played no part in the conception of *The Laugh*. The Cubist inspiration was indirect, coming through knowledge of Severini's works—*The Dance of the "Pan-Pan" at the Monico* (1909–11, cat. 45) and *The Obsessive Dancer* (1911, cat. 48)—prior to the trip to Paris.

P. S.-L.

1 Palazzeschi, *Il Controdolore. Manifesto futurista*, in *Lacerba* (Florence), vol. 2, no. 2, 15 Jan. 1914, p. 21.
2 Lista, *Le Futurisme. Création et avant-garde*, (Paris: Éd. de l'Amateur, 2001), p. 83.
3 Damigella, "*Pittura. Il Dizionario del futurismo*, Godoli (ed.), (Florence: Vallecchi, 2001), vol. 2 (K-Z), p. 871.
4 "La Prima Esposizione d'arte libera", *Il Secolo* (Milan), 1 May 1911, quoted in Calvesi and Coen, *Boccioni. L'opera completa*, (Milan: Electa, 1983), p. 384.

5 Bergson, *Le Rire. Essai sur la signification du comique* was published in 1900.
6 *Exhibition of Works by the Italian Futurist Painters*, exh. cat., London, The Sackville Gallery, March 1912, p. 21.
7 In a lecture at La Fenice theatre, Venice (7 May 1911), Marinetti referred to the incident at the *Mostra Arte libera*, Padiglioni Ricardo, Milan, 30 April–7 May 1911; see Drudi Gambillo, Fiori, *Archivi del futurismo*, (Rome: De Luca Editore, 1958),

vol. 1, p. 475. For a newspaper report of the incident, see Coen, *Umberto Boccioni: A Retrospective*, exh. cat., The Metropolitan Museum of Art, New York, 1988, p. 107.
8 According to Severini; see Ballo, *Boccioni: La vita e l'opere*, (Milan: Il Saggiatore, 1964), p. 230.
9 Calvesi and Coen, *Boccioni. L'opera completa*, op. cit., p. 384 and Coen *Umberto Boccioni: A Retrospective*, op. cit., pp. 107–9.

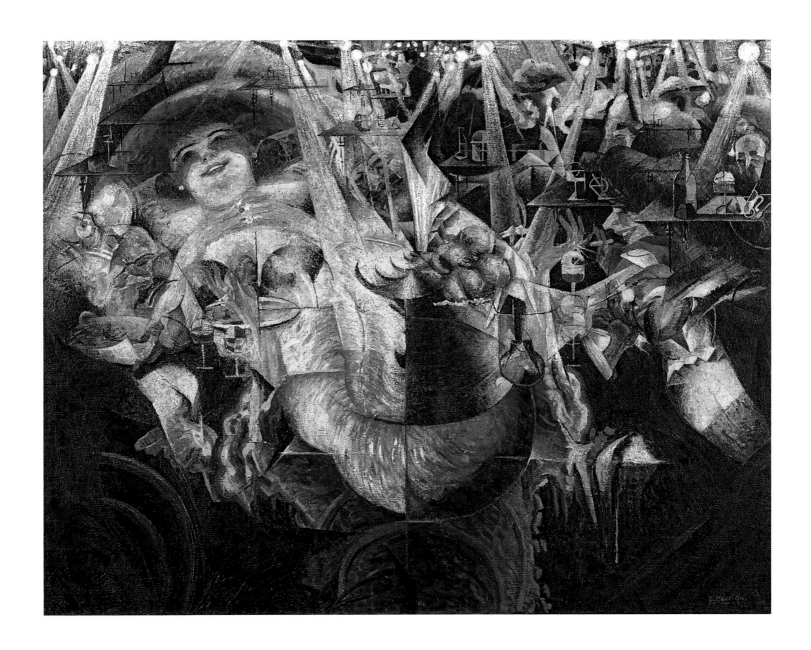

28 **Umberto Boccioni**
 La città che sale, **1910–1911**
 [The City Rises]
 Oil on canvas, 199.3 x 301 cm
 The Museum of Modern Art, New York
 Mrs Simon Guggenheim Fund, 1951

Boccioni worked on *The City Rises* from the summer of 1910 to the spring of 1911. His project was aimed at expressing the energy peculiar to the modern era, and so prompted him to invent new means of expression, to re-appraise the codes of Divisionism and Expressionism, so as to make vehement, extreme use of them. The *Technical Manifesto* describes this plastic revolution thus: "The time has passed for our sensations in painting to be whispered. We wish them in the future to sing and re-echo upon our canvasses in deafening and triumphant flourishes."[1] This programme could only be achieved through works on a par with this ambition which, in order to celebrate this modern life, aims to erect "a new altar throbbing with dynamism as pure and exultant as those which were elevated to divine mystery through religious contemplation".[2]
The City Rises is this lyrical vision, this huge vortex of colourful gasses, this mass of molten energy, this expression of primordial forces, and this image of modernity in action; a hitherto unknown power calling for revitalised plastic methods. The force-lines which structure the picture by following its diagonals are part of this new vocabulary. They underscore the gestures of the people and the horses' fury. The repetition of the chimneys, pylons and buildings manages to give to the image both its rhythm and its dynamism. Colour becomes light, light becomes movement and movement becomes the pure expression of the space peculiar to modern times.
The picture rejects the age-old laws of harmony, it is aimed at dissonance and expresses the simultaneity, fragmentation and contradictory character which characterise modern sensibility. A vibrant, edgy and flickering brushstroke, at times broad and dense, at others unravelled and diaphanous, becomes the vehicle of forces, the agent of the shift of energies from one body to another, from one form to another and from one colour to its complementary.
The City Rises represents an essential phase in Boccioni's quest to re-invent the plastic space bequeathed by the Renaissance: "We have abolished pyramidal architecture for a spiral architecture."[3] The Renaissance perspective is done away with and put back together by a network of straight and oblique lines, curves and counter-curves, vigorous movements and sudden halts, and whirlwinds of matter and void. Light here plays a new part: "All shadows have their light, each shadow being an autonomous unit forming a new individuality with its own *chiaroscuro*: it is no longer a form that is half-shadow, half-light, as has hitherto been the case; it is a *light-form*."[4] This welter produces a new space, a phenomenology reinvented with the yardstick of a lyrical modernity.

C. Z.

1 *Manifeste des peintres futuristes*, in *Les Peintres futuristes italiens*, exh. cat., Galerie Bernheim-Jeune & Cie, Paris, 5–24 Feb. 1912, p. 19; *Futurist Painting: Technical Manifesto*, in *Exhibition of Works by the Italian Futurist Painters*, Sackville Gallery, London Mar. 1912, republished in Umbro Apollonio (ed.), *Futurist Manifestos*, (London: Thames and Hudson, 1973 and 2001), p. 29.
2 Letter from Boccioni to Nino Barbantini,

11 May 1910, quoted in Boccioni, *Gli Scritti editi e inediti*, Birolli (ed.), (Milan: Feltrinelli, 1971), p. 345. Our translation.
3 Ideas put forward by Boccioni at his lecture "Dynamisme plastique", given at the Verdi Theatre in Florence, on 12 December 1913; cited in Lista, *Le Futurisme. Création et avant-garde*, (Paris: Éd. de l'Amateur, 2001), p. 172.
4 Boccioni, "Complémentarisme dynamique"

(chap. 14), *Dynamisme plastique. Peinture et sculpture futuristes*, (Lista pref., Lausanne: L'Âge d'homme, 1975), p. 84. Italian edition: *Pittura e scultura futuriste (Dinamismo plastico)*, 1914, Birolli (ed.), (Milan: Abscondita, 2006), p. 118.

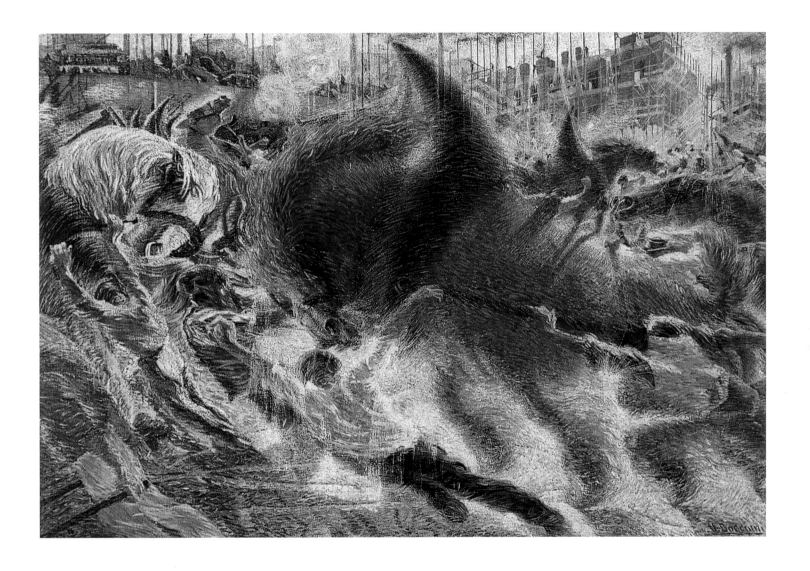

29 **Umberto Boccioni**
 ***Visioni simultanee*, 1911**
 [Simultaneous Visions]
 Oil on canvas, 60.5 x 69.5 cm
 Von der Heydt-Museum Wuppertal, Wuppertal

In February 1912, simultaneity lay at the heart of the Futurist artistic output on view in Paris.[1] Boccioni claimed authorship of the pictorial presentation of this concept when he declared, two years later: "The first painting to appear with an affirmation of simultaneity was mine and had the following title: *Simultaneous Visions*. It was exhibited at the Galerie Bernheim in Paris, and in the same exhibition my Futurist painter friends also appeared with similar experiments in simultaneity."[2] This principle would help towards the plastic display of a "marvellous spectacle—modern life".[3]

In *Simultaneous Visions*, the frenzy of the contemporary city and the varied range of sensations it triggered materialised around the face of a young woman, possibly Ines, the painter's girlfriend. She is leaning out of the window of his apartment, looking over the street, busy with vehicles and pedestrians. The location of the scene is not coincidental. The catalogue for the Futurist exhibition at the Sackville Gallery in London in March 1912, noted about this work: "The sensation of the inside and the outside, of space and motion, in all directions experienced on approaching a window."[4] The cropping of the picture's edge corresponds exactly to that of the window. Through this device, the viewer merges with the female figure leaning into the outside world.

The welter of sensations perceptible from the top of the building is encapsulated in the spiralling structure, a formal element that Boccioni used on numerous occasions. The blue, grey and green coils are a direct reference to Symbolist forms and have encouraged some to see it embodying "the acoustic energy of the noises which rise up from the city and violate the bourgeois space".[5] Other critics see in it the depiction of a pitcher and a platter:[6] a still life which might be the prefiguration of the helicoid structure adopted in Boccioni's sculpture *Development of a Bottle in Space* (1912, cat. 79). In order to bring to resolution the particularly Futurist theme of simultaneity, Boccioni adapted plastic solutions borrowed from Cubist works: the compenetration of planes and facetted deconstruction. The central figure of *Simultaneous Visions* is depicted from two different angles; duplicated, the face is visible side-on and head-on, where it seems to loom up from the street.

The Cubist experiments carried out by Delaunay had a particular influence on Boccioni's work, and he retained the urban iconography and the use of bright, shimmering colours. The distortion of buildings and their convergence towards one another probably originated, in a formal sense, from Delaunay's *Eiffel Tower[s]* (see cat. 10). Boccioni used the same arrangement of vertical elements over this picture's outlines. The lateral buildings lend the composition a theatrical look; like stage curtains, they form a setting around the central character. Such Cubist devices were nevertheless nothing more than a source of inspiration for Boccioni. He only borrowed the form while modifying the end purpose. In *Simultaneous Visions*, his goal was above all the representation of perception; its title incidentally attests to this Futurist wish to reject conventions of perception. The duality between Cubism and Futurism was typical of the works the painter produced in 1911.

P. S.-L.

1 The dating of Boccioni's work *Simultaneous Visions* remains uncertain. As it takes up the same theme, it must follow the completion of *The Street Enters the House* (cat. 26) in the summer of 1911; but it is unknown whether it was painted before or after Boccioni's stay in Paris in the autumn. It actually reveals a better understanding of Cubist solutions by the Italian artist.
2 Boccioni, *Pittura scultura futurista*, Milan 1914,

p. 458; trans. in Coen, *Umberto Boccioni: A Retrospective*, exh. cat., The Metropolitan Museum of Art, New York, 1988, p. 132.
3 Ibid.; trans. ibid.
4 *Exhibition of Works by the Italian Futurist Painters*, exh. cat., The Sackville Gallery, London, Mar. 1912, p. 21.
5 Lista, Lemoine, Nakov, "Le Futurisme", *Les Avant-gardes*, (Paris: Hazan, 1991), p. 31.
6 See in particular Martin, *Futurist Art and Theory*

1909–1915, (Oxford: Clarendon Press, 1968), p. 112; Calvesi and Coen, *Boccioni. L'opera completa*, (Milan: Electa, 1983), p. 81.

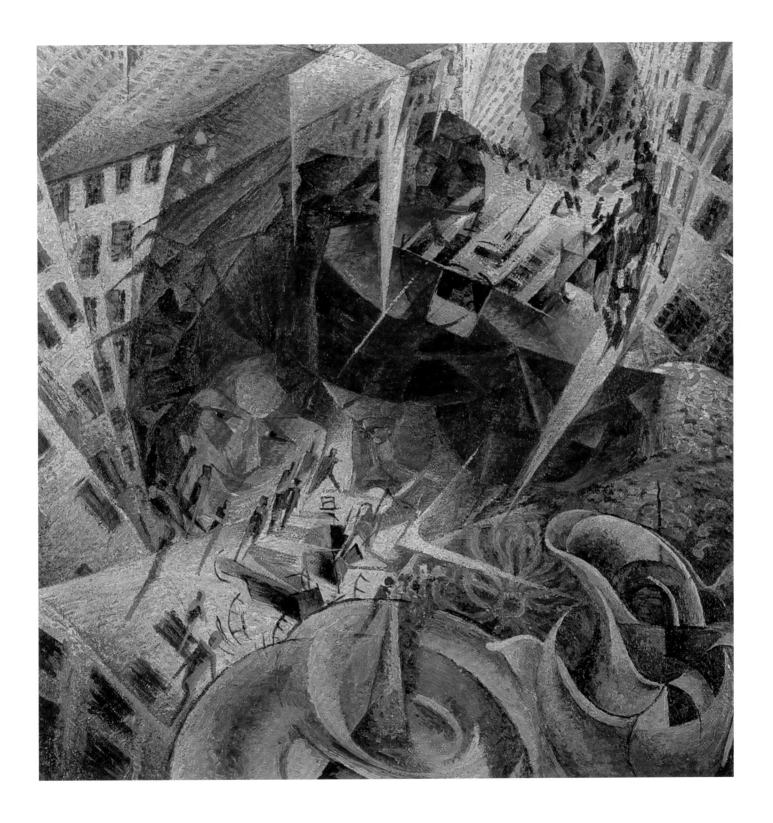

30 **Umberto Boccioni**
 Idolo moderno, 1910–1911
 [Modern Idol]
 Oil on board, 60 x 58.4 cm
 Estorick Collection, London

The first public appearance of *Modern Idol*, painted by Boccioni between late 1910 and early 1911, was at the exhibition of Futurist painters organised by the Galerie Bernheim-Jeune in February 1912. The setting for this manifesto-like exposure could not have been better chosen for an image summing up the values of Futurist *modernity*. The figure is an allegory of the energy and hubbub found in cafés in big cities. The artificial colours in which the electric lighting bathes *Modern Idol* lend it a sharp and pernicious character. In this disconcerting and hallucinatory portrait, Maurizio Calvesi detected recollections of Munch's expressionism, and the stamp of that Nordic liking for the grotesque. Giulio Argan, for his part, saw in it the combination of the social modernism of Henri de Toulouse-Lautrec and the neo-impressionism of Georges Seurat, two lessons re-interpreted by the Italian painter through the symbolism of Gaetano Previati and the divisionism of Giacomo Balla.[1] Boccioni's divisionism had no scientific or positivist aims. He transformed it into a psychological and emotional tool capable of revealing "the links which exist between the exterior (concrete) scene and the interior (abstract) emotion[2]."

Modern Idol is a primitive apparition, the result of a violent and passionate emotion. The application of the laws of simultaneous contrast, as theorised by Michel-Eugène Chevreul, was aimed at exacerbating the frenzy which Boccioni attributed to this persona: an "idol" which re-invents femininity to make of it an artificial being, one of those *Electric Dolls* to which Marinetti devoted a drama in 1909.[3] The colours of the make-up, the white of the powder and the red of the lips were for Boccioni just like the idol's life: bewildering, excessive, and violent like an electric shock. The *Idol* "shrieks out the most heart-rending expressions of colour"[4]: "it will be readily admitted that brown tints have never coursed beneath our skin; it will be discovered that yellow shines forth in our flesh, that red blazes, and that green, blue and violet dance upon it with untold charms, voluptuous and caressing."[5] *Modern Idol* takes its place in the long theory of 'new' women and men born through the marvels of a Promethean science. The electricity which gives it its energy is the same electricity which drives *L'Ève future* by Villiers de L'Isle-Adam (1886), and the creature of Dr Frankenstein conceived by Mary Shelley in 1817.

D. O.

1 Calvesi, "Il futurismo di Boccioni: formazione e tempi", *Arte antica e moderna*, (Bologna) no. 2, Apr.–June 1958, p. 156; Argan and Calvesi, *Umberto Boccioni* (Rome: De Luca, 1953), p. 34.
2 Boccioni et al., "Les exposants au public", *Les Peintres futuristes italiens*, exh. cat., Galerie Bernheim-Jeune & Cie, Paris, 5–24 Feb. 1912, p. 12; trans. as "The Exhibitors to the Public", in Apollonio (ed.), *Futurist Manifestos*, (London: Thames and Hudson, 1973 and 2001), p. 50.

3 Marinetti, *Les Poupées électriques*, (Paris: Éd. Sansot, 1909).
4 Boccioni et al., *Manifeste des peintres futuristes*, in *Les Peintres futuristes italiens*, exh. cat., Galerie Bernheim-Jeune & Cie, Paris, 5–24 Feb. 1912, p. 18; *Futurist Painting: Technical Manifesto*, in *Exhibition of Works by the Italian Futurist Painters*, Sackville Gallery, London, Mar. 1912, republished in Apollonio, op. cit., p. 29. The phrase refers to "the suffering of the electric lamp".

5 Ibid., p. 19; ibid.

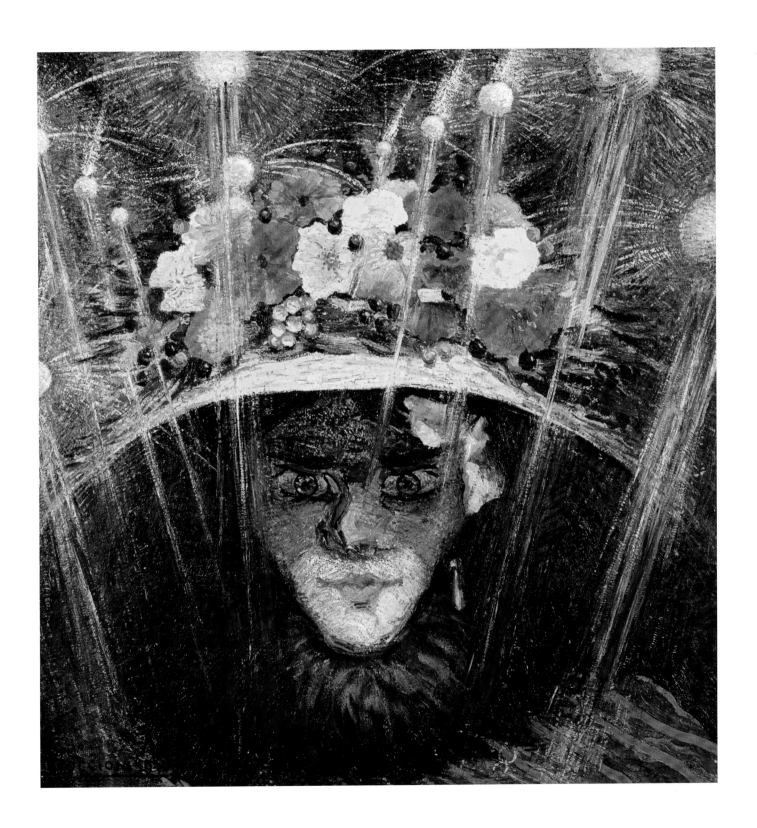

31 **Umberto Boccioni**
 Le forze di una strada, 1911
 [The Forces of the Street]
 Oil on canvas, 99.5 x 80.5 cm
 Osaka City Museum of Modern Art, Osaka

With his *The Forces of the Street*, Boccioni wanted to capture the energy of the modern city. In the urban night, rent by electric lights, a tram makes its way among pedestrians and carriages. The city had been a favourite subject for all of the Futurist painters, exemplified by Boccioni' s own *The City Rises* (1910–11, cat. 28). Its frenetic bustle gave rise to several lyrical passages in Marinetti's *Manifesto of Futurism*: "We will sing of great crowds excited by work, by pleasure, and by riot; we will sing of the multicoloured, polyphonic tides of revolution in the modern capitals."[1] *Futurist Painting: Technical Manifesto* (11 April 1910) included this dynamism at the core of this new art.

According to some art historians, *The Forces of the Street* was completed at the end of 1911, after the visit that Boccioni paid to Paris that autumn.[2] The crystalline structure of the work was the result of Cubist geometrisation as discovered at that time by the Italian painter. For others, the canvas might have been finished earlier, at the end of the summer of 1911.[3] Boccioni would not have needed direct contact to lend his work a structure akin to that of Cubism.

This picture marks a turning-point in Boccioni's art as it was one of his least descriptive pieces. Its especially dynamic composition plays with abrupt planes and zigzagging force lines. The motif is reduced to a few schematic clues—the silhouettes of passers-by, carriage wheels, the tram-car reduced to a blueprint—caught in a whirl of contradictory movements. The tram's headlight, visible at three points, and the cubic form of the tram-car, duplicated in a network of lines, develop the vehicle's motion in time. Its fragmentation is, nevertheless, not as evident as in *Simultaneous Visions* (1911, cat. 29), an almost contemporary work with a similar subject. *The Forces of the Street* illustrates an evolution in Boccioni's pictorial technique. The divisionist handling—typical of his early period—no longer dominates but takes a subsidiary role. The darkened palette is lit by triangles with warmer hues showing up the tram's swift movement as it "disembowels" the night. This is a procedure that would be borrowed by Russolo in his *Dynamism of an Automobile* (1913, Musée national d'art moderne, Paris).

With this tram advancing at full speed towards the onlooker, Boccioni reinstated the sensation of shock and impact, excitement peculiar to the streets of the modern city. In the preface of the catalogue of their Paris show of February 1912, the Futurist painters asserted that their art had to turn the viewer into an active participant, plunged in the scene depicted: "These *force-lines* must encircle and involve the spectator so that he will in a manner be forced to struggle himself with the persons in the picture."[4] In spite of formal coincidences with Cubism, *The Forces of the Street* describe the difference that set the Parisian and Italian movements apart. Cubism—cognitive and intellectual painting—differed from a lyrical form of Futurism inviting its spectators to an "ecstatic" and extremely intense relationship with the work. Cubism was a studio-centred art, a scholarly meditation on painting itself, precisely where Futurism saw itself as a celebration of street culture, and the hitherto unfelt sensations it inspired. It was this difference in nature that prompted the Futurist painters to see in Cubism a classical and academic art, its back turned to the explosive forces peculiar to modern subjects.

I. S.-M.

1 Marinetti, *Manifeste du futurisme, Le Figaro*, 20 Feb. 1909 ; trans. as "The Founding and First Manifesto of Futurism", in Apollonio (ed.), *Futurist Manifestos*, (London: Thames and Hudson, 1973 and 2001) p. 22.
2 See Calvesi and Coen, *Boccioni. L'opera completa*, (Milan: Electa, 1983), p 412; *Boccioni. A Retrospective*, Coen (ed.), exh. cat., New York, The Metropolitan Museum of Art, 1988, p. 134.

3 Mattioli Rossi ("Boccioni between Painting and Sculpture", *Boccioni's Materia: A Futurist Masterpiece and the Avant-Garde in Milan and Paris*, exh. cat., New York, Solomon R. Guggenheim Museum, 2004, p. 36) suggests that Soffici's article "Picasso e Braque" (*La Voce*, Florence, vol. 3, no. 34, 24 Aug. 1911; see Antliff and Leighton (eds.), *A Cubism Reader: Documents and Criticism, 1906–1914*, [Chicago and London: University

of Chicago Press, 2008], pp.128–140) could have been enough to steer Boccioni's painting towards something more geometric.
4 Boccioni et al., "Les exposants au public", *Les Peintres futuristes italiens*, exh. cat., Galerie Bernheim-Jeune & Cie, Paris, 5–24 Feb. 1912, p. 8; trans. as "The Exhibitors to the Public", in Apollonio, op. cit, p. 48.

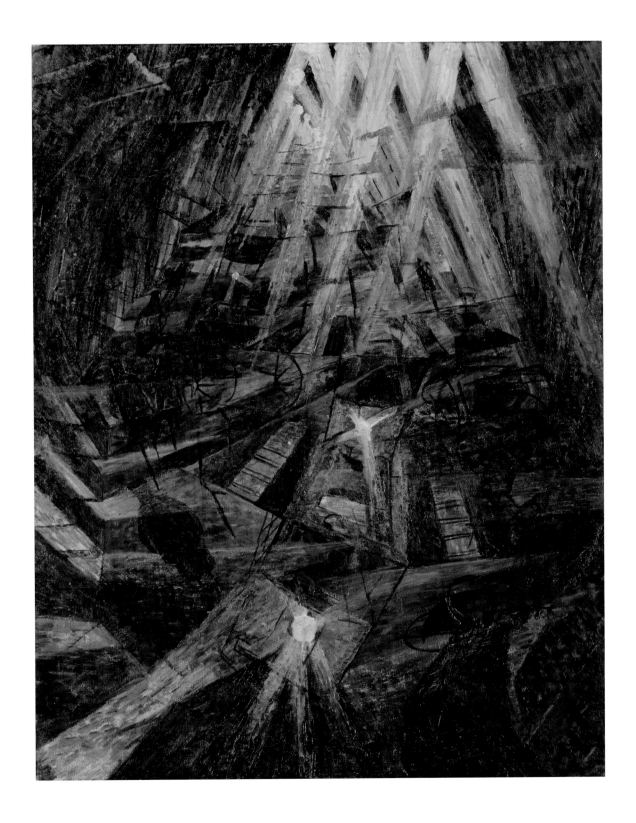

32 **Carlo Carrà**
 I funerali dell'anarchico Galli, **1910–1911**
 [The Funeral of the Anarchist Galli]
 Oil on canvas, 198.7 x 259.1 cm
 The Museum of Modern Art, New York
 Acquired through the bequest of Lillie P. Bliss, 1948

In 1904 Italy saw a major upsurge of workers' protests. The city of Milan was paralysed by a general strike. Via Carlo Farini was the scene of a demonstration which grew rapidly in intensity, culminating in its tragic epilogue: the assassination of the anarchist Galli. His funeral attracted a popular gathering which the police strove to confine to the square by the Musocco cemetery. The anarchists, nevertheless, organised and led a procession. This march degenerated into a violent altercation with mounted troops, who ended up charging the protesters. Carrà, who was an eyewitness to these events, subsequently tried to transcribe the brutality in a series of drawings made from memory.

It was based on these sketches that, six years later, Carrà started work on a huge picture, *The Funeral of the Anarchist Galli*. In 1910 and 1911, this work was re-organised several times. The revolutionary lyricism with which he imbued it resulted from his sympathies for the anarchist cause. When in Paris in the early years of the Twentieth Century, he had been in touch with former members of the Paris commune—the Communards—and took part in a number of anarchist meetings.[1] When he left Paris for London, Carrà once more found himself within these circles: "Stumbling into the midst of anarchists, barely 18 years old, I too started to dream of 'inevitable changes in human society, free love, etc.'"[2] On several occasions, Marinetti had likened the values of Futurism to anarchist values, (a rejection of the past, opposition to the systematic mind, and praise for the *tabula rasa*).[3]

Félix Fénéon, artistic director of the Galerie Bernheim-Jeune, and a former militant anarchist himself, was not indifferent to this revolutionary idealism shared by the Futurist painters. In addition to Carrà's canvas, two other works shown in the 1912 exhibition had as their subject scenes of revolutionary violence: *The Raid* (1910, present whereabouts unknown) by Boccioni, and Russolo's *Rebellion* (1911, cat. 42). This iconography of crowds in motion would find an echo in Britain in Wyndham Lewis' work, *The Crowd* ([1915], cat. 106).

The introductory essay in the catalogue for the exhibition of Italian painters in February 1912 underlined the exemplary nature of *The Funeral of the Anarchist Galli*, which sums up the essential features of Futurist painting. In addition to its actual subject, linked to a 'dynamism' of revolutionary ideas capable of setting the masses in motion, the work proceeds to make an exemplary analysis of movement: "If we paint the phases of a riot, the crowd bustling with uplifted fists and the noisy onslaughts of cavalry are translated upon the canvas in sheaves of lines corresponding with all the conflicting forces, following the general law of violence of the picture."[4] It aims at immersing viewers in the heart of the action: "These *force-lines* must encircle and involve the spectator so that he will in a manner be forced to struggle himself with the persons in the picture."[5] It was in response to such energy that Villon would recall those 'force-lines' and that positioning of the spectator in the thick of the action in his *Soldiers on the March* (1913, cat. 65).

B. M.

1 Carrà, *La mia vita*, 1945, Carrà (ed.), (Milan: Abscondita, 2002), pp. 28–9.
2 Ibid., p. 31.
3 In a letter sent to one of his Paris correspondents, he had likened his manifesto to a "glorification of anarchism"; see Lista, *F.T. Marinetti. L'anarchiste du futurisme. Biographie,* (Paris: Nouvelles Éditions Séguier, 1995), p. 43.

4 Boccioni et al., "Les exposants au public", *Les Peintres futuristes italiens*, exh. cat., Galerie Bernheim-Jeune & Cie, Paris, 5–24 Feb. 1912, p. 8; trans. as "The Exhibitors to the Public", in Apollonio (ed.), *Futurist Manifestos*, (London: Thames and Hudson, 1973 and 2001), p. 48.
5 Ibid.; ibid.

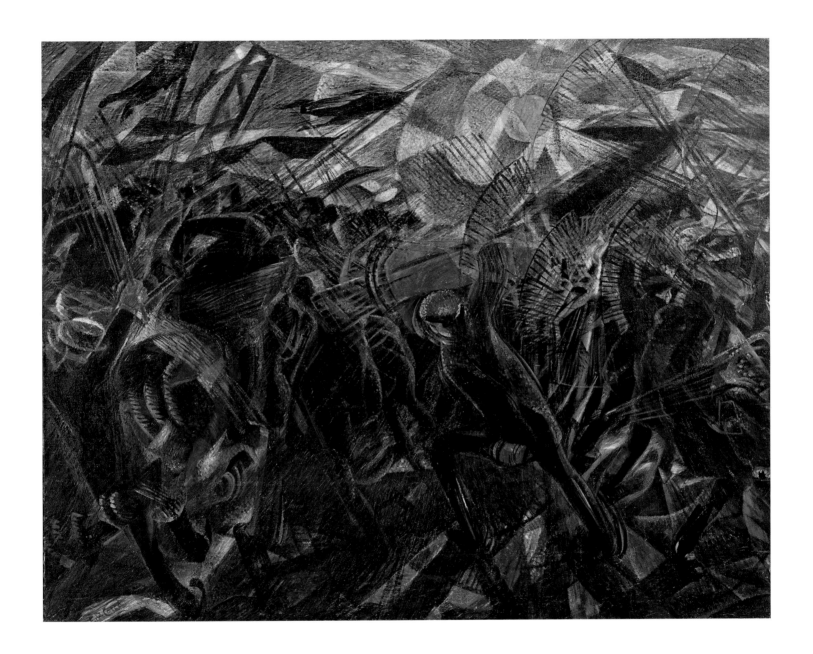

33 **Carlo Carrà**
Sobbalzi di carrozza, 1911
[Jolts of a Cab]
Oil on canvas, 52.3 x 67.1 cm
The Museum of Modern Art, New York
Gift of Herbert and Nanette Rothschild, 1966

Just as with *What the Tram Told Me* (1911, cat. 35), in *Jolts of a Cab* Carrà chose the street and the movement of a vehicle as the frame and object of a new sensory experience, the point of departure for a redefinition of the plastic space.[1] The carriage motif, a detail slipped into the background of *Leaving the Theatre* (1910 c., cat. 39), is treated here in an autonomous way and involves a radical reconstruction based on the principles of Futurist aesthetics. A preliminary ink drawing, titled *Carrozzella* [Hackney Carriage] sheds light on the desire to find in the rhythmic scansion of lines, curves and arabesques a plastic equivalent of movement. Over the canvas unfurls a dense network of straight and curved lines which intersect, create contrasting links, and echo one another. Colour obeys the same law of contrasts, proceeding from deep red to green. The powerful articulation of the whole composition offers a plastic architecture open to centrifugal forces. The "chaos and clashing rhythms, totally opposed to one another … assemble into a new harmony."[2]
The canvas offers the synthetic equivalent of the breakdowns, twists and reductions to which movement subjects form. A principle which a Parisian journalist, both ironic and dumbfounded, summarised in 1912 as: "What I have personally retained from his demonstrations is that a horse has twenty legs, no lessss [*sic, moinsss* in the original French], and that, when one makes a portrait, the model's eye must be in one corner of the picture and his detachable collar in the other corner."[3] Emphasising this, Carrà wrote in March 1913: "we insist that our concept of perspective is the total antithesis of all static perspective. It is dynamic and chaotic in application, producing in the mind of the observer a veritable mass of plastic emotions".[4] In *The Painting of Sounds, Noises and Smells* published in *Lacerba* on 1 September 1913, Carrà provided a broader sense to the notion of plastic emotion by linking sound, noise and smell to forms and colours through analogical relations. Recalling the works of the Galerie Bernheim exhibition, he concluded: "This bubbling and whirling of forms and lights, composed of sounds, noises and smells has been partly achieved by me in my *Anarchical Funeral* [*sic*; 1910–11, cat. 32] and in my *Jolts of a Taxi-cab* [*sic*], by Boccioni in *States of Mind* [1911, cat. 20-25] and *Forces of a Street* [1911, cat. 31] by Russolo in *Rebellion* [1911, cat. 42] and Severini in *Pan-Pan* [*sic*; 1909–11/1959–60, cat. 45], paintings which were violently discussed at our first Paris exhibition in 1912."[5] As with *What the Tram Told Me*, the recomposition of the form in space in *Jolts of a Cab* was also the result of a merger of two foci of visions and sensations. The picture was thus described, in the catalogue for the London Futurist show of 1912, as the synthesis of "the double impression produced by the sudden jolts of an old cab upon those inside it and those outside".[6]
The work's subject nevertheless remains identifiable because of certain details: a horse seen sideways on, the grooved surface of a step and the divided circle of a wheel. This latter motif, already announced in the ink sketch, is possibly the most striking for its clarity and its radicalism. Carrà cut the wheel in two as if halving an orange, anticipating the poetic game of Apollinaire in the last line of *Zone*: "Soleil cou coupé" [The sun a severed neck].[7] If *Jolts of a Cab* has often been linked to the growing influence of Cubism on Carrà's work between 1910 and 1913, observers have been quick to point out what distinguished it from the aesthetics of the Parisian movement: the attention to movement, the chromatic variety, and the impulsive and expressive use of the brushstroke.[8] This picture also highlights Carrà's individuality within the Futurist movement. He was less susceptible than Boccioni to painting "states of mind", but exemplified a "physical" Futurism, attentive to the "density of the perceptible", searching ceaselessly in the "thick layers" of sensation.[9]

J. P.

1 Shown in Paris in *Les Peintres futuristes italiens* in February 1912, the picture was later acquired for 200 marks by Dr. Borchardt, and subsequently sold to the Rothschilds.
2 Boccioni et al., "Les exposants au public", *Les Peintres futuristes italiens*, exh. cat., Galerie Bernheim-Jeune & Cie, Paris, 5–24 Feb. 1912, p. 9; trans. as "The Exhibitors to the Public", in Apollonio (ed.), *Futurist Manifestos*, (London: Thames and Hudson, 1973 and 2001), p. 49.
3 Helsey, "Après le cubisme, le futurisme", *Le Journal* (Paris), 10 Feb. 1912, p. 1.

4 Carrà, "Piani plastici come espansione sferica nello spazio", *Lacerba* (Florence), vol. 1, no. 6, 15 March 1913, p. 54; and Carrà, *Tutti gli scritti*, (Milan: Feltrinelli, 1978), p. 8; trans. as *Plastic Planes as Spherical Expansions in Space*, in Apollonio, op. cit., p. 92.
5 Carrà, "La Pittura dei suoni, rumori, odori. Manifesto futurista" (11 Aug. 1913), *Lacerba* (Florence), vol. 1, no. 17, 1 Sept. 1913; id., *Tutti gli scritti*, op. cit., p. 21; trans. in Apollonio, op. cit., p. 115.
6 *Exhibition of Works by the Italian Futurist Painters*, exh. cat., London, The Sackville Gallery, March 1912, p. 22.

7 Apollinaire, "Zone", *Alcools*, Paris 1913; tr. by Shattuck in *Selected Writings of Guillaume Apollinaire*, (New York: New Directions, 1971), p. 127. As it first appeared in *Les Soirées de Paris* (no. 11, Nov. 1912, p. 337) the last line was: "Soleil levant cou tranché" [literally "Sun rising neck cut"].
8 See in particular Roche-Pézard, *L'Aventure futuriste, 1909–1916*, (Rome: École française de Rome, 1983), p. 344.
9 Calvesi, "I futuristi e la simultaneità: Boccioni, Carrà, Russolo e Severini", *L'Arte moderna*, vol. 5, no. 39, 1967, p. 94.

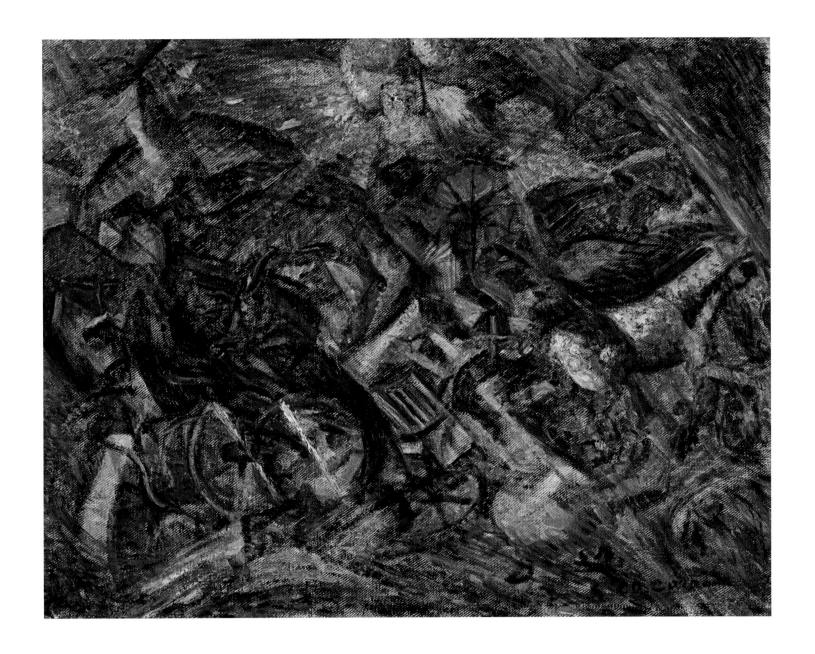

34 **Carlo Carrà**
 ***Il movimento del chiaro di luna*, 1910–1911**
 [The Movement of Moonlight]
 Oil on canvas, 75 x 70 cm
 Mart–Museo di Arte Moderna e Contemporanea di Trento e Rovereto

Carrà's Futurist output can, in some ways, be disconcerting for, with a metronomic and macrophagic regularity, the artist would year in year out absorb numerous lessons in order to assimilate them, and then, in many instances, reject them. The beginning of the 1910s thus saw him endlessly renewing solutions which, when one considers the period as a whole, nevertheless demonstrate an underlying continuity and logic. In this respect, a synoptic scrutiny invites a comparison between *The Movement of Moonlight* and other noteworthy works by the artist, such as *The Funeral of the Anarchist Galli* (1910–11, cat. 32) and *Milan Station* (1910–11, cat. 41). While the powerful significance of the Lombard and Piedmont cultures led him to take on politically committed themes into which he injected formal innovations, by analysing 'moonlight' Carrà displayed a lyricism untainted by any social factor and focused solely on the chromatic interplay brought on by the movement of the earth's satellite. Moons, suns, stars: cosmology purveyed many themes for a Futurism mindful of the fluctuating sensations and fleeting manifestations of the outside world. With *Street Light* (1910, The Museum of Modern Art, New York), Balla had opened the way to the attractions of light, albeit artificial, explored further in prestigious works such as his own *Mercury Passing in Front of the Sun as Seen through a Telescope* (1914, Musée national d'art moderne, Paris) and in Russolo's *House + Light + Sky* (1912, Kunstmuseum, Basel). However, it would be a misunderstanding only to consider *The Movement of Moonlight* in relation to Futurist principles. Trained as an academic painter and well versed in art history, Carrà was well aware of the valuable examples of his elders, whose ranks included the literally 'radiant' canvases of an artist like Pellizza Da Volpedo (*The Rising Sun*, 1904, Galleria nazionale d'Arte moderna, Rome) or those showing a Symbolist aesthetics particularly rich in solar and lunar effects. In this respect Carrà's own painting *Nocturne in Piazza Beccaria* of 1910 (cat. 3), made less than a year earlier, is quintessential, in so much as it made it possible to combine and exceed the Divisionist and Symbolist experiments inherited in particular from Odilon Redon. *The Movement of Moonlight* thus complies strictly with Futurist precepts: two years after the Marinetti pamphlet titled *Let's Murder the Moonshine!* (April 1909),[1] Carrà broke down the movement of the moon which he reinstated using stripes of colour, creating an unstable and moving dynamic, at once Bergsonian and dislocated. By making bold use of complementary hues (orange and blue, green and red, purple and yellow) Carrà methodically arranged exploded forms and violent hatching in a shimmering kaleidoscopic vision—the term 'movement' in the title indicates as much. This verges on musicality and culminates in a knowing synaesthesia. In this connection, it is possible to evoke the subsequent Futurist experiments with the photography of Anton Giulio Bragaglia; while his term *photodynamism* could, in itself, describe Carrà's painting, it could be guessed—and an effort at virtual re-creation could confirm this—that a slow shutter speed might capture similar forms. Vibrations, compenetrations, undulations, ridges, simultaneity—with its flawless Futurist rigour, *The Movement of Moonlight* was shown in the ground-breaking 1912 show at the Galerie Bernheim-Jeune, where it won approval before travelling for a whole year from Paris to Brussels by way of London and Berlin.

C. L.

1 Published in French in *Poesia* (Milan), nos. 7–9, Aug.–Oct. 1909, pp. 1–9; trans. by Flint and Coppotelli in Flint (ed.), *Marinetti: Selected Writings*, (London: Secker and Warburg, 1972), pp. 45–54.

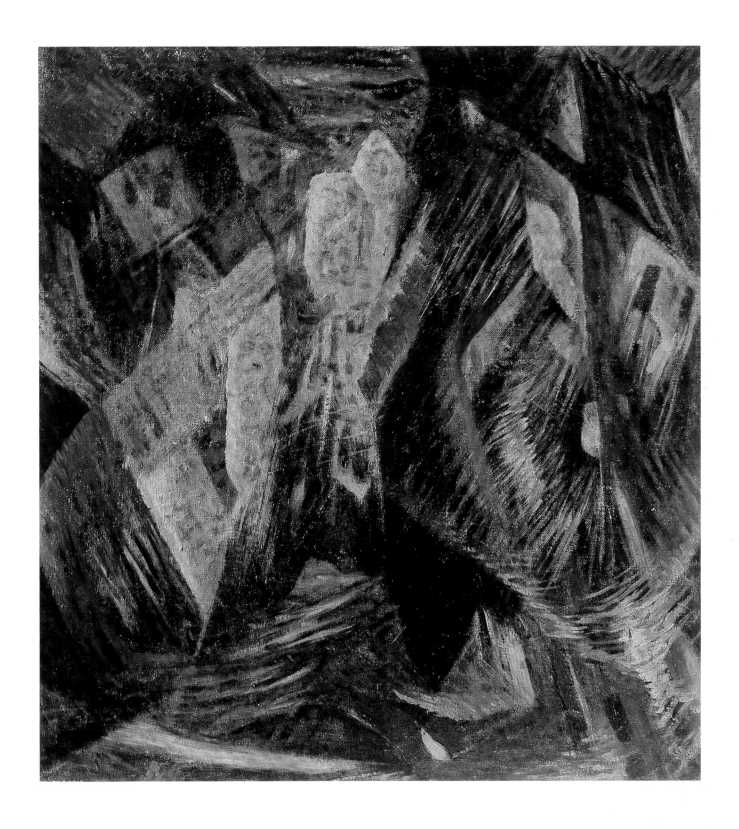

35 **Carlo Carrà**
 Ciò che mi ha detto il tram, 1911
 [What the Tram Told Me]
 Oil on canvas, 52 x 62 cm
 Mart–Museo di Arte Moderna e Contemporanea di Trento e Rovereto,
 Fondazione VAF

What the Tram Told Me was first exhibited in February 1912, in *Les Peintres futuristes italiens* at the Galerie Bernheim-Jeune in Paris.[1] This picture appeared to be one of the illustrations of the Futurist determination to render "*dynamic sensation*"[2] of things by creating a "style of motion".[3] The seeming chaos of lines and planes, the destruction of "realistic forms and the obvious details"[4] refer to this desire to describe a world in motion where the mutual links between the elements are being forever changed, where the profiles of things collide and mingle.

The tram or bus in motion is one of the exemplary experiences in which the new Futurist sensibility is to the fore, a *topos*, both literally and figuratively, of perpetual mobility.[5] "The sixteen people around you in a rolling omnibus are in turn and at the same time one, ten, four, three; they are motionless and they change places; they come and go, bound into the street, are suddenly swallowed up by the sunshine, then come back and sit before you, like persistent symbols of universal vibration. How often have we not seen upon the cheek of the person with whom we are talking the horse which passes at the end of the street."[6] This *topos* augments that of the window, the classic paradigm of a painting where things are 'put in front of us' with a certain distance between them and within a space governed by the laws of perspective. The tram is at the conjunction of two Futurist obsessions which partly overlap: movement and the city. It is accordingly one of those subjects of a new order, whose visual and expressive power was championed in Futurist painting. The moving tram acts as a catalyst which absorbs and redistributes the urban space. The boundaries between interior and exterior are blurred. Within a plastic space, punctuated by the rhythmic use of abstract planes, a certain number of details remain more or less recognisable, as if having evaded dislocation: the profile of a man walking, a horse's head, a woman's hat topped by a red feather, a panel with only a few letters still legible.

At the heart of the picture's plastic composition, Carrà explained in 1913, lie: "Constructions of a-rhythmical forms, the clash between concrete and abstract forms."[7] Moreover, the painter made calculated use of the angles to achieve maximum power of expression: "The acute angle" he added, for example, "is passionate and dynamic, expressing will and a penetrating force."[8] For the Futurists, movement was more than a merely accidental physical phenomenon. Through it was revealed the actual truth of the object. "The Cubists, to be objective, restrict themselves to considering things by turning around them, to produce their geometric writing. So they remain at a stage of intelligence which sees everything and feels nothing, which brings everything to a standstill in order to describe everything. We Futurists are trying, on the contrary, with the power of intuition, to place ourselves at the very centre of things, in such a way that our ego forms with their own uniqueness a single complex. We thus give plastic planes as plastic expansion in space, obtaining this feeling of something *in perpetual motion* which is peculiar to everything living."[9]

Thenceforth, a dialogue begins (encapsulated by the title of the picture) between the veritable visual laboratory formed by the tram as subject and the Futurist painter, culminating in this new plastic form. What is *expressed* by the tram, its impact and noise, summons the creation of a new *expression*, a new plastic language.

J. P.

1 It was entered (no. 14); as *Ce que m'a dit le tramway* it was then shown in London, Berlin (where it was bought by Dr Borchardt for 200 marks) and Brussels.
2 Boccioni et al., "Les exposants au public", *Les Peintres futuristes italiens*, exh. cat., Galerie Bernheim-Jeune & Cie, Paris, 5–24 Feb. 1912, p. 6; trans. as "The Exhibitors to the Public", in Apollonio (ed.), *Futurist Manifestos*, (London: Thames and Hudson, 1973 and 2001) p. 47.
3 Ibid. p. 2; Apollonio, op. cit., p. 46.

4 Ibid. p. 13; Apollonio, op. cit., p. 50.
5 On the recurrence of this motif in Futurist painting, see Lamberti, "Milano. La città dei futuristi", in *Metropolis. La città nell'immaginario delle avanguardie, 1910-1920*, exh. cat., Galleria civica d'Arte moderna e contemporanea, Turin, 4 Feb.–4 June 2006 (Turin, Fondazione Torino Musei, 2006), pp. 200–11.
6 Boccioni et al., *Manifeste des peintres futuristes*, in *Les Peintres futuristes italiens*, exh. cat., Galerie Bernheim-Jeune & Cie, Paris, 5–24 Feb. 1912, p. 17; *Futurist Painting: Technical Manifesto*, in *Exhibition*

of Works by the Italian Futurist Painters, Sackville Gallery, London Mar. 1912, republished in Apollonio, op. cit, p. 28.
7 Carrà, "Piani plastici come espanzione sferica nello spazio", *Lacerba* (Florence), vol. 1, no. 6, 15 Mar. 1913, p. 53; id., *Tutti gli scritti*, (Milan: Feltrinelli, 1978), p. 7; trans. as *Plastic Planes as Spherical Expansions in Space*, in Apollonio, op. cit, p. 91.
8 Ibid. p. 54; ibid. p. 7; trans. Apollonio, op. cit., p. 91.
9 Ibid. p. 54; ibid. p. 9.

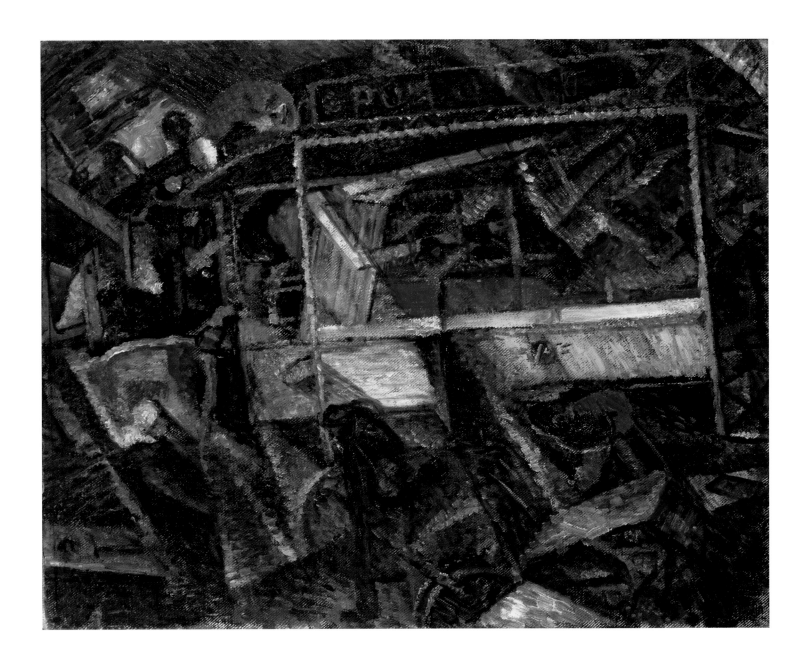

36 **Carlo Carrà**
Ritratto del poeta Marinetti, 1910
[Portrait of the Poet Marinetti]
Oil on canvas, 100 x 82 cm
Private collection

"I have said that Marinetti was … exceptionally gifted, and I should add that I never saw him twiddling his thumbs even for ten minutes; … beside his desk he often kept piles of books in which he would write dedications … invariably with the purpose of spreading the word about Futurism."[1] It is tempting to compare this evocation of Marinetti in Carrà's memoirs with the portrait shown in the various Futurist exhibitions held in 1912, and purchased at that time by the poet for his personal collection. It was first exhibited under the title *Portrait du poète Marinetti* in Paris in February 1912, but renamed *Come sento Marinetti* [How I feel about Marinetti] for the Rome exhibition in 1913.[2] As such, the picture was at once a personal memory and an official portrait of the "leader of Futurism"[3] virile poet, urgent agitator, driving force behind the Futurist "advertising machine".[4] Marinetti appears at his desk, pen in hand, cigarette between his lips, with a determined gaze as he stares at the onlooker. The presentation of the figure leaning forward, the inclusion of geometric planes at the heart of the organic structure, the use of bright colours, all attest to Futurism's interest in the body. Its appearance finds one of its most obvious expressions in Balla's unpublished *Futurist Manifesto of Men's Clothing* (1914) dedicated to Marinetti.[5]

The portrait that we see today differs significantly from the one (known to us through a photograph) that the visitor to the Galerie Bernheim-Jeune would have seen in February 1912. An examination of the two versions reveals a series of additions and retouches. The dedication to the Marchesa Casati is the most evident addition.[6] Another important addition is the clock which occupies an area where previously there had only been a pale round shape. The sheet of paper on which Marinetti is writing has moved. The alterations achieve in a more essential way a change in the style and architecture of the picture. They culminate in the introduction of simple geometric forms which frame the human figure and encroach upon it: the ellipse which encompasses the lower part of the portrait, the quadrilateral that is overlaid on Marinetti's body, and the outline of the clock were added or accentuated. A scattering of irregular and disjointed touches, brown, red and yellow, appears in the second version behind the figure. A line that once ran across the painter's face in the eye's axis has, on the other hand, been erased. The modifications, overall, tend towards simplification and greater legibility.

With regard to the significance of the divergences, and based on differences in the format, Fanette Roche-Pézard has put forward the hypothesis of two distinct pictures, one painted between 1910 and 1911 (and shown in the travelling Futurist exhibition), and the other produced in 1914 or thereabouts.[7] In the absence of any second canvas, we are confined to the realm of speculation. If we espouse the idea of a single retouched painting, the date of a second campaign remains unknown. It is possible that Carrà reworked the portrait between the Rotterdam show in 1913 and his solo show at the Galleria Chini in Milan in 1917, but some critics have prudently proposed a much longer period, with a *terminus ad quem* of 1950.[8]

J. P.

1 Carrà, *La mia vita*, 1945, Carrà (ed.), [Milan: Abscondita, 2002].
2 *Prima Esposizione di pittura futurista*, Galleria Giosi, Rome [February] 1913; it appeared as *Comment je sens Marinetti* in *Les Peintres et les sculpteurs futuristes italiens*, Kunstkring, Rotterdam, 18 May–15 June 1913.
3 In *Exhibition of Works by the Italian Futurist Painters*, exh. cat., The Sackville Gallery, London, Mar. 1912, p. 15, it was described as: "A synthesis of all the impressions given by the leader of Futurism."
4 Carrà, op. cit.
5 Balla wrote: "Use materials with forceful MUSCULAR colours – the reddest of reds, the most purple of purples, the greenest of greens, intense yellows,

orange, vermilion – and SKELETON tones of white, grey and black." Materials here means cloth. Balla continued: "And we must invent dynamic designs to go with them and express them in equally dynamic shapes: triangles, cones, spirals, ellipses, circles, etc." Unpublished and undated manuscript, Balla Archives, reproduced in Lista, *Marinetti et le futurisme*, (Lausanne: L'Âge d'homme, 1977), p. 208; dated "1913" and trans. in Apollonio (ed.), *Futurist Manifestos*, (London: Thames and Hudson, 1973 and 2001), p. 132.
6 "I am giving my portrait painted by Carrà to the great Futurist, the Marchesa Casati, with her slow jaguar eyes digesting in the sun the steel poultry devoured", signed by Marinetti.

7 "There are two portraits of Marinetti, or at the very least Carrà painted two, the first of which, almost square in format, has probably been destroyed, and the second, larger work, painted on a standard French-style format cannot possibly be dated 1910–1911." See Roche-Pézard, *L'Aventure futuriste, 1909–1916*, (Rome: École française de Rome, 1983), p. 394. However the dimensions of the picture exhibited in 1912 were never published and remain uncertain.
8 See Monferini, *Carlo Carrà 1881–1966*, exh. cat., Galleria nazionale d'Arte moderna, Rome, 15 Dec. 1994–28 Feb. 1995 (Milan: Electa, 1994), p. 196.

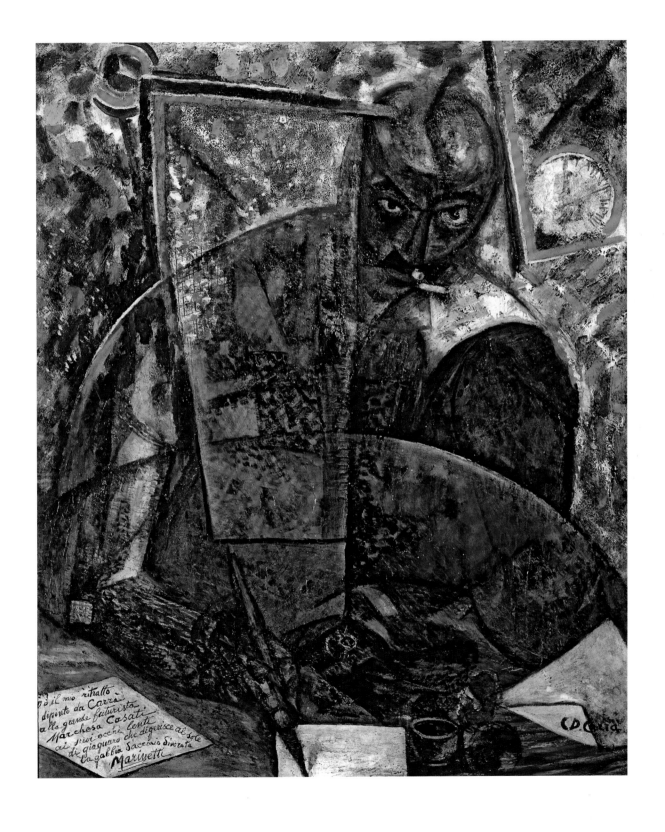

37 **Carlo Carrà**
 Simultaneità. La donna al balcone
 (Ragazza alla finestra), 1912
 [Simultaneity. Woman on a Balcony (Girl at the Window)]
 Oil on canvas, 147 x 133 cm
 Private collection

Simultaneity. Woman on a Balcony fits, as in a mirror, the definition that Duchamp gave to his *Sad Young Man in a Train* (1911, Peggy Guggenheim Collection, Venice). If, with hindsight, Duchamp's painting appeared to its author to be a "Cubist interpretation of a Futurist formula",[1] then Carrà's picture, for its part, can be seen as "a Futurist interpretation of a Cubist formula". The Cubism in question is more precisely that of Léger's *Nudes in the Forest* (1909–11, cat. 18), and his *Study for Three Portraits* (1911, Milwaukee Art Center), in other words a "Tubism" tending to turn human figures into disjointed metal robots. Carrà would have discovered *Nudes in the Forest* either through its reproduction in the *Marches du Sud-Ouest* of June 1911,[2] or during his stay in Paris that October, when he certainly had a chance to see *Study for Three Portraits* at the Salon d'Automne. For *Woman on a Balcony* Carrà retained from those works the metallic shades and tints, and the metamorphosis of an anatomy in the form of bits of curved sheet metal; a "Cubist interpretation" yes, but "of a Futurist formula".

The Futurism of *Woman on a Balcony* is first and foremost that of its claimed "simultaneity", that opens the figure up to its environment. It draws the formal conclusions of the statement made in "The Exhibitors to the Public", which pre-supposes the inter-penetration between a form and the surroundings in which it is located, between an inside and an outside, all interactions for which a figure at its window (on its balcony) represents the almost ideal subject.[3] It is to this that this text-cum-manifesto of the catalogue for the exhibition at the Galerie Bernheim-Jeune refers, in a pedagogic way: "Let us explain again by examples. In painting a person on a balcony, seen from inside the room, we do not limit the scene to what the square frame of the window renders visible; but we try to render the sum total of visual sensations which the person on the balcony has experienced; the sun-bathing throng in the street, the double row of houses which stretch to right and left, the beflowered balconies, etc. This implies the simultaneousness of the ambient, and, therefore, the dislocation and dismemberment of objects, the scattering and fusion of details, freed from accepted logic, and independent from one another."[4] This exemplary quality of the figure on the balcony explains how, in addition to Carrà's picture, two works by Boccioni on view in the Galerie Bernheim–Jeune show, *The Street Enters the House* and *Simultaneous Visions* (both 1911, cat. 26 and 29) were devoted to the same subject.

The Cubo-Futurism of *Simultaneity. Woman on a Balcony* introduced Carrà's art to a phase in which the equilibrium of the form becomes a major stake. This was an evolutionary development which would gradually lead him to challenge Futurism and celebrate the virtues of classical form.

D. O.

1 Cabanne, *Entretiens avec Marcel Duchamp*, [1967] (Paris: Somogy éditions d'art, 1995), p. 43; trans. as *Dialogues with Marcel Duchamp*, [London: Thames and Hudson, 1971], p. 35.
2 Allard, "Sur quelques peintres", *Les Marches du Sud-Ouest* (Paris), no. 2, June 1911, repr. p. 61. This was a review of the Salon des Indépendants, where Léger's work was shown.

3 Boccioni et al., "Les exposants au public", *Les Peintres futuristes italiens*, exh. cat., Galerie Bernheim-Jeune & Cie, Paris, 5–24 Feb. 1912; trans. as "The Exhibitors to the Public", republished in Apollonio (ed.), *Futurist Manifestos*, (London: Thames and Hudson, 1973 and 2001), pp. 45–50.
4 Ibid., pp. 4, 6; ibid. Apollonio, op. cit., p. 47.

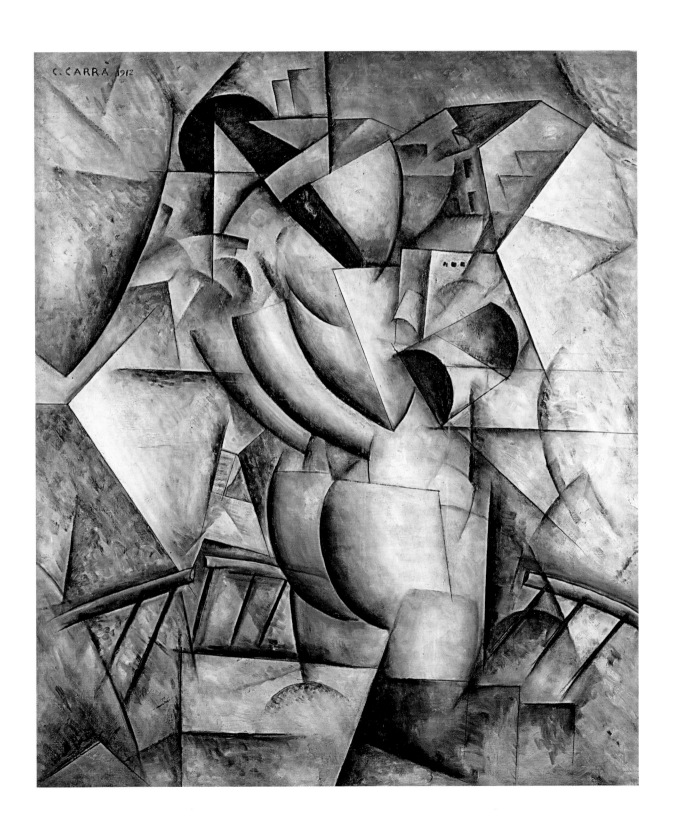

38 **Carlo Carrà**
 ***Nuotatrici*, 1910–1912**
 [Women Swimmers]
 Oil on canvas, 105.3 x 155.6 cm
 Carnegie Museum of Art, Pittsburgh
 Gift of G. David Thompson, 1955

Women Swimmers, which Carrà showed at the Galerie Bernheim-Jeune in February 1912, contrasted with the urban themes which otherwise marked his pictures in that exhibition.[1] The work was probably inspired by the poem by Libero Altomare: "Swimming in the Tiber", which was read by Marinetti at several Futurist evenings. The poem describes the disappearance of bodies swept away by a fierce current. Carrà translated this energy by a diagonal composition, and a nervous brushstroke reproducing the movement of the water. Seen as if from a high angle shot, the figures seem to merge in the dynamic flow that bears them off. But while Carrà appears to strive to reinstate movement through the "Futurist" virtues of sport and speed, *Women Swimmers* is still a surprising subject in the context of a Futurism celebrating machinery and the urban world. Its iconographic antecedents are primarily Symbolist.[2] Through its angular treatment of the figures, and the palette playing with strident harmonies, the work also conjured up certain pictures by Die Brücke artists.[3] In the context of the Paris show of February 1912, however, Carrà introduced into his picture elements which set it apart from the works of Symbolism and Expressionism.[4]

A cartoon by Boccioni, *A Futurist Evening in Milan* (1911) shows the Futurists (Boccioni himself, Balilla Pratella, Marinetti, Carrà and Russolo) gesticulating in front of a collection of canvases. The one in the middle depicts lush naked women swimming, and might well be an initial version of this work.[5] After Carrà's trip to Paris in October 1911, he rethought *Women Swimmers*, cladding them in, then very fashionable, long swimming costumes. This sartorial modernisation also allowed his picture to get rid of nudes deemed in *Futurist Painting: Technical Manifesto* to be "as nauseous and as tedious as adultery in literature".[6] By borrowing from Cubism its technique of breaking forms down into facets, Carrà geometrised the bodies, which were initially smooth and curvaceous. He finally gave up on the divisionist technique, still very present in his works produced around the time of *Women Swimmers*.[7]

This canvas reveals Carrà's desire to introduce into his painting the formal innovations of Cubism. Back in Milan after his autumn 1911 trip to Paris, he completed *Simultaneity. The Woman on a Balcony* (1912, cat. 37), which lent substance to his plan to explore these lessons more deeply. This work, which brings together the interpenetration of figure and landscape, echoes Boccioni's *Materia* (1912, Mattioli Collection, on permanent loan to the Peggy Guggenheim Collection, Venice), likewise marked by Cubism.

I. S.-M.

1 See in particular *Milan Station* and *Leaving the Theatre* (cat. 39 and 41).
2 See von Stuck, *Vice* (1894, private collection); Klimt, *Moving Water* (1898, private collection).
3 See Kirchner, *Bathers at Moritzburg* (1909/1926, Tate, London); Heckel, *Bathers* (1912–13, Saint Louis Art Museum).
4 See article by Hirsh, "Carlo Carrà's *The Swimmers*", *Arts Magazine* (New York), vol. 53, no. 5, Jan. 1979, pp. 122–9.

5 This "first" version of *Women Swimmers* was shown in June 1911 at the *Mostra d'Arte Libero* Padiglione Ricordi, Milan. The Boccioni caricature was first published in *Uno, due, e… tre*, 17 June 1911. Hirsh, op. cit., of this first 1910 version, based on the many areas touched-up after this date and visible in the present-day work (pp. 126–7).
6 Boccioni et al., *Manifeste des peintres futuristes*, in *Les Peintres futuristes italiens*, exh. cat., Galerie Bernheim-Jeune & Cie, Paris, 5–24 Feb. 1912, p. 21;

Futurist Painting: Technical Manifesto, in *Exhibition of Works by the Italian Futurist Painters*, Sackville Gallery, London Mar. 1912, republished in Apollonio (ed.), *Futurist Manifestos*, (London: Thames and Hudson, 1973 and 2001), p. 30.
7 See *Nocturne in Piazza Beccaria* (1910, cat. 3).

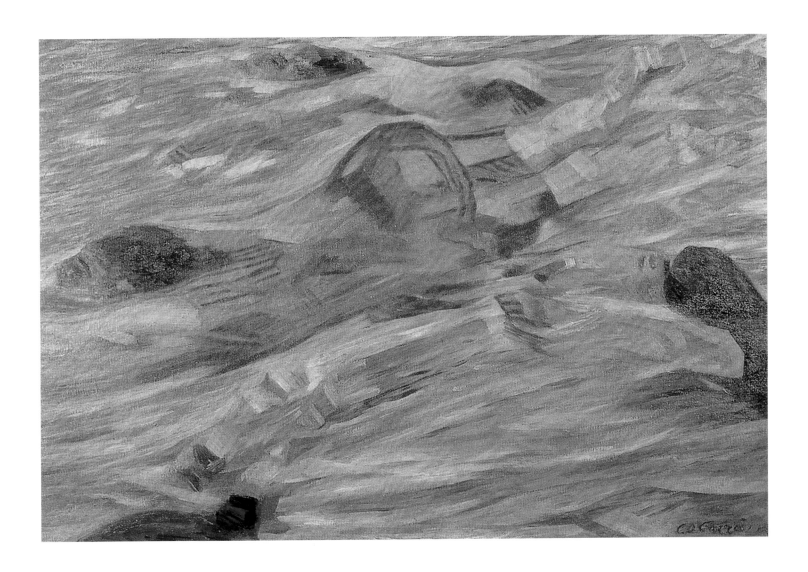

39 **Carlo Carrà**
***Uscita dal teatro*, c. 1910**
[Leaving the Theatre]
Oil on canvas, 69 x 89 cm
Estorick Collection, London

"The idea for this picture came to me one winter's night as I was leaving La Scala. In the foreground there is a snow sweeper with a few couples, men in top hats and elegant ladies. I think that this canvas, which is totally unknown in Italy, is one of the paintings where I best represented the conception I had at the time about my art."[1] That is how Carrà described *Leaving the Theatre* in his memoirs. The scene is borrowed from the night life of large modern cities, the celebration of which lay at the heart of the Futurist avant-garde, who held that night owls and their activities, just like speed, offered the experience of an intensification of things visible. "How is it possible still to see the human face pink, now that our life, redoubled by noctambulism, has multiplied our perceptions as colourists? The human face is yellow, red, green, blue, violet."[2]

The artificial light of the lamps spreads in this scene with watery tones, multiplying the interplay of reflections and back-lighting. The greens, blues, mauves and reds are all set down in elongated brushstrokes. The dark masses of the sweeper, of the man in the foreground and the two horse-drawn carriages stand out, hemmed or streaked with flashes of red. In this picture, Carrà made his own personal use of divisionism. More than the other canvases on view at the travelling Futurist show of 1912, *Leaving the Theatre* illustrates its major influence, and in particular of the painter Gaetano Previati, in the very early days of Futurism. Did *Futurist Painting: Technical Manifesto* not declare, in 1910, that there could be no modern painting without divisionism?[3]

In the foreground, three iridescent female forms—"phosphorescent fairies"[4]—are walking away from the square in front of the theatre in different directions. The rhythm provided by these three figures is enhanced by echoes and intensification in the background. A carriage drawn by two white horses hastens off in the upper right part of the picture. As if *sotto voce*, a dark figure repeats the motif of the woman in the centre. *Leaving the Theatre* holds a "mysterious content of complex rhythms".[5] The rhythmic structure is based on the state of tension of two series of oblique parallels: the upper part of the sweeper's body, the couple on the right, and the horses, on the one hand, and, on the other, the two women, the dark male figure in the background, the leaning carriages, and the sweeper's leg. So the angle formed by the two women on the right seems like the rhythmic module lending structure to the entire picture. So much so that no vertical, no fulcrum and no line is retained to which stability might be attributed.

The atmosphere of this square by the theatre, still filled with movement, light and colour, but on the point of becoming empty, hovers between happiness and melancholy. This is probably as close as Carrà got to the "states of mind" dear to Boccioni (cat. 20–25). The leaning bodies of the figures even call to mind the first version of his *States of Mind: Those Who Stay* (1911, cat. 22, Civiche Raccolte d'Arte, Milan). The veiled female forms, in which we cannot make out the faces, lend certain Symbolist aspects to the canvas. At once a "slice of night life" and a supernatural vision, a hymn to artificial light and an allusion to Symbolism, *Leaving the Theatre* is firmly entrenched within the spirit of the day, between science, Symbolism and spiritualism—an 'epistemis' which was to pave the way for the positions of early Futurism. The *Futurist Painting: Technical Manifesto* noted: "Who can still believe in the opacity of bodies since our sharpened and modifed sensitivity has already penetrated the obscure manifestations of the medium? Why should we forget in our creations the doubled power of our sight, capable of giving results analogous to those of the X-rays?"[6]

J. P.

1 Carrà, *La mia vita*, 1945, Massimo Carrà (ed.), [Milan: Abscondita, 2002], p. 99.
2 Boccioni et al., *Manifeste des peintres futuristes*, in *Les Peintres futuristes italiens*, exh. cat., Galerie Bernheim-Jeune & Cie, Paris, 5–24 Feb. 1912, p. 19; *Futurist Painting: Technical Manifesto*, in *Exhibition of Works by the Italian Futurist Painters*, Sackville Gallery, London Mar. 1912, republished in Apollonio (ed.), *Futurist Manifestos*, (London: Thames and Hudson, 1973 and 2001), p. 29.

3 Ibid., p. 20; Apollonio, op. cit., p. 29.
4 Roche-Pézard, *L'Aventure futuriste, 1909–1916*, (École Française de Rome, 1983), p. 249.
5 Carrà, "Piani plastici come espansione sferica nello spazio", *Lacerba* (Florence), vol. 1, no. 6, 15 March 1913, p. 54, and Carrà, *Tutti gli scritti*, (Milan: Feltrinelli, 1978), p. 8; trans. as *Plastic Planes as Spherical Expansions in Space*, in op. cit., p. 92.
6 Boccioni et al., op. cit., p. 17; in Apollonio, op. cit., p. 28.

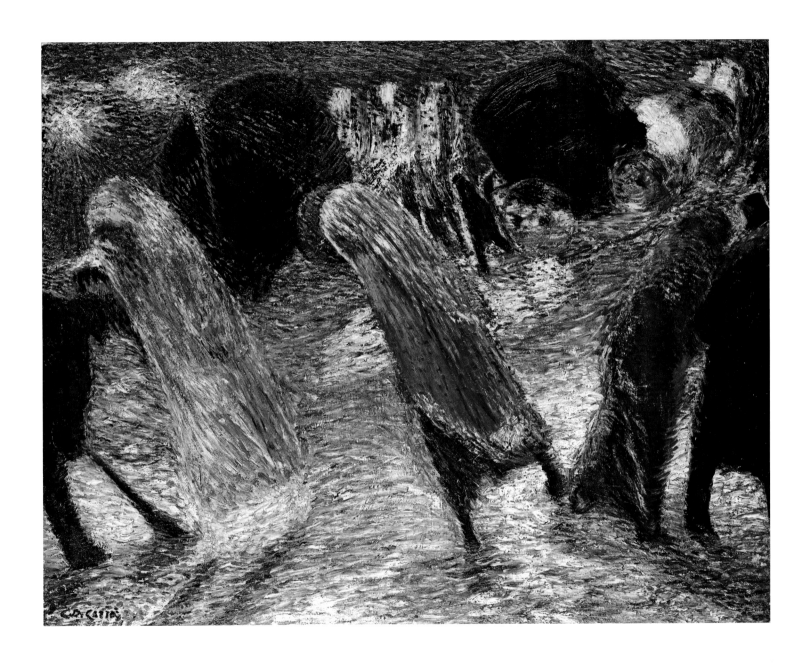

40 **Carlo Carrà**
 La donna al caffè (Donna e assenzio), **1911**
 [Woman in a Café (Woman and Absinthe)]
 Oil on canvas, 67 x 52 cm
 Private collection

A comparison of Carrà's *Woman in a Café* with Umberto Boccioni's *Modern Idol* (cat. 30) enables us to gauge the individual nature of Carrà's Futurist work. His quest for a formal synthesis, inherited from Cézanne and Picasso, set him radically apart from the other members of the movement. This quest made his art relatively resistant to spiritualism and Symbolism—both tendencies to which Boccioni and Russolo were attracted. Instead, his art predisposed him to draw upon the lessons of Cubism, discovered during his stay in Paris with Boccioni in the autumn of 1911.

Woman in a Café was probably painted between this trip and the exhibition of the Futurists held in February 1912 in the Galerie Bernheim-Jeune. The artist borrowed the method of monochromatic painting from the austere painting of analytical Cubism. Futurist principles, for their part, prompted Carrà to introduce rotating motion and centrifugal energy into his composition: this produced the openness of his forms which he made susceptible to their spatial surroundings. The use of reverse perspectives, as in the table in the foreground, also helped to include the viewer within the space of the work. Psychological research, including research involving an emotional transposition (as announced in *Futurist Painting: Technical Manifesto*), was expressed by the dramatic violence of the interplay of light and shadow, by the confrontation of opaque and transparent planes and by the rhythmic alternation of soft curves and sharp lines. This modern femininity, which *Woman in a Café* was keen to re-instate, shows through in the composition by way of shapes associated with a circular movement, attenuating the acute, aggressive force-lines of Carrà's earlier works. The subtle modulation of colours, the alternating warm and cold shades and the divisionist brushstroke intended to conjure up the noise of the café, all lend a 'plastic polyphonic' whole to the scene.[1] Apollinaire, who was very aware of the painter's effort in aiming to recreate, pictorially, the actual sensation of modernity by way of an austere palette, saw in Carrà a "kind of Rouault, but more vulgar than our artist".[2]

C. Z.

1 Carrà, 'La Pittura dei suoni, rumori, odori. Manifesto futurista' (11 Aug. 1913), *Lacerba* (Florence), vol. 1, no. 17, 1 Sept. 1913; trans. in Apollonio (ed.), *Futurist Manifestos,* (London: Thames and Hudson, 1973 and 2001), p. 114.
2 Apollinaire, "La vie artistique. Les peintres futuristes italiens", *L'Intransigeant,* 7 Feb. 1912; trans. in Breunig (ed.) *Apollinaire on Art: Essays and Reviews 1902–1918,* (New York: Da Capo Press, 1972) p. 200.

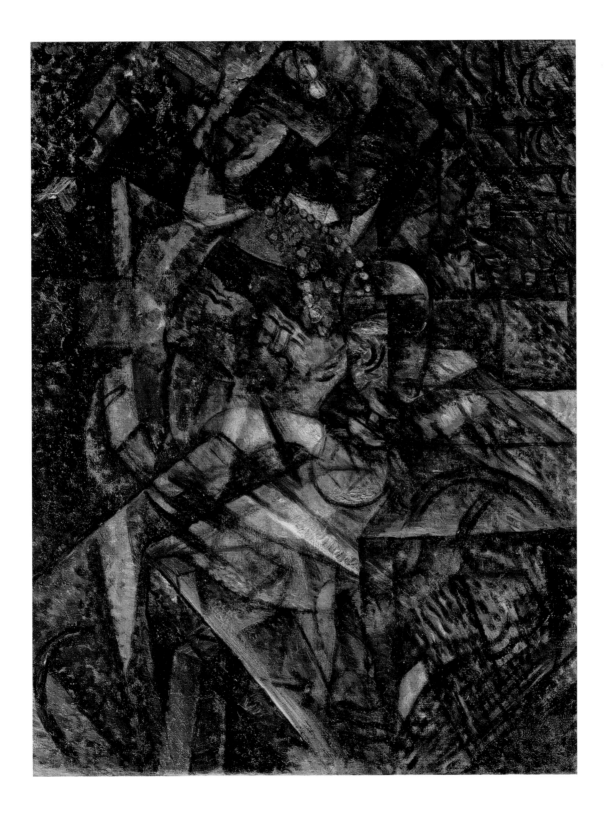

41 **Carlo Carrà**
La stazione di Milano, 1910–1911
[Milan Station]
Oil on canvas, 50.5 x 54.5 cm
Staatsgalerie Stuttgart, Stuttgart

"Time and Space died yesterday. We already live in the absolute, because we have already created eternal, omnipresent speed. … We will sing of … the vibrant nightly fervour of arsenals and shipyards with violent electric moons; greedy railway stations that devour smoke-plumed serpents; … deep-chested locomotives whose wheels paw the tracks like the hooves of enormous steel horses."[1] Thus Marinetti, in his *Manifesto of Futurism*, which appeared on the front page of *Le Figaro* on 20 February 1909, turned rallying places for urban crowds into meeting-points for the barter of goods and merchandise, symbols of that modernity with which Futurism had to connect. Stations, ports, factories and arsenals, melting-pots and crossroads of the currents of modern forces, all thrilled Futurist painters. Under the influence of his meeting with Marinetti in 1910, Carrà in turn celebrated subjects and sites where machinery encountered urban throngs. The station was at once the temple and the vortex of these energies. It was the framework for the panel of Boccioni's *States of Mind: The Farewells* (1911, cat. 20 and 24), and Gino Severini's *Suburban Train Arriving in Paris* (1915, cat. 113).

Unlike Boccioni, in *Milan Station* Carrà abandoned the psychologism bequeathed by Symbolism, as he did with the division-ist technique which he had still been using a few months earlier. His creation of a fragmented space corresponded to the dynamism of the locomotive, and the energy giving rise to its motion. The exploded cityscape was pushed back to the edges of the composition. Like a wedge, the machine penetrates the city, just like it makes its way into the consciousness—and the conscience. This obeyed the invitation made in *Futurist Painting: Technical Manifesto* to a perception made up of collisions and interpenetrations of forms: "Our bodies penetrate the sofas upon which we sit, and the sofas penetrate our bodies. The omnibus rushes into houses which it passes, and in their turn the houses throw themselves upon the omnibus and are blended with it."[2]

Carrà ignored the picturesque aspect of Milan's railway station, and used just its quality of being a hub of energy absorbing its users. He trapped them in a huge web in which their individual consciousnesses dissolved. According to the laws of energy peculiar to Futurist painting, the dynamism suggested here passes through the picture with a movement oriented towards the left of the composition, in other words against the direction in which images are often read.

B. M.

1 Marinetti, *Manifeste du futurisme*, in *Le Figaro*, 20 Feb. 1909; trans. as "The Founding and Manifesto of Futurism", in Apollonio (ed.), *Futurist Manifestos*, (London: Thames and Hudson, 1973 and 2001), p. 22.
2 Boccioni et al., *Manifeste des peintres futuristes*, in *Les Peintres futuristes italiens*, exh. cat., Galerie Bernheim-Jeune & Cie, Paris, 5–24 Feb. 1912, pp. 17–18; *Futurist Painting: Technical Manifesto*, in *Exhibition of Works by the Italian Futurist Painters*, Sackville Gallery, London Mar. 1912, republished in Apollonio, op. cit., p. 28.

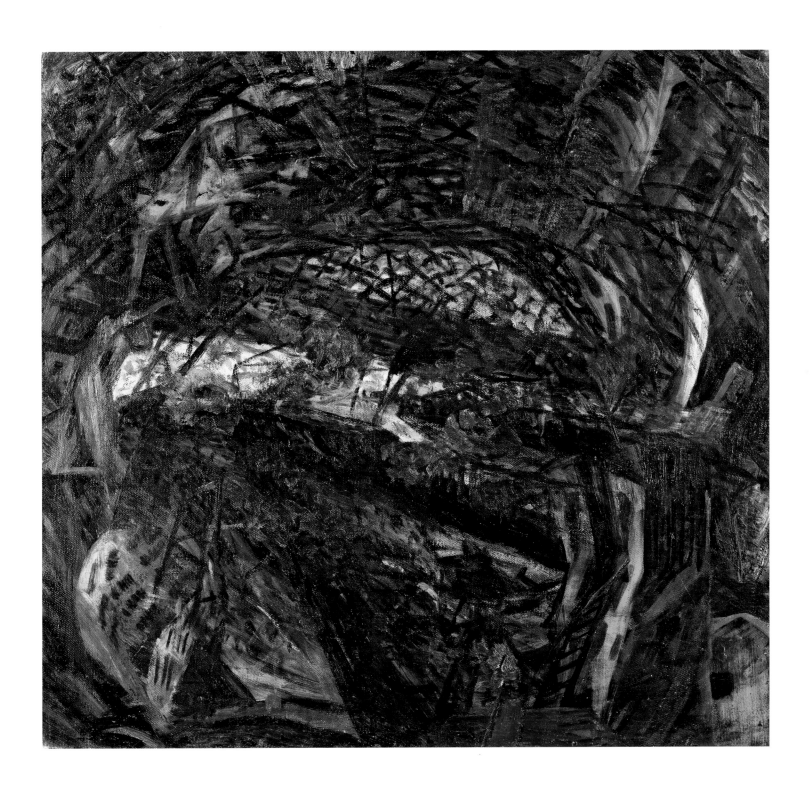

42 **Luigi Russolo**
La rivolta, 1911
[The Rebellion]
Oil on canvas, 150.8 x 230.7 cm
Collection Gemeentemuseum Den Haag, The Hague

In the catalogue for the Sackville Gallery exhibition in London, in March 1912, *The Rebellion* was described as being the illustration of "the collision of two forces, that of the revolutionary element made up of enthusiasm and red lyricism against the force of the inertia and reactionary resistance of tradition".[1] Russolo illustrated the sense of opposition inherent in this *Rebellion* by a specific use of form and colour. The atmosphere of political challenge and anarchistic tensions is rendered by the use of red, a colour that helps to capture the uproar and hubbub of the demonstration. Evidence for this is provided by the 1913 manifesto *The Painting of Sounds, Noises and Smells*, where Carrà would, lay claim to: "Reds, rrrrreds, the rrrrrreddest rrrrrrreds that shouuuuuuut."[2] At the end of the manifesto the painter also makes reference to different Futurist works, including Russolo's *The Rebellion*, within which "this bubbling and whirling of forms and lights, composed of sounds, noises and smells has been partly achieved".[3]

The impact of the red mass of the demonstrators, preceded by an explosion of yellow and green, is heightened by the penetrating form assumed by the crowd. Through a simple geometric vocabulary, Russolo renders perceptible the power of the group of rebels who "cross the canvas like arrows",[4] adopting the profile of a 45 degree angle. The city, represented by its blue buildings in the background, seems to shudder. We are seeing here a symbolic clash between popular power and traditional middle-class society, where "the perspective of houses is destroyed just as a boxer is bent double by receiving a blow in the wind [*sic*]".[5]

The demonstrators, depicted by small diagrammatic and repetitive silhouettes, are indistinguishable from one another. They blend into the same unity, giving the scene a certain universality. Hence, unlike Carrà's *Funeral of the Anarchist Galli* (1910–11, cat. 32), *The Rebellion* does not seem to be the account of any precise historical event. This "violently revolutionary"[6] picture echoes Marinetti's ideas, who, in the *Manifesto of Futurism*, declared that he wanted to "sing the great crowds excited by work, by pleasure and by riot; we will sing the multicoloured, polyphonic tides of revolutions in the modern capitals".[7]

Unlike other Futurist works shown at the Galerie Bernheim-Jeune in February 1912, *The Rebellion* does not appear to be influenced by Cubist pictures; only the geometric simplicity of the composition might betray a slight impact from French painters. On the other hand, the triangular shapes given pride of place by Russolo would inspire several artists close to the Futurist movement. Thus, in 1915, C. R. W. Nevinson chose this vocabulary of acute angles to convey the explosion of a shell pictorially in *Bursting Shell* (cat. 111). The American painter Max Weber likewise used a succession of acute angles, akin to that in *The Rebellion*, to convey the crowd movements of an American metropolis in *Rush Hour, New York* (1915, National Gallery of Art, Washington).[8] El Lissitzky, on his part, took inspiration from it for his *Rote Armee der Arbeiter und Bauern* [Monument to the Red Army] (1934, Izogiz, Moscow). *The Rebellion* was the work by Russolo that was met with the greatest acclaim in the press, being described as a "brilliant and original work" by a journalist in the *Daily Telegraph* when it was shown in London in March 1912.[9]

P. S.-L.

1 *Exhibition of Works by the Italian Futurist Painters*, exh. cat., London, The Sackville Gallery, Mar. 1912, p. 23.
2 Carrà, "La Pittura dei suoni, rumori, odori. Manifesto futurista" (11 Aug. 1913), *Lacerba* (Florence), vol. 1, no. 17, 1 Sept. 1913, and Carrà, *Tutti gli scritti*, (Milan: Feltrinelli, 1978) p. 21; trans. in Apollonio (ed.), *Futurist Manifestos*, (London: Thames and Hudson, 1973 and 2001), p. 112.
3 Carrà, op. cit.; tr. Apollonio, op. cit., p. 115.
4 Roche-Pézard, *L'Aventure futuriste : 1909–1916*, (Rome: École française de Rome, 1983), p. 6.

5 *Exhibition of Works by the Italian Futurist Painters*, p. 23.
6 Anon., "Yes, but the Futurists paint better", *Excelsior* (Paris), 5 Feb. 1912, p. 8; Zanovello Russolo, *Russolo l'uomo l'artista*, (Milan: Cyril Corticelli, 1958), p. 29.
7 Marinetti, *Manifeste du futurisme*, in *Le Figaro*, 20 Feb. 1909; trans. as "The Founding and Manifesto of Futurism", in Apollonio, op. cit., p. 22.
8 Weber could have known Russolo's *The Rebellion* as it was reproduced in an article on Futurism in the *New York Sun* (25 Feb. 1912), and in Eddy, *Cubists and Post-Impressionism*, (Chicago: A.C. McClurg &

Co, 2nd ed.; London: Richards, 1915). El Lissitzky, for his part, took inspiration from Russolo's canvas for his *Monument to the Red Army* (1934, Izogiz, Moscow).
9 Phillips, *Daily Telegraph* (London), 2 Mar. 1912; Russolo, op. cit., p. 29.

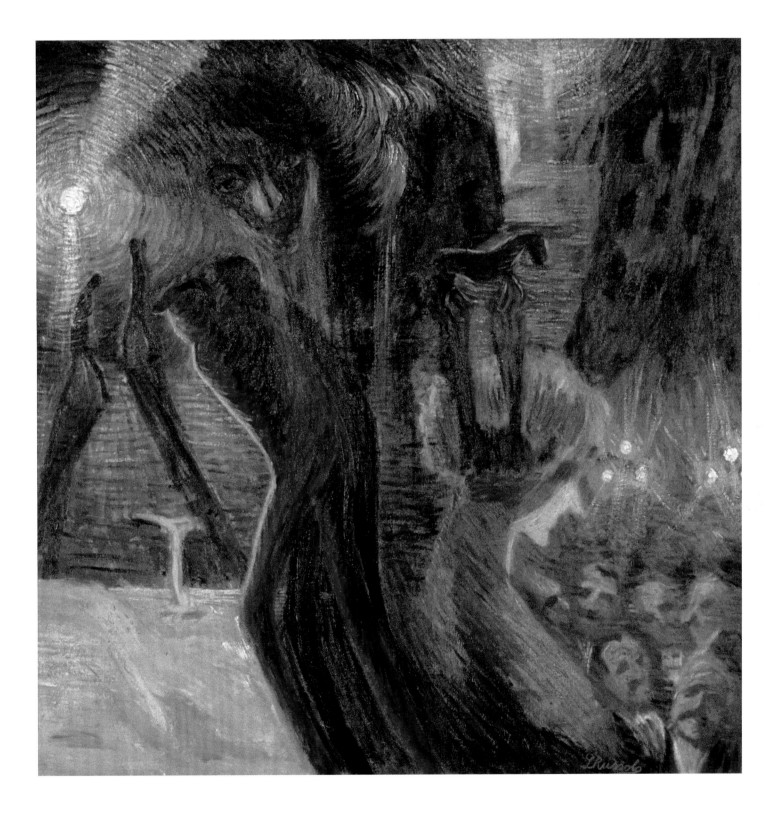

44 **Luigi Russolo**
 ***Chioma (I capelli di Tina),* 1910–1911**
 [Head of Hair (Tina's Hair)]
 Oil on canvas, 71.5 x 49 cm
 Private collection

In 1909, at the annual Famiglia Artistica art exhibition in Milan, Russolo encountered Carrà and Boccioni, with whom he developed a very close friendship. In the following year he met Marinetti and threw in his lot with Futurism, to which he made personal contributions, literary and musical, pictorial and sculptural. In 1913 the very specific interest he had in musical experimentation culminated in the publication of his *Art of Noises.*[1] His painting output, on which he embarked in 1909, was marked by powerful Symbolist and Divisionist influences, inspired by Gaetano Previati, and guided by Boccioni. This affinity is well illustrated by comparing his *Perfume* (1910, Museo di Arte moderna e contemporanea, Trento and Rovereto) with Boccioni's *Woman's Head* (1909–10, private collection). The two painters showed the same preference for an anti-naturalist chromatic vigour, for a wispy stroke and a synaesthetic expression (capable of merging different registers of sensations) as applied by Previati.

With Boccioni, Russolo created an almost supernatural model of femininity. The artist's young sister, already portrayed in two prints in 1906 (*Tina's Hair*) and 1910 (*Head of Hair*), was the model for this painting, also called *Tina's Hair*. Russolo turns the hair into the vehicle of a mysterious radiant force, comparable to the electric light haloing Boccioni's *Modern Idol* (1910–11, cat. 30). In a more explicit way than in Boccioni's work, however, Russolo endowed *Tina's Hair* with an esoteric power, rendered visible by the material quality of the shafts of blue light fanning out from her gaze. Consistent with his musical training, Russolo was seeking to transpose pictorially the spirituality and the undefined feelings peculiar to music. He sought out the equivalent of musical pitches and colours in harmonic chromatic chords, anticipating, in this way, the research undertaken by Orphism. His search for a multi-sensorial art transformed his painting into a dynamic and all-encompassing flow of energy, the equivalent of a sound wave in which space and figure tend to dissolve. Apollinaire, appreciating this musicalism which transcends artistic pigeon-holing, wrote of Russolo on the day after the exhibition of Futurist painters at the Galerie Bernheim-Jeune: "one must look for his mentors in Munich or in Moscow".[2]

C. Z.

1 *L'Arte dei rumori,* [11 Mar. 1913] Milan, July 1913; extracts trans. as *The Art of Noises,* in Apollonio (ed.), *Futurist Manifestos,* (London: Thames and Hudson, 1973 and 2001), pp. 74–88. Parallel to Russolo's booklet, Carrà published "La Pittura dei suoni, rumori, odori. Manifesto futurista" (11 Aug. 1913), *Lacerba* (Florence), vol. 1, no. 17, 1 Sept. 1913; trans. in Apollonio, op. cit., pp. 111–15.

2 Apollinaire, "La vie artistique. Les peintres futuristes italiens", *L'Intransigeant,* 7 Feb. 1912; trans. in Breunig (ed.) *Apollinaire on Art: Essays and Reviews 1902–1918,* (New York: Da Capo Press, 1972), p. 200.

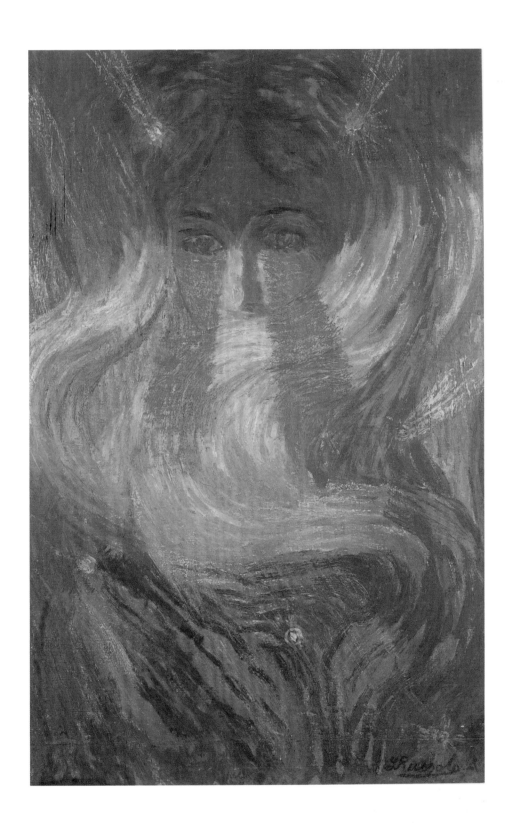

45　**Gino Severini**
La Danse du «pan-pan» au Monico, 1909–1911/1959–1960
[The Dance of the "Pan-Pan" at the Monico]
Oil on canvas, 280 x 400 cm / replica of the original work painted in Rome by the artist (1959–60)
Centre Pompidou, Musée national d'art moderne, Paris
Gift of Jeanne Severini and her daughters, 1967

The unusual scale of this work, combined with the exuberance of its colours, ensured that *The Dance of the "Pan Pan" at the Monico* would be eye-catching. When the dumbfounded Paris public discovered the canvases by the Italian Futurists on the walls of the Galerie Bernheim-Jeune in February 1912, Severini's painting established itself right away as the exhibition's main attraction. It exercised curious onlookers and art critics alike, and is one of the most commented-upon of all Futurist works. In spite of his reservations about the other pictures on view in the rue Richepance, Guillaume Apollinaire even described Severini's *"Pan Pan"* as "the most important work yet painted by a Futurist".[1]

The theme of *The Dance of the "Pan-Pan" at the Monico* probably helps to explain its relatively positive reception. This picture with its jolly, swirling rhythms originated in Severini's sorties which took him from the *Moulin de la Galette* to the *Bal Tabarin* and the *Rat mort* as soon as he arrived in Paris in 1906.[2] From the no less famous Monico, he brought back the preparatory drawings in which, from 1910 on, he had captured the dancing women, onlookers and decorative features which he would then use to compose his immense canvas.[3] The young painter's fascination with the nocturnal dazzle of the 'City of Light', with its serried ranks of cabarets, open-air cafés and restaurants where people danced [the *guinguettes*], and ordinary cafés and bars, definitely included the *"Pan Pan"* in a tradition extending from Henri de Toulouse-Lautrec, Pierre-Auguste Renoir and Édouard Manet through to the last works of Georges Seurat.[4] As a vibrant hymn to the nightlife spectacles of big cities, the work thus offered an arresting contrast to the latent violence of the other scenes which the Futurists were throwing in the face of visitors to the Galerie Bernheim-Jeune.

Whether the Paris critics came out somewhat in favour of or radically against the Futurists' proposals, in 1912 they were forever flushing out possible French influences in the canvases on view in the exhibition. There can be no doubt that the debt owed by *The Dance of the "Pan-Pan" at the Monico* to Post-Impressionism aroused the enthusiasm of Gustave Kahn who, just like Félix Fénéon (Bernheim-Jeune's artistic director), was numbered among the most ardent champions of both Georges Seurat and Paul Signac.[5] In order to convey movement and motion, which lay at the root of his concerns, Severini drew upon the Divisionist principle of colour deriving from the theories of Eugène Chevreul, Hermann von Helmoltz and Charles Henry, and strove to juxtapose areas of pure colour. Over and above the obvious tribute paid to the artist whom he regarded as his master,[6] this major painting was intended as an ambitious attempt to re-invent the Neo-Impressionist lesson. The painter abandoned the Divisionist touch dear to his elders in favour of schematic facets, colourful and whirling, which invaded the whole canvas. Inevitably, this procedure meant that the work produced would be unfailingly compared to a "great big jigsaw puzzle".[7] Some years later, and north of the Channel, David Bomberg would recall the kaleidoscopic effect created by the fragmentation of forms into geometric segments.[8]

In March 1912, the catalogue for the London stage of the Futurists' exhibition linked Severini's canvas with an acoustic atmosphere: "Sensation of the bustle and hubbub created by the Tsiganes, the champagne-sodden crowd, the perverse dancing of the professionals, the clashing of colours and laughter at the famous night-tavern at Montmartre."[9] The painter would even describe the work as "as a uniquely musical picture".[10] Contrasting lines, contrasting forms, and contrasting complementary colours: the optical vibrancy running across the surface of the canvas brings in a merry muddle of the objects, human forms and sounds which fill the Monico dance-hall, thus making the *"Pan Pan"* "the first pictorial creation of sounds and movement".[11]

At the Berlin exhibition of the Futurists, held at the Galerie Der Sturm in the spring of 1912, the picture was sold by Herwarth Walden to the German collector Borchardt, before it vanished from view, probably being destroyed during the war. So it was in a commemorative gesture, that Severini produced this replica canvas, based on a postcard and a painted enamel in 1959–60.

M.-L. B.

1 Apollinaire, "Les peintres futuristes italiens", *L'Intransigeant* (Paris), 7 Feb. 1912, p. 2; trans. in Breuning (ed.), *Apollinaire on Art: Essays and Reviews 1902–1918* (New York: Da Capo Press, 1972), p. 200.
2 Severini established a studio in the impasse Guelma on Montmarte which would be used as the starting-point for many a nocturnal excursion.
3 See Fonti, *Gino Severini, catalogo ragionato,* (Milan: Mondadori / Edizioni Philippe Daverio, 1988), pp. 121–22. In the end, it took him two years to complete the picture.
4 One thinks in particular of a canvas such as *Le Chahut* (1889–90, Kröller-Müller Museum, Otterlo).

5 Kahn observed that "people had certainly never seen any innovative movement this significant since the Pointillists' first exhibitions" (*Mercure de France* [Paris], 16 Feb. 1912, p. 868).
6 Severini would later write in *La Vita di un pittore,* (Milan: Edizioni di Comunità, 1965), p. 47; trans. Franchina as *The Life of a Painter* (Princeton: Princeton University Press, 1995), p. 35: "I chose Seurat as my master for once and for all and would do so again today."
7 "Severini's great big obvious puzzle is garish and shouts out. You have to blink (or even shut your eyes…) to make out one or two amusing details in the hurly-burly", wrote Vauxcelles

(*Gil Blas* [Paris], 6 Feb. 1912, p. 4.
8 Bomberg saw Severini's canvas at the *Exhibition of Futurist Painters,* Sackville Gallery, London, in March 1912. The influence is evident in works such as *In the Hold* (c. 1913–14, cat. 103) and *Ju-Jitsu* (c. 1913) both held in the Tate.
9 See *Exhibition of Works by the Italian Futurist Painters,* exh. cat., London, Sackville Gallery, March 1912, p. 25.
10 Letter from Severini to Soffici, 27 September 1913, quoted in Drudi Gambillo and Fiori, *Archivi del futurismo,* vol. 1, (Rome: De Luca, 1958), vol. 1, p. 292.
11 Ibid.

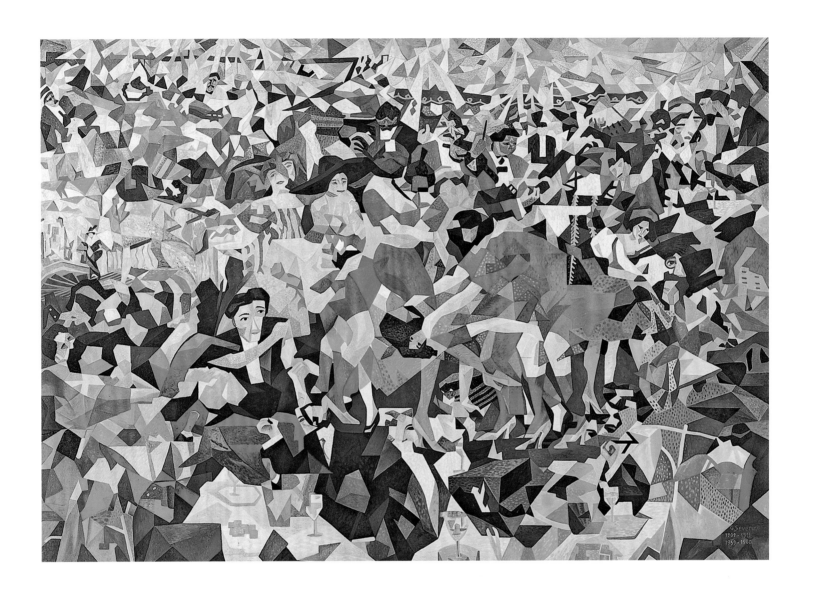

46 **Gino Severini**
Souvenirs de voyage, 1910–1911
[Memories of a Journey]
Oil on canvas, 80 x 100 cm
Private collection

We come across several references to this work in Severini's writings. In "The Plastic Analogies of Dynamism", written in 1913, Severini describes it thus: "I had realised the possibility of expanding *ad infinitum* the range of plastic expression, totally doing away with the unities of time and place with a painting of memory which brought together in a single plastic whole things perceived in Tuscany, in the Alps, in Paris, etc."[1] In 1931, Severini returned at greater length to this picture, specifying the intentions that had presided over its making: "I had an excessive wish to go beyond Impressionism in an absolute way, by destroying the subject's unity of time and place. Instead of grasping the object in its ambient surroundings, in its atmosphere, with the objects and things around it, I took it as a being apart, and I associated it with other objects and things which apparently had nothing to do with it, but which, in reality, were linked to it by my imagination, by my memories, and by a feeling. In the same canvas I brought together the Arc de Triomphe, the Eiffel Tower, the Alps, my father's head, a bus, the *palazzo communale* in Pienza, the boulevard …; this picture is perhaps the basis of all my art."[2]

The destruction of the "unity of time and place" was achieved by the juxtaposition and superimposition of objects represented from heterogeneous viewpoints. Severini put together a locomotive, two cars, various houses, the Arc de Triomphe, the Sacré-Coeur (but not the Eiffel Tower), trees, figures of differing proportions and colours, etc.; they were "individual beings put side by side", like toys stuffed into a box. Bright colours, contrasting with the grey and brown hues of Cubism, were preferred. Memories, for Severini, were not nostalgic but "an element of plastic intensification".[3] As a "painting of memories", the picture has often been likened to Henri Bergson's thinking. By the artist's own admission, it was after reading Bergson's *Introduction à la métaphysique* that he embarked on the painting.[4] Severini gave free rein to associations and leaps of memory, between the two affective poles of his life, Paris and his native Tuscany, the world of boulevards and the world of fields. Certain codes for landscape painting, the skyline, mountains in the distance, a certain rendering of near and far, admittedly jostling unceremoniously at times, have been retained, creating a powerful tension between unity and multiplicity. This tension was partly resolved by the radial structure of the composition: the figurative elements seem to revolve around the well, in the middle of the painting.

In his memoirs, Severini once more makes reference to this work, relating an anecdote that attests to his close links with the Parisian milieu of the day and in particular the almost daily dialogue that bonded him with Picasso: "I showed him my painting, *Souvenirs de voyage*, which he liked very much … A short while later in his studio on rue Ravignan, he showed me his painting, *Souvenir du Havre* [1912, private collection, Basel], completely different from mine."[5] After being shown for the first time at the *Exhibition of Futurist Painters* in Paris, in February 1912, *Memories of a Journey* went missing for a long time—Severini thought it had been destroyed during the war—and only reappeared recently.[6]

J. P.

1 Severini, *L'Art plastique néofuturiste* (1913, text translated into French by the author in 1957), published in Seuphor, *Dictionnaire de la peinture abstraite*, (Paris: Hazan, 1957), p. 92; the Italian version (of which there are numerous variants) was published under its initial title, *Le Analogie plastiche del dinamismo. Manifesto futurista*, (Sept.–Oct. 1913), in Drudi Gambillo and Fiori, *Archivi del Futurismo*, (Rome: De Luca, 1958), vol. 1, pp. 76–80; trans. as "The Plastic Analogies of Dynamism. Futurist Manifesto", in Apollonio (ed.), *Futurist Manifestos*, (London: Thames and Hudson, 1973 and 2001), p. 121.
2 Severini, "Processo e difesa di un pittore d'oggi",

L'Arte, no. 6, Nov. 1931, p. 525.
3 Severini 1913; trans. Apollonio, op. cit., p. 121.
4 Bergson, "Introduction à la métaphysique", *Revue de métaphysique et de morale*, Paris, [no. 1], Jan. 1903, pp. 1–36.
5 Severini, *La Vita di un pittore*, (Milan: Edizioni di Comunità, 1965), p. 118; trans. Franchina as *The Life of a Painter* (Princeton: Princeton University Press, 1995), p. 96.
6 This explains the mistaken measurement in Fonti, *Gino Severini: Catalogo ragionato*, (Milan: Mondadori, 1988), which gives 47 x 75 cm. What is more, the illustration reproduced there, like those in Courthion (*Gino Severini*, [Milan: Ulrico Hoepli

Editore, 1941], 2nd ed.) and Maritain ("Gino Severini", 1930 [*Brefs écrits sur l'art*, Paris: Mercure de France, 1999, pp. 59–72]), shows a light form in the middle of the sky. Coffin Hanson has shown that, in the absence of the original painting, a photograph had been made from a reproduction published in the *Sketch* in London in March 1912. This had been pasted into a scrapbook by Jeanne Severini and the glue had caused the mark in the sky; see Coffin Hanson, *Severini futurista: 1912–1917*, exh. cat., Yale University Art Gallery, New Haven, 18 Oct. 1995–7 Jan. 1996, pp. 63–4.

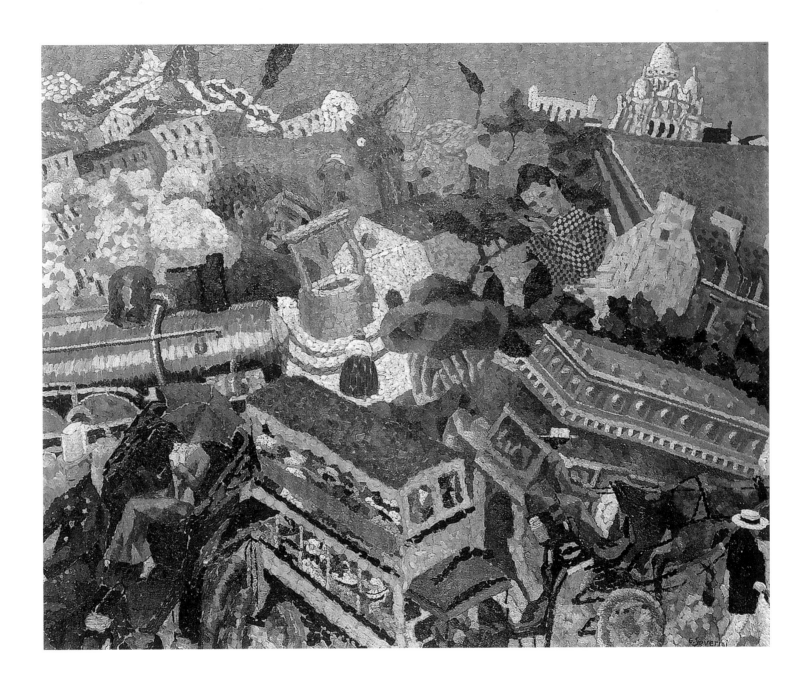

47 **Gino Severini**
Le Chat noir, **1910–1911**
[The Black Cat]
Oil on canvas, 54.4 x 73 cm
National Gallery of Canada, Ottawa / Purchased, 1956

Severini, who mixed with avant-garde artists and writers in Montmartre influenced by the beginnings of analytical Cubism, applied some of its principles in his canvases, particularly when it came to cutting up planes. His painting was nevertheless still associated with that of his Milan friends, both by virtue of the Neo-Impressionist technique he used and as a result of his desire to express simultaneity and dynamics. *The Black Cat* is a one-off in the painter's output as it summons up a literary reference to Edgar Allan Poe's novella of the same title. This short story recounts the devilish acts of a drunkard who blinds his cat before hanging it. The drama is continued in the revenge taken by a second black cat, which takes the role of the narrator, witness to the man's cruelty. Severini made only succinct reference to Poe's nightmarish short story, but in an evident manner: through the depiction of the two black cats, the one on the right as if obliterated, and the one on the left with a piercing, triumphant gaze (the only yellow touch in the entire composition), as well as by are allusion to alcoholism implicit in the glass of red wine in the foreground. The frontal composition of these narrative elements is part and parcel of coloured geometric planes. Their juxtaposition creates a reflecting mosaic of essentially blue and green hues, punctuated by brief coloured strokes applied to the canvas itself, leaving it visible in places. Severini grasped the dramatic elements of the narrative, steering the onlooker's eye from the two cats back to the glass, slightly off-centred, whose see-through quality plays with its shadow, as well as with the stain made probably by spilt wine.

As specialists have suggested,[1] this work was probably started in late 1910 and completed in 1911, just before *The Obsessive Dancer* (1911, cat. 48), in which the motif of the two black cats is again found in the lower part of the composition. These two pictures also proceed in a similar way in their fragmentation of strokes and planes, creating a colourful patchwork, even if the composition of *The Obsessive Dancer* is dynamic, where *The Black Cat* imposes a static quality reminiscent of the images described by the American writer. Severini may have actually intended to describe a sense of morbid oppression after reading Edgar Poe's tale.[2] This picture tallies with the period when the artist was striving to paint sensations, like Boccioni in his *States of Mind* (1911, cat. 20-25). What is more, *The Black Cat* contrasts with Severini's other works on view at the exhibition of Futurist painters in Paris in 1912 by the disconcerting immobility of the cats. Its title also links it with the famous Parisian cabaret in Montmartre, a place much frequented by artists at that time.

C. M.

1 See the entry on the work in *Gino Severini,* exh. cat., Palazzo Pitti, Florence, 25 June–25 Sept. 1983 (Milan: Electa 1983), p. 164.
2 Comment by the dealer Meyer in *Exhibition of Works by the Italian Futurist Painters,* exh. cat., Sackville Gallery, London, Mar. 1912, p. 26.

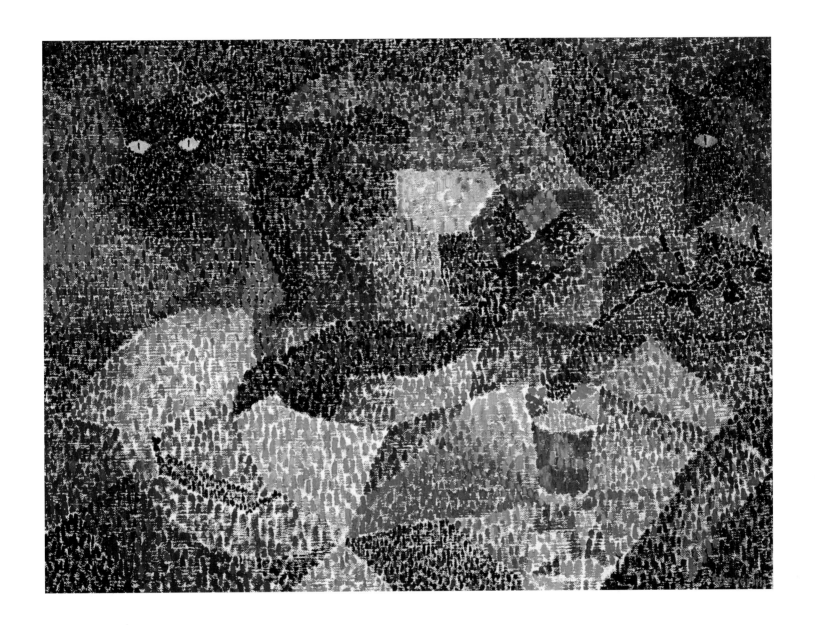

48 **Gino Severini**
 La Danseuse obsédante, **1911**
 [The Obsessive Dancer]
 Oil on canvas, 73.5 x 54 cm
 Private collection

As a recurrent theme in Severini's œuvre, dance inspired many pictures in his Futurist period (*The Dance of the "Pan-Pan" at the Monico* [1910–11/1959–60, cat. 45]; *The Blue Dancer* [1912, Peggy Guggenheim collection, Venice]). Nevertheless, the enigmatic figure of *The Obsessive Dancer* differs from the other cabaret 'darlings' painted by the artist; some critics liken the work to a dazzling depiction of a stage dancer.[1] This portrait of a woman, with a black cat—calling to mind the animal previously depicted in *The Black Cat* (1910–11, cat. 47)—is steeped in mystery. Duplicated (like the feline creature) in the foreground and in the upper part of the canvas, and illuminated by a cluster of light rays which fragment the face, this portrait, nothing less than a patchwork of colourful geometric figures, conjures up the composition of *The Milliner* (1910–11, cat. 50). Severini here manages to reconcile the Symbolist legacy of a melancholic atmosphere with the Neo-Impressionist optical perception of Georges Seurat. "The sum total of impressions, of past and present, near and distant, small or exaggerated of THE DANCER, according to the various states of mind of the painter who has studied her at many periods of his life …".[2] The canvas refers to the poetics of Boccioni's *States of Mind* (1911, cat. 20–25) and the theme of memory already transposed in other works, likewise exhibited in February 1912 at the Galerie Bernheim-Jeune: *Memorie of a Journey* (1910–11, cat. 46) and *The Voices of My Room* (1911, cat. 52).

By going beyond the Aristotelian conception of the unity of space and time, the artist here re-asserts the theory of simultaneity, dear to Futurist painters. Through a "synthesis" of sensations, memories and visual perceptions, he applies the principles set forth in the *Manifesto of Futurist Painters* of 1910: "A profile is never motionless before our eyes, but it constantly appears and disappears. On account of the persistency of an image upon the retina, moving objects constantly multiply themselves; their form changes like rapid vibrations, in their mad career. … We declare, for instance, that a portrait must not be like the sitter … To paint a human figure you must not paint it; you must render the whole of the surrounding atmosphere."[3] It is precisely this atmosphere, enveloping and obsessive, like memories, that emanates from this dancer.

Once again, the onlooker's eye is surprised and fascinated by the Cubist alteration of the face on the right of the composition: the face is broken up by intersecting planes; the eye is off-centre. We may suppose that what was involved here was a reminiscence of the right-hand figure of *Les Demoiselles d'Avignon* (1907, The Museum of Modern Art, New York).[4] Several years later, Severini would admit in his memoirs: "Was I closer to the Cubists or to the Futurists idiom? I confess that I did not worry about such matters at all."[5]

V. C.

1 See the interpretation by Martin, *Futurist Art and Theory 1909–1915*, (Oxford: Clarendon Press, 1968), p. 100, note 2: Severini has a precise recollection of May Belfort (painted on several occasions by Toulouse-Lautrec) who only ever went on stage holding her black cat.
2 See Severini, *Exhibition of Works by the Italian Futurist Painters*, exh. cat., London, The Sackville Gallery, March 1912, p. 26.

3 Boccioni et al., *Manifeste des peintres futuristes*, in *Les Peintres futuristes italiens*, exh. cat., Galerie Bernheim-Jeune & Cie, Paris, 5–24 February 1912, p. 16, Futurist Painting: Technical Manifesto, in Exhibition of Works by the Italian Futurist Painters, Sackville gallery, London, Mar. 1912, republished in Apollonio (ed.), *Futurist Manifestos*, (London: Thames and Hudson, 1973 and 2001), pp. 27–8.
4 Martin (op. cit., p. 101) suggests that Severini may

have seen the picture in 1911 in Picasso's studio, a fact mentioned by the Italian painter in his autobiography, *La Vita di un pittore*, (Milan: Edizioni di Comunità, 1965), pp. 79–80; trans. Franchina *The Life of a Painter* (Princeton: Princeton University Press, 1995), p. 62–3.
5 Severini, ibid., p. 126; trans. p. 103.

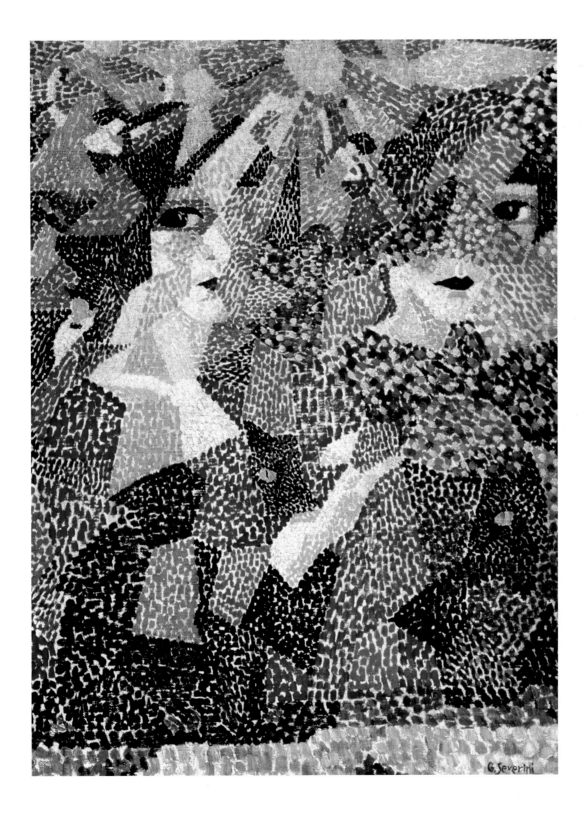

49 **Gino Severini**
***Danseuses jaunes*, c. 1911–1912**
[Yellow Dancers]
Oil on canvas, 45.7 x 61 cm
Harvard University Art Museums, Fogg Art Museum, Cambridge (MA)
Gift of Mr & Mrs Joseph H. Hazen, 1961

Among the eight canvases exhibited by Severini in February 1912 at the exhibition *Les Peintres futuristes italiens,* held in Paris at the Galerie Bernheim-Jeune, the *Yellow Dancers* directly announced the Orphic project of a painting able to suggest simultaneously sound, movement and light. The dynamism of the dancing figures, combined with the prismatic fragmentation of the light, is subjected here to a geometric transposition bordering on abstraction. As Severini wrote of a later painting: "On one side I group all the colours and forms of heat, of the dance, of joy, and on the other all the colours and forms of freshness, of transparency, of noises and sounds; while in the centre I bunch forms-colours in contrast to the forms-colours at the sides."[1]

The catalogue of the London stage of the exhibition of Futurist painters describes its "forms destroyed by electric light and movement."[2] This dissolution of form scrupulously respects a rule in *Futurist Painting: Technical Manifesto* which states that "movement and light destroy the materiality of bodies."[3]

Through many of his canvases—*The Obsessive Dancer* (1911, cat. 48), *The Dance of the "Pan-Pan" at the Monico* (1909–11/1959–60, cat. 45), *Dynamic Hieroglyph of the Tabarin Ball* (1912, The Museum of Modern Art, New York)— Severini helped make the dance one of the major themes of Futurism and part of its legacy. It was also one of Picabia's favourite subjects in 1912–14 (see in particular *Dances at the Spring I*, cat. 62; *Udnie*, cat. 63 and *I See Again in Memory My Dear Udnie*, cat. 64). However, with its analytical approach and the practical application of optical and kinetic theories, the *Yellow Dancers* might rather be linked with some Balla's works, such as the *Girl Running on a Balcony* (1912, cat. 49). Severini, who was the most Parisian of the Italian Futurist painters, worked his way from Symbolist Divisionism—bequeathed by Previati, Segantini and Pellizza da Volpedo, and acquired during his training in Italy—to the Futurist aesthetics that was connected to French cultural circles. The *Yellow Dancers* reveal the influence of scientific theories concerning the 'dematerialisation' of bodies by X-rays,[4] and of the Neo-Impressionist breakdown of light by Seurat, a seminal master for Severini.[5] "Yes, I'd like my colours to be diamonds and to be able to use them plentifully in my pictures to make them more sparkling with light and richness."[6] It was through their shared attachment to the lessons of Post-Impressionism that Severini, like Delaunay, Metzinger and a few others, would overcome the anti-Impressionism, regarded as anathema during the early days of Cubism, and place colour at the centre of their pictorial research.

V. C.

1 Statement by Severini published in *L'Araldo poliziano* (Montepulciano, a town in Tuscany where the painter briefly sojourned), 13 Sept. 1914, in reply to the criticism of a columnist in the same magazine on 6 Sept. 1914; quoted by Gage, "Severini's Socks or the Dancing Colours", in *Gino Severini, The Dance 1909–1916*, exh. cat. Peggy Guggenheim Collection, Venice, 26 May–28 Oct. 2001, (New York: The Solomon R. Guggenheim Foundation, 2001), pp. 34–5.
2 *Exhibition of Works by the Italian Futurist Painters*, exh. cat., The Sackville Gallery, London, March 1912, p. 26.
3 Boccioni et al., *Manifeste des peintres futuristes* (11 avril 1910), *Les Peintres futuristes italiens*, exh. cat., Galerie Bernheim-Jeune & Cie, Paris,

5–24 February, 1912, p. 21; *Futurist Painting: Technical Manifesto*, in *Exhibition of Works by the Italian Futurist Painters*, Sackville Gallery, London Mar. 1912, republished in Apollonio (ed.), *Futurist Manifestos*, (London: Thames and Hudson, 1973 and 2001), p. 30.
4 Ibid., p. 17; ibid. p. 28 reads: 'Who can still believe in the opacity of bodies, since our sharpened and multiplied sensitiveness has already penetrated the obscure manifestations of the medium? Why should we forget in our creations the doubled power of our sight, capable of giving results analogous to those of the X-rays?' See also Martin, *Futurist Art and Theory 1900–1915*, (Oxford: Clarendon Press, 1968), pp. 101–2.

5 Severini wrote in *La Vita di un pittore* [1946], (Milan: Edizioni di Comunità, 1965), p. 47; trans. Franchina *The Life of a Painter* (Princeton: Princeton University Press, 1995), p. 62–3. "I chose Seurat as my master for once and for all and would do so again today". The Seurat retrospective held in 1908 at Bernheim-Jeune and the republication in 1911 of the theoretical book by Signac *D'Eugène Delacroix au néo-impressionnisme* were basic sources for Severini.
6 Letter of 1910 published by Pontiggia, "Una lettera futurista', *Questarte*, no. 49, March 1986, pp. 5–42 and Pontiggia, 'Il primo rapporto sul Cubismo: lettera di Severini a Boccioni", *Critica d'Arte*, LII/12, Jan.–Feb. 1987, pp. 62–70.

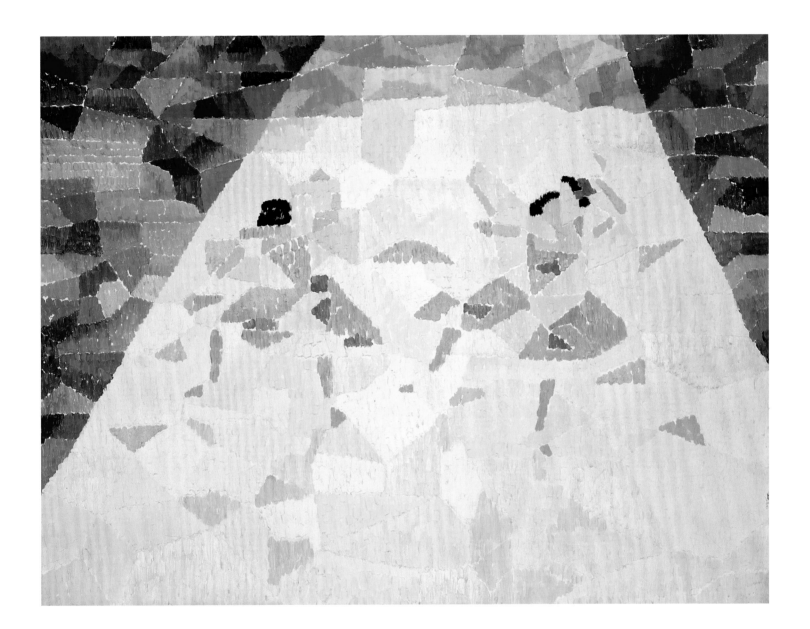

50 **Gino Severini**
La Modiste, c. 1910–1911
[The Milliner]
Oil on canvas, 64.8 x 48.3 cm
Philadelphia Museum of Art, Philadelphia
Gift of Sylvia and Joseph Slifka, 2004

In *The Milliner*, Severini chooses a subject resorted to on numerous occasions by Henri de Toulouse-Lautrec, Edgar Degas and Pablo Picasso.[1] This—now archetypal—female figure is undoubtedly an echo of his contemporary dancers, *The Dance of the "Pan-Pan" at the Monico*, (1910–11, cat. 45), *Dynamic Hieroglyph of the Bal Tabarin* (1912, The Museum of Modern Art, New York) and expresses the dynamic rhythm of forms and colours and, in particular, "An arabesque of the movement produced by the twinkling colours and iridescence of the frills and furbelows on show, the electric light dividing the scene into defined zones. A study of simultaneous penetration".[2]

The intense dynamic energy and the power of the colour, present in other Severini works, (*Memories of a Journey*, 1910–11, *Yellow Dancers*, c. 1911–12, cat. 46 and cat. 49), are extremely emphatic in this picture. Two clusters of light rays, coming from the top of the canvas, and calling to mind those in *The Obsessive Dancer* (1911, cat. 48), light up the face of the figure, whose profile is enlivened by an array of prismatic colours and planes, pierced by the light.

In *The Milliner* we find once more the idea of the movement of light, rotating and radiant, centripetal and centrifugal, illustrated in Severini's significant manifesto, *The Plastic Analogies of Dynamism*: "All sensations, when they take artistic form, become immersed in the sensation Light, and therefore can only be expressed with all the colours of the prism. Painting and modelling forms, other than with the entire spectrum of colours, would mean suppressing one of the sources of life in the object, that of *irradiation*. The coloured expression of the sensation Light, in accordance with our spherical expansion in space, can only be centrifugal or centripedal [*sic*] with relation to the organic structure of the work."[3]

Compared with the other pictures exhibited by Severini at the Galerie Bernheim-Jeune in February 1912, *The Milliner* attests to the artist's distance with regard to the Pointillist touch—still present in works such as *The Obsessive Dancer* and *Black Cat* (1910–11, cat. 47 and 48)—in favour of a thicker brush stroke and a dense rendering of the paint. For the patchwork of juxtaposed geometric figures, *The Milliner* can be likened to *The Boulevard* (1911, cat. 51); the dynamic breakdown of the forms, however, does not tally with any abstract spatial logic, but is intended to suggest the undulating rhythm of the ribbons and trimmings of the workshop of a hat maker.

The work has aroused controversy over its dating. Although mentioned in the painter's memoirs, where he says he produced it in 1910 at Civray, in Charente, during one of his stays with his friend Pierre Declide, it would appear not to have been actually completed until the following year.[4] Severini returned to this theme in 1916 with various studies and sketches, combining Futurist and Cubist features and culminating in a print published in the magazine *Sic*, under the title *The Milliner*.[5]

V. C.

1 See Toulouse-Lautrec, *The Milliner*, (1900, Musée Toulouse Lautrec, Albi); Degas, *The Milliners*, (1882–83, Musée d'Orsay, Paris) and *The Ironers*, (1884, Musée d'Orsay, Paris); and subsequently Picasso, *The Milliner's Workshop*, (1926, Musée national d'art moderne, Paris).
2 *Exhibition of Works by the Italian Futurist Painters*, The Sackville Gallery, exh. cat., Sackville Gallery, London March 1912, no. 32, p. 26.
3 Severini, *Le analogie plastiche del dinamismo. Manifesto futurista* (Sept.–Oct. 1913); in Drudi

Gambillo e Fiori, *Archivi del futurismo*, (Roma: De Luca, 1958), vol. 1, p. 76–80; trans. as "The Plastic Analogies of Dynamism. Futurist Manifesto", in Apollonio (ed.), *Futurist Manifestos*, (London: Thames and Hudson, 1973 and 2001), p. 124. The French version of this text was written by Severini in 1957, and published under the title *L'Art plastique néofuturiste* (1913–14), reissued in Seuphor, *Dictionnaire de la peinture abstraite*, (Paris: Hazan, 1957), p. 94.
4 A letter of invitation from Pierre Declide to Severini

of 26 June 1911 suggests that the picture was completed the following year. Severini, *La Vita di un pittore*, (Milan: Edizioni della Comunità, 1965), p. 70; trans. Franchina *The Life of a Painter* (Princeton: Princeton University Press, 1995), p. 55. See Fonti, *Gino Severini. Catalogo ragionato*, (Milan: Mondadori / Edizioni Philippe Daverio, 1988), p. 119.
5 *Sic*, Paris, no. 8–10, Aug.-Oct. 1916. See Fonti, op. cit., pp. 249-50 (nos. 263–64).

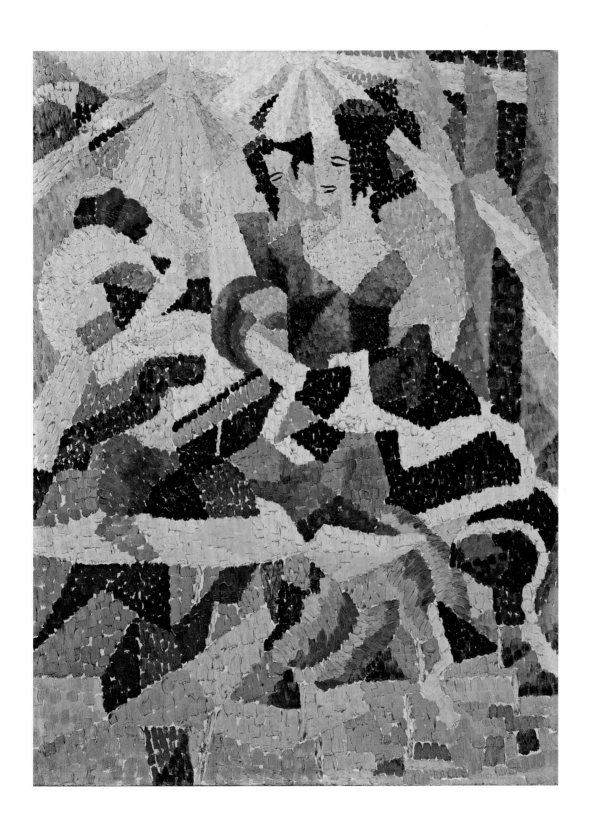

51 **Gino Severini**
Le Boulevard, 1911
[The Boulevard]
Oil on canvas, 63.5 x 91.5 cm
Estorick Collection, London

The Boulevard has been interpreted as a transposition of the verses of Jules Romains' epic poem, *La Vie unanime* [The Unanimous Life],[1] in which the modern city regains a positive value, having been regarded in late nineteenth-century poetry as the crucible of every manner of social vice and deviance. The metropolis, identified by Severini as Paris, is a place dear to the hearts of the Unanimists, a space in which the individual gains access to his private essence, and finds fulfillment through contact with urban energies, in the way he merges with the throng. Severini's "Unanimism" overlaps with the Futurist celebration of the big city, whose frenzied pace contrasts with the old-fashioned nature of a backward-looking civilization. In this work, the painter defines the general principles upon which he bases his interpretation of Futurist dynamism and the concept of simultaneity.

What is transforming the boulevard?
The pace of the passers-by is barely physical.
These are no longer movements, they are rhythms,
And I do not need my eyes to see them.
The air we breath has an almost mental taste.
Men resemble ideas brushing against a spirit … [2]

The Boulevard highlights what distinguishes Severini's dynamic vision from that of his Futurist companions. Drawing inspiration from Georges Seurat's chromatic analysis,[3] he develops his own ideas about complementarism and colour comparison and juxtaposition. The evocation of the feverish movement of the Paris thoroughfare no longer has to do with the impressionistic dusty haze of the atmosphere (see *Spring in Montmartre*, 1909, private collection), but rather with a technique of allusive and musical transposition, relating to the energy of the scene. The divisionist touch gives way to a marquetry of coloured planes, alternating between figuration (trees and passers-by, albeit diagrammatically depicted, can be identified) and abstraction. In addition to heightening the decorative tendency of Severini's painting, this procedure emphasises the dynamic function of colour and its suitability when it comes to suggesting reliefs and depths.

The Boulevard thus gives rise to experiments which Severini would develop in his manifesto *Neo-Futurist Plastic Art*: "Complementarity in general or Divisionism of analogous colours makes up the technique of colour analogies … using colour analogies one can obtain the greatest luminous intensity, heat, musicality, optical and constructional dynamism."[4]

As nothing less than a patchwork of geometric figures, *The Boulevard*—whose structure calls to mind that of the "great puzzle" of *The Dance of the "Pan-Pan" at the Monico* (1909–11, cat. 45)—was seen by David Bomberg when it was shown at the London *Exhibition of Italian Futurist painters*;[5] this is attested to by the composition of some of the English painter's own works (see *Ju-Jitsu*, c. 1913; *In the Hold*, c. 1913–14, cat. 97, both Tate).

D. O.

1 Fonti, *Gino Severini, Catalogo ragionato*, (Milan: Mondadori / Edizioni Philippe Daverio, 1988), no. 92, p. 117.
2 Romains, *Intuitions*, La Phalange, Paris, no. 2, 15 Aug. 1906, p. 107.
3 Severini regarded the French painter as his master: "I chose Seurat as my master once and for all and I still feel the same way today" ["Io elessi Seurat come maestro una volta per tutte e ancora oggi

penso così."]. See Severini, *La Vita di un pittore*, (Milan: Ed. della Comunità, 1965), p. 47; trans. Franchina as *The Life of a Painter* (Princeton: Princeton University Press, 1995), p. 35.
4 Id., *Le Analogie plastiche del dinamismo. Manifesto futurista*, (Sept.–Oct. 1913), in Drudi Gambillo and Fiori, *Archivi del Futurismo*, (Rome: De Luca, 1958) vol.1, pp. 76–80; trans. as "The Plastic Analogies of Dynamism. Futurist Manifesto", in Apollonio (ed.),

Futurist Manifestos, (London: Thames and Hudson, 1973 and 2001), p.123.
5 *Exhibition of Works by the Futurist Italian Painters*, exh. cat., The Sackville Gallery, London, March 1912. In the catalogue (p. 26), the work is described thus: "Light and shadow cut up the bustle of the boulevard into geometrical shapes."

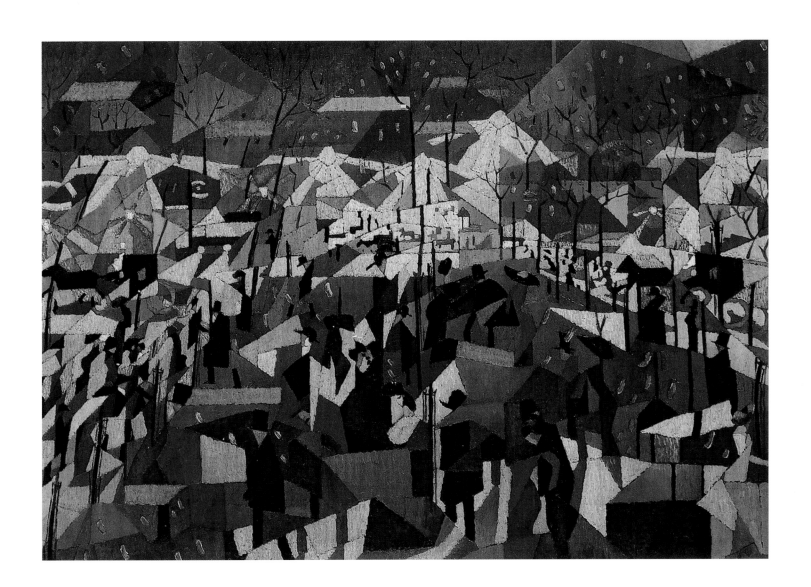

52 **Gino Severini**
Les Voix de ma chambre, 1911
[The Voices of My Room]
Oil on canvas, 37.7 x 55.2 cm
Staatsgalerie Stuttgart, Stuttgart

In 1956, in the preface to his exhibition at the Galerie Berggruen in Paris, Severini recalled the way in which he had tried to reconcile Cubism and Futurism: "My first contact with Seurat's art, having adopted him once and for all as my master, greatly helped me to express myself in accordance with two simultaneous and often contrasting aspirations."[1] *The Voices of My Room* illustrates the path he embarked upon between 1911 and 1915. Having gone to Paris to penetrate "both the letter and the spirit of Seurat's œuvre"[2] he then took up Neo-Impressionist Divisionism, using it extensively in *The Black Cat* (cat. 47), and with more moderation in this picture. The small strokes of paint, covering the surface of the canvas with a host of flowers and leaves, are more connected with each other in the middle of the composition, giving the illusion of various flat tint areas.

Faithful to their perceptions as 'colourists' advocated by the painters in their *Technical Manifesto* of 1910,[3] Severini adopted a vivid language heightened by clear shades, a chromatic violence of intense blues, greens and ochres which set him apart from the Cubists. However, Severini retained from Picasso (whom he discovered at Kahnweiler's early in 1911) and Braque (whom he met after visiting the famous room 41 at the Salon des Indépendants in the spring of the same year) the same subject-matter: everyday objects like pipes, packets of tobacco, glasses and newspapers, and their break-down, their geometric fragmentation: a chandelier in pieces, distorted books.

In illustrating the diverse range of Futurist solutions, Severini brilliantly mixed different modes—Cubist, Futurist, Neo-Impressionist—in this mysteriously titled work. The *Voices* here are those of objects arranged on the bedside table, an allusion to the noiseless life of things, or a 'pictorial description' of a state of mind, the very title that Boccioni, who was becoming interested in psychological transcription, was to give to his triptych *States of Mind* (cat. 20-25).

I. M.

1 Severini, "Preface", *Severini: œuvres futuristes et cubistes*, exh. cat., Galerie Berggruen, Paris, 1956, n.p.
2 Ibid.
3 Boccioni et al., *Manifeste des peintres futuristes*, in *Les Peintres futuristes italiens*, exh. cat., Galerie Bernheim-Jeune & Cie, Paris, 5–24 Feb. 1912; *Futurist Painting: Technical Manifesto*, in *Exhibition of Works by the Italian Futurist Painters*, Sackville Gallery, London Mar. 1912, republished in Apollonio (ed.), *Futurist Manifestos*, (London: Thames and Hudson, 1973 and 2001), p. 29.

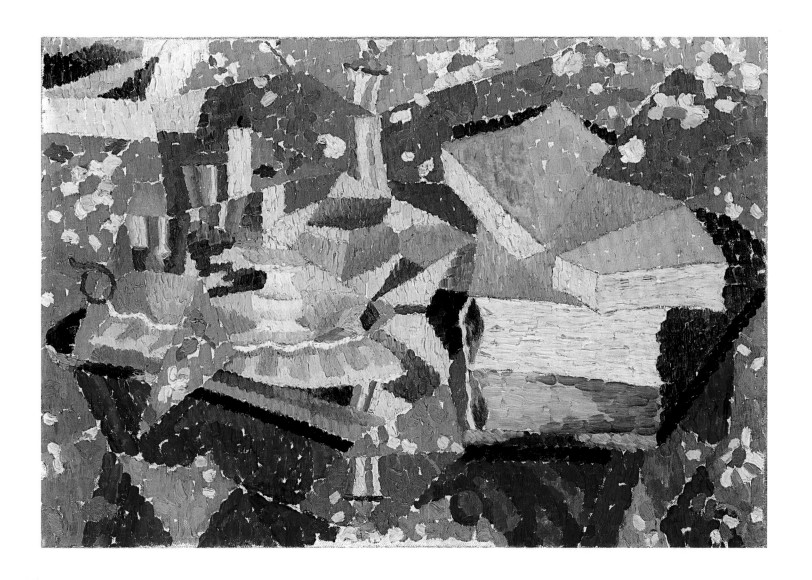

53 **Félix Del Marle**
 Le Port, **1913**
 [The Port]
 Oil on canvas, 80.8 x 64.8 cm
 Musée des Beaux-Arts de Valenciennes, Valenciennes

The Port, a large composition (about 300 x 190 cm) which can probably be regarded as Del Marle's greatest Futurist achievement, was exhibited at the 1914 Salon des Indépendants and noticed by Apollinaire, who observed that: "This year, Futurism has begun to invade the Salon".[1] This work, whose whereabouts are today unknown, marked the critics' recognition of Del Marle: "The French Futurist Delmarle [sic] is exhibiting a picture that is not without interest, in which one can detect the influence of Albert Gleizes."[2]

Several studies, including this one, which was probably the last, help us to grasp what the final version looked like. The composition remains identical from one study to the next: the ship fills the centre of the canvas, formed by two open ellipses organised around a central axis which lends structure to the whole. This construction in the form of a broken ellipse creates a powerful dynamic tension and seems to be the preferred form of Del Marle's Futurist compositions. The large flat areas, in the middle of the picture, contrast markedly with the harbour surroundings, rendered by a proliferation of colourful strokes crossed by dovetailed lines. The central void, essential in Marinetti's theory, is thus presented here, placing the viewer at the hub of the action.

"We have abandoned the motif completely developed on the basis of its frozen and consequently artificial balance, but, as in music, we suddenly intersect each motif by one or more others, where we only give the initial, central, and final notes. In our canvases you may see marks and spots, lines and areas of colour which apparently do not match any reality … Referring just to the lines, they may be confused, 'somersaulting', or curved but they will produce a chaotic frenzy of feelings … The same goes for colours as for sounds."[3] The result is an immersion in the busy activity of port life, witnessing the symphony of modern life with its noises, smells and colours, in a simultaneity complying with the main Futurist theories.

This work parallels a theme that Picasso had explored in 1912 in *Souvenir du Havre* (private collection, Basel), a canvas which Marinetti regarded as obvious evidence of the painter's susceptibility to Futurist ideas. The theme and its treatment call to mind the invitation proffered by Carrà: henceforth pictures would express "the plastic equivalent of the sounds, noises and smells found in theatres, music-halls, cinemas, brothels, railway stations, ports".[4] This plastic synthesis of port life may plausibly be associated with Del Marle's experience on board a steamship of the Compagnie des Chargeurs Réunis, between 1907 and 1909. The stencilled words 'New York', 'U.S.A.', 'Touraine', 'Niagara', so many intrusions of reality into the pictorial space, are akin to the techniques used by Braque and Picasso. The synthetic depiction is thus anchored in reality to conjure up the record transatlantic crossing made by the *Touraine* (6 days and 21 hours) and its arrival in New York, the model city of modernity. But the compenetration of planes and the synthesis of perceptions of this ship, which merges with its surroundings, plunge the viewer into a confused state, where departure, crossing, and arrival are intermingled.

J. C. L.

1 Apollinaire, "Le 30ᵉ Salon des indépendants", *Les Soirées de Paris*, no. 24, March 1914, p. 184; trans. in Breunig (ed.) *Apollinaire on Art: Essays and Reviews 1902-1918*, (New York: Da Capo Press, 1972), p. 365.
2 Id., "Au Salon des indépendants", *L'Intransigeant*, 5 March 1914; ibid., pp. 358-9.
3 Del Marle, "Un peintre futuriste à Lille" *Le Nord illustré* (Lille), 5ᵗʰ year, no. 8, 15 April 1913, pp. 122–3.

4 Carrà, *La Pittura dei suoni, rumori, odori. Manifesto futurista*, (11 August 1913), *Lacerba* (Florence), vol.1, no. 17, 1 Sept. 1913, pp. 185–7; trans. Apollonio (ed.), *Futurist Manifestos*, (London: Thames and Hudson, 1973 and 2001), p. 114.

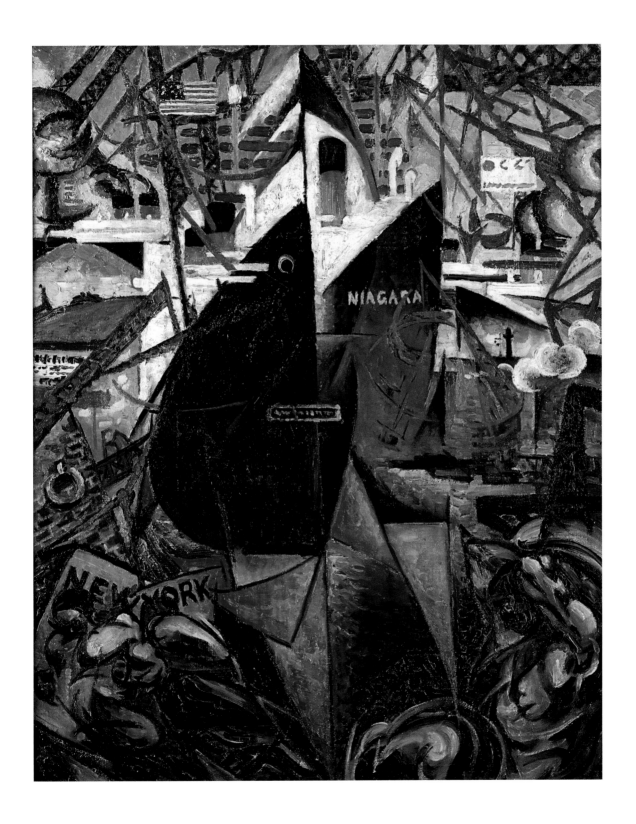

54 **Robert Delaunay**
La Ville de Paris, 1910–1912
[The City of Paris]
Oil on canvas, 267 x 406 cm
Centre Pompidou, Musée national d'art moderne, Paris / Purchased, 1936
Attribution, 1937 / On permanent loan to the Musée d'Art moderne de la Ville de Paris, 1985

Delaunay spent the first two years of his painter's training in the workshops of the theatrical set designer Eugène Ronsin.[1] It was probably because of his mastery of the large format that, in an exceptionally short period of time, he managed to produce the composition which he dispatched to the Salon des Indépendants in 1912.[2] That undertaking was nothing less than an amazing feat. Delaunay had undoubtedly heard Guillaume Apollinaire's call for a return to "vast subjects"[3] in painting, and *The City of Paris* displayed monumental proportions which enabled him to rival the "grandes machines" traditionally earmarked for Salons.

When the canvas was shown at the Indépendants, the response to the Futurists was still ringing in Parisians' ears. Hardly a month had elapsed since the Italians strode upon the Paris scene, at the 'shocking' exhibition organised by the Galerie Bernheim-Jeune. The Italian painters had at that time challenged the artistic leadership of the French capital in the preface to their catalogue, an unusually cheeky text which fulminated against the Cubists: "They obstinately continue to paint objects motionless, things frozen, and all the static aspects of nature; they worship the traditionalism of Poussin, of Ingres, of Corot, ageing and petrifying their art with an obstinate attachment to the past, which in our eyes remains totally incomprehensible … It is indisputable that several of the aesthetic declarations of our French comrades display a sort of masked academicism."[4] Paying no heed to these accusations, Delaunay rooted his picture firmly in an historical line. Right away, the three-part division of the canvas—the parts being unified by the transparent quality of coloured planes—included the canvas within a lengthy pictorial tradition. From El Greco to the Douanier Rousseau, the many different references and quotations gradually appearing as the frieze unfurls attest, furthermore, to the desire to be included in the wake of those he regarded as his masters.[5] By putting the ancient motif of the Three Graces in the middle of his composition, the painter rehabilitated the nude, a classical subject if ever there was one, whose banishment from painting for a ten-year period had been clamoured for by the Futurists, who reckoned that its prolific reproduction had "transformed the Salons into arrays of unwholesome flesh!"[6]

The French alternative to Futurism, as proposed by Delaunay, aroused Apollinaire's enthusiasm, the latter regarding *The City of Paris* as the Salon's most important canvas and tauntingly hailing it as "the advent of a conception of art that seemed to have been lost with the great Italian painters".[7] Yet, beyond its rejection of their principles, the work seems to illustrate an affinity, in terms of quest, with the Futurists. Delaunay, after all, wrote to Sam Halpert that "what they're saying is okay"![8] Looming out of his earlier works, the elements of an urban iconography, symbols of modern life (buildings, roofs, the Eiffel Tower ablaze), found their way into the fresco and existed side by side with Pompeiian figures. Delaunay might have lambasted a Futurist transcription of the dynamism which he regarded as purely mechanical and designed after the model of the cinematograph,[9] but the accelerated unfolding that gradually took place as the eye roamed over the canvas, based on a "cinematic" process, conjured up the solutions explored by the Futurists. Lastly, the synthesis of mental images evoking the past, present and future of the city undoubtedly referred back to what Boccioni had attempted: to convey a "simultaneity of ambience" in his *States of Mind* (1911, cat. 20-25).

On the eve of the great duel that pitted Delaunay against the Futurists,[10] he retraced the stages of his artistic career and claimed that his research had come first. *The City of Paris* valiantly withstood the assaults of the Italian painters, and seemed to be the first attempt at any kind of synthesis between Cubism and Futurism.

M.-L. B.

1 Between 1901 and 1902.

2 The canvas might have been produced between early February and mid-March 1912. See Spate, *Orphism: The Evolution of Non-Figurative Painting in Paris 1901–1914*, (Oxford: Clarendon Press, 1979), p. 182.

3 Apollinaire, preface to the catalogue of the 8th annual Salon des indépendants, Brussels, Cercle d'art, 10 June–31 July 1911; trans. in Breuning (ed.), *Apollinaire on Art: Essays and reviews 1902–1918*, (New York: Da Capo Press, 1972), p. 172.

4 Boccioni et al., "Les exposants au public", in *Les Peintres futuristes italiens*, exh. cat., Galerie Bernheim-Jeune & Cie, Paris, 5–24 Feb. 1912, pp. 2–3; trans. as "The Exhibitors to the Public", in Apollonio (ed.), *Futurist Manifestos*, (London: Thames and Hudson, 1973 and 2001), p. 46.

5 Delaunay borrowed the view of the Seine embankments from the Douanier Rousseau's *Moi-même – portrait-paysage* (1890, Národní Galerie, Prague).

6 Boccioni et al., *Manifeste des peintres futuristes*, in *Les Peintres futuristes italiens*, exh. cat., Galerie Bernheim-Jeune & Cie, Paris, 5–24 Feb. 1912, p. 22; *Futurist Painting: Technical Manifesto*, in *Exhibition of Works by the Italian Futurist Painters*, Sackville Gallery, London Mar. 1912, republished in Apollonio (ed.), *Futurist Manifestos*, (London: Thames and Hudson, 1973 and 2001), p. 30.

7 Apollinaire, "Le Salon des indépendants", *L'Intransigeant* (Paris), 19 March 1912; trans. in Breuning, op. cit., p. 212.

8 Letter of February 1912 (Bibliothèque nationale de France. Delaunay Collection), quoted in *Robert Delaunay 1906-1914. De l'impressionnisme*

à l'abstraction, exh. cat., Paris, Musée national d'art moderne, 3 June–16 Aug. 1999 (Éd. du Centre Pompidou, 1999), p. 157.

9 Delaunay, *Du cubisme à l'art abstrait*. Hitherto unpublished documents, published by Francastel and followed up by a catalogue of Delaunay's œuvre by Habasque, (Paris: SEVPEN, 1957), p. 142; trans. Shapiro and Cohen in *The New Art of Color: The Writings of Robert and Sonia Delaunay*, Cohen (ed.), New York 1978.

10 The quarrel over Orphism which broke out in late 1913 carried on until 1914 in the European press: *Lacerba* (Florence), *Der Sturm* (Berlin), *Les Soirées de Paris* and *Paris-Journal*. See also Ester Coen, *Simultaneity, Simultaneism, Simultanism* in this volume.

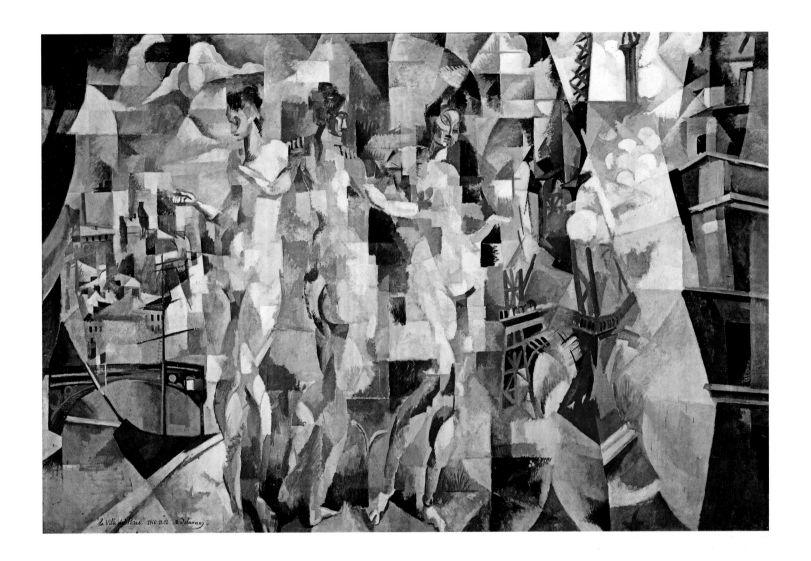

"La Ville de Paris" 1910-11-12 R Delaunay

55　　**Fernand Léger**
La Noce, **1911–1912**
[The Wedding]
Oil on canvas, 257 x 206 cm
Centre Pompidou, Musée national d'art moderne, Paris
Gift of Alfred Flechtheim, 1937

The only work submitted by Léger to the Salon des Indépendants in March 1912, with the title *Composition with Figures* affixed to the back of the canvas, with an unusual format for those days, marked a major turning-point within the Cubist research being carried out by the painter. From 1909 on he had been pursuing the breakdown of the image into many facets, planes and volumes, creating bumpy, uneven effects. From Cézanne's legacy Léger remembered that drawing "should be rigid, and not in the least bit sentimental",[1] a principle which he applied in this picture. In it, the painter associated figurative and abstract elements with undisguised exultation, referring to a subject while at the same time wanting not to give in to any referent. "Striving to make his canvas non-sentimental (the opposite of the theme chosen)", Léger said that he "had been inspired by self-consciously posed wedding photos".[2] These may well have been photos of the wedding of his boyhood friend, the artist André Mare, which was celebrated in July 1910. In his critique of the Salon des Indépendants, Apollinaire reported: "Léger's picture is an example of pure painting: no subject, a great deal of talent."[3] Following a vertical construction, the narrative features (a series of houses around a bell tower, a row of trees, the newly-weds in the middle, hands being shaken and seeking each other, guests layered one on top of the other) were confined in small spaces invaded by vaporous white and hazy ochre masses, tending to erase the dynamic motif. These geometric and moving forms, clouds and haze with black outlines, frame the bustle of the wedding, lending it an aerial dimension. Léger, like Delaunay, was associated with the Section d'or artists, and here re-introduced the colour and movement abandoned by Braque and Picasso, as well as a subject more akin to those chosen by the Futurist painters, like Severini, who from 1909 painted numerous pictures with dance as their subject. The composition itself is the product of a Futurist inspiration—or anticipation—that the undated canvas, an unusual omission for Léger, might underscore. This picture was probably finished late in 1911 or early in 1912.[4] According to Christopher Green, the painter might have reworked the canvas in 1912, between the respective openings of the exhibition of Futurist painters at Bernheim-Jeune in February, and the Salon des Indépendants in March, drawing inspiration in particular from the *Farewells* canvas (cat. 24) in Boccioni's *States of Mind* series (cat. 20-25).[5] It might, conversely, also be a matter of an influence Léger had on the Italian painters who had visited his studio in the autumn of 1911. As an "unfinished work that will only impress the well-informed viewer",[6] according to Apollinaire, also designated as "a masterpiece of Cubism"[7] by Alfred Flechtheim (who purchased the canvas in 1912–13), *The Wedding* ably illustrates Léger's uniqueness within Cubism: the painter jolted the fragmentation of spaces, freed up colour and veered towards a vibrant dynamism akin to the Futurists, thus establishing a personal plastic and aesthetic vocabulary.

C. M.

1 Léger quoted in Le Noci, *Fernand Léger, sa vie, son œuvre, son rêve,* (Milan: Edizioni Apollinaire, 1971), p. 70; *Œuvres de Fernand Léger au Musée national d'art moderne,* (Paris: Éd. du Centre Pompidou, 1981), p. 20.
2 Léger, "Conversation avec Albert Elsen" (written communication from Elsen, 3 June 1979); *Œuvres de Fernand Léger au Musée national d'art moderne,* op. cit., p. 22.

3 Apollinaire, "Les 'Indépendants'. Les nouvelles tendances et les artistes personnels", *Le Petit Bleu,* 20 Mar. 1912; trans. in Breunig (ed.) *Apollinaire on Art : Essays and Reviews 1902–1918,* (New York: Da Capo Press, 1972), p. 220.
4 See also *Sketch for the Wedding,* oil, 1912, private collection, *Œuvres de Fernand Léger au Musée national d'art moderne,* op. cit., pp. 19–22.
5 Green, *Léger and the Avant-Garde,* (New Haven

and London: Yale University Press, 1976), pp. 42–45.
6 Apollinaire, "Vernissage aux Indépendants", *L'Intransigeant,* 3 Apr. 1912; trans. Breunig, op. cit., p. 215.
7 Alfred Flechtheim to Georges Huisman, London, 7 Feb. 1937; *Œuvres de Fernand Léger au Musée national d'art moderne,* op. cit., p. 22.

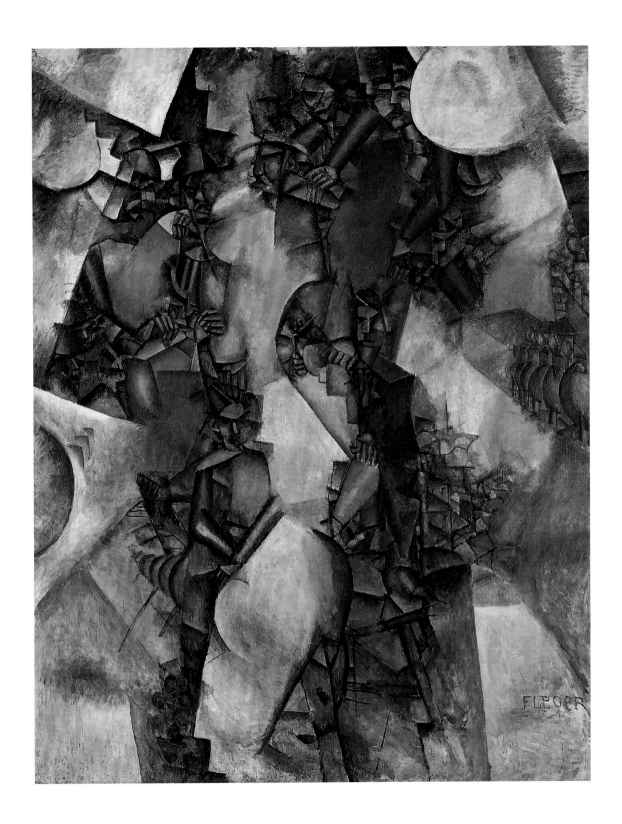

56 **Jean Metzinger**
Danseuse au café, 1912
[Dancer in the Café]
Oil on canvas, 146.1 x 114.3 cm
Albright-Knox Art Gallery, Buffalo (NY) / General Purchase Funds, 1957

Metzinger's *Dancer in the Café* is one of the most eloquent plastic expressions of the dialogue that began in Paris between Cubism and Futurism. By way of Max Jacob, Metzinger was introduced at the end of 1907 into the Cubist grouping that gravitated around Picasso (Georges Braque, André Derain, André Salmon and Guillaume Apollinaire, among others). Metzinger's *Nude*, which he showed at the 1910 Salon d'Automne, made him a pivotal figure of Cubist research—a position facilitated by the deliberate withdrawal of Braque and Picasso from participating in the Paris Salons. With its radical formalism, his *Nude* was clearly inspired by contemporary paintings by Picasso. In room 41 of the Salon des Indépendants of 1911, which for the first time brought together the artists claiming membership of the Cubist movement, Metzinger exhibited four canvases including a portrait of his wife (*Portrait of Madame Metzinger*, 1911, Philadelphia Museum of Art) and *Two Nudes* (1910–11, destroyed), whose 'softened' Cubism tempered the radical nature of his 1910 work. Drawing closer to Gleizes, with whom, from 1911 onwards, he wrote the first theoretical treatise devoted to Cubism,[1] his art became more susceptible to Bergsonian ideas of movement, duration and challenges to Cubist formalism. "Formerly a picture took possession of space, now it reigns also in time", he wrote in 1911.[2] This switch in his work made him more receptive to the values and iconography of his friend Severini, a painter with whom he shared a Post-Impressionist past and a passionate interest in the work of Georges Seurat.

In February 1912, at the exhibition of Italian Futurist painters organised in Paris by the Galerie Bernheim-Jeune, Severini brought together three of the many pictures he had devoted to dance: *The Dance of the "Pan-Pan" at the Monico,* 1909–11 cat. 45, *Yellow Dancers,* c. 1911–12, cat. 49, and *The Obsessive Dancer,* 1911, cat. 48). The capturing of movement, shifting lines as it goes, was alien to Cubist inspiration (a Cubism for which, symptomatically, the still life was then the main subject). Like Gleizes and Delaunay, who appropriated subjects associated with sport (such as *The Footballers* of 1912–13 and *The Cardiff Team* of 1913, cat. 57), Metzinger painted *Dancer in the Café,* which owes as much to Severini's many dancers as to memories of Seurat (see *The Can-Can*, 1889–90, Kröller-Müller Museum, Otterlo).

In the same year as he painted his dancer, Metzinger joined the artists who met every Sunday on the heights of Puteaux, in Villon's studio. He was one of the principal architects of the Salon de la Section d'or which, in October 1912, attested to the recent development of Cubism in its many different component parts (it was at this Salon that Apollinaire referred to an "exploded Cubism").[3] In accordance with the Salon's title, an ideal of equilibrium and construction borrowed from tradition (that of Leonardo da Vinci) was claimed by the leading Section d'or figures. It was this exercise in equilibrium that was accomplished by the *Dancer in the Café,* reconciling Futurist dynamism and the constructive element issuing from mathematical Cubist speculations (those popularised by the 'mathematician Princet', and those which Villon found in ancient manuals). With this piece, Metzinger worked out one of those numerous "Cubist interpretation[s] of a Futurist formula"[4] among those which, in the years 1912–14, helped to give birth to the broad scope of Cubo-Futurism.

D. O.

1 Gleizes and Metzinger, *Du "cubisme"*
(Paris: Éditions Eugène Figuière, 1912).
2 Metzinger, "Cubisme et tradition", *Paris-Journal,*
16 Aug. 1911, p. 5; trans. in Fry, *Cubism,*
(London: Thames and Hudson, 1966), p. 67.
3 On 11 October 1912, within the premises
of the Galerie La Boëtie, Apollinaire gave the first
Salon de la Section d'or lecture, titled "L'écartèlement
du cubisme" [The Dismemberment of Cubism].

4 Cabanne, *Entretiens avec Marcel Duchamp,* [1967]
(Paris: Somogy éditions d'art, 1995), p. 43;
trans. as *Dialogues with Marcel Duchamp,*
(London: Thames and Hudson, 1971), p. 35.

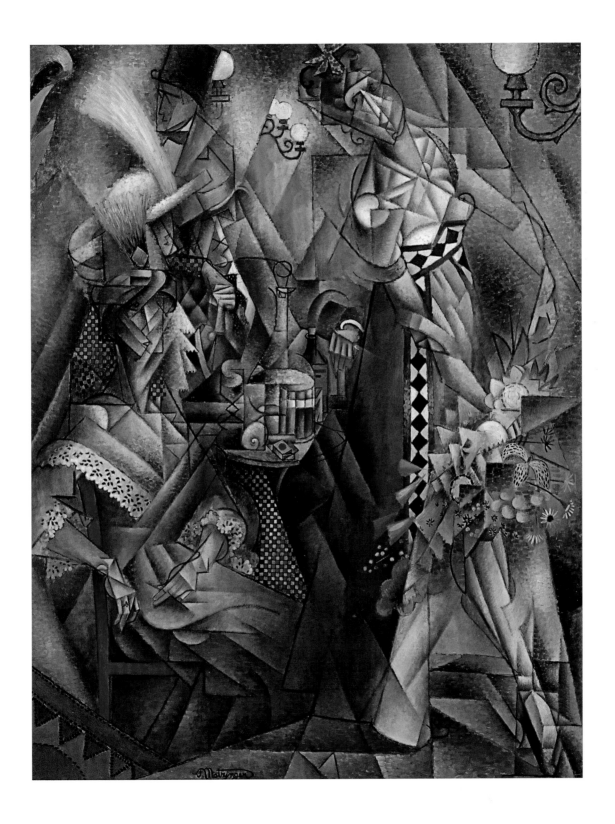

57 **Robert Delaunay**
L'Équipe de Cardiff (3ᵉ représentation), **1912–1913**
[The Cardiff Team (3ʳᵈ representation)]
Oil on canvas, 326 x 208 cm
Musée d'Art moderne de la Ville de Paris, Paris

With *The Cardiff Team*, Delaunay produced a painting about modern life: sport, conquest of air, ordinary pastimes, the visual culture of the poster and the advertisement are all conjured up, signified and magnified.[1] In his review of the 1913 Salon des Indépendants, where the picture was shown for the first time, Guillaume Apollinaire hailed the "definitely popular character" of the canvas.[2] In the foreground Delaunay depicted a sporting scene.[3] At the top of the picture are arrayed three themes that recurred in the painter's œuvre: the Eiffel Tower, the Big Wheel, and the biplane.[4] Between these three structures and the jumping rugby player, there is a powerful visual and symbolic affinity, around the theme of impetus and momentum.

In comparison to *The City of Paris* (1910–12, cat. 54), *The Cardiff Team* goes beyond Cubist positions towards a reduction of fragmentation and a free use of colour contrasts, peculiar to Orphism: "The Women of *The City of Paris*", the painter wrote in 1924, "sums up the Cubist period. … *The Cardiff Team*, 1913, is more significant in the expression of colour, less shattered. The yellow poster in the complete picture contrasts with the blues, greens, and orange."[5]

After erasing the motif in the previous *Windows* cycle, Delaunay returned, with *The Cardiff Team*, to painting a subject. "The subject", wrote Apollinaire, again in his report on the Salon, "has come back into painting, and I am more than a little proud to have foreseen the return of what constitutes the very basis of pictorial art."[6] The assertion reveals Apollinaire's U-turn since his negative view on the Subject in painting uttered in his accounts of the Futurist show at the Galerie Bernheim-Jeune in February 1912.[7]

By making modern life the central theme of his picture and by putting 'simultaneity' at the heart of his aesthetics, Delaunay moved the aims that had theoretically separated the analytical style of Cubist still-lifes and the dynamic style of Futurist *modernolâtres* pictures. It was around these two points—the return of the subject and the aesthetics of simultaneity—that the quarrel between Futurism and Orphism was first launched in 1913.

In an essay on *The Cardiff Team*—one of the triggers of the polemic—Apollinaire compared simultaneity and Orphism: 'Here is Orphism. … This is simultaneity. … This is the new tendency in Cubism'.[8] The critic made no mention of the Futurists whereas the term lay at the core of the preface to the catalogue for the 1912 Futurist exhibition.[9] The passage was in large part borrowed by Boccioni in his article "The Futurists Plagiarised in France" which, in a tone of bitter irony, accused the Orphists of plagiarism: "They are copying us while pretending to know nothing about us!"[10] Delaunay, for his part, asserted the earlier date of his discovery of simultaneity and stood aloof from Futurist dynamism, which he described as "mechanised", and a "simulacrum of motion".[11] But without going into detail about this argument,[12] we should point out, over and above any polemic, the gap existing between Delaunay's canvas and the Futurist aesthetic. When Futurist 'simultaneity' bent the field of vision along the force lines of one or more moving objects, Delaunay sought the "simultaneism of colours": "The rhythmic representation of colours, which is not dynamic, successive, or even the movement of visual perception, but is rather the harmonic simultaneity of colours. The movement of colours that creates art in painting."[13] Futurism proceeded by the folding, merging and colliding of lines and colours; *The Cardiff Team* derived more from the aesthetics of 'montage'.[14] The comparison of the Delaunay canvas with Boccioni's *Dynamism of a Footballer* (1913, The Museum of Modern Art, New York) reveals the distance separating the two artistic stances. The dynamic explosion of the Italian picture contrasted with the 'harmonic' use of colours in the Delaunay painting, as if in a state of weightlessness.

J. P.

1 In 1913 he produced two other canvases on the same subject (now in the collections of the Bayersrische Staatsgemäldesammlungen in Munich and the Stedelijk Van Abbemuseum in Eindhoven).
2 Apollinaire, 'À travers le Salon des indépendants', *Montjoie !* (Paris), supplement no. 3: "Numéro spécial consacré au XXIXᵉ Salon des indépendants", 18 Mar. 1913, p. 4; trans. in Breunig (ed.) *Apollinaire on Art: Essays and Reviews 1902–1918*, (New York: Da Capo Press, 1972), p. 291.
3 Delaunay drew upon a photograph published in "Match Toulouse-SCUF", *Vie au grand air*, 18 Jan. 1913, see *Robert Delaunay 1906–1914. De l'impressionnisme à l'abstraction*, exh. cat., Musée national d'art moderne, (Paris: Centre Pompidou, 1999), p. 185.
4 The Eiffel Tower was a theme explored almost obsessively by Delaunay from 1909. Severini tells how he had to give up painting the Eiffel Tower, which had become a 'Delaunian' trademark; see *La Vita di un pittore,* (Milan: Ed. di Comunità, 1965), p. 149; trans. Franchina as *The Life of a Painter*

(Princeton: Princeton University Press 1995), p. 122.
5 Delaunay, "À Sam Halpert?", *Du cubisme à l'art abstrait*, new documents published by Francastel and followed by a catalogue of Delaunay's œuvre by Habasque, (Paris: SEVPEN, 1958), p. 98, trans. Shapiro and Cohen in *The New Art of Color: The Writings of Robert and Sonia Delaunay*, Cohen (ed.), New York 1978, p. 36.
6 Apollinaire 1913, trans. Breunig, op. cit., p. 292; Apollinaire wrote this in relation to *The Footballers* by Gleizes (1912–13), presented at the same Indépendants as *The Cardiff Team*.
7 "The Italian Futurists declare that they will not abandon the advantages inherent in the subject, and it is precisely this that may prove to be the reef upon which all their good will will be dashed to bits." Apollinaire, "Les peintres futuristes italiens", *L'Intransigeant*, 7 Feb. 1912; trans. Breunig, op. cit., p. 199.
8 Apollinaire 1913, trans. Breunig, op. cit., pp. 290–1.
9 Boccioni et al., "Les exposants au public", *Les Peintres futuristes italiens*, exh. cat., Galerie Bernheim-Jeune & Cie, Paris, 5–24 Feb. 1912, p. 4

trans. as "The Exhibitors to the Public", in Apollonio (ed.), *Futurist Manifestos*, (London: Thames and Hudson, 1973 and 2001), p. 47.
10 Boccioni, "I futuristi plagiati in Francia", *Lacerba*, vol.1, no. 7, 1 Apr. 1913, p. 66.
11 See Delaunay, "Simultanisme de l'art moderne contemporain. Peinture. Poésie" (Oct. 1913), in *Du cubisme à l'art abstrait*, 1958, pp. 109–12. trans. as "Simultanism in Contemporary Modern Art, Painting, Poetry", in Cohen *The New Art of Color* (New York, 1978), pp. 47–51.
12 On this quarrel, see Coen's article 'Simultaneity, simultanéism, simultanism', in this volume, p. 52.
13 Delaunay, "La peinture est proprement un langage lumineux (Cortège d'Orphée)" [c. 1924?], *Du cubisme à l'art abstrait*, 1958, p. 168; trans. as "Painting is by Nature, A Luminous Language (The Orphic Group)", in Cohen, op. cit., pp. 103–4.
14 Rousseau, "La construction du simultané. Robert Delaunay et l'aéronautique", *Revue de l'art* (Paris), no. 113, Oct. 1996, p. 22.

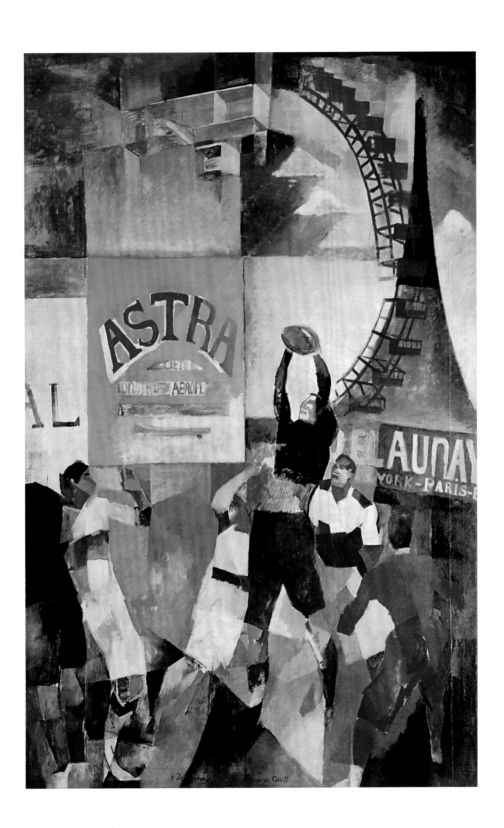

58　**Sonia Delaunay**
La Prose du Transsibérien et de la petite Jehanne de France, 1913
[Prose of the Trans-Siberian Railway and of Little Jehanne of France]
Watercolour and relief print on paper, 195.6 x 35.6 cm
Tate, London / Purchase, 1980

In November 1913, the modest publishing house Éditions des Hommes nouveaux, founded by Blaise Cendrars, published his poem *Prose of the Trans-Siberian and of Little Jehanne of France*, illustrated by Sonia Delaunay. With this 'first simultaneous book', the artists reasserted the authorship of the concept of simultaneous painting, to which the Futurist painters had laid claim.[1] Even before its publication,[2] this poem-painting fuelled a heated argument between the Delaunays, the Italian Futurists, and followers of the Abbaye de Créteil group, in particular the poet Henri-Martin Barzun, with each of them claiming to be the first to introduce the concept. "The poem of the Trans-Siberian gave rise to much discussion and debate in the various newspapers and reviews both in Paris and abroad. Orphism had come into full swing. From the moment simultaneism appeared, there was a great to do about it. … The book, however, was duly praised by a number of sophisticated critics and the poem was read in Paris, in the *Montjoie* loft, which at the time was the meeting place of the French avant-garde."[3] It was this debate which prompted Sonia Delaunay and Blaise Cendrars to write, in a letter addressed to André Salmon on 12 October 1913: "The simultaneism of this book lies in its simultaneous and non-illustrative representation. *The simultaneous contrasts of colours* and the *text* form depths and movements which are the *new inspiration*."[4]

This 'poem-painting' is presented in the form of a tall, narrow sheet of paper with the verses of the poem on the right, printed in more than ten different typefaces and highlighted with colours, corresponding on the left with an interwoven tracery of colourful arabesques by Sonia Delaunay: "It was a sheet of paper measuring 2 m by 0.36 m, which was intended to be seen and read vertically and lengthwise. For this reason, the work was a veritable picture that could obviously be hung. But it was also a book insofar as it could be scaled down like a simple volume: it then took on the form of a complicated folded sheet, similar to road maps."[5] The poem which describes the long journey from Moscow to Paris, made by a young poet and the prostitute Jehanne de France, is itself an ode to rhythm, light and colour. Numerous references to the painter's profession punctuate the text: "If I were a painter, I would pour a lot of red and a lot of yellow over the end of that journey." Music is also very present in this text which the author dedicates "to musicians":[6] "Blaise Cendrars and Mme. Delaunay-Terk have made a first attempt at written simultaneity where colour contrasts accustom the eye to read, at a single glance, the entirety of a poem, the way a conductor reads at a single glance the notes of a score."[7] Landscapes file past the poet's eyes, offering the whole wealth and diversity of modern life, also rendered perceptible by Sonia Delaunay's colourful symphony. The throbbing rhythms of the Trans-Siberian, in which the poet travels "wrapped in a multi-coloured plaid", offer a synchronous response to the painter's colourful rhythms which culminate in the evocation of a flamboyant Eiffel Tower—the composition's only 'figurative' element—conjured up in the final lines of the poem: "Paris / City of the Single Tower of the great Gallows and the Wheel."

The whole, which is devised to be seen, read and heard at the same time, gives rise to a simultaneity of sensations which calls to mind the ambitions of the Futurists. This book achieves a synthesis between poetry, painting and music, which corresponds to Marinetti's wish to produce a total art of the kind aspired to by the Russian avant-gardes. Many Russian Futurists were both poets and painters. As early as 1912 they published an impressive series of lithographed books conceived as a pictorial surface combining words and drawings. On 22 November 1913, at his lecture "The Simultaneous", which he gave in *The Stray Dog*, a St. Petersburg art club, Alexander Smirnov presented the Russian public with a copy of the *Prose of the Trans-Siberian* … If this work managed to be a catalyst in the squabble between Cubists, Futurists and Orphists over the authorship of the concept of simultaneity, this was because it illustrated the aims shared by these movements, and the symbiosis at work between their values in around 1913.

J. C. L.

1 See in particular the articles by Boccioni: "I futuristi plagiati in Francia", *Lacerba* (Florence), vol.1, 1 April 1913, pp. 66–8, and "Simultanéité futuriste", *Der Sturm* (Berlin), no. 190–1, December 1913, p. 151; also discussed by Ester Coen in her essay "Simultaneity, Simultaneism, Simultanism" in this volume. 2 Blaise Cendrars had previously launched a subscription bulletin in April 1913, then handed out a prospectus to the press of the day. In addition, the original maquette of the Sonia Delaunay composition (left side of the book-to-be) was exhibited in October

1913 at the Erster Deutscher Herbstsalon in Berlin. 3 Delaunay, "Sonia Delaunay-Terk", *Du cubisme à l'art abstrait*, previously unpublished documents published by Francastel and followed by a catalogue of the work of Delaunay by Habasque, (Paris: SEVPEN, 1958), pp. 201–2; tr. Shapiro and Cohen in *The New Art of Color: The Writings of Robert and Sonia Delaunay*, Cohen (ed.), New York 1978, p. 134. 4 This letter sent care of *Gil Blas* (in response to the article "La dernière invention" by Salmon, which appeared the day before in the daily newspaper)

was not published. Sidoti, *Genèse et dossier d'une polémique. La Prose du Transsibérien et de la petite Jehanne de France, novembre-décembre 1912–juin 1914*, (Paris: Lettres modernes, 1987), p. 59. 5 Ibid., p. 26. 6 Sidoti (ibid., p. 28) nevertheless points out that the 1913 edition, unlike the following ones, had no dedication and was, according to Sonia Delaunay, the only one that tallied with the "real intentions of the authors". 7 Apollinaire, "Simultanisme-Librettisme", *Les Soirées de Paris*, no. 25, 15 June 1914, pp. 323–4.

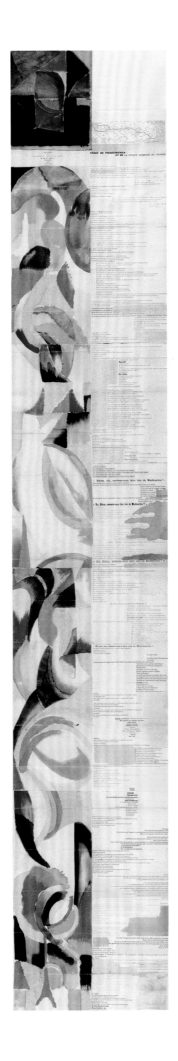

59 **Marcel Duchamp**
Nu descendant un escalier n° 2, 1912
[Nude Descending a Staircase No. 2]
Oil on canvas, 147 x 89.2 cm
Philadelphia Museum of Art, Philadelphia
The Louise and Walter Arensberg Collection, 1950

In December 1911, Duchamp embarked upon a painting of a figure descending a staircase. Some time before this, his interest in the chrono-photographs of Étienne Jules Marey—which he probably discovered in the magazine *La Nature*—prompted him to explore ways of pictorially expressing movement. In January 1912, he completed the second version of his *Nude Descending a Staircase*, in which the "wood-coloured" chromatic range, as Duchamp himself called it, was the same as in contemporary Cubist pictures. At the Salon des Indépendants, of which the opening was planned for 20 March, the work would feature in the room which housed artists affiliated with Cubism. When Gleizes and Metzinger discovered the *Nude Descending a Staircase*, they objected to its overly visible links with the canvases that the Italian Futurist painters had just exhibited at the Galerie Bernheim-Jeune, in their show that had closed on 24 February. The resounding success of the Futurist exhibition and the challenge made by it to the predominance of Parisian painting encouraged the Cubists to close ranks. This controversial backdrop prompted a vexed Duchamp to take down his picture from the walls of the Salon des Indépendants (its presence in the show is attested to in the Salon catalogue).

In New York, a year later, the *Nude Descending a Staircase* became the star attraction in the Armory Show.[1] It was popularised in comic competitions by appropriations made by cartoonists working for major American papers (*The American Art News* invited its readers to "find the woman" in it). Well removed from the chauvinism of the Paris art scene, in the United States Duchamp freely admitted his sympathies for the value laid claim to by Futurist painters. Interviewed by the American press, he declared that Georges Seurat was "the greatest scientific mind of the nineteenth century, greater in this sense than Cézanne."[2] Though in no way giving in to Futurist anti-nostalgic iconoclasm, he further declared: "I think your idea to demolish old buildings and old memories is a good one."[3]

For some time already, like the painters of the Italian avant-garde, he had subscribed to the anarchist cult of fierce individualism (a glorification of the ego which he got from Max Stirner), showing a loyalty to a psychologism rooted in symbolism, illustrated by his *Sad Young Man in a Train* (1911, Peggy Guggenheim Collection, Venice), which followed on from several genuinely Symbolist works. To show how close his research was to the work of the Italian painters, Duchamp would, on several occasions, refer to Balla's *Dynamism of a Dog on a Leash* (1912, Albright-Knox Art Gallery, Buffalo, N.Y.), which he was sure he had seen in February 1912 during his repeated visits to the exhibition at the Galerie Bernheim-Jeune (although the picture was not shown there).

In New York, Duchamp's 'Futurism' became so famous that, in the same year as the Armory Show, J. Nilsen Laurvik published *Is it Art? Post-Impressionism–Futurism–Cubism*, which he illustrated with a group portrait of the Duchamp brothers with the explicit caption: 'The Futurist Brothers'.[4] In qualifying this assimilation as far too exclusive, in his interviews with Pierre Cabanne, Duchamp would apply to his *Sad Young Man in a Train* a definition which also applied to his *Nude*: "a Cubist interpretation of a Futurist formula".[5] The triumph of his *Nude Descending a Staircase No. 2* in the United States was above all the triumph of the synthesis to which Duchamp aspired, the one worked by Cubo-Futurism.

D. O.

1 The Armory Show was officially the *International Exhibition of Modern Art*, 69th Infantry Regiment Armory, New York, 17 Feb.-15 Mar. 1913 and travelled on to Chicago and Boston. After withdrawing it from the Indépendants Duchamp had shown *Nude Descending a Staircase No. 2* in *Cubism*, Galeries Dalmau, Barcelona, Apr.–May 1912.

2 Duchamp, "A Complete Reversal of Art Opinions by Marcel Duchamp, Iconoclast", *Art and Decoration* (New York), September 1915.
3 Ibid.
4 Laurvik, *Is it Art? Post-Impressionism– Futurism– Cubism,* (New York: The International Press, 1913), unpaginated.

5 Cabanne, *Entretiens avec Marcel Duchamp,* [1967] (Paris: Somogy éditions d'art, 1995), p. 43; trans. as *Dialogues with Marcel Duchamp,* (London: Thames and Hudson, 1971), p. 35.

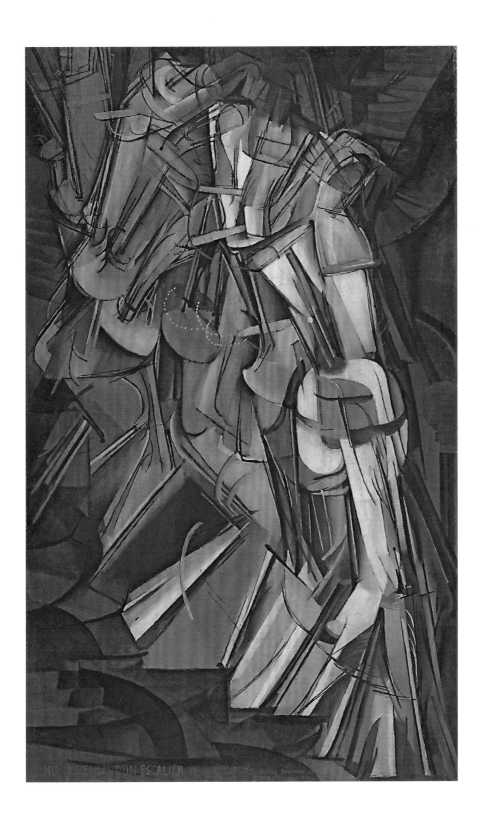

60 **Marcel Duchamp**
 Les Joueurs d'échecs, 1911
 [The Chess Players]
 Oil on canvas, 50 x 61 cm
 Centre Pompidou, Musée national d'art moderne, Paris / Purchased, 1954

The game of chess was one of Duchamp's lifelong passions. In the 1920s, when he would introduce himself as a "defrocked artist", he took part in many international tournaments as a member of the French team. He developed a passionate interest for it in his youth in a family setting where chess was a favourite pastime. In 1904 Jacques Villon made an engraving showing his brother Marcel and his sister Suzanne having a game in the garden of the family home. Six years later, in a style still influenced by Fauvism, it was Marcel who produced a first picture showing his two brothers Jacques and Raymond with a chess board. A year later, when he revisited the same subject with *The Chess Players*, his style and his ambitions had radically changed. At the Salon des Indépendants, for the first time Cubism was displayed both collectively and publicly. Echoing this new context, Duchamp adopted a range of browns, typical of Cubist pictures, including it in the chromatic change which his work began to undergo in October of that same year with *Dulcinea* (1911, Philadelphia Museum of Art). If *The Chess Players* seems to originate from a Cubist approach, through its palette and its iconography which can be interpreted as a tribute to Cézanne's *Cardplayers* (1890–95, Musée d'Orsay, Paris)—Cézanne being the presumed father of the new Cubist school—the treatment of the subject illustrates the fundamental originality (and the heterodoxy?) of Duchamp's research. The openness and dislocation of the forms he proceeds to paint do not, as in Cubist canvases, work so much in the name of speculation about space, but rather in relation to research connected with time. Duchamp focused on a temporal unfurling of the chess game. The protagonists are depicted several times in the composition with each one of these appearances tallying with the precise moment in the game, a decision to be taken about how to move pieces, visibly super-imposed on the figures. This keenness to express duration brought Duchamp close to the Futurist painters whose programme he seemed to be following to the letter: "Not only have we radically abandoned the motif fully developed according to its determined and, therefore, artificial equilibrium, but we suddenly and purposely intersect each motif with one or more other motifs of which we never give the full development but merely the initial, central, or final notes … We thus arrive at what we call the *painting of states of mind*."[1]

The *Sad Young Man in a Train*, produced in 1911 (Peggy Guggenheim Collection, Venice) had already shown how Duchamp was still reliant on the psychologism which Boccioni with his *States of Mind* triptych (1911, cat. 20-25) would soon claim as a Futurist legacy. Even if Duchamp shifted 'states of mind' from the register of feelings towards that of pure reflection, he remained attached to a painting depicting spiritual life alien to Cubism (studies for *The Chess Players*, made into a triptych, confirm this attachment to the tradition of Symbolist spiritualism).

D. O.

1 Boccioni et al., "Les exposants au public",
Les Peintres futuristes italiens, exh. cat., Galerie
Bernheim-Jeune & Cie, Paris, 5-24 Feb. 1912, p. 9;
trans. as "The Exhibitors to the Public", in Apollonio
(ed.), *Futurist Manifestos*, (London: Thames
and Hudson, 1973 and 2001), p. 49.

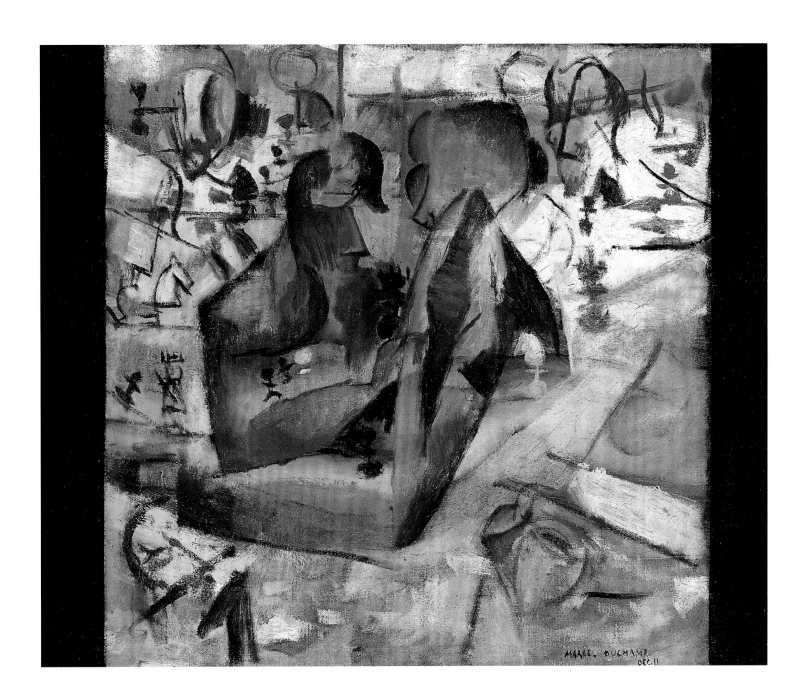

61 **Marcel Duchamp**
Moulin à café, 1911
[Coffee Mill]
Oil and pencil on board, 33 x 12.7 cm
Tate, London / Purchased, 1981

"My brother [Raymond Duchamp-Villon] had a kitchen in his little house in Puteaux, and he had the idea of decorating it with pictures by his buddies. He asked Gleizes, Metzinger, La Fresnaye, and I think, Léger, to do some little paintings of the same size, like a sort of frieze. He asked me too, and I painted a coffee grinder which I made to explode".[1] These might be the opening words of the thoroughly prosaic legend that gave birth to Duchamp's *Coffee Mill*. The little story behind the big one, in a nutshell. A group of friends—whose brief would merely retain the topography ('of Puteaux')—called upon to decorate a bare, unattractive wall. In other words, a pact between comrades, sealed in remembrance of a large fresco painting reinterpreted on a household scale. Initially, the kitchen, turned into a modern and secular arena, at once intimate and trivial, had a coffee-pot in it which was painted by Roger de la Fresnaye and this probably gave Duchamp his subject. But the coffee mill allowed for a more anatomical study than the mere pot, because its mechanism—cogs, handle, hub—could be "stripped bare" and eviscerated, beating the *Bride* to it. Duchamp accordingly opted for a format that was unusually elongated, which by meeting the various ornamental limitations—those of an art that had quite literally become 'applied'—helped to present a vertical cross-section typical of the Cubist aesthetic.

A preparatory ink-on-paper sketch (1911, private collection) reveals—by contrast—the chromatic seduction worked by the oil painting. Using tricks of colour and brush, the artist actually managed to restore the co-existence of the mill's wooden effects and metal forms. In this respect, the plastic concision and the "diagrammatic aspect"[2] of his work in no way clashed with the sovereignty of his talents when it came to handling paint. Duchamp consequently infringes upon a traditional language while at the same time borrowing some of its idiom. He broke any link with mimetic verisimilitude, but this was as a result of *how* he painted rather than of *what* he painted. In spite of everything, and despite himself, there is an after-image-like persistence of knowledge and technique, or, to borrow Henri Focillon's words, a "praise of the hand". There is just one extra-pictorial clue: the arrow which, in the top left corner, indicates the clockwise movement of the handle. More than a seditious annotation, it forms a surreal sign outside the conventional field of the picture. It stands up to 'serious painting' and, combined with the repeated shape of the handle, helps to suggest movement in a static image, in an unprecedented way. So within what is today seen as the first 'mechanised' painting in art history, it adds an inaugural kinetic dimension that was not alien to Futurist aspirations. Apollinaire said just this when, in order to emphasise that "Marcel Duchamp has abandoned the cult of appearances", he noted that his "conceptions are not determined by an aesthetic, but by the *energy* of a few lines (forms or colours)."[3]

By taking on some of the principles inherent to Cubism and Futurism, Duchamp cannily united them by proving the worth of breaking things up into their component parts as well as the worth of form and movement. This became clearer once this *Coffee Mill*, intended for seeming domestic frivolities, swiftly earned the status of a major painting. Proof enough lies in the many reproductions to which it would give rise,[4] and the works it foreshadowed, ranging from Kliun's noteworthy *Ozonator* (1914, cat. 93) to the works of Duchamp himself (*The Large Glass*, 1915–23, Philadelphia Museum of Art) and Picabia (*Parade amoureuse*, 1917, The Morton G. Neumann Family Collection), which would adapt that cold mechanical aspect to the fierier one of desire. The Duchamp work guaranteed a very broad latitude to interpretations, be they literal, symbolic or formal. It opened up many avenues of possibility, from the moment its author saw fit to keep his subject as modest and discreet as possible. Herein lies the secret of great works and great artists, as Max Jacob sensed: "Very modern art is already no longer that when the person creating it starts to understand it. When those who might understand it start no longer to want to understand it, and when those who have understood it want an art that they do not yet understand."[5]

C. L.

1 Cabanne, *Entretiens avec Marcel Duchamp*, [1967] (Paris: Somogy Éditions d'art, 1995), p. 38; trans. as *Dialogues with Marcel Duchamp*, (London: Thames and Hudson, 1971), p. 31.
2 Ibid.
3 Apollinaire, *Les Peintres cubistes. Méditations esthétiques*, (Paris: Hermann, 1980), pp. 110–11; trans. Lionel Abel, *The Cubist Painters: Aesthetic Meditations* (New York: Wittenborn and Company, 1944), pp. 33–34.

4 The *Coffee Mill* was reproduced many times: from the lithograph made for the 1947 re-edition of Gleizes and Metzinger's *Du "cubisme"* (Paris: Compagnie Française des Arts Graphiques) to the two collotype and stencil reproductions for the dust-jacket and frontispiece of Robert Lebel's *Sur Marcel Duchamp [On Marcel Duchamp]* (Paris–London: Éd. Trianon, 1959).
5 Jacob, *Art poétique* [1922], (Paris: L'Élocquent, 1987), p. 17.

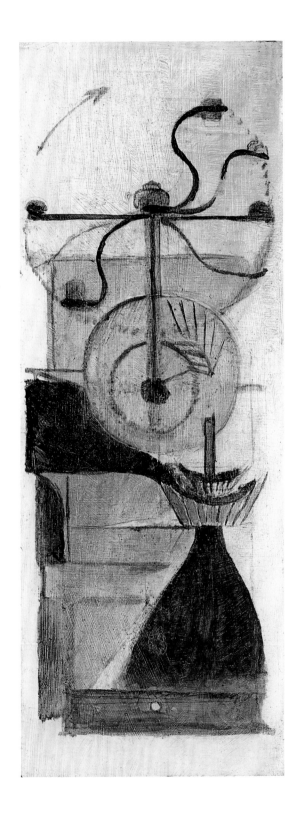

62 **Francis Picabia**
Danses à la source I, 1912
[Dances at the Spring I]
Oil on canvas, 120.5 x 120.6 cm
Philadelphia Museum of Art, Philadelphia
The Louise and Walter Arensberg Collection, 1950

The dance theme took on a crucial role in Picabia's œuvre from 1912 on. In addition to the two versions of *Dances at the Spring*, it is found in *Tarentelle* (1912, whereabouts unknown), then from 1913 on by works inspired by the artist's encounter with the dancer Stasia Napierkowska: *Udnie* (1913, cat. 63), and *I Still See in Memory My Dear Udnie* ([1913]–1914, cat. 64). The painter's interest in the choreographic art—to the point of letting viewers imagine a possible crossing of boundaries—had been noted by Guillaume Apollinaire in *The Cubist Painters*: "Picabia, who seems to be looking for a dynamic art, might abandon the static picture for other means of expression (as Loïe Fuller did)."[1] The importance attached to the movements of the body in space was an essential point of convergence between Picabia's work and Futurist research. In 1910, Severini made dance his favourite subject. *Yellow Dancers* (1911–12, cat. 49), shown at the Galerie Bernheim-Jeune in February 1912, was, by virtue of its mosaic-like composition in particular, a possible source for Picabia's picture. It can nonetheless be noted that, while Severini and the Futurists experienced dance in the urban and man-made setting of music-hall and cabaret, Picabia used his titles to conjure up a natural, bucolic world.

Dances at the Spring I presents a fragmented space in a host of planes of "colours form unities or contrasts, are orientated in space, and increase or decrease in intensity so as to elicit an aesthetic emotion".[2] The picture offers us the image of a jolting world where sensations of proximity and distance, suspense and brutal acceleration follow one another in abrupt leaps. One American critic compared this work to a "chipped block of maple sugar",[3] while another, in the witty form of a dialogue between a little girl and her mother, described the sensations of dizziness and nausea felt when seeing the picture.[4] Picabia created a "style of movement", just like that defined by the Futurists: "the dislocation and dismemberment of objects, the scattering and fusion of details".[5]

"It is not a recognisable scene", Picabia wrote about the two versions of *Dances at the Spring*. "There is no dancer, no spring, no light, no perspective, nothing other than the visible clue of the sentiments I am trying to express … I would draw your attention to a song of colours, which will bring out for others the joyful sensations and feelings inspired in me on those summer days when I found myself somewhere in the country near the Italian border, where there was a spring in a wonderful garden. *A photograph of that spring and that garden would in no way look like my painting*."[6]

Dances at the Spring I was shown for the first time at the Salon d'Automne in Paris in 1912.[7] This picture was then among those sent by Picabia to the Armory Show in New York in March 1913. With Duchamp's *Nude Descending a Staircase No. 2* (1912, cat. 59), it was one of the works that stirred up the most curiosity and the liveliest reactions.

J. P.

1 Apollinaire, *Les Peintres cubistes. Méditations esthétiques*, [1912] (Paris: Hermann, 1980), p. 108; trans. Lionel Abel, *The Cubist Painters: Aesthetic Meditations* (New York: Wittenborn and Company, 1944), p. 31.
2 Ibid., p. 107; trad., op. cit., p. 31.
3 Quoted in Camfield, *Francis Picabia. His Art, Life and Time*, (Princeton: Princeton University Press, 1979), p. 44.
4 [Anon.], *Chicago Daily Tribune*, 31 Mar. 1913, quoted in ibid., p. 44.
5 Boccioni et al., "Les exposants au public", *Les Peintres futuristes italiens*, exh. cat., Galerie Bernheim-Jeune & Cie, Paris, 5–24 Feb. 1912, p. 6; trans. as "The Exhibitors to the Public", in Apollonio (ed.), *Futurist Manifestos*, (London: Thames and Hudson, 1973 and 2001), p. 47.

6 Bealty, "The New Delirium", *Kansas City Star*, 23 Feb. 1913; quoted in Pierre, *Picabia. La peinture sans aura*, (Paris: Gallimard, 2002), p. 110. There are several conflicting accounts of the picture's source of inspiration. If Picabia talked of "somewhere in the country near the Italian border", Apollinaire, for his part, situated the initial scene "near Naples" (*Les Peintres cubistes*, op. cit., p. 108; trans. op. cit., p. 31). According to Gabrielle Buffet-Picabia, it was an episode during the newlyweds' honeymoon in Spain in 1909 which provided the biographical key to the work. The Picabias apparently stopped to watch a young shepherdess dancing just for herself while keeping an eye on her flock (*Rencontres avec Picabia, Apollinaire, Cravan, Duchamp, Arp, Calder*, (Paris: Pierre Belfond, 1977), p. 44).
7 It certainly disconcerted the critics. A Parisian critic

wrote: "I think that the record for high fantasy is held this year by Mr. Picabia … His two works are titled *The Spring* and *Dances at the Spring*. They are beautiful titles … The two pictures, I have to say, in no way bear any relation to each other. They are huge panels on which have been drawn triangles, lozenges, trapezoids, squares, rectangles, all haywire, and mixing in their inextricable hotch-potch, brown with pink, brick red with orangey-red and bluish-green with russet black … It is ugly. It conjures up incrusted linoleum but is not as useful" (*Le Petit Parisien*, 30 Sept. 1912; quoted in Pierre *Les Peintres cubistes. Méditations esthétiques*, op. cit., pp. 82–3).

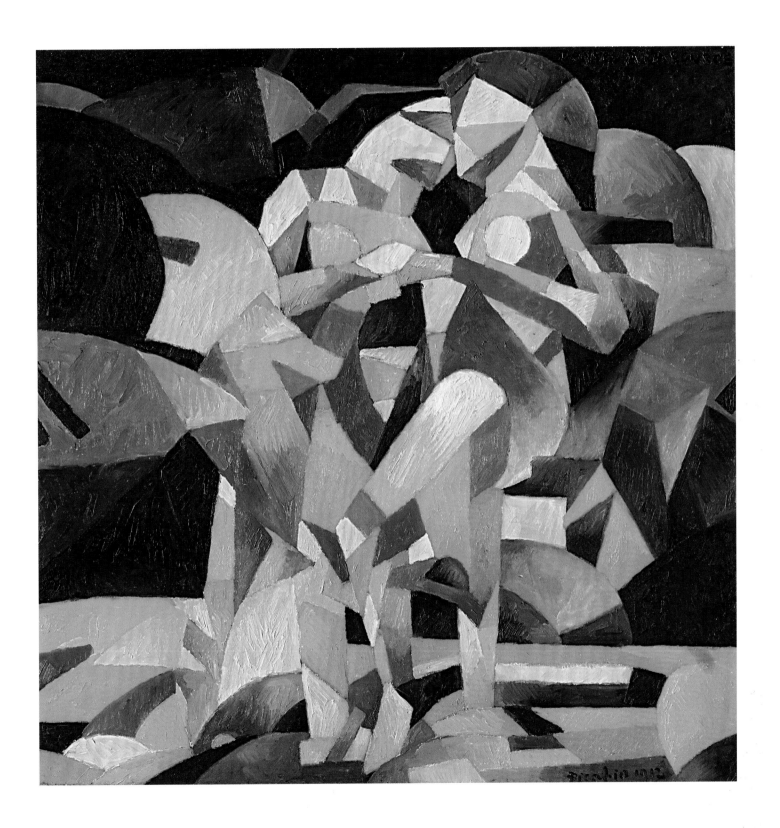

63 **Francis Picabia**
Udnie (Jeune fille américaine; La Danse), 1913
[Udnie (American Girl; The Dance)]
Oil on canvas, 290 x 300 cm
Centre Pompidou, Musée national d'art moderne, Paris
Acquired by the State, 1948 / Attribution, 1949

A masterpiece of abstract painting, this canvas was completed during the summer of 1913. It was made in memory of the dances performed by Stasia Napierkowska on the liner *La Lorraine* taking Picabia to the Armory Show in New York in January 1913, where he was acclaimed as the "leader of Cubism". In the tradition of canvases depicting the dance theme, as from 1912, and described as "Orphic" by Apollinaire, this large picture, almost square in format, was the culmination of watercolours inspired by the dancer made in New York and exhibited by Stieglitz in March and April. The watercolours combined mechanical elements and anatomical forms. *Udnie* and its counterpart *Edtaonisl* [Ecclesiastic] (1913, The Art Institute of Chicago), shown at the Salon d'Automne in November 1913, elicited few reactions apart from Apollinaire's liking "the large, very pure, very lucid paintings by Picabia … ardent, lyrical paintings".[1] Picabia told a journalist: "*Udnie* is no more the portrait of a young girl than *Edtaonisl* is the image of a prelate, as we ordinarily conceive of them. They are memories of America, evocations of over there which, subtly set down like musical chords, become representative of an idea, a nostalgia, a fleeting impression."[2]

The composition of *Udnie* is a plastic synthesis of the dancer's sensual, graceful movements, rendered by arabesques and fragments of colourful volumes, themselves subject to the ship's motions. The centrifugal dynamic is slightly disturbed by the divergent force-lines and planes with their acute edges. By means of colour contrasts, Picabia also conjures up his fascination with the dynamics of the young American woman and dance, as indicated by the double title of the canvas. Its wordplay is something novel, formed around "one dimension", according to Picabia, or around "nue" [nude], or alternatively the myth of "Undine", or possibly (according to Arnauld Pierre) after the name of the music critic Jean d'Udine, a theoretician of synaesthesia.[3] The enigma of the riddle is part of the anecdotal structure of the composition, whose non-representative forms deliver the musicality of refined tones. The influence of Severini's canvases (the explosion of the dance planes) and those of Boccioni (centrifugal force), which Picabia had seen at the Paris show of Italian Futurist painters in February 1912, is palpable. *Udnie* was also inspired by the "mechanism" of Duchamp's *The Bride* (1912, Philadelphia Museum of Art), given by the painter to Picabia, as well as the "musicalism" declared by Henri Valensi, František Kupka and Jacques Villon in the exhibition of the Section d'or artists at the Galerie La Boëtie, in October 1912, to which Picabia also contributed. In his article "The Futurists plagiarised in France",[4] Boccioni claimed authorship of the simultaneity and lyricism of forms taken up by Apollinaire in Orphism. In *Udnie*, and in proposing a *Manifesto of the Amorphist School*,[5] Picabia ushered in the synaesthetic connections of painting, dance and music, imbued with the process of memory; *Udnie* produces a plastic equivalent to a harmony of sounds and sensations.[6]

C. M.

1 Apollinaire, "M. Bérard inaugure le Salon d'automne", *L'Intransigeant,* 14 Nov. 1913; trans. in Breunig (ed.) *Apollinaire on Art: Essays and Reviews 1902–1918,* (New York: Da Capo Press, 1972), p. 324.
2 Anon. [Picabia], "Ne riez pas, c'est de la peinture et ça représente une jeune Américaine", *Le Matin* (Paris), 1 Dec. 1913, p. 1; Picabia, *Écrits: vol.1, 1913–1920,* (Paris: Belfond, 1975), p. 26.

3 Pierre, *Francis Picabia. La peinture sans aura,* (Paris: Gallimard, 2002), pp. 102–3.
4 Boccioni, 'I futuristi plagiati in Francia', *Lacerba,* vol. 1, no. 7, 1 Apr. 1913, pp. 66–8.
5 *Camera Work* (New York), no. 41–44 (special issue: *A Photographic Quarterly*), June 1913, p. 57.
6 The erotic and mobile image of Napierkowska also inspired *Petite Udnie* (1913–14, private collection), and *I See Again in Memory My Dear Udnie*

([1913]–1914, cat. 64). *Udnie* was repainted by Picabia in 1947 with the help of Christine Boumeester.

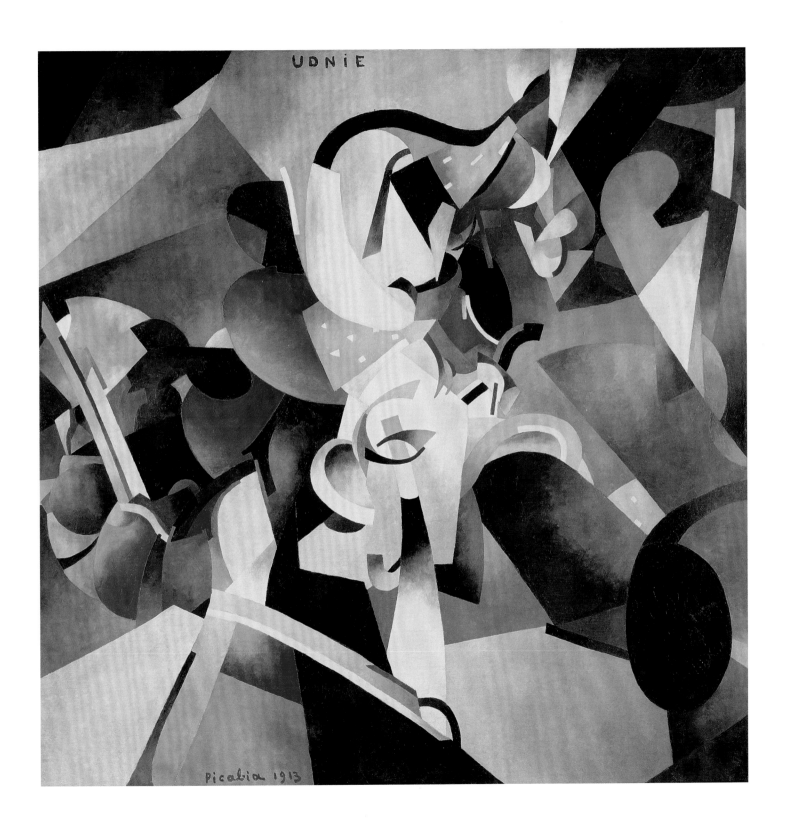

64 **Francis Picabia**
 Je revois en souvenir ma chère Udnie, [1913]–1914
 [I See Again in Memory My Dear Udnie]
 Oil on canvas, 250.2 x 198.8 cm
 The Museum of Modern Art, New York / Hillman Periodicals Fund, 1954

"Giving plastic reality to inner states of the mind",[1] such was the way in which in 1913 Picabia described the aim of modern painting. Borrowing ideas that were already widely in circulation, if not always accepted, the artist called for a rejection of the 'photographic' reproduction of the real. Like other large canvases of 1913—*Edtaonisl* (The Art Institute of Chicago) and *Udnie* (cat. 63)—*I See Again in Memory My Dear Udnie* broke radically with all naturalist representation, even when stylised and reorganised in a Cubist manner.[2] "But I have gone beyond that stage", Picabia said in 1913, "and I do not consider myself a Cubist either because I have come to the conclusion that cubes are not always made for expressing the thought of the brain and of the feeling of the spirit."[3] In pursuit of a subjective art, Picabia came across themes already developed in spiritualist abstraction circles (by Kandinsky, Kupka and others) and by the Italian Futurists, who, in 1912, had asserted the principles of a "painting of states of mind",[4] a formula which emerges frequently in Picabia's writings.

One of the key elements in going beyond Cubism was the handling of the visual sensation, which is not analysed or clinically broken down, but clarified, matured for a long time within the memory: "I capture all these impressions" Picabia confirmed, "without any hurry to transfer to the canvas. I let them rest in my brain and then, when I am visited by the spirit of creation, I improvise my paintings just as a musician improvises his music."[5] Memory is the third essential term—towards which the title *I See Again in Memory My Dear Udnie* explicitly refers—in the renewed connection between painting and reality. The picture may be seen as an externalisation of an inner moment in the realisation of the 'image-memory', an ambiguous moment when there is a quest for form, like a "haze that becomes condensed", to borrow Henri Bergson's formulas,[6] whose thinking influenced Futurism every bit as much as the Paris art scene.

"These pictures represent *a priori* abstractions to such a minimal degree that the painter could tell you a story about every single one of them,"[7] Apollinaire wrote of Picabia's works. We know the story of *Udnie*. In January 1913, on the ship taking the Picabias to New York, where the painter had been invited to take part in the Armory Show, Francis and Gabrielle met an actress of Polish extraction, Stasia Napierkowska, whose 'Hindu' dance show made a vivid impression on the artist's imagination. *Star Dancer with her Dance School* (1913, The Metropolitan Museum of Art, New York), *Star Dancer on a Transatlantic Cruise* (1913, whereabouts unknown), *Udnie* and *I See Again in Memory My Dear Udnie* all refer to this common source of inspiration.

The picture's formal vocabulary conjures up both the mechanical world and the biological kingdom, with electrical and botanical bulbs, stems and hafts. In merging the female body and the mechanical, the figure of *Udnie* appears like an exuberant relative of Duchamp's erotic machines, or Fortunato Depero's mechanical ballerinas. The organic forms of the picture call to mind the plant-like structures of Art Nouveau, but these reminiscences are captured in a wild proliferation, in a multiplication of shoots.

If the problem of the links between painting and memory is rooted far back in the history of art, Futurism probably contributed to its reinstatement at the heart of avant-garde debate. The manifesto introduction to the catalogue for the Paris Futurist exhibition in 1912 asserted: "the picture must be the synthesis of *what one remembers* and of *what one sees*."[8] Nevertheless, Picabia's purpose seems noticeably different from that of the Futurists. Among the latter, memory was a factor that disturbed the settings of vision. It introduced into the representation something that *moved*, helping to obtain the lines of force of an object in motion. Picabia's memory-related aesthetics involved, instead, the slow sublimation of the thing seen, a painting not of a dynamic trajectory but of an inner itinerary of metamorphosis.

J. P.

1 Picabia quoted in Hapgood, "A Paris Painter", *The Globe and Commercial Advertiser*, 20 Feb. 1913, p. 8; cited in Borràs, *Picabia*, (Paris: Albin Michel; London: Thames and Hudson, 1985), p. 107.
2 The work's title, in accordance with a procedure developed by Picabia, was inspired by the French translation of a Latin quotation taken from the pink pages of the *Petit Larousse* : "Mourant, il revoit en souvenir sa chère Argos" (Virgil, *Aeneid*, 10, 782 "dying, he saw again in memory his beloved Argos"). The canvas was first shown from 12 to 26 Jan. 1915 in "An Exhibition of Recent Paintings—Never Before Exhibited Anywhere—by Francis Picabia", Photo-Secession, New York.

3 Picabia, "How I see New York", *The New York American* (New York), 30 Mar. 1913, p. 11; cited in Borràs, *Picabia*, op. cit., p. 110.
4 Boccioni et al., "Les exposants au public", *Les Peintres futuristes italiens*, exh. cat., Galerie Bernheim-Jeune & Cie, Paris, 5–24 Feb. 1912, p. 4 trans. as "The Exhibitors to the Public", in Apollonio (ed.), *Futurist Manifestos*, (London: Thames and Hudson, 1973 and 2001), pp. 45-50.
5 Picabia, *New York*, op. cit.; Borràs, *Picabia*, op. cit., p. 110.
6 See Bergson, *Matière et mémoire*, [1896], (Paris: Presses Universitaires de France, 2004), pp. 147, 148; trans. Paul and Palmer, London 1911.

7 Apollinaire, *Les Peintres cubistes. Méditations esthétiques*, (Paris: Hermann, 1980), p. 108.
8 Boccioni et al., "Les exposants au public", *Les Peintres futuristes italiens*, exh. cat., Galerie Bernheim-Jeune & Cie, Paris, 5–24 Feb. 1912, p. 4 trans. as "The Exhibitors to the Public", in Apollonio (ed.), *Futurist Manifestos*, (London: Thames and Hudson, 1973 and 2001), p. 47.

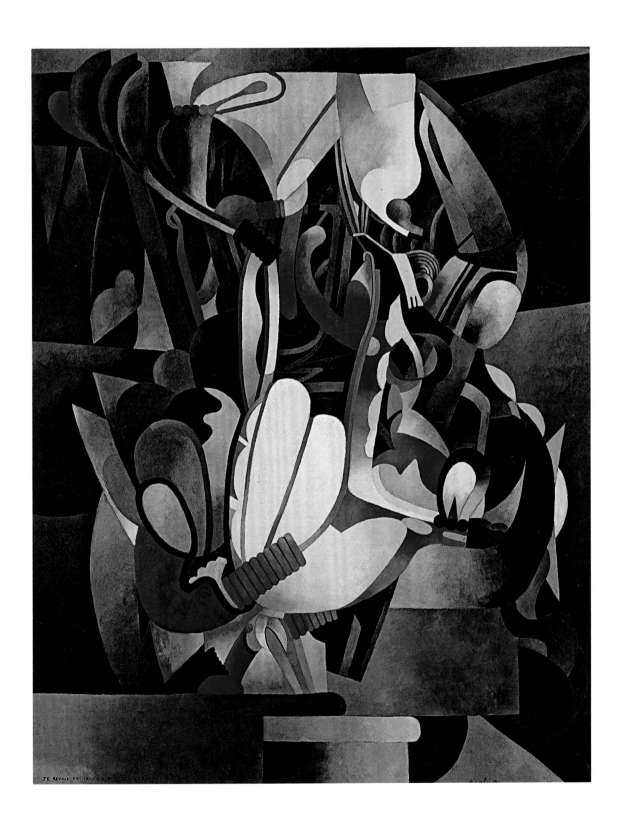

65 **Jacques Villon**
Soldats en marche, 1913
[Soldiers on the March]
Oil on canvas, 65 x 92 cm
Centre Pompidou, Musée national d'art moderne, Paris / Purchased, 1976

A series of sketches made by Villon during military training gave him the inspiration for his *Soldiers on the March*.[1] These studies help us to gauge the importance of the formal synthesis that led to the final and definitive work. The movement of the troop is reduced to a system of force-lines. The column of soldiers has taken on the form of polyhedra staggered within the depth of the picture. The movement that Villon has striven to recreate is that of two columns of soldiers marching on either side of an onlooker placed in the middle of the composition. There was no way this work could not be aligned with Futurism. But Villon defended himself against any such assimilation, later recalling: "I was quite surprised when I read articles by critics asserting that I had been influenced by Futurism."[2] Despite this, the painter's plan to make movement the actual object of his picture was undoubtedly Futurist. Likewise, the chromatism of his work, with its acid colours distinct from the Cubist palette, was also Futurist, and the outcome of its impact on Parisian art circles. The place that Villon gave to the person looking at the military manoeuvre was also essentially Futurist. As Colette de Ginestet suggested: "Walking among the others he made a first sketch; with the help of a pair of dividers he took measurements noting the distance indicated by the dividers from the principal points of his drawing to the edge; he then transferred these measurements to a new drawing marking each place with a dot, and then he joined together all these essential dots by straight lines".[3] The application of an amalgamative aesthetics, a justification for a Dionysiac phenomenology, lies at the heart of the Futurist project (as such, it contrasts rigorously with the distance advocated by Cubism). This aesthetics was clearly announced by the painters' *Technical Manifesto*: "We shall henceforward put the spectator in the centre of the picture".[4] Such kinship with Futurist principles explains why it was possible to place the *Soldiers on the March* within the current of the Italian movement.

On the other hand, other features of the work explain its direct relationship with Cubist painting. As the leading theoretician of the Section d'or, Villon applied to his canvas the subdivision of the surface using a layout and applying the numerology of the Golden Section taken from Leonardo da Vinci's *Treatise on Painting*, in Luca Pacioli's *De Divina Proportione*. Far from de-stabilising its composition, the movement upon which Villon focused reinforced its symmetry. Neither strictly Cubist nor completely Futurist, *Soldiers on the March* perfectly illustrates that Cubo-Futurist art which blossomed in the movement of the Salon de la Section d'or. The picture might well find itself described using the formula invented by Duchamp to describe his *Sad Young Man in a Train* (1911, Peggy Guggenheim Collection, Venice): "Cubist interpretation of a Futurist formula."[5]

D. O.

1 A photograph of one of these drawings highlighted with wash belongs to the collections of the Musée national d'art moderne.
2 Villon, "Un travail solitaire dans un chemin privé" (report on Futurism), *Arts*, 26 April 1961; quoted in *Jacques Villon*, exh. cat., Rouen, Musée des Beaux-Arts, 14 June–21 Sept. 1975; Paris, Grand Palais, 11 Oct.–15 Dec. 1975 (Paris: Réunion des musées nationaux, 1975), p. 80.

3 Ideas put forward by de Ginestet and Pouillon, cited in *Jacques Villon*, ibid., and *La Section d'or 1925, 1920, 1912*, exh. cat., musées de Châteauroux, 21 Sept.–3 Dec. 2000; Montpellier, musée Fabre, 15 Dec. 2000–18 Mar. 2001 (Paris: Éd. Cercle d'art, 2000), p. 271.
4 Boccioni et al., *Manifeste des peintres futuristes*, in *Les Peintres futuristes italiens*, exh. cat., Galerie Bernheim-Jeune & Cie, Paris, 5–24 Feb. 1912, p. 16;

Futurist Painting: Technical Manifesto, in *Exhibition of Works by the Italian Futurist Painters*, Sackville Gallery, London Mar. 1912, republished in Apollonio (ed.), *Futurist Manifestos*, (London: Thames and Hudson, 1973 and 2001), p. 28.
5 Cabanne, *Entretiens avec Marcel Duchamp*, [1967] (Paris: Somogy éditions d'art, 1995), p. 43; trans. as *Dialogues with Marcel Duchamp*, (London: Thames and Hudson, 1971), p. 35.

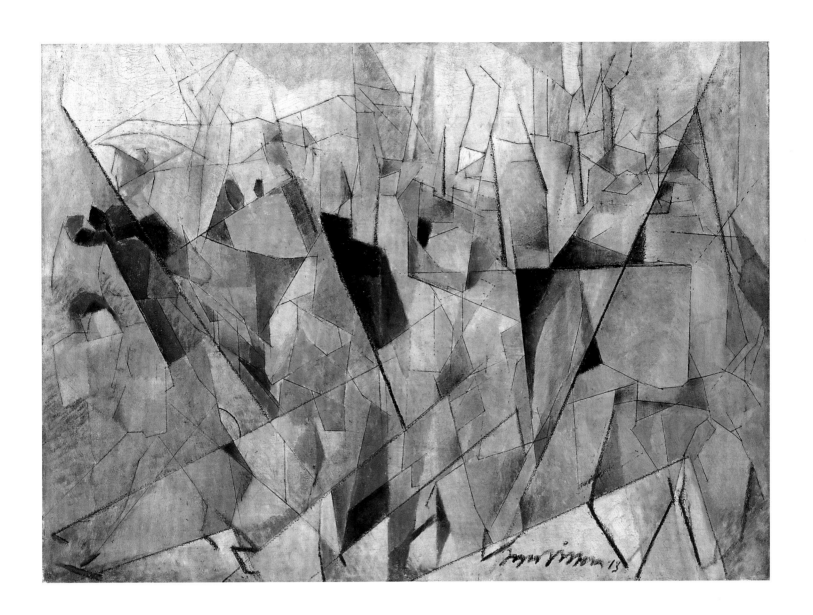

66 **Jacques Villon**
Jeune Femme, 1912
[Young Woman]
Oil on canvas, 146.2 x 114.3 cm
Philadelphia Museum of Art, Philadelphia
The Louise and Walter Arensberg Collection, 1950

If there were pivotal years in art history, 1912 would definitely be one of them. Three notable events—one publication and two shows—would support any such assertion: in February, the inaugural Futurist exhibition held at the Galerie Bernheim-Jeune, and in October, both the publication of *On "Cubism"* by Gleizes and Metzinger, and the exhibition of the Salon de la Section d'or at the Galerie La Boëtie. Now, these three conspicuous facts seem to have met with different historiographical fortunes, but a simple genealogy is enough to make Jacques Villon the crucial figure, literally the figure "at the crossroads" of all three. So it is not surprising that the same year, 1912, was a decisively one for Villon himself who, in order to hold onto only the finest fragrances and the most fecund of avant-garde stock, immersed himself in it.

To realise fully the perspicacity of the borrowings made by the eldest of the Duchamp clan, we must draw up a calendar of the daily innovations made in that fruitful year, which secured something exceptional. His canvas *Young Woman* gives us a chance to envisage them. It was part of a series initiated by *Study for Young Woman* (1912, private collection) and completed a year later with the resulting engraving (1913, Museum of Fine Arts, Boston). So *Young Woman* is the outcome of a process of distillation based on a 'study' marked by a great respect for reality. In fact, by making a portrait of his younger sister Yvonne reading in an armchair, Villon was merely choosing a classical subject hallowed by a tradition that he was not about to disparage.[1] Seated in three-quarter profile, her face slightly inclined and her gaze lost in some solitary daydream, Yvonne made herself into a docile model: the slight affectedness of the pose does not really suggest a live study. In addition, the apparent triviality of this *a priori* intimist scene has been re-thought by a brother keen to promote it to the rank of a Portrait with a capital P, by intentionally conventional devices and traditional tricks. Villon's academic propensity was one of the recognised and, as such, almost novel and hitherto unseen mainsprings of his aesthetics, because this appropriation of norms, rules and measurements links him to art history as much as it gives rise to a constraint which, often intuitively experienced, freed up innovative solutions. And already the interest in the Section d'or showed through, with the very first such exhibition including *Young Woman*, which was—and is—as modern as it was—and is—programmatic.[2] Villon managed to reinstate the original model at the end of a process of a prismatic breakdown which, by exploding the forms, tried to reorganise them methodically. Triangles and curves alternate in a rigorous way and their juxtaposition defines a figurative network from which emerges, centrally, the twenty-three-year-old sister. To do this, the artist recalled the prescriptions of Leonardo da Vinci in his *Treatise on Painting*, recently translated (into French), which invite one "to paint the forms and colours of the objects contemplated by pyramids".[3] Two colour ranges, both relatively distinct, rival each other but never do one another harm. One, working in a refined *camaïeu* of red and oranges, circumscribes the figure, while the other, composed of lighter, at times purplish hues, is reserved for the surrounding space. This chromatic decision, decidedly flamboyant although it may seem sensitive to the tonal nuances, helps to make even more evident forms already suggested by the linear structuring. The colours thus have an additional value and confirm the forms to which they are strictly subordinate. What is more, this chromatic and thoroughly scientific orientation belongs far more to Futurist research than to contemporary Cubist experiments, which approve colour without ever making it subordinate to the line. When Cubist ochres help to create a certain stasis, the shimmerings and sparklings of the Futurists galvanise the composition. It would indeed seem that Villon was not indifferent to this, all the more so because *Young Woman* is permeated by a vibrating pulse enhanced by the repetition of certain elements, from the face which seems duplicated, to the hips exaggerated by bold curves. In that same year Duchamp had finished his *Nude Descending a Staircase No. 2* (cat. 59), these two works were exhibited in New York, though with varying success, at the Armory Show in March 1913.

C. L.

1 That he felt happy laying claim to tradition is attested to by the choice of his patronymic, borrowed from one of the most famous 15th century French poets, François Villon.
2 After the 1912 Salon, the members of the Section d'or would organise two other exhibitions in Paris: at the Galerie La Boëtie in March 1920, and at the Galerie Vavin-Raspail in January 1925.

3 Leonardo da Vinci, *Traité de la Peinture*, trans. Sâr Péladan, Paris 1910.

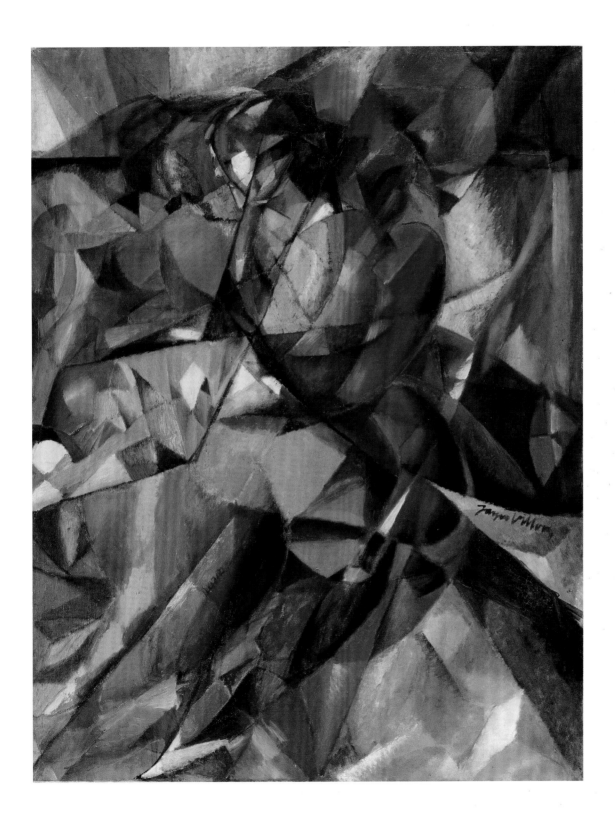

67 **Raymond Duchamp-Villon**
Le Grand Cheval, 1914
[The Large Horse]
Bronze, cast under the supervision of Jacques Villon 1961
100 x 98.7 x 66 cm
Tate, London / Purchased, 1978

There are very few sculptures which, like Duchamp-Villon's *Large Horse* (1914), can boast having galvanised such a welter of comment, not to say gossip. To his credit, André Salmon, a keen observer of modernity, wrote one of the most apt assessments on which to base a close study of this work: "Let me say it straight out: Raymond Duchamp-Villon's premature death is a disaster comparable to the death of Georges Seurat at the age of 30 and that of Guillaume Apollinaire before he had reached 40."[1]

Donatello, Verrocchio and Bernini, earlier masters who excelled in equestrian statues, might have scared him. But such was not the case. All the more so because that choice of subject, coming from a major figurative tradition, was oddly related to Futurism—rich in sunsets, lunar effects, and full-length portraits—whereas Cubism preferred the poetic triviality of the everyday to such meaningful images. In order to do away with academic figuration, it was necessary to proceed by way of academicism: the debt of the Futurist sacrifice was often at this price. Duchamp-Villon acquitted himself without any trouble at all with this piece that Alfred H. Barr Jr. regarded as being his "most important work".[2] Had the war spared him, he would have become, according to Bernard Dorival, the "number one contemporary French avant-garde sculptor".[3]

Several rough sketches done in 1912 show Duchamp-Villon's intention to create an equestrian statue—an intention confirmed in 1913 by his sketches during a polo match at Bagatelle. In 1914, various projects indicated his orientation towards a form of dynamic research going beyond the mere anatomical verisimilitude that his training as a doctor would originally have suggested. Thenceforth, from the *Cavalier penché* [Leaning Rider] to the *Small Mechanised Horse* by way of the *Cavalier droit* [Upright Rider], forms became simpler and stiffer. The alteration of details, and the synthesis of volumes and their organisation in the intermediate *Horse* made it possible to transform the animal's anatomy through its mechanical correlative: connecting rod, axle, gears and piston. The clarification process for the syntax was worked out: the naturalism that was the *signifier* at the outset gave way, in following studies, to a prevalence of the *signified*, until the very idea of the horse would become nothing more than a mere *sign*, only harking back to that whence it came, once it had, possibly, retraced its course back to the source of the subject. Consequently, Christian Zervos was undeniably among the most probing of commentators when he conjures up an "ideographic style".[4]

The enlargement of the *Horse* to the *Large Horse*, carried out in 1931 by Jacques Villon, attests to the monumentality of this spiralling work which is organised around a central axis, and unfurls as if it were mounted on a spring. While the volutes, crests, solids and voids all generate a supreme kineticism, the fragmented distribution of forms creates a certain static quality: the outcome is a bold impetus, diagonal and as if frozen, which seems to run counter to the laws traditionally governing the distribution of masses and volumes. This tension, which has two forebears—Boccioni and the lessons of Puteaux—thus comes from the encounter between Futurist and Cubist aesthetics, to a point where they converge perfectly. It is precisely these two influences that Walter Pach, one of the best commentators on Duchamp-Villon's work, tacitly designated in the first major study to have been published on this quintessential sculpture: "No matter from where you look at it, the balance is maintained in equal degree, *the profiles soar to their zenith with vivid lines like flames* or else flee perspectively away with an *orchestral arrangement*."[5]

C. L.

68

Le Grand Cheval, 1914/1931
[The Large Horse]
Bronze, 1955 edition,
100 × 55 × 95 cm
Centre Pompidou, Musée national
d'art moderne, Paris / Purchased,
1955 / On loan at the Musée d'art
moderne et contemporain,
Strasbourg

1 Salmon, 'Préface', *Sculptures de Duchamp-Villon, 1876–1918*, exh. cat., Galerie Pierre, Paris 1931.
2 Barr. Jr, *Cubism and Abstract Art*, exh. cat., The Museum of Modern Art, New York, 1936 and 1964, p. 104.

3 Dorival, "Raymond Duchamp-Villon au Musée d'art moderne", *Musées de France*, April 1949, no. 3, p. 68. It is not surprising that it was Dorival who had secured a plaster cast for the collections of the Musée national d'art moderne in 1948.
4 Zervos, "Raymond Duchamp-Villon", *Cahiers d'art* (Paris), vol. 6, no. 4, 1931, p. 227.

5 Pach, *Raymond Duchamp-Villon sculpteur 1876–1918*, (Paris: Éd. Jacques Povolozky, 1924), p. 15. Our italics.

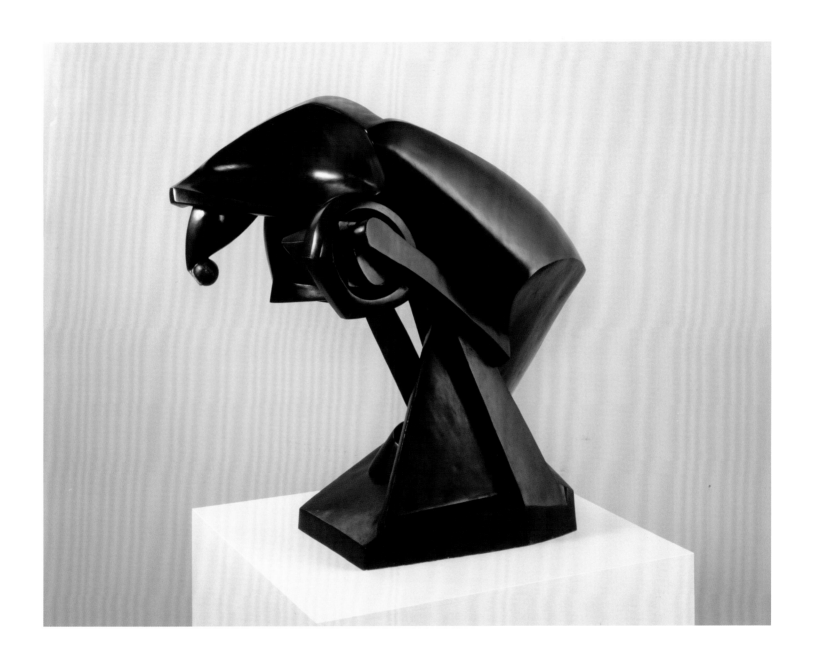

69 **Sonia Delaunay**
Contrastes simultanés, **1912**
[Simultaneous Contrasts]
Oil on canvas, 46 x 55 cm
Centre Pompidou, Musée national d'art moderne, Paris
Donated by Sonia and Charles Delaunay, 1964

In 1912, after the birth of her son Charles, Sonia Delaunay returned to a more significant pictorial activity and started to produce abstract works, including the *Simultaneous Contrasts,* which had engaged her in 1907–8. Here, she drew inspiration from the *Windows* series painted by Robert Delaunay that same year, where the principle was based on the interplay between contrasts of complementary colours, deduced from Chevreul's law.[1] Sonia Delaunay's composition, based on the reconstruction of form by colour, is similar to her husband's *Windows*, but she extended her own research into "simultaneous" works on fabric (*The Cradle Blanket*, 1911, Musée national d'art moderne, Paris).

The motif depicted in this painting is obliterated in a colourful vibrancy, and the outlines of the Eiffel Tower are scarcely suggested by the two rising green forms, while the sun, a coloured circle with ringed rays, heightens the overall dynamism through its rotating movement. This use of Charles Henry's principles of 'dynamogenics' and Chevreul's simultaneous contrasts, already applied by Seurat, seemed, in 1912, like claiming the Impressionist legacy rejected by the Cubists. In a context where the term 'simultaneous' had become the prerogative of the Italian Futurists, it is not surprising that the Delaunays were not always regarded as Cubist painters by critics of the day. The principle of simultaneity, whose key words are light, rhythm and colour, actually represents an undeniable link between the research undertaken by Sonia and Robert Delaunay, on the one hand, and the Italian painters, on the other. These *Simultaneous Contrasts* of 1912 may thus be seen as a reappropriation of the term 'simultaneous' by the Cubists at a moment when the Paris public had just discovered the Futurist works at the Galerie Bernheim–Jeune in February 1912. In the controversy stirred up by the authorship of "pictorial simultaneity", the invention of Orphism by Apollinaire (a term he used in relation to the *Windows*) attempted to legitimise a legacy which was in fact that of the Delaunays from their earliest days—and one which they had at one time turned their backs on, at least in terms of vocabulary, in order not to be likened to the Futurists.

J. C. L.

1 Chevreul, *De la Loi du contraste simultané des couleurs …,* Paris, 1839. Delaunay, "À Sam Halpert?", *Du cubisme à l'art abstrait,* new documents published by Francastel and followed by a catalogue of Delaunay's œuvre by Habasque, (Paris, SEVPEN, 1958), p. 98. trans. Shapiro and Cohen in *The New Art of Color: The Writings of Robert and Sonia Delaunay,* Cohen (ed.), New York 1978, p. 36.

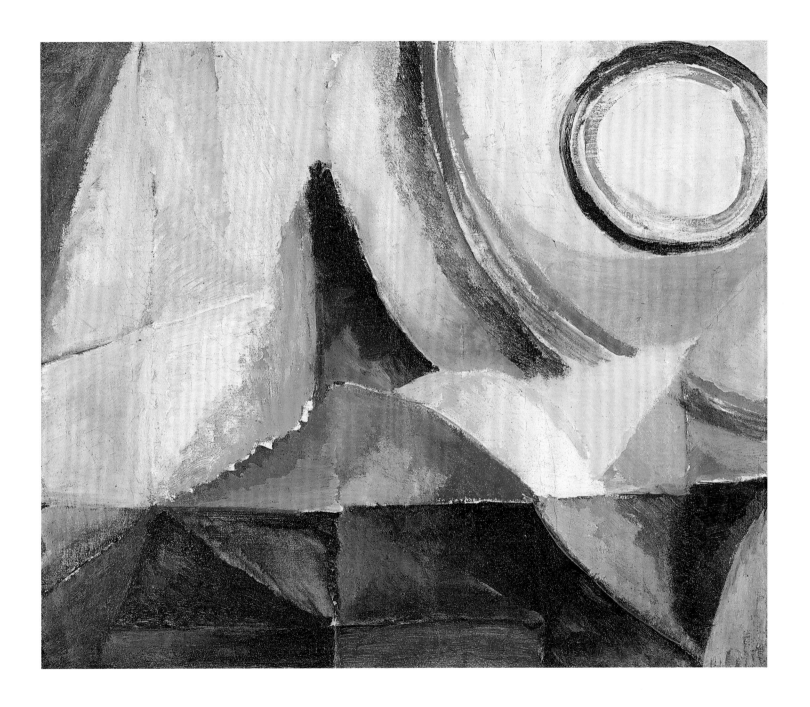

70 **Robert Delaunay**
Formes circulaires. Soleil n° 2, **1912–1913**
[Circular Forms. Sun No. 2]
Glue-based paint on canvas, 100 x 68.5 cm
Centre Pompidou, Musée national d'art moderne, Paris
Gift of the Société des Amis du Musée national d'art moderne, 1961

"Your eyes accustomed to the half-light will soon open onto more radiant visions of clarity. The shadows that we shall paint will be more luminous than the full lighting of our predecessors, and our pictures, alongside those in museums, will shine forth like a dazzling day, contrasting with tenebrous night."[1] This passage in the form of a prophecy in the *Technical Manifesto of Futurist Painting* of 1910 could be inscribed on Robert Delaunay's sun painting.

Circular Forms, Sun No. 2 belongs to a series of canvases on which Delaunay was at work in the spring and summer of 1913, at Louveciennes (the *Circular Forms, Sun,* the *Circular Forms, Moon* and the *Circular Forms, Sun and Moon*). This series is the very core of what the painter submitted to the Erste Herbstsalon in Berlin, organised by the magazine *Der Sturm*, from 20 September to 1 December 1913.

A tale told by Sonia Delaunay presents the genesis of these works: "Robert wanted to look straight at the midday sun, the absolute disk. … He made himself stare at it until he was bedazzled. He closed his eyelids and focused on his retinal reactions. Back home, what he tried to commit to canvas was what he had seen with his eyes wide open and his eyes shut; all the contrasts his retina had recorded: 'Sonia, I can see the black spots of the sun…' He had discovered disk-shaped blotches. He would proceed from prismatic colour to circular forms."[2]

On a vertical canvas, Delaunay arranged a series of areas of pure colours (blue, red, purple, yellow…) forming a chromatic, dynamic disk, as if pulled into a spinning motion.[3] The picture shows many different mobile round forms, an arrangement of curved planes, coloured arcs and semi-circles, a painting of "bright colour".[4] Georges Roque has reconstructed with precision the optical theories which feature the painter's work on colour and light.[5] Some experimental devices (Newton and Maxwell disks, for example) may incidentally have inspired the composition of the *Circular Forms*.

The arrangement of the colours in *Sun No. 2* borrows an organisation already tried and tested in *Sun No. 1* (1912–13, Wilhelm-Mack Museum, Ludwigshafen). But the spinning motion seems more pronounced in the second canvas: in the heart of the disk right angles have been replaced by curves. This freeing-up of colour and movement alike is further heightened with *Sun No. 3*.

The link between round form, light and movement also interested the Futurists. Severini's manifesto, *L'Art plastique néofuturiste*, attests to this: "The coloured expression of the *light* sensation, in keeping with the spherical expansion in Futurist painting, can only be centrifugal or centripetal …. I call this new plastic expression of light: EXPANSON SPHÉRIQUE DE LA LUMIÈRE DANS L'ESPACE [Spherical expansion of light in space]."[6] The astral theme of Delaunay's picture can also conjure up certain Futurist research projects involving astronomical phenomena, at the heart, for example, of Balla's series *The Mercury Passing in Front of Sun* (1914).

In this quest for a painting of light, Divisionism represented the progressive point of the tradition based on which Delaunay as well as the Italian Futurists took off. Among their shared sources, we can doubtless include Gaetano Previati. In his *Principes scientifiques du divisionnisme* (1906), the Italian artist asserted that contemporary painting "tend[ed] to identify … the picture's subject with the meaningful expression of the effect of light swathing the subject".[7] Delaunay's *Circular Forms*, through their reduction of the phenomenon of light to abstract forms, are set on a path parallel to the one taken by Balla in his *Iridescent Compenetrations* (1912).[8]

J. P.

1 Boccioni et al., *Manifeste des peintres futuristes* (11 April 1910), in *Les Peintres futuristes italiens,* exh. cat., Galerie Bernheim-Jeune & Cie, 5–24 Feb. 1912, p. 20; *Futurist Painting: Technical Manifesto,* in *Exhibition of Works by the Italian Futurist Painters,* Sackville Gallery, London Mar. 1912, republished in Apollonio (ed.), *Futurist Manifestos,* (London: Thames and Hudson, 1973 and 2001) .
2 Delaunay, *Nous irons jusqu'au soleil,* (Paris: Robert Laffont, 1978), p. 44.
3 The disk is a recurrent motif in Delaunay's œuvre. *Landscape with solar disk* (1905–06) shows the painter's longstanding interest in the representation of the sun. The leitmotiv of the Big Wheel, present in the series of *Windows* (1912) and in *The Cardiff Team* (1913, cat. 57) likewise represents the scene of experimentation for the circle as radicalised by the *Circular Forms* series.
4 Delaunay, *Du cubisme à l'art abstrait,* new

documents published by Francastel and followed by a catalogue of the œuvre of Delaunay by Habasque, (Paris: SEVPEN, 1958), p. 174; trans. in Cohen (ed.) *The New Art of Color: The Writings of Robert and Sonia Delaunay,* New York 1978.
5 Roque, "Les vibrations colorées de Delaunay: une vie des voies de l'abstraction", *Robert Delaunay. 1906–1914. De l'impressionnisme à l'abstraction,* exh. cat., Paris, Musée national d'art moderne, 3 June–16 Aug. 1999 (Paris: Éd. du Centre Pompidou, 1999), pp. 53–64.
6 Severini, "L'art plastique néofuturiste" (text translated into French by the author in 1957), published in Seuphor, *Dictionnaire de la peinture abstraite,* (Paris: Hazan, 1957), pp. 94–95; Lista, *Futurisme. Manifestes, proclamations, documents,* op. cit., pp. 188–189. The Italian version of this manifesto (of which there are many variants) was published under its initial title, *Le Analogie*

plastiche del dinamismo. Manifesto futurista (Sept.–Oct. 1913), in Drudi Gambillo and Fiori, *Archivi del Futurismo,* (Rome: De Luca, 1958), vol. 1, p. 79; trans. as "The Plastic Analogies of Dynamism. Futurist Manifesto", in Apollonio (ed.), *Futurist Manifestos,* (London: Thames and Hudson, 1973 and 2001).
7 Quoted in *Robert Delaunay. 1906–1914. De l'impressionnisme à l'abstraction,* op. cit., p. 195.
8 The comparison is proposed by Boccioni in a letter written in 1913 to Roberto Longhi : "Although he sometimes looks as if he's going to cast himself into the void, Balla is involved in the truth, deeply involved in the truth. If you saw Delaunay's colourist abstractions, and Picabia's formal ones—artists who are often mentioned—you would see where Balla is situated", quoted by Grisi, "Boccioni e Longhi", *Boccioni cento anni,* Tallarico (ed.), (Rome: Volpe Editore, 1982), p. 243.

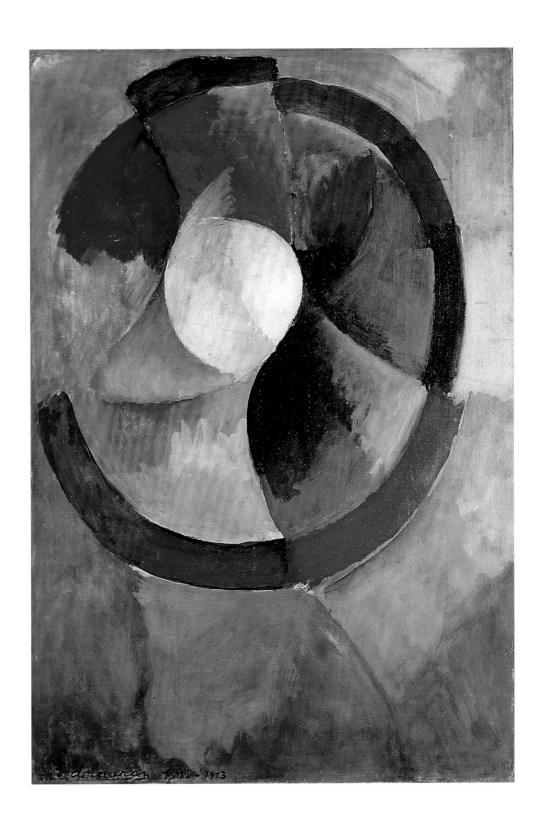

71 **František Kupka**
La Primitive (Éclats de lumière), **[1910–1913]**
[The Primitive (Burst of Light)]
Oil on canvas, 100 x 72.5 cm
Centre Pompidou, Musée national d'art moderne, Paris / Gift of Eugénie
Kupka, 1963 / On permanent loan to the musée de Grenoble, Grenoble, 2004

In the early 1910s, Futurist experiments were infusing the most significant European artworks of the day. By encouraging the broad dissemination of manifestos and works alike, Marinetti's movement became internationalised to the point of giving birth to a luxuriant classification whose newly-coined terminology—Orphism, Ray(on)ism, Vorticism—pointed to the multiple meanings of the arena of action. No geneaological diagram (such as Alfred Barr might conceive) could illustrate the complexity of logical origins, silent reversions and local alliances in those significant years.

In this respect, the case of František Kupka is a significant one, for his irrepressible career makes a point of permanently challenging labels. It was probably his Czech origins which steered him, at a very early stage, towards an unusual form of esotericism, fuelled by reading Edgar Allan Poe and the German philosophers. He illustrated his pantheistic aspirations with compositions which are among the most brilliant pages of European Symbolism,[1] but Kupka subsequently grew interested in the contemporary innovations with which he was in contact once he had established himself in Puteaux, in 1906. In this way, his participation in the Section d'or exhibition in October 1912,[2] and his relationships with Villon, Duchamp, Delaunay and Picabia plunged him headlong into the adventure of the avant-gardes, without causing him to abandon his desire to probe the Ineffable.

The Primitive comes at the end of his figurative phase, as rich as it is coherent, in which this work would be one of the pivotal points. According to Eugénie Kupka this painting was made after a visit to an Auvergne church.[3] This biographical claim confirms what the work seems to denote, namely the transcription of a spiritual immateriality rendered tangible on the canvas. Something spiritual in art, in a word, whose revealing title reinforces the expressly sacred dimension. Faithful to his talents as a colourist, Kupka creates a radiant composition where brown clusters punctuated by green and blue touches converge on a white nebula. If the burnt sienna rays conjure up the piano keys in a canvas of 1909 (Národní Galerie, Prague), the downy epicentre seems to anticipate the biomorphism of the pistils to come in *Tale of Pistils and Stamens No. 1* (1919-23, Musée national d'art moderne, Paris). When associated with bold framing, the dynamism of the geometrical construction means that formality is possible: more centripetal than centrifugal, the image proceeds from an amazing eruptive energy. When Nevinson makes use of violent potential in his *Bursting Shell* (1915, cat. 111), Kupka prefers to go along with the formal challenge permitted by this composition with its Futurist-oriented accents. In fact, the juxtaposition of the 'Straight Lines' and the 'Circular Lines'—whose use by the artist in *Creation in the Plastic Arts* in 1923 would strive to unveil its arcana—goes beyond just the initial subject which (as has been pertinently noted by Denise Fédit) matters little.[4] *Form of Yellow* (1911, private collection), also titled *Notre-Dame*, had already set up a prismatic deconstruction around a cosmic vision. One is once again entitled to think that *The Primitive* investigates the luminosity of a stained-glass window, even though the radiance makes it much closer still to Baroque aureoles, those very same ones which, in Bohemia, had revealed to the young Kupka his love of art. Perhaps it was necessary to transfigure the Cornaro chapel of Bernini on the altar of modernity in order to lend coherence to a distinctly syncretic work. In this sense, the dynamic structure and luminous, scintillating glitter of the canvas give it something in common with contemporary research, where the names can designate Kupka's determinedly independent undertaking: 'Orphism' for dreamlike simultaneity, 'Rayonism' for chromatic vibrations, and 'Vorticism' for kaleidoscopic swirl and whirl.

C. L.

1 See Jumeau-Lafond's most astute study *Les Peintres de l'âme: Le symbolisme idéaliste en France*, exh. cat., Musée d'Ixelles, Brussels 15 Oct.–31 Dec. 1999 (Pandora) Antwerp 1999, pp. 81–3.
2 Although Kupka's name does not feature in the Salon catalogue or in its supplement, many reports attest to the fact that three of his works were shown there. See the article by Brullé on this subject, "La création de Kupka et le cubisme 'écartelé' de la Section d'or: un rapprochement problématique", *La Section d'or 1925, 1920, 1912*, exh. cat., musées de Chateauroux, 21 Sept.–3 Dec. 2000, musée Fabre, Montpellier 15 Dec. 2000–18 Mar. 2001 (Paris: Cercle d'art, 2000), pp. 85–9.
3 Reported by Fédit, *L'Œuvre de Kupka*, (Paris: Éd. des Musées nationaux, 1966), p. 52.
4 Ibid.

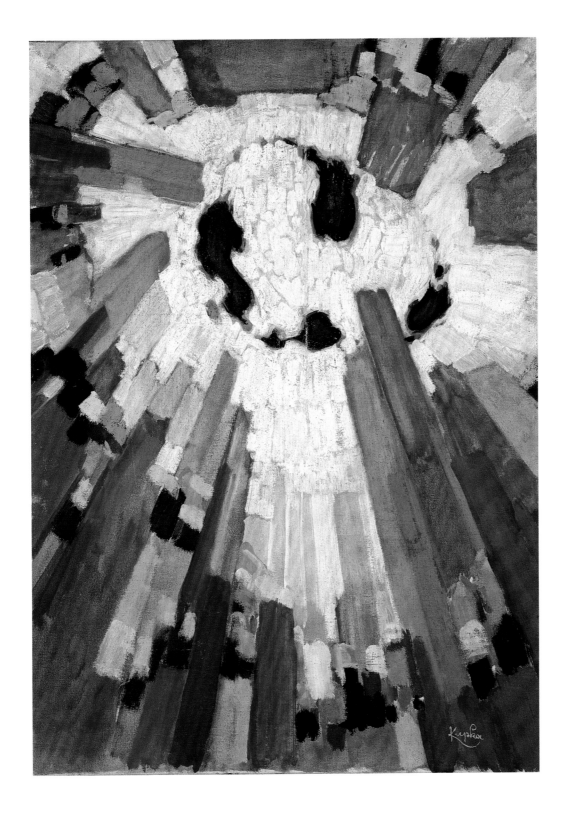

72 **Fernand Léger**
***Contraste de formes*, 1913**
[Contrast of Forms]
Oil on canvas, 100 x 81 cm
Centre Pompidou, Musée national d'art moderne, Paris
Donated by Jeanne and André Lefèvre, 1952

The *Contrast of Forms* series, produced between 1913 and 1914, consists of forty-five canvases.[1] Superabundant, it has enjoyed the advantages peculiar to prodigious bodies of work—having given rise to systematically divergent, if not radically antithetical, studies. So the principal coherence of the series lies precisely in the fact that it has not stimulated coherence in those who have commented upon it. The reason for this has to do partly with the theoretical and rhetorical talent of Léger himself, who in fact sowed a certain confusion in oscillating between revelations and denials. The very term "Contrast of Forms" exemplifies this apparent lack of distinction, because it has tended to divert attention from the colours which play an exceedingly significant role. While notions of Cubo-Futurism and Orphism can aid an analysis of the picture, any attempt (or temptation) to label it inevitably sidesteps its object. Although these two tendencies helped to reintroduce, on the one hand, methodical rigour and, on the other, the idea of a movement, they are ill-suited when it comes to expressing Léger's extraordinary chromatic modernity.

This canvas, produced in 1913, is an assemblage of forms—cones, tubes and ovals—inherited from the lesson imparted by Cézanne, which, when distributed by means of a subtle arrangement, give the illusion of depth and dynamism. Or rather, an illusion of a dynamic depth, so well does this analytical, albeit disjointed, arrangement create a stereoscopic feeling. The central figure is indecipherable—and in this respect Léger was categorical when he described "abstract" pictures to Kahnweiler—and seems to loom out of the surface of the canvas. While inspection of *Woman Lying Down* (1913) and *Woman in Red and Green* (1914, both Musée national d'art moderne, Paris) culminates in a certain legibility, *Contrast of Forms* merely invites speculation about the prior existence of a realist subject. Is this a figure, whose green oval shape (at top centre) might conjure up the face and the truncated red elements suggest dislocated limbs? However, the colours, within this obscure network of signs, do not seem to signify meaning. The blue and white ground, consisting of broad verticals, may be a last concession to the figurative tradition, but the other bright hues—yellow, red and green—may be considered part of a code that is made the more mysterious and mute by the fact that the artist never commented upon it. Their distribution over the rough surface of the canvas, whose weave—and texture—can just be made out, might suggest a certain casualness; this is not the case. The vaporous effect, wavering between the expressive flat hue and the subdued nuance, lends a quite novel strength to the colours which seem to live all by themselves, just docile enough to hug the black outlines squeezing in upon them. The glowing white, playing, for its part, with the blank areas, accentuates the brightness of the tones alongside, lending this chromatic weave the look of stained glass.

Comparisons can be drawn between *Contrast of Forms* and the three canvases that Malevich submitted to the Salon des Indépendants a year later, in 1914, including *Portrait of Ivan Kliun* (1913, cat. 95).[2] Similarly, it may be compared to the Futurism whose fierce attacks the February 1912 show had helped to spread abroad. But if the dynamic dovetailing of the forms and the zigzag structure of the lines link this work to the research undertaken by artists like Severini and Boccioni, the daring use of its colours goes beyond any 'scintillist' Futurist sparkle and Cubist monochromatism. The year 1913 was a pivotal one for Léger, for in it he published a brilliant and scholarly two-part article in which he tried to set out a position distancing himself from pan-Futurist ideas.[3] Some—quite rightly—would see in this solemn pronouncement the signs of a divorce resulting from an over-hasty engagement.

C. L.

1 See Bauquier and Maillard, *Fernand Léger: Catalogue raisonné de l'œuvre peint, 1903–1919*, vol. 1, (Paris: Adrien Maeght, 1990).
2 The other two Malevich works shown at the 1913 Salon des Indépendants were: *Morning in the Village after Snowstorm* (1912–13, The Solomon R. Guggenheim Museum, New York) and *Samovar* (1913, The Museum of Modern Art, New York).

3 Léger, "Les origines de la peinture et sa valeur représentative", *Montjoie !*, no. 8, 29 May 1913, p. 7 and nos. 9–10, 14–29 June 1913, pp. 9–10.

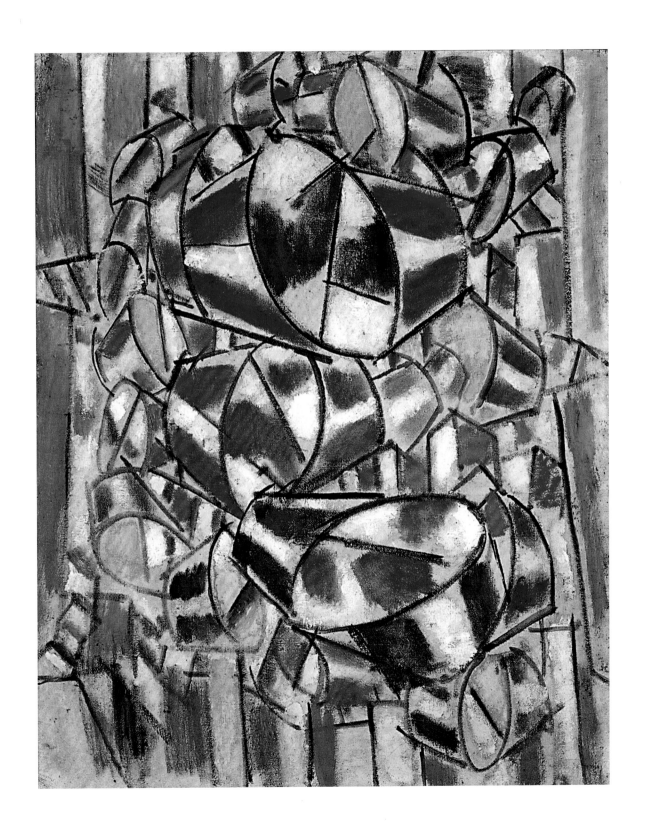

73 **Stanton Macdonald-Wright**
***Conception Synchromy*, 1914**
Oil on canvas, 91.3 x 76.5 cm
Hirshhorn Museum and Sculpture Garden, Smithsonian Institution,
Washington D.C. / Gift of Joseph H. Hirshhorn, 1966

Synchromism's propaedeutic was of the most orthodox sort: declarations and declamations, exhibitions and manifestos providing many an assimilation and repudiation, often paradoxical and hyperbolic, in accordance with a rhetoric tried and tested by the previous avant-gardes. Signifying the inviolability of movement came through the celebration of an immunity from other trends, as well as a strict endogamy. As a result, although Macdonald-Wright met Delaunay, and although his output approached the latter's, the Synchromist profession of faith in the catalogue for the exhibition held at the Galerie Bernheim-Jeune in 1913 acknowledged the debt to Orphism while rejecting it violently.[1] This dogged denial raised certain specific challenges: by nurturing an aesthetics wilfully safeguarded from any outside intrusion, Macdonald-Wright and Morgan Russell had the stated intention of establishing themselves as pioneers, because the modernist Eldorado of the Parisian scene rarely accommodated other gold-diggers. In this way, if Synchromism may appear to have been the first transatlantic avant-garde movement, the acknowledgement of it as such remained dependent on the recognition that bound it to established figures, including Delaunay and Kupka.

Conception Synchromy, painted in 1914, belongs to the artist's most productive period. The distribution of the coloured forms is based in Chevreul's scientific theories, but it also borrows, as if the truism merited being systematically greeted by silence, from the Impressionists, whose major works invited viewers to think of light in terms of colour. In any event, Macdonald-Wright's knowledge of the qualities of light also drew upon the American Ogden Rood's *Scientific Theory of Colors*, which added an analysis of the luminous potential of bodies to Chevreul's theories. Because pigments and spectrum had become inseparable, the Synchromist artist acted as an alchemist of a modernity governed by a scientific base illustrated by Rood's famous frontispiece. Through emblematic shapes of optic rhythm and vibration—circles and cones— Macdonald-Wright set up a remarkable dynamic structure whose lines were the colours themselves. In juxtaposing each primary colour with its complementary hue—and, in addition, investigating purple and mauve in ways that few artists knew, and would know, how to do—the painter created a eurhythmy wavering between mathematics and aesthetics. The material quality of certain tones at times fleecy, at others satin-smooth evokes pastel, while the methodical arrangement of cold shades makes it possible, based on Cézanne-inspired principles, to introduce a perspectival feeling.

Like the stained-glass windows of which it seems to be a radically modern transcription, this vibrating canvas is the product of a tremendous underlying complexity which some have suggested is indebted to the analysis which Henri Focillon (at one time Macdonald-Wright's teacher at the Sorbonne) made of Buddhist art.[2] And if the undulating distribution of these glowing colours is harmonious, it is also and above all harmonic because it is aimed at suggesting music—just like the neological hybridisation of 'Synchromism'. The optical speed cleverly created and the visual rhythm coming from the chromogenic interstices and relations of the forms between each other lend the painting this 'fourth', Bergsonian and Futurist, dimension, which gives the illusion of temporality, or rather of a beat or tempo. The declaration in the Bernheim-Jeune catalogue is eloquent in this respect: "The picture develops, like a piece of music, in value."[3] Not that it was determinedly original, but this claimed desire for a sort of *ut pictura musica* was aimed at bestowing upon Synchromist theory, and upon this canvas in particular, an *additional* merit, setting it apart from the contemporary Orphic production from which, without it being the pale offspring, it is nevertheless inseparable.

C. L.

1 Russell and Macdonald-Wright, "Introduction générale", *Les Synchromistes. Morgan Russell et S. Macdonald-Wright,* exh. cat., Galerie Bernheim-Jeune & Cie, Paris, 27 Oct.–8 Nov. 1913.
2 *Color, Myth and Music: Stanton Macdonald-Wright and Synchromism,* exh. cat., South (ed.), North Carolina Museum of Art, Raleigh 2001, p. 58.
3 Russell and Macdonald-Wright, *Les Synchromistes. Morgan Russell et S. Macdonald-Wright,* op. cit.

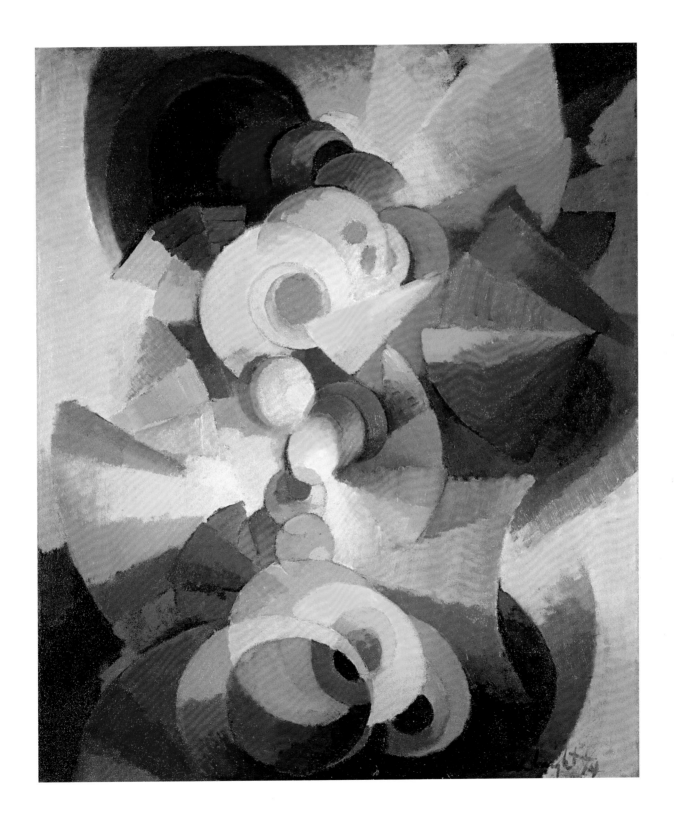

74 **Morgan Russell**
Cosmic Synchromy, **1914**
Oil on canvas, 58.4 x 50.8 cm
Munson-Williams-Proctor Arts Institute, Museum of Art, Utica (NY)

The coherence of the exhibitions held at the Galerie Bernheim-Jeune tended to make it something of a bastion of anti-Cubism, the hub of an alternative modernity based on a scientific aesthetic approach and on a focus on subjects drawn from contemporary reality. In February 1912, its artistic director, Félix Fénéon, an historical champion of Post-Impressionism, had opened the gallery's doors to the Italian Futurist painters, whose anarchist sympathies—part of the Post-Impressionist legacy—made them, in his book, heirs to Georges Seurat and Paul Signac. In autumn 1913, less than two years after that first Futurist exhibition, the gallery once again showed works by the pictorial disciples of the scientific theoreticians of colour (Eugène Chevreul, Ogden Rood, Charles Henry). Like the Futurists before them, the Synchromists Morgan Russell and Stanton Macdonald-Wright asserted loud and clear their opposition to Cubism and its latest variant, Orphism. With regard to the latter, they reviled its realist atavism—its atmospheric use of colour, and its inability to "conjure up volumes". Despite the manifesto-like texts featured in their catalogue, however, Russell and Macdonald-Wright were at pains to distance themselves from a form of Orphism with which their painting showed so many similarities. The link between their compositions and the "disks" of Delaunay and Kupka seemed to belie their claim to radical originality. The fact that they had inherited scientific theories of colour was something shared with all the renegade Cubists of Post-Impressionism (Delaunay, Metzinger etc.). In his essay, Russell tries to present his "rhythmic colours incorporating the notion of time in painting"[1] as an original contribution, overlooking the Bergsonism that was widespread in a whole part of Cubist painting. Likewise, the parallel he established between painting and music was, in 1913, part of the gospel of Orphism: "We are thus proceeding towards an entirely new art which will be to painting, as hitherto envisaged, what music is to literature. It will be pure painting, just as music is pure literature."[2] Despite these common references, Synchromism conveyed its own features, which were totally alien to works produced by Orphism. At the risk of giving in to the various forms of determinism of another age, let us hazard the suggestion that these specific traits were… "American". The quest for a dynamic plasticity and a lyrical and expressive volumetry represented the touchstone of this distinction. As a "failed sculptor" (to borrow Will South's term)[3], Morgan Russell spent time with Rodin, with whom he shared an enthusiasm for Michelangelo. The Synchromists' insistent references to the Italian sculptor (in the very preface to the catalogue for the exhibition held in the autumn of 1913)[4] inspired an ironical remark in the writing of an art critic from *La Plume*, who reproached Macdonald-Wright for "[copying] Michelangelo's Slave with a dirty broom".[5] Back in the United States, Macdonald-Wright would hand these values down to the painter Thomas Hart Benson—for a short while a disciple of Synchromism—who would make them one of the foundations of his own art, and subsequently of the lessons he would impart, among others, to his pupil Jackson Pollock. Fate would also smile in a different way on the posterity of this plastic dynamism peculiar to Synchromism, when the teachings of Hans Hofmann in New York would reveal the "Push and Pull" formula (involving colours hollowing out and dilating space), re-interpreting the principle of "The Hollow and the Bump", dear to both Russell and Macdonald-Wright. With Delaunay's student Hofmann, who saw the exhibition of Italian Futurist painters in Paris—where he lived from 1904 to 1914— the American legacy of a Synchromism fuelled by discussions stirred up in Paris by the dialogue between Cubism and Futurism, had come full circle.

D. O.

1 Russell, "Introduction particulière",
Les Synchromistes Morgan Russell et S. Macdonald-Wright, exh. cat., Paris, Bernheim-Jeune & Cie gallery, 27 October–8 November 1913, unpaginated.
2 Apollinaire, "Du sujet dans la peinture moderne", *Les Soirées de Paris,* no. 1, February 1912, p. 2.
3 South, "Synchromies", *Color, Myth and Music, Stanton Macdonald-Wright and Synchromism,* exh. cat., Raleigh, North Carolina Museum of Art,

4 Mar.–3 July 2001; Los Angeles County Museum of Art, 5 Aug.–29 Oct. 2001; Houston, Museum of Fine Arts, 2 Dec. 2001–24 Feb. 2002, p. 48.
4 Russell, S. Macdonald-Wright, "Introduction générale", *Les Synchromistes Morgan Russell et S. Macdonald-Wright,* op. cit., n.p.
5 Dervaux, "Le Salon d'automne", under the heading "Notes sur l'art", *La Plume* (Paris), no. 424, 1 Dec. 1913, p. 244. Transl. into English in Wright,

Modern Painting: Its Tendency and Meaning, (New York: John Lane, 1915), p. 338.

75 **Joseph Stella**
Battle of Lights, Coney Island, Mardi Gras, 1913–1914
Oil on canvas, 195.6 x 215.3 cm
Yale University Art Gallery, New Haven (Conn.)
Gift of Collection Société Anonyme

One year after the Armory Show, Stella's *Battle of Lights, Coney Island, Mardi Gras*, became, like Duchamp's *Nude Descending a Staircase No. 2*, (1912, cat. 59), an object of both alarm and scandal, and one that was also frequently caricatured. In the eyes of art critics, the work seemed to be one of the first paintings produced in the United States capable, through its audacity and its formal achievement, of rivalling European avant-garde painting.

In Paris, where he lived in the early 1910s, Stella witnessed the emergence of a Cubo-Futurism. He witnessed the preparations for the *Exhibition of Italian Futurist Painters* at the Galerie Bernheim-Jeune in February 1912, and Severini's, *The Danse of the "Pan-Pan" at the Monico* (1909–11/1959–60, cat. 45), the largest picture in the show, long remained etched in his memory.

Back in New York, Stella looked for a subject capable of expressing the energy and dynamism extolled by Futurist manifestos. Picabia, who was in New York when the Armory Show was on, told journalists that the city was itself both Cubist and Futurist. All Stella had to do was find a place capable of reconciling this Futurism intrinsic to the city with the movement and symphony of artificial lights which Severini had discovered in the Monico cabaret.

On Mardi Gras, in September 1913, Stella took the bus to the amusement park at Coney Island: "Arriving at the Island I was instantly struck by the dazzling array of lights. It seemed as if they were in conflict. I was struck with the thought that here was what I had been unconsciously seeking for many years."[1] Under the impact of this revelation, the painter produced several pictures in a Post-Impressionist style calling to mind works of proto-Futurism. In *American Cubists and Post-Impressionists*, organised in December 1913 at the Carnegie Institute in Pittsburgh, he exhibited *Battle of Lights, Coney Island, Mardi Gras*, whose intertwined curves evoked the grounding of Italian Futurist artists in the Symbolist tradition of Giovanni Segantini and Gaetano Previati. Between the exhibition in Pittsburgh and its New York presentation in February 1914 at the Montross Gallery, Stella produced a new version of *Battle of Lights, Coney Island, Mardi Gras*. It was formally more synthetic and more 'abstract' than earlier works, and was in its own right part and parcel of the movement of 'Orphic' Cubo-Futurism.

The picture is not so much an urban view as a psychological landscape, the pictorial transposition of sensations felt by the artist. His concept corresponded with the project often repeated by Picabia in his American interviews: "The aim of art is to get us to dream, just like music, for it expresses a mood projected onto a canvas, which arouses identical sensations in the viewer."[2] The 'musicalism' of *Battle of Lights, Coney Island, Mardi Gras* was the same as that being explored at the very same moment by two American painters, Russell and Macdonald-Wright. They also drew aesthetic conclusions from the discussions blossoming in Paris between Cubist and Futurist painting, writing in the introduction to their exhibition of 1913 (held in the same premises as the Paris exhibition of Futurist painters): "An art can come into being which, in emotional power, might go beyond contemporary painting, the way a modern orchestra may outdistance the ancient harpsichord solo. As forerunners, we have given vague needs something tangible and concrete and shown in what direction efforts must be directed."[3]

D. O.

1 Haskell, *Joseph Stella*, exh. cat., Whitney Museum of American Art, New York, 1994, p. 42.
2 Picabia interview with Hapgood, "A Paris Painter", *Globe and Commercial Advertiser*, 20 Feb. 1913, p. 8, reprinted in *Camera Work*, Apr.–July 1913; quoted in Borràs, *Picabia*, (Paris: Albin Michel, 1985), p. 107.
3 Russell and Macdonald-Wright, "Introduction générale", *Les Synchromistes. Morgan Russell et S. Macdonald-Wright*, exh. cat., Galerie Bernheim-Jeune & Cie, Paris, 27 Oct.–8 Nov. 1913.

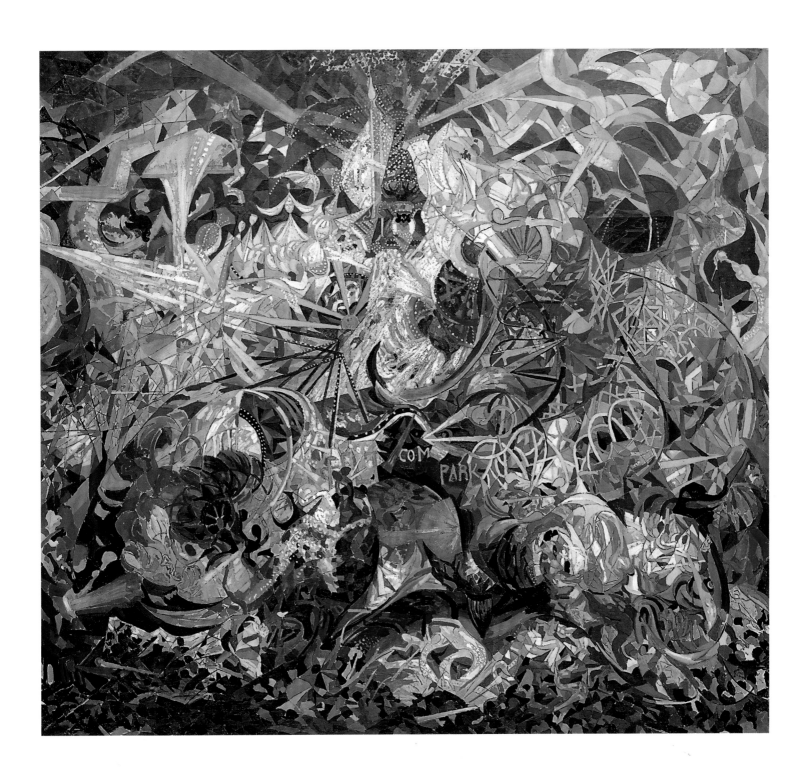

76 **Umberto Boccioni**
 Antigrazioso, **1912**
 Oil on canvas, 80 x 80 cm
 Private collection

It is striking to see Boccioni adopting, in 1912, a primitive and plastic pictorial vocabulary referring back to the origins of Cubism at the time of Picasso's *Les Demoiselles d'Avignon* (1907, The Museum of Modern Art, New York). This development certainly challenged the dictates of Futurism—the stylistic directions as defined by its manifestos—although it did not contradict its spirit. Boccioni's primitivism was just one of the forms of the Futurist struggle against Italian art in general and against the forms he deemed to be outmoded in relation to his modern evolution in particular. In *The Plastic Foundations of Futurist Sculpture and Painting* (1913), he wrote: "Gauguin's voyage to Tahiti, and the appearance of Central African idols and fetishes in the ateliers of our friends in Montmartre and Montparnasse, are events of historical destiny in European sensibility, like the invasion of a barbarian race in the body of a decadent people, since our past is the greatest in the world and thus all the more dangerous for our life! … We must smash, demolish, and destroy our traditional harmony, which makes us fall into a '*gracefulness*' created by timid and sentimental cubs."[1] The *Antigrazioso* [literally 'anti-gracious'] was the "barbaric" response which Boccioni set against the paralysing refinement of Italian art. The masculine gender of the title applies to the portrait genre and not to the figure itself, although it should not be ruled out that this masculinisation might also refer to 'the new Eve', to that energetic and intellectual muse which forever represented the feminine ideal of Futurism.

The primitivism of the *Antigrazioso* was foreshadowed in the series of portraits that Boccioni made of his mother, culminating in the figure of 1912 (Civiche Raccolte d'Arte, Milan) which seems to come straight out of the brothel of Picasso's *Les Demoiselles d'Avignon.* A study for the *Antigrazioso*, however, may enable us to identify Boccioni's model as the writer Margherita Sarfatti.[2] This identification turns the *Antigrazioso* into the counterpart of the *Portrait of the Poet Marinetti* painted by Carrà (1910, cat. 36), with a similar framing structure, pose and setting. Laura Mattioli Rossi has seen in this parallel a controversial positioning of Sarfatti as an alternative to Marinetti as the sentinel and defender of contemporary Italian art;[3] as events subsequently unfolded, such a reading would indeed materialise in the development of Italian art under Fascism, polarised between the modernism of the Futurist poet, on the one hand, and, on the other, the return to Italian values in *Il Novecento*, the movement championed by Sarfatti.

D. O.

1 Boccioni, "Fondamento plastico della pittura e scultura futuriste", *Pittura, scultura futurista,* Milan 1914, p. 463; trans. in Coen, *Umberto Boccioni: A Retrospective*, exh. cat., The Metropolitan Museum of Art, New York, 1988, p. 150.

2 See *Study of a Head*, made on a sheet of headed notepaper from the Savini Restaurant (1912–13, Civiche Raccolte d'Arte, Milan), repr. in Calvesi and Coen, *Boccioni. L'opera completa,* (Milan: Electa, 1983), p. 444, no. 791.

3 Mattioli Rossi, "Dalla scultura d'ambiente alle forme uniche della continuità nello spazio", in *Boccioni. Pittore scultore futurista*, exh cat., Milan, Palazzo Reale, 6 Oct. 2006–7 Jan. 2007 (Milan: Skira, 2006), pp. 48 and 52.

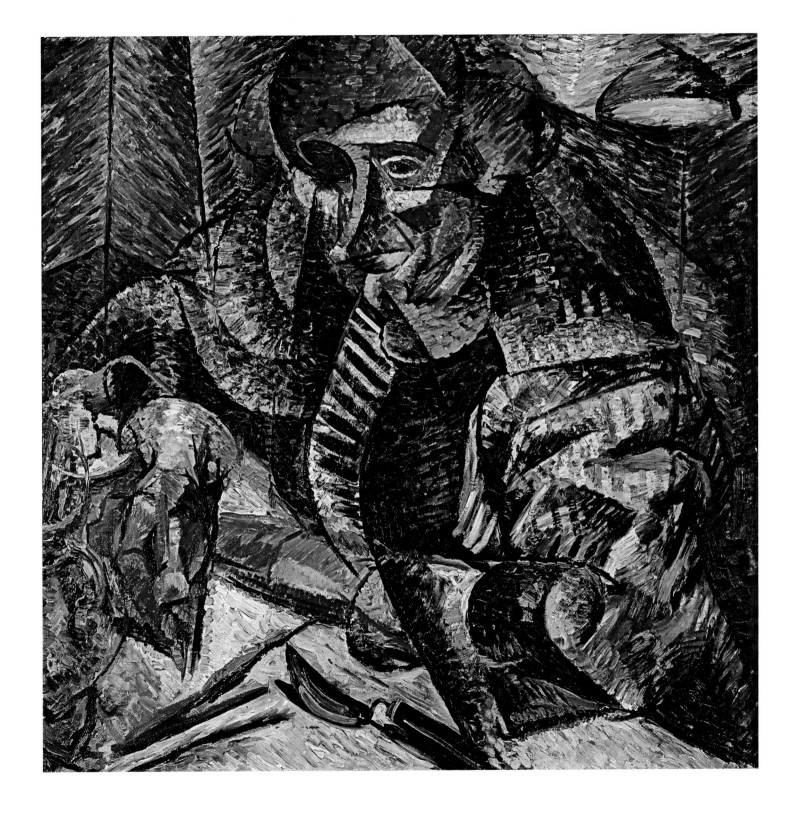

77 **Umberto Boccioni**
Costruzione orizzontale (Volumi orizzontali), **1912**
[Horizontal Construction (Horizontal Volumes)]
Oil on canvas, 95 x 95.5 cm
Bayerische Staatsgemäldesammlungen, Pinakothek der Moderne, Munich

A seated woman poses, hands in her lap. When Boccioni decided to depict his mother on a balcony of his Milan apartment at 23, via Adige, he addressed a subject laden with antecedents. As the latest canvas in a sequence of works celebrating the same scene, *Horizontal Construction* stands apart from two earlier paintings—*The Street Enters the House* (1911, cat. 26) and *Materia* (1912, Mattioli collection on loan to Peggy Guggenheim Collection, Venice)—because of its surprisingly classical style. Whereas in the previous year he had chosen to depict his mother from behind, leaning on the balustrade, before opting for a frontal, back-lit portrait, which called for raising the skyline, the artist finally returned to a more traditional composition which, apart from the square format, resorted to relatively academic devices. So the balustrade splits the composition half way up, while, because of a closer framing, the figure becomes the focus of the composition, where the earlier paintings had appeared to resist the subject of portraiture.

Several preparatory drawings produced in 1912 reveal Boccioni's intensity and fervour, his repertoire having been fuelled by his stay in Paris in the previous autumn. In particular, they illustrate his considerable research as to how to reinstate his mother's face which he hesitated for a long time to render either in profile or head-on. In eventually opting for the second solution, he might seem somewhat cautious and unadventurous, but, on the contrary, this apparent concession to a traditional figuration was intended to allow him to exaggerate subtle innovations. In fact the very title, *Horizontal Construction*, which is purely formal and as though abstracted from the subject depicted, indicates Boccioni's elimination of narrative. It was actually less a matter of recording an intimate family scene than achieving the Futurist fantasy of the compenetration of planes and the merger between object and surroundings. To this end, the figure's head—with the whole body dislocated by numerous vibrant and spiralling effects—is overlaid on the background buildings to the point of merging with them. Under a hieratic guise, the artist's mother is a dynamic source for all that surrounds her: the balustrade (which should continue on the right) disappears, the roofs and walls help to make of the face a magnetic vanishing point, while the purple shade of the clothing chromatically contaminates the adjacent elements. So the figure is the core of the vibratory structure to the point of being, once and for all, an energetic epicentre, which only the colour of the head and the hands make it possible to *really* identify on closer inspection.

The inscriptions scattered over the canvas—"122 m", "200 m" and "60 paces"—attest to the rigour governing this subtle figurative structure. They literally show the measurements of things, be it broken down or shattered. To this effect, the geometric background, which is akin to the facetting of Cubism, is important insomuch as it indicates Boccioni's interests when it comes to structuring and organising forms. Thus this canvas, which was shown in Rome in 1913 at the *Prima Esposizione di pittura futurista*,[1] issues from an unusual syncretism where the experimental challenges of sculpture come to the fore for an artist who published his famous *Technical Manifesto of Futurist Sculpture* in the year that this work was made.[2]

C. L.

1 *Prima Esposizione di pittura futurista*,
Teatro Costanzi (organised by Galleria G. Giosi),
Rome, opened 11 Feb. 1913.
2 *Manifesto tecnico della scultura futurita*,
11 Apr. 1912; trans. as *Technical Manifesto
of Futurist Sculpture*, in Apollonio (ed.), *Futurist
Manifestos*, (London: Thames and Hudson, 1973
and 2001), pp. 51–2, 61–5.

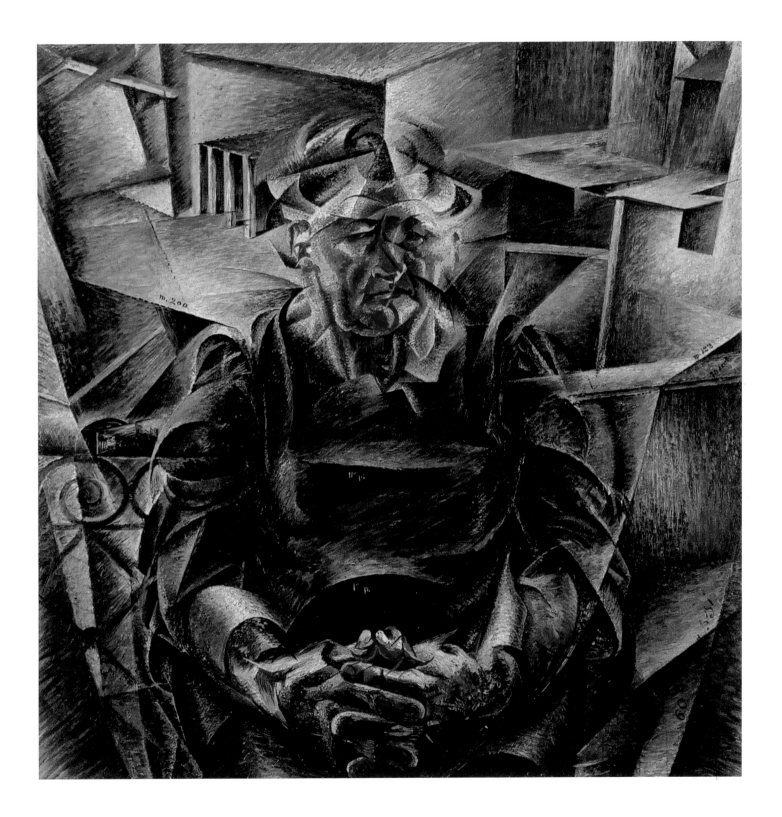

78 **Umberto Boccioni**
Il bevitore, 1914
[The Drinker]
Oil on canvas, 87.5 x 87.5 cm
Civiche Raccolte d'Arte, Museo del Novecento, Milan

It was during his stay in Naples, for a Futurist exhibition organised in 1914,[1] that Boccioni painted *The Drinker*. In this work, as in *Beneath the Pergola in Naples* (1914, Civico Museo d'Arte, Milan), people have often seen a return to Cubism and a Cézanne-like inspiration running counter to the painter's Futurist approach. But far from challenging certain positions that he had asserted through his writings and works, this canvas marks a new phase in his career.

The riot of colours and the explosion of sensations glorified by many of his paintings from previous years[2] may give way here to a tighter subject and plan, but dynamism still lies at the core of the picture. Though in less obvious, it seems to be as central as it is in his works depicting "movement", such as *Dynamism of a Footballer* (1913, The Museum of Modern Art, New York). After having grasped the liveliness of the urban world in its immediacy, Boccioni here continues to illustrate his manifestos by painting life as conveyed by a static subject: "There is no immobility; only movement exists, immobility being just an appearance, or something relative."[3] And a solitary man, sitting at a table, with his bottle, are all the more alive because they are "still" (like a "still life"), motionless, *a priori*, and empirically dizzy in their fall.

Only the bottle seems to rise up, emphasised by a halo which, by being reversed and anything but aglow, takes on the dark green and blue shades of the object whence it comes, drawing it closer to the picture's background. These cold colours contrast with the yellow-ochre tones of the figure, the table, the floor, and the chair. Only the red of the hat, reflected in the glass and the bottle through a tiny sparkle, upsets this impression. It evokes the colour of the bottle's drained contents, allowing space for the bitterness ensuing from its consumption. These objects seem to bear the trace of a private drama, heightened by the picture's 'sky', as cumbersome as the 'grotto' in Picasso's *Dryad* (1909–11, cat. 5).

This was nothing new in Boccioni's work: the representation of affects had always taken precedence over that of urban modernity. If the subject does not, at first glance, seem apt for Futurism, nor does the palette. It is less harsh, less garish than in many Futurist works, akin to the palette adopted by the Cubists: the tones of colour, even in their contrasts, refer to the canvases painted by Braque in the summer of 1908, during his stay at L'Estaque. And yet this new palette serves a Futurist design, and even more especially a Boccioni-esque one: it is a *state of mind* that turns out to be the work's real subject. Emanating from the figure, it invades colours and objects alike. Boccioni puts the onlooker behind the figure seen in three-quarter profile, which is all the more broken and curved because of the light striking the man's shoulder. A hand, almost as big as the head, grips the glass to the point of breaking it, creating an impression of compenetration between the two objects. Despite the hand's rough texture, it takes on the importance that it had in *Materia* (1912, Mattioli collection).[4] Geometrised and quasi-Cubist, it still withstands the decomposition undergone by the drinker's face, which is no more than the juxtaposition of a cheek, nose, and ear. The mind-numbing and lethargic effects produced by the alcohol reside in the weight given to this hand, like a Léger machine that has turned into a dynamic abstraction. The glass crystallises the simultaneity of two states, psychological fragility and physical collapse, conveyed by this downward pull, which passes through a static surface. And it is here that Boccioni manages to show how much dynamism statsis has, and how tumultuous immobility can be at the very heart of something feverish.

Following on from the *Antigrazioso* (1912, cat. 76), *The Drinker* tries to strip art of its aristocratic exterior, and link it to what Hegel called "the prose of human life"; "thought and reflection have gone beyond beautiful art".[5] Beyond the bottle, that prosaic object so dear to the Cubists, right up to the sculptures Boccioni made of it,[6] and beyond a scene taken from everyday life, what Boccioni is at pains to depict here is a sailor's oilskin or smock,[7] and no longer drapery or the smooth skin of a nude. So from the point of view of form, he demonstrates what was asserted in the painter's technical manifesto: "The harmony of the lines and folds of modern dress works upon our sensitiveness with the same emotional and symbolical power as did the nude upon the sensitiveness of the old masters."[8]

From the Futurism of *The Drinker*, nurtured by borrowings from Cubism, to the Cézanne-like construction, we shall retain the realisation of a plastic state of mind. Boccioni here invalidates the subject, using it as a means and not an end, and this in favour of emotion, well beyond the abstraction which he had attained in 1913.

M. D.

1 "Prima esposizione di pittura futurista", Naples, Galleria futurista, May–June 1914.
2 E. g. *The Laugh* (1911, cat. 27), *The City Rises* (1910–11, cat. 28), etc.
3 Boccioni, *Sculpture futuriste* (1913); Lista, *Futurisme. Manifestes, proclamations, documents*, (Lausanne: L'Âge d'homme, 1973), p. 191.
4 The work is currently on permanent loan to the Peggy Guggenheim Collection, Venice.

5 Hegel, *Esthétique*, (Paris: Le Livre de Poche, 2004), pp. 60 and 220.
6 *Development of a Bottle in Space* (1912, cat. 79).
7 The figure's hat is part of this interpretation, and Naples was already, at that time, one of Italy's major fishing ports.
8 Boccioni et al., *Manifeste des peintres futuristes*, in *Les Peintres futuristes italiens*, exh. cat., Galerie Bernheim-Jeune & Cie, Paris, 5–24 Feb. 1912;

Futurist Painting: Technical Manifesto, in *Exhibition of Works by the Italian Futurist Painters*, Sackville Gallery, London Mar. 1912, republished in Apollonio (ed.), *Futurist Manifestos*, (London: Thames and Hudson, 1973 and 2001).

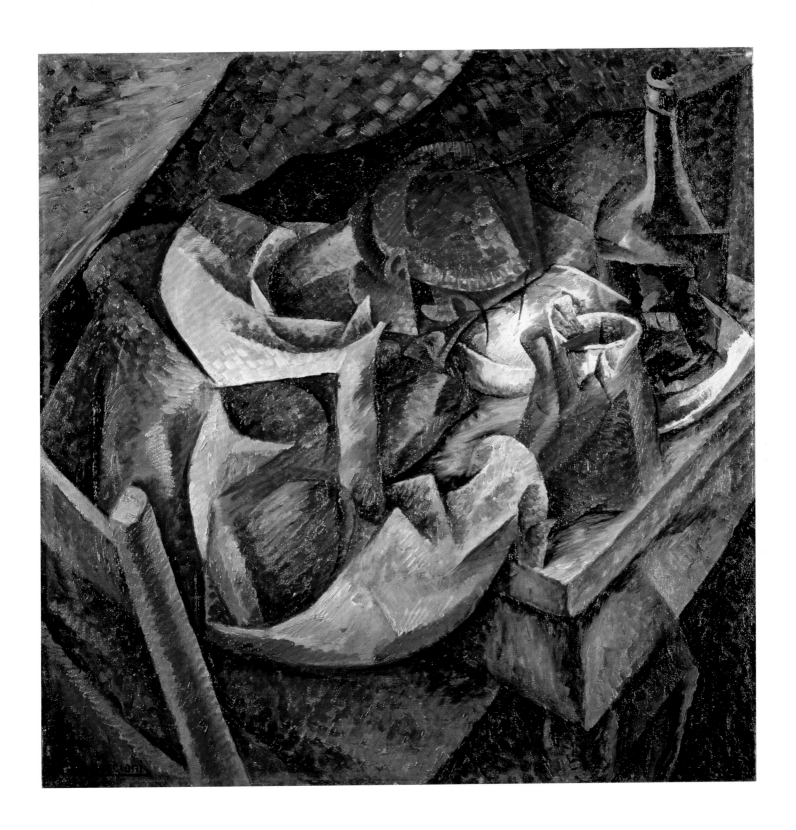

79 **Umberto Boccioni**
Sviluppo di una bottiglia nello spazio, 1912
[Development of a Bottle in Space]
Bronze, cast 1951–2, 39 x 60 x 30 cm
Kunsthaus Zürich, Zurich

"Boccioni's sculpture looms up and imposes itself in what was hitherto just the desert—with scattered, parched oases—of modern sculpture, and in the heart of this desert, in its most depressed part, Italy."[1] Roberto Longhi's declaration in his masterly essay on the Italian artist is enough, on its own, to justify all attempts to analyse this vitally important and extremely complex œuvre.

This peremptory, not to say subversive and challenging declaration, is above all remarkably responsive because it was made in 1914, only two years after Boccioni's own celebrated first efforts in the field of sculpture. For 1912 was the date in which the artist embarked on being a sculptor. The *Development of a Bottle in Space* is the earliest surviving work, and the *Technical Manifesto of Futurist Sculpture*, of 11 April, the theoretical statement. This had the effect, therefore, of joining the action to the word because 1912 also saw the publication of Gleizes and Metzinger's *On "Cubism"*, which tried not only to provide a basis for the specific features inherent in a movement but also to define itself "in reaction to", or "against" Futurism. Finding the watertight argument, circumscribing the inviolability of a territory, 1912 was to be a year of denials and ripostes, definitions and splits and, moreover, often of definition by way of division.

With this sculpture of paramount importance, Boccioni trespassed on the hallowed ground of Cubism, annexing the major theme for the experiments of artists like Braque and Picasso, namely the triviality of daily existence where the bottle had become the metonymic symbol and private domain. Boccioni's sculpture borrowed its subject from Picasso's *Portrait of Daniel-Henry Kahnweiler* (cat. 13), where the lower left corner suggests a bottle broken down in accordance with the precepts of analytical Cubism. A carefully-engineered scheme, furthermore, provides an insight into the chronology of the plan: "Take down all possible information about the Cubists, about Braque and Picasso. Go to Kahnweiler's and if he has photos of recent works (taken after my departure), buy one or two", Boccioni suggested to Severini.[2] The graphite drawing *Table + Bottle + Block of Houses* (1912, Civiche Raccolte d'Arte, Milan), documented and produced from memory after his stay in Paris in 1911, thus attests to Boccioni's assimilation of the Picasso bottle to which he adds a dynamic and spatial analysis. The two notes: "6 cm.", for their part, give a suggestion of the possible three-dimensional translation of the graphic work and, consequently, the desire to go beyond Picasso's innovation, thanks to the sculptural medium.

The sacrilege of re-using the Cubist cult object—the bottle—was not enough to guarantee the resolution of a Futurist sculpture. To achieve this, Boccioni literally went about it like an iconoclast: using the paradigmatic icon of the bottle, he broke it in order to deconstruct and then split it up, quite sure that it would rise again, brand new, from its ashes. Set on a dish, or fruit bowl as some have suggested, the bottle is broken down by means of different movements—'absolute' and 'relative'—and is rolled spiral-like around an axis that becomes the hub of this formal exploded mechanism. The curved and angular forms show the inside and the outer shape of the bottle, its structure and its dynamics. In this way Boccioni proceeded just as much to an unfurling as to a stripping-down aimed at probing the mystery of the object, its essence and its arcana. So what is involved is not so much a skeleton as a dissection or an evisceration which, by explaining the organic functioning of the object and its link to space, conjures up Tatlin's Constructivist experiments. Boccioni's crucial work veers towards demonstration, to the point of illustrating a flow of energy and a 'life force' or *élan vital*.[3]

C. L.

1 Longhi, *La Scultura futurista di Boccioni*, (Florence: Libreria della Voce, 1914).
2 Letter from Boccioni to Severini, [June–July 1911], Severini Archives, Sev. 1.3.2.8, Museo di Arte moderna e contemporanea di Rovereto e Trento; also recorded by Ottinger, "Le Futurisme, la naissance de l'avant-garde", *Ligeia*, 69–72, July–Dec. 2006, p. 41.
3 The equivalent and more faithful English subtitle *Still Life* is, therefore, preferable to the French 'Nature morte', used when it was exhibited in *Première Exposition de sculpture futuriste du peintre et sculpteur futuriste Boccioni*, Paris, Galerie La Boëtie, 20 June–16 July 1913, p. 28.

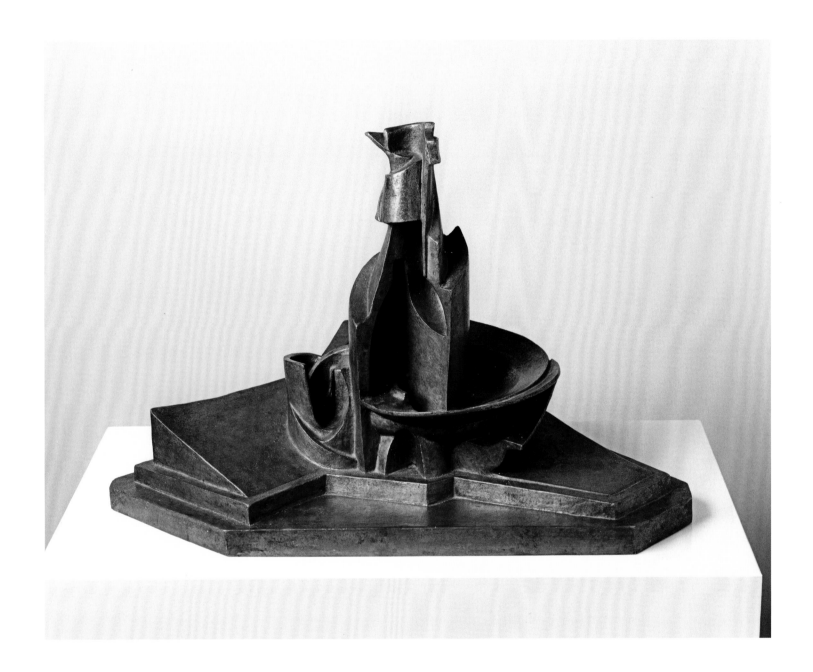

80 **Umberto Boccioni**
Forme uniche della continuità nello spazio, 1913, cast 1972
[Unique Forms of Continuity in Space]
Bronze, 117.5 × 87.6 x 36.8 cm
Tate, London / Purchased, 1972

On 11 April 1912, while he may not yet have materially tackled three dimensional problems—as in the other Futurist manifestos a proclamation was put forward as an initial, purely theoretical reflection—Boccioni signed the *Futurist Manifesto of Sculpture*.[1] In fact on that day he was still in Berlin, as borne out by a letter written on 13 April to his friend Barbantini.[2] However, as he wrote on 15 March from Paris to his supporter Vico Baer: "These days I am obsessed by sculpture! I believe I've seen a complete renewal of this mummified art."[3] Clearly this was after seeing the work of artists who were involved at the time in the transformation of sculptural expressiveness. It was only several months later that he returned to the question, writing to Severini: "I work a lot but don't seem to finish. That is, I hope what I'm doing means something because I don't know what I'm doing. It's strange and terrible but I feel calm. Today I worked non-stop for six hours on a sculpture and I don't know what the result is … Planes upon planes, sections of muscles, of a face and then? And the total effect? Does what I create live? Where will I end up?"[4] And again, a few days later: "The commitment I've made is terrible and the plastic means appear and disappear at the moment of implementation. It's terrible … And the chaos of will? What law? It's terrible! … Then I struggle with sculpture: I work, work and work and I don't know what I give. Is it interior? Is it exterior? Is it sensation? Is it delirium? Is it brain? Analysis? Synthesis? I don't know what the f… it is! … Forms on forms … confusion … The Cubists are wrong… Picasso is wrong. The academics are wrong. We're all a bunch of d…heads."[5]
In the manifesto Boccioni had attacked the sculpture of the past, Egyptian and Greek forms and the grandeur of Michelangelo, underscoring the anachronism of such expressions in relation to the fast rhythm of modern times: "This new plastic art will then be a translation, in plaster, bronze, glass, wood or any other material, of those atmospheric planes which bind and intersect things. This vision, which I have called PHYSICAL TRANSCENDENTALISM … could provide for the plastic arts those sympathetic effects and mysterious affinities which create formal and reciprocal influences between the different planes of an object."[6] Then, as for painting, he pointed out that the renewal of sculpture must stand out from the close relationship between figure and surroundings: no more a closed form with a value in itself, but the existence of an object intimately correlated with the space surrounding it: "Sculpture must, therefore, make objects live by showing their extensions in space as sensitive, systematic and plastic; no one still believes that an object finishes off where another begins or that there is anything around us—a bottle, a car, a house, a hotel, a street—which cannot be cut up and sectionalised by an arabesque of straight curves."[7] He acknowledges Medardo Rosso, though with considerable limitations, for having regenerated the traditional form and opened it up to atmospheric variations. To Cubist analysis, to the idea of fragmenting and breaking down, he opposes the thought of a synthesis of all possible realities in a single image. Not however the mechanical repetition of a passage from stasis to motion but the re-composition of all the parts, physical and mental, in a process of interaction valid also for inanimate things. In accordance with the teachings of Bergson, representation should recreate the "duration of apparition."
Urged on by a powerful emotive tension the artist elaborated his ideas while being fully aware of the work of Picasso, Archipenko, Duchamp-Villon and Brancusi. In his first plastic experiments Boccioni gave way to a Baroqueism of the image in an attempt to apply his ideas on dynamism and render three-dimensionality through transparency of the planes, further seeking to bring about a strong impact on the surroundings with the insertion of real elements in different materials.
With *Antigrazioso* the artist created a group that is more homogeneous, but still with a strong influence of Picasso, than the forcing of materials inserted into the moulded clay of his initial sculptures. So head and house are captured in a winding spiral that begins from below, whereas in the painting of the same subject (cat. 76) the sense of a spatial interpenetration of the figure appears more resolved in the interweaving of colours and lines.
In *Unique Forms of Continuity in Space* we see the foremost example of Boccioni's plastic research, as many critics have highlighted (from Roberto Longhi's youthful essay to John Golding's wide-ranging and masterly analysis).[8] In this sculpture the body follows a trajectory of motion that is now simplified and grasps the space, harpooning the projecting parts to the atmosphere. To the extent of representing all the possible variations of a movement in a single, absolute form, it synthesises with great skill the contrast between object and surroundings. The form has become more architectonic, more symbolic in the fusion of the compositional elements. Boccioni himself called it a "liberated" work, his most felicitous plastic creation.

E. C.

81

Antigrazioso, 1913
Bronze, cast 1950-51
58.4 x 52.1 x 50.8 cm
The Metropolitan Museum of Art,
New York / Bequest of Lydia Winston
Malbin, 1989

1 *Manifesto tecnico della scultura futurista*, reprinted in *Archivi del Futurismo*, collected and ordered by Drudi Gambillo and Fiori, (Rome: De Luca Editore, 1958), vol. 1, pp. 65–67; trans. as *Technical Manifesto of Futurist Sculpture*, in Apollonio (ed.), *Futurist Manifestos*, (London: Thames and Hudson, 1973 and 2001), pp. 51–2, 61–5.
2 In *Boccioni Gli scritti editi e inediti*, by Birolli (ed.), preface by De Micheli, (Milan: Feltrinelli, 1971),

pp. 351–52, then in Perocco, *Le origini dell'Arte moderna a Venezia (1908-1920)*, (Treviso: Editrice Canova, 1972), p. 112.
3 In Birolli, op. cit., pp. 349–51.
4 Ibid., pp. 358–59. The undated letter is attributed here to "July or August 1912".
But in view of other information in the letter I feel that a more pertinent dating would be November 1912.
5 Ibid., op. cit., p. 359.

6 Apollonio (ed.), *Futurist Manifestos*, (London: Thames and Hudson, 1973 and 2001).
7 Ibid.
8 Longhi, *Scultura futurista: Boccioni*, (Florence: Libreria della Voce, 1914); Golding, *Boccioni's Unique Forms of Continuity in Space*, (Newcastle upon Tyne: University of Newcastle upon Tyne, 1972).

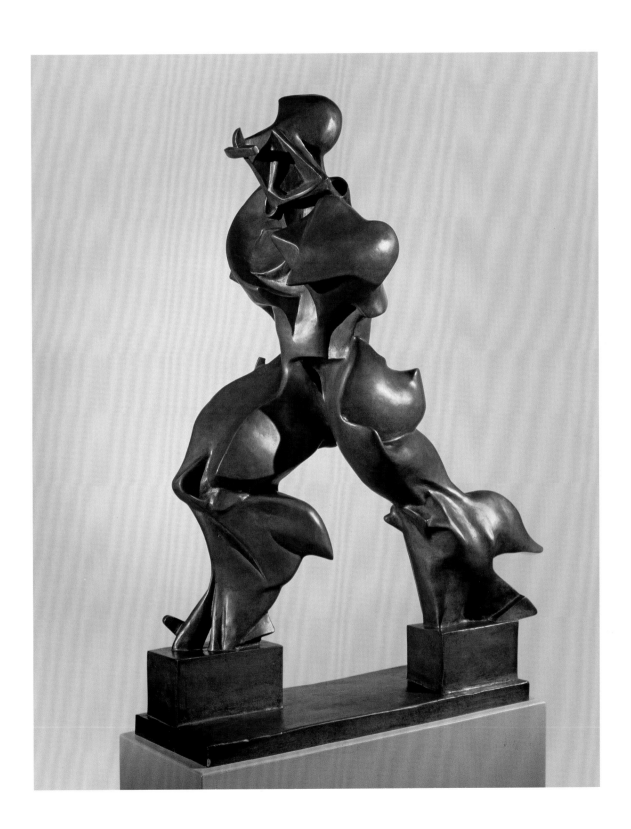

82 **Umberto Boccioni**
 ***Elasticità*, 1912**
 [Elasticity]
 Oil on canvas, 100 x 100 cm
 Civiche Raccolte d'Arte, Museo del Novecento, Milan

"*A horse in movement is not a stationary horse that moves but a horse in movement, which is to say something other, that should be conceived and expressed as something completely different.* It is a question of conceiving objects in movement over and above the motion they carry within themselves. That is, a question of finding a form which is the expression of this new absolute …. A question of studying the aspects that life has taken on in haste and in consequent simultaneity."[1] A breakdown of lines of force, an interpenetration of planes and a rhythm of plastic values are the aspects around which Boccioni moved his pictorial and sculptural reflection from 1912 onwards. From that moment the artist developed his research in an increasingly dynamic direction, concentrating on the possibilities of representing an individual form deriving from the fusion of subject and surroundings, perceived as a single spatial reality. In *Elasticity*, in which the artist returns to his beloved subject of the horse, which he was to take up again in 1914, the lines create that geometrical synthesis enlivened by brilliant colours, by almost phosphorescent greens, pinks and light-blues, where the parts interlock to create the fulcrum of the image at the heart of the composition. This fulcrum forms the energy of a dynamic impulse, a thrust that increases the intensity of the trajectory of signs aimed at shattering space and transforming its boundaries. The wedging in of the planes in the atmosphere follows the expansion of the animal's body, rendered mechanical by motion, while the extension of the atmospheric zones around forms an inextricable dimension between subject and reality.

E. C.

1 *Pittura scultura Futuriste,* (Milan: Edizioni futuriste di *Poesia,* 1914), p. 187.

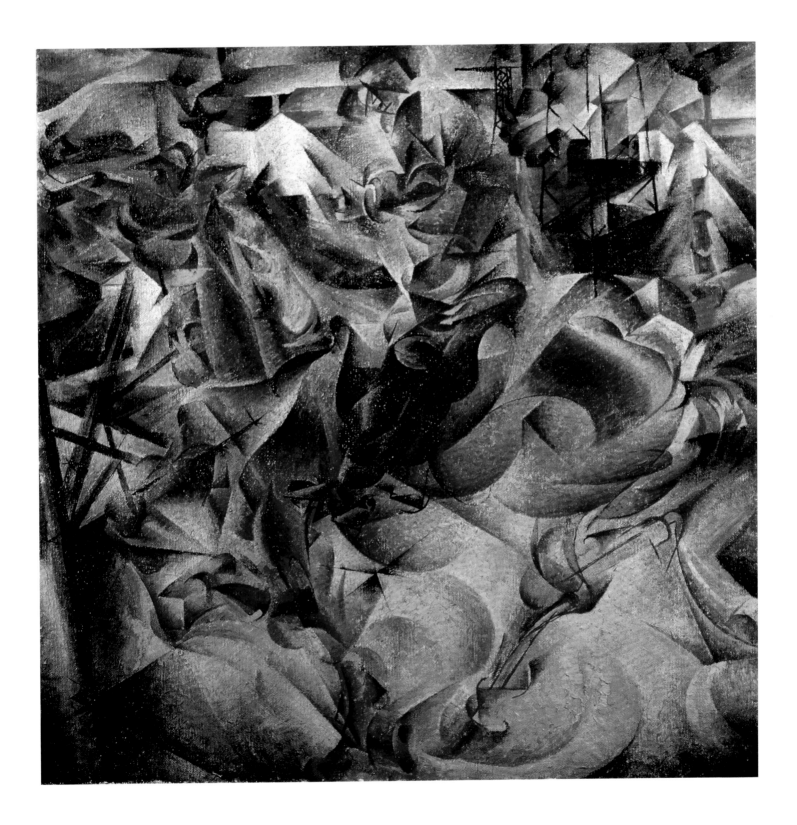

83 **Umberto Boccioni**
 Dinamismo di un corpo umano, **1913**
 [Dynamism of a Human Body]
 Oil on canvas, 100 x 100 cm
 Civiche Raccolte d'Arte, Museo del Novecento, Milan

By 1913, a constructive and more firmly dynamic syntax had taken shape in Boccioni's art, transforming the very substance of painting from the vibrant, airy and impalpable manner to a more solid and compressed definition of the image. Boccioni countered the Cubists' volumetric breakdown with a dynamic synthesis of vision through simultaneity of forms and the interpenetration of figure and environment to create "a sort of analogical synthesis" which, as the artist wrote, "lives on the boundary between the real object and its ideal plastic potency."[1] If the memory of Divisionist techniques is still visible in the chromatic passages and in the definition of a luminous spatiality, the amalgam and tension of these various passages create a construction that tends towards a higher solidity. In his 1913 paintings Boccioni brings a new plastic language into focus, in parallel with his sculptural research. The various planes of the image now intersect in accordance with the new experimentation, creating reciprocal and solid formal influences. In the *Dynamisms* series the artist arrives at a form of abstraction which nonetheless does not exclude recognisability of the subject in its lines of dynamic tension, since they derive from the analysis and fusion of two motions: the "characteristic motion peculiar to the object (absolute motion) with the transformations the object undergoes in its shifting in relation to the environment, mobile or immobile (relative motion)."[2]

E. C.

1 *Pittura scultura Futuriste*, (Milan: Edizioni futuriste di *Poesia*, 1914), p. 199.
2 Ibid., p. 195.

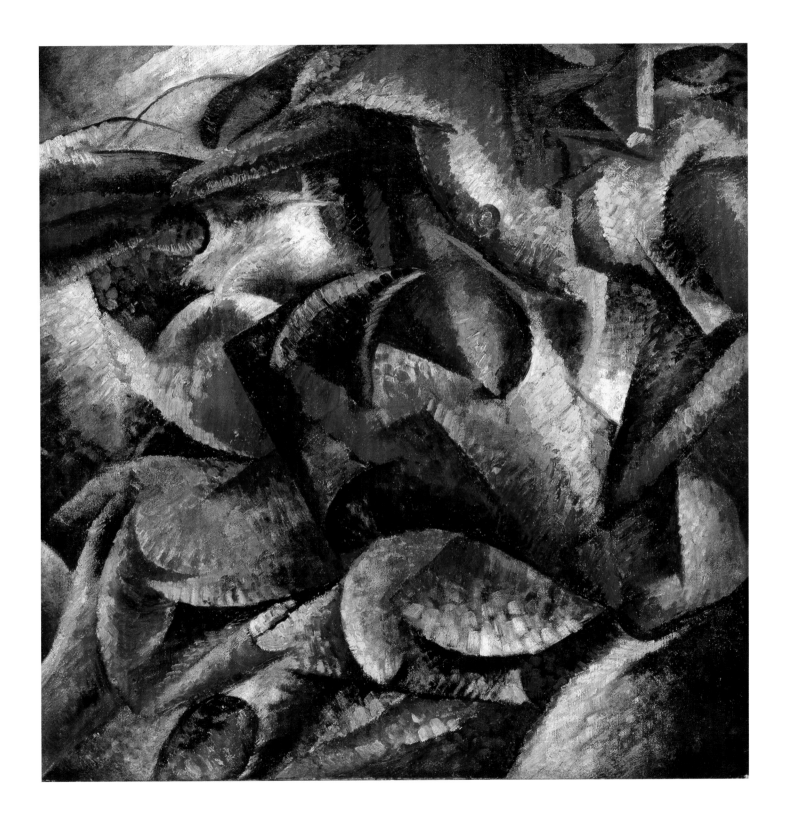

84 **Ardengo Soffici**
 Linee e volumi di una persona, **1912**
 [Lines and Volumes of a Person]
 Oil on canvas, 65 x 48 cm
 Civiche Raccolte d'Arte, Museo del Novecento, Milan

As a link between French art and Italian cultural circles, Soffici lived through the crucial years that saw the birth of the Cubist and Futurist avant-gardes, retracing the far-reaching motivations behind their shared desire to renew the language of expression. His at once artistic and literary experience also shed light on the complexity of the relations within the movement founded by Marinetti, especially in the quite specific adventure of Florentine Futurism. As with Severini, Soffici's itinerary was influenced by a long stay in France. Even though he maintained a strong bond with his roots, he felt a need for action that would extricate Italian art from its provincialism. He set up home in Paris from 1900 to 1907, then stayed in France on several occasions, keeping in close touch with that cultural scene right up to the outbreak of the First World War. During those years, Soffici forged friendships with figures prominent in the French intelligentsia—Jean Moréas, Gustave Kahn and Guillaume Apollinaire introduced him to the milieu of the new Symbolist poetry, whose creative force was a valuable source of inspiration, not least for the artist's formal research in the figurative arts.

At the same time, and again thanks to Apollinaire's friendship, Soffici frequented the rue Ravignan, where Cubist artists were to be found. With Picasso he forged a deep relationship based on mutual esteem, and this enabled him to follow the creation of *Les Demoiselles d'Avignon* (1907, The Museum of Modern Art, New York). It was this intense participation in the artistic life of the Parisian avant-garde that helped him to come by an in-depth knowledge of Cubism—from its initial experimental phase to its developments as a mature movement. His critical reflections became the stuff of numerous studies which in turn formed the first significant theoretical contributions to be published in Italy.[1]

For Soffici, the exploration of Cubist art nevertheless had a broader significance, which was reflected in the evolution of his pictorial language. *Lines and Volumes of a Person* clung thoroughly to the principles of the Cubist breakdown of composition. The figure, frozen in a motionless pose, is structured on the basis of a compenetration of geometrically inclined volumes which define the different parts of the body. The choice of colours—which intensifies the monochrome character of the work, wavering between powdery shades of grey and ochre—also derives from Cubist orthodoxy. The rigour of the composition emphasises the solid plasticity of the forms, bolstered by carefully distributed *chiaroscuro* contrasts. This work's closeness to certain empirical themes and procedures of Cubism highlights everything that separates Soffici's poetics from contemporary Futurist research: the idolatry of modernity, dynamism, and strident colour. Technical innovations in the structure of the artwork seem to have had no influence on this painting. This partly explains the artist's difficult relations with Futurism, punctuated from the movement's birth in 1909 by theoretical controversies and differences of opinion. These tensions nevertheless abated with the publication in the magazine *La Voce* of his article on the Parisian *Exhibition of Italian Futurist Painters* held in February 1912.[2] They would be reabsorbed by the fact that the hard core of Florentine artists, gathered about Soffici and Giovanni Papini, paid allegiance to Futurism. This reconciliation lay at the root of the creation, in January 1913, of the Florentine magazine *Lacerba*, one of the main mouthpieces for disseminating information and propaganda pertaining to the Futurist movement. This switch of position, for Soffici, matured within a critical development during which the artist recognised, in Marinetti's movement, a new opportunity to break with the Italian cultural situation—an important instrument of artistic renewal. While Soffici sided with Futurism, a Cubist inflection, aimed at the glorification of formal values, nevertheless still prevailed in his work.

Z. D. L.

1 See in particular his article "Picasso e Braque",
La Voce (Florence), vol. 3, no. 34, 24 August 1911;
trans. in Antliff and Leighton (eds.), *A Cubism
Reader: Documents and Criticism, 1906–1914*
(Chicago and London: University of Chicago Press,
2008), p. 128–40.
2 Soffici, "Ancora del futurismo", *La Voce* (Florence),
vol. 4, no. 28, 11 July 1912.

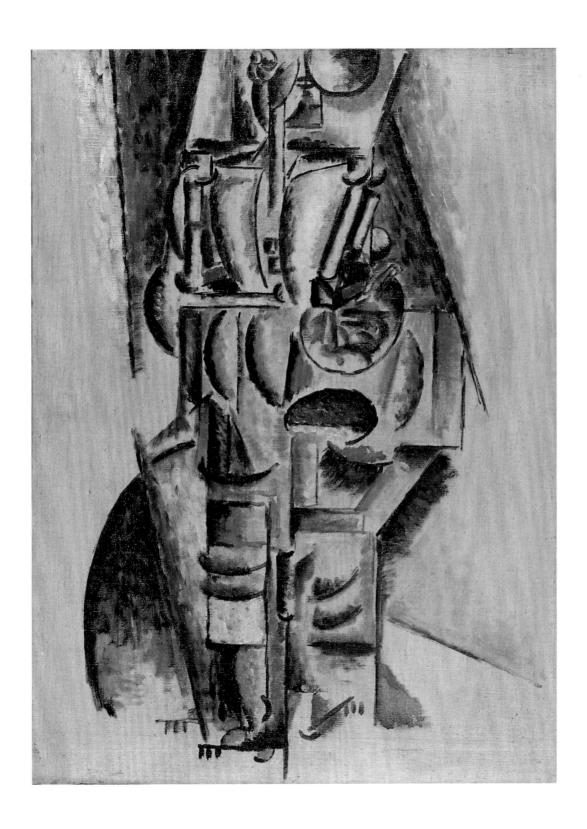

85 **Gino Severini**
Nature morte au journal «Lacerba», **1913**[1]
[Still Life with the Newspaper *"Lacerba"*]
Glued paper, Indian ink, pencil, charcoal, gouache and chalk on paper, 50 x 66 cm
Fonds national d'art contemporain, Ministère de la culture et de la communication, Paris
On permanent loan to the Musée d'art moderne de Saint-Étienne, Saint-Étienne, 1956

"He was—and this was his originality, even, doubtless, his greatness—he was the bridge between Futurism and Cubism."[2]
Bernard Dorival thus summed up the predominant role played by Severini in the relations between Futurism and Paris, where, from 1911 onwards, he started seeing Picasso, Braque, and many other artists on the art scene. As a driving force behind the Italian Futurist group, Severini invited his colleagues to visit him in the French capital, and, in October 1911, introduced them to the studios of Picasso, Brancusi, Archipenko and Léger.

Still Life with the Newspaper "Lacerba" reveals the extent to which Severini was already steeped in the research and works of the Parisian Cubists. He evidently took up their favourite themes: newspaper, fruit bowl, bottle, glass, discarding—one by one, to start with—those of Futurism. He adopted their formal vocabulary, the sober hues and the structured composition. It is typical that the fruit bowl was placed centrally, propped on the right by the powerful verticality of the bottle; the geometric forms were clearly delimited, either by paper cut-out or by precise lines. Severini also appropriated their technique—in this instance that of *papier collé*. While using this procedure, which had been developed during the spring of 1912 by Braque and Picasso, Severini displayed his own daring and inventiveness by making added use of the diversity of materials. Each outline was different: drawn in chalk, Indian ink, gouache, pencil or charcoal; each type of paper brought its specific character: one evoking a wooden table through its motif, another rendering the transparency of glass and yet another using corrugated cardboard to strike horizontal lines across the entire surface of the canvas. Severini himself confided in 1930: "I think that today I can admit my debt to Braque and Picasso without diminishing myself."[3] As an allusion to Futurism in this Cubist-inspired composition, the fragment of the Florentine periodical *Lacerba* found an echo the following year in Picasso's *Pipe, Glass, Newspaper, Bottle of Old Marc* (1914, cat. 87), where the bottle of rum has turned into a bottle of old marc.

In *Still Life with the Newspaper "Lacerba"* Severini offered a foretaste of his Cubist period, as he moved away from the Futurist movement between 1916 and 1920, joining Picasso, Braque, Gris, Léger, Laurens and Metzinger, who were grouped around and supported by Léonce Rosenberg. The latter, who owned *Still Life with the Newspaper "Lacerba"* at one time, organised a show for him in his Galerie de l'Effort moderne in May 1919; it fell between exhibitions of Juan Gris (April) and Picasso (June), thus including Severini once and for all at the heart of what has been called the "second Cubism".

I. M.

1 The work is signed and dated by the artist 1913.
Fonti, however, in her *catalogue raisonné*
of Severini's work, ascribes the canvas to 1918.
2 Dorival, *Gino Severini*, cat. exh., Paris, Musée
national d'art moderne, July–Oct. 1967, p. 5.
3 Quoted in Maritain, "Gino Severini" [1930],
Brefs écrits sur l'art, (Paris: Mercure de France,
1999), p. 65.

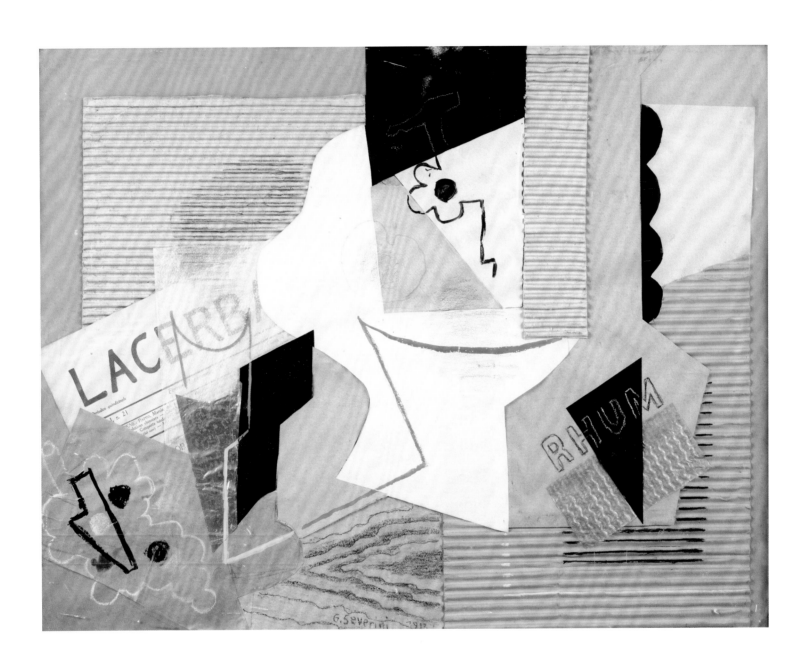

86 **Gino Severini**
Portrait de Paul Fort, **1915**
[Portrait of Paul Fort]
Glued paper on canvas, 81 x 65 cm
Centre Pompidou, Musée national d'art moderne, Paris
Gift of Mrs Severini and her daughters, 1967

"In the midst of so many poets, the pure poet, the 'integral poet' as Maeterlinck called him, was Paul Fort. He had structured his own prosody somewhere between the Alexandrine and free verse: a rhythmical, musical prose … rarely had such a rich abundance of poetic talent been seen"[1] wrote Severini, describing the editor of the magazine *Vers et Prose*, and founder of the Théâtre d'Art.

Paul Fort was also the driving force behind all the literary exchange at the café *La Closerie des Lilas*. Marinetti introduced Severini to it, so he was able to witness the debate focused on the renewal of the language of art which would before long so drastically change literature, poetry and the plastic arts. *La Closerie* very swiftly became the meeting-place for many young artists, in particular the independent Cubists—Jean Metzinger, Albert Gleizes, Francis Picabia and the Duchamp brothers. Severini was thoroughly involved in the cultural life of Montparnasse, and became the official spokesman for the Futurist movement in Paris. He was at pains to maintain a live dialogue between Italian research and the discussions peculiar to the French avant-gardes. In diplomatic ways, he strove to do away with the disagreements and rancour stirred up by the exhibition of Italian Futurist painters held in February 1912.[2] The following year he married Jeanne, Paul Fort's daughter, with Apollinaire and Marinetti as witnesses.

Severini's work was fuelled by his active participation in the cultural discussions encountered in Paris, and stimulated by eclectic propositions. In his *Portrait of Paul Fort*, executed in 1915, the artist thus introduced the use of collage, a technique with which Georges Braque and Pablo Picasso had been experimenting since 1912. On the background of the canvas appear printed pages from the magazine *Vers et Prose*, a programme from the Théâtre d'Art and a visiting card. Added to these descriptive elements were actual objects: spectacles, moustaches, and bits of fabric, all representing the characteristic "attributes" of the model.

Z. D. L.

1 Severini, *Tutta la vita di un pittore* [1946],
(Milan: Edizioni di Communità, 1965), p. 89;
trans. Franchina as *The Life of a Painter* (Princeton:
Princeton University Press 1995), p. 71.
2 Ibid.

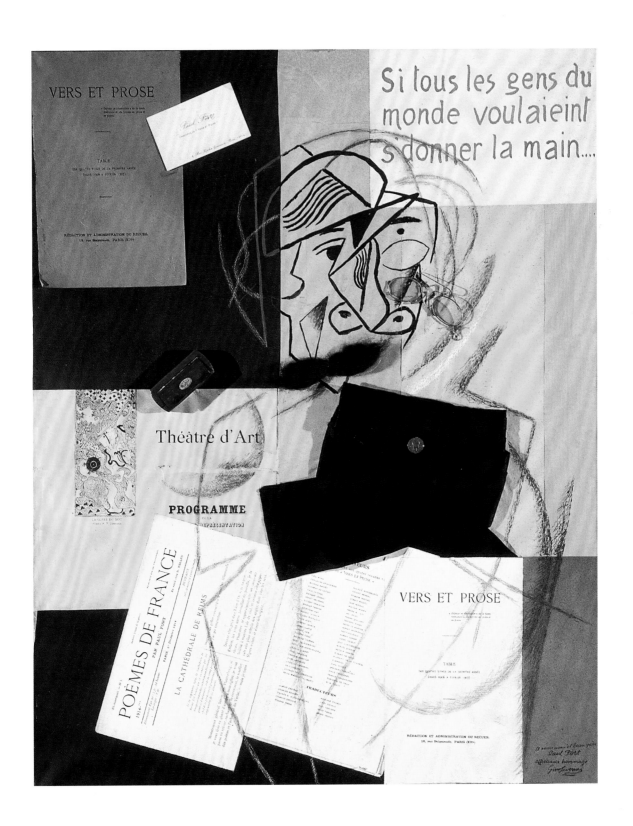

87 **Pablo Picasso**
Pipe, verre, journal, guitare
et bouteille de Vieux Marc: «Lacerba», spring 1914
[Pipe, Glass, Newspaper, Guitar, and Bottle of Vieux Marc: *"Lacerba"*]
Pasted paper, oil and chalk on canvas, 73.2 x 59.4 cm
Peggy Guggenheim Collection, Venice (Solomon R. Guggenheim Foundation, New York)

In March 1914, Carrà informed Severini that he had talked at length with Picasso and that, but for his suspicion of various hangers-on, "he is almost one of us".[1] Although this may seem a rather extravagant claim, it is a measure of the convergence of Futurism and Cubism that was strengthened by the presence of a group of Italians in Paris that spring. Carrà was in the company of Papini and Soffici, and their base was with Baroness d'Oettingen and Serge Férat, the publishers of *Les Soirées de Paris*, newly placed under the editorship of Apollinaire. This concentration of, mainly Florentine, Futurists beginning to diverge from Marinetti and Boccioni may cast light on the use of their periodical *Lacerba* in collages by both Braque and Picasso in early 1914, and especially *Pipe, Wineglass, Newspaper, Guitar, and Bottle of Vieux Marc*. Picasso was careful to preserve the masthead of the 1 January 1914 issue, contrasting its bold typography with his hand-drawn label for the bottle. While playing the future off against the "old" (Vieux Marc), Picasso also, in a different register, set the periodical against the section of found wallpaper.

Although it is likely that Picasso's main interest lay in this visual impact through which he 'enframed' *Lacerba* within his own work,[2] the visibility of the names of the first three contributors to the 1 January 1914 issue seems deliberate. The preservation of Folgore, Marinetti and Soffici (together with the prominent *fumatori* echoing the pipe) may suggest an openness to a dialogue. This may be especially the case with Picasso's old friend Soffici, the title of whose article, "Il soggetto nella pittura futurista", is both visible and pertinent, for here Futurism is, in the form of *Lacerba*, one of the subjects of the work. That this dialogue was conducted in the new form of the collage may also be significant, as Apollinaire's decision to illustrate Picasso's collages in *Les Soirées de Paris* in December 1913 is said to have been the cause of a massive fall in subscribers in protest. Through the incorporation of *Lacerba* Picasso was, therefore, associating Futurism with this most radical of departures. This was not a public gesture, however, and it is doubtful whether the Italians were even aware of this engagement. Indeed, in his article on the Salon d'Automne, though somewhat disingenuous about his own interest in Futurism, Apollinaire claimed: "Futurism is not unimportant, and the Futurist manifestos written in French have no small influence on the terminology used by today's newest painters. From an artistic point of view, Futurism bears witness to the world-wide influence of French painting, from Impressionism to Cubism."[3] Parochial though such a view could be, it reflects some of the impetus behind the engagement occurring in Paris shortly afterwards.

M. G.

1 Carrà to Severini (in Anzio), 13 Mar. 1914, in Carrà and Fagone (eds.), *Carlo Carrà - Ardengo Soffici: Lettere 1913–1929*, (Milan: Feltrinelli, 1983), p. 246; the original reads: "Egli è quasi dei nostri".
2 Leighton, *Re-Ordering the Universe: Picasso and Anarchism, 1897–1914*, (Princeton: Princeton University Press, 1989), p. 176, note. 13.
3 Apollinaire, *Les Soirées de Paris*, 15 Dec. 1913, trans. Suleiman in Breunig (ed.), *Apollinaire on Art: Essays and Reviews 1902–1918*, (New York: Da Capo, 1972), p. 334.

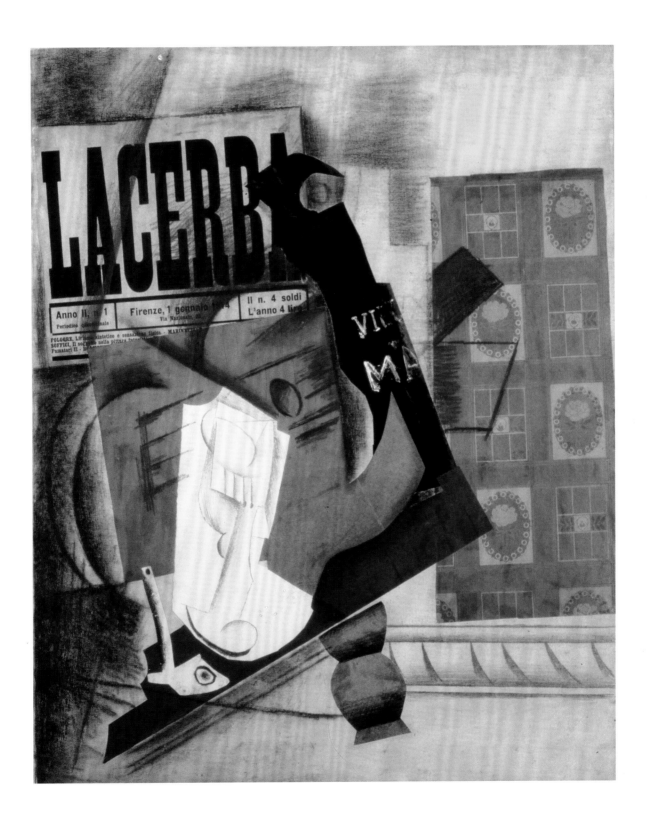

88 **Giacomo Balla**
Bambina che corre sul balcone, 1912
[Girl Running on a Balcony]
Oil on canvas, 125 x 125 cm
Galleria d'Arte Moderna, Milan / Grassi Collection

Although belonging to a generation prior to that of Carrà, Russolo, Boccioni and Severini (the last two being his former students from the Scuola Libera del Nudo in Rome), Balla threw in his lot with Futurism in 1910, when the movement was endowing itself with a pictorial component. He did not yet feature among those signing the first version of the *Manifesto of Futurist Painting* in April 1910, but his name certainly does appear in the definitive version which he co-signed.[1]

Two years later, his participation in the exhibition at the Galerie Bernheim-Jeune in February 1912 was announced in the catalogue which mentioned one of his paintings: *Street Light*. Despite this information, it turned out that Balla's work did not feature in the exhibition of Italian Futurist painters. This ostracism was the handiwork of Boccioni, who at that time reckoned that the Futurist conversion of his former teacher was not yet sufficiently clear in his painterly production.[2] It may have been in response to this challenge that Balla produced three pictures, *Leash in Motion* (1912, Albright-Knox Art Gallery, Buffalo, N.Y), *Girl Running on a Balcony* and *Rhythms of a Bow* (1912, Estorick Collection of Modern Italian Art, London), that share a focus on the depiction of the *dynamic sensation itself*, which *Futurist Painting: Technical Manifesto* had included at the heart of its programme.[3]

The analytical aspect of the movement applied in *Dynamism of a Dog on a Leash* and in *Rhythms of a Bow*, which tends to produce kinetic effects by an evanescence of forms, echoes the "photo dynamics" of the Bragaglia Brothers, discovered by Balla not long before. Another source, from Paris this time, more directly anticipates the composition of the *Girl Running on a Balcony*, as Giovanni Lista has mentioned: Balla's discovery of Jules-Etienne Marey's photographs at the 1900 *Exposition Universelle*. In a letter to his fiancée he talked about the excitement of looking at Marey's study of movement and about starting work on a picture inspired by those photographs: "It will interest artists because, in it, I have made a special study of the *way of walking* of this girl, and, in fact, I have succeeded in *giving the illusion* that she is in the process of moving forward."[4] The memory of Marey's photographs was still present in Balla's mind when, more than ten years later, he embarked upon the task of futuristically re-introducing his daughter Luce running around the balcony of his house in Rome. The numerous graphic studies which preceded the painting demonstrate this link. They reduce the figure in motion to an interplay of abstract lines, the very same ones which Marey had included in the black clothing of the characters whose gestures he was analysing. This scientific analysis of movement persisted in the form of the mathematical equation *Bambina x balcone,* which Balla submitted as the title to his picture, when it was shown in Naples in 1914.[5]

The link between Balla's painting and Marey's chrono-photography lay at the root of its being likened to the contemporary pictures of Duchamp, and particularly with the *Nude Descending a Staircase No. 2* (1912 cat. 59). Through his evocation of movement based on the duplication of a figure whose physical integrity is preserved, Duchamp showed himself to be a zealous disciple of Marey, in contrast to Balla's interest to fragment any such integrity. The colour which Balla, like other Futurists, inherited from his Post-Impressionist past, was the agent of this dissolution. It is here that he showed himself to be one of the most 'orthodox' of Futurists. He applied to the letter a programme from *Futurist Painting: Technical Manifesto*, asserting that "movement and light destroy the materiality of bodies".[6] With regard to this "destruction", Duchamp showed himself to be the student of a Cubism (at least of Braque and Picasso in the years 1908–11) for which the integrity of the form was a basic factor.

Balla's three 1912 pictures proved his unconditional support for the thesis and aesthetics of Futurism. In a letter written early in 1913 to Severini, Boccioni recounted the conversion of their former teacher: "Balla flabbergasted us because, not content with being involved in a Futurist campaign, as you can well imagine him doing, he launched himself into a complete transformation. He rejected all his works and all his working methods. He started work on four pictures of movement, which were still realist but incredibly ahead of their time … He confided this to Aldo Palazzeschi: 'They did not want anything to do with me in Paris and they were right: they have gone much further than I, but I will work and I too will progress'."[7]

D. O.

1 Boccioni et al., *Manifesto dei pittori futuristi*, Milan 11 Feb.1910; trans. as *Manifesto of Futurist Painters*, in Apollonio (ed.), *Futurist Manifestos*, (London: Thames and Hudson, 1973 and 2001), pp. 24–7.
2 See Boccioni to Severini, [Jan. 1913] quoted in Pacini, "Futurismo e oltre", *Critica d'arte* (Florence), no. 111, May–June 1970 and Lista, *Balla futuriste,* (Lausanne: L'Âge d'homme, 1984), p. 44.
3 Boccioni et al., *Manifeste des peintres futuristes*, in *Les Peintres futuristes italiens*, exh. cat., Galerie

Bernheim-Jeune & Cie, Paris, 5–24 Feb. 1912, p. 16; *Futurist Painting: Technical Manifesto*, in *Exhibition of Works by the Italian Futurist Painters*, Sackville Gallery, London Mar. 1912, republished in Apollonio, op. cit., p. 27.
4 Lista, *Balla* [catalogue raisonné], (Modena: Edizioni Galleria Fonte d'Abisso, 1982), p. 22.
5 In "Prima esposizione di pittura futurista", Naples, Galleria futurista, May–June 1914; the canvas had already been shown,with the title *Bambina moltiplicata*

[multiplied girl], in "Prima esposizione di pittura futurista", Rome, Galleria G. Giosi, [February] 1913.)
6 Boccioni et al., *Manifeste des peintres futuristes*, op. cit., p. 21; in Apollonio, op. cit., p. 30.
7 Boccioni to Severini [Jan. 1913] quoted in Pacini, op. cit. and Lista, op. cit., p. 44; discussed also in Ottinger, "Cubism + Futurism = Cubofuturism", in the present volume.

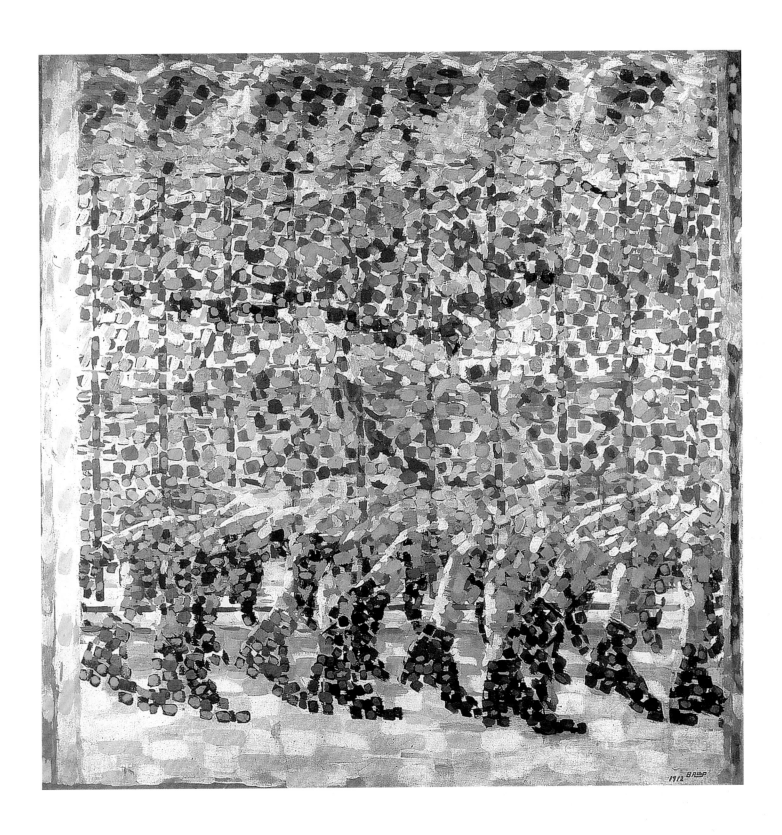

89 **Alexandra Exter**
Florence, **1914–1915**
Oil on canvas, 109.6 x 145 cm
Tretyakov National Gallery, Moscow

In freeing herself from analytical Cubism and Italian Futurism, and distancing herself from the arguments of her com-patriots advocating a "budetlânstvo" [Futuraslavia], Exter exhibited her city compositions in 1914 in Paris[1] and in Rome.[2] The city was still the theme most capable of rendering the simultaneity of past, present and future, as well as the simul-taneity of nocturnal and hidden worlds. In 1912 the painter travelled around Italy and went to Florence with Ardengo Soffici, where the latter would subsequently run the magazine *Lacerba* from 1913 to 1915. Pursuing her urban explorations, and influenced by Soffici's picture *Synthesis of the City of Prato* (1912–13, subsequently destroyed), she started to paint Florence, jewel of the Italian Renaissance. Unlike many Cubo-Futurist canvases depicting the city, with its more or less anonymous space, *Florence* was a synthesis of existing architectural themes, such as the typical arch of Santa Maria Novella. The composition, whose lines and planes echo one another unhierarchically, seems to accumulate and layer geo-metric segments in a frontal way. But the arcs of circles (the dome and bridge) link the profusion of architectural elements, from the most stylised to the most discreet. The brushstroke and colouring provide a kind of patchwork issuing from a gen-tle, reflecting alchemy. Between the figurative elements in the foreground and the abstract elements in the upper part of the canvas, there is an interweaving of shimmering and transparent shifts. The visible surface of the canvas and the brushstrokes, be they fine or thick (zigzagging, broken, or flat) together create surprising effects of colours, both liquid and luminous, quivering with hues responding to each other, dovetailing to bring the viewer inside the space of the city of Florence. The rigorous and varied segmentation of the planes, both oblique and frontal, at the bottom of the picture, opens up several perspectives. As in Soffici's depiction of Prato, Exter multiplies the staircase motif using concentric shapes, narrow and broad, as an invitation to venture into secret places like the city's colonnades. The word "Firenze" painted on the canvas has more to do with an advertising hoarding, a shop sign or a signpost than something helping us to read the work, in the manner of Picasso and Braque. The title becomes a graphic feature ("to the letter", as Khlebnikov put it), underscored by the oblique plane of the Italian flag at bottom left. The artist would use national flags, in addition to words, in several of her works, both for their colour ranges and their geometric form.
Florence was shown in the *Tramway V* Futurist exhibition, organised by Ivan Puni in Petrograd, in March 1915, along-side a homonymous canvas,[3] as well as twelve other works by Exter. In her many city pictures, Exter imposed a free and personal Cubo-Futurism which was forever being re-invented, both through colours and through spatial constructions. Her poetic and lyrical style, well removed from the ideological and political convulsions then common in Moscow, St. Petersburg, Rome and Paris, would lead her to a non-objective art. In 1914, the war took this most western of Russian painters back home.

C. M.

1 At the Salon des Indépendants, Champ
de Mars, Paris, 1 March–30 April 1914.
2 At the "Esposizione libera futurista internazionale.
Pittori e sclutori italiani–russi–inglesi–belgi–
nordamericani", Rome, galleria futurista, April–May
1914.
3 These two paintings were numbered
79 and 80 in the exhibition.

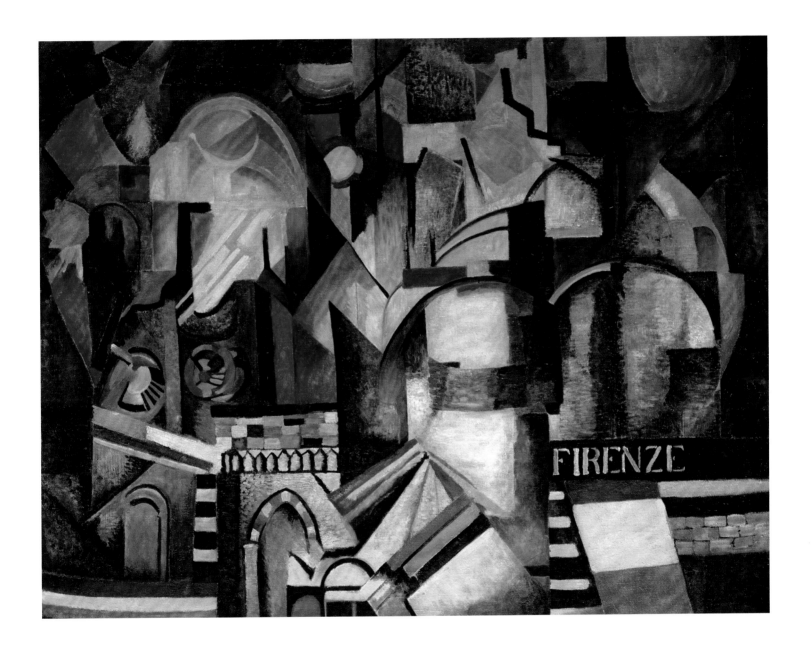

90 **Alexandra Exter**
Gorod noč 'û, **[1913]**
[City at Night]
Oil on canvas, 88 x 71 cm
State Russian Museum, St. Petersburg

Associated with the Burliuk brothers, with whom she organised the exhibition *Zveno* [The Link][1], held in Kiev in November 1908, and with the poet Benedikt Livshits from 1909 onwards, Alexandra Exter was never short of nicknames (such as "the messenger of the avant-gardes" and "Léger's little pupil"). From 1908 onward, she went regularly to Paris where she frequented in Cubist circles Apollinaire, Picasso, Braque and, in particular, Léger. The year 1912 was decisive for her: she took part in exhibitions in Moscow (2nd Salon of the Jack of Diamonds), Paris (Salon des Indépendants and Salon de La Section d'or) and St Petersburg (5th exhibition of the Union of Youth). In February 1912, while visiting the Futurist show at the Galerie Bernheim-Jeune, Alexandra Exter took exception to statements Marinetti made about women and museums, but she was interested in Boccioni's aesthetic potential and especially his urban theme, redefined on the basis of post-Cézanne artwork and simultaneity. In Paris, in April 1912, through Serge Férat and Baroness Helen d'Œttingen, she met the Futurist painter Ardengo Soffici, with whom she would share her Paris studio at 18 rue Boissonade, from 1913 to 1914. In 1912, the city became the major subject of many Cubo-Futurist canvases, most of them depicting cities by night like the one exhibited in St. Petersburg (some were exhibited at the 6th and last exhibition of the Youth Union, November 1913–January 1914, which ushered in Cubo-Futurism). Like the Russian avant-garde artists, Alexandra Exter relied on a much brighter colour range than her Cubist and Futurist referents. Her painting, nevertheless, did not adopt the 'primitivist' character specific to the Cubo-Futurist works of Malevich and Goncharova. The picture *City at Night* was the crowning point of the painter's Futurist lyricism and her undisguised fondness for a dazzling chromatism from the Baroque ardour of her native Ukraine. The composition of the canvas is based on a central brilliance (possibly the yellow headlights of a car hurtling down a deserted street) which hurls various inert elements and geometric urban fragments about; arches of bridges, triangles and quadrilaterals of houses seem to come to life and spill over beyond the space of the canvas. The chaos of the sloping planes and lines, both attracted and repelled by the central light, stands out against a background of abandoned buildings in darkness. Out of instinct, Alexandra Exter, who had been rebuked by Léger for "the excessive brightness of her canvases",[2] let the virulence of the colours take over, lending the whole a vibrant and rhythmic character. *City at Night* offers us one of the most dynamic compositions in the *Cities* series, which also calls to mind Robert Delaunay's series on Paris. Through the centrifugal frenzy of this picture, probably painted in Paris in 1913–14, the painter plunges us into the very core of a city divided between light and shadow, between frenzy and anxiety, and between the elusive and the transitory.

C. M.

1 Burliuk distributed the tract-cum-manifesto "La voie
de l'impressionnisme pour la défense de la peinture".
2 Livshits, *L'Archer à un œil et demi,* translated,
prefaced and annotated by Sébald and Marcadé,
(Lausanne: L'Âge d'homme, 1971), p. 142.

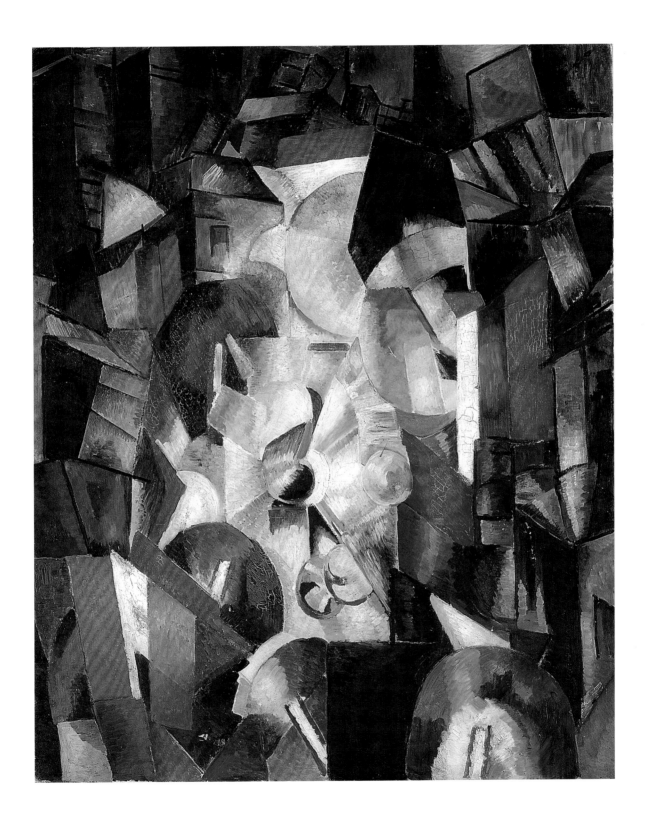

91 **Natalia Goncharova**
 Velosipedist, **1913**
 [The Cyclist]
 Oil on canvas, 79 x 105 cm
 State Russian Museum, St. Petersburg

In its dynamic force, Natalia Goncharova's *Cyclist* belongs to the purest expression of European Futurism. The painter displays her command of the vocabulary relating to the transcription of movement and time by the multiplication of forms and the repetition of outlines. The combination of circles and lines undeniably calls to mind the procedures used by the Italian Futurists, in whose work circular energies collide with rays of light to create a force filled with a cosmological value. Goncharova remains perhaps more prosaic, in her choice of subject.[1] In this sense she comes close to Malevich's famous *Knife-Grinder*, painted in 1913 (Yale University Art Gallery, New Haven). Jean-Claude Marcadé has indeed emphasised the isolated character of Goncharova's picture, as much in the artist's body of work as in the whole of Russian Futurism.[2] The fact remains, nonetheless, that the canvas is related to the kinetic principles explored by Balla between 1912 and 1914. Whereas the Italian painter was fascinated by the speed of the automobile, that machine emblematic of the modern world, Goncharova turned to the bicycle, a more peaceful vehicle. This choice had its reasons. We should remember Marinetti, drunk with speed at the wheel of his car, performing the wildest manoeuvres and finding himself, after a daring spin, facing two cyclists, likened to "two equally convincing but nevertheless contradictory arguments".[3] The epic account of that incident served as a preamble to the *Manifesto of Futurism*, published on 20 February 1909 on the front page of *Le Figaro*. Goncharova became acquainted with that text in its Russian translation, published the same year in *Večer* [Evening] on 8 March 1909.

It is well known that she strongly criticised Marinetti when the latter visited Russia early in 1914. She reproached the Italian poet for posing as the founding father of Futurism. Rejecting this arrogant hegemony, she declared: "This individual is of little interest in my opinion",[4] and "Marinetti and his Futurism contribute nothing to modern art."[5] In fact she laid claim to a specific feature of the Russian avant-garde, which was seeking its source of inspiration in traditional art forms, notably in mediaeval icons and all forms of primitive art, such as the (popular print) *lubok*, painted shop signs and Scythian stelae, dating back to the remote past of Russia and to its Eastern roots.

In this picture, the cyclist heading to the left upsets the usual direction of image reading. So the new man, living in symbiosis with his vehicle—the image is not unrelated to the centaur motorist dreamed of by Marinetti—is at liberty to turn to the past to reach modernity. He wilfully takes the road counter to the direction indicated by the authoritarian pointing finger. Even if his head hits the vertical red ochre line and even if the road ahead is paved with massive round stones, he advances doggedly, pursuing the path he himself has chosen.

The Russian character is further underlined by the recourse to the Cyrillic letters of signs and posters of the urban world, which are overlaid on the human figure, incorporating it within the cityscape. The inscriptions in Cyrillic letters make truncated words ring out, based on a technique of the *sdvig*, fashioned by Russian Futurist poets and artists. The word *sdvig*, based on a root evoking motion, means a discrepancy, gap, displacement, shift, subsidence, and slip within the verbal and pictorial matter. Even though incomplete, the words "*lâ[pa]*" [hat], "*ëlk*" [silk] and "*nit[ka]*" [thread] remain perfectly identifiable. This eruption of references to clothes reminds us that Goncharova, with several of her compatriots, explored the link between life and fine arts by promoting the decorative arts. At her first retrospective exhibition in Moscow in September 1913,[6] alongside her canvases she exhibited projects for textiles and embroideries.

The static character of the letters contrasts strikingly with the dynamics of the Rayonist treatment that marks the central motif. In this formal conflict, the artist was possibly seeking to affirm her femininity. The letter "Я" ["I" in Russian] of the word for "hat" stands out clearly from the others. Thus isolated, it alludes to the subject "I" and becomes a kind of discreet signature by the painter, her personality undeterred by the din of the manifestos being proclaimed by her contemporaries.

I. K.

1 It is worth remembering that the theme attracted the attention of Boccioni who, in 1913, devoted to it nine drawings and a picture, *Dynamism of a Cyclist*. In addition, Marinetti and the Futurists served during the war in a cycle brigade.
2 Marcadé, *L'Avant-garde russe, 1907-1927* (Paris: Flammarion, 1995), p. 89.
3 Marinetti, *Manifesto du futurisme*, Le Figaro, 20 Feb. 1909; trans. as "The Founding and Manifesto of Futurism", in Apollonio (ed.), *Futurist Manifestos*, (London: Thames and Hudson, 1973 and 2001), p. 20.
4 See *Večernie izvestiâ* no. 381 (24 Jan. 1914), p. 2.
5 See *Moskovskaâ Gazeta* no. 297 (27 Jan. 1914), p. 6.
6 Exhibition organised by the dealer Mikhailova (30 Sept.–5 Dec. 1913).

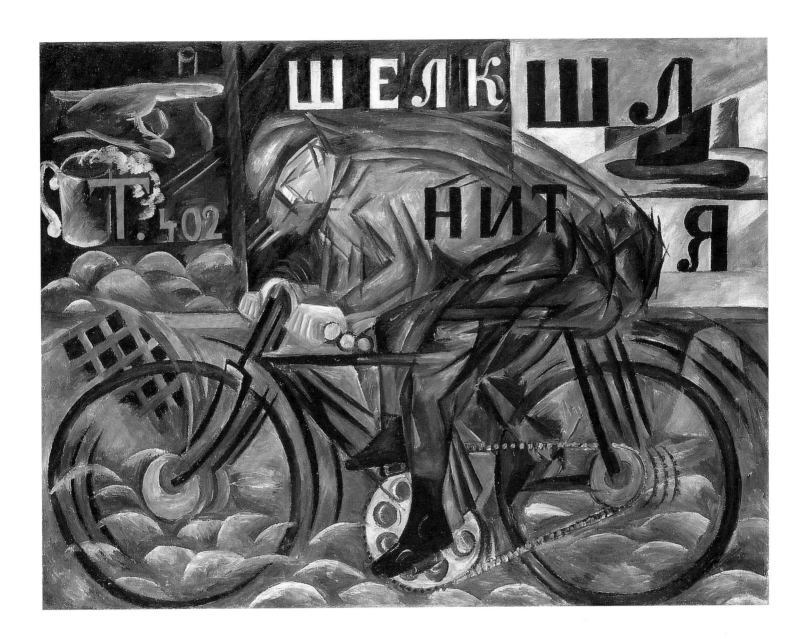

92 **Natalia Goncharova**
La Lampe électrique, **[1913]**
[The Electric Light]
Oil on canvas, 105 x 81.5 cm
Centre Pompidou, Musée national d'art moderne, Paris
Gift of the Société des Amis du Musée national d'art moderne, 1966

The Electric Light was shown along with eighteen other works by Natalia Goncharova, including the Cubo-Futurist picture *Woman with Hat* (1913, Musée national d'art moderne, Paris) in Moscow in March–April 1914, at the last exhibition put on by Mikhail Larionov before the Great War, titled *Exhibition of Painting No. 4*. This show, first planned for spring 1913 to promote Neo-Primitivist painting, then programmed for the following autumn, took on an international dimension with the inclusion of Italian Futurists and French Orphists, as announced, through its subtitle, "Futurist, Rayonist and Primitivist works". Proclaiming, like Larionov, a Russian artistic identity through references to popular [*lubok*] and religious images (icons), Goncharova initially painted Neo-Primitivist works, but in 1912 she began to create Futurist 'book-objects'. These were launched by Alexei Kruchenych, the poet and theoretician of transrationality (the *zaum*, invented by the poet Velimir Khlebnikov to describe an art "beyond reason"). From reading Marinetti's *Manifesto of Futurism*, published on 8 March 1909 in Moscow in the *Večer* [Evening News], and the text-cum-manifesto "The Exhibitors to the Public" written for the Paris *Exhibition of Futurist painters* in February 1912 (published the following April in St. Petersburg by the Union of Youth), Natalia Goncharova did not remember so much the machine and the beauty of speed as the force-lines (in her work, ornamental) and the succession of planes creating an image.

In this picture, it was not just a matter of painting the electric light coming from an electric street lamp, as in Balla's work (*The Arc Lamp*, 1911, The Museum of Modern Art, New York), but of rendering its power of diffusion with the help of curved lines (like ropes), tracing sound waves. The light source (the globe of a kitsch light with purplish colours) is done away with in favour of dazzling white and yellow forms. The mouldings of a frame partly reproduced on the canvas may conjure up the presence of a mirror purposely duplicating the halo of light. Electricity, symbol of modernity, here refers to an abstract image where the concentric circles, white rays, and contrasting choice of complementary colours assert the "Rayonist" link between Goncharova and Larionov (whose manifesto she signed in April 1913). In the preface to the catalogue for their show at the Galerie Paul Guillaume in Paris in June 1914, where *The Electric Light* was shown, Guillaume Apollinaire suggested that Goncharova's aesthetic added "first, the modern harshness contributed by Marinetti's metallic Futurism, and, second, the refined light of this Rayonism, which is the purest and newest expression of contemporary Russian culture".[1] In Paris, by glorifying light and resorting to dynamic zigzag strokes, breaks in planes and in rhythm, Goncharova proposed an abstract composition linked with music and the gilded dazzle of icons, based on a subject much used by the Italian Futurists.

C. M.

1 Apollinaire, "Preface", *Natalie de Gontcharowa et Michel Larionow*, exh. cat., Galerie Paul Guillaume, Paris, 17–30 June 1914, unpaginated; trans. in Breuning (ed.), *Apollinaire on Art: Essays and Reviews 1902–1918*, (New York: Da Capo Press, 1972), p. 413.

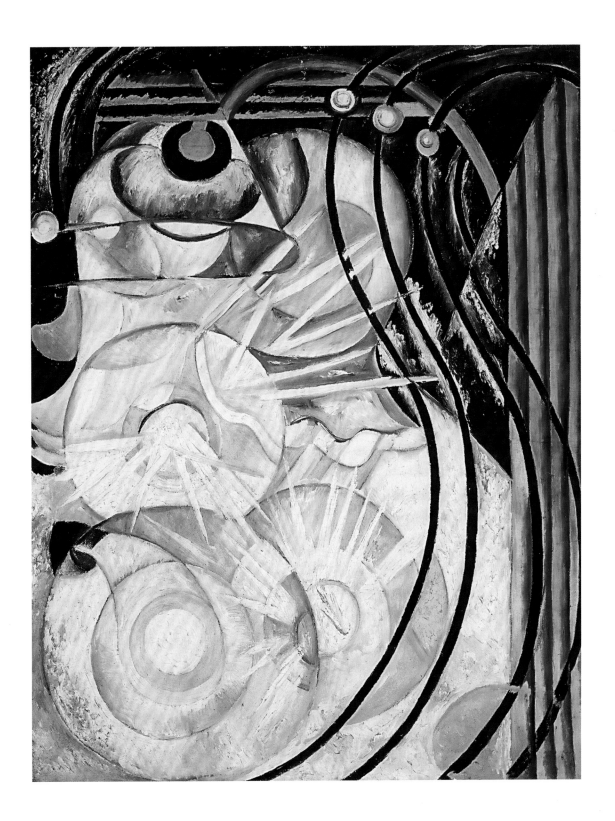

93 **Ivan Kliun**
Ozonator (èlektr. perenosnyj ventilâtor), **1914**
[Ozonator or Electric Fan]
Oil on canvas, 75 x 66 cm
State Russian Museum, St. Petersburg

Ivan Kliun attached particular value to his *Ozonator*. In the five years following its completion, he showed it in four different exhibitions.[1] The painting attracted the attention of the art critic Osip Volzhanin at its first public showing. In his review, he placed the picture in the Cubist sphere of influence. He noted that Kliun was "trying to render the speed of the fan's rotation. Needless to say, this is a fantasy for the time being, but it is possible that it contains the path of the future".[2]
The actual subject of the picture was not foreign to Futurist preoccupations. The electric fan belongs in its own right to the technical and dynamic world glorified by Futurist manifestos. As a household appliance, the fan is also among those everyday objects which make up Cubist still-lifes. Its circular motion does not disturb a balanced composition, based essentially on quadrilaterals arranged around the vague form of a pyramid. The painstaking treatment of the texture of the wood and the palette of ochres and browns bring the *Ozonator* close to Cubist aesthetics. In his memoirs Kliun deemed that aesthetics as compatible with the choice of an industrial object, favourable to "the simplification of forms to the point of geometric reduction, as well as their dynamic shift".[3] The painter also recalled that this attitude was in keeping with the spirit of the day, marked by the triumph of technology. "At that time, I painted the ozonator, the arithmometer, the phonograph and other similar items… Malevich, for his part, painted the kerosene stove…"[4]
Kliun's writings attest to his profound admiration for Picasso's œuvre, with which he had become familiar through regular visits to the Sergei Shchukin collection. In 1912–14, this Russian patron of the arts had acquired from Daniel-Henry Kahnweiler groundbreaking canvases of analytical Cubism (today held in the Pushkin Museum).
Kliun did not like rowdiness and rejected the deafening manifestations of the Russian Futurists. In his memoirs, he describes them criss-crossing "the streets of Moscow in extravagant costumes (Mayakovsky, Golschmidt), their faces daubed with paint (Larionov and the others) … My friend Malevich bubbled in Futurism, as in a cauldron; Futurism never managed to win me over… In art, I was never interested in scandal (nor in life, for that matter); I always sought out a new, rigorous form, a new vision of the world. In this area, Futurism did not introduce anything new—it just had the effect of a balloon filled with peas striking people's heads, nothing more. That is why I did not dwell long on Futurism and moved on very quickly to Cubism, insomuch as Cubism had its own vision of the world, a specific form, and a strict style. I tried hard to persuade Malevich to give up on Futurism and adopt the Cubist approach. Which he did rather quickly".[5] In spite of this harsh criticism of Futurism, Kliun did acknowledge his debt to the movement, willingly claiming his closeness to the Cubo-Futurism advocated by Malevich.

I. K.

1 The work was first shown between Dec. 1914–Jan. 1915 at the charity exhibition *Vystavka kartin i skul'ptury 'Hudožniki Moskvy–žertvam vojny'* [Exhibition of pictures and sculpture 'Moscow artists to war victims'], Lianozov House, Moscow, Dec. 1914–Jan. 1915. A few months later it featured in the *First Futurist Exhibition of Painting 'Tramway V'*, March 1915, St. Petersburg (no. 3); the following year at the *Futurist 'Magazine' Exhibition*, Moscow, and finally at the *5th State Exhibition of Painting*, 1918–19, Museum of Fine Arts, Moscow.
2 See *Žurnal dlâ hozâek* [Magazine for Housewives] no. 1, 1 Jan. 1915, p. 30.
3 Kliun, *Moj put' v iskusstve* [My Way in Art], (Moscow: RA, 1999), p. 83.
4 Ibid.
5 Ibid., pp. 77 and 83.

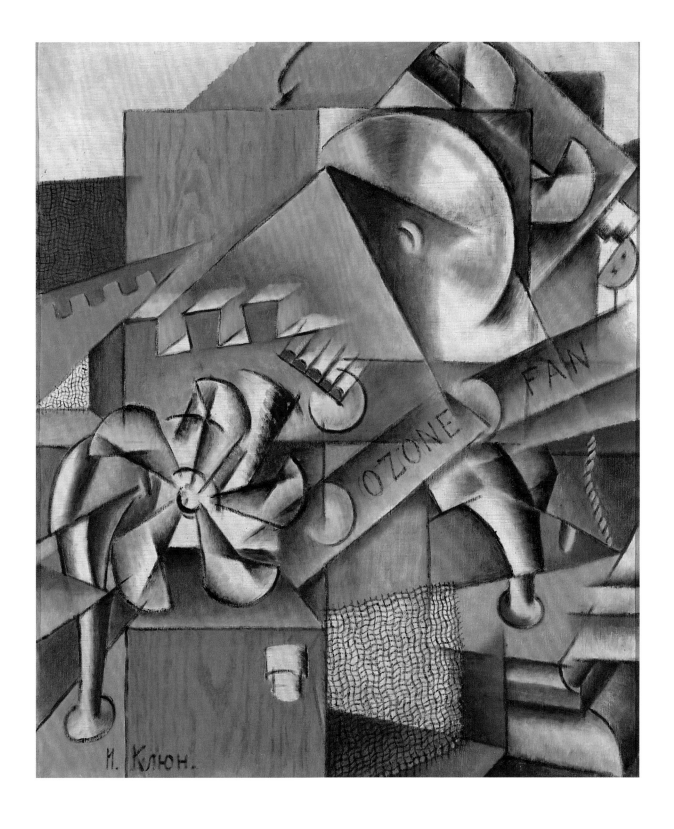

94 **Mikhail Larionov**
Promenade, Vénus de boulevard, **[1912–1913]**
[Promenade, Venus of the Boulevard]
Oil on canvas, 117 x 87 cm
Centre Pompidou, Musée national d'art moderne, Paris / Purchased, 1983

This picture was probably finished in 1913, and first shown at the exhibition *Mir iskusstva* [The World of Art] in Moscow in December 1913, where it was the only work submitted by Mikhail Larionov. Dated 1912[1] by the artist in the catalogue for the large exhibition *Natalie de Gontcharowa et Michel Larionow* which opened in Paris at the Galerie Paul Guillaume on 17 June 1914 (where it was reproduced under the title *Le Vénus du Boulevard*), it was nevertheless not present at the *Mišen* show [Target] that he organised in Moscow in March–April 1913 (featuring his Neo-Primitivist works and the first Rayonist paintings). Among the characters in a drawing produced during the summer of 1913—illustrating Constantin Bolchakov's book *The Future*[2]—is the related "provincial flirt", already present in Larionov's work in the *Venus* series, treated according to the "theory of transparency" attributed to the Muscovite painter Ivan Firsov. In *Promenade, Vénus de the Boulevard*, Larionov isolates this figure, dressed in a seductive way in garish colours, holding an umbrella and wearing a hat. He decodes the successive movements of her body coming from the street scene, which is akin to a parade.

Larionov was interested in the implications of vision and light derived from optical theories, and developed Rayonism, which appeared in his works in 1912 as a synthesis of the western avant-gardes (Cubism, Italian Futurism, Orphism) and Russian pictorial traditions (icon, *lubok*, shop sign). As the Italian Futurists emphasised in their 1910 manifesto, this was a matter of decomposing the motif based on "the doubled power of our sight, capable of giving results analogous to those of X-rays".[3] Beyond these references, Rayonism moulded its identity from the theory of "ray-men", an expression coined by the poet Velimir Khlebnikov, to give visibility to the radiation that links an object to its surroundings, and express just the vibrations that the decisive colour creates. Larionov's Rayonism triumphed, accompanied by a manifesto signed by ten painters, including Goncharova, at the *The Target* exhibition, in the spring of 1913.

This canvas illustrates Larionov's still figurative "realist" Rayonism, where the reduction of the figure/ background distinction is at work. Without denying his affinities with Italian Futurism (Balla's *Girl Running on a Balcony*, 1912, cat. 69, and Russolo's *Synthesis of a Woman's Movements*, 1912–13, musée de Grenoble), this picture describes the consecutive images of the spectator's gaze and, according to Waldemar George, keeps the figure in its lightning-like "fulguration", thus underscoring the painter's originality. An enthusiastic Guillaume Apollinaire, whom the painter met in 1914, wrote the preface to the catalogue for the Paris show held at the Galerie Paul Guillaume, along with several press articles. He took note of Larionov's contribution to Russian and European painting by referring to "a new refinement: Rayonism", "a genuine aesthetic discovery" where "the light that constitutes works of art, manages to express the most subtle, most joyous, most cruel feelings of modern humanity".[4]

C. M.

1 Still dated 1911 in the monograph by George, *Michel Larionov* (Paris: Bibliothèque des arts, 1966), repr. p. 85.
2 See the lithograph repr. p. 19 in *A Slap in the Face! Futurists in Russia,* exh. cat., Estorick Collection of Modern Italian Art, London, 2007. One copy of the book by Bolchakov (which probably did not get past the censors) was dedicated by Larionov: "à mon sher [*sic*] ami Marinetti", seemingly without ever

having been given to the dedicatee (held in London at the Victoria and Albert Museum).
3 Boccioni et al., "Manifeste des peintres futuristes", in *Les Peintres futuristes italiens,* exh. cat., Galerie Bernheim-Jeune & Cie, Paris, 5–24 February 1912, p. 17; *Futurist Painting: Technical Manifesto,* in *Exhibition of Works by the Italian Futurist Painters,* Sackville Gallery, London, Mar. 1912, republished in Apollonio (ed.), *Futurist Manifestos,*

(London: Thames and Hudson, 1973 and 2001), p. 28.
4 *Natalie de Gontcharowa et Michel Larionow,* exh. cat., Galerie Paul Guillaume, Paris, 17–30 June 1914, unpaginated; trans. in Breuning (ed.), *Apollinaire on Art: Essays and Reviews 1902–1918,* (New York: Da Capo Press, 1972), p. 413.

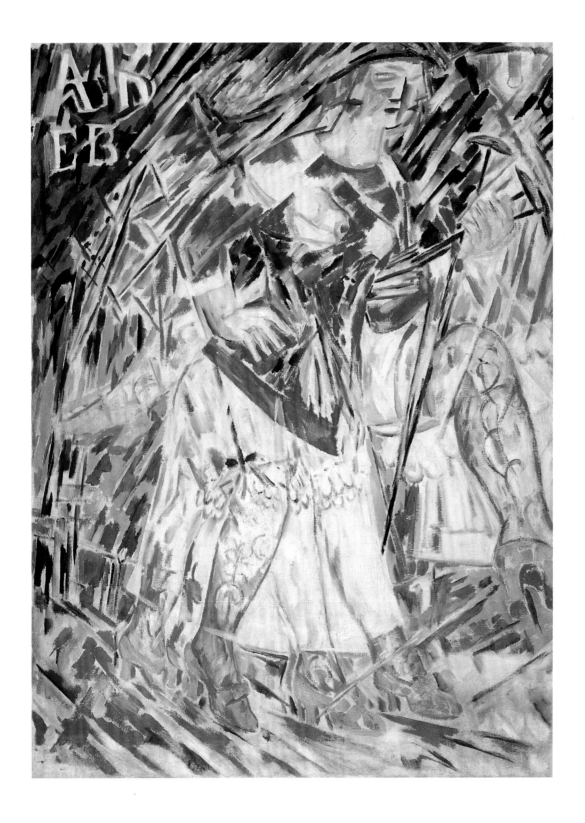

95 **Kazimir Malevich**
Portret Ivana Klûna (Stroitel'), 1914
[Portrait of Ivan Kliun (Constructor) or Perfected Portrait of Ivan Vassilievich Kliunkov]
Oil on canvas, 111.5 x 70.5 cm
State Russian Museum, St. Petersburg

In the catalogue for the sixth exhibition of the *Sojuz Molodezhi* (Union of Youth), which opened in St. Petersburg on 10 November 1913, Malevich included his *Perfected Portrait of Ivan Vasilievich Kliunkov* among the canvases belonging to *zaumnyj realizm* (transrational realism).[1] While the word 'realism' implied an intention to transcend the physical phenomenon to reach the essence of the world, to go beyond figurative, and hence illusory, contingencies, the epithet 'transrational' referred to a new philosophical and aesthetic praxis, rejecting ordinary logic.

The friendship between Malevich and Kliun dated back to their student days. They met in Rerberg's studio, some time in the first decade of the century.[2] Numerous portraits of Kliun painted by Malevich and the preparatory sketches made by Kliun for Malevich's portrait attest to the fact that the two artists spent a great deal of time together. It is clear that the *Perfected Portrait of Ivan Vasilievich Kliunkov* is an abstraction of Kliun's physical resemblance, and is removed from any psychological approach. The diagrammatic face takes up the structure he had been exploring for over a year in a series of canvases and graphic works dealing with the theme of the peasant, which Malevich places in the same category as (to use one of his titles) 'the orthodox'.[3] According to John Milner, this figure of the rural world who reappears in the late works, between 1928 and 1932, became an emblem of a new space-time, an icon of the universe.[4]

This cosmic dimension is incorporated within the composition. Kliun's face, dominated by a long beard, fills the whole surface of the canvas. Its hieratic frontal aspect clearly refers to the aesthetic language of the icon. The single eye, broken down into a prism, is subject to a shift corresponding to the notion of the *sdvig*, advocated by the Russian Futurists. It homes in on the viewer, in an almost hypnotic quest, just like the gaze of icons which, in the Orthodox tradition, are made less for contemplation than for manifesting the presence of the divine figure looking at the believer. Kliun's head is not circumscribed, or reified. On the contrary, it opens up to reveal the person's inner world, while at the same time indicating the place he fills in the infinite universe, one of the fundamental obsessions in Malevich's thinking. Jean-Claude Marcadé has emphasised that the Kliun portrait puts the new face of man at the hub of the world's "eternal rest", as Malevich put it.

If the peasants painted in 1912 were incorporated into an environment evoking the Russian countryside, the portrait of Kliun remains more enigmatic. Insofar as the few identifiable features—a portion of architecture made of logs, a saw, smoke rising from a chimney—are projections of the inner world of the model, they are part of an associative sequence of ideas complying with the alogic championed by Malevich.

For a while, with the Kliun portrait, Malevich abandoned rural themes. In 1913, he showed a keen interest in the research of the Cubists and the Futurists. He worked with the poets Khlebnikov and Kruchenykh, as well as with the musician Matiushin. Together they created the opera *Victory over the Sun*. Jean-Claude Marcadé has noted that the primitivist features in the Kliun portrait are combined with a "very insistent geometric Cézannism", and a "stereometric [treatment] of forms".[5] From the Futurists the artist borrowed the concern for the interpenetration between man and his world. The local shades seem to echo their commands: "How is it possible still to see the human face pink, now that our life, redoubled by noctambulism, has multiplied our perceptions as colourists? The human face is yellow, red, green, blue, violet."[6] With Malevich, however, the colour range and the reduction of forms stem just as much from the tradition of Russian popular art.

The recurrent motif of the saw in the canvases Malevich painted in the years 1913 and 1914—one just has to think of *Aviator* (1914, cat. 96) and *An Englishman in Moscow* (1914, Stedelijk Museum, Amsterdam)—seems symptomatic of the artist's various sources of inspiration. The instrument cuts up the shapes, like the Cubists, but in a very prosaic way, possibly tinged with a touch of irony. At the same time, its incongruous presence distances current logic and gives way to the transrational.

I. K.

1 The work was first featured in the *Mishen* [The Target] exhibition in spring 1913 (no. 92 in the catalogue).

2 See Avtonomova, *I.V.Klun v Tretâkovskoj galeree*, (Moscow: RA, 1999), p. 18.

3 A drawing and a lithograph, titled *Perfected Portrait of a Constructor*, are also very similar to the Kliun portrait. The image appeared in the Futurist book by Kruchenyh, *Porosyata* [Piglets], St. Petersburg, 1913.

4 Milner, *Kazimir Malevich and the Art of Geometry*, (New Haven and London: Yale University Press, 1996), p. 78.

5 Marcadé, *L'Avant-garde russe 1907-1927*, (Paris: Flammarion, 1995), p. 84.

6 Boccioni et al., "Manifeste des peintres futuristes", in *Les Peintres futuristes italiens*, exh. cat., Galerie Bernheim-Jeune & Cie, Paris, 5–24 February 1912, p. 17; *Futurist Painting: Technical Manifesto*, in *Exhibition of Works by the Italian Futurist Painters*, Sackville Gallery, London, Mar. 1912, republished in Apollonio (ed.), *Futurist Manifestos*, (London: Thames and Hudson, 1973 and 2001), p. 29.

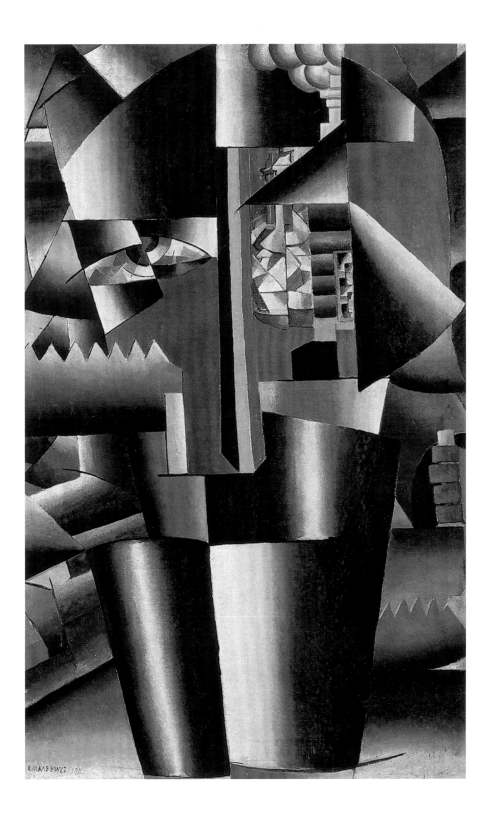

96 **Kazimir Malevich**
Aviator, 1914
Oil on canvas, 125 x 65 cm
State Russian Museum, St. Petersburg

Both through its title and its form, *Aviator*[1] recapitulates the research conducted by Malevich during his collaboration on the Futurist opera *Victory over the Sun* staged in St. Petersburg in 1913.[2] The canvas, which belongs to the alogical works of that period, incorporates a human figure, painted in the Neo-Primitivist style. The figure, made up of truncated cones, calls to mind both the peasant cycle and the sketches for the opera's costumes. The aviator is surrounded by unusual objects, the emergence of the world of 'transrationality'. A gigantic fish crosses his torso. Its dorsal and ventral fins echo the motif of the saw, typical of the alogical portraits painted between 1912 and 1914.[3]

It is above all through the choice of theme that the work is connected with the Futurist opera. *Victory over the Sun* presents an aviator who, like another of the protagonists, the Traveller Through All Centuries, embodies the heroic figure of the new man, capable of crossing time and space. His appearance in the final scene, after his aircraft has crashed, diverts the attention of all the characters, who begin to forget the main action of the drama, the ultimate victory over the sun, symbol of the ancient world. This dénouement marks the final triumph of intuitive reason and the new space-time, liberated from Euclidean perceptions.

The accident from which the aviator emerges unscathed, "the wings just a bit crumpled and his shoe ruined", is inspired by an incident involving the Futurist poet Vassily Kamiensky who, shortly before the creation of the opera, almost lost his life at the controls of his aircraft. In the painting, the syllable "KA" of the word "A-PTE-KA" (pharmacy), cut out using the Futurist slip principle (*sdvig*), probably refers to the name of the pilot. Among Russian Futurist poets it nevertheless had another meaning. John Milner has analysed the retrieval of the *Ka* from Egyptian religion, the life force of the human being, foundation of the belief in the afterlife.[4] Velimir Khlebnikov, who worked closely with Malevich and wrote the prologue to *Victory over the Sun,* evoked the *Ka* in many of his works. For him the *Ka* is "the shadow of the soul, its double. … It crosses time. … It settles comfortably into the centuries, like in a rocking-chair".[5] "The *Ka* is the encounter of many points in motion and consequently their fixation at a motionless point. From here flows its ultimate meaning—repose."[6] In Malevich's mystical thought, the "eternal repose of the world" is the ideal state to which every human being should aspire, outside the limits of the perceptible world and linear time.[7]

The relation of man to time and death is evoked by the incongruous term "PHARMACY". Since the publication in 1912 of Alexander Blok's poem *Night, street, lamp, pharmacy,* the word *apteka* has been associated with the cyclical character of time, with tragic, fatal reincarnation: "Night. Street. Lamp. Pharmacy. / Light Meaningless and dull. / Another quarter of a century / Won't change a thing. / You die—you start again it all: / The night, Iced-rippled the canal, / The pharmacy. The street, The street-light."[8] The Futurist Malevich borrowed the theme from the Symbolist poet, with a dash of polemic added.

Malevich's aviator has been freed from the earth's gravity. His feet do not rest on the ground, they float in a space which is no longer subject to empirical laws. "The past goes full steam ahead."[9] Of the grey smoke coming from the painted chimney in the *Perfected Portrait of Ivan Vasilievich Kliunkov* (cat. 95) all that remains is vague traces, turned into Cubo-Futurist abstract forms. For Malevich, weightlessness marks the signs of man drawing near to God. He often emphasised the need to be free of the weight of everyday life to achieve union with divine weightlessness.[10] The abstract forms, which surround the aviator, as if emanating from his head, belong to his inner world. They materialise his contemplation (*umozrenie*). Malevich interprets literally the term made up of the roots *um* (intellect) and *zrenie* (sight, vision) by showing rays starting from the figure's eye and head. He thus conjures up the inner light that is the mark of the new man. "Our face is gloomy, our light is inside",[11] sing the conquerors of the sun in Kruchenykh's opera. A red arrow points towards the zero written on the aviator's headgear, reduced to a black quadrilateral. The figure foreshadows Malevich's declaration in 1915, "I have transformed myself in the zero of form", written in the context of the last Futurist exhibition of pictures "0, 10", at which the artist first showed his *Black Square*.[12]

I. K.

1 The work was exhibited at the *First Futurist Exhibition of Painting "Tramway V"*, held in St. Petersburg in March 1915.
2 The opera was the joint work of the Futurist poet Kruchenykh, author of the libretto, Matiushin who composed the music and Malevich who produced the costumes and sets.
3 The saw is present in the series of peasant figures, as well as in the canvases of 'alogical realism', such as *Perfected Portrait of Ivan Vasilievich Kliunkov* (cat. 95) and *An Englishman in Moscow* (1914, Stedelijk Museum, Amsterdam).
4 See Milner, *Kazimir Malevich and the Art*

of Geometry, (New Haven and London: Yale University Press, 1996), p. 100.
5 Khlebnikov, *Ka* [1916], in *Velimir Hlebnikov, Tvoreniâ*, (Moscow: Sovetskij Pisatel', 1986), p. 524.
6 Khlebnikov, *Zanghezi* [1922], ibid., p. 481.
7 See his treatise *Suprematism: World as Nonobjectivity or Eternal Rest* (1922) (*Kazimir Malevič, Sobranie sočinenij v pâti tomah*, vol. 3, (Moscow: Gileâ, 2000). The Ludwig Museum in Cologne holds an undated sketch by Malevich in which the word *Ka* is inscribed on the clothing of an alogical male figure.
8 English translation by Meerson. Marcadé makes

reference to another literary source in his essay in this catalogue, p. 58.
9 Kroutchonykh, Matiouchine, Malevich, *La Victoire sur le soleil,* and Marcadé (trans.), Marcadé (postface), (Lausanne: L'Âge d'homme, 1976), act II, scene V, p. 41.
10 See Malevich, *God Is Not Cast Down: Art, Church, Factory* (1922).
11 Kroutchonykh, Matiouchine, Malevich, *La Victoire sur le soleil,* op. cit., act I, scene IV, p. 39.
12 The reference to zero is borrowed from the first theoretical text by Malevich, *From Cubism to Suprematism. The New Realism in Painting* [1915].

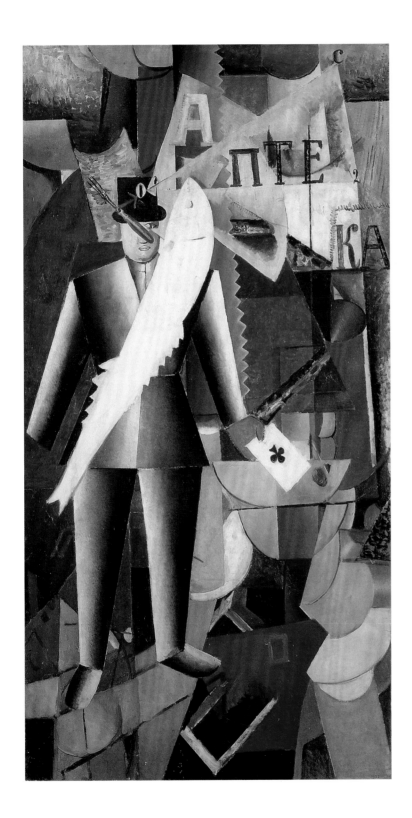

97　**Kazimir Malevich**
Portret hudožnika Mihaila Vasileviča Matûšina, 1913
[Portrait of Mikhail Vassilievitch Matiushin]
Oil on canvas, 106.6 x 106.6 cm
Tretyakov National Gallery, Moscow

The portrait of the composer Matiushin marks a new stage in the abandonment of the object sought by Malevich. It illustrates a perfect mastery of the Cubist vocabulary that the artist intended, however, to surpass. The canvas is invaded by geometric surfaces forming a dense fabric in which referential elements—Matiushin's forehead and hair, obstructed by the alignment of the keys of a keyboard—are lost to achieve a new order subject to irrational logic. The range of hues—streaked ochres, browns and greys—borrowed from analytical Cubism, is rounded off by pure shades of colour. The blues and greens, plus the combination of red, black and white, refer by their contrast as much to the Futurist palette as to the Russian tradition. In a letter written to Matiushin in 1913, Malevich declared: "We have rejected reason because we have found another reason that could be called transrational, which has its own law, construction and sense. … This reason has found a way—Cubism—of expressing the object."[1] So the Cubist approach was used for its capacity to achieve alogical, transrational logic, upsetting established ideas and the dogmas of old art.

Malevich sought to transcribe onto his canvas the sensation produced when listening to music composed by Matiushin for the opera *Victory over the Sun*: "Matiushin's sound shattered the sticky exterior of the sounds of the music, soiled by applause. The words and sound-letters of Alexei Kruchenykh shattered the object-word. The curtain was torn, by the same token tearing the scream of consciousness of the old brain."[2] The portrait of Matiushin is based on visual and acoustic impressions, linked in associative sequences and aimed at expressing the very essence of man.

Matiushin saw in Cubism a link with the mystical thinking of the philosopher Piotr Uspensky. The Russian translation of the treatise *On "Cubism"* by Metzinger and Gleizes, which the composer published in 1913, was associated with passages from Uspensky's *Tertium organum* (1911). This book, in which are described the principles of the alogical and the transrational, as well as the laws of infinity, explores the different spatial dimensions. To the fourth dimension, likened to the notion of time, are added a fifth—the height of consciousness transcending time—and a sixth—the line, concentration of all the consciousnesses in the world. The book had a profound influence on Malevich's theories. In his writings, Uspensky stressed this capacity of each thing to contain the whole. "Each thing is the Whole. … And each isolated speck of dust, without even talking about each specific life and each human consciousness, shares the life of the *entirety* and contains within itself the totality.[3]" Dmitri Sarabianov points out that, through Cubist fragmentation, the face tends to become a comprehensive image of the world.[4] This observation can also be applied to the portrait painted by Malevich.

The work is presented like a jigsaw puzzle—a sort of alogical rebus. The piano's keyhole invites the onlooker to unlock the reading key. The reference to the key plays on the different semantic fields of the word, referring to the musical stave. These associations of ideas are perfectly in keeping with the spirit of *budetliânstvo*, a neologism coined by Khlebnikov to designate Russian Futurism.

Malevich met Matiushin in 1912. The latter, a musician, painter, sculptor and art theorist, became, along with the Futurist poet Kruchenykh, one of Malevich's main associates in the following year. Following the summer they spent in Finland, in Matiushin's holiday home, the three men began a joyful collaboration on the opera *Victory over the Sun*. Jean-Claude Marcadé has suggested that the *Portrait of Mikhail Vassilievitch Matiushin*, probably made in that period, was inspired by a photograph showing the three friends having fun by a grand piano hanging from the ceiling. In the photo Matiushin's head seems to penetrate the instrument.[5]

Another link, probably more significant, can be made between the picture and the opera. The almost square format of the canvas hallmarks the many sketches for the set of *Victory over the Sun*, first created in 1913, and then two years later, with a view to restaging the show. These compositions are dominated by the square, which Malevich regarded as "the source of all possibilities". Its ubiquity prepared the way for the creation of the "icon of our time", the *Black Square*.

I. K.

1 Letter written to Matiushin in June 1913, Kuntsevo, see Vakar, Mihienko (ed.), *Malevič o sebe. Sovremenniki o Maleviče* (2 vols.), (Moscow: RA, 2004), vol. 1, p. 52.
2 Malevich in his article "Theatre" (1917); *Kazimir Malevič, sobranie sočinenij v 5 tomah*, (Moscow: Gileâ 2004), vol. 5, p. 79.
3 Uspensky, *Tertium Organum: klûč k zagadkam mira*, (St Petersburg: Trud 1911), chap. 19, unpaginated.

4 See Adaskina, Sarabianov, *Popova*, (New York: Harry N. Abrams, 1990), p. 68.
5 See Marcadé, *Malévitch*, (Paris: Nouvelles Éditions françaises, 1990), chap. 13: "Alogisme, 1914–1915", p. 121.

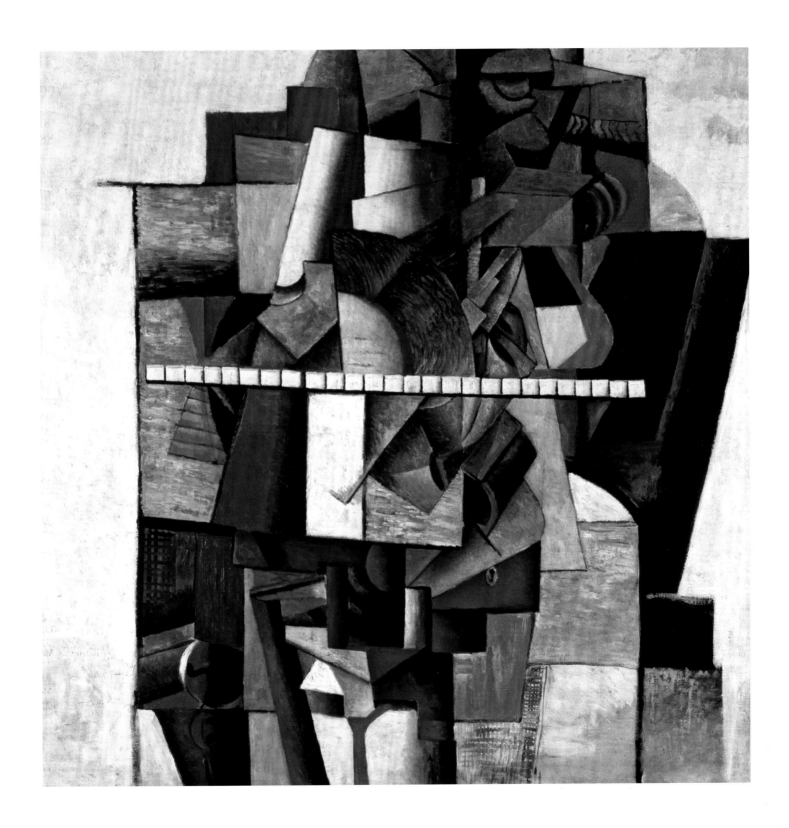

98 **Liubov Popova**
Čelovek + Vozduh + Prostranstvo, **1913**
[Figure + Air + Space]
Oil on canvas, 125 x 107 cm
State Russian Museum, St. Petersburg

In 1910, the *Futurist Painting: Technical Manifesto* demanded "for ten years, the total suppression of the nude in painting!"[1] It was a nude, however, that Liubov Popova chose in order to explore form and volumes in a series of pictures she executed in 1913. These works, striking by their almost repetitive homogeneity, constitute a real field of investigation and assimilation of avant-garde experiments. They were conceived on Popova's return from Paris, where she attended the Académie La Palette and developed her knowledge of Cubism through mixing with Henri Le Fauconnier, André Dunoyer de Segonzac, and Jean Metzinger.

Popova organised the composition of *Figure + Air + Space* around a small number of volumetric shapes. The model's monumental body, reduced to a set of cones and cylinders, is caught in a motion of spirals and volumes with straight edges, whose rhythm recurs behind the figure. The upper right corner focuses on two motifs borrowed from the Futurist vocabulary: the city, suggested by a bridge and an arcade, and electric light, coming from a shaded lamp. The diagonals running across the canvas converge towards the central figure and project it onto the foreground, lending it an impressive base, enhanced by the effects of light. The body is totally incorporated in its surroundings, against which it stands out solely by virtue of the colouring of the flesh. This merger of motif and ground was, in the early 1910s, one of Popova's major concerns.

The muted colour range of the work, reduced to browns and bluish and purplish greys, heightens the impression of weight produced by its powerful volumetry. Popova's picture foreshadows the pictorial principles formulated a few years later in her contribution to the catalogue for the *Tenth State Exhibition: Non-Objective Creativity and Suprematism* in 1919 (Moscow): "Construction in painting = the sum of the energy of the parts. The surface is maintained, but the form is volumetric. The line, as colour and trace of a transversal plane, takes part in and guides the forces of the construction. Colour contributes to the energetic aspect by its weight."[2]

Through its construction and palette, the picture is related to Cubism, but its three-part title, set out like a mathematical equation—*Figure + Air + Space*—affirms its link to Italian Futurism. It echoes Balla's work *Automobile Speed + Light + Noise* (1913, Kunsthaus, Zurich) and Boccioni's *Horse + Rider + Houses* (1914, Galleria nazionale d'Arte moderna, Rome) and the sculpture *Head + Houses + Light* (1912, work destroyed). Popova discovered that sculpture when she visited Boccioni's exhibition, at the Galerie La Boëtie in Paris in June-July 1913. The following year, she made another trip to Western Europe, going first to France, then to Italy, where she came into contact with the Futurists.

Figure + Air + Space stands at the confluence of different sources of inspiration for the artist. It is marked by the lessons of Cubism and Futurism, and also tallies with the researches of Vladimir Tatlin; whose studio Popova visited during the winter of 1913–14. During that period, Tatlin was experimenting with the volumetric approach which gradually led him to make his reliefs.

I. K.

1 Boccioni et al., "Manifeste des peintres futuristes", in *Les Peintres futuristes italiens*, exh. cat., Galerie Bernheim-Jeune & Cie, Paris, 5–24 February 1912, p. 22; *Futurist Painting: Technical Manifesto*, in *Exhibition of Works by the Italian Futurist Painters*, Sackville Gallery, London, Mar. 1912, republished in Apollonio (ed.), *Futurist Manifestos*, (London: Thames and Hudson, 1973 and 2001), p. 31.

2 Popova, Statement in the exhibition catalogue for the *Tenth State Exhibition: Non-Objective Creativity and Suprematism*, Moscow 1919. English translation in *Russian Art of the Avant-Garde: Theory and Criticism, 1902–1934, anthology*, Bowlt (ed. and trans.), (London: Thames and Hudson, 1976).

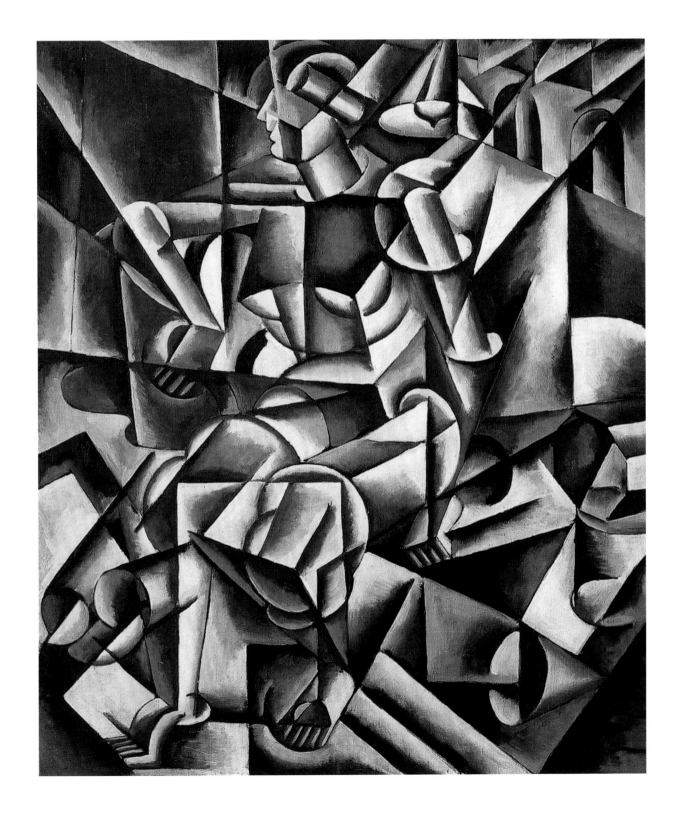

99 **Liubov Popova**
Femme voyageante ou **Voyageuse**, 1915
[Woman Travelling or The Traveller]
Oil on canvas, 158.5 x 123 cm
State Museum of Contemporary Art, George Costakis Collection, Thessalonika

The Traveller, painted in 1915, marks a new stage in Liubov Popova's artistic development. The picture can be compared to *Figure + Air + Space* (cat. 98) executed in 1913. We find the same formal elements explored by the artist over the previous two years. Although the work's title is still referential, the figurative elements and the geometric forms which dominate the canvas have moved further and further away from any representation of the real. The composition is organised around a large acute triangle which runs across the canvas, emphasising its vertical axis while deviating slightly from it by an oblique tilt. Its base touches the lower edge of the picture, giving it an architectural construction. The vertical movement seems to interrupt the movement of the triangles, circles, spirals, diagonals and quadrilaterals arranged on the horizontal and oblique lines of force crossing the surface. Through this distribution of forms, the background is no longer separate from the foreground, nor the object from its environment. Everything is bound together in a homogeneous web. Jean-Claude Marcadé has drawn a comparison with Balla, observing: "In the series of 'people travelling' of 1915, … it is the influence of the Balla of the variations on the theme of *Mercury Passing in Front of the Sun as Seen through a Telescope* (1914, Musée national d'art moderne, Paris) that we find, with his system of horizontal concentric movements crossed by vertical triangular rays … In *Woman Travelling* and *The Traveller*, an ordinary subject is treated by compositional breakdown and dynamic simultaneisation, whereas in the pyramidal constructions of 1920, it would be Balla's cosmic iconography that was pared down to abstract rhythms."[1]

Popova took up the limited range of dark reds and greys verging on purple and black. The white highlights exaggerate the contrasts and organise the picture in a dynamic *chiaroscuro*, dominated by the vertical triangle which forms something akin to a dark bundle. This formal vocabulary, which combines the almost total breakdown of the object based on the principles of analytical Cubism on the one hand, and, on the other, the quest for dynamic effect, proposes nothing less than a synthesis of the French and Italian movements.

The artist introduces Cyrillic characters into the canvas. The truncated words are part of the logic of formal decomposition. If the four letters placed in the upper left corner seem to denote the end of a word—probably "[sema]phore" conjuring up the journey theme—the other letters are not attached to any intelligible semantic field. They belong, rather, to the transrational order advocated by the Russian Futurist poets. In this sense, they are akin to the formal approach that refuses the Euclidean logic of the representation of the real. So the letters, too, become geometric forms which help to emphasise the surface's flatness and linearity. *The Traveller*, which testifies to a full assimilation of Cubist and Futurist experiments, is part of the evolution which led Malevich's pupil to an art totally freed from figuration, and to the creation of an "object-less" world.

I. K.

1 Marcadé, *L'Avant-garde russe 1907-1927*,
(Paris: Flammarion, 1995), p. 111.

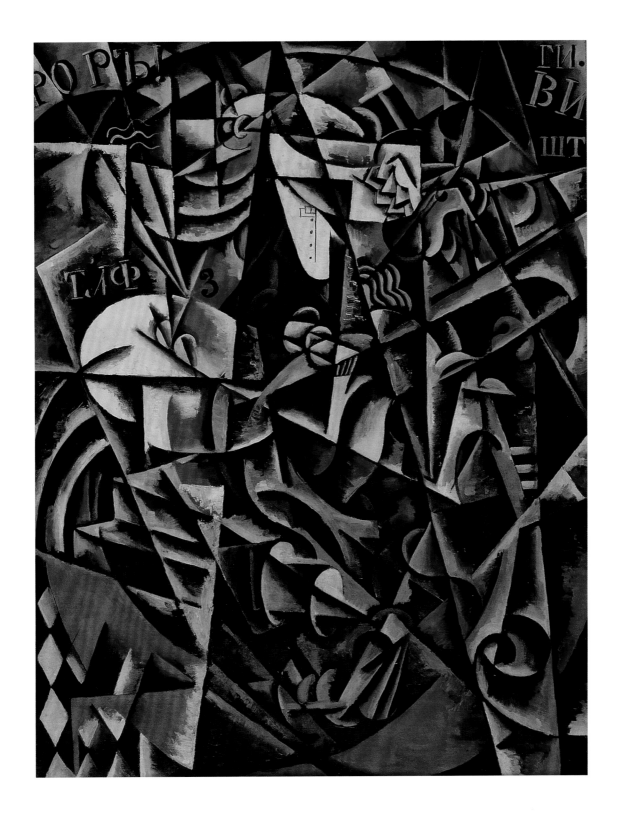

100 **Liubov Popova**
Étude pour un portrait, **1914–1915**
[Study for a Portrait]
Oil on cardboard, 59.5 x 41.6 cm (recto[1])
State Museum of Contemporary Art, George Costakis Collection, Thessalonika

"Cubi[sme]-futurismo": rarely did Liubov Popova use letters in such an explicit way, by writing two perfectly identifiable words on the canvas. The use of the Latin, rather than the Cyrillic, alphabet, unlike the characters used in *The Traveller* (1915, cat. 99), paves the way for a dialogue between the French and Italian movements. With this kind of ironic passing reference, Popova implied that the period was marked by the development of different 'isms' which at times gave rise to controversies. Yet as early as 1913, by inventing the term "Cubo-Futurism", Malevich seemed to reject the debate, affirming a way of synthesis. In *Study for a Portrait*, started the following year, Popova showed that she had assimilated Picasso's lessons of synthetic Cubism. The hair suggested by the parallel waves is an acknowledged borrowing, just like the form of the face which conjures up the belly of a stringed instrument and the breakdown of the forms into large facets. Furthermore, it is through the dynamics of the force lines of the composition that the work is related to Futurism. The artist plays on flat, juxtaposed, interlocking and overlapping planes, and planes which overlap, to produce an effect of depth, heightened by the use of tonal values. This treatment of planes calls to mind Vladimir Tatlin's counter-reliefs. Popova took part in the experimentation of this new genre, where there is a mixture of painting, sculpture and bas-relief.

This work is part of a series of portraits produced between 1914 and 1915. They have in common a quest for the simplification of forms which echoes the painter's theoretical writings. Popova actually saw the evolution of contemporary art as a path towards non-figuration. For her, Cubism had merely triggered this quest by "the omission of parts of form". Art, henceforth, had to focus on "painterly" and not "figurative" values.[2] This approach culminated in the architectonic compositions of the years 1918–20, where all that remained were the colour surfaces superimposed in a tectonic rhythm.

I. K.

1 *Study for a Portrait: Italian Still Life*, oil, marble dust,
collage mounted on cardboard (verso).
2 Popova, Statement in the catalogue of the *Tenth
State Exhibition: Non-Objective Creativity
and Suprematism*, Moscow. English translation in:
*Russian Art of the Avant-Garde: Theory and Criticism,
1902–1934, anthology,* Bowlt (ed. and trans.),
(London: Thames and Hudson, 1976), p. 148.

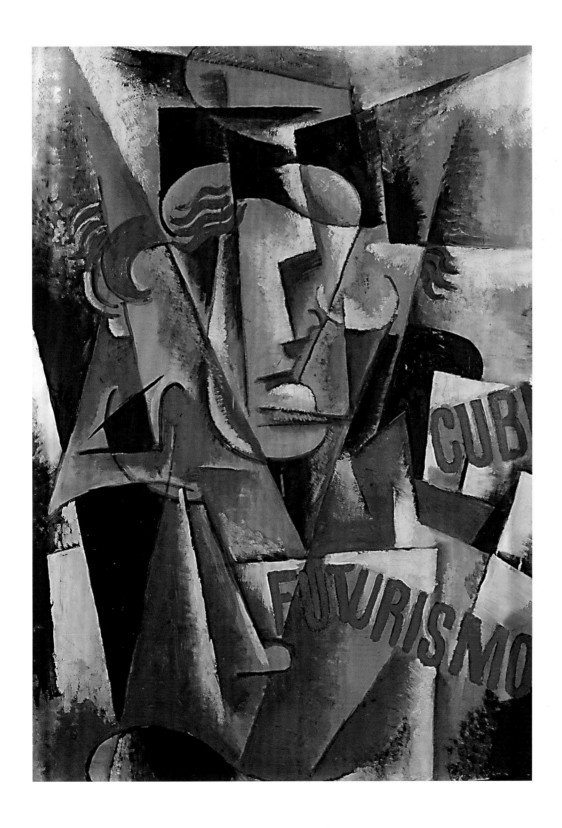

101 **Olga Rozanova**
Homme dans la rue (Analyse de volumes), 1913
[Man in the Street (Analysis of volumes)]
Oil on canvas, 83 x 61.5 cm
Museo Thyssen-Bornemisza, Madrid

In an essay written after Olga Rozanova's death, the famous critic Abram Efros declared that the artist was " … born a Futurist. If she had not encountered that tendency when it was already well established and formed, she would have invented something similar, very close in its form and perfectly identical in its essence".[1] In fact, from 1913 on, her art veered towards new forms whose Futurist character has often been emphasised. In particular she produced a series of canvases devoted to the theme of the city. Alongside *Man in the Street (Analysis of Volumes)*,[2] we can mention two other works, each titled *The City*, held respectively in the National Museum of Art, Nijni-Novgorod, and at the Regional Museum Samara.

As a keen observer of the artistic trends of her day and age, Olga Rozanova nevertheless sought to go beyond the apparent antagonism between Cubism and Futurism. Her theoretical thoughts prompted the fertile dialogue that was enjoined between the two currents. In that same year, 1913, she wrote the article "The Bases of the New Art and the Reasons Why It Is Misunderstood", which appeared in the third issue of the almanac of the Union of Youth. Making reference to both movements, she wrote: "If one overlooks their diametrical opposition at the outset (dynamism, staticism), they mutually enriched one another by a series of shared positions. It is these shared positions that have given this unity of tone to all contemporary art trends."[3]

The canvas *Man in the Street (Analysis of Volumes)* perfectly illustrates what she is getting at. It would be futile to try and dissect her proposal in order to distinguish the features that are linked with Cubism or Futurism, so intrinsically linked are they. The fragmenting of shapes into facets, the reduced palette of greys and ochres, the introduction of letters, the sub-title—*Analysis of Forms*—which has a marked Cézanne-inspired echo, all appear like reminiscences of Cubist experiments. However, the surface is informed by a movement created by sharp diagonal stripes. This dynamism clearly conjures up Futurist research. The reference to the theme of the city is part of this connection. The total incorporation of man in his urban environment is one of the bases of the Futurists' positions, proclaiming as they do: "Our bodies enter the sofas we sit upon, and the sofas enter us. The bus hurtles into the houses it passes, and in their turn the houses fall upon the bus and merge with it."[4]

All the kinetic energy of the work seems to be squeezed into the motif in the lower right corner, which calls to mind a mechanical cog. The same round form appears in the illustration titled *The Destruction of the City*, which Olga Rozanova used in her book *War*, created in conjunction with the Futurist poet Kruchonyk in 1916. The mechanised limb of *Man in the Street…* becomes, in the book, the wheel of a cannon. So Olga Rozanova's machine-man appears as an emblem of modernity. The artist has slipped letters into her picture. These characters, used in printing and drawn by hand, clearly evoke the typography of Russian Futurist books. Along with Alexei Kruchenytch and fellow-poet Velimir Khlebnikov, Olga Rozanova was a pioneer in this area. As formal features of the picture *Man in the Street…*, the consonants are also chosen for their value as sounds. The absence of vowels, and the Cyrillic "R" and "T", clearly decipherable, stress the reference to the mechanical noises of the city. The effect sought after is not alien to the principle of "polyphonic simultaneity" put forward by the Italian Futurists. The sounds are part of the pictoriality, as are the colours, forms, graphics and light, all aiming to grasp the sensation of the modern city. For their part, the Futurist poets stressed the visual value of the word that they often reduced to rudimentary sounds, to attain *zaum* (transmental language).

I. K.

1 Efros, *Profiles*, Moscow, 1930, p. 339, quoted by Gur'ânova, *Olga Rozanova i rannij russkij avangard*, (Moscow: Gileâ, 2002), p. 57.
2 The picture was shown at the "Esposizione libera futurista internazionale. Pittori e scultori. Italiani, russi, inglesi, belgi, nordamericani", organised by the Galleria Futurista (Sprovieri) in Rome in April–May 1914 and purchased by Marinetti.

3 Cited in *Art en théorie 1900-1990*, Harrison, Wood (eds.), (Paris: Hazan, 1997), p. 238.
4 *Manifeste des peintres futuristes*, in *Les Peintres futuristes italiens*, exh. cat., Paris, Galerie Bernheim-Jeune & Cie, 5–24 Feb. 1912, pp. 17–18. The Russian translation of this text was published in 1912 in the second issue of the almanac of the Union of Youth.

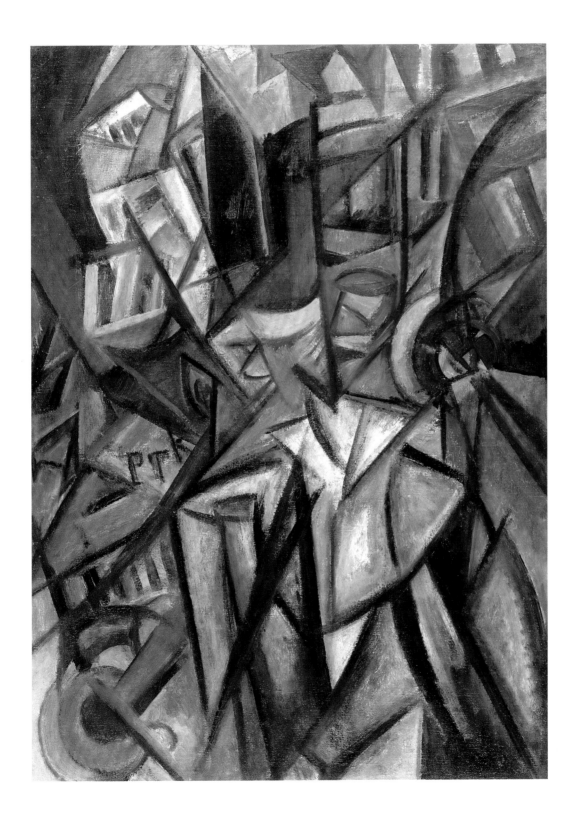

102 **David Bomberg**
The Mud Bath, 1914
Oil on canvas, 152.4 x 224.2 cm
Tate, London / Purchased, 1964

The year 1914 saw the zenith of the Futurist onslaught on the British art scene with a second group show at the Doré Galleries in London,[1] accompanied by a series of *intonarumori* or 'noise intoner' concerts by Russolo, as well as readings and performances. This Futurist wave was crowned by the publication in June of the manifesto *Vital English Art*, signed by Marinetti and Nevinson, in which they called on the English public to "defend and glorify its most revolutionary and advanced innovative artists".[2] In support, the authors named a series of avant-garde British artists, including Bomberg, Epstein, Lewis and William Roberts , alongside Nevinson himself. This initiative, made without their approval, was met with a strong denial from the artists close to Lewis and gathered in the Rebel Art Centre (which foreshadowed the Vorticist movement), and their proclamation of independence in view of what was perceived as an attempt at co-opting them. In signing this objection, Bomberg may have been trying to distance himself from Futurism, but he was also concerned not to see himself absorbed under the Vorticist banner, and he refrained from appearing in the columns of the magazine *Blast*, mouthpiece of the British movement.[3]

It was in this context that in July 1914, Bomberg's first solo show was held at the Chenil Gallery in Chelsea, bringing together fifty-five canvases, including *The Mud Bath*. Like other Bomberg compositions—*The Jewish Theatre* (1913, Leeds City Art Galleries), *Ju-Jitsu* (c. 1913, Tate, London), *In the Hold* (cat. 103)—*The Mud Bath* took as its point of departure a scene from everyday life in the East End of London (here the Schevzik steam baths in Brick Lane), but the representation is subjected to an extreme geometrisation. In "Mr. Bomberg's Futurist Bombshells" (an article whose title attests to the use at that time of the word 'Futurist'), a journalist writing for the *Pall Mall Gazette* deplored the artist's formal short cuts.[4] The figures in *The Mud Bath* are assemblages of segmented planes which, in abandoning all superfluity,[5] stand out starkly from a large red plane which runs across the canvas, a sort of platform which calls to mind the composition of *Vision of Ezekiel* (1912, Tate, London). The distribution of light and shadow is conveyed by a clear contrast between the white planes and the blue planes. In some earlier canvases (*Ju-Jitsu* and *In the Hold*) Bomberg adopted a geometric grid confining the interplay of fragmentation to the coloured planes in a way akin to the works of Severini,[6] but *The Mud Bath* introduces a freer space permeated by an undeniable 'physical vigour'.[7] In it the figures take on a density and a simplicity which they did not have before. Through the resolute drawing and the restricted choice of colours, this work seems closer to certain contemporary research work carried out by Balla and Depero and to the *Arte meccanica* of the 1920s than to the fragmented representations of the first Futurist works.

If Bomberg was keen to remain independent from associated trends, this work nevertheless illustrated a close link with Futurist and Vorticist aesthetics. The formal purification of *The Mud Bath* calls to mind certain positions in the *Vorticist Manifesto*, in particular the praise for the "CLEANS ARCHED SHAPES and ANGULAR PLOTS".[8] One might also think of the "happy precision of gears and well-oiled thoughts"[9] extolled by Marinetti at the same moment in *Geometric and Mechanical Splendour and the Numerical Sensibility*.

With regard to these formal principles, the work's title, evoking the formless material *par excellence*—mud—certainly seems surprising. One might see therein an allusion to Marinetti's hallucinatory narrative which opens the *Manifesto of Futurism*, and, especially, to the key moment when the driver of the vehicle veers off the road and plunges into a muddy ditch, and in this 'mud bath' experiences both death and resurrection.[10]

J. P.

1 *Exhibition of the Works of the Italian Futurist Painters and Sculptors*, The Doré Galleries, London, April 1914.
2 Marinetti, Nevinson, "A Futurist Manifesto: Vital English Art", *Observer*, 7 June 1914, Italian "Manifesto futurista", *Lacerba* (Florence), vol. 2, no. 14, 15 July 1914, pp. 209–11; republished in Walsh, *C.R.W. Nevinson: The Cult of Violence*, (New Haven and London: Yale University Press, 2002), pp. 76-7.
3 See Cork, *David Bomberg*, (New Haven and London: Yale University Press, 1987), p. 77.
4 Ibid., p. 90.
5 The artist's preface to the catalogue for *David Bomberg* (Chenil Gallery, London, July 1914),

proclaims: "Where I use Naturalistic Form, I have *stripped it of all* irrelevant matter", quoted in *David Bomberg*, Cork (ed.), exh. cat., Tate Gallery, London, 1988, p. 72.
6 Bomberg had seen Severini's works at the *Exhibition of Italian Futurist Painters* at the Sackville Gallery in March 1912, then in Severini's solo show (*The Futurist Painter Severini Exhibits his Latest Works*, Marlborough Gallery, London, April 1913).
7 Cork, *Vorticism and Abstract Art in the First Machine Age; Vol.1: Origins and Development*, (London: Gordon Fraser, 1976), p. 208.
8 *Manifesto*, in *Blast* no. 1, (London), 20 June 1914, p. 25; quoted in Adams, 'Futurism and the British Avant-Garde', *Blasting the Future! Vorticism in Britain*

1910–1920, Black (ed.), exh. cat., Estorick Collection of Modern Italian Art, London, and The Whitworth Art Gallery, Manchester 2004, p. 14.
9 Marinetti, *La Splendeur géométrique et mécanique et la sensibilité numérique* (11 Mar. 1914); published in Italian as a poster (dated 18 Mar. 1914) and in two parts as *Lo Splendore geometrico e meccanico nelle parole in libertà* , and *Onomatopee astratte e sensibilità numerica, Lacerba*, vol. 2, nos. 6 and 7, 15 Mar. and 1 Ap. 1914; trans. in Apollonio (ed.), *Futurist Manifestos*, (London: Thames and Hudson, 1973 and 2001), pp. 154–60.
10 Marinetti, "Le Futurisme", *Le Figaro*, 20 Feb. 1909, p. 1; trans. as *Founding and Manifesto of Futurism*, in Apollonio, op. cit., p. 21.

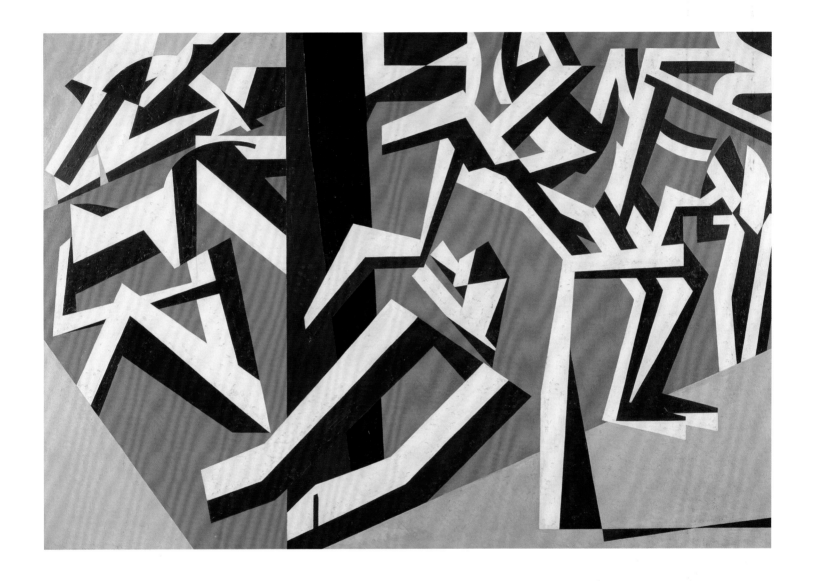

103 **David Bomberg**
 In the Hold, c. 1913–1914
 Oil on canvas, 196.2 × 231.1 cm
 Tate, London / Presented by the Friends of the Tate Gallery, 1967

Bomberg's *In the Hold* is one of the most individual paintings produced on the eve of the First World War. Together with *The Mud Bath* (cat. 102), completed later, in 1914, the combination of a grand scale and abstract composition marked Bomberg out as an artist of substantial ambitions with both works serving as manifesto paintings for his own abstracted vision. He was already working on *In the Hold* in 1913, and its evolution coincided with his involvement in two important exhibitions: his contribution as a selector of *Twentieth Century Art: A Review of the Modern Movements* at the Whitechapel Art Gallery in June 1914,[1] and his large solo show for the Chenil Gallery in the following month. For *A Review of the Modern Movements* Bomberg had visited studios in Paris and familiarised himself with current practices, and this may be reflected in the radicalism of his statement for his solo exhibition at the Chenil Gallery: "I am searching for an *interior* expression … My object is the *Construction of Pure Form*."[2]

Certainly a purity of form seems to govern *In the Hold*. The grid of sixty-four rectangles sliced by diagonals approximates that generated by Golden Section proportions (1:1.618). While such fragmentation may echo the dynamism of Severini's *The Dance of the "Pan-Pan" at the Monico*, as is often suggested, this modernised academic practice was also comparable to that being explored contemporaneously by Juan Gris. The philosopher T.E. Hulme remarked how Bomberg's painting ensured that "one never sees it as a whole, one's eye travels over it".[3] Embedded within the large structure of *In the Hold*, whose glitter is subdued and controlled with black, is an initially unintelligible image. Just as with the much smaller *Ju-Jitsu* (1913, Tate), where the same fragmentation is used, the source image emerges slowly and with close inspection: it shows stevedores, close-up, working in the hold of a ship. Although the colouring has been rationalised, the presence of the black seems directly indicative of the generating situation in the dark interior of the cargo ship. In common with Bomberg's other paintings of this moment, the subject is drawn from his experience of the East End of London, with the geometricised figures implying their role within the mechanism of the city. Where *In the Hold* differs is in turning the focus from the activities of immigrant communities, such as found in *The Mud Bath*, to the heart of the city and the Empire the docks with its implication of a wider socio-political engagement. The workers may thus be seen as 'in the hold' of the British Empire.

It was the radical abstraction of *In the Hold* that elicited divergent views when Bomberg first showed it at the *London Group* exhibition in March 1914.[4] The geometric structure led to discussion of 'design' encouraged, no doubt, by the fashion for avant-garde interior decoration that Roger Fry's Omega Workshops had fostered and which Wyndham Lewis' Rebel Art Centre (founded in the same month as the exhibition) sought to rival. While close to Lewis (who had included him in the 'Cubist Room' in Brighton five months earlier),[5] Bomberg maintained his individuality, and it was only Marinetti and Nevinson's *Vital English Art* in June 1914 that encouraged him to support Lewis' protest against being named as Futurists.[6] Individualism, however, was little protection against criticism. One reviewer of the London Group exhibition, described the "kaleidoscopic glitter" of *In the Hold* as "splendid if it were the pattern of a silk shawl",[7] while (on a later occasion) another identified Bomberg's "ingenious Cubist design, very suitable for oil-cloths".[8] Even though Fry was generous when he saw *In the Hold*, he, too, began with the idea of pattern: "In his colossal patch-work design, there glimmers through a dazzling veil of black squares and triangles the suggestion of large volumes and movements. I cannot say that it touched or pleased me, but it did indicate new plastic possibilities, and a new kind of orchestration of colour. It clearly might become something, if it is, as I suspect, more than mere ingenuity."[9]

M. G.

1 As the exhibition was held at the Whitechapel Art Gallery in the East End, Bomberg was given responsibility for the "Jewish Section", a notion that now seems very much of its time.
2 Bomberg, "Preface", *David Bomberg*, Chenil Gallery, London, July 1914.
3 Hulme, "Modern Art III: The London Group", *The New Age*, 26 Mar. 1914, cited in Cork, *Vorticism and Abstract Art in the First Machine Age*, (London: Gordon Fraser, 1976), p. 200.
4 *London Group*, Goupil Gallery, London, March 1914.

5 Lewis, "The Cubist Room", Nov. 1913, in Michel and Fox (eds.), *Wyndham Lewis on Art: Collected Writings 1913-1956*, (London: Thames and Hudson, 1969), p. 56.
6 Marinetti tried to get Bomberg to join the Futurists on the strength of his Chenil exhibition, and therefore, *after* Lewis' establishment of Vorticism (see Bomberg's unpublished *Memoir* 1957, cited in Cork, *Vorticism*, op. cit., p. 201); for these events see Gale's essay, *A Short Flight*, p. 66 in this volume.
7 Unidentified review, [March 1914], Nevinson

Press Cuttings, TGA 7811-1-13.
8 Phillips, "Art in Whitechapel: Twentieth Century Exhibition", *Daily Telegraph*, [June 1914], Nevinson Press Cuttings, TGA 7811-1-25. Oil cloth was material used for waterproof table-cloths.
9 Fry, "Two views of the London Group", *The Nation*, 19 Mar. 1914, Bomberg Press Cuttings TGA 878.9.

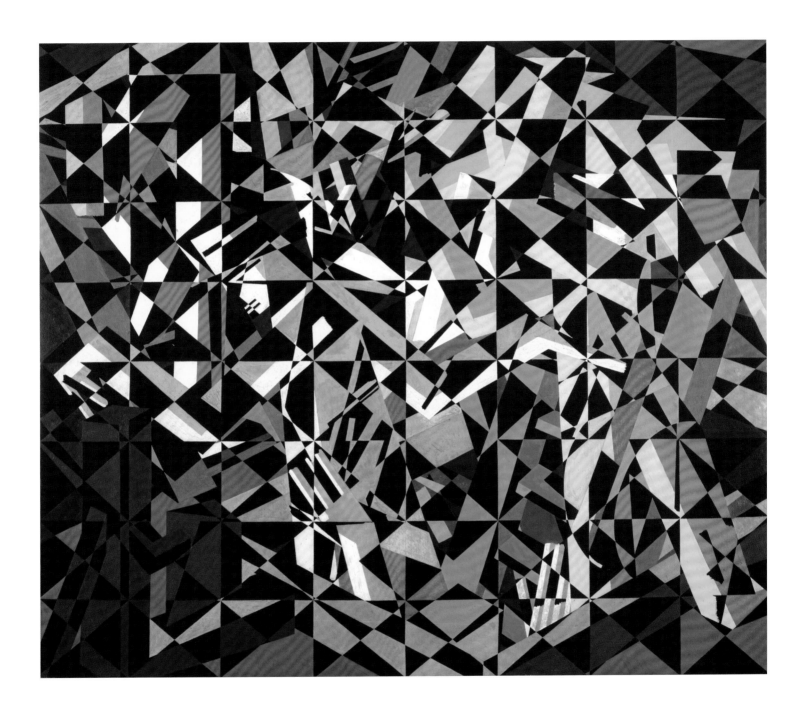

104 **Jacob Epstein**
 Torso in Metal from "The Rock Drill", **1913–1914**
 Bronze, 70.5 x 58.4 x 44.5 cm
 Tate, London / Purchased, 1960

"The sculptors who followed in Epstein's footsteps in this country would have been much more insulted than they were if the public hadn't in large part vent its rage on him, and if this rage had not turned out to be totally crazy."[1] This was how, at the end of a stirring tribute, Henry Moore reminded people that his older colleague had been fiercely attacked by the critics, in a way that even today seems excessive. If Epstein's output had something variable about it, as fecund as it was multi-facetted and made up of accelerations and consolidations, *Torso in Metal from "The Rock Drill"* is undoubtedly a major sculpture which is, in itself, enough to justify celebrating the innovations of an eminent precursor.

It was the artist who provided, in retrospect, the most succinct account of this major piece: "It was in the experimental pre-war days of 1913 that I was fired to do the rock drill, and my ardour (short-lived) for machinery expended itself on the purchase of an actual drill, second-hand, and upon this I made and mounted a machine-like robot, visored, menacing, and carrying within itself its progeny, protectively ensconced."[2] Marked by the caustic and possibly violent forms of this incarnation of a new and bewitchingly mechanical age, the artist enhanced the drill with a plaster figure which, being geometrical and angular, married it perfectly, joined as it was at the level of the pelvis. The result was a complex feeling: the apparent dislocation between the robotised, white plaster character and the dark metal machine were exceeded by their subtle conjunction which made it difficult to establish which element dominated the other. In other words, what part enjoined the other to follow and obey it? Is this an anthropomorphic machine or a mechanomorphic person? The malaise exists all the more because this mechanical realm refers to a threatening animal kingdom: the tentacular tripod and the visored helmet of the figure conjure up an evolved insect, which Epstein even imagined as mobile thanks to an elaborate compressed air system. In addition, this unsettling transformation of an element borrowed from the reality of positivist 'modern times' encompassed a challenge that was both ideological and aesthetic. So the maintenance of the confusion stems not only from an aesthetic malaise, but also from a "malaise in civilization" (to borrow the phrase of Sigmund Freud the father of the 'uncanny'), because what was involved with *The Rock Drill* was a thoroughly modern application of the death wish and binomial attraction/repulsion.

If Epstein initially succumbed to the lure of this machine laden with a meaning, which in return it divested of humanity, he gradually moved away from it. In this way, although the work exhibited in 1915 at the Goupil Gallery in London met Futurist and Vorticist aspirations, Epstein soon preferred to do away with the machine element. Having altered the position of the arms he cast just the human torso in bronze. The sculpture thus brought to resolution, was austere in terms of the edifying character arising from the assembly of its two original parts, but lost nothing of its expressive and emotional impact: fascination became repulsion: "All this I realised was really child's play."[3] Two world wars driven by 'mechanical' barbarism ended up making Epstein's work and his commentary more startling: "Here is the armed sinister figure of today and tomorrow. No humanity, only the terrible Frankenstein's monster we have made ourselves into."[4]

C. L.

1 Moore, "Jacob Epstein" [obituary], *Sunday Times*, 23 August 1959.
2 Epstein, *An Autobiography*, London, Hutton, 1955, p. 56.
3 Ibid., p. 57.
4 Ibid., p. 56.

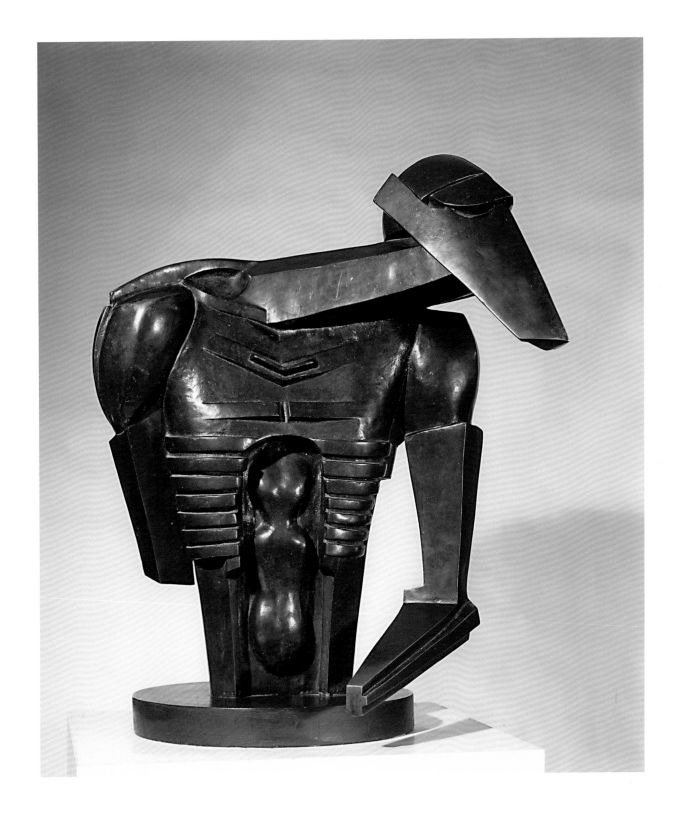

105 **Henri Gaudier-Brzeska**
Red Stone Dancer, **c. 1913**
Red Mansfield stone, 43.2 x 22.9 x 22.9 cm
Tate, London
Presented by C. Frank Stoop through the Contemporary Art Society, 1930

By choosing sculpture as a means of expression, in 1911, Henri Gaudier-Brzeska readied himself to experiment with the vast domain of sculpture ranging from Rodin, to whom he paid tribute, to Cubism and Futurism, which he viewed with a critical eye. He swiftly defined his own style—an achievement that Ezra Pound, his admirer and first biographer, regarded as nothing less than a "victory"[1], which could never be underestimated. But the speed with which he went through all the various trends seemed to presage a premature and tragic end (he was killed on the Front in 1915 at the age of only 23), cutting short the development of an artist who was nevertheless to influence modern sculpture. Among the works referred to in his insightful writings on art (such as his article "Vortex")[2], *Red Stone Dancer*, by focusing on ideas conveyed by the representatives of Cubism and, more specifically, Futurism, is undoubtedly the manifesto, in sculptural form, of that key moment. On 9 July 1914, Gaudier-Brzeska drew up a list of his sculptures and entered under no. 27 the work *Red Stone Dancer*, which he described as "The Dancer, red stone, varnished. Reproduced as an illustration; very beautiful". He emphasised the beauty of this piece with evident satisfaction, probably because it was the incarnation of his research in terms of volumetric analysis (especially the volumes of the human body), and of the interplay between solids and voids, and not least because the piece illustrated the ease with which he lent an impression of motion to each one of these masses. In 1911, he was already writing to his companion Sophie Brzeska: "The line is a bar, a limit, an infringement upon freedom, it is slavery. The mass is free, I can multiply it *ad infinitum*, and treat it in a hundred different ways: I am free and best of all it is true, it exists."[3]

In the many drawings accomplished prior to this work, his main concern had to do with the movement he dealt with in 'uninterrupted sequences', which he regarded as "a translation towards life". He observed and drew wrestlers, athletes and boxers just as much as dancers. *The Dancer*, a 1913 plaster cast into bronze (Tate), still had fluidity of movement and elegance in her swaying body. Breaking with these features, Gaudier-Brzeska would try to treat masses in a circular distribution around a central void, from which burst the whirling force. With *Red Stone Dancer* he freed himself from anatomy, distorting the body parts by twisting the silhouette.

Whereas Archipenko, with his 1912 *Dancer*, translated bodily movement and rhythm with the help of synthetic and fragmentary forms, Gaudier-Brzeska followed movement by framing it along clearly defined geometrical lines. So the spiral suggested by the twisting of the body on the left foot follows the intertwining of the parts of the torso in a somewhat unnatural motion: the right arm elongated in an extreme extension, rests on the left shoulder, enclosing the upper mass in a triangle, in turn heightened by the triangle of the diagrammatic face. The left hand, discreetly placed between the two breasts, themselves accentuated by two different geometric figures, prolongs and underscores this spiral by a snaking curve. The interweaving of this tracery ends by transcribing the complex movement of dance.

In his description of the artist, Pound demonstrated that "the triangle moves toward organicism and becomes a spherical triangle (the central life-form for both Brzeska and Lewis). These two developed motifs work as themes in a fugue. … The 'abstract' or mathematical bareness of the triangle and circle are fully incarnate, made flesh, full of vitality and of energy."[4] He also recorded that these elements were signs of the freedom seized by Gaudier-Brzeska when compared to his predecessors, and even to some of his contemporaries.

D. L.

1. Pound, *A Memorial Exhibition of the Work of Henri Gaudier-Brzeska*, exh. cat., The Leicester Galleries, London 1918, republished Milan 1957, p. 11.
2. Gaudier-Brzeska, "Vortex", *Blast* 1, July 1914, London.
3. Letter to Sophie Brzeska, 19 May 1911, Gaudier-Brzeska archives, Tate Gallery, London.
4. Pound, op. cit., pp. 12–13, and quoted in Silber, *Gaudier-Brzeska: Life and Art, with a* Catalogue Raisonné *of the Sculpture*, (London: Thames and Hudson, 1996), p. 107.

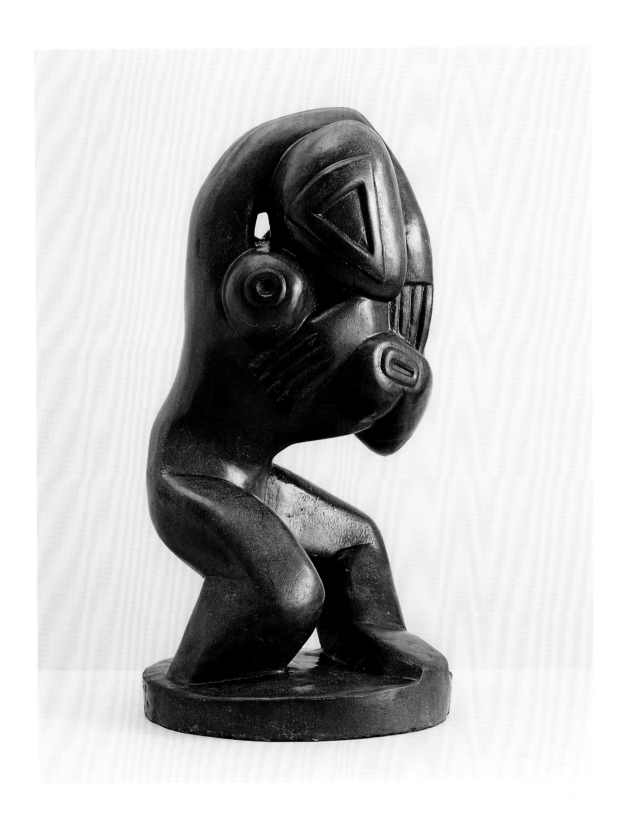

106 **Percy Wyndham Lewis**
 The Crowd, **[exhibited 1915]**
 Oil and pencil on canvas, 200.7 x 153.7 cm
 Tate, London / Presented by the Friends of the Tate Gallery, 1964

On the eve of the Great War Wyndham Lewis published the *Vorticist Manifesto* in the opening pages of the first issue of the magazine *Blast* (dated 20 June), that appeared on 2 July 1914. Around this moment he may also have started *The Crowd*. The work was shown in March 1915 at the Goupil Gallery in London, and still seems to resist any kind of exegetical pigeonholing—despite the welter of analysis it has stirred up.

In turning his back on the traditional Euclidean system of space, Lewis managed to establish a highly personal geometric vision within which the city was shown to be labyrinthine. Geometric forms, distributed in overlaid planes, trace a floating network that excludes perspectival illusion. In shading the outlines of this monochrome grid with broad flat colours, the painter creates a vast and complex architectural tracery where strangeness vies with legibility. In this respect, *The Crowd* is akin to Russolo's *Rebellion* (1911, cat. 42), a canvas which Lewis would have seen at the first *Exhibition of Futurist Painters* held in London in March 1912, at the Sackville Gallery. The elaborate design of the picture may be a response to the dynamic web advocated by Futurism, which had its second London show at the Doré Galleries in April 1914. However, the geometry of Lewis' composition suggests a more direct legacy of Cubism. The refined chromatism of the canvas may even be related to the contemporary experiments of Braque and Picasso: the *camaïeu* of dull ochres corresponding to the burnt sienna whose invigorating power was also adopted by Mario Sironi, Carrà and others in international avant-garde circles. Within this geometric structure, Lewis placed numerous figures, some holding red flags, which serve to indicate the social dimension of the work. In his probing analysis of the painting, Paul Edwards has explored this political dimension, remarking, for instance, on how the three curves at top right are reminiscences of the donkey-powered wheels at Carisbrooke castle and seem to stand for the enslavement of work from which the crowd of the title seek liberation.[1] Alternatively the presence of the red-white-and-blue French flag at bottom left might well evoke the operations led in 1908 in Paris by the Action française,[2] the nationalist and monarchist movement in which Lewis had been interested, and whose notion of the crowd encapsulated systemisations and challenges that moved from anarchism to hegemony. We could well take things a step further and speculate that Lewis might have sought to contrast the patriotism of those separatist groups, settled comfortably in at the *Café de Flore* in Saint Germain-des-Près, with the red-bannered socialism in the background.[3]

An important prose piece by Lewis entitled "The Crowd Master" appeared in the second issue of *Blast* in 1915 and helped readers to go beyond mere speculations about the contemporary painting.[4] The city, described as the place of the 'masses' and of the annihilation of individuality, was shown to incarnate the modern parable of the apocalypse. As an object of fascination and repulsion alike, its urbanisation could only be fenced-in, made prison-like and marginal. As a catalyst of life, the city is the *in vitro* and *intra muros* laboratory of death. The crowd is its experiment with and experience of this existence, here again a marginal one. Like Epstein, Lewis conveyed an anxious fascination with modernity, as is well illustrated by the fine drawings held at the Victoria and Albert Museum, *Combat No. 2* and *Combat No. 3*, produced in 1914. His succinct pictographic grammar echoes Bomberg's *The Mud Bath* (1914, cat. 102) every bit as much as it reverberates with the works of Malevich and El Lissitzky. Though owing something to Russolo's *Rebellion*, *The Crowd* is distinct, as it manages to freeze the disorder of humanity while at the same time lending it order. It was undoubtedly this refusal of any kind of 'automobilism' that Lewis indicated to Marinetti by borrowing a line from Baudelaire: "I hate movement that shifts lines."[5]

C. L.

1 Edwards, *Wyndham Lewis Painter and Writer*, (New Haven: Yale University Press, 2000), pp. 131–37.
2 This is one of the theses in *Wyndham Lewis*, exh. cat., Manchester, City Art Gallery, 1980, p. 69.
3 The letters 'ENCLO', identifiable on a sign, might also refer, by virtue of the ironical wordplay, to the famous 'CLOSERIE'—des Lilas—which had become one of the bastions of left-wing intellectuals.

4 Lewis, "The Crowd Master 1914, London, July", *Blast* (London), no. 2, July 1915, p. 94.
5 Lewis, *Blasting and Bombardiering*, London 1937, and [Calder & Boyars] 1967, pp. 37–8.

107 **Percy Wyndham Lewis**
Workshop, c. 1914–1915
Oil on canvas, 76.5 × 61 cm
Tate, London / Purchased, 1974

"He is by nature highly gifted and by training highly accomplished," wrote Roger Fry in reviewing Wyndham Lewis's works at the *London Group* exhibition in March 1914, "so that whatever he does has a certain finality and completeness. In front of his abstract designs one has to admit the close consistency, the clear and definite organising power that lies behind them. But it is rather the admission at the end of a piece of close reasoning than the delighted acceptance of a revealed truth. He makes us admit his power; he does not invite us to feel as he felt."[1] Although Fry's assessment must pre-date *Workshop* by some months, the assertion of Lewis's organising power holds true for the painting which was among those shown with the same group a year later.[2] In its disjunctive interlocking planes of unusual colours (acrid ochre, sienna and pink predominate) held between planes of white and black outlines, *Workshop* demonstrates the mastery with which Lewis could convey the sense of architectural structure through the arrangement of complex cells, angled shafts and planes. While the contemporary photographs of Alvin Langdon Coburn and the architectural drawings of Antonio Sant'Elia have both been cited as comparators,[3] *Workshop* is strikingly devoid of the recognisable references to reality that lingered in related watercolours (such as *Red Duet*, 1914, private collection) or even in Lewis's only other surviving canvas from this moment, *The Crowd* (cat. 106).
The austerity of means, robust composition and allusion to a mechanised world that was, nonetheless, distinct from the dynamic vision favoured by Futurism, embodied Lewis's idea of Vorticism. About a year after it was made, the poet Ezra Pound told the American collector John Quinn (who purchased the painting): "It is part of his [Lewis'] general surge toward the restitution of the proper valuation of conception, i.e. CONCEPTION then finish."[4] The dominance of the idea over technique was, thus, also associated with the primacy of abstraction. In this respect the title acts as the main link back to reality; the forms reminiscent of ladders, windows and cells can be read as suggesting a specific location, but the flattened spatial scheme defies this. It radicalised from Cubism in a way that, beyond the works of Bomberg and Wadsworth, may find its closest parallels in contemporary developments in Russia. The 'workshop' might signal the realm of the modern artist-engineer, rather than the traditional studio, although there may also be a barbed echo of Fry's Omega Workshop that Lewis had left dramatically in late 1913. More generally, it suggested the industrial powerhouse of Britain as Lewis himself indicated in *Blast* no. 1: "Bless England, Industrial Island Machine, Pyramidal Workshop, its apex at Shetland discharging itself into the sea."[5]
In his assessment of the *London Group* exhibition of 1915, in the first spring of the war and to which he submitted both *Workshop* and *The Crowd* (and Epstein showed *The Rock Drill*, cat. 104), Lewis refrained from discussing his own works. However, he took the opportunity to contrast, once again, the simultaneity of Futurism with the "imaginatively co-ordinated impression that is seen in a Vorticist picture. In Vorticism the direct and hot impressions of life are mated with Abstraction, or the combinations of the Will."[6] Later that summer, he showed both paintings again in the *Vorticist Exhibition* that coincided with the second (and final) issue of *Blast*. In the catalogue introduction, Lewis resumed the combative and oppositional tone that had characterised the inception of Vorticism the year before and may be seen to comment upon his own development: "By Vorticism we mean (a) *Activity* as opposed to the tasteful *Passivity* of Picasso; (b) SIGNIFICANCE as opposed to the dull or anecdotal character to which the Naturalist is condemned; (c) ESSENTIAL MOVEMENT and ACTIVITY (such as the energy of a mind) as opposed to imitative cinematography, the fuss and hysterics of the Futurists."[7]

M. G.

1 Fry, "Two views of the London Group", *Nation*, 19 Mar. 1914, Bomberg Press Cuttings TGA 878.9.
2 *London Group*, Goupil Gallery, March 1915.
3 See Cork, *Vorticism and Abstract Art in the First Machine Age*, (London: Gordon Fraser, 1976), pp. 341–5, and Edwards, *Wyndham Lewis: Painter and Writer*, [New Haven and London: Yale University Press, 2000], p. 128.
4 Pound to Quinn, 19 July 1916, in Zinnes (ed.),

Ezra Pound and the Visual Arts, [New York: New Directions, 1980], p. 140, cited in Edwards 2000, p. 130.
5 Lewis, "Manifesto", *Blast*, no. 1, July 1914.
6 Lewis, "The London Group", Mar. 1915, republished in Michel and Fox (eds.), *Wyndham Lewis on Art: Collected Writings 1913–1956*, (London: Thames and Hudson, 1969), p. 88.
7 Lewis, "Preface", *Vorticist Exhibition*, Doré Galleries,

London, June 1915, republished in Michel and Fox, *Wyndham Lewis*, op. cit., p. 96.

108 **Christopher Richard Wynne Nevinson**
 Le Vieux Port, **1913**
 Oil on canvas, 91.5 x 56 cm
 Government Art Collection, London
 Purchased from Leicester Galleries, February 1959

Christopher Richard Wynne Nevinson was the only British convert to Futurism, declaring his allegiance by accompanying Marinetti in a performance of *The Siege of Adrianople* in April 1914 and co-signing *Vital English Art* with him in June. Though excited by Marinetti's polemics, the roots of Nevinson's commitment ran deeper. From an energetic generation at the Slade School of Art (that included Wadsworth and Bomberg), he was still a student when he saw the *Exhibition of Italian Futurist Painters* at the Sackville Gallery in 1912; it promised to sweep away much of the weight of tradition in which he was being educated.

He befriended Severini when the Italian painter returned to London for his solo show at the Marlborough Gallery in April 1913, and they met again in Paris that year.[1] *Le Vieux Port* is one of the first works to show Nevinson's response to these experiences, and his attempt to synthesise Futurism and Cubism, through the steep stacked-up composition. Though the high vantage point was probably imagined, it allowed for the interlocking of the different layers of space—cranes, quays, houses, tugs—so that they could be integrated within a shallow picture space. This was achieved through clouds of steam in the closely related, but lost, painting *The Departure of the Train de Luxe*, which was hailed at the time as "the first English Futurist picture".[2]

In his choice of subject matter for *Le Vieux Port* and *The Departure of the Train de Luxe*, Nevinson appeared to be working through the industrialised systems of mass transportation that Marinetti had famously listed in the *Founding and First Manifesto of Futurism*: shipyards, stations, factories, bridges, steamers, trains and aeroplanes.[3] In this cataloguing of enthusiasms the Englishman was certainly not alone. At Severini's Montmartre studio that he shared with Felix Del Marle, Nevinson would have seen the Italian's paintings of the Parisian metro and the Frenchman's *The Port*,[4] and during his stay in Paris he may have encountered other modernist imaginings of the city by Delaunay, Gleizes and others. Certainly, his rather tentative response in *Le Vieux Port* points the way towards the more sophisticated realisation of such Bergsonian subjects in Nevinson's other port scene, *The Arrival* (cat. 109).

M. G.

1 The key work on Nevinson is Walsh, *C.R.W. Nevinson: The Cult of Violence*, (New Haven and London: Yale University Press, 2002); see also Gale "A Short Flight: between Futurism and Vorticism" in this catalogue.

2 Rutter, quoted in Cork, *Vorticism and Abstract Art in the First Machine Age*, (London: Gordon Fraser, 1976), p. 243.

3 Marinetti, *The Founding and First Manifesto of Futurism*, 20 Feb. 1909, trans. in Apollonio, op. cit., p. 22.

4 Walsh, op. cit., p. 83.

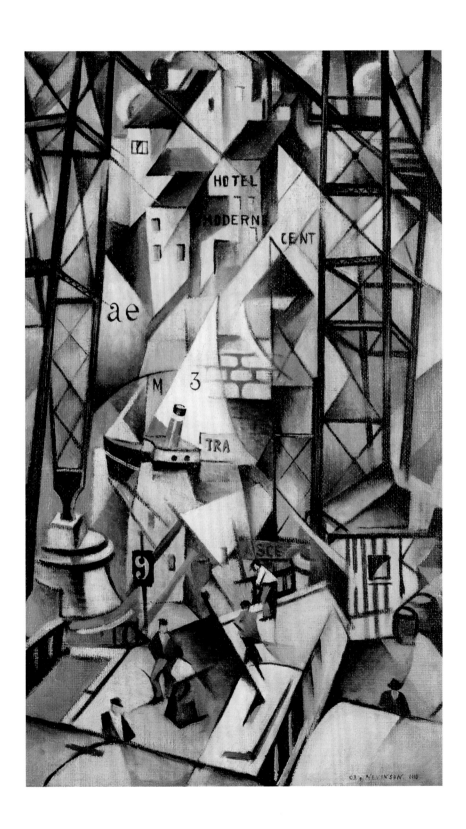

109 **Christopher Richard Wynne Nevinson**
The Arrival, c. 1913
Oil on canvas, 76.2 x 63.5 cm
Tate, London / Presented by the artist's widow, 1956

Nevinson's *The Arrival* has recourse to traditional figuration, though associated with an original layout, while at the same time combining avant-garde research and an orthodoxy reflected in its descriptive title.

Water has never ceased to catch the eye of artists and has long authorised metonymic short-cuts and syntactic innovations. The beginning of the Twentieth Century saw navigation become confirmed as a preferred area of experimentation. In crystallising the progressive hopes of a generation, the sea , long an element of separation, became the bridge for insular Britain. Air-water, sky-sea: the earth opened up as technological discoveries were made, something to which artists' imaginations lent substance. If the steamship was to the ocean what the aeroplane was to the sky, Nevinson here yielded a thoroughly solemn image of the former before being soon engulfed by the latter in the thick of war.

In reinstating an academic kaleidoscopic vision, the artist turned the transatlantic liner into the central motif of the composition. While the ship's hull forms two vanishing diagonals, the edge of its angular prow creates the only salient vertical of the canvas. As for the quay, it represents a bold perspectival short-cut disturbed by just three figures. Saturated by figurative elements functioning like so many clues borrowed from reality—mooring ropes, wooden boarding, railings, metal footbridges—the prismatic composition thwarts a possible, but endlessly resisted, legibility. This fragmentary arrangement of stripes and curves indisputably draws close to the Futurism of Severini, whose *Dynamic Hieroglyph of the Bal Tabarin,* produced in 1912 (The Museum of Modern Art, New York) Nevinson had had a chance to admire. Even more important was the example of Félix Del Marle's *The Port* (1913, cat. 53), that evokes the plastic options applied in *The Arrival*, similarly focusing on disturbed analogies. Nevinson thus veered towards a simultaneism which, while perfectly controlled, is no less permeated by a reluctance to radicalise formal choices. The constructive rigour and linear assurance of the canvas, sparing in optical vibrations, point to the influence of the Cubism of one such as Gleizes, whose *Port* (1912, Art Gallery of Ontario, Toronto) was exhibited in 1913 at the Indépendants. In fact, Nevinson's use of colour, involving an austere precision—as illustrated as much by the elegant gradations as by the geometric boundaries in the chromatic deployment—may be associated with a Cubo-Futurism that was by that time thoroughly well established.

Marinetti saw in the English artist an ally, a valuable conduit for disseminating his ideas in Great Britain. "I wish … to cure English art of that most grave of all maladies: passéism. I have the right to speak plainly and without compromise, and together with my friend Nevinson, an English Futurist painter, to give the signal for battle."[1] Nevinson's work may have been exempt from all manner of Victorianism but it was nonetheless governed by a classicism, offering glimpses—quite distinct from the fiery lectures at the Doré Galleries in 1914[2]—of an aspiration to the order that his later pictures would establish. In appropriating a traditional imagery re-introduced by a thoroughly contemporary mythology, he executed with *The Arrival* a work which was intoxicated by the liberating solutions of Futurism, and flirted with a certain aesthetic conformism.

C. L.

1 Marinetti, Nevinson, "A Futurist Manifesto: Vital English Art", *Observer*, 7 June 1914, in Italian as "Manifesto futurista", *Lacerba* (Florence), vol. 1, no. 14, 15 July 1914, pp. 209–11; republished in Walsh, *C.R.W. Nevinson: The Cult of Violence*, (New Haven and London: Yale University Press, 2002), pp. 76–7.
2 Lectures given to mark the *Exhibition Italian Futurist Painters and Sculptors*, London, Doré Galleries, April 1914.

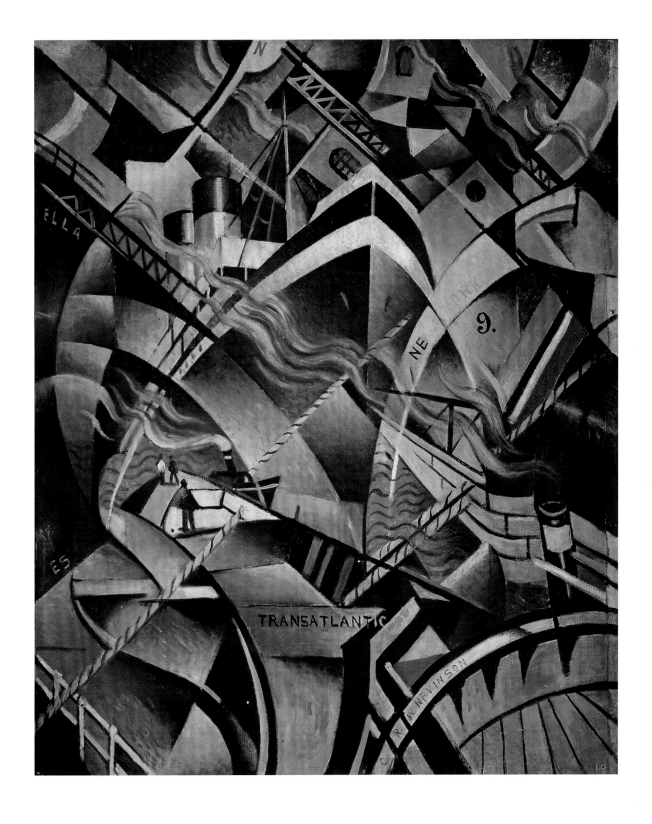

110 **Christopher Richard Wynne Nevinson**
Returning to the Trenches, 1914–1915
Oil on canvas, 51.2 x 76.8 cm
National Gallery of Canada, Ottawa
Gift of the Massey Collection of English Painting, 1946

Nevinson was the only English painter to align himself officially under the banner of Futurism. In 1913 he made paintings, such as *The Departure of the Train de Luxe* (lost), which echoed the stylistic and iconographic approach of the Italian Futurist painters, whom England had discovered the year before at the exhibition held at the Sackville Gallery in March 1912 (the London stage of the Bernheim-Jeune exhibition). Nevinson's Futurist ardour prompted him to share Marinetti's nationalism and zeal. Before the Italian poet's enlistment in his country's army in May 1915, the English painter joined the British army's Friends' Ambulance Unit in the autumn of 1914. From 'behind the lines', he told the *Daily Express*: "This War will be a violent incentive to Futurism, for we believe there is no beauty except in strife, and no masterpiece without aggressiveness. … Our Futurist technique is the only possible medium to express the crudeness, violence and brutality of the emotions seen and felt on the present battlefields of Europe."[1] It is worth noting that, at the same moment, and likewise involved in the fighting, Léger saw the same battlefields as one big Cubist opera. *Returning to the Trenches*, Nevinson's first war painting, was intended to live up to such declarations. The picture was preceded by lengthy preparatory work, as attested to by many graphic studies.[2]

The force-lines of the composition were inspired, through their orientation, by the great models represented by Carrà's *The Funeral of the Anarchist Galli* (1910–11, cat. 42) and Russolo's *Rebellion* (1911, cat. 32). The energy of masses in motion is to be read, according to Futurism, from right to left. As in Léger's war-inspired paintings, the individuals painted by Nevinson are no longer anything more than cogs in the gigantic machinery that modern war has become. Nevinson's painting is often compared to Villon's *Soldiers on the March* (1913, cat. 65), and *Returning to the Trenches* precisely indicates the gap existing between the Cubist treatment and the Futurist treatment of the subject. The analytical concern of the former contrasts with the fervour of the latter. Where energy is the key word in Nevinson's research, equilibrium and moderation seem to be the ultimate ends of Villon's. The empathy that the English artist was keen to bestir among those looking at his picture prompted him to emphasise its realist dimension: "My Futurist training … had convinced me that a man who lives by the public should make his appeal to that public and meet that public."[3]

In this profession of realist faith, Nevinson marked his remove from a Vorticism that was a direct heir to Cubist formalism. The time of the squabbles pitting Nevinson against the Vorticist group were by now over—they had rebuked him for his allegiance to Futurism— and Wyndham Lewis agreed to a reconciliation, approving the reproduction of *Returning to the Trenches* in the magazine *Blast*, mouthpiece of the English avant-garde movement. The work then became the object of what might be called 'Vorticisation', making it possible to get an idea of how the aesthetics being advocated by Ezra Pound and Lewis differed from the aesthetics of Futurism. *Returning to the Trenches* was reproduced in the second issue of *Blast*, in the form of a wood engraving.[4] This rendering of Nevinson's work, which was as technical as it was stylistic, led it to undergo an almost abstract metamorphosis. The single colour of the engraving underscored the harmonisation of the elements making up the composition. The 'Vorticisation' of *Returning to the Trenches* brings the work closer to *Soldiers on the March* and demonstrates the deep connection between Vorticism and French Cubo-Futurism.

D. O.

1 Nevinson, "Interview", *Daily Express*, 25 Feb. 1915, quoted in Cork, *Vorticism and Abstract Art in the First Machine Age;* vol. 2: *Synthesis and Decline*, (London: Gordon Fraser, 1976), p. 483.

2 See in particular *Study for "Returning to the Trenches"* (1914–15, Tate, London).

3 Nevinson, *Paint and Prejudice*, (London: Methuen, 1937), p. 91, quoted in Cork, *orticism and Abstract Art in the First Machine Age*, op. cit, p. 484.

4 Print entitled *On the Way to the Trenches* (present whereabouts unknown) reproduced in *Blast* no. 2, July 1915, p. 89; Cork, op. cit., p. 486.

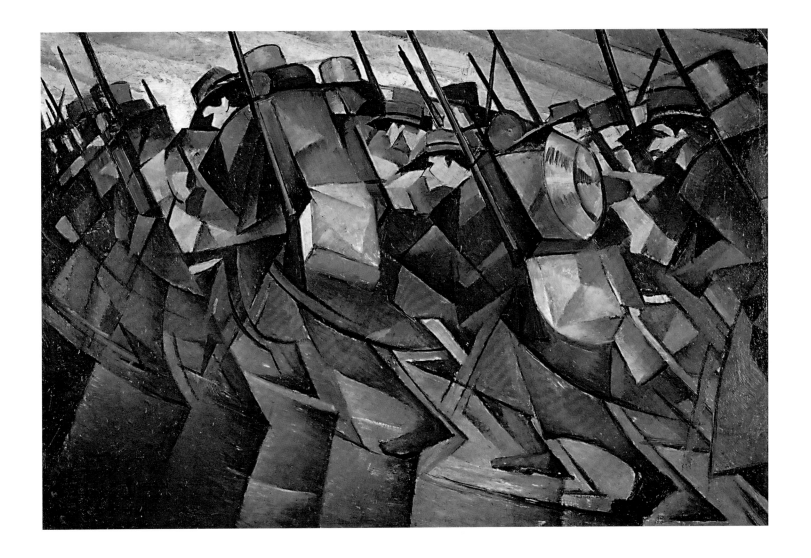

111 **Christopher Richard Wynne Nevinson**
Bursting Shell, 1915
Oil on canvas, 76 x 56 cm
Tate, London / Purchased, 1983

For a generation which was nurtured on its readings of Friedrich Nietzsche, fuelling the dream of a rebirth of both man and culture, the war, which released the most violent and sacred of instincts, came across like the unexpected catalyst of a reinvention of the world and its laws. In Germany it was Otto Dix who painted night-time explosions like some fantastic pyrotechnic fairyland. This spectacle of radiating powers, the sight of the fabulous energy of exploding shells, could not fail but fascinate those artists who had elected to put their works under the aegis of a magazine titled *Blast*. Gaudier-Brzeska was the first to succumb to this macabre spell. As a founding member of that Vorticism which glorified the virtues of an unchecked dynamism, pursuing in each of its manifestations its point of highest energy (in other words, the vortex), on the Somme front he produced a series of drawings illustrating the very explosions which would before long claim his life.[1] The explosion that Nevinson painted in 1915 was more melancholic in nature. Initially fascinated, in the name of his Futurist commitment, by the enormous machinery of war, his enlistment in a Friends' Ambulance unit permitted him to discover a human reality that was far less elating: "When a month had passed I felt I had been born in the nightmare."[2]

It was Wyndham Lewis who, in the second issue of *Blast*, expressed this change of heart: "Marinetti's one and only (but very fervent and literal) disciple in this country, had seemingly not thought out, or carried to their logical conclusion, all his master's precepts. For I hear that, *de retour du Front* [back from the Front], this disciple's first action has been to write to the compact Milanese volcano that he no longer shares, that he REPUDIATES, all his [Marinetti's] utterances on the subject of War, to which he formerly subscribed. Marinetti's solitary English disciple has discovered that War is not *Magnifique*, or that Marinetti's *Guerre* [War] is not la *Guerre. Tant Mieux* [So much the better]."[3] The appearance in the same issue of *Blast* of an engraved reproduction of *Returning to the Trenches* (1914–15, cat. 110)[4] ushered in a reconciliation between Nevinson and the Vorticists, and a *de facto* distancing from Futurism. *Bursting Shell*, which he painted in 1915, did a whole lot more than merely destroy his old Futurist persuasions. In an interview given after the war to *The New York Times*, Nevinson, in a seemingly odd way, associated modern art itself with the period of terror that had just swept through Europe: "Everything in war was a turmoil—everything was bursting—the whole talk among artists was of war. They were turning their attention to boxing and fighting of various sorts. They were in love with the glory of violence. They were dynamic, Bolshevistic, chaotic. … Everything was being destroyed; canons of art were sacrificed everywhere. And when war eventually came, it found the modern artist equipped with a technique perfectly well able to express war."[5] Through their own technical experiments, modern artists had incorporated war even before it had broken out. Their renewed sensibility was the inhuman sensibility of conflict and terror itself; this was the curious message conveyed by Nevinson, the most Futurist of all English painters, after the war was over. More so than the alleged pressures of a backward-looking sponsor (Paul George Konody, responsible for the war painting programme on behalf of the Canadian government), the arguments behind this introspection explained Nevinson's post-1915 development, which was deemed "Neo-Classical". In reverting to a form attached to the conventions of beauty and classical culture, it was with a form of humanism that Nevinson intended to connect. What exploded in his painting in 1915 only bore the shape of a shell: for what exploded was indeed its modernist ideals, its cult of violence, and its pre-war mechanisation.

D. O.

1 See in particular *One of the Shells Exploding* (1915, Musée national d'art moderne, Paris).
2 Nevinson, *Paint and Prejudice*, (London: Methuen, 1937), p. 78; quoted in Cork, *Vorticism and Abstract Art in the First Machine Age*, vol. 2: "Synthesis and Decline", (London: Gordon Fraser, 1976), p. 483.
3 Lewis, "The Six Hundred, Verestchagin and Uccello", *Blast* (London), no. 2, July 1915, p. 25.

4 This engraving titled *On the Way to the Trenches* (1914–15, work destroyed) is reproduced p. 89 in the second issue of *Blast*, op. cit.; Cork, *orticism and Abstract Art in the First Machine Age*, vol. 2, op. cit, p. 486.
5 Nevinson, interview with the *New York Times*, 25 May 1919; quoted in Cork, op. cit., p. 485.

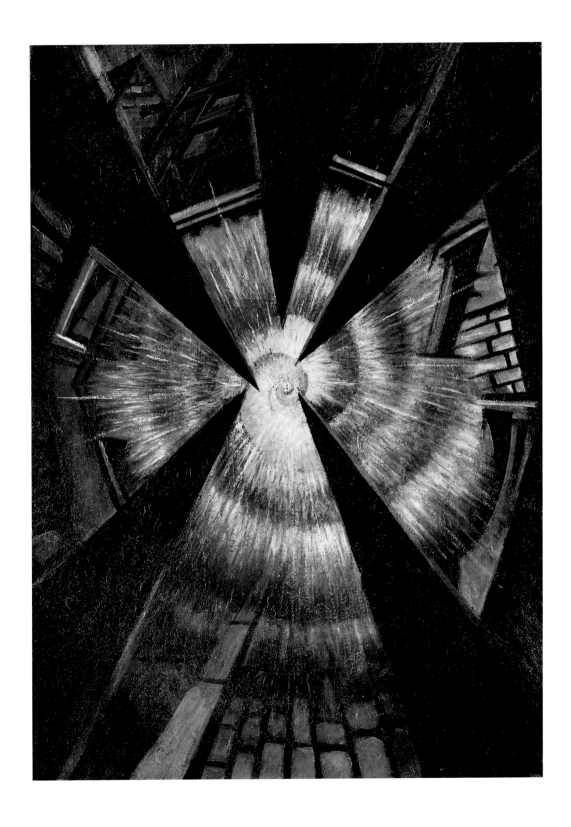

112 **Edward Wadsworth**
Vorticist Composition, 1915
Oil on canvas, 76.3 x 63.5 cm
Museo Thyssen-Bornemisza, Madrid

"Mr Wadsworth is very austere", wrote Arnold Bennett in 1920, adding: "He depends on his central vitalising emotion, and he allows no extrinsic facts … to interfere with the expression of that emotion."[1] Bennett's comments, though made of the artist's slightly later work, may equally apply to *Vorticist Composition*. The austerity is evident in the structured sequence of forms, the vitality in their echoing and rhyming across the painting. The vertical zig-zagging of steps up the centre provides the spine of the composition. By subtle inflections of the width and attenuation of these elements, converging and splaying as they build upwards, a dialogue of movement and flatness is created. The curved forms to the left contrast with the repeated rods of colour stacked on the right. These are typical of Wadsworth's jagged and repeated forms (here 'E', 'F' and 'K' shapes predominate) that Wyndham Lewis saw in another painting (*Blackpool*) as "striped ascending blocks … condensed into the simplest form possible for the retaining of its vivacity."[2]

Vorticist Composition dates from the brief life of the British movement after the publication of *Blast* no. 1 coincided with the outbreak of war.[3] The painting's centralised structure has encouraged a figurative reading, and encouraged the artist's daughter to proffer an alternative title, *Vorticist Abstraction (Guitar Player)*,[4] presumably in acknowledgment of the resemblance to later musician works by Juan Gris and Jacques Lipchitz. Lewis's comments in *Blast* no. 2 of July 1915 have also been related to the possibility of abstraction from the figure in Wadsworth's contemporary work. In particular Lewis dismissed the "masonry" of Picasso's Cubist figures and, instead, favoured "at least the suggestion of life and displacement that you get in a machine".[5] The vertical structure of *Vorticist Composition* may implicitly combine such a figurative source and a machine aesthetic. The discovery of a previous painting of a half-length portrait underlying *Vorticist Composition*, deliberately obscured by the grey border, has lent further weight to this association. Although the figure is a smoker rather than a musician, the proposed identification of the sitter as Lewis, and dating to the artists' shared trip to Hebden Bridge in August 1915, embeds a condensed history within this only survivor from among Wadsworth's oil paintings of the Vorticist period.[6]

M. G.

1 Bennett, "Note", in *The Black Country, Drawings by Edward Wadsworth*, Leicester Galleries, London, Jan. 1920, extracted in *Blasting the Future! Vorticism in Britain 1910–1920*, exh. cat. (Philip Wilson Publishers), Estorick Collection of Modern Italian Art, London;Whitworth Art Gallery, University of Manchester, 2004, p. 109.
2 Lewis, "The London Group", Mar. 1915, republished in Michel and Fox (eds.), *Wyndham Lewis on Art:*

Collected Writings 1913–1956, (London: Thames and Hudson, 1969), p. 85.
3 The key discussion of this painting is Christopher Green, *The Thyssen-Bornemisza Collection: The European Avant-Gardes, Art in France and Western Europe 1904–c. 1945*, London, 1995, pp. 488–93.
4 Wadsworth, *Edward Wadsworth: A Painter's Life*, Salisbury, 1989, Appendix A W/A 37.

5 Lewis, *Blast no. 2*, July 1915, p. 44, cited in Cork, *Vorticism and Abstract Art in the First Machine Age*, (London: Gordon Fraser, 1976), pp. 328–30.
6 See *The Thyssen-Bornemisza Collection: The European Avant-Gardes*, Green, op. cit., pp. 490–92.

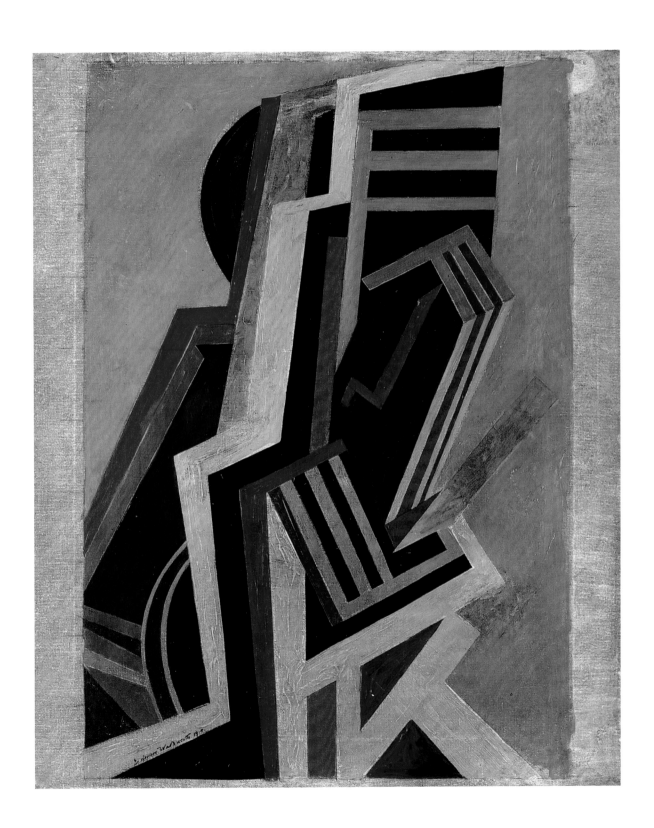

113-116 **Gino Severini**
Train de banlieue arrivant à Paris, **1915**
Train de la Croix Rouge traversant un village, **1915**
Écroulement, **1915**
Train de blessés, **1915**

It was not until the beginning of 1916 that Severini made his war paintings public by exhibiting them together in Paris.[1] However misguided it might already have appeared to be by then—with the unimaginable loss of life evident daily—they reflected the Marinettian fervour for social change, of which war, "Futurism intensified",[2] would be the first stage. Severini was an unlikely candidate for this task, as his poor health exempted him from military service. However, he was impressed at the spectacle of France on a war footing as his Parisian friends joined up,[3] and he was encouraged by Marinetti to show his support through his art: "Try to live the war pictorially, studying it in all its mechanical forms, (military trains, fortifications, wounded men, ambulances, hospitals, parades, etc.)."[4] The resulting paintings show Severini's desire to make such a commitment: "I have tried to express the idea 'war' by a plastic ensemble composed of these realities: cannon, factory, flag, mobilization order, aeroplane, anchor."[5]

Severini's *Plastic Art of War*, as he titled his 1916 exhibition, presented the dynamic integration of time and space that united his works: building, destruction, movement, detonation, reportage. Paintings such as *Cannon in Action* and *Plastic Synthesis of the Idea: War* (both 1914–15) integrated words and images, a strategy already present in his work in early 1914, and reinforced by the example of Marinetti's *parole in libertà* and Apollinaire's *calligrammes*. It is also evident in *Red Cross Train* (cat. 116), completed during the summer of 1915, where registration numbers, town-signs and the masthead of *Le Figaro* contribute a sense of the wartime obsessions with regulations, geography and news. Fragmentation conveys a Bergsonian simultaneity experienced by the train's occupants: the wounded soldier, whose arm and blanketed feet on a stretcher hold the centre, and the nurse who forms a stabilising triangle below. The upwards thrust of the motion suggests the urgency of the mission, acknowledging the crisis of casualties.[6]

Trains dominated the works that Severini made during the summer of 1915, which he spent near a strategic railway line outside Paris at Igny (signposted in *Red Cross Train*). As the means of mass transportation, the train already had a long and excited history within Futurism, but, with the war, it accumulated other associations. Evacuation is the subject of Severini's *Red Cross Train Passing a Village* (cat. 114), while supply may the subject of *Suburban Train Arriving in Paris* (cat. 113).[7] In both the steaming train rockets to the right, buckling the images of suburbia around it under the force of its speed. Through action and sound it fragments time and space. The solidification of these planes in *Red Cross Train Passing a Village* indicates that Severini's personal reconciliation between Futurism and Cubism was already underway.[8] The more elevated viewpoint of *Suburban Train Arriving in Paris* effects a compositional unity of extreme energy. In contrast to such synthesised imagery, *Crash* is shockingly direct (cat. 115). A dense interlocking of facets that capture brickwork and rubble, smoke and dust, presents an impenetrable vision notably different in character and sentiment from the related works. Here disaster is fixed in a way closer to the grim power of Nevinson's *Bursting Shell* (cat. 111).

By depicting French subjects, Severini's war paintings were located in a subtly different context from the Futurist impetuosity towards violent change. Where Futurism was an interventionist movement in Italy, Severini worked within a Parisian avant-garde under renewed attack from conservative critics eager to equate modernism with Germany, and Germany with barbarism. The disastrous bombing of Reims cathedral and subsequent fire on 19 September 1914 rapidly became a national myth (alluded to in a war poem by Severini's father-in-law Paul Fort), 'confirming' that such an enemy disregarded the values of culture and civilization.[9] By showing his war paintings in Paris in 1916, Severini responded to this accusation. He effectively asserted that the formal experimentation of the pre-war avant-garde generally, and his merging of Futurism and Cubism more specifically, could support the allied war effort. The fragmentation of reality present in the work was posed in Bergsonian terms of fleeting sensation overlaid with patriotism and a continuing faith in technology. Such a view was echoed by Pierre-Albert Birot, whose open letter to Severini in the new periodical *Sic* saw the paintings in cinematic terms: 'You try to represent for us the complex, fugitive image which appears on the screen of your mind when you push the button: Idea of "War".'[10] As they celebrated this new vision, the Battle of Verdun had just begun.

M. G.

1 *Première exposition futuriste d'art plastique de la guerre et d'autres oeuvres antérieures*, Galerie Boutet de Monvel, Paris 15 Jan.–1 Feb. 1915.
2 Marinetti, Settimelli and Cora, "Futurist Synthetic Theatre", 11 Jan. 1915, trans. in Apollonio (ed.), *Futurist Manifestos*, (London: Thames and Hudson, 1973 and 2001), p. 183.
3 See Fonti, *Gino Severini: Catalogo ragionato*, (Milan: Mondadori, 1988) p. 32.
4 Marinetti to Severini, 20 Nov. 1914, cited in Tisdall and Bozzolla, *Futurism*, (London: Thames and Hudson, 1977), p. 190.

5 Severini, "Symbolisme plastique et symbolisme littéraire", *Mercure de France*, vol.113, no. 423, Feb. 1916, quoted in Fonti, op. cit., p. 32.
6 Severini is likely to have been aware of Nevinson's experience as an ambulance driver during 1914–15.
7 For these works see, respectively, Zander Rudenstine, *The Solomon R Guggenheim Collection, New York*, New York, 1976, pp. 649–55, and Alley, *Catalogue of The Tate Gallery's Collection of Modern Art other than works by British Artists*, London, 1981, pp. 684–5.
8 See Fonti, op. cit., p. 196, and Green, "Border

Crossings and Border Controls", in Fraquelli and Green, *Gino Severini: From Futurism to Classicism*, exh. cat., National Touring Exhibitions, South Bank Centre, 1999, p. 27.
9 For Reims see Lambourne, "Production versus Destruction: Art, World War I and art history", *Art History*, vol. 22, no. 3, Sept. 1999, pp. 350–63; for Fort's response see Fraquelli, "From Futurism to Classicism", in Fraquelli and Green, op. cit., p. 13.
10 Birot, *Sic*, no. 2, Feb. 1916, p. 5, quoted in Green, *Léger and the Avant-Garde*, (New Haven and London: Yale University Press, 1976), p. 121.

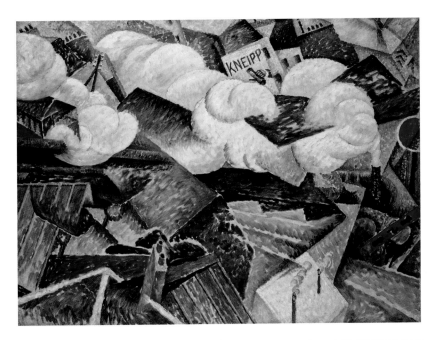

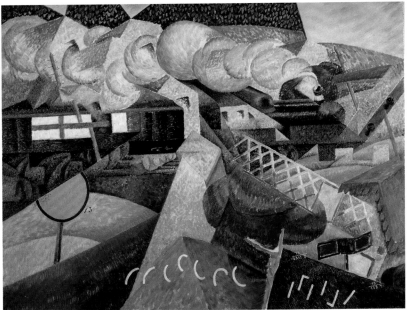

113 *Train de banlieue arrivant à Paris*, **1915**
[Suburban Train Arriving in Paris]
Oil on canvas, 88.6 x 115.6 cm
Tate, London / Purchased with assistance from a member of The Art Fund, 1968

114 *Train de la Croix Rouge traversant au village*, **1915**
[Red Cross Train Passing a Village]
Oil on canvas, 89 x 116.2 cm
Solomon R. Guggenheim Museum, New York / Solomon R. Guggenheim Founding Collection

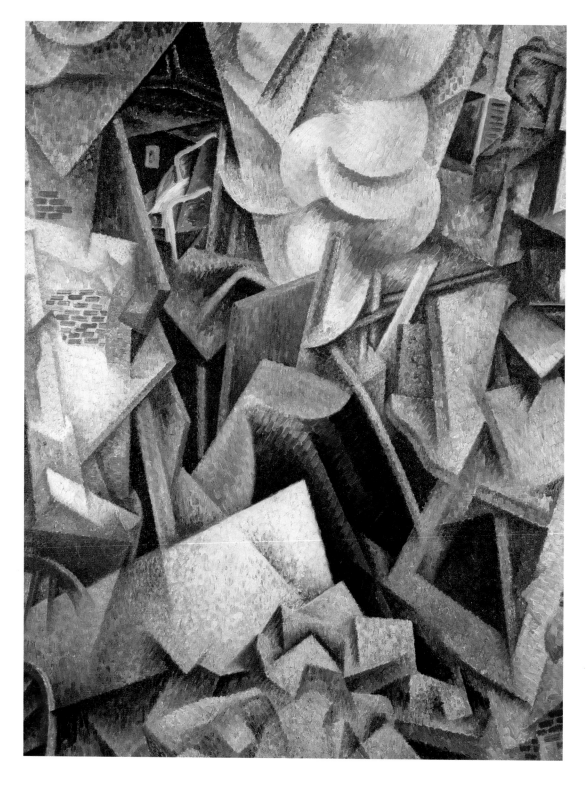

115 ***Écroulement*, 1915**
[Crash]
Oil on canvas, 92 x 73 cm
Private collection

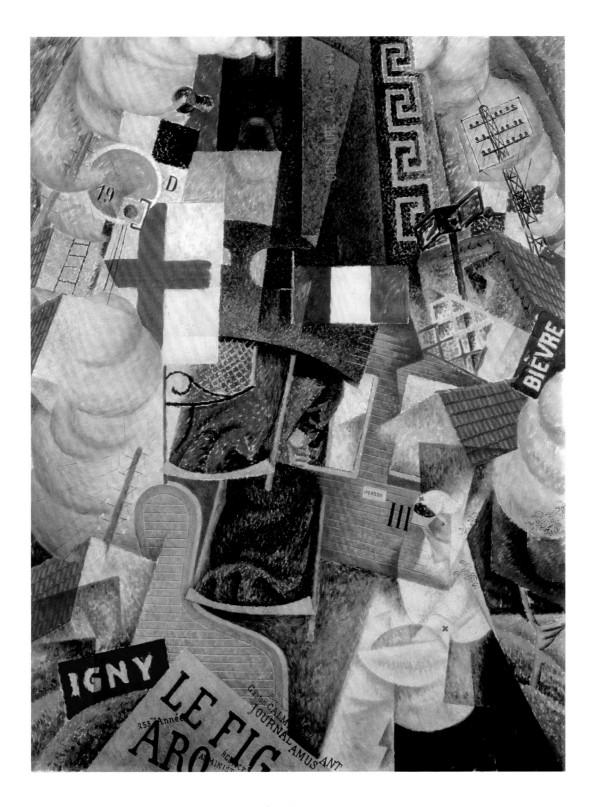

116 **Train de blessés, 1915**
[Red Cross Train]
Oil on canvas, 117 x 90 cm
Stedelijk Museum, Amsterdam

117-119 **Giacomo Balla**
Forme Grido Viva l'Italia, 1915
Dimostrazione Patriottica, 1915
Insidie di Guerra, 1915

"We will sing of great crowds excited by work, by pleasure and by riot", Marinetti wrote in the *Founding and First Manifesto of Futurism*, adding: "we will sing of the multicoloured, polyphonic tides of revolution in the modern capitals."[1] Perhaps more than any other group of Futurist works, Giacomo Balla's interventionist paintings of 1915 capture both the events and the synaesthetic experience of the mass demonstrations of which Marinetti had written six years earlier. Through their twisting and turning forms, Balla brought a new abstract language to the service of the Futurist desire to capture the simultaneity of everyday life focused on political aspirations. For many on the radical fringes, the official maintenance of Italian neutrality after the outbreak of war in August 1914 seemed to betray the ideals of the Risorgimento. Although neutrality honoured the commitment to the Triple Alliance with Germany and Austria-Hungary, and acknowledged a lack of readiness for conflict, it appeared weak in the face of anti-Austrian sentiment directed against the occupation of Italian-speaking lands to the north and east, and along the Dalmatian coast.

Within Futurist circles alone, Prezzolini had declared himself in favour of intervention in August 1914 and Papini had converted *Lacerba* entirely to the cause.[2] As Boccioni recorded,[3] he, Marinetti, Russolo and others were arrested and briefly imprisoned for leading interventionist demonstrations in Milan on 15–16 September and, on their release, published *Sintesi futurista della guerra* [Futurist Synthesis of War].[4] Although Balla himself had just published *Il vestito antineutrale, Manifesto futurista* (11 September 1914), the grafting of interventionist themes onto an earlier text was evident. While Marinetti continued to produce manifestos into 1915 that declared for the war ("Futurism intensified") and brought him into alliance with other radicals including Benito Mussolini,[5] Balla's response was rather detached, aspiring to make the universe "more joyful".[6] The *Ricostruzione Futurista dell'universo* [Futurist Reconstruction of the Universe], published with the young Fortunato Depero on 11 March 1915, encouraged "spontaneous laughter" and proposed, somewhat subversively, to "construct millions of metallic animals for the vastest war … which will undoubtedly follow the current marvellous little human conflagration".[7] Despite the titanic ambition of reconstructing the whole universe, such claims might be taken as frivolously ironic in the circumstances of the unprecedented losses suffered across Europe.

It is perhaps through this tone of mischievous activism, in which humour could be used to anticipate change, that Balla's interventionist paintings of May 1915 may be gauged. They extend a longer trajectory in his work, from the burst of energy evident in *Street Light* to the spiralling of the passing cars, infused with the pioneering experiments with abstraction, the "irridescent compenetrations" that fixed movement into formal geometric shards. What makes the interventionist paintings significant, however, is their response to Sorelian mass events rather than individual experience: they were an attempt to synthesise a broader emotional energy, which—more than any of Balla's works to date—echoed the aspirations of his Milanese colleagues during 1911–12. The painter implicitly acknowledged this continuity when noting an attempt towards "the domination of the states of mind with the new abstract forms".[8]

Perhaps not since the galas depicted by Baroque *vedutisti* or the racing on the Corso captured by the Romantics had the activities of the Roman populace provided so vivid a subject. Balla's challenge was to translate into a pictorial form that was at once intelligible and modern the fervour experienced around the affirmation of unity in the Italian flag. National colours bear the weight of national sentiment and expectation (extending, even, to the artist's own painted frames), and some aspects of this were enacted near the heroic sites of Risorgimento history, notably the demonstrations in the Villa Borghese near the breach that Garibaldi made during the siege of Rome in 1860. Balla adopted a centrifugal energy that may reflect an awareness of Severini's abstract experiments undertaken in Anzio in 1913–14 and shown in Rome at the Galleria Sprovieri, and to the development of Balla's own work based upon the observation of the effects of speed—notably in the speeding car series. Like Severini, Balla also wrote of "analogy" as a way of linking the depiction of one event to stand for wider experience.[9]

Insidie di Guerra has been identified as the *Insidie del 9 maggio* that Balla showed in his solo exhibition in 1918 (cat. 119).[10] This earlier title identifies the demonstration of 9 May 1915 that greeted the neutralist politician Giovanni Giolitti at Termini, the central railway station in Rome. While the location epitomised the injection of modernity into the heart of the ancient city, the explicitly political protest generated a threatening tonality and overbearing composition. Against the—literal—greyness of neutrality, the colours of the Italian tricolore interlock dynamically in buckling, triangulated forms.[11] Dynamism was made manifest and the viewer placed at the centre of the canvas (as Carrà had imagined it),[12] while the forms stand for the tumultuous noise of the assembled crowd.

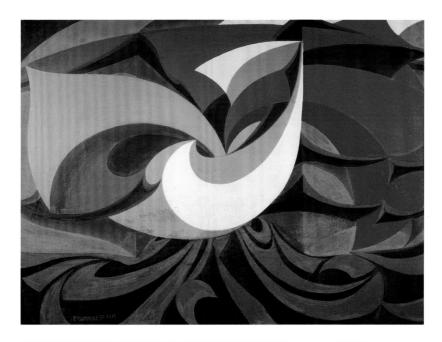

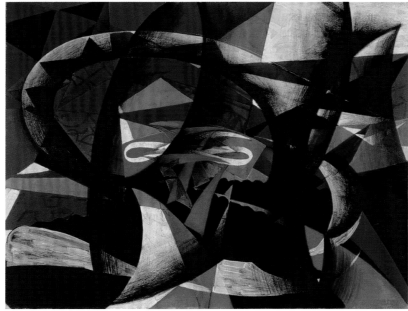

117 **Forme Grido Viva l'Italia, 1915**
 [Forms Cry Long Live Italy]
 Oil on canvas, 134 x 187 cm, painted frame
 Galleria Nazionale d'Arte Moderna, Rome

118 **Dimostrazione Patriottica, 1915**
 [Patriotic Demonstration]
 Oil on canvas, 101 x 137.5 cm
 Museo Thyssen-Bornemisza, Madrid

The same 9 May event, though combined with evident references to the structure of his speeding car compositions, seems to have formed the basis of Balla's *Dimostrazione patriottica* (cat. 118), as the preliminary composition included the words "Morte Giolitti" (also found in a contemporary drawing) floating above the bobbing heads of the crowd.[13] That this did not survive into the final composition may suggest that the speed of events in May—with the King supporting Prime Minister Salandra's pro-war position—ran ahead of Balla's ability to complete the canvas. Instead, the painting seems to have evolved into a more generic image (also suggested in the title) with tricolour forms strikingly dynamic. Mixed in is the knotted white loop at the centre of the painting (and seen again in related works) which has been connected to the insignia of the royal family.[14] It remains possible that he continued to work on this more generalised image even once Italy had joined the war, and the interventionist sentiment was transformed into more general patriotism.

One of the key events that helped to precipitate the declaration of war was a further demonstration on 21 May. Though led by D'Annunzio (the target of so much of Marinetti's earlier criticism), the event in question was the very simple, but electrifying, cry with which the King greeted the crowds assembled outside the Quirinale Palace: "Viva l'Italia". Though not able to commit himself explicitly to the interventionist cause, the conjunction of the patriotic exhortation and the circumstances of the gathering was a master-stroke of populism, readily interpreted as tacit support for the popular enthusiasm for the war; four days later Italy declared war on Austria-Hungary. In contrast to *Insidie di Guerra*, antagonistically focused on Giolitti, Balla's *Forme Grido Viva l'Italia* was celebratory (cat. 117). The tripartite form echoes the tricolore flag: the green on the left zooms into the centre, while the white at the centre soars upwards, and the red at the right is sucked into the vortex. The orange elements stand for the buildings around the square, with blue crowds surging below. The whole is a schematic accumulation of the overpowering feelings of political and popular commitment, of enthusiasm—high above the ancient city—for the completion of the project of national unification.

In picturing mass movements of people, Balla was able to bring together avant-garde interests in synaesthetic experience explored by contemporaries in Paris (including Picabia and Kupka). This was the multi-dimensional experience of everyday life taken to new levels of intensity, through the demonstration, the riot and the manipulation of the crowd. These had an explicitly political dimension in the interventionist cause, which drew Italy into the war, and as an anticipation of the general strike and urban revolution that the Futurists saw as the desirable consequence of mass action. With such images, Balla established for himself a central position within Futurism—made more vital as the Milanese painters volunteered *en masse* on the declaration of war—and within a wider cross-section of concerns that epitomised the energy of the pre-war avant-garde.

M. G.

1 Marinetti, *Manifesto del Futurismo* republished in Drudi Gambillo and Fiori, *Archivi del Futurismo*, (Rome: De Luca Editore, 1958), vol. 1, p. 17; trans. as *The Founding and First Manifesto of Futurism*, in Apollonio (ed.), *Futurist Manifestos*, (London: Thames and Hudson, 1973 and 2001), p. 22.
2 Prezzolini, *La Voce*, 28 August 1914.
3 Boccioni to his mother, 19 September 1914, in Drudi Gambillo and Fiori, vol. 1, op. cit., p. 346.
4 *Sintesi futurista della guerra*, 20 September 1914.
5 Marinetti, Settimelli and Corra, *Teatro sintetico futurista*, 11 Jan. 1915, trans. as "Futurist Synthetic Theatre" in Apollonio, op. cit., p. 183.
6 Balla and Depero, *Ricostruzione futurista dell'universo*, 11 March 1915, in Drudi Gambillo and Fiori, op. cit.,

p. 49; trans. as *Futurist Reconstruction of the Universe*, in Apollonio, op. cit., p. 197.
7 Drudi Gambillo and Fiori, op. cit., vol. 1, p. 50; trans. Apollonio, op. cit., pp. 199–200.
8 Quoted in Lista, *Giacomo Balla*, Modena, 1982, p. 84, cited in De Feo, Rosazza Ferraris and Velani, *La Donazione Balla e le altre opere dell'artista nelle collezioni della Galleria Nazionale d'Arte Moderna*, exh. cat. Galleria Nazionale d'Arte Moderna, Rome, 1988, p. 18.
9 Balla and Depero, in Drudi Gambillo and Fiori, op. cit., vol. 1, p. 51; trans. Apollonio, op. cit., p. 200.
10 "Personale di Balla", Casa d'Arte Bragaglia, Rome, October 1918, no. 22, see De Feo, Ferraris and Velani, op. cit., p. 18, no. 20.

11 Discussed in Lista, op. cit., p. 86.
12 Balla, Boccioni, Carrà, Russolo and Severini, "Les Exposants au public", *Les Peintres futuristes italiens*, exh. cat., Galerie Bernheim-Jeune & Cie., Paris, 5–24 Feb. 1912; trans. as "The Exhibitors to the Public", in *Exhibition of Works by the Italian Futurist Painters*, Sackville Gallery, London, 1912 and republished in Apollonio, op. cit., p. 47.
13 See the investigation of the painting in Green, *The Thyssen-Bornemisza Collection: The European Avant-Gardes, Art in France and Western Europe 1904–c. 1945*, London, 1995, p. 38.
14 Dortch Dorazio, *Giacomo Balla: An Album of his Life and Work*, New York, 1972, unpaginated.

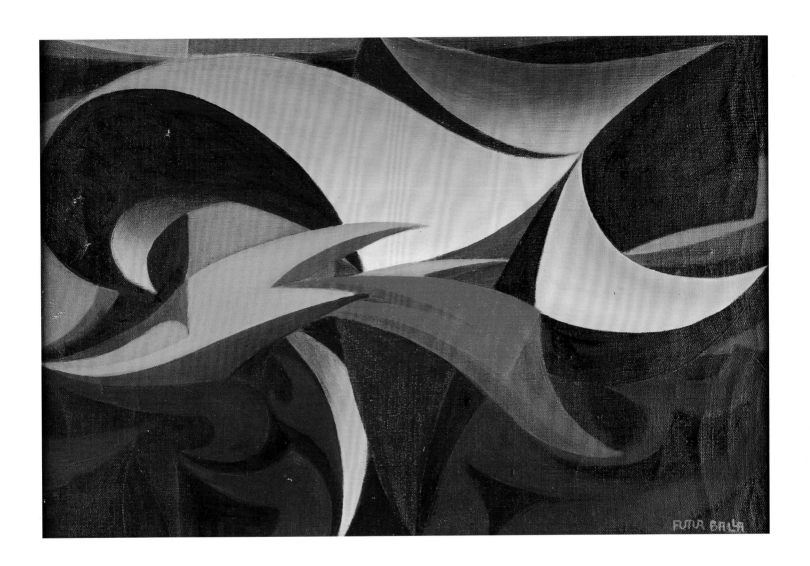

119 **_Insidie di Guerra_, 1915**
[The Risks of War]
Oil on canvas, 115 x 175 cm, painted frame
Galleria Nazionale d'Arte Moderna, Rome

Appendices

Chronology

Nicole Ouvrard

1900

15 April–12 November: in Paris, for the World Fair, three Italian Futurist painters made their first visits to the French capital: Carlo Carrà, there to design some of the pavilions; Giacomo Balla, who stayed in Paris from September 1900 to March 1901—where he painted *Luna Park in Paris* (cat. 1) and discovered the photographs of Etienne Jules Marey, which would influence his Futurist pictures; and Ardengo Soffici, there to visit the fair with friends. The latter set up home of Paris, where he stayed until 1907. Back in Italy, he would make annual visits to the French capital.

Late June–mid-December: Carrà went to London for a few months, where he frequented Italian anarchist circles.

Publication of Henri Bergson's *Laughter: An Essay on the Meaning of the Comic.*

1901

Now living in Paris, among other activities, Soffici contributed to the satirical magazines *Le Rire, Gil Blas, L'Assiette au beurre* and *Frou-Frou,* which enabled him to move in Parisian literary and art circles. He struck up a friendship with the young Dutch poet Fritz Vanderpijl, who introduced him to Alexandre Mercereau[1] and the works of Jules Laforgue, Lautréamont and Arthur Rimbaud.

In Rome, Umberto Boccioni and Gino Severini got in touch with Balla, more than ten years their elder, who was already enjoying a certain amount of fame.

Filippo Tommaso Marinetti, who had been making frequent appearances in Paris since 1894, attended Gustave Kahn's lectures on the theme of the aesthetic value of urban culture, subsequently published under the title *L'Esthétique de la rue* (Paris, E. Fasquelle).

1902

At the Scuola Libera del Nudo in Rome, Boccioni and Severini attended Balla's courses on the principles of Impressionism and Divisionism.

In Paris, Soffici joined the Société des artistes indépendants. He met Max Jacob and Pablo Picasso, and visited the latter's studio.

In Italy, Marinetti took part in literary soirées held to introduce the French Symbolists in Italy. English painters made regular trips to Paris, in particular Percy Wyndham Lewis, who stayed there on several occasions until 1908.

Publication of Marinetti's *La Conquête des étoiles* [Conquest of the Stars] (Paris, La Plume).

One of the first historical group photographs
of the Futurist avant-garde.
From left to right: standing, Aldo Palazzeschi,
Giovanni Papini, F. T. Marinetti; seated, Carlo Carrà,
Umberto Boccioni, 1914.
Giovanni Lista Archives, Paris

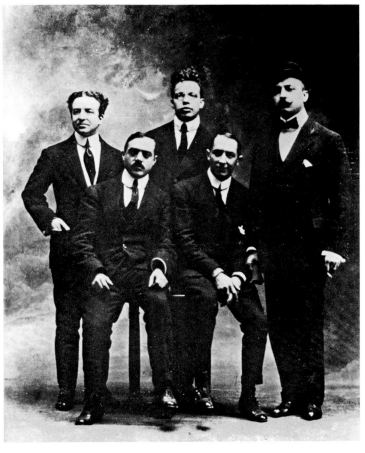

1903

August: Soffici moved into a studio at La Ruche in the passage Dantzig. He met Apollinaire through Serge Férat, the brother of Baroness Hélène D'Œttingen, with whom he had an affair until 1907. In her home he rubbed shoulders with the Parisian avant-garde. "She wrote. She painted. She was a Cubist just like her brother, then I thought she had been converted to Futurism by Soffici, who was always in her company."[2]

Publication of Marinetti's *Gabriele d'Annunzio Intime* (Milan, published by the newspaper *Verde e Azzurro*).

1904

September: Milan was shaken by a general strike, epilogue to the tragic murder of the anarchist Galli, whose funeral was painted by Carrà (*The Funeral of the Anarchist Galli*, 1910–11, cat. 32).

In Milan, with Sem Benelli and Vitaliano Ponti, Marinetti founded the magazine *Poesia*, the first issue of which was planned for the month of November.

He took part in the "Literary Thursdays" which were held in Marseilles.

Publication of *Destruction, poèmes lyriques* (Paris, Vanier-Messein), from *The Bleeding Mummy* (Milan, published by the newspaper *Verde e Azzurro*) by Marinetti, and of *La Beauté rationnelle* by Paul Souriau (Paris, F. Alcan).

1905

1 February: publication of the first issue of *Poesia*, "incubatory mouthpiece", no less, of the Futurist movement, whose leadership was assumed by Marinetti alone from June–July 1906. This issue was marked by the launch of an international survey on free verse and the initial responses (Emile Verhaeren, Gustave Kahn and Gian Pietro Lucini, among others) were published in the November–December issue (10–11). Until it folded, at the end of 1909, the magazine would publish many new poems by French and Italian writers.

Sonia Terk (who would marry Robert Delaunay in 1910) arrived in Paris and enrolled at the La Palette Academy.

Publication of *La Nuova Arma: la macchina* (Turin, Bocca) by Mario Morasso, a contributor to *Poesia*.

1 A. Mercereau (1884–1945), poet and writer. As French representative of the Russian magazine *Zolotoe runo* [The Golden Fleece], he took part in selecting French artists to apppear in Russian exhibitions.

2 F. Olivier, *Picasso et ses amis*, (Paris: Stock, 1973).

The Abbaye de Créteil studio.
In the foreground: Albert Gleizes. Far right, standing:
Charles Vildrac; partly hidden: Georges Duhamel.
In the background, from left to right:
Henri-Martin Barzun, Alexandre Mercereau
(who joined the group in 1907), René Arcos
and the typographer Lucien Linard, who taught
the printer's trade to the "abbots"

Manuscript of the *Manifesto of Futurism* (1908)
by Filippo Tommaso Marinetti, on
"Grand Hôtel – Paris" headed notepaper;
this was where the Italian poet wrote the prologue
to the *Manifesto*

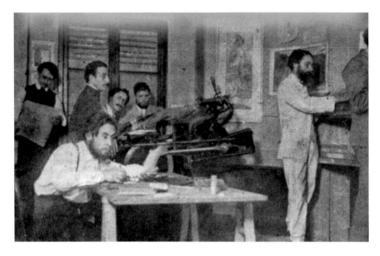

1906

1 April–27 August: Boccioni left Rome for Paris, and then went on to Russia. He returned by way of Warsaw and Vienna.

October: Severini set up home in Paris at 36 rue Ballu, near the Place Clichy. At *Le Lapin Agile*, which attracted young Montmartre painters and poets, he met Max Jacob and André Salmon, among others.

Autumn: Creation of the Abbaye de Créteil group (37, rue du Moulin) by René Arcos, Albert Gleizes, Charles Vildrac, Georges Duhamel, Henri-Martin Barzun, Berthold Man and Jacques d'Otémar. This was a truly tight-knit association, which held meetings with "a few young writers, poets, painters, draughtsmen and musicians, all deeply devoted to their art … Far from excessive utilitarianism and appetites, they founded their abbey …, unfettered and retaining all their individualism, united in their enthusiasm, pooling their needs and their resources."[3] "In order to swell the resources of their respective art, they are creating and using in their abbey … art publishing and a lithographic and typographic printing shop (Lucien Linard) where they themselves ply the trade."[4]

The place was visited by many artistic figures: Paul Castiaux, Jacob, Pierre Jean Jouve, Mercereau, Marinetti, Metzinger, the "mathematician" Maurice Princet, Valentine de Saint-Point, Jules Romains, etc.

Soffici struck up a friendship with Apollinaire: "For a long time we talked about ourselves and our preoccupations. He talked ironically and bitterly about the difficulties of his—our—lives as poets and artists, immersed in the "crowded" solitude of Paris … That was when our real friendship began."[5]

October: Mikhail Larionov discovered Paris; with Natalia Goncharova, he took part in the exhibition of Russian art organised by Serge Diaghilev as part of the Salon d'Automne.

Metzinger made the acquaintance of Robert Delaunay.

Representing the Russian art magazine *Zolotoe runo* [The Golden Fleece], Mercereau went to Russia. Throughout 1906, many Russian artists visited the studios of Paris-based painters.

1907

Braque and Picasso met—probably for the first time—at the Salon des Indépendants. In the spring, Picasso worked on *Les Demoiselles d'Avignon* (The Museum of Modern Art, New York) which Soffici was fortunate in seeing in the painter's studio.

Autumn: after a stay in Italy, Severini moved into a studio on the rue de Turgot in Paris. Aurélien Lugné Poe, director of the Théâtre de L'Œuvre where he had the run of the place, introduced him to Félix Fénéon, an art critic in charge of the contemporary art section at the Galerie Bernheim-Jeune.

1–22 October: the Salon d'Automne was held in Paris, with a retrospective of Paul Cézanne's work. There, Braque showed a first version of his *Viaduct at L'Estaque* (Minneapolis Museum). November: Braque visited Picasso's studio and discovered *Les Demoiselles d'Avignon* and *Nude with Drapery* (1907, Hermitage Museum, St. Petersburg). He started work on the *Large Nude*, which he finished in 1908 (cat. 6).

Winter: Braque returned to L'Estaque and abandoned the stridency of his Fauvist palette for a schematic treatment of the composition and simplified motifs.

Alexandra Exter embarked on life in Paris. She enrolled at the Academy of La Grande Chaumière, met Bergson who had just published *Creative Evolution* and Apollinaire through Férat. In that same period, Metzinger was introduced by Max Jacob to the clutch of Cubists gravitating around Picasso: Braque, Salmon, Apollinaire, etc..

25 December 1907–15 January 1908: The exhibition *Stephanos. Venok* [The Crown] was held in Moscow, organised by Mikhail Larionov and David and Vladimir Burliuk, an event which was linked with the first attempt at an foreward-looking stance, as illustrated by the participation of many future members of the Russian avant-garde.

1908

In Paris, Severini showed his work at the Salon des Indépendants and the Salon d'Automne.

18 April–24 May: in Moscow, the first Golden Fleece show juxtaposed Russian and French artists, the latter selected by Mercereau and including Braque, Cézanne, Gleizes, Henri Le Fauconnier, Henri Matisse and Metzinger.

30 May: in Paris, Marinetti gave a lecture on poetry.

June: in the Milanese suburbs, Marinetti had an accident in his 4-cylinder Fiat: the episode was described in the prologue to the *Manifesto of Futurism*: "I stopped short and to my disgust rolled over into a ditch with my wheels in the air … O maternal ditch, almost half full of muddy water! Fair factory drain! I gulped down your nourishing sludge; and I remembered the blessed black breast of my Sudanese nurse."[6]

Summer: at L'Estaque, Braque painted landscapes, including *Viaduct at L'Estaque* (cat. 4).

October: Marinetti decided to found an avant-garde movement, forerunner of Art-Action.

In Paris, the members of the Salon d'Automne jury refused almost all the works submitted by Braque, who duly decided to withdraw the whole lot. The art dealer and patron Daniel-Henry Kahnweiler organised a show of Braque's recent works from 9–28 November in his gallery at 28 rue Vignon, with the catalogue's preface written by Apollinaire. The critics were up in arms: "[Braque] proceeds from an a priori geometry to which he subjects all his field of vision, and he aims at rendering the whole of nature by the combinations of a small number of absolute forms."[7]

November: in Florence, founding of the magazine *La Voce,* edited by Giuseppe Prezzolini,[8] with the first issue coming out on 20 December; Soffici and Giovanni Papini were regular contributors.

2–30 November: in Kiev, the Burliuk brothers and Exter organised the exhibition *Zveno* [The Link], which travelled from St. Petersburg to Ekaterinoslav. For this first showing of the Russian avant-garde, David Burliuk published an essay, "The Way of Impressionism for the Defence of Painting".

7 December: Marinetti gave a lecture on D'Annunzio at the People's University in Trieste. He finished writing the *Manifesto of Futurism*, distribution of which was delayed because of the national mourning decreed after the Messina earthquake which occurred on 28 December.

In Montmartre, at 13 rue de Ravignan, the Bateau-Lavoir group was formed, composed of artists and art-lovers including not only Braque and Picasso, but Apollinaire, Kahnweiler, Juan Gris, Jacob, Marie Laurencin, Salmon, Princet and Maurice Raynal, as well as Gertrude and Leo Stein.

A special relationship developed between Braque and Picasso: "Almost every evening, either I went to Braque's studio or Braque came to mine. Each of us had to see what the other had done during the day. We criticised each other's work,"[9] Picasso would tell Françoise Gilot, at a later date.

In Milan, Carrà met with the painters Boccioni, Aroldo Bonzagni, and Romolo Romani.

Publication of *La Vie unanime* [The Unanimist Life] by Jules Romains (published by the Abbaye de Créteil), Georges Sorel's *Réflexions sur la violence* [Reflections on Violence], Lucini's *Ragion e programma del verso libero* [Reason and programme of vers libre] and two books by Marinetti, *Les Dieux s'en vont. D'Annunzio reste* [The Gods Depart. D'Annunzio Remains] (Paris, Sansot), and *La Ville charnelle* [The Carnal City] (Paris, Sansot).

3 "Statuts de l'association", article 1, *Les Cahiers de l'Abbaye de Créteil* (Créteil), no. 25: "L'abbaye de Créteil et ses prolongements", December 2006, p. 14.

4 Ibid, article 2, p. 17. Fourteen books would be published by the Éditions de l'Abbaye, including *La Vie unanime* by Jules Romains. The Abbaye closed up shop on 28 January 1908.

5 A. Soffici, *Opere,* (Florence: Vallecchi, vol. 6, 1959–68), pp. 230–31.

6 F. T. Marinetti, *Manifeste du futurisme* (20 February 1909) ; trans. in Apollonio (ed.), *Futurist Manifestos*, (London: Thames and Hudson, 1973 and 2001), p. 20–21.

7 C. Morice, "Exposition Braque (galerie Kahnweiler, 28, rue Vignon)", "Art moderne" section, *Mercure de France* (Paris), 16 December 1908; trans. in Fry, *Cubism*, (London: Thames and Hudson, 1966, p. 52.

8 Magazine edited by Giuseppe Prezzolini (from December 1908 to December 1914), then by Giuseppe De Robertis (until December 1916).

9 F. Gilot, *Vivre avec Picasso,* (Paris: Calmann-Lévy, 1965), p. 88; trans. as *Life with Picasso,* (New York: McGraw Hill, 1964), p. 76.

312

Cover of the magazine *Poesia* (Milan) edited
by F. T. Marinetti, no. 3–4–5–6, April–July 1909:
"Il Futurismo". Issue containing a report on:
"Futurism and the international press".

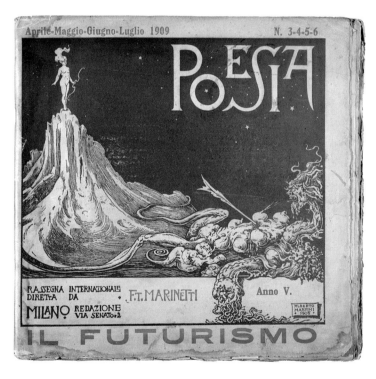

1909

January–February: from Milan, Marinetti sent
the tract-like first version of the *Manifesto of
Futurism* to Italian and foreign newspapers. On
5 February it was headline news in the
Bolognese paper the *Gazzeta dell'Emilia*; on
the 9th it appeared in the daily *Gazzeta di
Mantova*, on the 9th and 10th in the Verona
paper *L'Arena*, and on the 14th in the Neapolitan
literary review *Tavola rotunda*.

11 January–15 February: the 2nd Franco-
Russian Golden Fleece show was held in
Moscow, a less comprehensive show than the
1908 one; the French contribution emphasised
the Fauves.

15 January: at the Teatro Alfieri in Turin,
Marinetti's play *La Donna è mobile* [revised title
of *The Electric Dolls*] was staged for the first
time and stirred up quite a hostile reaction from
the public.

Mid-February: at the Grand Hotel in Paris, the
leader of Futurism wrote the prologue to the
manifesto.

20 February: publication on the front page of
Le Figaro of Marinetti's *Manifesto of Futurism*,
complete with the prologue.[10] "Literature hav-
ing hitherto magnified pensive immobility,
ecstasy and slumber, we want to glorify
aggressive movement, feverish insomnia, the
gymnastic stride, the mid-air somersault, the
slap and the punch. We declare that the splen-
dour of the world is enriched by a new beauty.
The beauty of speed … We will celebrate the
great crowds jostled by work, pleasure and
revolt; the multicoloured and polyphonic back-
wash of revolutions in modern capitals; the
nocturnal vibration of arsenals and construc-
tion sites beneath their violent electric moons;
voracious smoking serpent swallower stations;
factories suspended from clouds by the strings
of their smoke; bridges with the gymnast's
spring thrown across the diabolical cutlery

Letter of Marinetti attached to the *Manifeste du futurisme*, 1909, on headed notepaper from the Edizioni futuriste di *Poesia*. Giovanni Lista Archives, Paris

"After a Large Futurist Assembly", drawing by Manca published in the newspaper *Pasquino* (Turin), then reprinted in the magazine *Poesia* (Milan), no. 7–8–9, August–October 1909

Cover of F. T. Marinetti's 'African novel', *Mafarka le futuriste*, Paris, Éditions Sansot, 1910

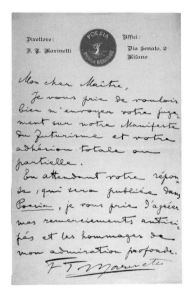

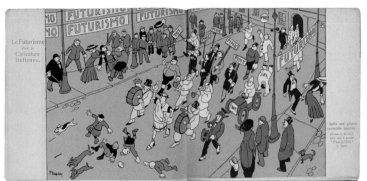

works of sunny rivers, adventurous steamships sniffing the horizon; locomotives with their great chests, champing on the tracks, like huge steel steeds bridled with long pipes, and the slithering flight of aeroplanes, whose propellers make sounds of flapping flags and clapping from an enthusiastic throng."[11]

March: the Toulouse-based magazine *Poésie* published the *Manifesto of Primitivism*, accompanied by a survey on the way the *Manifesto of Futurism* was being received.

8 March: excerpts from the *Manifesto of Futurism* appeared in the Russian daily *Večer* [The Evening].

March–April: in St. Petersburg, the Burliuk brothers (David, Nicolas and Vladimir) organised the exhibition *Venok* [The Crown].

25 March–2 May: Braque, Delaunay, Marcel Duchamp and Raymond Duchamp-Villon, among others, showed their works at the Salon des Indépendants. In the 25th May issue of *Gil Blas*, Louis Vauxcelles spoke out against Braque's "cubic oddities".

3 April: in Paris, first staging of *Le Roi Bombance* at the Théâtre de l'Œuvre, but the public reacted no better than they had at Marinetti's previous play: "Here we are back to the heroic days. The spectacle at the Œuvre reminds us of the tumultuous evenings of *Ubu Roi* and *Pan*. *Le Roi Bombance* was received in various ways; there was as much acting in the auditorium as on stage. There were a few whistles and some frenzied applause. Marinetti has been reproached above all for his crude language, overlooking the fact that Rabelais, if adapted for the stage, would have been every bit as extraordinary. In a word—and despite everything—the play is not and cannot be met with indifference."[12]

17 April: at the Parc des Princes, the leader of Futurism duelled with Charles-Henry Hirsch who had made one or two criticisms about *Le Roi Bombance*.

Before making his first trip to London, he launched his proclamation *Let Us Kill the Moonlight!*[13]

Goncharova made a statement to the press, in which she made known her enthusiasm for French artists, in particular Le Fauconnier, Braque and Picasso.[14]

At Viggiù, Marinetti wrote the preface for *Mafarka the Futurist. An African Novel*, in which he urged painters to join his movement: "O my brother Futurists! All of you, look at yourselves! … In the name of that Human Pride we so adore, I proclaim that the hour is nigh when men with broad temples and steel chins will give birth magnificently, with a single thrust of their bulging will, to giants with flawless gestures."[15]

Soffici published, at his own expense, *Medardo Rosso proceduto de l'impressionismo e la pittura italiana*.

Summer: Braque stayed at La Roche-Guyon, on the banks of the Seine; his range of colours became more limited (greens, greys and ochres) and his forms more and more geometric. Picasso, for his part, spent several weeks at Horta de Ebro, where he painted landscapes and portraits of his partner Fernande (see *Head of a Woman (Fernande)*, 1909, cat. 14).

1 October–8 November: Boccioni and Balla exhibited in a section of the Salon d'Automne devoted to Italian art, but their works, in particular Balla's, drew reservations from Apollinaire: "Doesn't this committee think it has betrayed the interest of French art … by authorising the grotesque display of Italian painters to take possession of five or six rooms … It's disgraceful … Perhaps these pitiful aeroplane flights are a manifestation of Futurism … Italian art or not, none of it should have been allowed."[16]

From November on: the patron Sergei Shchukine opened his collection to the Moscow public, thus affording Russian artists a view of the works of the French painters.

4 December 1909–24 February 1910: the First Izdebski International Salon opened in Odessa; it showed 776 items and travelled (until July 1910) to Kiev, St. Petersburg and Riga. (Participants included Pierre Bonnard, Braque, Balla, Gleizes, Goncharova, Alexei Jawlensky, Wassily Kandinsky, Larionov, Mikhail Matiushin, Paul Signac, Le Fauconnier and Exter).

27 December 1909–31 January 1910: in Moscow, the 3rd and last *Golden Fleece* show, an exclusively Russian exhibition, introduced the public to popular and contemporary artworks.

At *La Closerie des Lilas*, Severini met many poets and artists, in particular Paul Fort, whose daughter Jeanne he would marry on 28 August 1913.

From 1909 onward, Picasso and Braque no longer featured in the French Salons (until 1919 in Picasso's case and 1920 in Braque's). Publication of *Les Poupées électriques* [The Electric Dolls] (Paris, Sansot), *Mafarka le futuriste. Roman africain* [Mafarka the Futurist. An African Novel] (Paris, Sansot), and *The International Survey on Free Verse* (Milan, *Poesia* publications), all by Marinetti.

10 The magazine *Poesia* published the Italian version dated 11 February 1909 (no. 1–2, February–March 1909). The following issue printed excerpts of reports appearing in the international press. Between 1909 and 1912, it would be translated in many languages.

11 Quoted in G. Lista, *Futurisme. Manifestes…*, op. cit., p. 87.

12 Casella, "La vie au théâtre: *Le Roi Bombance*", *L'Intransigeant* (Paris), 4 April 1909.

13 This proclamation, "réponse aux insultes dont la vieille Europe a gratifié le 'Futurisme'", was published in French in issues 7, 8 and 9 of *Poesia* (August to October 1909), then as a broadsheet in Italian and French inserted in the following issues. Its German version appeared in Berlin in issues 111 and 112 of *Der Sturm* (May and June 1912), where it was presented as a "second Futurist manifesto".

14 See "Besseda s N. S. Goncharovoi" ["Discussion with N.S. Goncharova"], *Stoličnayaâ molvâ*, [Rumours of the Capital], no. 115, 5 April 1910, p. 3.

15 F. T. Marinetti, *Mafarka le futuriste. Roman africain* (1909–10), (Paris: Christian Bourgois, 1984), p. 17.

16 G. Apollinaire, "Le Salon d'automne", *Le Journal du soir* (Paris), 20 September 1909; id., *Écrits sur l'art, OC*, (Paris: Gallimard, "Bibliothèque de La Pléiade", vol. 2, 1991), pp. 117–18.

Umberto Boccioni, cartoon of the Futurist evening of 18 March 1910 at the Politeama Chiarella in Turin. On stage: Carlo Carrà, Armando Mazza, F. T. Marinetti and Umberto Boccioni. Giovanni Lista Archives, Paris

The Futurist poets and painters, F. T. Marinetti et al., *Venise Futuriste*, a manifesto scattered from the top of the Piazza San Marco, April 1910

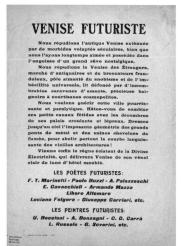

1910

12 January: the first "Futurist Evening"[17] at the Politeama Rossetti in Trieste, during which the public made spirited protests: "The beginning is extremely violent … Marinetti asserts his determination to free the living from the dead, his determination to undertake a relentless struggle so that scores of poets, painters, musicians, and sculptors of our day and age … can rid themselves once and for all from the cult of the past and of those consecrated, relentlessly-consecrated glories to which mankind entirely devotes itself with idle misoneism."[18]

24 January: Soffici and Picasso begin corresponding.

Late January (or early February): Marinetti, then in Milan, gets in touch with Boccioni, Carrà and Russolo[19] and exhorts them to write a manifesto of Futurist painters. The painters Bonzagni and Romani were initially included in the project, but before long backed out; they were replaced by Severini (living in Paris) and Balla (settled in Rome), who joined the group in April.

Two years later, Apollinaire would go back over those stormy beginnings: "The only Futurists there from the very beginning were Messrs. Boccioni, Carrà and Russolo. They alone appeared on 8 March 1910—a date which would become famous if Futurism were to become a major literary and artistic movement—on the stage of the Chiarella in Turin. [20] That was the third Futurist evening … The leading Futurists made their appearance alongside Mr. Marinetti, namely Messrs. Boccioni, Carrà, Bonzagni, Russolo and Romani. Together, they read their manifesto which, according to the releases was 'a long cry of revolt against academic art, against museums, against the reign of professors, archaeologists, bric-à-brac traders and antique dealers', and a huge uproar was immediately unleashed in the auditorium.

People fought with fists and sticks, the police intervened, etc. As of that day, the Futurists painters lost two of their own. Who will ever tell us what happened to Messrs. Bonzagni and Romani? [They] have been replaced by Balla and Severini. It is they who signed the manifesto which, filled with impoverished anti-plastic ideas, may nevertheless, through its violence, be regarded as a stimulant, good for the weakened senses of the Italians."[21]

11 February: publication of the *Manifesto dei pittori futuristi*[22], in the form of a tract.

February: at the bidding of Prezzolini, Soffici went to Paris to select some Impressionists works for an exhibition organised by *La Voce*—it would open on 20 April at the Lyceum in Florence, with a whole room devoted to Medardo Rosso. During that visit to Paris, he spent time with Picasso, Braque and Max Jacob.

3 March: the Berlin magazine *Der Sturm*, founded by Herwarth Walden and devoted to literature and the fine arts, brought out its first issue.

March–April: Boccioni, Bonzagni, Carrà and Russolo exhibited in Milan, at the Famiglia Artistica. The *Manifesto of Futurist Painters* described this exhibition as a "brilliant event": "At last! The Futurists are revolutionising Italy. D'Annunzio has been converted: the Salon of Futurist Painters has just opened in Milan; in the major cities, Mr. F. T. Marinetti and his friends have embarked on a series of Futurist evenings. In Trieste, Milan and Turin people are struck with sticks and canes. And they will be again in Rome, Florence, Naples, and Palermo. Long live Futurism! Long live Marinetti!"[23]

At the same time, in St. Petersburg, there opened the first exhibition of a secession (created by Matiushin and his wife Elena Guro) called *Soûz molodiëži* [Union of Youth]. It featured, among others, Goncharova, Pavel Filonov, Larionov and Olga Rozanova. The

exhibition then moved to Riga with different artists.

In the early spring, Marinetti undertook a round of lectures—in French in London. The first was given in the Lyceum Club for Women in Piccadilly before a gathering of women, which Wyndham Lewis apparently infiltrated. On 2 April, Marinetti delivered his *Futurist Speech to the English*, in which he paid tribute to those who "welcome with open arms individualists from every country, be they libertarian or anarchists", but he spoke out against their prudishness.

18 March–1 May: in Paris, for the first time, the Salon des Indépendants showed works of Cubist inspiration. Exhibitors included Delaunay, Duchamp, Duchamp-Villon, Gleizes, Le Fauconnier, Léger, Metzinger, and Severini. Spring: Braque and Picasso produced ever more abstract still lifes; the latter also finished several highly-structured portraits of his dealers and gallery owners, including the *Portrait of Daniel-Henry Kahnweiler* (cat. 13). Delaunay and Fernand Léger met.

April–May: In Florence, at the Lyceum Club, Soffici staged the exhibition *Prima mostra italiana dell' Impressionismo* [First Italian Show of Impressionism]".

11 April: publication in tract form of the *Manifesto of Futurist Painters*, jointly signed by Boccioni, Carrà, Russolo, Balla and Severini[24]: "Our growing need for truth can no longer be content with Form and Colour as they have hitherto been understood. The gesture that we wish to reproduce will no longer be a fixed split second of universal dynamism. It will simply be the dynamic sensation itself. In fact, everything is moving, everything is running, everything is swiftly changing. [...] Given the persistence of the image in the retina, objects in motion are increasing in number, changing shape, by pursuing one another, like hasty vibrations, in

André Warnod, *Venise Futuriste*, *Comœdia* (Paris), 17 June 1910, p. 3. A longer variant of the text printed in the tract

Manifeste des Peintres futuristes, illustrated with cartoons by André Warnod, published in *Comœdia* (Paris), 18 May 1910, p. 3

17 The Futurist evening was a kind of Futurist theatre-tribune-spectacle, with the exhibition of Futurist works which Marinetti described as "crazy electric storms … geometrised by punches, with their corollary of scuffles in streets and squares, [which] glorified the idea of a greater, faster Italy".
See G. Lista, *F.T. Marinetti. L'anarchiste du futurisme. Biographie*, (Paris: Éd. Séguier, 1995), p. 121.
18 *Il Piccolo* (Trieste), 13 Oct. 1910, see ibid., p. 120.
19 In an interview with Édouard Roditi (*Propos sur l'art*, Paris, Librairie José Corti, 1987, p. 30), Carrà wrongly placed this encounter in 1909: "It was in 1909 that Boccioni, Russolo and I met Marinetti for the first time. … At that first meeting we devoted several hours to discussions about the hopeless state of Italian painting, and we swiftly agreed that we would publish a manifesto."
20 The evening was described as a "veritable Hernani battle".
21 G. Apollinaire, "Les Futuristes", "Chronique d'art" column, *Le Petit Bleu* (Paris), 9 Feb. 1912; *Écrits sur l'art*, op. cit., pp. 408–409.
22 The *Manifesto of Futurist Painters* was printed by Marinetti immediately after Romani's defection—he quit the group in March—but prior to Balla's joining it in April. The original edition of the text bore just the signatures of Boccioni, Bonzagni, Carrà, Russolo and Severini (the manifesto was read by Boccioni on 20 April 1910 at the Mercadante Theatre in Naples, a Futurist soirée which coincided with the new defection of Bonzagni, alarmed by the violence accompanying the Futurist protest).
23 Les Treize, [untitled], *L'Intransigeant*, 29 March 1910.
24 This manifesto is the translation of the *Manifesto tecnico della pittura futurista* of 11 April 1910 with the addition of the final declarations of the *Manifesto dei pittori futuristi* of 11 February 1910, whose title it took. It was briefly reported on in *L'Intransigeant* of 17 May and was published on the 18th in *Comœdia* (Paris), accompanied by cartoons by André Warnod: "With fine ardour they [the Futurist painters] annihilate everything that represents the art of today and shower opprobrium on the modern schools … But they are not content just to destroy, they, too, want to construct, and the few principles they put forward to steer future art will definitely revolutionise the world of painters". Quoted in G. Lista, *Futurisme. Manifestes, proclamations, documents*, op. cit., p. 166. It was published in German in *Der Sturm* (Berlin), no. 103, March 1912, in Russian in *Soûz molodëzi*, (St. Petersburg), no. 2, June 1912, and in English in *The Academy* (London), 30 November 1912.

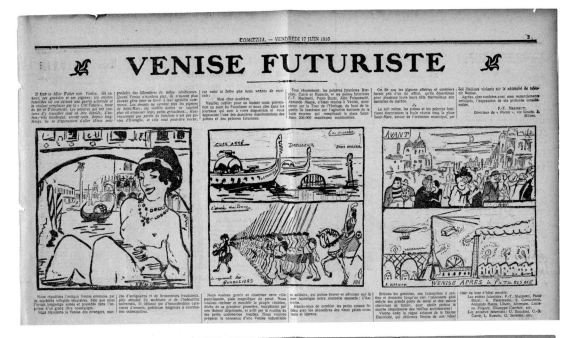

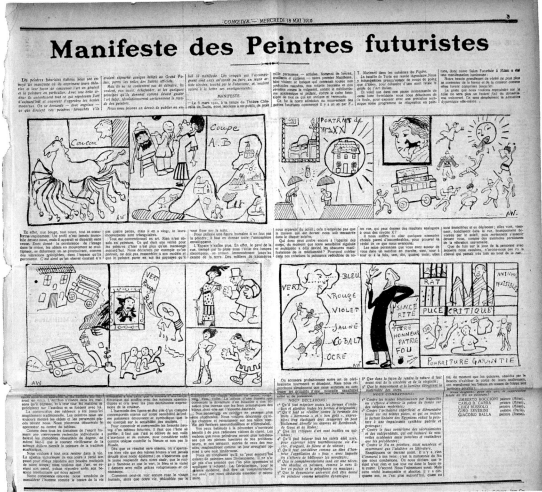

Postcard sent by Guillaume Apollinaire
to F. T. Marinetti on 24 August 1910 (both sides)

the space they cross. And thus a cantering horse does not have four legs, but twenty, and their movements are triangular."[25]

The publication of this manifesto certainly interested the Russian painters: "We have recently managed to read the manifesto of the Italian *pittori futuristi* who are struggling for the 'destruction of all artistic norms and standards' in the name of what they call cinematographic 'truth' … It seems undeniable to us that this 'Futurist' way, which leads to contemporary deformism, leads furthermore to a complete transformation, and that, alongside … the work of these 'lunatics' who have declared war on all continuity based on the stylistic norms of bygone centuries, the canvases of Matisse and Picasso seem very outdated."[26]

20 April: Futurist soirée at the Mercadante Theatre in Naples.

27 April: Marinetti published *Contre Venise passéiste* [Against Backward-Looking Venice], an essay signed jointly by the Futurist painters and poets.[27] It was launched on 8 July, with thousands of copies scattered from the top of the Clock Tower.

April: Soffici made the acquaintance of Bergson who, in his *Journal*, painted the following portrait: "Soffici is tall and thin, face clean-shaven, long, with a shrewd look, much more outward-going and talkative than Prezzolini, and livelier; but a devilish theoretician, aesthetician, and seeker after reasons for clashes of both feeling and art."

11–18 May: *A Trap for Judges I*, the first co-production to involve both the Moscow avant-garde and the St. Petersburg avant-garde, satisfied the censors (St. Petersburg, La Grue). The Russian Futurists regarded this compilation, to which the Burliuk brothers, Elena Guro, Vassily Kamiensky and Velimir Khlebnikov contributed, as their first manifesto. A second volume of *A Trap for Judges* would be published

in 1913 (with the help of Goncharova and Larionov).

19 May: in *La Voce* (2nd year, no. 23) there appeared an article by Soffici, "Riposta ai futuristi" [Reply to the Futurists], in which the Futurists were called "clowns plastered with white and red lead".

June: Marinetti published his *Proclama futurista a los Españoles*.

June–July: at the Labour Exchange in Naples, the Chamber of Unionised Labour in Parma and the Revolutionary Hall in Milan, Marinetti gave a lecture, "Necessity and Beauty of Violence", advocating once again the creation of a united revolutionary front between avant-garde artists and anarcho-syndicalists.

September: Boccioni exhibited forty pictures at the Ca' Pesaro in Venice: the catalogue had a preface by Marinetti. Soffici visited it, then confessed to Prezzolini: "In Venice, I met Serge [Férat] and his sister [Hélène]. I saw the exhibition [the Biennale] as well as the show of the Futurist Boccioni [Ca' Pesaro]. Stupid, very mediocre, and not at all Futurist. Am seeing nothing and I'm bored."[28]

13 June–8 August: in Riga, exhibition of the Union of Youth, considered as a travelling version of the previous show (the one held in March–April 1910), despite a different list of works; among the new exhibitors were Exter and David and Vladimir Burliuk.

Summer: Larionov and Khlebnikov stayed at the Burliuks' property (Tchernianka), cradle of Russian Futurism, located in the province of Tauride (Herodotus' Hylea) in the Ukraine.

1 August: Futurist evening at the La Fenice theatre in Venice, during which Marinetti read his *Futurist Speech to the Venetians*. The editorial board of the magazine *Poesia* published a report: "The battle between Futurists and Devotees of the past was terrible. The former were whistled at, the latter pummelled; the

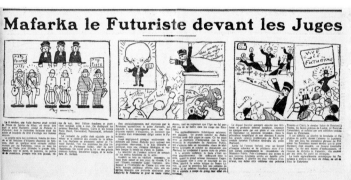

speech was heard all the way through despite the hubbub—The Futurist painters Boccioni, Russolo and Carrà punctuated it with loud slaps. The punches of Armando Mazza, a Futurist poet who is also an athlete, were unforgettable."[29]

August: English translations of the manifesto *Against Backward-Looking Venice* and excerpts from the *Manifesto of Futurism* published in *The Tramp: An Open Air Magazine*.

Summer: Severini stayed in Milan, where he met Carrà and Russolo.

20–30 September: Boccioni, Carrà and Russolo exhibited at *L'Esposizione intima* at the Famiglia Artistica, Milan.

September: Marinetti joined the Italian Avant-Garde Association, future hub of Italian nationalism.

1 October–8 November: in Paris, Duchamp, Duchamp-Villon, Gleizes, Le Fauconnier, Léger, Metzinger and Francis Picabia took part in the Salon d'Automne.

8 October: in Milan, conclusion of Marinetti's trial, which had been going on since April and which he had turned into a public platform. He had been accused of "affront to public decency" after the publication in Italian of *Mafarka the Futurist*.

October–November: publication in *Pan*, an avant-garde art review (Paris, 3rd year, no. 10) of a "Note on Painting" by Metzinger, one of the first artists to theorise about the foundations of Cubism.

8 November 1910–15 January 1911: in London, at the Grafton Galleries, the critic Roger Fry organised the exhibition *Manet and the Post-Impressionists*. It was visited by Edward Wadsworth and David Bomberg. On that occasion, Marinetti once again stayed in London.

10 December 1910–January 1911: Moscow saw its first *Bubnovyj* [Knave of Diamonds]

exhibition, although the association of artists with the same name was not created until late 1911. This exhibition of "Leftist painters", whose eyes were riveted on the very latest western artworks, unleashed passions. The Burliuk brothers, Exter, Goncharova, Kandinsky, Larionov and Malevich[30] were represented, as well as French painters Gleizes, Le Fauconnier and Metzinger, whose works were selected by Mercereau. Kazimir Malevich met Goncharova and Larionov there.

December: at the Lyceum Club for Women in London's Piccadilly, Marinetti gave a lecture entitled "Futurism and Woman".

End of the year: Severini industriously frequented Parisian cafés and cabarets (the *Moulin de la Galette*, the *Moulin Rouge*, the *Bal Tabarin*, the *Monico*) and dance became one of his favourite subjects. He visited Picasso in his boulevard de Clichy studio, where he met Apollinaire.

Winter: in Paris, French painters, poets and art critics who shared Cubist aesthetics gathered in Le Fauconnier's studio on the rue Visconti and at the *Closerie des Lilas*. Among them were Apollinaire, Arcos, the Delaunays, Fort, Gleizes, Jouve, Léger, Metzinger, Mercereau and André Salmon.

Late 1910–early 1911: Picabia made the acquaintance of Duchamp.

At the Kahnweiler Gallery, Léger met Picasso and Braque.

Opening in Paris of the Vassilieff Academy, at 54 avenue du Maine, home to the community of Russian artists in Paris.

25 U. Boccioni et al., *Manifeste des peintres futuristes*; G. Lista, *Futurismes…*, op. cit., p. 163.

26 S. Makovski, "Hudožestvennye itogi" ["Artistic Reports"], *Apollon* (St. Petersburg), 10, 1910, pp. 27–28; quoted in C. Douglas, "Cubisme français / cubo-futurisme russe", *Les Cahiers du Musée national d'art moderne* (Paris), no. 2, Oct.–Dec. 1979, p. 187.

27 Publication in *Comœdia* of 17 June 1910, with cartoons by Warnod ("Venice and Futurism"). There are several variants of this tract.

28 A. Soffici, Letter to Prezzolini, 19 September 1910; quoted in *Soffici, immagini e documenti (1879–1964)*, (catalogue raisonné), (Florence: Vallecchi Editore, 1986), p. 105.

29 Quoted in G. Lista, *Futurisme. Manifestes…*, op. cit., p. 112.

30 According to Malevich, "the knave signifies youth, the diamond, colour".

From left to right: Jacques Villon, Raymond Duchamp-Villon and Marcel Duchamp in front of the Puteaux studio (rue Lemaître), ca. 1910–15

František Kupka preparing a canvas in his garden at Puteaux, ca. 1910–15

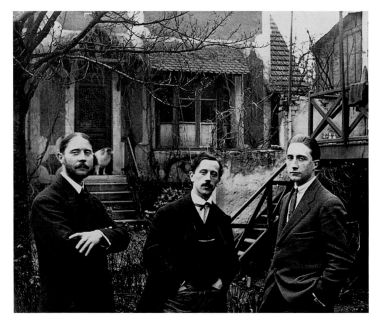

1911

The year 1911 saw the formation of the Puteaux group, which met on Sundays at n. 7 rue Lemaître, in the studio shared by the Duchamp brothers, and on Tuesdays at the evenings organised by Gleizes in his Courbevoie studio. Apart from the Duchamp brothers and Gleizes were Gris, La Fresnaye, Le Fauconnier, František Kupka, Léger, Metzinger, and Picabia; Apollinaire and Walter Pach sometimes joined them. These artists were at the origin of a Cubism that differed from its Montmartre version. In October 1912 they organised the Salon de la Section d'or. Nevertheless, neither Braque nor Picasso attended those meetings, or those held at the *Closerie des Lilas*.

9 February: in Paris, at the *Le Globe* café, Marinetti was summoned as representative of the Futurist movement to the banquet in honour of Paul Fort.

11 February: publication in the review *Poesia* of the *Manifesto of Futurist Playwrights*, signed by Marinetti.

January–March: in Odessa, the 2nd Izdebsky International Show was held. Participants included the Burliuk brothers, Goncharova, Kandinsky, Larionov, Vladimir Tatlin and Georgy Yakulov.

2 March: a stormy Futurist action at the La Scala theatre in Milan; Marinetti launched his manifesto *Against La Scala: Pompeii of Italian Theatre*.

9 March: in Paris, Marinetti gave a lecture on Futurism at the Maison des étudiants.[31]

11 March–May: Soffici stayed in Paris, where he regularly saw Picasso and Apollinaire.

14 March: interview with Marinetti on Futurism, published in *Le Temps*.

March–April: Futurist evenings at the Bonaccosi theatre in Ferrara (25 March), in Mantua, and in Parma—those planned for the

Reinach theatre from 26–28 March were banned, which sparked violent student demonstrations at the university, where Marinetti was arrested—as well as in Como.

Mid-April–13 May: in St. Petersburg, *2nd Exhibition of the Union of Youth*. In the press there was already talk of a secession within the Knave of Diamonds. In disagreement with this movement which he deemed too "Cézannian", Larionov, together with Goncharova, Malevich and Tatlin, founded the Oslinnyj Hvost [The Donkey's Tail] group in Moscow, which was closer to vernacular art.

21 April–13 June: in Paris, the Salon des Indépendants was held, the first major group show—and a spectacular one at that—of the Cubists, all on view in Room 41: Duchamp, Duchamp-Villon, Gleizes (*Portrait of Jacques Nayral*, cat. 19) and *The Hunt*, Kupka, Metzinger (*Teatime*, see cat. 16), Léger (including his *Nudes in the Forest*, 1909–11, cat. 18), Picabia, and Jacques Villon. Exter visited it. The critic Gabriel Mourey lamented "their novelty, which is the return to primitive savagery and barbarism, consisting in an ignorance and debasement of all the beauties of nature and life", and attacked the artists "upon whom the snobbery of critics and art-lovers, the so-called avant-garde, weave crowns and are already erecting statues."[32]

Apollinaire, for his part, saw in these artists the promoters of a novel art: "Here, however, we find with more force than anywhere else … the sign of the times, the modern style … At this moment, an art is forming that is spare and sober, whose at times still rigid appearances will not take long to become humanised. We shall at a later date discuss the influence wielded by the works of an artist like Picasso in the development of such a novel art."[33]

Roger Allard was especially full of praise: "That painting, of all the arts, is currently occupying,

on the ideal graph of evolution, the most forward point, is in no doubt, for any impartial observer with an inquiring mind … Without committing any injustice, as far as influences are concerned, I could fail to mention Pablo Picasso and Braque. The violent personality of one of those two lies decidedly outside French tradition, and the painters [Robert Delaunay, Gleizes, Le Fauconnier, Léger, Metzinger] with whom I am here concerned have instinctively sensed as much … It was all the more necessary, in this instance, to immediately express my feeling that I think it is possible to detect elsewhere the omens of a happy reversal of aesthetic values. The advent of a new canon is thus an eventuality which it behoves us to imagine with the most attentive sympathy. The old-fashioned advocates of individualism will be greatly shocked—and so they should be—to see a *group* being so powerfully formed, in the grip of an attraction leading towards this same ideal: *Reacting with violence against the instant notation, the insidious anecdote and all the substitutes for Impressionism*."[34]

This Salon had an undeniable effect on Paris-based Russian artists and critics: "Delaunay, Léger, Gleizes and Le Fauconnier, who have turned towards original and primitive architecturality, chisel in different ways and create landscapes and people. Their compositions call to mind geometric bodies and twisted stone columns."[35]

If we are to believe observers, the Russian painters, "in most cases cling to the new trends in present-day painting which for them is, because of its colourful and purely pictorial goals, an extremely rich book in which they can find treasures. The Russians are the most gifted pupils of the new prophets in painting."[36]

April: after Severini visited the Salon, he wrote to Boccioni about Braque and Picasso. "The subjects and colours of these artists scarcely vary …

Cartoon by Umberto Boccioni depicting a Futurist evening in Milan in June 1911.
From left to right: Umberto Boccioni, Balilla Pratella, F. T. Marinetti, Carlo Carrà and Luigi Russolo

Cover of the book *Le Futurisme*
(Paris, Éditions Sansot, 1911) by F. T. Marinetti

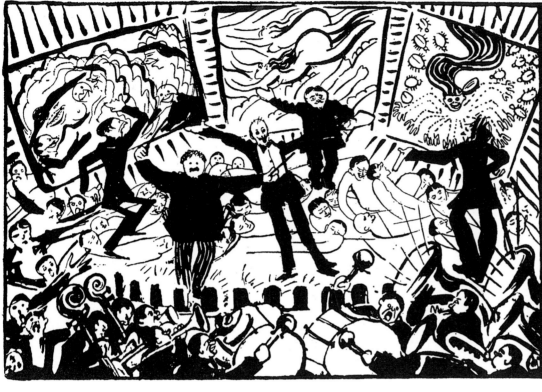

Where colours are concerned, they use just three earthy shades as well as a white and a black. This is because, in their view, a being extremely sensitive to colour does not need bright and beautiful colours to be stirred. Greys and shades are enough. The same goes for motion."[37]

Spring: Braque and Picasso took part in the Berlin Secession.

22 April: *Manifesto of Futurist Playwrights*, written in 1910 by Marinetti.[38]

30 April–7 May: The Padiglione Ricordi in Milan hosted the opening of the *Mostra d'arte libera*, the first major Futurist exhibition, where works by Boccioni, Carrà, and Russolo were on view. Boccioni's *Laugh* was damaged.

7 May: Marinetti's lecture at the La Fenice theatre in Venice.

29 May: Boccioni's lecture at the International Art Club in Rome; the text was the basis for the preface "Les exposants au public" published in the catalogue for the Paris *Exhibition of Italian Futurist Painters* in February 1912.

3 June: in Treviso, a tumultuous Futurist evening, which obliged the police to protect Boccioni, Marinetti and Russolo from the audience.

14 June: opening in London of the first exhibition of the Camden Town Group; at it, Lewis showed works, as he did in the December show.

22 June: returning from Paris, where he stayed after visiting the exhibition at the Padiglione Ricordi, Soffici published, in issue 23 of *La Voce*, a highly critical article titled "Arte libera e pittura futurista", in which he compared the Italian painters "to the thickest-skinned pig dealers in America".

29–30 June: in Florence, during a punitive outing made by Marinetti, Carrà and Boccioni to the café *Le Giubbe Rosse*, the latter opened hostilities by slapping Soffici in the face. Next day, there was a new altercation between the Florentines and Milanese, which wound up at

the police station, where Boccioni and Soffici ended up engaging in dialogue. In November of the same year, questioning the objectives being pursued by the Futurist painters, Apollinaire described that event: "I haven't yet seen the Futurist pictures but if I've properly understood the sense of the research being undertaken by the new Italian painters … these young people are still keen to get away from natural forms, and they want to be the inventors of their art … This painting … is being defended by the Futurists, where necessary, with sticks. Florence was recently the scene of one of these fights where the parties present were, on the one hand, the Futurists headed by Mr. Marinetti, and, on the other, Mr. Ardengo Soffici and his friends from *La Voce*. There were injuries, and one or two hats were rendered useless … Eventually, everyone made amends at the police station, and in front of the police commissioner, Messrs. Boccioni and Soffici demonstrated their mutual respect … It is in March (*sic*) 1912 that the Futurists will be exhibiting in Paris. There can be no doubt that if they want to have recourse to the same argument, they may, at that time, find themselves up against it."[39]

10 June–3 July: the Société des artistes indépendants in Brussels organised an exhibition to which several Cubist painters were invited. Apollinaire wrote the preface for the catalogue: "The new painters who have shown together this year their artistic ideal at the Salon des artistes indépendants in Paris accept the name of Cubist that has been given to them."[40]

Summer: the Milanese painters discovered Cubist painting through the reproduction of works appearing in the press, especially those illustrating the article "Sur quelques peintres" by Roger Allard published in *Les Marches du Sud-Ouest*[41]: *Village* by Le Fauconnier, *Naked*

Man by Gleizes, *Eiffel Tower* by Delaunay (cat. 10), and *Nudes in the Forest* by Léger (cat. 18).

Summer: Braque (until January 1912) and Picasso (for three summers) stayed in Céret and carried out experiments that were important to the beginnings of analytical Cubism.

August: in Paris, the publisher Sansot brought out Marinetti's *Le Futurisme*, the first theoretical work about the movement.

16 August: publication of "Cubisme et Tradition" by Metzinger in *Paris-Journal*.

24 August: in the magazine *La Voce*, Soffici published an article devoted to the fathers of Cubism: "Braque and Picasso are like a hieroglyphic which is used to write a physical reality … identical to some extent with the elliptical syntax and grammatical transpositions of Stéphane Mallarmé."[42]

Late summer: Severini met Soffici in Paris.

9 October: Marinetti, working as correspondent for the daily *L'Intransigeant*, went to the Libyan front of the Italo-Turkish war. He launched the Italian *Manifesto in Tripoli*. The plan to exhibit the Futurist painters scheduled in Paris for the end of the year was postponed.

Autumn: at Severini's request, Boccioni and Carrà went to Paris to see the Cubist works, check their choice for the upcoming exhibition and "take the measure of the Cubist structures". They met Apollinaire, visited the Salon d'Automne and various French painters' studios and went to the Kahnweiler Gallery, where there was an exhibition of Cubists.

1 October–8 November: at the 9th Salon d'Automne, the Cubists, all confined to room 8, caused nothing less than a scandal. Exhibiting there were Duchamp, Duchamp-Villon, Gleizes (*Portrait of Jacques Nayral* and *The Hunt*), Kupka, Léger, Metzinger (*Teatime*), Picabia and Villon (Delaunay did not take part).

A violent controversy around Cubism exercised the popular dailies, most of them hostile to the

31 At 13 and 15 rue de la Bûcherie (quai de Montebello).

32 G. Mourey, *Le Journal* (Paris), 20 April 1911.

33 G. Apollinaire, "Le Salon des indépendants", *L'Intransigeant*, 21 April 1911; *Écrits sur l'art…*, op. cit, pp. 317–18.

34 R. Allard, "Sur quelques peintres", *Les Marches du Sud-Ouest* (Paris), no. 2, June 1911, p. 57–60.

35 A. Kurgannyj, "L'Exposition des Indépendants", *Le Messager de Paris*, no. 19, 13 May 1911, p. 5, quoted in J.-C. Marcadé, "L'avant-garde russe et Paris", *Cahiers du Musée national d'art moderne* (Paris), no. 2, Oct.–Dec. 1979, p. 177.

36 Quoted in J.-C. Marcadé, ibid.

37 Quoted in G. Lista, *Le Futurisme. Création et avant-garde*, (Paris: Les Éditions de l'Amateur, 2001), p. 80.

38 Published for the first time in *Il Nuovo Teatro*, no. 5–6, 25 Dec. 1910–5 Jan.1911. The Italian edition was dated 11 January 1911.

39 G. Apollinaire, "Les peintres futuristes", *Mercure de France*, 16 November 1911; id., *Écrits sur l'art*, op. cit, pp. 436–37.

40 Id., pref. to the catalogue of the 8th Salon annuel du Cercle d'art des indépendants, Brussels, Musée moderne, 10 June–3 July 1911, n.p.; ibid., p. 358.

41 R. Allard, "Sur quelques peintres", art. cit.

42 A. Soffici, "Picasso e Braque", *La Voce* (Florence), 3rd year, no. 34, 24 August 1911, pp. 635–37.

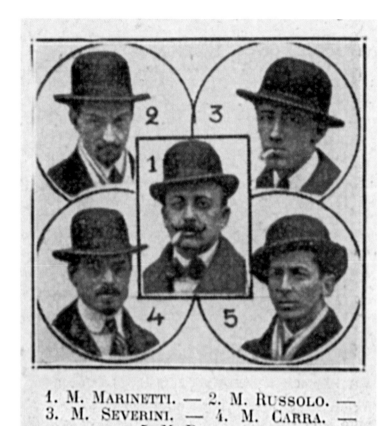

1. M. MARINETTI. — 2. M. RUSSOLO. —
3. M. SEVERINI. — 4. M. CARRA. —
5. M. BOCCIONI.

The five Futurists [in Paris in February 1912], in F. T. Marinetti, "La peinture futuriste. La doctrine de F. T. Marinetti", *Excelsior* (Paris), 15 February 1912, p. 2

43 G. Mourey, *Le Journal,* 30 Sept. 1911.
44 G. Apollinaire, "Le Salon d'automne", *L'Intransigeant* (Paris), 10 Oct. 1911; id., *Écrits sur l'art,* op. cit., pp. 371–72.
45 A. Archipenko, "Salon O-a Nezavisimyh" ["Le Salon de la Société des Indépendants"], *Parižskij Vestnik,* no. 24, 17 June 1911, p. 3; quoted in J.-C. Marcadé, "L'avant-garde russe et Paris", art. cit.
46 A. Kurganny, "Le Salon d'automne", *Le Messager de Paris,* no. 41, 14 Oct. 1911, p. 3.
47 G. Apollinaire, "Un vernissage", *L'Intransigeant* (Paris), 19 Nov. 1911; id., *Écrits sur l'art,* op. cit., pp. 380–81.
48 Author of *The One-and-a-Half Eyed Archer.* Livshits recalled his memories, which include a major part of the history of the avant-garde in Russia at the beginning of the 20th century.

movement. Describing the room earmarked for the Cubists, Gabriel Mourey wrote: "Will I be permitted to admit that I do not believe in the future of Cubism, any more than I do in the Cubism of its inventor, Mr. Picasso, and the Cubism of Messrs. Metzinger, Le Fauconnier, Gleizes, etc., his imitators … Cubism, integral or otherwise, has already said its last word: it is the swansong of pretentious impotence and complacent ignorance."[43] Just a handful of newspapers and magazines had a favourable word of criticism to say about the Cubists: *Paris-Journal* to which Salmon contributed, *La Revue indépendante* in which Allard championed the new painting, the *Mercure de France* which featured the writings of Kahn and *L'Intransigeant,* where Apollinaire had the art column: "The mocking remarks which greeted the exhibition of their works …, while showing the importance of their event, demonstrate absolutely nothing against their art. Those who take Cubism for a joke are completely mistaken … The public, accustomed to the dazzling but almost shapeless blotches of the Impressionists, has not been keen to understand, straight off, the greatness of the formal conceptions of our Cubists. To begin with, the contrast of dark forms and illuminated areas were shocking … Cubism is a necessary reaction, from which, whether we like it or not, will emerge great works. For is it possible and can we for one moment believe that the, in my view, undeniable efforts made by these young artists will remain fruitless? … I am quite sure that Cubism is the highest expression today in French art."[44]

Alexander Archipenko predicted a grand future for these Cubists: "This group of artists [Gleizes, Léger, Metzinger, Le Fauconnier] constructs its masterpieces on extremely interesting principles. The geometrism of the forms, rhythmically repeated on their canvases, clearly shows that the painters of this School have studied not only the classics, but the great Egyptian style in which the architecture of bodies was constructed from almost exact geometric figures. In their works, in this display of geometric figures, we see an amazing logic … Their pictures present a whole and rigorous mark, their varied range of colours is reduced to a calm, clear shade, this School has a very great future." [45] Just like the Salon des Indépendants, the Salon d'Automne stirred up contrasting reactions from Russian critics: "A whole room is given over to those calling themselves 'Cubists', 'Cylindrists', 'Crystallists' and God knows what other kinds of 'ists'. It is a very merry company, colourful and noisy; before the dazzle and excess of their colours, everything pales that is more or less calm and without cheekiness. The public visits this room solely to have some fun."[46]

October: while studying at the Slade School of Art, Christopher Nevinson and Edward Wadsworth formed a group they called "Neo-Primitives".

October-November: Gleizes met Picasso.

November: Wyndham Lewis stayed in Paris where he visited the Salon d'Automne; he took special note of the works of Gleizes, Léger and Metzinger.

In the rue Tronchet, the Galerie d'art ancient et d'art contemporain organised, under the aegis of the Société normand de peinture moderne, an exhibition of young French artists which actually foreshadowed the Salon de la Section d'Or which would be held in October 1912. Apollinaire was still every bit as enthusiastic: "The most daring group is well represented by Miss Marie Laurencin, Albert Gleizes, R. de La Fresnaye, Fernand Léger, Duchamp, very much on the up and up, and Jean Metzinger, who has become a colourist. This offers me a chance to declare once again that I regard the preoccupations of the young artists who are called Cubists as the loftiest preoccupations that anyone can have today."[47]

Goncharova and Larionov broke once and for all with the Knave of Diamonds group.

Christmas: David Burliuk met Benedikt Livshits[48] at Exter's home. It was during this year 1911 that intense artistic exchanges were struck up between the Russians who had settled in Paris and those who had remained back home.

From left to right: Umberto Boccioni and F. T. Marinetti at the opening of the exhibition *Les Peintres futuristes italiens*, Galerie Bernheim-Jeune & Cie, Paris, 5–24 February 1912. On the wall: *Laugh* (1911) by Umberto Boccioni

One of the exhibition rooms for the show *Les Peintres futuristes italiens* held at the Galerie Bernheim-Jeune & Cie, Paris, 5–24 February 1912. On the left and from top to bottom: *Tina's Hair* (1909–10) and *One-three Heads* (1912, whereabouts now unknown) by Luigi Russolo. On the right: *The Dance of the "Pan-Pan" at the Monico* (1909–11) by Gino Severini

Giacomo Balla, *Lampada ad Arco* [*Street Light*], 1910, oil on canvas, 174.7 x 114.7 cm The Museum of Modern Art, New York

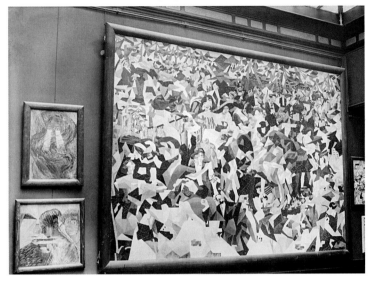

1912

4 January–12 February: the *3rd Exhibition of the Union of Youth* was held in St. Petersburg, jointly organised with the Donkey's Tail group headed by Larionov.

25 January–late February: in Moscow the *2nd Knave of Diamonds Exhibition* was held which brought Russian artists face to face with French artists (including Derain, Gleizes, Le Fauconnier, Léger, Matisse, Picasso and Van Dongen), the Die Brücke Expressionists (Erich Heckel, Ernst Ludwig Kirchner, Max Pechstein) and those of the Blaue Reiter (Kandinsky, Franz Marc, August Macke, Gabriele Münter). Though mentioned in the catalogue, Delaunay did not exhibit. The critics spoke out against this Russian avant-garde's lack of daring: "The Union of Youth exhibition (at St. Petersburg), reminds us less than any other show of the cheekiness of youth; it even makes one think of senility. Where we would have liked to see original passion—sometimes even impertinence—we note an almost servile imitation of the 'new gods' … In each one of the works, the master's ghost can be felt … The whole tragedy of our young people resides in the fact that they always remind us of someone (else), and doesn't this come to the same thing as poorly imitating the 'Cubists' or being the epigone of the académie des Ambulants [the Academy of the Itinerant]?"[49]

5–24 February: the exhibition *The Italian Futurist Painters*[50] was held at the Parisian Galerie Bernheim-Jeune & Cie, run by Fénéon; works were shown by painters who had signed the manifesto, except Balla, whose *Street Light* had been 'censored' by Boccioni. In addition to the *Manifesto of Futurist Painters* of 11 April 1910, the catalogue included their manifesto text titled "Les exposants au public". The numerous visitors included Exter, Duchamp, Picabia and Joseph Stella.

Although these painters were getting their works circulated in most of Europe's capital cities up until 1914, the exhibition stirred up a great deal of criticism in the Paris press: "Mr. Marinetti does not trifle. Kerosene and dynamite seem to him like the instruments best suited to regenerating painting … This declamatory Erostrates[51] preaches a painting that is 'ethical, aesthetic, dynamic and psychic'. The one thing that is certain is that these Futurist painters claim to be painting without colours, brushes or canvases. A young psychiatrist … might possibly have enabled us to better understand 'the dynamic principles of the representation of the body in motion by groups of gases', such as Mr. Marinetti has set them forth for us, in an incendiary but hazy language. For myself, all I can recall of those demonstrations is that a horse has twenty legs, no less, and that when you make a portrait, the model's eye must be in one corner of the picture and the model's detachable collar in the other.[52] 'The Futurist painters—says Mr. Marinetti—are the primitives of the future.' That is certainly true as far as primitive is concerned."[53]

Salmon was somewhat circumspect: "What have you done, my dear Marinetti? I regained a bit of composure, no exhibition in the manner of room 8 was announced … Here you are, dear poet, followed by your friends the Futurist Painters … Starting with a compliment which will not go unnoticed by your compatriots and disciples, I most readily recognise that the Futurist painters have nothing in common with the band of modern Italian scribblers and daubers, lamentable makers of signs for confectioners … Have the Futurists got more talent? They have, at least, more fantasy and probably more culture. I haven't yet written that I liked them … There was a tremendous crush in front of Russolo's *Memories of a Night* [1911, cat. 43]; people stamped their feet in front of Carrà's *The Funeral of the Anarchist*

Galli (cat. 32); they shrieked in front of Severini's "*Pan-Pan" at the Monico* [1909–11/ 1959–60, cat. 45], people stood as if dumbfounded in front of Balla's *Street Light*[54] and Boccioni's *States of Mind* [1911, cat. 20–25]. Should I say that I took part in the unanimous panic? All this is quite new, painted at great expense and with agility (truly agility rather than dexterity) to astonish us, good Parisians who are still at the Fauvism stage, and it seems to me that I've already seen all this somewhere before. It's the greatest reproach one can make about denigrators who despise the past. They are all the product of someone, or even of several persons. The models of Cubism have been made use of; Van Dongen's palette has been scratched right down to the wood; Picabia is not an unknown to the young masters, and I don't see why the author of *Tonton Lavilène* and *La Soif et la Volupté dans le Désert* shouldn't lay claim to the enviable title of Futurism's precursor."[55]

Kahn was more admiring: "I just don't have room … to study the theory of the Italian Futurist painters and deal with their painting … But it should be said right away that works like *The City Rises* by Mr. Boccioni [1910–11, cat. 28], and *Raid* by the same painter, Mr. Carrà 's *The Funeral of the Anarchist Galli*, Russolo's *The Speeding Train*[56] and Mr. Severini's *The Dance at Monico* [sic] are all the work of excellent artists, that this exhibition deserves serious attention, and that as well as being this Salon d'Automne with its room of Cubists, it is a significant date in art history. People have definitely never seen such a considerable and innovative meeting since the early exhibitions of the Pointillists. The Futurists are very well-informed as to the latest efforts of contemporary painting. They have found guides in Paris, but they have added a great deal, coming from themselves, with much enthusiasm and brilliance."[57]

49 N.V., *Apollon*, supplement to no. 3, February 1912; quoted in *Nathalie Gontcharova, Michel Larionov*, exh. cat. , Paris, published by the Centre Pompidou, p. 230; Paris, Musée national d'art moderne, 21 June–18 Sept. 1995; Martigny, Fondation Pierre Gianadda, 10 Nov. 1995–21 Jan. 1996; Milan, Fondazione Antonio Mazzotta, 24 Feb.–26 May 1996.
50 The exhibition was to have been held in Paris, in the same venue, from 11 Nov. to 2 Dec. 1911; it was delayed because of the Italo-Turkish war and Marinetti's departure for Tripoli as correspondent for *L'Intransigeant*.
51 The day before (9 Feb. 1912), Marinetti had given a lecture at the Maison des étudiants, in Paris.
52 Ideas held by the Futurist painters in their manifesto of 11 April 1910. See G. Lista, *Futurisme. Manifestes…*, op. cit., p. 163.
53 É. Helsey, "Après le cubisme, le futurisme", *Le Journal*, 10 February 1912.
54 The Balla canvas was not exhibited; Boccioni had withdrawn it from the exhibition even though it is mentioned here.
55 A. Salmon, "Les futuristes", *Paris-Journal*, 6 Feb. 1912.
56 Whereabouts unknown, canvas probably destroyed.
57 G. Kahn, "Arts", *Mercure de France*, 23, vol. 95, no. 352, 16 Feb. 1912.

Cover of the catalogue *Italian Futurist Painters* at The Sackville Gallery, March 1912, the London leg of the Bernheim-Jeune exhibition

The blind man on the Pont des Arts, "Le Salon des indépendants", *Le Sourire* [*The Smile*], (Paris), 4 April 1912, annotated by Pablo Picasso for Daniel-Henry Kahnweiler

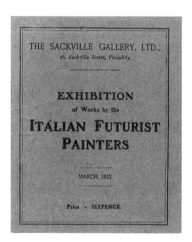

THE SACKVILLE GALLERY, LTD.,
28, Sackville Street, Piccadilly.

EXHIBITION
of Works by the

ITALIAN FUTURIST
PAINTERS

MARCH, 1912

Price - SIXPENCE.

Well removed from those who mocked, André Warnod was very much aware that he was attending an event of primary importance: "Although the Futurists sometimes use a technique which resembles Cubism, they distance themselves from it completely. As for the very soul of their art, they seem keen to perfect Impressionism by seeking for style what has been found for content. The Cubists are concerned only with form, and this is why Futurist painting a more complete art than Cubism … Don't start to guffaw noisily as soon as you enter the small room because the technique that you see there seems extraordinary to you. If you want to go there to have a laugh, the way you go to look at clowns at a fair, you will certainly have a laugh … It is not a definitive art, far from it. A lot of people will make an outcry, and they'll almost be right to do so. But the fact remains that through these canvases you at times see the sensation of something that no other school of painting could ever have come up with."[58]

During their stay in Paris, Boccioni, Carrà, Marinetti and Russolo met various figures from the art world, including Gleizes, Fénéon, Kahn, Léger, the collectors Leo and Gertrude Stein.

1 February: in his article "La tendance de la peinture contemporaine", Olivier-Hourcade attempted to make a synthesis of Cubism's contribution.[59]

February: first issue of the monthly magazine *Les Soirées de Paris*, edited by Apollinaire, André Billy, René Dalize, Salmon and André Tudesq. (The magazine got into financial trouble in the winter of 1913–14, but was bailed out by Serge Férat and Baroness Hélène d'Œttingen).

12 February: in Moscow, there was a public debate organised by the Knave of Diamonds Association, with lectures by Nicholas Kulbin ("Avant-garde Art, Basis of the World") and

David Burliuk ("Cubism and the Other Trends in Painting"). Goncharova and Larionov officially took their leave of the Knave of Diamonds after being spoken to in an aggressive manner, with Larionov calling Burliuk a "decadent disciple of Munich" and accusing the Cézannians of conservativism and eclecticism.

24 February: the second public debate organised by the Knave of Diamonds, with talks by Ivan Axionov ("Contemporary Art") and David Burliuk ("Contemporary Art in Russia and the Way It Is Received by Critics"); Vladimir Mayakovsky was among the audience.

9 February: in Paris, a lecture by Marinetti at the Maison des étudiants.

15 February: at the Galerie Bernheim, Marinetti gave a lecture, taken from an unpublished text titled "Origins of Pictorial Futurism". Faced with hostility from part of the audience, Gleizes, Metzinger and Severini defended their friend.

March: Marinetti and Boccioni visited London for the exhibition of Italian Futurist painters organised by the Sackville Gallery. On view were the same works as in the Paris exhibition of February 1912: "With regard to the Futurists, the good people of London had made a marvellous resolution. By way of disdain, they were to promote a conspiracy of silence around the noisy exhibitors at the Sackville Gallery. Nobody would talk about it, nobody would set foot in it, nobody would cast a glance at it … And the reception by the English public is not at all the one that that public had predicted … There was a throng at the exhibition of the Futurists in London."[60]

March: in Paris, at the Maison des étudiants, Valentine de Saint-Point gave a lecture titled, "La femme et les lettres" [Woman and the Arts], with Marinetti participating.

11 March–April: first exhibition of The Donkey's Tail, organised by Larionov at the Stroganov School in Moscow. Goncharova, Malevich,

Tatlin and Marc Chagall (whose work was dispatched from Paris) also took part.

12 March–12 April: in Berlin, the Der Sturm Gallery held its first exhibition, opened by Walden and dedicated to the Blaue Reiter.

20 March–16 May: the Salon des Indépendants was held in Paris (Boccioni apparently visited it), with participants including Exter[61], Delaunay (*The City of Paris*, 1910–12, cat. 54, and an *Eiffel Tower*), Gleizes, Gris (*Homage to Picasso*, 1912), Léger (*The Wedding*, [1911-12], cat. 55), and Metzinger. Duchamp was forced to take down his *Nude Descending A Staircase No. 2* (1912, cat. 59), deemed too Futurist by Gleizes and Villon (it would nevertheless be shown that same year at the Cubist exhibition in Barcelona held in April and May, and at the Section d'or). At that show, Apollinaire and Severini perceived the emergence of new artistic trends. Apollinaire: "Several tendencies clearly appear when you walk through the rooms. Picasso's influence is the most far-reaching, it changes however, and the very painters who were the most steeped in it have been making such efforts over the past two years that their personality now shows through as if embellished and fortified by the stern discipline of Picasso, which they suffered lovingly and painfully. Matisse's influence seems almost totally dismissed … These influences apart, there remain two major and quite distinct tendencies, one of which, staying well away from anecdote and trying to raise itself up to the sublime through efforts that are by no means laughable, is the very glory of present-day painting. It brings together artists such as Delaunay, Le Fauconnier, Metzinger, Gleizes, Marie Laurencin, Dunoyer, de Segonzac, Luc-Albert Moreau, Vlaminck, Rouault, etc."[62]

Severini: "The Salon des Indépendants of that year, as well as the following Salon d'Automne, revealed not only the influence of Futurist ideas

Cover of the first issue of *Les Soirées de Paris*,
February 1912

First page of the galley proof of the *Manifeste de la Femme futuriste* (Paris, 25 March 1912) by Valentine de Saint-Point

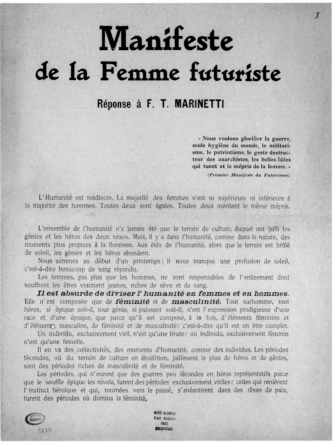

Cover of the first issue of *Les Soirées de Paris*, February 1912

on several worthy artists, but also a veritable transformation of the artistic atmosphere in general: the museum-colours of the early Cubist canvases were gone, giving way to the bright colours of the prism."[63]

25 March: *Manifesto of the Futurist Woman* by Valentine de Saint-Point.[64]

12 April–15 May: in Berlin, the exhibition of Futurist painters was held under the title *Futuristen* at the Der Sturm Gallery (Tiergartenstrasse 34a). Marinetti hired a taxi: with Walden as company, he drove through the streets tossing out his manifestos and yelling "Long live Futurism!"

The exhibition stirred up interest among German painters: "The notion of 'painting' is, to the connoisseur who is well abreast of modern pictorial art, what black lips—or any other sign of a thoroughbred—are to the breeder ... The collector of Picasso dashes to the Futurist exhibition and exclaims: 'Very beautiful, wonderful, but it is not 'painting', gentlemen. Then someone more intelligent replies to him: 'Ma pittura, signore.' That is when the conversation ends. Then you can read a Japanese poem: 'If you open a window, all the noise of the street, the movements and the material nature of the things outside suddenly come into the room.' Or this: 'The power of the street, the life, the ambitions, the fear that you can observe in the city, the sensation of oppression that noise causes.' It is all this that the Futurists managed to paint, and in a masterful way, even. Carrà, Boccioni and Severini would mark the history of modern art. We shall still envy Italy her sons and we shall hang their works in our galleries."[65]

April: with Baroness d'Œttingen acting as go-between, Exter met Soffici in Serge Férat's studio: "Paris, 3 April, Café Niel, night ... We met an hour ago in Serge's studio, ... but it's as if we'd lived side by side for years"[66] wrote Soffici. In 1914 they would share his studio.

11 April: in Milan, Boccioni published the *Technical Manifesto of Futurist Sculpture*.[67] In a letter dated 15 March 1912, he noted his deep interest in this art: "These days I'm obsessed by sculpture! I think I've seen a complete renewal of this mummified art."[68]

April: the *4th Union of Youth Exhibition* was held in St. Petersburg.

20 April–10 May: the Dalmau Gallery, in Barcelona, put on the "Exposició d'art cubista", which showed works by Duchamp, Gleizes, Gris, Laurencin, Metzinger, Le Fauconnier and Léger. Jacques Nayral, brother-in-law of the publisher Eugène Figuière, wrote the preface to the catalogue.

11 May: Marinetti's *Technical Manifesto of Futurist Literature*, followed on 11 August by its *Supplement*.

May–June: in St. Petersburg, publication of issues 1 and 2 of the Union of Youth magazine, in which appeared the Russian translation of the *Manifesto of Italian Futurist Painters* and that of their preface to the catalogue for the exhibition of February 1912, "Les exposants au public".

31 May–5 June: the exhibition *Les Peintres futuristes italiens* was held at the Georges Giroux Gallery in Brussels; in it were the same works as in Paris, London and Berlin.

3 June: in the same gallery, a reading of the *Manifesto of the Futurist Woman* by Valentine de Saint-Point.

15 June–15 July: Salon de la Société normande de peinture in Rouen (run by Pierre Dumont), Grand Skating, where Duchamp, Gleizes, Gris, Léger and Picabia exhibited.

27 June: in Paris, at the Gaveau hall, lecture by Valentine de Saint-Point with a reading of the *Manifesto of the Futurist Woman*, followed by a debate moderated by Marinetti.

June–July: on a visit to Paris, Boccioni showed a real interest in the sculptures of Archipenko, Constantin Brancusi and Duchamp-Villon.

July: Wyndham Lewis exhibited *Kermesse*, a huge canvas influenced by Futurism, at the *5th Allied Artists Salon*, which was held in the Royal Albert Hall, London.

11 July: Soffici published "Ancora del Futurismo" in *La Voce*, a very guarded article about the February exhibition of Futurist painters.

Mid-July: in Düsseldorf, Balla designed his first Futurist clothing (an asymmetrical black suit with white stripes) and undertook the decoration of the Lowensteins' house, where he was staying.

Summer: Larionov worked on "Rayonism", a movement which "had the closest affinity with Futurism in particular."[69]

September: first dinner of the Passy artists in Balzac's old home in the rue Raynouard. Among the diners were Allard, Apollinaire, the three Duchamp brothers, Gleizes, Laurencin, Metzinger, Le Fauconnier, Roger de La Fresnaye, Léger, Picabia and Henri Valensi.

1 October: sent by *L'Intransigeant* as its correspondent to cover the war in the Balkans, Marinetti witnessed the bombing of Adrianopole.

1 October–8 November: the 10th Salon d'Automne showed, among others, the three Duchamp brothers, Gleizes (*Portrait of Jacques Nayral*), Metzinger (*Dancer in the Café*, 1912, cat. 56), Léger, Kupka and Boccioni. The Salon once again caused an outcry and bolstered its Selection Committee's hostility to Cubism, in particular on the part of its director Frantz Jourdain. In protest, Villon, who had been a member since 1904, resigned. A violent argument broke out in the Chamber of Deputies because of the presence of the Cubists and foreign artists at the Salon: "I even hope that you will say in a whisper: 'am I entitled to lend a public monument to a gang of miscreants who behave in the art world like hooligans in ordinary life?' You will ask yourself, Minister, when you leave [the Chamber] if nature and

58 A. Warnod, "L'exposition des futuristes", *Comœdia*, 6 Feb. 1912.

59 Olivier-Hourcade, "La tendance de la peinture contemporaine", *La Revue de France et des Pays Français* (Paris), 1st year, no. 1, Feb. 1912, pp. 35–41.

60 R.-R.M. Sée, [untitled], *Gil Blas* (Paris), 6 March 1912.

61 In his report on the Salon, Apollinaire would note her presence: "Room 17. Mme Exter recalls the old studies of Delaunay, dramatic crumblings." "Le Salon des indépendants. Suite de la promenade à travers les salles", *L'Intransigeant*, 25 March 1912; id., *Écrits sur l'art*, op. cit., p. 430.

62 Id., "Les Indépendants. Les nouvelles tendances et les artistes personnels", *Le Petit Bleu*, 20 March 1912; ibid., p. 435.

63 G. Severini, "Apollinaire et le futurisme", *xxᵉ siècle* (Paris), no. 3, June 1952, p. 14.

64 Published in German in *Der Sturm* (Berlin), 3rd year, no. 108, May 1912, pp. 26–7.

65 F. Marc, "Die Futuristen", *Der Sturm*, 3rd year, no. 132, Oct. 1912, p. 187.

66 L. Cavallo, *Soffici. Immagini e documenti (1879–1964)*, (Florence: Vallecchi Editore, 1959–1968), p. 133.

67 This manifesto was published in Italian in *L'Italia* of 30 September 1912; in French in *Je dis tout* of 6 October, in *L'Escholier de France* (Paris) of 25 January 1913; in English in *The Tripod*, no. 5, Nov. 1912.

68 Letter from Boccioni to Vico Baer, Paris, 15 Mar. 1912, repr. in *Archivi del futurismo*, II, p. 43.

69 Letter from Guiseppe Sprovieri to Anthony Parton, repr. in A. Parton, *M. Larionov and the Russian avant-garde*, (London: Thames and Hudson, 1993), p. 142.

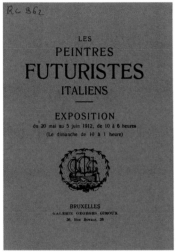

Cover of the catalogue for the Brussels leg
of the exhibition *Les Peintres futuristes italiens*,
at the Galerie Georges Giroux, 20 May–5 June 1912

Cover of the catalogue *Futuristen* at the Galerie
Der Sturm, 12 April–15 May 1912 the Berlin leg
of the Bernheim-Jeune exhibition

First page of the *Manifeste technique
de la sculpture futuriste* by Umberto Boccioni
(Milan, 11 April 1912)

Exhibition catalogue for the *Section d'or*, Paris,
Galerie La Boétie, 10–30 October 1912

the human form have ever been subject to such outrages; you will sadly note that, in this Salon, they are displaying and accumulating the saddest things, ugly and vulgar alike, that you can imagine."[70]

October–January: in London, the *Second Post-Impressionist Exhibition* was organised by Roger Fry at the Grafton Galleries, with the participation of British, French and Russian artists (the Russian works did not get there until November).

10–30 October: in Paris, the La Boëtie Gallery hosted the Salon de la Section d'or—"the largest Cubist exhibition", in Apollinaire's words—which brought together the painters who met on Sundays at Puteaux, in Courbevoie in Gleizes' studio, at the Passy dinners, and in the *Closerie des Lilas*. Thirty-one artists chose the works most representative of their development up to Cubism. More than 200 works were thus put on view, among them those of Duchamp (including the *Nude Descending a Staircase No. 2* and the *Chess Players* [1911, cat. 60]), Duchamp-Villon (including *The Horse*), Exter, Gleizes (including the *Portrait of Jacques Nayral* and *The Hunt*), Gris (including his *Homage to Pablo Picasso*), Léger, Metzinger (including *Teatime*), Picabia (including *Dances at the Spring I*, [1912, cat. 62]) and Villon (*Young Woman*, 1912, cat. 66). As part of the Salon, Apollinaire, René Blum and Maurice Raynal gave lectures. The press gave wide coverage of the lecture given on 11 October by Apollinaire, titled "L'écartèlement du cubisme" [The Quartering of Cubism]. In addition to the catalogue, a first and one-off issue of the magazine *La Section d'or* was published to mark the occasion.

Louis Vauxcelles pursued his acerbic critique of the Cubists: "The Section d'or and room 11 of the Salon d'Automne are causing much ink to flow. I won't go so far as to say, with Salmon, that families are at each other's throats … for or against the Cubist bores. I in no way think that this fleeting fit of pictorial geometry will have worldwide repercussions."[71]

Apollinaire, on the other hand, saw in this movement an artistic renewal: "The Cubists, no matter what tendency they belong to, appear to all those who are concerned about the future of art as the most serious and interesting artists of our day and age … Why so much anger, you censors? Do you have no interest at all in the Cubists? All right, don't take any interest in them. But here come cries, gnashing of teeth, and appeals to the government. So much bile in the hearts of art critics, this violence, these lamentations all go to show the vitality of the new painting and the works it is producing will be admired for centuries to come, while the poor detractors of contemporary French art will be swiftly forgotten."[72]

October: publication of *Du "cubisme"* [On "Cubism"] by Gleizes and Metzinger (Paris, Figuière), the first overall book dealing with the movement, whose name it consecrated. The Russian translation of this treatise, which Matiushin published in 1913, was frequently combined with passages from Peter Ouspensky's *Tertium Organum* (1911): "The publication of the book by Gleizes and Metzinger, *Du "cubisme"*, was of very great and lasting importance for Russian painters … for Cubism was defined in it in a way that was thoroughly compatible with their usual interests, and this made the whole of the Cubist pictorial vocabulary accessible. The vocabulary of Braque and Picasso, as well as that of the Passy group."[73]

Autumn: Liubov Popova and Nadezhda Udaltsova stayed in Paris, enrolling at the La Palette studio, where their teachers included Metzinger, Le Fauconnier and André Dunoyer de Segonzac.

View of one of the rooms at the Salon d'Automne in 1912. From left to right: *Amorpha. Fugue à deux couleurs* by František Kupka, *Le Printemps* by Francis Picabia, *La Danseuse au café* by Jean Metzinger. In the foreground: sculptures by Amedeo Modigliani alongside small Cubist pictures

First page of the first and only issue of *La Section d'or*, 9 October 1912

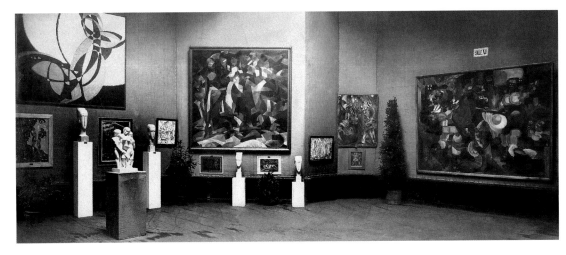

3 December: Léon Bérard was summoned to the Chamber of Deputies by Jules-Louis Breton with regard to the last Salon d'Automne: "I ask him quite simply to demand, from the concessionary bodies, certain essential guarantees, especially with relation to the formation of the admissions jury, and to warn them that if, in the future, the scandal of this year were to be repeated, he would then be obliged to refuse their Grand Palais concession … It is, in effect, gentlemen, altogether unacceptable that our state-owned historic buildings should be used for events of a character that is so clearly anti-artistic and anti-national."[74]

Marcel Sembat, a Socialist Member of Parliament, came to the defence of Cubism: "People don't protest when the State hands its historic edifices over to schemers, to crooked businessmen, and people protest when it hands them over to artists to show pictures that are deemed to be bad … When a picture seems bad to you, you have an indisputable right: the right not to look at it and to go and see other works. But one doesn't call in the police."[75]

The press ranted and raved, as Apollinaire noted: "The Cubists assembled at the end of the retrospective of portraits, in a gloomy room, are no longer being jeered at like last year. Now they arouse hatred. They are getting ready for their group exhibition: *The Section d'or*.[76]

The poet had sensed all the uniqueness of the work of the artists present: "These form, this year again, the typical Salon d'Automne group. However, they have hardly enjoyed the jury's favour, and if most of them had not been saved, by being reconsidered, we would not have any Cubist show this year … The influence that this art already wields abroad has not escaped the notice of the organisers of the Salon d'Automne. New series of works produced, no longer with the elements of the reality of vision, but with those purer ones of the reality of conception,

the Cubist works lend themselves well, in their detail, to criticism, but the tendencies they obey seem to me to be *worthy of interesting those who are concerned with the future of art*."[77]

4 December 1912–10 January 1913: *5th Union of Youth Exhibition*[78] in St. Petersburg, with contributions by, among others: Burliuk, Goncharova, Malevich, Matiushin, Rozanova and Larionov (the first showing of one of his Rayonist works).

The year 1912 saw the publication of Marinetti's *Le Monoplan du pape* [The Pope's Aeroplane] (Paris, Sansot) and *La battaglia di Tripoli* (Edizioni futuriste di *Poesia*), and the anthology *I Poeti futuristi* (July).

70 Open letter from M. Lampué, Dean of the Paris City Council, addressed to M. Léon Bérard, Under-Secretary of State for Fine Arts; quoted in P.F. Barrer, *Quand l'art du xxe siècle était conçu par des inconnus*, (Paris: Arts et Images du monde, 1992), pp. 93–4.

71 L. Vauxcelles, "Les Arts. Discussions"; *Gil Blas* (Paris), 22 October 1912, quoted in *La Section d'or 1925, 1920, 1912*, exh. cat., Châteauroux, musées [de], 21 Sept.–3 Dec. 2000; Montpellier, musée Fabre, 15 Dec. 2000–18 March 2001 (Paris: Éd. Cercle d'art, 2000), p. 309.

72 G. Apollinaire, "Jeunes peintres, ne vous frappez pas", *La Section d'or* (Paris), 9 Oct. 1912; id., *Écrits sur l'art*, op. cit., pp. 484–85.

73 C. Douglas, "Cubisme français/cubo-futurisme", *Cahiers du Musée national d'art moderne* (Paris), no. 2, Oct.–Dec. 1979, p. 190.

74 Quoted in ibid., p. 94.

75 Ibid., p. 98.

76 G. Apollinaire, "Demain a lieu le vernissage du Salon d'automne", *L'Intransigeant* (Paris), 30 Sept. 1912; id., *Écrits sur l'art*, op. cit., pp. 476–77.

77 Id., " Vernissage. L'inauguration du Salon d'automne", *L'Intransigeant* (Paris), 1 Oct. 1912; *Écrits sur l'art*, op. cit., pp. 478–79.

78 Because of the inaccuracy of the date mentioned in the catalogue, the event was sometimes predated by a year.

Manifeste futuriste
de la
Luxure

RÉPONSE aux journalistes improbes qui mutilent les phrases
pour ridiculiser l'Idée;
à celles qui pensent ce que j'ai osé dire;
à ceux pour qui la Luxure n'est encore que péché;
à tous ceux qui n'atteignent dans la Luxure que le Vice,
comme dans l'Orgueil que la Vanité.

La Luxure, conçue en dehors de tout concept moral et comme élément essentiel du dynamisme de la vie, est une force.

Pour une race forte, pas plus que l'orgueil, la luxure n'est un péché capital. Comme l'orgueil, la luxure est une vertu incitatrice, un foyer où s'alimentent les énergies.

La luxure, c'est l'expression d'un être projeté au-delà de lui-même; c'est la joie douloureuse d'une chair accomplie, la douleur joyeuse d'une éclosion; c'est l'union charnelle, quels que soient les secrets qui unifient les êtres; c'est la synthèse sensorielle et sensuelle d'un être pour la plus grande libération de son esprit; c'est la communion d'une parcelle de l'humanité avec toute la sensualité de la terre; c'est le frisson panique d'une parcelle de la terre.

La Luxure, c'est la recherche charnelle de l'Inconnu, comme la Cérébralité en est la recherche spirituelle. La Luxure, c'est le geste de créer et c'est la création.

La chair crée comme l'esprit crée. Leur création, en face de l'Univers, est égale. L'une n'est pas supérieure à l'autre. Et la création spirituelle dépend de la création charnelle.

Nous avons un corps et un esprit. Restreindre l'un pour multiplier l'autre est une preuve de faiblesse et une erreur. Un être fort doit réaliser toutes ses possibilités charnelles et spirituelles. La Luxure est pour les conquérants un tribut qui leur est dû. Après une bataille où des hommes sont morts, **il est normal que les victorieux, sélectionnés par la guerre, aillent, en pays conquis, jusqu'au viol pour recréer de la vie.**

Après les batailles, les soldats aiment les voluptés où se détendent, pour se renouveler, leurs énergies sans cesse à l'assaut. Le héros moderne, héros de n'importe

Valentine de Saint-Point, *Manifeste futuriste de la Luxure,* Paris, 11 January 1913

Félix Del Marle with the sculptor Léon Fagel in Paris in January 1913. Giovanni Lista Archives, Paris

David Burliuk et al., Poščëčina obščestvennomu vkusu [*A Slap in the Face of Public Taste*]*,* Manifesto, Moscow, Kuzmin and Dolinski, December 1912

1913

1 January: in Moscow, opening of the French exhibition *L'Art contemporain* with more than 200 works by the Nabis, Fauves and Cubists (Gris, Léger and Picasso all took part).

1 January: publication of the first issue of the bi-monthly magazine *Lacerba* (Florence), edited in a collaborative manner by Aldo Palazzeschi, Papini (at that time a columnist with the *Mercure de France*) and Soffici. *Lacerba* came into being after tensions within the Florentine magazine *La Voce* and made its columns available to French painters and writers, in particular to Jacob, Apollinaire and Remy de Gourmont. It published numerous Futurist manifestos, reproduced works of French Cubists and Italian Futurists, and welcomed the pens of Boccioni, Carrà, Marinetti and Soffici with open arms.

Early January: Boccioni stayed in Paris in order to prepare an exhibition of his sculptures planned for June and July of that same year.

January: Balla went to Milan to meet the Futurist painters living there.

11 January: Valentine de Saint-Point's *Futurist Manifesto of Lust* was published simultaneously in French and Italian[79]. It elicited few reactions from the Paris press[80] but received a warmer reception overall from the female readership than the *Manifesto of the Futurist Woman* of 25 March 1912. With "Let's stop scorning desire" as its buzzword, it promoted lust as an end in itself.

Beginning of the year: in Paris, Félix Del Marle met Severini, who introduced him to Futurist painting; together, they shared the Italian painter's studio at 32 rue Dutot.

17 January–1 February: the Berthe Weill Gallery in Paris held an exhibition of Cubists works by Gleizes, Léger and Metzinger.

23 January–20 February: Delaunay exhibited his work at the Der Sturm Gallery (Königin

Augustastrasse 51). For the show, the Delaunays went to Berlin with Apollinaire who gave a lecture on Orphism.

January: in Moscow publication by Kuzmin and Dolinski of the compilation *A Slap in the Face of Public Taste* (the book had been ready since December 1912, but only got past the censors between 7 and 14 January 1913). It contained the first manifesto of the *Gilea* [Hylea] Group—the first Futurist movement derived from the Greek name for the Tauride in the Ukraine, in which, in a provocative preface, David Burliuk, Khlebnikov, Kruchenykh and Mayakovsky formulated the concepts of the Russian Futurists: "You who read our novella; first, unexpected / We alone are the face of our Time / Through us rings out the horn of time in the art of words. / The past is narrow. / The academy and Pushkin are more incomprehensible than hieroglyphs. / We must throw Pushkin, Dostoevsky, Tolstoy and co. overboard from the Ship of the Contemporary Age."[81]

At the same time, Nevinson made the acquaintance of Lewis by way of Wadsworth.

10 February: in Paris, publication of the first issue of the monthly gazette *Montjoie !*[82], subtitled "Organ of French Artistic Imperialism". The aim of its editor, Ricciotto Canudo, was to find a common bond between all the arts (dance, music, decorative arts, plastic arts, etc.) and open the magazine to "all the promised rebirths of art". Many artists belonging to the avant-garde contributed to it (Gleizes and Léger among others), as did Apollinaire, Mercereau and Salmon, who published articles favourable to Cubism and Orphism. The *Montjoie !* Mondays, which were held in the premises of the Chaussée-d'Antin, brought together some of the greatest artists of the day, including Barzun, Patrick Henry Bruce, Bakst, Cendrars, Delaunay, Duchamp-Villon, Léger, Russell, Satie, Zweig, Varèse, Villon and Walden.

17 February–15 March: opening in New York of the Armory Show (*International Exhibition of Modern Art at the Armory of the 69th Infantry*). The Italian Futurists refused to see their works on view alongside those of other artists, so did not feature in the show, thus damaging the spread of their movement on the other side of the Atlantic. But exhibitors did include Braque (three works), Duchamp (four works including *Nude Descending A Staircase No. 2*), Duchamp-Villon (five works), Jacob Epstein (one work), Gleizes (two works), Léger (two works), Picabia (four works, including *Dances at the Spring I*), Picasso (seven works), Russell (two works), Stella (two works), and Villon (nine works, including *Young Woman*). Delaunay was to have shown three canvases, including *The City of Paris*, which could not be hung because of its size, but he withdrew his pictures during the opening of the show. The exhibition was presented, with variants, at the Art Institute of Chicago from 24 March to 16 April, and then at the Copley Society in Boston, from 28 April to 19 May.

21 February–9 March: in Rome, the G. Giosi Gallery held the *Prima Esposizione pittura futurista*, which showed canvases by Balla (*Girl Running on a Balcony*, 1912, cat. 88), Boccioni, including the triptych *States of Mind, Horizontal Construction* (1912, cat. 77) and *Antigrazioso* (1912, cat. 76), Carrà, Russolo, Severini and Soffici (including *Lines and Volumes of a Person*, 1912, cat. 84). The works selected differed to a considerable degree from those shown with Bernheim-Jeune in February 1912. At the opening, Papini read his manifesto *Against Rome and Against Benedetto Croce.*[83] A few days later, on 26 February, Boccioni gave a lecture that was interrupted by the public.

February: in St. Petersburg, the Union of Youth organised two debate evenings, during which

79 Italo Tavolato wrote a critical reply to this manifesto, "Glossa sopra il manifesto futurista della lussuria", which appeared in *Lacerba* (vol. 1, no. 6, 15 March 1913, pp. 58–9).

80 Mindful of her independence, Valentine de Saint-Point distanced herself from the Italian Futurists. Most Parisian artists and critics kept away from her, with the exception of the Delaunays and Cendrars, who had friendly relations with her and Ricciotto Canudo, and encouraged them in their non-conformist propaganda work. Despite the poor repercussions of her Futurist proclamations in Paris, her stances enjoyed a degree of success abroad, in particular in several European capitals.

81 Quoted in V. Marcadé, *Le Renouveau de l'art pictural russe*, (Lausanne: L'Âge d'homme, 1971), p. 210.

82 The title of the magazine was borrowed from the war cry of the Kings of France, used in a stanza of the *Chanson de Roland*. From 1914 on, the publication dates of *Montjoie !* became more spaced out.

83 Speech published in *Lacerba* (vol. 1, no. 5, 1 March 1913, pp. 37–41), under the title "Il Discorso di Roma", then distributed in the form of a manifesto; G. Lista, *Futurisme. Manifestes…*, op. cit., pp. 114–19.

Luigi Russolo, *L'Art des bruits. Manifeste futuriste,*
dated "Milan, 11 March 1913"

Cover of the almanac (magazine-compendium)
of the Union of Youth (St. Petersburg), no. 3, 1913.
Cover drawing by I. Skol'nik

L'ART DES BRUITS

Manifeste futuriste

Mon cher Balilla Pratella, grand musicien futuriste,

Le 9 Mars 1913, durant notre sanglante victoire remportée sur 4000 passéistes au Théâtre Costanzi de Rome, nous défendions à coups de poing et de canne ta **Musique futuriste,** exécutée par un orchestre puissant, quand tout-à-coup mon esprit intuitif conçut un nouvel art que, seul, ton génie peut créer: l'Art des Bruits, conséquence logique de tes merveilleuses innovations.

La vie antique ne fut que silence. C'est au dix-neuvième siècle seulement, avec l'invention des machines, que naquit le Bruit. Aujourd'hui le bruit domine en souverain sur la sensibilité des hommes. Durant plusieurs siècles la vie se déroula en silence, ou en sourdine. Les bruits les plus retentissants n'étaient ni intenses, ni prolongés, ni variés. En effet, la nature est normalement silencieuse, sauf les tempêtes, les ouragans, les avalanches, les cascades et quelques mouvements telluriques exceptionnels. C'est pourquoi les premiers sons que l'homme tira d'un roseau percé ou d'une corde tendue, l'émerveillèrent profondément.

Les peuples primitifs attribuèrent au son une origine divine. Il fut entouré d'un respect religieux et réservé aux prêtres qui l'utilisèrent pour enrichir leurs rites d'un nouveau mystère. C'est ainsi que se forma la conception du son comme chose à part, différente et indépendante de la vie. La musique en fut le résultat, monde fantastique superposé au réel, monde inviolable et sacré. Cette atmosphère hiératique devait nécessairement ralentir le progrès de la musique, qui fut ainsi devancée par les autres arts. Les Grecs eux-mêmes, avec leur théorie musicale fixée mathématiquement par Pythagore et suivant laquelle on admettait seulement l'usage de quelques intervalles consonnants ont limité le domaine de la musique et ont rendu presqu'impossible l'harmonie qu'ils ignoraient absolument. La musique évolua au Moyen Age avec le développement et les modifications du système grec du tétracorde. Mais on continua à considérer le son dans son déroulement à travers le temps, conception étroite qui persista longtemps et que nous retrouvons encore dans les polyphonies les plus compliquées des musiciens flamands. L'accord n'existait pas encore: le développement des différentes parties n'était pas subordonné à l'accord où ces parties pouvaient produire ensemble: la conception de ces parties n'était pas verticale, mais simplement horizontale. Le désir et la recherche de l'union simultanée des sons différents (c'est-à-dire de l'accord, son complexe) se manifestèrent graduellement: on passa de l'accord parfait assonant aux accords enrichis de quelques dissonances de passage, pour arriver aux dissonances persistantes et compliquées de la musique contemporaine.

L'art musical recherche tout d'abord la pureté limpide et douce du son. Puis il amalgama des sons différents, en se préoccupant de caresser les oreilles par des harmonies suaves. Aujourd'hui l'art musical, recherche les amalgames de sons les plus dissonants, les plus étranges et les plus stridents. Nous nous approchons ainsi du *son-bruit.* **Cette évolution de la musique est parallèle à la multiplication grandissante des machines** qui participent au travail humain. Dans l'atmosphère retentissante des grandes villes aussi bien que dans les campagnes autrefois silencieuses, la machine crée aujourd'hui un si grand nombre de bruits variés que le son pur, par sa petitesse et sa monotonie ne suscite plus aucune émotion.

Pour exciter notre sensibilité, la musique s'est développée en recherchant une polyphonie plus complexe et une variété plus grande de timbres et de coloris instrumentaux. Elle s'efforça d'obtenir les successions les plus compliquées d'accords dissonants et prépara ainsi le **bruit musical.**

Cette évolution vers le son-bruit n'est possible qu'aujourd'hui. L'oreille d'un homme du dix-huitième siècle n'aurait jamais supporté l'intensité discordante de certains accords produits par nos orchestres (triplés quant au nombre des exécutants). Notre oreille au contraire s'en réjouit, habituée

Larionov set forth the principles behind his new movement: Rayonism.

Beginning of March: St. Petersburg, Žuravl' [The Crane], published *Sadok sudej II* [A Trap for Judges II], an anthology of the "Hylean" Futuroslavs including writings by David Burliuk, Khlebnikov, Mayakovsky, (illustrated by David Burliuk, Goncharova, Elena Guro, Khlebnikov and Larionov).

March: in the third and last almanac of the Union of Youth publication of voluminous excerpts from the book On *"Cubism"* by Gleizes and Metzinger, translated and commented on by Matiushin and accompanied by passages from Ouspensky's *Tertium Organum.* In the same year, 1913, the entire text was published in St. Petersburg in the translation by Ekaterina Nizen, and in Moscow in the one by Maximiliane Volochin.

11 March: Russolo's manifesto *The Art of Noises*[84], dedicated to the "great Futurist musician Balilla Pratella": "On 9 March 1913, during our bloody victory over 4,000 past-lovers at the Costanzi Theatre in Rome, we defended with punches and sticks your *Futurist Music,* played by a mighty orchestra, when all of a sudden my intuitive mind came up with a new art which your genius alone can create: the Art of Noises, a logical consequence of your marvellous innovations."[85] In Russolo's manifesto, he challenged the hierarchy of sounds and noises inherent to the modern world: "In the resounding atmosphere of large cities as well as in formerly noiseless countrysides, the machine today creates such a large number of varied noises that pure sound no longer arouses any emotion, because of its smallness and its monotony."[86] For him, music should follow this evolution by producing not only sounds but also noises, making it possible to experience "infinitely more pleasure in ideally combining the noises of trams, cars, vehicles, and shrill crowds

than in listening, for example, to the *Eroica* or the *Pastoral.*"[87]

17 March: with the publisher Eugène Figuière, Apollinaire brought out *The Cubist Painters: Aesthetic Meditations,* a collection which included a certain number of articles which had already appeared in the magazine *Les Soirées de Paris,* as well as some studies of 'new painters' (Braque, Duchamp, Duchamp-Villon, Gleizes, Gris, Metzinger, Marie Laurencin and Picasso). In this book, the poet proposed an historical account of Cubism, with its distinctive features specified, but his work was the target of sharp criticism: "With regard to the *Aesthetic Meditations* which form the text of the volume, I shall thus say nothing except express my admiration for the virtuosity with which the author defends the oddest of paradoxes ... As for the reproductions of Cubist canvases embellishing the volume, they are undeniably interesting, through them we can follow the dizzy march of the masters of the Cubist School towards their ideal of obscurity, and we can see how, over the past two years, they have succeeded, with every exhibition, in pushing ever further back the limits of incomprehensibility. But what a pity that these reproductions only have to do with Cubism! It might have been possible to show, with the support of documents, how from Impressionism, then from Neo-Impressionism and Pointillism, we have arrived at Sauvagism, Futurism and Cubism."[88] Neither Picasso nor Kahnweiler greatly appreciated the book. The painter wrote to his dealer: "You are giving me very sad news about discutions [*sic*] on painting. I have received Apollinaire's book on Cubism. I am quite upset by all this gossip."[89] In reaction, Apollinaire turned to Kahnweiler: "I understand that you are of the opinion that what I have to say about painting is not interesting, which, coming from you, seems strange to me—I have defended

Cover of the magazine *Montjoie !* (Paris), supplement to issue 3, 18 March 1913 (report by Guillaume Apollinaire on the Salon des Indépendants)

Waltz attributed to Marinetti by the magazine *Fantasio* (Paris), 15 April 1913. Giovanni Lista Archives, Paris

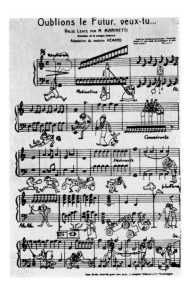

alone in writing various painters whom you have only chosen in my wake."[90]

19 March–18 May: in Paris, the Salon des Indépendants saw the emergence of a new Cubist tendency called Orphism, which marked the comeback of colour and a refinement of forms. Among the works exhibited were canvases by Delaunay (including *The Cardiff Team (third representation)*, 1913, cat. 57), Gleizes (including *The Footballers*, 1912–13), Kupka, Léger, Stanton Macdonald-Wright, Metzinger and Russell.

Apollinaire became the self-appointed champion of this new direction: "If Cubism is dead, long live Cubism. The reign of Orpheus is beginning."[91] "This year, the Salon des Indépendants is more alive than ever; in it, the latest painting schools are represented: Cubism, Impressionism of forms, and its latest tendency, Orphism, pure painting, *Simultaneity*."[92] Apollinaire's ideas, closely associating "pure painting" and "simultaneity", lay at the root of a controversy over the authorship and meaning of the concept of simultaneity. This would pit Boccioni violently against Delaunay between November 1913 and March 1914.[93]

23 March: in Moscow, the conference titled "The East, Nationalism and the West" was held, a day of debate organised by Larionov who gave a talk on "Rayonism". Ilya Zdanievich gave a lecture on "Marinetti's Futurism", flaunting men's shoes "more lovely than the *Venus de Milo*", which caused such an outcry that the police had to be called in.

23–24 March: in St. Petersburg, two public debates were organised by the Union of Youth, with talks by David Burliuk ("The Art of Innovators and Academic Art in the 19th and 20th Centuries") and Malevich ("The Knave of Diamonds and The Donkey's Tail"). During this event a manifesto-like tract by Rozanova was also distributed.

24 March–7 April: in Moscow, Larionov organised the exhibition *The Target*, which confirmed the break, already triggered with the exhibition *The Donkey's Tail*, between his group and the Knave of Diamonds group (which he rebuked for its dependency on Munich painters, Cézannian principles and avant-garde French painters). *The Target* was the last in a cycle of exhibitions commencing with *The Knave of Diamonds* and followed up with *The Donkey's Tail*.[94] Malevich exhibited his *Portrait of Ivan Kliun* (1912, cat. 95). The exhibition catalogue included a manifesto text co-signed by Larionov. Publication of the Russian translation of the *Technical Manifesto of Futurist Painting*, which Exter had brought back from Paris.

1 April: in issue no. 7 of *Lacerba,* Boccioni published "Futurists Plagiarised in France", an article which also helped to fuel the violent controversy between French and Italian painters over the authorship and meaning of the concept of simultaneity: "The Cubists are thus embarking on a new direction, to judge by what G. Apollinaire writes in the new magazine *Montjoie !* … edited by our friend Ricciotto Canudo, a native of Bari. With this new tendency, the Cubism dubbed "Impressionism of forms", according to Apollinaire, is entering a final and glorious phase: "… Orphism, pure painting, simultaneity…" … And there you have it, as many obvious plagiaries of what has formed, from its earliest appearances, the essence of Futurist painting and sculpture. This is how our colleagues from France acknowledge the solidarity, sincerity and sympathy which we have always shown towards them. They copy us, and pretend to ignore us … But we insist on sorting things out. Orphism, let us say right away, is just an elegant masquerade of the basic principles of Futurist painting. This new trend simply illustrates the profit that our French colleagues managed to derive from our

first Futurist exhibition in Paris".[95] This controversy had many different repercussions between November 1913 and June 1914: Apollinaire, Boccioni, Delaunay, Carrà, Papini and Soffici in turn all published articles in which each one claimed authorship of the disputed concept.[96]

7 April–7 May: in London, huge success awaited Severini's one-man show ("The Futurist Painter Severini Exhibits his Latest Works") at the Marlborough Gallery. The Severinis took advantage of his London stay during the month of April to meet the Nevinsons on the 13th. In addition, the Italian painter prepared Marinetti's upcoming journey to the English capital, planned for the autumn.

15 April: Del Marle confirmed his membership of the Futurist movement with the publication of "Futurist Painting" in issue no. 8 of the *Nord illustré* (Lille).

Late April: Larionov's brochure *Lučizm* [Rayonism] was published in Moscow by the publisher Munster; it was regarded as the first manifesto of the genre[97]: "Rayonism is the painting of those non-tangible forms, those *infinite* products in which the whole space is filled. … It wants to consider painting as an end in itself, and no longer as a means of expression."[98]

5 May: at the Vassilieff Academy, Léger gave a lecture titled "Essay on the Origins of Contemporary Painting and on its Representative Value."[99] In it he advocated a new "realism" by contrasting it with the imitative realism of previous painting: "If the imitation of the object in the field of painting had a value *per se*, all pictures by just anybody with an imitative value would in addition have a pictorial value; since I don't believe it's necessary to emphasise and discuss any such case, I would therefore affirm something already stated, but which must be repeated here: "The realist merit of a work is thoroughly independent of any imitative quality."[100]

84 A report on this manifesto was published in the *Paris-Journal* of 1 April 1913. Russolo later published an eponymous book (Milan: Edizini futuriste di *Poesia*, 1916).

85 L. Russolo, *L'Art des bruits*; G. Lista, *Futurisme. Manifestes…*, op. cit., p. 312.

86 Ibid., p. 323.

87 Ibid.

88 L. Perceau, *La Guerre sociale*, 7–13 May 1913; quoted in G. Apollinaire, *Les Peintres cubistes. Méditations esthétiques,* (Paris: Hermann, 1980), p. 163.

89 Picasso to Kahnweiler, 11 April 1913, Céret; *Donation Louise et Michel Leiris. Collection Kahnweiler-Leiris*, exh. cat., Paris, 22 Nov.1984–28 Jan. 1985, p. 170.

90 Letter from Apollinaire to Kahnweiler; W. Spies, "Vendre des tableaux – donner à lire", *Daniel-Henry Kahnweiler, marchand, éditeur, écrivain…*, p. 35. According to W. Spies, p. 34, it was sent to Picasso in late April 1913.

91 G. Apollinaire, "Le Salon des indépendants", *Montjoie !* (Paris), 1, no. 4, 29 March 1913, p. 7; id., *Écrits sur l'art*, op. cit., p. 540.

92 Id., "À travers le Salon des indépendants", *Montjoie !*, 1, supplement to no. 3, 18 March 1913, p. 1; ibid., p. 529–30.

93 See Ester Coen's essay, "Simultaneity, simultaneism, simultanism", in this volume, p. 60.

94 After the exhibition *The Target*, the shows organised by Larionov would be identified by a number.

95 U. Boccioni, "Les futuristes plagiés en France", published in Italian in *Lacerba* (Florence), i, no. 7, 1 April 1913, pp. 66–8; G. Lista, *Futurisme. Manifestes…*, op. cit., pp. 387–88.

96 See articles by G. Apollinaire ("Chronique mensuelle", *Les Soirées de Paris*, no. 18, 15 Nov. 1913, pp. 2–6; "Le Salon d'automne (suite)", *Les Soirées de Paris*, no. 19, 15 December 1913, pp. 46–49; "La Vie artistique. Au Salon des indépendants", *L'Intransigeant* (Paris), 5 March 1914; id., *Écrits sur l'art*, op. cit., p. 650), by U. Boccioni "Simultanéité futuriste" *Der Sturm* (Berlin), 15 Dec. 1913, nos. 190–191, p. 151), by R. Delaunay ("Lettre ouverte au Sturm", *Der Sturm*, nos. 194–95, 15 Jan. 1914, p. 167 and "Au Salon des indépendants. Réponse à une critique", *L'Intransigeant*, 6 March 1914, p. 2), by C. Carrà, G. Papini and A. Soffici ("Une querelle artistique", *L'Intransigeant*, 8 March 1914, p. 2).

97 The magazine *Montjoie !* published this text in French, under the title "Le rayonnisme pictural" (2, no. 4–5–6, April–May–June 1914, p. 15), attesting to the steady relations between the French and Russian artists of the day.

98 M. Larionov, "Le Rayonnisme", *La Queue d'âne et la Cible*, in *Une avant-garde explosive*, edited, translated and annotated by M. Hoog and S. de Vigneral, (Lausanne: L'Âge d'homme, 1978), p. 84.

99 The text of this lecture would be published in *Montjoie !* (Paris), 1, no. 8, 29 May 1913, p. 7 and 1, nos. 9–10, 14–29 June 1913, pp. 9–10; E. Fry, *Cubism*, (London: Thames and Hudson, 1966.

100 F. Léger, "Les origines de la peinture et sa valeur représentative", *Montjoie !*, 1, no. 8 and nos. 9–10, 29 May 1913, p. 7 and 14–19 June 1913, pp. 9–10; E. Fry, ibid., p. 120.

Cover of the catalogue for the exhibition of sculptures by Umberto Boccioni, Paris, Galerie La Boétie, 20 June–16 July 1913

Boccioni in his studio, ca. 1913, with the sculpture *Synthesis of Human Dynamism* in the foreground (lost?)

Cover of no.18 of the magazine *Lacerba* (Florence), 15 September 1913, the mouthpiece of Futurism, edited by Giovanni Papini and Ardengo Soffici

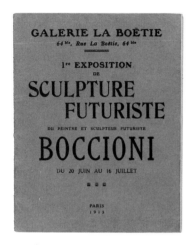

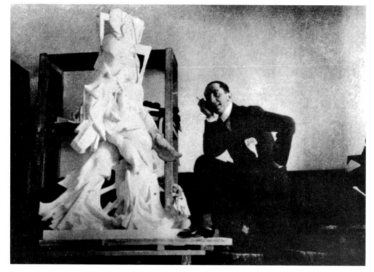

11 May: Marinetti published *Imagination without Wires and Words at Liberty*, a manifesto which he would read out on 22 June during his contradictory lecture, i.e. one giving more than one viewpoint, organised as part of the exhibition of Boccioni's sculptures.[101]

16 May: Valentine de Saint-Point published "Théâtre de la femme" in *Montjoie !* (I, no. 7: "Issue devoted to the Crisis in French Theatre", p. 6).

18 May–15 June: the Rotterdam Kunstkrink hosted the exhibition *The Italian Futurist Painters and Sculptors*. In it were the same works as those shown in Rome in February, to which were added three new canvases by Russolo and two Boccioni sculptures.

May: Nevinson, painter of pictures calling for Futurist stylistic technique and iconography (see *The Departure of the Train de Luxe*, c. 1913, lost), stayed in Paris where he once again saw Severini.

2 June: in Modena, at the Storchi Theatre, Russolo gave the first concert by Futurist *intonarumori* ("noise-makers"), during which the public discovered the instrument termed "discharger". This concert was followed on 11 August by a presentation at the Red House in Milan of four compositions by an orchestra made up of sixteen "noise-makers".[102]

20 June–16 July: at the La Boëtie Gallery, the *First Exhibition of Futurist Sculpture by the Futurist painter and sculptor Boccioni* (*Development of a Bottle in Space*, 1912, cat. 79), visited in particular by Popova. At the opening, Del Marle made the acquaintance of the sculptor and of Marinetti. A contradictory lecture on Futurist sculpture, with Boccioni and Marinetti both speaking, took place in the gallery on 27 June. Kahn let his reservations about this show be known: "Mr. Boccioni is currently exhibiting some sculptures and I still owe him all the truth, or at least all the honesty,

because I may well be mistaken, and simply perplexed by the novelty of his effort; I think he's on the wrong track. In these experiments with the dynamism of forces, I do indeed find his relief and his vigour, but I fail to see their rational use ... It is irksome that a painter such as Mr. Boccioni should condescend to these little games of juxtaposition of artistic matter—paint—and vulgar materials as practised, and quite mistakenly, apart from the example of the more gifted, by one or two lost offspring of Cubism. It will never be artistic to mix with clay, or stick to the canvas, glass, hair, or cut timber ... His determination to follow in space the forms of a finite and inert object, like a bottle, cannot lead him to the work of art ... This is a leap into the invisible and it is in no way a leap towards any kind of harmony. Mr. Boccioni is just, I do believe, at a stage in his research."[103]

June: in Florence, *La Voce*'s Libreria publishing arm produced Soffici's *Cubismo e oltre* [Cubism and Beyond], which brought together a certain number of articles previously published in the magazine *Lacerba*.

8 July: in London, the official opening of Omega Workshops (an applied arts association guaranteeing a certain financial security for artists) founded by Fry, Duncan Grant and Vanessa Bell. Its members included Frederick Etchells, Henri Gaudier-Brzeska, Cuthbert Hamilton, Lewis and Wadsworth.

10 July: Del Marle published the *Futurist Manifesto against Montmartre*[104], a scathing criticism of the Montmartre-based painters described as "romantic old lepers". The tone of this manifesto was very Marinettian: "INTREPID DEMOLISHERS!!!/ MAKE ROOM FOR THE PICKAXES!!!/ MONTMARTRE MUST BE DESTROYED!!! ... Like us, you will try to release all the new beauty from the geometric constructions of stations, electric appliances and aeroplanes of all our whirlwind life of steel, fever and speed. THERE

ARE DEAD PEOPLE WHO MUST BE KILLED. MONTMARTRE MUST BE KILLED."[105] The publication of this manifesto stirred up a media furore initiated by Severini who, in a letter addressed to Salmon, wrote: "I ask you to note that the *Futurist-style* manifesto to which you allude in today's *Gil Blas* is a plagiary by someone who wants to sing his own praises with the help of Futurism. It is easy to realise the total artistic worthlessness of this gentleman when you see the photos published by one of your colleagues. The Futurist group is totally ignoring him."[106] Marinetti put an end to this controversy on 28 July in an "Open Letter to the Futurist Mac Delmarle": "I have followed the debate you have been having with our friend Severini who is both a nice man and a great Futurist painter. You should know that we attach no importance to this petty personal misunderstanding which you might easily defuse if you meet him in the near future. All that counts are Futurism's explosive ideas. The Futurists may even perish, if need be, after launching these ideas."[107]

Mid-July: Varsanophie Parkin published *The Donkey's Tail and The Target* (Moscow, Munster), which included five texts, three of them by Larionov: "Rayonist Painting" (written in June 1912), "Rayonism" and "The Manifesto of the Rayonists and the Aveniriens"[108], co-signed by Larionov, Goncharova and eleven artists in his group, including Malevich and Tatlin. The authors of this manifesto collected and compared stinging critiques against the "parasites" and popularisers of modern art and against the main literary and artistic groups: "Enough of Knaves of Diamonds, who disguise beneath this name their art of misery, paper slaps delivered by a little baby's hand ...; enough of unions, old and young alike! We don't need to be vulgar and keep abreast of public taste; let those who give a slap on paper, and who, in fact, give alms, take care of that. Enough of

Marinetti at the *Erster deutscher Herbstsalon* in Berlin, Galerie Der Sturm, 20 September 1913. On the wall, left: *Portrait of Marinetti* by Gino Severini, right: *Simultaneity. Woman on the Balcony* by Carlo Carrà

dung, now it's time to sow … We cry out: the whole brilliant style of our day and age is in our trousers, our jackets, our socks, in trams, buses, aeroplanes, trains and steamboats; what enchantment, what a grand unparalleled age in world history."[109]

3 August: publication in *Gil Blas* of the "manifesto-synthesis" text *The Futurist Antitradition* by Apollinaire (dated 29 June), with this comment by Salmon: "Futurism is alive! It's Mr. Apollinaire … who has delivered the fatal blow by signing the manifesto we're going to read. It had to be done: to be more Futurist than Marinetti! Mr. Guillaume Apollinaire has succeeded, to our joy. Here is the document whose typographic originality we are sorry we are unable to respect completely … We shall keep the rose earmarked for us, dear poet, my friend, as a souvenir of the century's most colossal buffoonery. Futurism has lived, and that's well worth rejoicing over."[110] In any event, this manifesto found little coverage in the French press.

11 August: Carrà published *The Painting of Sounds, Noises, and Smells*, a manifesto glorifying the works shown at the *Exhibition of Futurist Painters* in February 1912, "that dizzy seething of forms and acoustic lights, rowdy and smelly … To obtain this *total painting* which calls for the active cooperation of all the senses: *painting of the plastic mood of the universal*, you have to paint the way drunkards sing and vomit, sounds, noises and smells".[111]

28 August: Apollinaire and Marinetti were the witnesses at Severini's marriage to Jeanne, Paul Fort's daughter.

August: publication in French, in *Der Sturm*, of Léger's article on "The Origins of Contemporary Painting and Its Representative Value."[112]

20 September–1 December: the *Erster deutscher Herbstsalon* ["First German Salon d'Automne"] was held in Berlin, organised by Walden in his Der Sturm Gallery, an event which brought together painters of the international avant-garde including Balla, Boccioni, David and Vladimir Burliuk, Carrà (with *Simultaneity. Woman on a Balcony*, 1912, cat. 37), Robert Delaunay (including *The Cardiff Team (third representation)*, Sonia Delaunay (with the maquette of *The Prose of the Transsiberian and of Little Jehanne of France*, 1913, cat. 58), Gleizes (with *The Footballers*, 1912–13), Goncharova, Larionov, Léger, Metzinger, Picabia, Severini, Soffici and Russolo.

29 September: Marinetti's manifesto *The Music Hall*.[113]

5 October: Lewis, having trouble complying with the Omega Rules, made the most of a financial blunder by Fry to break with him, taking with him Etchells, Hamilton and Wadsworth.

12 October–16 January 1914: in London, at the Doré Galleries, the *Post-Impressionist and Futurist Exhibition*, whose catalogue was prefaced by Frank Rotter, brought together many artists from different tendencies. The painters exhibiting included Robert Delaunay, Epstein, Etchells, Hamilton, Lewis, Nevinson, Picasso, Severini and Wadsworth.

19 October: at the Moscow cabaret *The Pink Lantern*, Goncharova and Larionov caused a scandal by proposing to daub the spectators with paint, a prank going hand in hand with the publication of the proclamation "Why We Are Daubing Ourselves", signed by Larionov and Zdanievich: "We daub ourselves for a moment and the change of sensation calls to mind the change of daubing, the way one picture devours another picture, the way through the window of an automobile you see sparkling shop windows following on one from the other, this is our face."[114]

27 October–8 November: the Bernheim-Jeune Gallery in Paris hosted the exhibition *The Synchromists: Morgan Russell and Stanton Macdonald-Wright*. In the catalogue's preface, the two painters insisted that they differed from Orphism: "We reckon that the shift towards colour is the only direction which painters can take for the time being. So we will not talk here of Cubists or Futurists, finding, as we do, their efforts to be secondary and superficial, although we do not contest their legitimacy. In order to set down ideas and highlight the particular nature of our action through a contrast, let us first have a look at this young school of painting, Orphism. A superficial resemblance between the works of this school and a Synchromist canvas[115] exhibited at the last Salon des Indépendants permitted a certain number of critics to muddle the two: it was like mistaking a tiger for a zebra, on the pretext that both have a striped hide."[116]

10 November–12 January 1914: the 6th [and last] *Union of Youth exhibition* was held in St. Petersburg; at it were shown, among others, works by David and Vladimir Burliuk, Exter, Ivan Kliun, Malevich, Matiushin and Rozanova. The Larionov group did not take part.

November: the Éditions des Hommes Nouveaux published *The Prose of the Transsiberian and of Little Jehanne of France*, the "first simultaneous book", including a long poem by Cendrars and illustrations by Sonia Delaunay: "Blaise Cendrars and Mme. Delaunay-Terk have made a first attempt at written simultaneity, where colour contrasts accustomed the eye to read at a single glance the whole of a poem, the way a conductor reads, in one fell swoop, the superposed notes in the score, the way you see, in one fell swoop, the visual and printed elements of a poster."[117] With this book, the authors reaffirmed the anteriority of the concept of simultaneous painting claimed by the Italian Futurist painters. This painting-cumpoem also fuelled the controversy between the Delaunays, the Italian Futurists and the members of the phalanstery, in particular Barzun: "The

101 Manifesto published in Italian in *Lacerba*, vol. 1, no. 12, 15 June 1913, pp. 121–124. Reports were published in the 22 June issue of *Comœdia*, the *Paris-Journal* and *l'Excelsior* of 23 June, even before its distribution as a broadsheet, then in the *Gil Blas* of 7 July and the *Magazine de la revue des Français* of 10 July. Its English translation appeared in September 1913 in issue no. 3 of *Poetry and Drama*.
102 These concerts were at the root of the tract titled "Premier concert des bruiteurs futuristes" broadcast in French in September 1913 and published on the front page of *L'Intransigeant* of 30 September 1913, accompanied by this comment: "Futurist music does not soften mores"; G. Lista, *Futurisme. Manifestes…*, op. cit., pp. 317–18.
103 G. Kahn, "Première exposition de sculpture futuriste de M. Umberto Boccioni", *Mercure de France* (Paris), vol. 104, no. 386, 16 July 1913.
104 F. Del Marle published it at his own expense in the *Paris-Journal* of 13 July 1913. The manifesto appeared again in the 18 July 1913 issue of *Comœdia*, complete with cartoons and replies from Montmartre painters, then in *Lacerba* (vol. 1, no. 16, 15 August 1913, pp. 173–74) under the title *Manifeste futuriste contre Montmartre* and jointly signed by Marinetti. See G. Lista, *Futurisme. Manifestes…*, op. cit., pp. 119–21.
105 G. Lista, ibid., pp. 119–20.
106 G. Severini, Letter to A. Salmon, 18 July 1913, reprinted in *Gil Blas* and *Comœdia* on 19 July 1913; ibid., p. 390.
107 Letter translated into Italian and published in *Lacerba* (I, no.16, 15 Aug. 1913, pp. 173–74), accompanied by the *Manifeste futuriste contre Montmartre* in French. See G. Lista, *Futurisme. Manifestes…*, op. cit., p. 395.
108 "Avenirien" (translation of "budetlâne"): a neologism coined by Khlebnikov to differentiate between writers of the Russian avant-garde and Italian Futurists.
109 *Manifeste des rayonnistes et des aveniriens*, in *La Queue d'âne et La Cible*; quoted in M. Larionov, *Une avant-garde explosive*, op. cit., pp. 76–7.
110 The broadsheet with its typography, which, according to Carrà, was Marinetti's work, was published in French and Italian at the end of July. Its Italian version appeared two months later in *Lacerba* (vol. 1, no. 18, 15 Sept. 1913, pp. 202–03).
111 Published in Italian in *Lacerba* (Florence), vol. 1, no. 17, 1 Sept. 1913, pp. 185–86.
112 F. Léger, "Les origines de la peinture contemporaine et sa valeur représentative", *Der Sturm*, nos. 172–73, August 1913, pp. 76–9
113 Published in Italian in *Lacerba*, vol. 1, no. 19, 1 Oct. 1913, pp. 209–11; in English in the *Daily Mail* (London), 21 Nov. 1913 (under the title *The Meaning of the Music-Hall*); in Russian in *Iskusstvo*, no. 5, 1914.
114 The text of this manifesto was published in the magazine *Argus* (1913); see V. Marcadé, *Le Renouveau de l'art pictural russe*, op. cit., p. 218.
115 This was *Synchromy in green* by Russell.
116 M. Russell, S. Macdonald-Wright, "Introduction générale", exh. cat. *Les Synchromistes Morgan Russell et Stanton Macdonald-Wright*, Paris, Galerie Bernheim-Jeune, 27 October–8 November 1913, n.p.
117 G. Apollinaire, "Simultanisme – Librettisme", *Les Soirées de Paris*, no. 25, 15 June 1914, pp. 323–24.

La réponse du Pierrot Montmartrois au futuriste A.-F. M.c D.lm.rl.

(Dessin de Supparo.)

Cartoons illustrating the *Manifeste futuriste
à Montmartre* by Félix Del Marle, *Comœdia* (Paris),
18 July 1913, pp. 1–2

La scie à M.c D.lm.rl. (Dessin de Depaquit.)

poem of the Transsiberian generated debates in Parisian and foreign newspapers and magazines. Orphism had just been in full swing, Simultanism was coming into being amid much scandal."[118]

11 November: at a lecture in Moscow, Mayakovsky openly criticised Marinetti, who replied, on 31 December, in a letter sent to the newspaper *Russkie vedomosti* [Russian Bulletin]: "It is beyond any doubt that the Futurist theory, created by myself and my Italian friends, has spread in Russia with extraordinary speed, thanks to the literary success of my book *Futurism* which, judging from what I have just learned from my publisher Sansot, has sold better in Russia than in any other part of the world."[119]

15 November–5 January 1914: the Salon d'Automne was held in Paris, its participants including Duchamp-Villon, Gleizes, Kupka, Metzinger, Picabia (with in particular *Udnie*, 1913, cat. 63) and Jacques Villon: "Room 6— this is the most overtly Cubist, as has even been avowed by the recalcitrant jury members, with resignation … Since the Cubists broke with the tight discipline of a school and the sectarianism that often used to bother me, Gleizes has enriched his palette. He is showing his most beautiful gifts as a colourist in a large industrial landscape, *Une Chicane*: let us leave to the Futurists this affectation, stolen from Picasso, of writing down, here and there, names and figures. It is a very puerile homage which, repeated too often, verges on vulgarity. Gleizes would be wise to give it up."[120]

16–20 November: passing through London, Marinetti gave some poetry recitals in the hot spots of the local avant-garde, the *Cave of the Golden Calf* (where he met Bomberg), The Poetry Bookshop, Clifford Inn Hall, and at the Doré Galleries. Describing these poetry readings, the English poet Richard Aldington wrote:

"Mr. Marinetti is currently reciting his new poems in London. London is vaguely alarmed and wonder-struck and doesn't know whether to laugh or not. It is mind-boggling that a sullen Anglo-Saxon should be looking at the prodigious gesticulations of Mr. Marinetti."[121] On the 18th, at the Florence restaurant in London, Lewis and Nevinson organised a dinner in honour of Marinetti, to which were invited, among others, Etchells, Hamilton and Wadsworth. Between November 1913 and June 1914, Marinetti gave more than ten lectures in the English capital.

30 November–18 January 1914: in Florence, the "Esposizone di pittura futurista di *Lacerba*", held in the Gonnelli Gallery, showed works by Balla, Boccioni, Carrà, Russolo, Severini and Soffici. For the duration of the show the artists commented on their works to the visitors.

November: André Billy, weary from financial troubles and a lack of collaborators, handed the editorship of *Les Soirées de Paris* over to Apollinaire. Henceforth backed by funding from Baroness d'Œttingen (who, with Ferat, used the alias Jean Cérusse), the magazine became—to borrow Billy's own words—"the organ of the newest, most advanced trends in poetry and art."[122]

2–5 December: two Cubo-Futurist spectacles were put on alternately at the Luna-Park theatre in St. Petersburg: *Vladimir Mayakovsky, Tragedy* by Mayakovsky (played by the author, with sets by Filonov and Viktor Chkolnik) and *Victory over the Sun*, an opera by Matiushin (with a prologue by Khlebnikov, a libretto by Alexei Kruchenykh, and sets and costumes by Malevich).

12 December: a Futurist evening was organised at the Verdi theatre in Florence, during which the public broke into a violent uproar.

16 December 1913–14 January 1914: the Brighton Art Gallery opened its doors to the exhibition *English Post-Impressionists, Cubists*

and Others. Works by Bomberg, Epstein, Etchells, Hamilton, Lewis, Nevinson, William Roberts and Wadsworth were shown in one and the same room.

20 December: at the Comédie des Champs-Elysées, the premiere was held of Valentine de Saint-Point's *La Métachorie*, a work aimed at the creation of a new art based on the dislocation between music and the choreographic movement.[123] "Instead of an instinctive and sensual dance, I dreamed of a dance which would be the equal of all the other arts by being inferior to none of them, and above all not to music … I am trying to express an idea, the spirit that informs one of my poems … So *La Métachorie* instead of turning dance into a slave, makes it an equal of modern music that has evolved cerebrally in a way diametrically opposed to the dance of our day and age."[124]

22 December: in St. Petersburg, at the artists' cabaret *The Stray Dog*, the literary critic Alexander Smirnov, a close friend of Sonia Delaunay, gave a lecture titled "Simultaneity, New Trend in French Art", during which he showed the audience a copy of *The Prose of the Transsiberian and of Little Jehanne of France*

28 December: Boccioni gave a lecture at the Sprovieri Gallery in Rome. In that early winter period, he also wrote a *Manifesto of Futurist Architecture*, which would remain unpublished.

December: first mention of the term "vortex" in a letter from Ezra Pound to William Carlos Williams. The English painters came up with the idea of creating a magazine which Nevinson suggested be called *Blast*.

Severini wrote "Great Religious Art of the 20th Century. The Painting of Light, Depth, and Dynamism"[125], as well as a manifesto in which he developed the concept of the plastic analogies of dynamism: *The Plastic Analogies of Dynamism. Futurist Manifesto*, which remained unpublished until 1957.[126]

118 R. Delaunay, "Sonia Delaunay-Terk", *Du cubisme à l'art abstrait* (previously unpublished documents published by P. Francastel and followed by a catalogue of the œuvre of R. Delaunay prepared by G. Habasque), (Paris: SEVPEN, 1958), pp. 201–02.
119 Quoted in J.-P. Andréoli de Villers, "Marinetti et les futuristes russes lors de son voyage à Moscou en 1914", *Ligeia* (Paris), nos. 69–72, July-Dec. 2006, p. 134.
120 A. Salmon, "Le Salon d'automne", *Montjoie !*, 1, no. 11–12, November–December 1913, pp. 5 and 6.
121 R. Aldington, *The New Freewoman* (London), 1 December 1913; quoted in R. Cork, *Vorticism and Abstract Art in the First Machine Age*, vol. 1: *Origins and Development*, (London: Gordon Fraser, 1976), p. 224.
122 A. Billy, preface to the exhibition catalogue for "Les Soirées de Paris", Paris, galerie Knoedler, 16 May–30 June 1958, n.p.
123 A veritable undertaking to revive the choreographic art that Valentine de Saint-Point promoted in her studio as well as in her lectures. The first such took place in Paris on 29 December 1913; excerpts were published in issue no. 7 of the *Miroir* on 11 January 1914.
124 The text of this manifesto was published in *Montjoie !*, 2, no. 1–2 : "Numéro consacré à la danse contemporaine", Jan.–Feb. 1914, pp. 5–7 (where also appeared the *Manifeste de l'art cérébriste* by Canudo, p. 9); G. Lista, *Futurisme. Manifestes…*, op. cit, p. 255.
125 Text published for the first time in *Mostra antologica di Gino Severini*, (Rome, Palazzo Venezia, 1961), pp. 32–7.
126 The first title proposed for this manifesto to be published in the magazine *Lacerba* was *Le Analogie plastiche del dinamismo*. In 1957, Severini translated it into French to meet the needs of the *Dictionnaire de la peinture abstraite* by M. Seuphor (Paris: Hazan, 1957), pp. 91–6. This French version had many variants in relation to the Italian version published in *Archivi del futurismo*, texts compiled and commented

Valentine de Saint-Point in a "danced poem", 1913

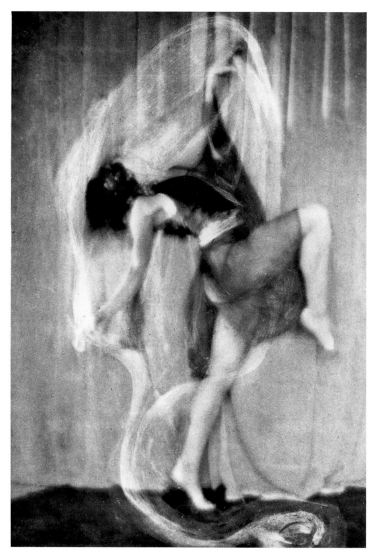

In Russia, *Futurism Unmasked* by Vadim Cherchenevich was published, as was *The Future* by Constantin Bolchakov, a lithographed poem illustrated by Goncharova and Larionov, whose drawings, deemed scandalous, would lead to the book being seized. The print run for *Parnassus Roars*[127] was financed by Ivan Puni and his wife Xenia Boguslavskaya, and also involved the painters Pavel Filonov and Rozanova. The violence of the attacks, the determination to demolish the adversaries were totally contained in the very first sentence of *Parnassus Roars*—"Get lost!"—which ended with much boasting in regard to other Russian art trends: "Today we are spitting out the past that had got stuck in our teeth, and we are communicating: Only in our group have all the Futurists been brought together. We have rejected our haphazard nicknames of 'ego' and 'cubo' and we have joined together in the sole literary company of the Futurists." (Signed David Burliuk, Alexis Kruchenykh, Benedikt Livshits, Vladimir Mayakovsky, Igor Severianin, and Viktor Khlebnikov).

upon by M. Drudi Gambillo and T. Fiori, (Rome: De Luca Editore, vol. 1, 1958) pp. 76–80.

127 Before it went on sale, the censors confiscated almost all the copies of this compilation because of the drawings by D. and V. Burliuk and Filonov, and because of indecent language.

128 P. W. Lewis, quoted by L. Veza, "Marinetti et le vorticisme", in *Présence de Marinetti*, Proceedings of the international conference held at UNESCO, J.-C. Marcadé (ed.), (Lausanne: L'Âge d'homme, 1982), p. 280.

129 Ibid.

130 F. T. Marinetti, *Down with the Tango and Parsifal* (Milan, 11 Jan. 1914), *Lacerba*, vol. 2, no. 2, 15 Jan. 1914, p. 27 (the text, in Italian and English, also appeared in tract form).

131 *Iz istorii russkogo futurizma* [Extracts from the history of Russian Futurism]; this unpublished manuscript by Kamienski is to be found in the department of manuscripts in the Lenin Library in Moscow and bears the date 26 January 1914; quoted in V. Marcadé, *Le Renouveau de l'art pictural russe*, op. cit., p. 211.

132 Marinetti described his stay in Moscow in his book *Sensibilità italiana nata in Egitto* (Milan: Mondadori, 1969), pp. 296–317.

133 The number of lectures given by Marinetti during his trip in Russia varies from six to eight, depending on the source.

134 V. Cherchenevich, "Letter to the Editor. A Futurist talks about Marinetti", *Nov*, 28 January 1914, quoted in V. Marcadé, *Le Renouveau de l'art pictural russe*, op. cit.

135 At the end of 1913, Yakulov, who had spent the summer with the Delaunays, was regarded as the representative of Russian Simultaneism.

136 V. Cherchenevich, "Letter to the Editor", *Nov*, 28 Jan. 1914, op. cit.

137 Malevich had written an open letter condemning Larionov's attitude toward Marinetti.

138 M. Larionov, "Letter to the Editor", *Nov*, 29 January (11 February) 1914.

139 Marinetti gave a third lecture in Moscow on 30 January (after which Larionov violently accosted him); its programming was a result of the success of the first two.

1914

This year marked a moment when the Russian Cubo-Futurists and the Vorticists kept their distance from Marinettian Futurism.

1 January: in an article published in the London magazine *The Egoist*, Lewis came out against Marinetti's Futurism; the pictorial revolution responded, in his opinion, to a need for stability: "The vortex proclaims the energy of immobility, the intensity of its centre, of its standstill whirlwinds, emptied at last of their strength, the effort of concentric gyrations to be attached to the tip of this cone which Vorticism extols in accordance with the pithy formula of the sculptor Gaudier-Brzeska: 'We have crystallised the sphere as a cube.'"[128] For Lewis and Pound, Marinetti was also associated with backward-looking Impressionism: "We are all Futurists insofar as we think along with Guillaume Apollinaire that we can't carry everywhere with us the corpses of our fathers. But 'Futurism', when applied to art, is largely a descendant of Impressionism. In a way it's a speeded-up Impressionism."[129]

8 January: in Rome, a Futurist evening at the Sprovieri Gallery.

11 January: Marinetti's proclamation *Down with the Tango and Parsifal!*[130].

26 January: in an article titled "Facts Taken from the History of Russian Futurism", Kamienski also came out against Italian Futurism: he asserted that the emergence of a new aesthetic tallying with the contemporary industrial world appeared as early as 1907 in Russia, Marinetti's ideas having merely theorised the impetus of a movement already in motion: "Our energy is the energy of radium. Our era is an era of rebirth. Our advent is the event of truth, clad in the ultraviolet fabrics of the future. / Our creation = intuition + knowledge + ardour … / Our century = the aero-century, speed, the beauty of form. / Our principle = the dazzling

renewal of man's feelings under the influence of scientific discoveries. / Our song is an intoxicated canticle about the degrees of the temple of art."[131]

January: the Futurists, including Marinetti, occupied Bologna University for a few days, to introduce the students to their movement.

Late January: invited by Genrikh Edmundovich Tasteven, Russian representative of the Société des grandes conférences de Paris and publisher of the Symbolist magazine *The Golden Fleece*, Marinetti went to Russia[132]: in Moscow and in St. Petersburg, he gave eight lectures in French.[133]

The Russian Futurists were not unanimous about the reception to be accorded the leading light of the Italian movement. Lamenting the ideas put across by Larionov, who summoned people to attack Marinetti, some influential Russians were up in arms: "With regard to the arrival of F. T. Marinetti, Mr. Larionov has declared: 'Marinetti has betrayed the principles of Futurism, which is why we, who hold Futurism dear, will smother that renegade with rotten eggs, we shall splatter him with yoghurt, etc.' Of course, it is not for Mr. Larionov to judge what Marinetti has done for Futurism and, what is more, I am still perplexed: what does he mean by the words 'we, who hold Futurism dear?' I ask you to inform your readers that Mr. Larionov's words and threats bear no relation to the intentions of the Russian Futurists, for, although we also hold Futurism dear, no one amongst us has any desire to display an obvious lack of culture at the Marinetti lecture."[134] "Mr. Larionov assures us that Futurism is the past, for we now have Rayonism. But if we judge everything solely by dates, Rayonism is also the past, for there is Simultaneism.[135] … Once again, I regret that my friends Messrs. Vl. Mayakovsky, I. Severianin, R.I. Ivnev, D. Burliuk, Kamiensky and others are

not in Moscow and cannot endorse my letter with their signatures."[136]

The response of the Rayonist leader was not long in coming: "For greater clarity, I would add that it might behove us to regard as true the fact that Marinetti deserves only the rotten eggs of the Futurists of today, and that the only people applauding him are the Russian petit bourgeois. Personally, I consider Marinetti's ideas of little interest and long since outdated. It should be stressed that those who have imitated him, received and written letters to defend him are not true Futurists in the sense which Marinetti is spreading abroad … In answer to Mr. Malevich[137], who insists on setting himself apart from me, I can say that I am no longer bound by any community of artistic opinions, and I am amazed that he numbers himself among the Futurists. For me, Mr. Malevich as Futurist is a native who has not been colonised."[138]

26–27 January: in Moscow, Marinetti gave two lectures[139] to two large audiences, but with no Russian Futurists present: one, titled "Futurism in Italy", at the Polytechnicum Museum, the other at the Conservatory of Music, where he gave a reading of the first part of his book *Zang Tumb Tumb*, and launched "words in freedom".

31 January: Marinetti left Moscow for St. Petersburg, where two lectures were organised on 1 and 4 February at the premises of the Kalachnikov stock exchange. Just as in Moscow, the absence of most of the Russian Futurists was noted: Burliuk, Kamiensky, Mayakovsky and Igor Severianin undertook a "propaganda tour" of their movement throughout southern Russia: "At the time of our hikes through the provinces, we followed from afar the tragicomic conquest of Moscow by Mr. Marinetti. Because we have realised that the authors of articles on Italian Futurism were completely disconcerted by our absence—so

Anon., Futurist evening with Carlo Carrà,
Luigi Russolo, F. T. Marinetti on the stage
of the Teatro del Corso in Bologna in 1914.
Giovanni Lista Archives, Paris

where are the Russian Futurists, what do they think about Mr. Marinetti and what side will most of them take, Larionov & Co (the rotten eggs) or Tasteven (the bunch of flowers)?—we believe it is our duty to declare here that, two years ago already, in *The Trap for Judges II*, we indicated that we had nothing in common with the Italian Futurists, except the name, because, in art, the lamentable conditions in Italy cannot measure up to the high voltage of Russian artistic life over the past five years."[140]

In St. Petersburg it was Livshits and Khlebnikov who were most vehement towards Marinetti, handing out a tract during his lecture on "Relations between Russian Futurism and Italian Futurism": "Today, certain natives and the Italian colony on the banks of the Neva are, for personal reasons, kneeling at Marinetti's feet, betraying the first step of Russian art on the path of liberty and honour and bending the noble neck of Asia under the yoke of Europe."[141]

The day after the first lecture given in St. Petersburg, Kulbin organised a supper in honour of Marinetti, to which he invited most of the Russian Futurists. In his memoirs, Livshits described the event, showing the degree to which cooperation between the Italian and Russian groups had become unthinkable: "The day after the first lecture by Marinetti, we got together with Kulbin in honour of the Italian guest. There were about fifteen of us, but the only people who took part in the conversation … were those who spoke some kind of French. Khlebnikov was obviously absent. And probably regarded me as a traitor, although he theoretically accepted the existence of sheep of hospitality who were not bedecked in the lace of servility. Marinetti behaved most tactfully, striving to look as little as possible like a star on tour."[142]

Marinetti would eventually stay for a week in St. Petersburg, spending his evenings at *The Stray Dog*, where the Russian avant-garde artists hung out.

9 February: Marinetti returned to Moscow where he gave a last lecture on the 13th, before going back to Italy.[143]

11 February–March: in Rome, the Galleria Futurista run by Sprovieri hosted the *Esposizione di pittura futurista*, showing works by Balla, Boccioni, Carrà, Russolo, Severini and Soffici. During this event, the Italian painters (Balla, Francesco Cangiullo, Fortunato Depero) organised Futurist evenings every Sunday, which took on a distinctly Dadaist character.

15 February: heated disagreements within the Futurist movement between the Florentine and Milanese groups, which turned into a succession of articles published in the magazine *Lacerba*: "The circle is closing" by Papini[144], followed by a reply from Boccioni titled "The circle is not closing!"[145], to which Papini in turn responded with "Open Circles"[146].

February: publication of Marinetti's first "words in freedom" book, *Zang Tumb Tumb* (started in 1912), several excerpts from which had already appeared in magazines.

The *Fourth Knave of Diamonds Exhibition* was held in Moscow, with, notably, works by Braque, Exter, Malevich, Picasso and Popova.

1 March–30 April: in Paris, the Salon des Indépendants opened its doors to Patrick Henry Bruce (*Movement Color, Space; Simultaneous*, work destroyed), Del Marle (*The Port*, 1913, see cat. 53), Robert Delaunay (*Hommage to Blériot*, 1914, Basel, Kunstmuseum), Sonia Delaunay (*The Prose of the Transsiberian and of Little Jehanne of France*), Exter, Gleizes, Macdonald-Wright, Malevich (three works including his *Portrait of Ivan Kliun*, 1913), Metzinger and Picabia.

Apollinaire referred to the mutual influences between Italian and French painters: "This year, Futurism started to invade the Salon and while the Italian Futurists appear, based on the reproductions they are publishing, to be increasingly subject to the influence of the innovators (Picasso, Braque) of Paris, it would seem that a certain number of Paris-based artists are allowing themselves to be influenced by the Futurists' theories."[147]

Salmon expressed reservations about the way the works on view were being received: "In the old days, at the Quai d'Orsay, you had to walk a long time before finding yourself lingering in front of a characteristic work. The Simultanists [*sic*] have changed all that, by crowing at the doorway. This is actually where you will find works by Mr. Robert Delaunay, Mrs. Sonia Delaunay, Mr. Bruce and Mr. Picabia who, however, is not a Simultanist, but who crows with no less generosity … Orphism and Simultanism seem perilous to me, as far as the future of the miraculously rediscovered form is concerned. There must be no return, be it to Fauvism or to Impressionism… and yet what I am saying here I am saying for the others and not for Mr. Delaunay and his group. Too total agreement on this point would make him lose the troublemaker's gift which steers him. What is more, his work of yesterday, which he does not censure, illustrates a painter who can both defend and stand up to himself. I think few people will be immediately seduced by the dispatches of this group. Nobody can deny the power of this, although its use may be apt for reprimand, any more than we might recognise that what is involved is one of those novel events—heroic medicine—crucial to the life of the already old society. This is what will draw the attention of the throng, just as it will disquiet one or two, and put ideas into their heads. I ought really to talk at length about all this. I have said that Mr. Picabia is also exhibiting on the threshold of the Salon. He is a colourist, but a dogged one; a man with systems but without

Cover of the catalogue of the *Esposizione Libera Futurista Internazionale. Pittori e scultori Italiani – Russi – Inglesi – Belgi – Nordamericani*, Rome, Galleria Futurista, April–May 1914

140 Letter from V. Khlebnikov which appeared in *Nov*, no. 19, 5 Feb.1914; quoted in J.-P. Andréoli De Villers, "Marinetti et les futuristes russes lors de son voyage à Moscou en 1914", art. cit. in note 118, p. 137.

141 B. Livshits, *L'Archer à un œil et demi*, (Lausanne: L'Âge d'homme, 1971), p. 209.

142 Ibid., p. 215.

143 Although J.-P. Andréoli de Villers mentions this lecture, he points out that no press cutting made reference to it.

144 G. Papini, "Il cerchio si chiude", *Lacerba*, vol. 2, no. 4, 15 Feb. 1914, pp. 49–50.

145 U. Boccioni, "Il cherchio no si chiude!", *Lacerba*, vol. 2, no. 5, 1 March 1914, pp. 67–9.

146 G. Papini, "Cerchi aperti" *Lacerba*, vol. 2, no. 6, 15 March 1914, pp. 83–4.

147 G. Apollinaire, *Les Soirées de Paris*, no. 22, 15 March 1914, pp. 184–85; id., *Écrits sur l'art*, op. cit, p. 652–53.

148 A. Salmon, "Le Salon", *Montjoie !*, II, no. 3, March 1914, p. 22

149 U. Boccioni, *Pittura scultura futuriste (Dinamismo plastico)*, (Milan: Edizioni futuriste di *Poesia*, 1914).

150 Manifesto published in Italian: the first part appeared under the title *Lo Spendore geometrico e meccanico nelle parole in libertà*, in *Lacerba* (vol. 2, no. 6, 15 March 1914, pp. 81–3); the second part was also reprinted, under the title *Onomatopee astratte e sensibilità numerica*, in *Lacerba* (vol. 2, no. 7, 1 April 1914, pp. 99–100). The Italian edition of the complete text as a broadsheet was dated 18 March 1914.

151 F. Del Marle, "Quelques notes sur la simultanéité en peinture", *Poème et Drame* (Paris), no. 7, Jan.–March 1914, p. 17; E. Fry, *Cubism*, op. cit..

152 Initially scheduled for spring 1913 as a Neo-Primitivist show, then planned in the form of an international exhibition—with the Italian Futurist painters and the French Orphists—in autumn 1913, its final subtitle announced "Futurist, Rayonnist and Primitive works". This was the first exhibition organised by Larionov before the First World War.

153 Cork, vol. 1, p. 234.

154 According to certain sources, works of Natalia Goncharova and Kandinsky were also shown.

155 The French version of this manifesto was published by Apollinaire in the *Mercure de France* of 16 April 1914.

156 Published in *Les Soirées de Paris*, no. 25, 15 June 1914, pp. 349–56.

method … If the generous ardour of the Simultanists cannot be denied, without wishing them—far from it—to directly attract a following (we want nothing to do with followings), we must strongly denounce the phoney boldness of the Synchromists, even when it mobilises temperaments as indisputable as that of the painter Rossiné."[148]

3 March–April: in Florence, the Galleria Gonnelli put on the *Esposizione di pittura futurista del pittore e scultore futurisa U. Boccioni*. For it, Boccioni published *Futurist Painting and Sculpture* which brought together, among other things, articles already published.[149]

6 March: at the Goupil Gallery, opening of the *First London Group Exhibition*. Among the exhibitors were Bomberg, Epstein, Etchells, Cuthbert Hamilton, Lewis, Nevinson, and Wadsworth.

11 March: Marinetti published another manifesto: *Geometric and Mechanical Splendour and Numerical Sensibility*[150].

13 March: Del Marle published "Notes on Simultaneity in Painting" in the magazine *Poème et Drame*, edited by Barzun. This article emphasised the importance the concept of simultaneity had as much among Cubists as among Futurists: "Simultaneity in the artwork is one of the many goals which is attracting the most interesting painters of our times … In search of simultaneity of aspects, dear to Cubism and evident in the latest works by its protagonists, we should add the affirmation of the Italian Futurists: "the simultaneity of states of mind, this is the goal of our art."[151]

30 March: to form an association of the Omega Workshops dissidents, Lewis set up the Rebel Art Centre. This fleeting association may not have achieved its aim—to be a creative and instructional institution—despite the efforts made by Marinetti who gave a lecture to raise funds for it, but it nevertheless strengthened the group's cohesion. Among its members were Etchells, Hamilton, Lewis, Nevinson and Wadsworth.

March: Carrà, Papini and Soffici stayed in Paris in the home of Baroness Hélène d'Œttingen, where they met Apollinaire, Kahnweiler, Modigliani and Picasso.

March–April: in Moscow, *Exhibition No. 4* where Larionov showed his abstract "pneumo-Rayonists" works; other participants included Goncharova, Kamienski, Le Dantyu and Alexander Shevchenko.[152]

1 April: appearance of the first advertisements for *Blast* in *The Egoist*, which saw itself as the champion of "Cubism, Futurism, Imagism and all vital forms of modern art."[153]

9 April: in St. Petersburg, at the cabaret *The Stray Dog*, Zdanievich gave a lecture titled "Daubed Faces".

13 April–May: in Rome, the first *Esposizione libera futurista internazionale: pittori e scultori italiani, russi, inglesi, belgi, nordamericani* was held. At it, four Russian artists showed works: Archipenko, Exter, Kulbin and Rozanova—whose canvas *Man in the Street (Analysis of volumes)* (1913, cat. 101)[154] was acquired by Marinetti.

21 April: first major Futurist concert of the "intonarumori" by Russolo at the Teatro dal Verme in Milan, with spirited reactions from the audience, followed by scuffles.

Late April–May: in London, *Exhibition of the Italian Futurist Painters and Sculptors* at the Doré Galleries. Alongside Boccioni, Carrà, Marinetti, Russolo and Severini were Balla and Soffici, participating for the first time in a London show. This event was matched by a series of lectures and "rumorist" concerts by Russolo. On 30 April, accompanied by Nevinson, Marinetti once again declaimed "The Siege of Adrianople", reviving his performance of October 1912, which had been given in the same venue.

Spring: Popova visited Western Europe, first France (in April), then Italy, where she got in touch with the Futurists.

The East-West clash, dear to the Russian Futurist avant-garde, was dealt with in a manifesto *Us and the West* (signed by Yakulov for the plastic arts, by Livshits for poetry, and by Arthur Lourié for music).[155]

8 May–20 June: in London, the premises of the Whitechapel Art Gallery hosted the *20th Century Exhibition*. Contributors included Bomberg, Etchells, Gaudier-Brzeska, Lewis, Nevinson, William Roberts and Wadsworth.

9 May: Léger's second lecture at the Vassilieff Academy: "Present-day Pictorial Works".[156]

20 May: Balla drew up the manifesto of *Futurist Men's Clothing* (never published).

24 May: creation at the Paris Opera of Nikolai Rimsky-Korsakov's *The Golden Cockerel*, with choreography by Mikhail Fokin and sets and costumes by Goncharova.

30 May: in the *New Weekly*, Lewis, who had declared to Marinetti in April 1914: "I am not a Futurist. I hate the movement which displaces lines", came round to the view that the art produced by this same Marinetti "distils in beings the importance of the present, the importance of life", and described him as the "Cromwell of our times".

May: at the Galerie Georges Giroux in Brussels, the exhibition *Cubism, Orphism, Futurism* opened, with works by Archipenko, Picabia, Villon and Metzinger on view. In the gallery premises, Del Marle gave a lecture on Cubist painting.

May–June: in Naples, the Galleria Futurista, run by Sprovieri, hosted the *Prima Esposizione di pittura futurista*, where the public could see works by Balla, in particular *Girl Running on a Balcony*, Boccioni, Carrà, Russolo, Severini and Soffici. For the occasion, the Italian painters organised various Futurist evenings.

"Lettre-Océan", ideogram by Guillaume Apollinaire
published in *Les Soirées de Paris*, no. 15,
15 May 1914, pp. 340–41

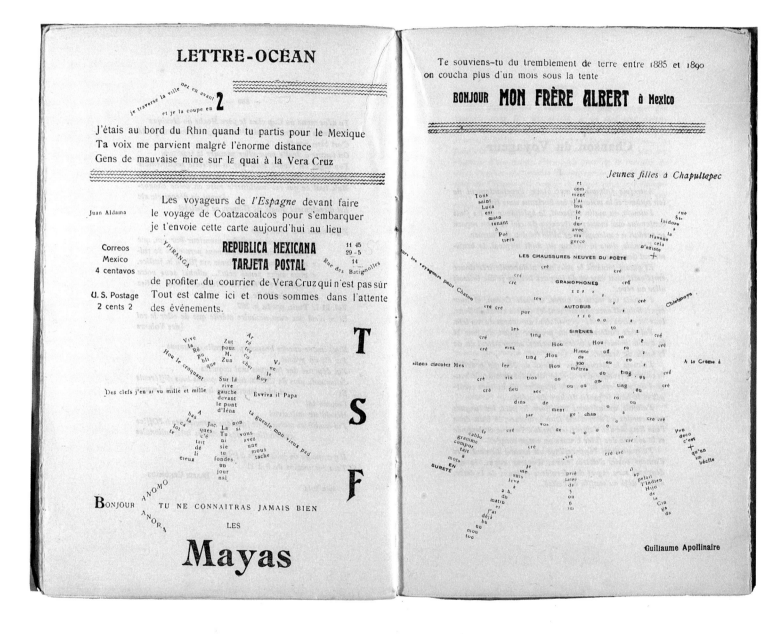

CONTRE L'ART ANGLAIS

Manifeste futuriste

lu à la Doré Galerie (Exposition des peintres futuristes Boccioni, Carrà, Russolo, Balla, Severini, Soffici) et à l'Université de Cambridge. — Juin 1914.

Je suis un poète futuriste italien qui aime passionnément l'Angleterre. Je veux guérir l'art anglais de la plus grave des maladies : le passéisme. J'ai donc tous les droits de parler haut et sans périphrases et de donner, avec mon ami Nevinson, peintre futuriste anglais, le signal du combat

CONTRE :

1. — le culte de la tradition, le conservatorisme artistique des académies, la préoccupation commerciale des artistes anglais, la mièvrerie efféminée de leur art, et leurs recherches purement décoratives ;

2. — les goûts pessimistes, sceptiques et nostalgiques du public anglais, qui adore stupidement le mièvre, le modéré, l'atténué, le médiocre, les ignobles Gardens Cities, Maypole, Morris dances et Fairy stories, le Moyen-âge, l'Esthétisme, Oscar Wilde, les Préraphaélites, les Néoprimitifs et tout ce qui vient de Paris ;

3. — le Snobisme mal canalisé qui ignore ou méprise toutes les originalités, les inventions et les audaces anglaises, et s'empresse d'adorer toutes les originalités et les audaces étrangères. Il ne faut pas oublier que l'Angleterre a eu de vaillants pionniers tels que Shakespeare, Swinburne, Turner, Constable, (qui fut le premier initiateur du mouvement impressioniste de l'école de Barbizon) Watts, Stevenson, Darwin, etc. ;

4. — les prétendus révolutionnaires de The New English Art Club qui hérita le prestige de la Royal Academy et son attitude grossièrement hostile aux mouvements d'avant-garde ;

5. — l'indifférence du Roi, de l'État et des Politiciens pour les Arts ;

6. — la conception anglaise selon laquelle l'art est un passetemps inutile, bon pour amuser les femmes et les jeunes filles, les artistes sont des pauvres fous à plaindre et à protéger, l'art une maladie bizarre dont tout le monde peut parler ;

7. — le droit universel de discuter et de juger en matière d'art ;

8. — le vieil idéal brûlé du génie ivrogne, crasseux, débraillé et hors cadre ; l'ivrognerie synonime d'art ; Chelsea, le Montmartre de Londres ; les sous-Rossetti à longs cheveux sous le sombrero et autres immondices passéistes ;

F. T. Marinetti and C. R.W. Nevinson, *Contre l'art anglais. Manifeste futuriste* (London, 11 June 1914) published in English under the title *Vital English Art*

From left to right: Cuthbert Hamilton (?), Edward Wadsworth, C. R. W. Nevinson and Wyndham Lewis hanging the painting *Caprice* by Edward Wadsworth at the Rebel Art Centre, London, 1914

7 June: the manifesto *Vital English Art*, jointly signed by Marinetti and Nevinson, was published in the *Observer*, then, a few days later, in the *Times* and the *Daily Mail*. The French version, *Contre l'art anglais*, was dated 11 June 1914.[157]

12 June: Marinetti and Nevinson gave lectures on Futurism at the Doré Galleries. They were interrupted by members of the Rebel Art Centre: Lewis, Epstein, Gaudier-Brzeska, Thomas Ernest Hulme and Wadsworth.

13 June: *The Spectator* introduced *Blast*, the Vorticists' magazine, as "The Manifesto of the Vorticists—The English Parallel Movement to Cubism and Expressionism [and] Death Blow to Impressionism and Futurism."

14 June: Lewis sent the editor-in-chief of the *Observer* a letter, jointly signed by Lawrence Atkinson, Bomberg, Etchells, Gaudier-Brzeska, Hamilton, Pound, Roberts and Wadsworth, in which he railed violently against the manifesto *Vital English Art*, thereby making official the Rebel Art Centre's break with Marinetti, who had described those artists as "great Futurists of English art", a viewpoint which those concerned never shared, as Laurette Veza reminds us; "The Vorticists did indeed intend to owe nothing to the Futurists for tactical reasons, at that time, but also for infinitely more far-reaching reasons. On the one hand, they had to stem the rising tide of Futurism, or else be engulfed by it; on the other, in the spirit of Lewis and Pound, any confusion between the two movements was tantamount to a betrayal. In fact, Vorticism spelled out the *place* of the vortex, while Futurism was unable to sidestep time because the label itself implied that the movement was situated in time."[158] Between Lewis and Marinetti, there was no shortage of stumbling blocks: "The Italian Futurists with their gospel of action and its corollaries, speed, violence, impressionism and sensationalism …,

were convinced disciples of the philosophy of time, and Marinetti, their prophet, was a thoroughbred Bergsonian."[159]

15–20 June: at the London Coliseum, Buzzi, Russolo and Ugo Piatti proposed a series of concerts for their "intonarumori", accompanied by Marinetti's declamations.

17–30 June: in Paris, the Galerie Paul Guillaume hosted an exhibition devoted to Larionov and Goncharova, whose catalogue was prefaced by Apollinaire. This show was reported in laudatory articles in the Paris press: "This will be the first time in a long while that we shall be seeing Russian painting from Russia in Paris, and also the first time that we shall be seeing Rayonist painting."[160] It was probably on that occasion that Larionov met Mercereau, organiser of exhibitions of French art in Russia.

2 July: publication in London of the first issue of the magazine *Blast* (dated 20 June), birth certificate of Vorticism. In these pivotal pages was published the *Manifesto of Vorticism (Manifesto)* jointly signed by Malcolm Arbuthnot, Lawrence Atkinson, Gaudier-Brzeska, Jessica Dismorr, Hamilton, Pound, Roberts, Helen Saunders, Wadsworth and Lewis.

The head-on attacks on Futurism grew in number in the pages of *Blast*: "We are not interested in changing the look of the world because we are not Naturalists, Impressionists or Futurists (the latest form of Impressionism) … Automobilism (Marinettism) bores us to death … Futurism is a sensational and sentimental mixture of the aesthete of the 1890s and the realist of the 1870s."[161]

"For our vortex, the present alone is action … Past and future are prostitutes offered by Nature. Art consists in getting out of this Brothel every now and then … The Vorticist finds his maximum energy point in immobility. The Vorticist is not the Slave of the movement but its Master."[162]

In addition you could read, in the manifesto published by the same magazine: "The modern world is almost entirely the product of Anglo-Saxon genius, its manifestation and its spirit … The machine, trains, steamboats, everything that, apparently, distinguishes our day and age finds its origin here rather than anywhere else."[163]

"The English are the inventors of this nudity, this harshness, they must be the greatest foes of Romanticism."[164]

"Today, in their discovery of sport, for example, their Futurist sentimentalism with regard to machines, aeroplanes, etc., the Latin people are the most romantic and most sentimental 'moderns' you can find."[165]

11 July: Antonio Sant'Elia published a manifesto on *The Futurist Architect*, a text already published in May in the exhibition catalogue of the group "Nuove Tendenze" (Milan), with additional material added by Marinetti.[166]

30 July: opening at the Scarborough School of Art (Vernon Place) of an exhibition bringing together Futurists, Cubists and Post-Impressionists.

July: in London, Bomberg's first solo show (he wrote the preface to the catalogue), held in Chelsea at the Chenil Gallery.

On his way through Paris, Carrà met Kahnweiler through Apollinaire: a draft agreement with the painter was in the offing, but the declaration of war interrupted their negotiations.

1st August: Germany declares war on Russia and on France two days later.

17 August: the magazine *Lacerba* and Marinetti conducted a campaign in favour of Italy's going to war alongside England and France (although Italy was a member of the Triple Alliance with Austria-Hungary and Germany).

Braque, Duchamp-Villon, Gleizes, Léger, Metzinger, Raynal, Salmon and Villon, among others, were called up. Apollinaire joined up, while Delaunay, declared unfit for military

157 The manifesto was published in Italian and English in *Lacerba* (vol. 2, no. 14, 15 July 1914, pp. 209–11).

158 L. Veza, op. cit, p. 281.

159 W. Lewis, *Time and Western Man*, New York, Paul Edwards (ed), 1928, quoted in ibid.

160 Anon., "Mme Nathalie de Goucharova et M. Larionow" [sic], *Paris-Journal*, 13 June 1914.

161 P. W. Lewis, "Long Live the Vortex!", *Blast* (London), no.1, 20 June [2 July] 1914, pp. 7-8. Our translation.

162 Id., "Our Vortex", *Blast*, no. 1, 20 June [2 July] 1914, pp. 147–48.

163 'Manifesto', ibid., p. 39.

164 Ibid., p. 41.

165 Ibid.

166 A. Sant'Elia, *L'Architecte futuriste, Lacerba*, vol. 2, no. 15, 1 August 1914, pp. 228–30.

MANIFESTO.

I.

1 Beyond Action and Reaction we would establish ourselves.

2 We start from opposite statements of a chosen world. Set up violent structure of adolescent clearness between two extremes.

3 We discharge ourselves on both sides.

4 We fight first on one side, then on the other, but always for the SAME cause, which is neither side or both sides and ours.

5 Mercenaries were always the best troops.

6 We are Primitive Mercenaries in the Modern World.

30

7 Our Cause is NO-MAN'S.

8 We set Humour at Humour's throat. Stir up Civil War among peaceful apes.

9 We only want Humour if it has fought like Tragedy.

10 We only want Tragedy if it can clench its side-muscles like hands on it's belly, and bring to the surface a laugh like a bomb.

31

Manifesto of Vorticism published in the first issue of *Blast* (London), 2 July 1914 (dated 20 June)

service, was detained in Spain where he was staying with his wife; Picasso and Gris were working in Paris and the provinces.

11 September: Balla's *Anti-Neutral Clothing* manifesto.

15–16 September: in Milan, at the Teatro del Verme and in Cathedral Square, the Futurists spear-headed anti-Austrian demonstrations, leading to their arrest.

20 September: *Futurist Synthesis of the War*, poster-manifesto signed by Boccioni, Carrà, Marinetti, Piatti and Russolo.

October: in Berlin, the Der Sturm Gallery organised *Die Futuristen. Umberto Boccioni, Carlo D. Carrà, Luigi Russolo, Gino Severini*, a partial repeat of the exhibition held in 1912.

13 November: Nevinson served with the Friends' Ambulance Unit (a medical unit in the British army) in northern France and in Flanders.

9 December: in front of Rome University, start of a series of interventionist demonstrations joined by Marinetti and Cangiullo, dressed for the occasion in Futurist clothes sporting the colours of the Italian flag.

December: Bomberg, Epstein, and Roberts, all keen to exhibit together, regularly met up with the lawyer Stuart Gray.

During the year 1914: according to Soffici,[167] Exter worked very closely on the book *Pikasso i okresnosti* [Picasso and His Surroundings], which was begun in 1912–13 by the Russian poet Axionov (Moscow, Centrifuga, 1917). More than a monograph on Picasso, this book was nothing less than an artistic manifesto which "sounded the death knell for Parisian Cubism and Italian Futurism". Exter produced a Cubo-Futurist collage for the cover. In Florence, the publishers Libreria della Voce published Soffici's *Cubismo e Futurismo*, a version of *Cubismo e oltre* [Cubism and Beyond] (June 1913), reworked and fleshed out by one or two articles published later in the magazine *Lacerba*.

Luigi Russolo and Ugo Piatti with the *bruiteurs* [noise-makers] in the via Stoppani studio in Milan, 1915

The Futurist room with, at the centre, the sculpture *Speeding Muscles* by Umberto Boccioni, at the *Panama Pacific International Exhibition* in San Francisco in 1915

William Roberts, *The Vorticists at the Restaurant de la Tour Eiffel, summer 1915,* 1961–62.
From left to right: Cuthbert Hamilton, Ezra Pound, William Roberts, Wyndham Lewis, Frederick Etchells and Edward Wadsworth; standing: Jessica Dismorr, Helen Saunders, Joe the waiter and Rudolph Stulik, owner of the restaurant. Oil on canvas, 232.5 x 97 cm.
Tate, London. Presented by The Trustees of the Chantrey. Bequest, 1962. T00528

1915

1 February [or 11 January]–18 February: preparation of the manifesto *Synthetic Futurist Theatre*, signed by Corra, Marinetti and Settimelli.
14 February: with an article published in issue 7 of *Lacerba* ("Futurismo e Marinettismo"), Palazzeschi, Papini and Soffici made their definitive break with the Futurist movement.[168]
18 February: in Rome, at an interventionist (pro-war) demonstration, Balla, Cangiullo, Depero and Marinetti were all arrested.
February–December: in San Francisco, the *Panama-Pacific International Exhibition* [PPIE], initially planned for autumn 1914, but delayed because of the declaration of war, brought in works from more or less every country in the world. In it was a French section with the Post-Impressionists Cézanne, Léger, Matisse, Picabia and Picasso, but also an "Italian Futurists" section, including works shown by the Doré Galleries of London in April 1914. Transported on board the *Jason* from the city of Bristol, the works of the Italian Futurists reached San Francisco in April 1915, and were shown in the annex of the Fine Arts Centre (room 141 was entirely given over to the Italian avant-gardes). This would be the only American journey made by the Italian Futurist painters.[169] The exhibition then went on to San Diego, in a smaller version.
3 March: in Petrograd, opening of the *'Tramway V' First Futurist Exhibition of Pictures* organised by Ivan Albertovich Puni. In it, among others, were works by Exter (*Florence*), Kliun (*Ozonator (Fan)*, 1914, cat. 93), Malevich (*The Aviator*, 1914, cat. 96, as well as various Cubo-Futurist works), Rozanova and Tatlin.
5 March: the second show of the London Group opened in London at the Goupil Gallery, with works by Epstein (*Torso in Metal from "The Rock Drill"*), Lewis (*The Crowd*, [1915?], cat. 106), Nevinson (*Returning to the Trenches*, 1914–15, cat. 110) and Wadsworth.

11 March: the manifesto *Futurist Reconstruction of the World* by Balla and Depero.
May: Italy went to war. The magazine *Lacerba* suspended its publication.
Boccioni, Depero, Marinetti, Piatti, Russolo, Sant'Elia, Sironi and Soffici lost no time in volunteering and going to the front.
1 June–January 1916: Nevinson signed on in the Royal Army Medical Corps, stationed in a London hospital.
5 June: fighting with the French army, Gaudier-Brzeska was killed in combat at Neuville-Saint-Vaast.
10 June: at the Doré Galleries in London, opening of the *Vorticist Exhibition*, its catalogue prepared by Lewis. In it were works by Dismorr, Etchells, Gaudier-Brzeska, Roberts, Saunders, Wadsworth and Lewis.
20 July: publication of the second and last issue of the magazine *Blast*, named the "War Number (Review of the Great English Vortex)", in which were reproduced works by Etchells, Nevinson and Wadsworth. The article by Gaudier-Brzeska "Gaudier-Brzeska Vortex" accompanied his obituary.
17 December–18 January 1916: in Petrograd, the last Futurist exhibition *0,10*, which showed the set of Malevich canvases titled *Suprematism of Painting*. On that occasion a manifesto-tract *(0,10)* was handed out, in which recipients could read declarations by Kliun, Malevich, Mikhail Mienkov and Puni.
Miscellaneous publications: *From Cubism to Suprematism. The New Pictorial Realism*, Malevich's first booklet-cum-treatise; *Guerra-pittura* [Warpainting] by Carrà; Soffici's *Simultaneità e Chimismi lirici* [Simultaneity and Lyrical Chemistries]; and *Guerra sola igiene del mondo* by Marinetti [War, the World's Only Hygiene], a reworked translation of *Futurism*, which had been published back in 1911.

167 A. Soffici, *Opere*, op. cit., vol. 7, p. 725.
168 A. Palazzeschi, G. Papini, A. Soffici, "Futurismo e Marinettismo", *Lacerba*, vol 3, no. 7, 14 Feb. 1915, pp. 49–51.
169 J.-P. Andréoli De Villers, "Les futuristes à la Panama Pacific International Exposition de San Francisco en 1915", in *Ligeia* (Paris), no. 57–60, Jan.–June 2005, p. 5.

LIST OF WORKS

* All works are shown at Tate Modern, with the exception of those marked by an asterisk.

Giacomo Balla (cat. 1)
Luna Park a Parigi, 1900
[Luna Park in Paris]
Oil on canvas, 65 x 81 cm
Civiche Raccolte d'Arte, Museo del Novecento, Milan

Giacomo Balla (cat. 88)
Bambina che corre sul balcone, 1912
[Girl Running on a Balcony]
Oil on canvas, 125 x 125 cm
Galleria d'Arte Moderna, Milan
Grassi Collection

Giacomo Balla (cat. 118)
Dimostrazione Patriottica, 1915
[Patriotic Demonstration]
Oil on canvas, 101 x 137.5 cm
Museo Thyssen-Bornemisza, Madrid

Giacomo Balla (cat. 117)
Forme Grido Viva l'Italia, 1915
[Forms Cry Long Live Italy]
Oil on canvas, 134 x 187 cm, painted frame
Galleria Nazionale d'Arte Moderna, Rome

Giacomo Balla (cat. 119)
Insidie di Guerra, 1915
[The Risks of War]
Oil on canvas, 115 x 175 cm, painted frame
Galleria Nazionale d'Arte Moderna, Rome

Umberto Boccioni (cat. 2)
Officine a Porta Romana, 1909
[Workshops at Porta Romana],
Oil on canvas, 75 x 145 cm
Intesa Sanpaolo Collection

Umberto Boccioni (cat. 28)
La città che sale, 1910–1911
[The City Rises]
Oil on canvas, 199.3 x 301 cm
The Museum of Modern Art, New York
Mrs Simon Guggenheim Fund, 1951

Umberto Boccioni (cat. 30)
Idolo moderno, 1910–1911
[Modern Idol]
Oil on board, 60 x 58.4 cm
Estorick Collection, London

Umberto Boccioni (cat. 20)
Stati d'animo: Quelli che vanno, 1911
[States of Mind: Those who Go]
Oil on canvas, 71 x 95.5 cm
Civiche Raccolte d'Arte, Museo del Novecento, Milan

Umberto Boccioni (cat. 21)
Stati d'animo: Gli addii, 1911
[States of Mind: The Farewells]
Oil on canvas, 71 x 96 cm
Civiche Raccolte d'Arte, Museo del Novecento, Milan

Umberto Boccioni (cat. 22)
Stati d'animo: Quelli che restano, 1911
[States of Mind: Those who Stay]
Oil on canvas, 71 x 96 cm
Civiche Raccolte d'Arte, Museo del Novecento, Milan

Umberto Boccioni (cat. 23)
Stati d'animo: Quelli che vanno, 1911
[States of Mind: Those who Go]
Oil on canvas, 70.8 x 95.9 cm
The Museum of Modern Art, New York
Gift of Nelson A. Rockefeller, 1979, inv. 65.1979

Umberto Boccioni (cat. 24)
Stati d'animo: Gli addii, 1911
[States of Mind: The Farewells]
Oil on canvas, 70.5 x 96.2 cm
The Museum of Modern Art, New York
Gift of Nelson A. Rockefeller, 1979, inv. 64.1979

Umberto Boccioni (cat. 25)
Stati d'animo: Quelli che restano, 1911
[States of Mind: Those who Stay]
Oil on canvas, 70.8 x 95.9 cm
The Museum of Modern Art, New York
Gift of Nelson A. Rockefeller, 1979, inv. 66.1979

Umberto Boccioni (cat. 26)
La strada entra nella casa, 1911
[The Street Enters the House]
Oil on canvas, 100 x 100 cm
Sprengel Museum Hannover, Hanover

Umberto Boccioni (cat. 27)
La Risata, 1911
[The Laugh]
Oil on canvas, 110.2 x 145.4 cm
The Museum of Modern Art, New York
Gift of Herbert and Nannette Rothschild, 1959

Umberto Boccioni (cat. 29)
Visioni simultanee, 1911
[Simultaneous Visions]
Oil on canvas, 60.5 x 69.5 cm
Von der Heydt-Museum Wuppertal, Wuppertal

Umberto Boccioni (cat. 31)
Le forze di una strada, 1911
[The Forces of the Street]
Oil on canvas, 99.5 x 80.5 cm
Osaka City Museum of Modern Art, Osaka

Umberto Boccioni (cat. 76)
Antigrazioso, 1912
Oil on canvas, 80 x 80 cm
Private collection

Umberto Boccioni (cat. 77)
Costruzione orizzontale (Volumi orizzontali), 1912
[Horizontal Construction (Horizontal Volumes)]
Oil on canvas, 95 x 95.5 cm
Bayerische Staatsgemäldesammlungen,
Pinakothek der Moderne, Munich

Umberto Boccioni (cat. 82)
Elasticità, 1912
[Elasticity]
Oil on canvas, 100 x 100 cm
Civiche Raccolte d'Arte, Museo del Novecento, Milan

Umberto Boccioni (cat. 79)
Sviluppo di una bottiglia nello spazio, 1912
[Development of a Bottle in Space]
Bronze, cast 1951–52, 39 x 60 x 30 cm
Kunsthaus Zürich, Zurich

Umberto Boccioni (cat. 81)
Antigrazioso, 1913
Bronze, cast 1950–51, 58.4 x 52.1 x 50.8 cm
The Metropolitan Museum of Art, New York
Bequest of Lidia Winston Malbin, 1989, inv. 1990.38.1

Umberto Boccioni (cat. 80)
Forme uniche della continuità nello spazio, 1913, cast 1972
[Unique Forms of Continuity in Space]
Bronze, 117.5 x 87.6 x 36.8 cm
Tate, London / Purchased 1972

Umberto Boccioni (cat. 83)
Dinamismo di un corpo umano, 1913
[Dynamism of a Human Body]
Oil on canvas, 100 x 100 cm
Civiche Raccolte d'Arte, Museo del Novecento, Milan

Umberto Boccioni (cat. 78)
Il bevitore, 1914
[The Drinker]
Oil on canvas, 87.5 x 87.5 cm
Civiche Raccolte d'Arte, Museo del Novecento, Milan

David Bomberg (cat. 103)
In the Hold, c. 1913–1914
Oil on canvas, 196.2 x 231.1 cm
Tate, London / Presented by the Friends of the Tate Gallery, 1967

David Bomberg (cat. 102)
The Mud Bath, 1914
Oil on canvas, 152.4 x 224.2 cm
Tate, London / Purchased 1964

Georges Braque (cat. 6)
Grand Nu, 1907–1908
[Large Nude]
Oil on canvas, 140 x 100 cm
Centre Pompidou, Musée national d'art moderne, Paris
Accepted in lieu of tax from Alex Maguy-Glass, 2002

Georges Braque (cat. 4)
Le Viaduc à L'Estaque, 1908
[Viaduct at L'Estaque]
Oil on canvas, 72.5 x 59 cm
Centre Pompidou, Musée national d'art moderne, Paris
Accepted in lieu of tax, 1984

Georges Braque (cat. 8)
**Le Sacré-Cœur de Montmartre*, 1909–1910
Oil on canvas, 55 x 40.5 cm
Musée d'Art moderne Lille Métropole, Villeneuve-d'Ascq
Donated by Jean and Geneviève Masurel, 1979

Georges Braque (cat. 12)
Le Guéridon, 1911
[The Guéridon; The Occasional Table]
Oil on canvas, 116.5 x 81.5 cm
Centre Pompidou, Musée national d'art moderne, Paris
Gift of Raoul La Roche, 1952

Georges Braque (cat. 11)
Nature morte au violon, 1911
[Still Life with Violin]
Oil on canvas, 130 x 89 cm
Centre Pompidou, Musée national d'art moderne, Paris
Donated by M^me Georges Braque, 1965

Carlo Carrà (cat. 3)
Notturno a Piazza Beccaria, 1910
[Nocturne in Piazza Beccaria]
Oil on canvas, 60 x 45 cm
Civiche Raccolte d'Arte, Museo del Novecento, Milan

Carlo Carrà (cat. 39)
Uscita dal teatro, c. 1910
[Leaving the Theatre]
Oil on canvas, 69 x 89 cm
Estorick Collection, London

Carlo Carrà (cat. 36)
**Ritratto del poeta Marinetti*, 1910
[Portrait of the Poet Marinetti]
Oil on canvas, 100 x 82 cm
Private collection

Carlo Carrà (cat. 32)
I funerali dell'anarchico Galli, 1910–1911
[The Funeral of the Anarchist Galli]
Oil on canvas, 198.7 x 259.1 cm
The Museum of Modern Art, New York
Acquired through the bequest of Lillie P. Bliss, 1948

Carlo Carrà (cat. 34)
Il movimento del chiaro di luna, 1910–1911
[The Movement of Moonlight]
Oil on canvas, 75 x 70 cm
Mart–Museo di Arte Moderna e Contemporanea di Trento e Rovereto

Carlo Carrà (cat. 41)
La stazione di Milano, 1910–1911
[Milan Station]
Oil on canvas, 50.5 x 54.5 cm
Staatsgalerie Stuttgart, Stuttgart

Carlo Carrà (cat. 38)
Nuotatrici, 1910–1912
[Women Swimmers]
Oil on canvas, 105.3 x 155.6 cm
Carnegie Museum of Art, Pittsburgh
Gift of G. David Thompson, 1955, inv. 55.54.5

Carlo Carrà (cat. 35)
Ciò che mi ha detto il tram, 1911
[What the Tram Told Me]
Oil on canvas, 52 x 62 cm
Mart–Museo di Arte Moderna e Contemporanea
di Trento e Rovereto, Fondazione VAF

Carlo Carrà (cat. 40)
La Donna al caffè (Donna e assenzio), 1911
[Woman in a Café (Woman and Absinthe)]
Oil on canvas, 67 x 52 cm
Private collection

Carlo Carrà (cat. 33)
Sobbalzi di carrozza, 1911
[Jolts of a Cab]
Oil on canvas, 52.3 x 67.1 cm
The Museum of Modern Art, New York
Gift of Herbert and Nanette Rothschild, 1966

Carlo Carrà (cat. 37)
**Simultaneità. La donna al balcone
(Ragazza alla finestra)*, 1912
[Simultaneity. Woman on a Balcony (Girl at the Window)]
Oil on canvas, 147 x 133 cm
Private collection

Robert Delaunay (cat. 54)
**La Ville de Paris*, 1910–1912
[The City of Paris]
Oil on canvas, 267 x 406 cm
Centre Pompidou, Musée national d'art moderne, Paris
Purchased 1936 / Attribution, 1937
On permanent loan to the Musée d'art moderne
de la Ville de Paris, 1985

Robert Delaunay (cat. 10)
Tour Eiffel, 1911
[Eiffel Tower]
Oil on canvas, 202 x 138.4 cm
Solomon R. Guggenheim Museum, New York
Solomon R. Guggenheim Founding Collection
Gift of Solomon R. Guggenheim, 1937, inv. 37.463

Robert Delaunay (cat. 57)
L'Équipe de Cardiff (3^e représentation), 1912–1913
[The Cardiff Team (3^rd representation)]
Oil on canvas, 326 x 208 cm
Musée d'Art moderne de la Ville de Paris, Paris

Robert Delaunay (cat. 70)
Formes circulaires. Soleil n° 2, 1912–1913
[Circular Forms. Sun No. 2]
Glue-based paint on canvas, 100 x 68.5 cm
Centre Pompidou, Musée national d'art moderne, Paris
Gift of the Société des Amis
du Musée national d'art moderne, 1961

Sonia Delaunay (cat. 69)
Contrastes simultanés, 1912
[Simultaneous Contrasts]
Oil on canvas, 46 x 55 cm
Centre Pompidou, Musée national d'art moderne, Paris
Donated by Sonia and Charles Delaunay, 1964

Sonia Delaunay (cat. 58)
*La Prose du Transsibérien et de la petite Jehanne
de France*, 1913
[Prose of the Trans-Siberian Railway and of Little Jehanne of France]
Watercolour and relief print on paper, 195.6 x 35.6 cm
Tate, London / Purchase 1980

Félix Del Marle (cat. 53)
Le Port, 1913
[The Port]
Oil on canvas, 80.8 x 64.8 cm
Musée des Beaux-Arts de Valenciennes, Valenciennes

Marcel Duchamp (cat. 60)
Les Joueurs d'échecs, 1911
[The Chess Players]
Oil on canvas, 50 x 61 cm
Centre Pompidou, Musée national d'art moderne, Paris / Purchased 1954

Marcel Duchamp (cat. 61)
Moulin à café, 1911
[Coffee Mill]
Oil and pencil on board, 33 x 12.7 cm
Tate, London / Purchased 1981

Marcel Duchamp (cat. 59)
**Nu descendant un escalier n° 2*, 1912
[Nude Descending a Staircase No. 2]
Oil on canvas, 147 x 89.2 cm
Philadelphia Museum of Art, Philadelphia
The Louise and Walter Arensberg Collection, 1950

Raymond Duchamp-Villon (cat. 67)
Le grand cheval, 1914
[The Large Horse]
Bronze, cast under the supervision of Jacques Villon 1961
100 x 98.7 x 66 cm
Tate, London / Purchased 1978

Raymond Duchamp-Villon (cat. 68)
**Le grand cheval*, 1914/1931
[The Large Horse]
Bronze, 1955 edition, 100 x 55 x 95 cm
Centre Pompidou, Musée national d'art moderne, Paris
Purchased 1955 / On loan at the Musée d'art moderne
et contemporaine, Strasbourg

Jacob Epstein (cat. 104)
Torso in Metal from "The Rock Drill", 1913–1914
Bronze, 70.5 x 58.4 x 44.5 cm
Tate, London / Purchased 1960

Alexandra Exter (cat. 90)
Gorod noč'ů, [1913]
[City at Night]
Oil on canvas, 88 x 71 cm
State Russian Museum, St. Petersburg

Alexandra Exter (cat. 89)
Florence, 1914–1915
Oil on canvas, 109.6 x 145 cm
Tretyakov National Gallery, Moscow

Henri Gaudier-Brzeska (cat. 105)
Red Stone Dancer, c. 1913
Red Mansfield stone, 43.2 x 22.9 x 22.9 cm
Tate, London / Presented by C. Frank Stoop through
the Contemporary Art Society, 1930

Albert Gleizes (cat. 19)
Portrait de Jacques Nayral, 1911
[Portrait of Jacques Nayral]
Oil on canvas, 161.9 x 114 cm
Tate, London / Purchased 1979

Albert Gleizes (cat. 9)
**La Cathédrale de Chartres*, 1912
[Chartres Cathedral]
Oil on canvas, 73.6 x 60.3 cm
Sprengel Museum Hanover, Hanover

Natalia Goncharova (cat. 91)
Velosipedist, 1913
[The Cyclist]
Oil on canvas, 79 x 105 cm
State Russian Museum, St. Petersburg

Natalia Goncharova (cat. 92)
La Lampe électrique, [1913]
[The Electric Light]
Oil on canvas, 105 x 81.5 cm
Centre Pompidou, Musée national d'art moderne, Paris
Gift of the Société des Amis du Musée national d'art moderne, 1966

Natalia Goncharova (ex cat.)
Linen, 1913
Oil on canvas, 95.6 x 83.8 cm
Tate, London / Presented by Eugène Mollo and the artist, 1953

Ivan Kliun (cat. 93)
Ozonator (èlektr. perenosnyj ventilãtor), 1914
[Ozonator or Electric Fan]
Oil on canvas, 75.5 x 66 cm
State Russian Museum, St. Petersburg

František Kupka (cat. 71)
La Primitive (Éclats de lumière), [1910–1913]
[The Primitive (Burst of Light)]
Oil on canvas, 100 x 72.5 cm
Centre Pompidou, Musée national d'art moderne, Paris
Gift of Eugénie Kupka, 1963
On permanent loan to the Musée de Grenoble, Grenoble, 2004

František Kupka (ex cat.)
Compliment, 1912
Oil on canvas, 89 x 108 cm
Centre Pompidou, Musée national d'art moderne, Paris
Gift of Eugénie Kupka, 1963

Mikhail Larionov (cat. 94)
Promenade, Vénus de boulevard, [1912–1913]
[Promenade, Venus of the Boulevard]
Oil on canvas, 117 x 87 cm
Centre Pompidou, Musée national d'art moderne, Paris
Purchased 1983

Fernand Léger (cat. 18)
**Nus dans la forêt*, 1909–1911
[Nudes in the Forest]
Oil on canvas, 120.5 x 170.5 cm
Kröller-Müller Museum, Otterlo

Fernand Léger (cat. 55)
La Noce, 1911–1912
[The Wedding]
Oil on canvas, 257 x 206 cm
Centre Pompidou, Musée national d'art moderne, Paris
Gift of Alfred Flechtheim, 1937

Fernand Léger (cat. 72)
Contraste de formes, 1913
[Contrast of Forms]
Oil on canvas, 100 x 81 cm
Centre Pompidou, Musée national d'art moderne, Paris
Donated by Jeanne and André Lefèvre, 1952

Percy Wyndham Lewis (cat. 107)
Workshop, c. 1914–1915
Oil and pencil on canvas, 76.5 x 61 cm
Tate, London / Purchased 1974

Percy Wyndham Lewis (cat. 106)
The Crowd, [exhibited 1915]
Oil and pencil on canvas, 200.7 x 153.7 cm
Tate, London / Presented by the Friends of the Tate Gallery, 1964

Stanton Macdonald-Wright (cat. 73)
Conception Synchromy, 1914
Oil on canvas, 91.3 x 76.5 cm
Hirshhorn Museum and Sculpture Garden, Smithsonian Institution,
Washington D.C. / Gift of Joseph H. Hirshhorn, 1966

Kasimir Malevich (cat. 95)
Portret Ivana Klũna (Stroitel'), 1911
[Portrait of Ivan Kliun (Constructor)
or Perfected Portrait of Ivan Vassilievich Kliunkov]
Oil on canvas, 111.5 x 70.5 cm
State Russian Museum, St. Petersburg

Kasimir Malevich (cat. 97)
**Portret hudožnika Mihaila Vasileviča Matũšina*, 1913
[Portrait of Mikhail Vassilievitch Matiushin]
Oil on canvas, 106.6 x 106.6 cm
Tretyakov National Gallery, Moscow

Kasimir Malevich (cat. 96)
Aviator, 1914
Oil on canvas, 125 x 65 cm
State Russian Museum, St. Petersburg

Jean Metzinger (cat. 17)
**Étude pour « Le Goûter »*, 1911
[Study for "Teatime"]
Pencil and ink on grey paper, 19 x 15
Centre Pompidou, Musée national d'art moderne, Paris
Purchased 1960

Jean Metzinger (cat. 16)
Le Goûter (Femme à la cuillère), 1911
[Teatime (Woman with Teaspoon)]
Oil on board, 75.9 x 70.2 cm
Philadelphia Museum of Art, Philadelphia
The Louise and Walter Arensberg Collection, 1950

Jean Metzinger (cat. 56)
**Danseuse au café*, 1912
[Dancer in the Café]
Oil on canvas, 146.1 x 114.3 cm
Albright-Knox Art Gallery, Buffalo (NY)
General Purchased Fund, 1957

Christopher Richard Wynne Nevinson (cat. 108)
Le Vieux Port, 1913–1915
Oil on canvas, 91.5 x 56 cm
Government Art Collection, London
Purchased from Leicester Galleries, February 1959

Christopher Richard Wynne Nevinson (cat. 109)
The Arrival, c. 1913
Oil on canvas, 76.2 x 63.5 cm
Tate, London / Presented by the artist's widow, 1956

Christopher Richard Wynne Nevinson (cat. 110)
**Returning to the Trenches*, 1914–1915
Oil on canvas, 51.2 x 76.8 cm
National Gallery of Canada, Ottawa
Gift of the Massey Collection of English Painting, 1946

Christopher Richard Wynne Nevinson (cat. 111)
Bursting Shell, 1915
Oil on canvas, 76 x 56 cm
Tate, London / Purchased 1983

Francis Picabia (cat. 62)
Danses à la source I, 1912
[Dances at the Spring I]
Oil on canvas, 120.5 x 120.6 cm
Philadelphia Museum of Art, Philadelphia
The Louise and Walter Arensberg Collection, 1950

Francis Picabia (cat. 63)
**Udnie (Jeune fille américaine; La Danse)*, 1913
[Udnie (American Girl; The Dance)]
Oil on canvas, 290 x 300 cm
Centre Pompidou, Musée national d'art moderne, Paris
Acquired by the State, 1948 / Attribution, 1949

Francis Picabia (cat. 64)
**Je revois en souvenir ma chère Udnie*, [1913]–1914
[I See Again in Memory My Dear Udnie]
Oil on canvas, 250.2 x 198.8 cm
The Museum of Modern Art, New York / Hillman Periodicals Fund, 1954

Pablo Picasso (cat. 5)
**La Dryade*, 1908
[The Dryad]
Oil on canvas, 185 x 108 cm
Hermitage Museum, St. Petersburg

Pablo Picasso (cat. 15)
**Tête de femme (Fernande)*, 1909
[Head of a Woman (Fernande)]
Bronze, 41.3 x 24.7 x 26.6 cm
Museo Nacional Centro de Arte Reina Sofia, Madrid

Pablo Picasso (cat. 14)
Tête de femme (Fernande), 1909
[Head of a Woman (Fernande)]
Plaster, 40.5 x 23 x 26 cm
Private collection on long loan to Tate, London 1994

Pablo Picasso (cat. 7)
Femme assise dans un fauteuil, 1910
[Woman in an Armchair]
Oil on canvas, 100 x 73 cm
Centre Pompidou, Musée national d'art moderne, Paris
Bequest of Georges Salles, 1967

Pablo Picasso (cat. 13)
**Portrait de Daniel-Henry Kahnweiler*, 1910
[Portrait of Daniel-Henry Kahnweiler]
Oil on canvas, 101.1 x 73.3 cm
The Art Institute of Chicago / Gift of Mrs. Gilbert W. Chapman
in memory of Charles B. Goodspeed

Pablo Picasso (cat. 87)
Pipe, verre, journal, guitare et boutteille de Vieux Marc:
« Lacerba », spring 1914
[Pipe, Glass, Newspaper, Guitar, and Bottle of Vieux Marc: "Lacerba"]
Pasted paper, oil and chalk on canvas, 73.2 x 59.4 cm
Peggy Guggenheim Collection, Venice,
(Solomon R. Guggenheim Foundation, New York)

Liubov Popova (cat. 98)
Čelovek + Vozduh + Prostranstvo, 1913
[Figure + Air + Space]
Oil on canvas, 125 x 107 cm
State Russian Museum, St. Petersburg

Liubov Popova (cat. 100)
Étude pour un portrait, 1914–1915
[Study for a Portrait]
Oil on cardboard, 59.5 x 41.6 cm (recto)
Study for a Portrait: Italian Still Life
Oil, marble dust, collage mounted on cardboard (verso)
State Museum of Contemporary Art, George Costakis Collection,
Thessalonika

Liubov Popova (cat. 99)
Femme voyageante ou Voyageuse, 1915
[Woman Travelling or The Traveller]
Oil on canvas, 158.5 x 123 cm
State Museum of Contemporary Art, George Costakis Collection,
Thessalonika

Olga Rozanova (cat. 101)
Homme dans la rue (Analyse de volumes), 1913
[Man in the Street (Analysis of volumes)]
Oil on canvas, 83 x 61.5 cm
Museo Thyssen-Bornemisza, Madrid

Morgan Russell (cat. 74)
Cosmic Synchromy, 1914
Oil on canvas, 58.4 x 50.8 cm
Munson-Williams-Proctor Arts Institute, Museum of Art, Utica (NY)

Luigi Russolo (cat. 44)
**Chioma (I Capelli di Tina)*, 1910–1911
[Head of Hair (Tina's Hair)]
Oil on canvas, 71.5 x 49 cm
Private collection

Luigi Russolo (cat. 42)
La rivolta, 1911
[The Rebellion]
Oil on canvas, 150.8 x 230.7 cm
Collection Gemeentemuseum Den Haag, The Hague

Luigi Russolo (cat. 43)
Ricordi di una notte, 1911
[Memories of a Night]
Oil on canvas, 100.9 x 100.9 cm
Collection Barbara Slifka

Gino Severini (cat. 45)
La Danse du « pan-pan » au Monico, 1909–1911/1959–1960
[The Dance of the "Pan-Pan" at the Monico]
Oil on canvas, 280 x 400 cm / replica of the original work painting
in Rome by the artist (1959–60)
Centre Pompidou, Musée national d'art moderne, Paris
Gift of Jeanne Severini and her daughters, 1967

Gino Severini (cat. 47)
**Le Chat noir*, 1910–1911
[The Black Cat]
Oil on canvas, 54.4 x 73 cm
National Gallery of Canada, Ottawa
Purchased 1956

Gino Severini (cat. 50)
**La Modiste*, c. 1910–1911
[The Milliner]
Oil on canvas, 64.8 x 48.3 cm
Philadelphia Museum of Art, Philadelphia
Gift of Sylvia and Joseph Slifka, 2004

Gino Severini (cat. 46)
Souvenirs de voyage, 1910–1911
[Memories of a Journey]
Oil on canvas, 80 x 100 cm
Private collection

Gino Severini (cat. 51)
Le Boulevard, 1911
[The Boulevard]
Oil on canvas, 63.5 x 91.5 cm
Estorick Collection, London

Gino Severini (cat. 48)
**La Danseuse obsédante*, 1911
[The Obsessive Dancer]
Oil on canvas, 73.5 x 54 cm
Private collection

Gino Severini (cat. 52)
Les Voix de ma chambre, 1911
[The Voices of My Room]
Oil on canvas, 37.7 x 55.2 cm
Staatsgalerie Stuttgart, Stuttgart

Gino Severini (cat. 49)
Danseuses jaunes, c. 1911–1912
[Yellow Dancers]
Oil on canvas, 45.7 x 61 cm
Harvard University Art Museums, Fogg Art Museum, Cambridge (MA)
Gift of Mr & Mrs Joseph H. Hazen, 1961

Gino Severini (cat. 85)
Nature morte au journal « Lacerba », 1913
[Still Life with the Newspaper *"Lacerba"*]
Glued paper, Indian ink, pencil, charcoal,
gouache and chalk on paper, 50 x 66 cm
Fonds national d'art contemporain, Ministère de la culture
et de la communication, Paris
On permanent loan to the Musée d'art moderne de Saint-Étienne,
Saint-Étienne, 1956, FNAC: 24875

Gino Severini (cat. 115)
**Ecroulement*, 1915
[Crash]
Oil on canvas, 92 x 73 cm
Private collection

Gino Severini (cat. 86)
Portrait de Paul Fort, 1915
[Portrait of Paul Fort]
Glued paper on canvas, 81 x 65 cm
Centre Pompidou, Musée national d'art moderne, Paris
Gift of Mrs Severini and her daughters, 1967

Gino Severini (cat. 113)
Train de banlieue arrivant à Paris, 1915
[Suburban Train Arriving in Paris]
Oil on canvas, 88.6 x 115.6 cm
Tate, London
Purchased with assistance from a member of The Art Fund, 1968

Gino Severini (cat. 116)
Train de blessés, 1915
[Red Cross Train]
Oil on canvas, 117 x 90 cm
Stedelijk Museum, Amsterdam

Gino Severini (cat. 114)
Train de la Croix Rouge traversant au village, 1915
[Red Cross Train Passing a Village]
Oil on canvas, 89 x 116.2 cm
Solomon R. Guggenheim Museum, New York
Solomon R. Guggenheim Founding Collection

Ardengo Soffici (cat. 84)
Linee e volumi di una persona, 1912
[Lines and Volumes of a Person]
Oil on canvas, 65 x 48 cm
Civiche Raccolte d'Arte, Museo del Novecento, Milan

Joseph Stella (cat. 75)
**Battle of Lights, Coney Island, Mardi Gras*, 1913–1914
Oil on canvas, 195.6 x 215.3 cm
Yale University Art Gallery, New Haven (Conn.)
Gift of Collection Société Anonyme

Jacques Villon (cat. 66)
Jeune Femme, 1912
[Young Woman]
Oil on canvas, 146.2 x 114.3 cm
Philadelphia Museum of Art, Philadelphia
The Louise and Walter Arensberg Collection, 1950

Jacques Villon (cat. 65)
Soldats en marche, 1913
[Soldiers on the March]
Oil on canvas, 65 x 92 cm
Centre Pompidou, Musée national d'art moderne, Paris
Purchased 1976

Edward Wadsworth (cat. 112)
Vorticist Composition, 1915
Oil on canvas, 76.3 x 63.5 cm
Museo Thyssen-Bornemisza, Madrid

SELECTED BIBLIOGRAPHY

MANIFESTOS AND PROCLAMATIONS

1909

Marinetti, Filippo Tommaso. *Manifesto del Futurismo* (1908–09),
tracts (several versions); *Fondazione e Manifesto del Futurismo*, in *Poesia*
(Milan), 5th year, nos. 1–2, Feb.–March 1909, pp. 1–8; *Le Futurisme*,
in *Le Figaro* (Paris), 20 Feb. 1909, p. 1; Russian translation:
Večer [Evening] (Moscow), 8 March 1909.

Manifeste du primitivisme. Poésie (Toulouse), March 1909.

Marinetti, Filippo Tommaso. *Tuons le clair de lune!* (April 1909), in *Poesia*
(Milan), nos. 7–9, Aug.–Oct. 1909; *Uccidiamo di Chiaro di Luna!* Milan:
Ed. Futuriste di *Poesia*, June 1911. German translation in *Der Sturm*
(Berlin), nos. 111 and 112, May and June 1912.

1910

Boccioni, Umberto et al. *Manifesto dei pittori futuristi*, tract, dated "Turin,
11 April 1910"; in *Comœdia* (Paris), 18 May 1910; *Les Peintres
futuristes italiens*. Galerie Bernheim-Jeune, 5–24 Feb. 1912.

Marinetti, Filippo Tommaso. *Contro Venezia passatista* (27 April 1910),
manifesto scattered from the top of Piazza di San Marco, Venice.

The Futurist poets and painters [F.T. Marinetti et al.]. *Venise futuriste*,
April 1910, in *Comœdia* 17 June 1910.

Marinetti, Filippo Tommaso. *Manifeste des auteurs dramatiques futuristes*,
in *Il Nuovo Teatro*, nos. 5–6, 25 Dec. 1910–5 Jan. 1911, tract in French
dated "Milan, 22 April 1911".

1912

Saint-Point, Valentine de. *Manifeste de la femme futuriste*
(Tract, Paris: 25 March 1912); *Der Sturm* (Berlin) no. 108, May 1912.

Boccioni, Umberto. *La scultura futurista*, tract, dated "Milan, 11 April
1912"; *Manifeste technique de la sculpture futuriste*, tract, dated "Milan,
11 April 1912"; *Première Exposition de sculpture futuriste du peintre et
sculpteur futuriste Boccioni*. Paris: Galerie La Boëtie, 20 June–16 July
1913.

Burluk [Burliuk], David et al. *Poščëčina obščestvennomu vkusu*
[A Slap in the Face], Moscow: Kuzmin and Dolinskij, December 1912.

1913

Saint-Point, Valentine de. *Manifeste futuriste de la luxure*, tract,
dated "Paris, 11 January 1913".

Russolo, Luigi. *L'Art des bruits. Manifeste futuriste*, tract, dated "Milan,
11 March 1913".

Marinetti, Filippo Tommaso. *Imagination sans fils et les mots en liberté*
(11 May 1913). Published in Italian as *L'immaginazione senza fili e le
parole in libertà*, in *Lacerba* (Florence), vol. 1, no. 12, 15 June 1913.

Picabia, Francis. *Manifeste de l'école amorphiste*, in *Camera Work* (New
York), nos. 41–44 (special issue: *A Photographic Quarterly*), June 1913.

Barzun, Henri-Martin. *Manifeste pour le simultanéisme poétique*, in
Paris-Journal, 27 June 1913.

Del Marle, Félix. *Manifeste futuriste contre Montmartre*, in *Paris-Journal*,
13 July 1913; *Manifeste futuriste à Montmartre*, in *Comœdia* (Paris),
18 July 1913; *Manifeste futuriste contre Montmartre*, in *Lacerba*
(Florence), I, no. 16, 15 Aug. 1913; *Umělecký Měsíčník* [Monthly Arts
Review] (Prague), 9 Aug. 1913.

Carrà, Carlo. *La Pittura dei suoni, rumori, odori. Manifesto futurista*
(11 August 1913), in *Lacerba* (Florence), I, no. 17, 1 Sept. 1913.

Boccioni, Umberto. *Il dinamismo futurista e la pittura francese*. *Lacerba*
(Florence), I, no. 15, 1 Aug. 1913.

Severini, Gino. *Le Analogie plastiche del dinamismo. Manifesto futurista*
(Sept.-Oct. 1913).

Boccioni, Umberto. "Simultanéité futuriste" (25 Nov. 1913),
Der Sturm (Berlin), nos. 190–191, 2 Dec. 1913.

1914

Marinetti, Filippo Tommaso. *Abbasso il tango e Parsifal!*, tract, dated
"Milan, 11 January 1914"; *Lacerba* (Florence), II, no. 2, 15 Jan., 1914.

Palazzeschi, Aldo. *Il Controdolore. Manifesto futurista*, in *Lacerba*
(Florence), II, no. 2, 15 Jan. 1914.

Marinetti, Filippo Tommaso, and Nevinson, C.R.W. *A Futurist Manifesto:
Vital English Art*, the *Observer* (London), 7 June 1914; *Contre l'art
anglais* (11 June 1914). Italian version (with a few variants): *Manifesto
futurista*, in *Lacerba* (Florence), II, no. 14, 15 July 1914.

Lewis, Percy Wyndham, Aldington, Richard et al., *Vorticism (Manifesto)*.
Blast (London), no. 1, 2 July 1914 (dated 20 June).

1915

Balla, Giacomo, and Depero, Fortunato. *Ricostruzione futurista
dell'universo*, tract, dated "Milan, 11 March 1915".

1921

Marinetti, Filippo Tommaso. *Il Tattilismo. Manifesto futurista*, tract dated
"Milan, 11 January 1921"; *Le Tactilisme* (11 January 1921).
Comœdia (Paris), 16 January 1921.

PRESS ARTICLES (1908–1917)

[Anon.], "F.T. Marinetti colla sua automobile in un fossato", *Il Corriere della sera* (Milan), 16 October 1908.

Vauxcelles, Louis. "Exposition Braque", *Gil Blas* (Paris), 14 November 1908.

Morice, Charles. "Exposition Braque (galerie Kahnweiler, 28, rue Vignon)", section on "Art moderne", *Mercure de France* (Paris), 16 December 1908.

Rabov, R. "Futurism: a new literary school", *Vestnik literatury tovaričšestva Vol'f* [] (Moscow), no. 5, [1909].

[Anon.], "Intermezzi: Il Futurismo", *L'Unione* (Milan), 4 February 1909.

Flok, "Dopo il caffé: Futurismo", *La Sera* (Milan), 4–5 February 1909.

[Anon.], "Cronache letterarie: il 'Futurismo'", *La Gazzetta dell'Emilia* (Bologna), 5 February 1909.

Il Cintraco, "Il Futurismo", *Il Caffaro* (Genoa), 5 February 1909.

Carli, D. "Tieni in mano!", *Monsignor Perelli* (Naples), 6 February 1909.

Spada, Cino . "Punto e taglio", *Il Pungolo* (Naples), 6 February 1909.

[Anon.], "Futurismo da tribunal", *I Tribunali*, (Milan/Naples), 7 February 1909, with a letter from A.G. Bianchi.

Il Beniamino, "Le Pasquinate della settimana", *Il Pasquino* (Turin), 7 February 1909.

[Anon.], "Il 'Futurismo'", *La Gazzetta di Mantova* (Mantua), 8 February 1909.

[Anon.], "Il 'Futurismo'", *Arena* (Verona), 9–10 February 1909.

Paphnedo. "Una nuova scuola letteraria", *Il Corriere delle Puglie* (Bari), 11 February 1909.

Snob. "I nipoti di Carneade", *Il Momento* (Turin), 13 February 1909.

Simplicissimus [Enrico Thovez]. "La poesia dello schiaffo e del pugno", *La Stampa* (Turin), 20 February 1909.

Ojetti, Ugo. "Accanto alla vita", *L'Illustrazione italiana* (Turin), 28 February 1909.

Buzzi, Paolo. "Toute la lyre", *Poesia* (Milan), 5th year, no. 1–2, February–March 1909.

[Anon.], "Furious Fight with Swords: Determined duel between novelist and well-known poet", *Police Budget* (London), 24 April 1909.

Vauxcelles, Louis. "Salon des indépendants", *Gil Blas* (Paris), 25 May 1909.

Mistral, Frédéric. "Du futurisme au primitivisme", *Poésie* (Toulouse), nos. 31–33 [summer 1909].

Copeau, Jacques. "*Poesia* et le futurisme", *La Nouvelle Revue française* (Paris), no. 7, 1 August 1909.

Marinetti, Filippo Tommaso. "D'Annunzio futuriste et le 'mépris de la femme'", *Poesia* (Milan), nos. 7–8–9, August–September–October 1909.
— "I nostri nemici comuni", *La Demolizione*, 16 March 1910.

Visan, Tancrède de. "La philosophie de M. Bergson et le lyrisme contemporain", *Vers et prose* (Paris), vol. 21, April–May 1910.

[Anon.], "Beseda s N.S. Gončarovoj" ["Discussion with N.S. Goncharova"], *Stoličnaâ Molva* [Rumors of the Capital] (Moscow), no. 115, 5 April 1910.

Soffici, Ardengo. "Riposta ai futuristi", *La Voce* (Florence), vol. 2, no. 23, 19 May 1910.

Apollinaire, Guillaume. "À propos du Salon d'automne", *Poésie* (Toulouse), Autumn 1910.

Metzinger, Jean. "Note sur la peinture", *Pan* (Paris), vol. 3, no. 10, October–November 1910.

Allard Roger, "Au Salon d'automne de Paris", *L'Art libre* (Lyons), no. 12, November 1910, p. 442.

Wynne Nevinson, Margaret. "Futurism and Woman", *The Vote*, 31 December 1910.

[Anon.], "Cinematografia: Muybridge", *La Fotografia artistica* (Turin), 8th year, no. 1, January 1911.

Apollinaire, Guillaume, "Le Salon des indépendants", *L'Intransigeant* (Paris), 21 April 1911.

[Anon.], "La Prima Esposizione d'arte libera", *Il Secolo* (Milan), 1 May 1911.

Allard Roger, "Sur quelques peintres", *Les Marches du Sud-Ouest* (Paris), no. 2, June 1911.

Soffici, Ardengo. "Arte libera e pittura futurista", *La Voce* (Florence), vol. 3, no. 25, 22 June 1911.

Cavacchioli, Enrico. "I futuristi", *Attualità, rivista settimanale di letteratura amena* (Milan), 25 June 1911.

Metzinger, Jean. "Cubisme et tradition", *Paris-Journal*, 16 August 1911.

Soffici, Ardengo. " Picasso e Braque", *La Voce* (Florence), vol. 3, no. 34, 24 August 1911.

Gleizes, Albert. "L'art et ses représentants. Jean Metzinger", *Revue indépendante* (Paris), no. 4, September 1911.

La Palette [André Salmon]. "Courrier des ateliers : Jean Metzinger", *Paris-Journal*, 3 October 1911.

Apollinaire, Guillaume,"Le Salon d'automne", *L'Intransigeant* (Paris), 10 October 1911.
— "Les peintres futuristes", *Mercure de France* (Paris), no. 346, 16 November 1911.

Salmon, André. "Bergson et le cubisme", *Paris-Journal*, 30 November 1911.

Apollinaire, Guillaume, "Du sujet dans la peinture moderne", *Les Soirées de Paris*, no. 1, February 1912.

[Anon.], "Oui, mais les futuristes peignent mieux", *Excelsior* (Paris), 5 February 1912.

Vauxcelles, Louis. "Les futuristes", *Gil Blas* (Paris), 6 February 1912.

Apollinaire, Guillaume. "La vie artistique. Les peintres futuristes italiens", *L'Intransigeant* (Paris), 7 February 1912.
— "Les Futuristes", *Le Petit Bleu* (Paris), 9 February 1912.

Helsey, Édouard. "Après le cubisme, le futurisme", *Le Journal* (Paris), 10 February 1912.

Wattman, Le. "On dit que…", *L'Intransigeant* (Paris), 14 February 1912.

Konody, Paul G. "The Italian Futurists: Nightmare Exhibition at the Sackville Gallery", *Pall Mall Gazette* (London), 1 March 1912.

Apollinaire, Guillaume, "Le Salon des indépendants", *L'Intransigeant* (Paris), 19 March 1912.

Croquez, Albert. "Le Salon des Indépendants", *L'Autorité* (Paris), 19 March 1912.

Vauxcelles, Louis. "Au Salon des indépendants", *Gil Blas* (Paris), 19 March 1912.

Apollinaire, Guillaume. "Les Indépendants". Les nouvelles tendances et les artistes personnels", *Le Petit Bleu* (Paris), 20 March 1912.
— "Vernissage aux Indépendants", *L'Intransigeant* (Paris), 25 March 1912.
— "Vernissage aux Indépendants", *L'Intransigeant* (Paris), 3 April 1912.
— "La peinture nouvelle. Notes d'art", *Les Soirées de Paris*, no. 4, May 1912.
— "Demain a lieu le vernissage du Salon d'automne", *L'Intransigeant* (Paris), 30 September 1912.

Raynal, Maurice. "L'exposition de la Section d'or", *La Section d'or* (Paris), 1st year, no. 1, 9 October 1912.

Apollinaire, Guillaume. "À la Section d'or, c'est ce soir que les cubistes inaugurent leur exposition," *L'Intransigeant* (Paris), 10 October 1912.

Vauxcelles, Louis. "Les Arts. Discussions", *Gil Blas* (Paris), 22 October 1912.

Hourcade-Olivier. "Courrier des arts. Discussions. A.M. Vauxcelles", *Paris-Journal*, 53rd year, no. 1478, 23 October 1912.

[Anon.], "Picabia, Art Rebel, Here to Teach New Movement", *New York Times*, section 5, 16 February 1913.

Hapgood, Hutchins. "A Paris Painter", *The Globe and Commercial Advertiser* (New York), 20 February 1913.

Bealty, J.G. "The New Delirium", *Kansas City Star*, 23 February 1913.

Gleizes, Albert. "Le cubisme et la tradition", *Montjoie !* (Paris), no. 1, 10 February 1913, and no. 2, 25 February 1913.

Apollinaire, Guillaume, "À travers le Salon des indépendants", *Montjoie !* (Paris), supplement to no. 3 a special issue devoted to the 29th Salon des indépendants, March 1913.

Mather, Frank Jewett. "Newest Tendencies in Art", *The Independent*, 6 March 1913.

Carrà, Carlo. "Piani plastici come espansione sferica nello spazio", *Lacerba* (Florence), vol. I, no. 6, 15 March 1913.

Apollinaire, Guillaume. "Le Salon des indépendants", *L'Intransigeant* (Paris), 25 March 1913.

Picabia, Francis. "How New York Looks to Me", *The New York American Magazine*, 30 March 1913.

Apollinaire, Guillaume, "Le Salon des Indépendants", *L'Intransigeant* (Paris), 2 April 1913.

Severini, Gino. "Get Inside the Picture: Futurism as the Artist Sees it", *The Daily Express*, 11 April 1913.

Del Marle, Félix. "La peinture futuriste", *Le Nord illustré* (Lille), 5th year, no. 8, 15 April 1913.

Farge, André. "Un peintre futuriste à Lille", *Le Nord illustré* (Lille), no. 8, 15 April 1913.

[Anon.], "Notes d'art: Le cubisme au Salon Biderman", *Gazette de Lausanne*, 4 May 1913.

Léger, Fernand. "Les origines de la peinture et sa valeur representative", *Montjoie !* (Paris), no. 8, 29 May 1913, p. 7 and nos. 9–10, 14–29 June 1913, p. 9; *Der Sturm* (Berlin), nos. 172–173, 1st fortnight of August 1913.

Apollinaire, Guillaume, "L'Antitradition futuriste", *Gil Blas* (Paris), 3 August 1913. Republished in *Lacerba* (Florence), vol. I, no. 18, 15 September 1913.

La Palette [André Salmon]. "La fin du futurisme", *Gil Blas* (Paris), 3 August 1913.

Phillips, Sir Claude. "Post-Impressionism", *Daily Telegraph* (London), October 1913.

Bell, Clive. "Art: The New Post-Impressionist Show", *The Nation*, 25 October 1913.

Nevinson, Henry. "Marinetti: The Apostle of Futurism", *Manchester Guardian*, November 1913.

Apollinaire, Guillaume. "M. Bérard inaugure le Salon d'automne", *L'Intransigeant* (Paris), 14 November 1913.
— "Chronique mensuelle", *Les Soirées de Paris*, no. 18, 15 November 1913.

Gleizes, Albert. "Opinions", *Montjoie !* (Paris), nos. 11–12, November–December 1913.

Dervaux, Adolphe. "Notes sur l'art : Le Salon d'automne", *La Plume* (Paris), no. 424, 1 December 1913.

Picabia, Francis. "Ne riez pas, c'est de la peinture et ça représente une jeune Américaine", *Le Matin* (Paris), 1 December 1913.

Allard Roger, "Les arts plastiques", *Les Écrits français* (Paris), no. 1, 5 December 1913.

Apollinaire, Guillaume, "Le Salon d'automne", *Les Soirées de Paris*, no. 19, 15 December 1913.

Delaunay, Robert' "Lettre ouverte au Sturm"(sent in French to Herwarth Walden on 17 December 1913), *Der Sturm* (Berlin), nos. 194–195, January 1914.

Del Marle, Félix. "Quelques notes sur la simultanéité en peinture", *Poème et drame* (Paris), no. 7, January–March 1914.

Papini, Giovanni. "Il cerchio si chiude", *Lacerba* (Florence), vol. 2, no. 4, 15 February 1914.

La Palette [André Salmon]. "Le Salon [des indépendants]", *Montjoie !* (Paris), no. 3, March 1914.

Boccioni, Umberto. "Il cerchio non si chiude", *Lacerba* (Florence), vol. 2, no. 5, 1 March 1914.

Papini, Giovanni. "Cerchi aperti", *Lacerba* (Florence), vol. 2, no. 6, 15 March 1914.

Apollinaire, Guillaume. "Le 30e Salon des Indépendants", *Les Soirées de Paris*, no. 22, March 1914.
— "Au Salon des Indépendants", *L'Intransigeant* (Paris), 5 March 1914.

Papini, Giovanni, and Ardengo Soffici. "Une querelle artistique", *L'Intransigeant* (Paris), 8 March 1914.

Fry, Roger. "Two Views of the London Group", *The Nation*, 19 March 1914.

Jackson, H. "Who's the Futurist: Wells or Marinetti?", *TP's Weekly* (London), 15 May 1914.

Galza Redolo, Gino. "Di notte, nei bassi fondi londinesi, in compagna di Marinetti", *Giornale d'Italia* (Rome), 31 May 1914.

[Anon.], "Vorticism", *Manchester Guardian*, 13 June 1914.

Apollinaire, Guillaume, "Simultanisme-Librettisme", *Les Soirées de Paris*, no. 25, 15 June 1914.

Léger, Fernand. "Les réalisations picturales actuelles", *Les Soirées de Paris*, no. 25, 15 June 1914.

Hind, C. Lewis. "Rebel Art: Exhibits by the Philistines; From the Ordinary to the Extraordinary", *Daily Chronicle* (Philadelphia), 25 June 1914.

Lewis, Percy Wyndham. "Long Live the Vortex!" *Blast* (London), no. 1, 2 July 1914 (dated 20 June).

Sant'Elia, Antonio. "L'Architecte futuriste d'Antonio", *Lacerba* (Florence), vol. 2, no. 15, 1st August 1914.

Palazzeschi [Aldo Giurni], Giovanni Papini and Ardengo Soffici. "Futurismo e Marinettismo", *Lacerba* (Florence), no. 7, 14 February 1915.

Nevinson, Christopher. "Painter of Smells at the Front: A Futurist's Views on the War", *Daily Express*, 25 February 1915.

Gaudier-Brzeska, Henri. "Vortex (written from the War)", *Blast* (London), no. 2, July 1915.

Lewis, Percy Wyndham. "Futurism, Magic Life / The Melodrama of Modernity" / "To Suffragettes" / "One Six Hundred Vereschagin and Uccello" / "Marinetti's Occupation" / "The London Group" / "The Crowd Master 1914, London, July", *Blast* (London), no. 2, July 1915.

[Anon.], "A complete reversal of art opinions by Marcel Duchamp, iconoclast", *Art and Decoration* (New York), 1 September 1915.
Marinetti, Filippo Tommaso. "La guerra complemento logico della natura", *L'Italia futurista* (Florence), 2nd year, no. 2, 25 February 1917.

BOOKS AND EXHIBITION CATALOGUES

1ère Exposition de sculpture futuriste du peintre et sculpteur futuriste Boccioni. Pref. Umberto Boccioni. Paris: Galerie La Boëtie, 20 June–16 July 1913.

The 1913 Armory Show in Retrospect. Amherst College, 17 February–17 March 1958.

Adaskina, Natalia, and Sarabianov, Dimitri. *Lioubov Popova*. Paris: Philippe Sers, 1989.

Affron, Matthew, and Antliff Mark, (eds.) *Fascist Visions: Art and Ideology in France and Italy*. Princeton (NJ): Princeton University Press, 1997.

Albert Gleizes : Le cubisme en majesté. Barcelona: Museu Picasso, 28 March–5 August 2001; Lyons: Musée des Beaux-Arts, 6 September–10 December 2001 (Paris: Réunion des Musées nationaux, 2001).

Allard, Roger. *Le Bocage amoureux ou le divertissement des amants citadins et champêtres*. Paris: Eugène Figuière, 1911.

Altomare, Libero. *Incontro con Marinetti e il futurism*. Rome: Corso, 1954.

André Derain: The London Paintings. London: Courtauld Institute of Art Gallery, (Paul Holberton Publishing, 2005).

Andréoli de Villers, Jean-Pierre. *Le Premier Manifeste du futurisme*. Critical edition with facsimile of the original manifesto by Filippo Tommaso Marinetti. Ottawa: University of Ottawa Press, 1986.

Antliff, Mark. *Inventing Bergson: Cultural Politics and the Parisian Avant-Garde*. Princeton (NJ): Princeton University Press, 1993.

Antliff, Mark, and Green Vivienne, (eds.) *Vorticism*. (Forthcoming, 2010).

Antliff, Mark, and Leighten Patricia. *Cubism and Culture*. London and New York: Thames & Hudson, 2001.

— *A Cubism Reader: Documents and Criticism, 1906-1914*. Chicago and London: University of Chicago Press, 2008.

Apollinaire e l'Avanguardia. Rome: Galleria Nazionale d'Arte Moderna (Rome: De Luca Editore, 1980).

Apollinaire, Guillaume. *Les Peintres cubistes. Méditations esthétiques*. [Paris: Eugène Figuière, 1913] Paris: Hermann, 1980.
— *Anecdotiques*. Paris: Librairie Stock, 1926.
— *Lettere a F.T. Marinetti con il manoscritto Antitradizione futurista*.

Jannini Pasquale A., (eds.) Milan: All'Insegna del Pesce d'Oro, 1978.

Apollonio, Umbro (ed.) *Futurist Manifestos*. London: Thames and Hudson, 1973 and 2001.

Armory Show-International Exhibition of Modern Art. New York: Armory of the Sixty-Ninth Infantry, 17 February–15 March 1913; Art Institute of Chicago, 24 March–16 April 1913; Copley Society of Boston, 28 April–19 May 1913.

Ashton, Dore. *Rencontre avec Marcel Duchamp*. Paris: L'Échoppe, 1996.

Avtonomova, Natalâ. *I.V. Klûn v Tret'âkovskoj galeree*. Moscow: RA, 1999.

Aksënov [Axionov] Ivan, and Ekster [Exter], Aleksandra, (eds.). *Pikasso i okresnosti [Picasso and environs]*. Moscow: Centrifuga, 1917.

Azouvi, François. *La Gloire de Bergson. Essai sur le magistère philosophique*. Paris: Gallimard, 2007.

Ballo, Guido. *Boccioni: La vita e l'opere*. Milan: Il Saggiatore, 1964.

Barrer, Patrick. *Quand l'art du xxe siècle était conçu par des inconnus : l'histoire du Salon d'automne de 1906 à nos jours*. Paris: Arts et Images du monde, 1992.

Barr, Alfred H., (ed.). *Cubism and Abstract Art*. New York: The Museum of Modern Art, 1936, reprinted 1964.

Barzun, Henri-Martin. *La Terrestre Tragédie*. Créteil: L'Abbaye, 1907.

Benjamin, Walter. *The Work of Art in the Age of its Technological Reproducibility and other Writings* [1935–1939]. New York: The Nation, 2008.

Berghaus, Günter, *Futurism and Politics: Between Anarchist Rebellion and Fascist Reaction, 1909–1944*. Providence (RI)/Oxford: Berghahn Books, 1996.

Bergson, Henri. *Matière et mémoire. Essai sur la relation du corps à l'esprit*. Paris: Félix Alcan, 1896.
— *Le Rire. Essai sur la signification du comique*. Paris: Félix Alcan, 1900.
— *L'Évolution créatrice* [1907]. Paris: Presses universitaires de France, 'Quadrige', 2007.
— *La Filosofia dell'intuizione*. Giovanni Papini, (ed.). Lanciano: Carabba, 1909.

Black, Jonathan, (ed.). *Blasting the Future! Vorticism in Britain 1910–1920*. London: Estorick Collection, 4 February–18 April 2004; Manchester; The Whitworth Art Gallery, 7 May–25 July 2004 (Philip Wilson Publishers, 2004).

Blaserna, Pietro. *La Teoria del suono nei suoi rapporti con la musica: Dieci conferenze*. Milan: Fratelli Dumolard, 1875, with the text on the "physiological causes of musical harmony" by Hermann Helmholtz in the appendix.

Birolli, Zeno, (ed.). *Umberto Boccioni, Gli Scritti editi e inediti*. Milan: Feltrinelli, 1971.
— *Altri inediti e apparati critici*. Milan: Feltrinelli, 1972.

Boccioni. Pittore scultore futurista. Milan: Palazzo Reale, 6 October 2006–7 January 2007 (Milan: Skira, 2006).

Boccioni's Materia: A Futurist Masterpiece and the Avant-Garde in Milan and Paris. New York: The Solomon R. Guggenheim Museum, 6 February–9 May 2004.

Boccioni, Umberto. *Pittura et scultura futuriste (Dinamismo plastico)*. Milan: Ed. futuriste di Poesia, 1914.

Bomberg. Pref. David Bomberg. London: Chenil Gallery at Chelsea, July 1914.

Borràs, Maria Lluïsa. *Picabia*. Paris: Albin Michel, 1985.

Bowlt, John E. (ed.). *Russian Art of the Avant-Garde: Theory and Crticism 1902–1934*. New York: Viking Press, 1976.

Bragaglia, Anton Giulio. *Fotodinamismo futurista* [1913]. Turin: Giulio Einaudi, 1970.

Braque. Pref. Guillaume Apollinaire. Paris: galerie Kahnweiler, 9–28 November 1908.

Breuining, Leroy C. (ed.). *Apollinaire on Art: Essays and Reviews 1902 –1918*. New York: Da Capo Press, 1972.

Brinton, Christian. *Impressions of the Art at the Panama Pacific International Exposition*. New York: John Lane Company, 1916.

Burlûk [Burliuk], David, and Vladimir Maâkovskij [Mayakovsky]. *Vzâl: Baraban futuristov [He Took: The Futurists' Drum]*. Moscow: December 1915.

Burlûk [Burliuk], David and Nikolaj, Guro Elena, Kamenskij Vasilij, lebnikov Velimir, Mâsoedov Sergei, and Nizen Ekaterina. *Sadok sudej [The Judges' Breeding Ground]*. St Petersburg: Žuravl', 1910, 1913.

Buffet-Picabia, Gabrielle. *Rencontres avec Picabia, Apollinaire, Cravan, Duchamp, Arp, Calder*. Paris: Pierre Belfond, 1977.

Buzzi, Paolo. *Futurismo: Scritti, carteggi, testimonianze*. Eds. Morini, Mario, and Pignatari, Giampaolo. Milan: Quaderni di Palazzo Sormani, 1982.

Cabanne, Pierre. *Interviews with Marcel Duchamp*. New York: Da Capo Press, 1979.

Calvesi, Maurizio. *Il Futurismo: La fusione della vita dell'arte*. Milan: Fratelli Fabbri, 1975.

Camfield, William A. *Francis Picabia. His Art, Life and Time.* Princeton (NJ): Princeton University Press, 1979.

Carpi, Umberto. *L'Estrema avanguardia del novecento.* Rome: Editori riuniti, 1985.

Carlo Carrà 1881–1966. Rome: Galleria nazionale d'Arte moderna, 15 December 1994–28 February 1995 (Milan: Electa, 1994).

Carrà, Carlo. *La Mia Vita* [1943]. Ed. Carrà, Massimo. Milan: Abscondita, 2002.
— *Tutti gli scritti.* Milan: Feltrinelli, 1978.
— *L'Éclat des choses ordinaires.* Violante, Isabel, and Jérôme Picon, (eds.) Paris: Images modernes, 2005.

Carrà, Massimo, and Fagone, Vittorio (eds.). *Carlo Carrà – Ardengo Soffici: Lettere 1913/1929.* Milan: Feltrinelli, 1983.

Cavacchioli, Enrico. *Le Ranocchie turchine.* Milan: Edizioni di *Poesia,* 1909.

Castiglioni, Ippolito [Adriano Cecioni]. *I Critici profani all'Esposizione nazionale di Torino.* Florence: Tipografia del Vocabolario, 1880.

Cendrars, Blaise. *Dix-neuf Poèmes élastiques.* Paris: Au Sans Pareil, 1919.
— *Du monde entier au cœur du monde.* Pref. Paul Morand. Paris: Denoël/Gallimard, 2001.

Cézanne. The Late Work. New York: The Museum of Modern Art, 7 October 1977–3 January 1978.

Charbonnier, Georges. *Le Monologue du peintre.* Paris: Julliard, 1959.

Cianci, Giovanni, (ed.). *Futurismo/Vorticismo.* Palermo: Quaderno 9, 1979.

Compton, Susan P. *The World Backwards: Russian Futurist Books 1912–1916.* London: British Library, 1978.

Coen, Ester, (ed.). *Boccioni. A Retrospective.* New York: The Metropolitan Museum of Art, 1988.

Color, Myth and Music, Stanton Macdonald-Wright and Synchromism. Raleigh: North Carolina Museum of Art, 4 March–3 July 2001; Los Angeles County Museum of Art, 5 August–29 October 2001; Houston: Museum of Fine Arts, 2 December 2001–24 February 2002.

Cork, Richard. (ed.). *Vorticism and its Allies.* London: Hayward Gallery, 27 March–2 June 1974.
— *Vorticism and Abstract Art in the First Machine Age.* London: Gordon Fraser, 1976, 2 vol.
— (ed.). *A Bitter Truth: Avant-Garde Art and the Great War.* London: Barbican Art Gallery, 1994.

Courthion, Pierre, *Gino Severini* [1930]. Trans. Prampolini, Giacomo. Milan: Ulrico Hoepli Editore, 1941.

Le Cubisme 1911–1918. Paris: Galerie de France, 25 May–30 June 1945.

Daix, Pierre. *La Vie de peintre de Pablo Picasso.* Paris, Le Seuil, 1977.
— *Dictionnaire Picasso.* Paris: Robert Laffont, 1995.

Henderson, Linda Dalrymple. *The Artist, "The Fourth Dimensions" and Non-Euclidean Geometry 1900–1930: A Romance of Many Dimensions.* New Haven (CT): Yale University Press, 1975.

Davenport-Hines, Richard. *A Night at the Majestic: Proust and the Great Modernist Dinner Party of 1922.* London: Faber & Faber, 2006.

De Angelis, Rodolfo. *Noi Futuristi.* Venice: Edizioni del Cavallino, 1958.

Décimo, Marc. *Maurice Princet. Le mathématicien du cubisme.* Paris: L'Échoppe, 2007.

Delaunay, Robert. *Du cubisme à l'art abstrait.* Previously unpublished documents published by Pierre Francastel and followed by a catalogue of Robert Delaunay's œuvre by Guy Habasque. Paris: SEVPEN, 1957;

trans. in Shapiro, David and Cohen Arthur A., *The New Art of Color: The Writings of Robert and Sonia Delaunay,* (A. Cohen, ed.), New York 1978.

Delaunay, Sonia. *Nous irons jusqu'au soleil.* Paris: Robert Laffont, 1978.

De Michelis, Cesare. *Il Futurismo italiano in Russia 1909–1929.* Bari: De Donato, 1973.

Donation Louise et Michel Leiris. Collection Kahnweiler-Leiris. Paris: Musée national d'art moderne, 22 November 1984–28 January 1985 (Paris: Centre Pompidou, 1984).

Drawings, Pastels, Watercolours and Oils of Severini. Pref. Gino Severini. New York: Photo Secession Gallery, March 1917.

Drudi Gambillo, Maria, and Fiori, Teresa. *Archivi del futurismo.* Rome: De Luca vol. I, 1958, vol. II, 1962.

Dubois, Félix. *Le Péril anarchiste.* Paris: Flammarion, 1894.

Eddy, Arthur Jerome. *Cubists and Post-Impressionism.* Chicago: A.C. McClurg & Co, 1914.

Edwards, Paul. *Wyndham Lewis: Painter and Writer.* New Haven (CT)/London: Yale University Press, 2000.

Edward, Paul (ed.). *Blast: Vorticism 1914–1918.* Aldershot: Ashgate Press, 2000.

Efros, Abram. *Profili* [*Profiles*]. Moscow: 1930.

Epstein, Jacob. *Epstein: An Autobiography.* London: Hulton, 1955.

Esposizione di pittura futurista di "Lacerba". Florence: Galleria Gonnelli, 30 November 1913–18 January 1914.

Exhibition of Works by the Italian Futurist Painters. Pref. Filippo Tommaso Marinetti. London: The Sackville Gallery, March 1912.

Exhibition of English Post-Impressionists, Cubists and Others. Brighton: December 1913–January 1914.

Exhibition of the Works of the Italian Futurist Painters and Sculptors. London: Doré Galleries, late April–May 1914.

Exposició d'art cubista. Pref. Jacques Nayral. Barcelona: Galeries Dalmau, 20 April–10 May 1912.

Fagiolo dell'Arco, Maurizio (ed.). *Giacomo Balla (1871-1958).* Rome: Galleria nazionale d'arte moderna, 2 December 1971–27 February 1972 (Rome: De Luca, 1971).

De Fattori à Morandi : Macchiaioli et modernes. Caen: musée des Beaux-Arts, 25 July–27 September 1998.

Fauchereau, Serge. *Hommes et mouvements esthétiques du xxᵉ siècle.* Paris: Cercle d'Art, 2005.

Faure, Élie. *L'Arbre d'Éden.* Paris: Georges Crès & Cie, 1922.

Fédit, Denise. *L'Œuvre de Kupka.* Paris: Éd. des Musées nationaux, 1966.

Fernand Léger. Rétrospective. Saint-Paul: Fondation Maeght, 2 July–2 October 1988.

Fernand Léger. Paris: Musée national d'art moderne, 29 May–29 September 1997 (Éd. du Centre Pompidou, 1997).

Fonti, Daniela, (ed.). *Gino Severini. The Dance 1909–1916.* Venice: Peggy Guggenheim Collection, 26 May–28 October 2001 (Milan: Skira, 2001).

Foster, Hal. *Prosthetic Gods.* Cambridge (MA)/London: The MIT Press, 2004.

František Kupka (1871–1957). A Retrospective. New York: The Solomon R. Guggenheim Museum, 10 October–7 December 1975.

František Kupka ou l'invention d'une abstraction. Paris: musée d'Art moderne de la Ville de Paris, 22 November 1989–25 February 1990 (Paris-Musées, 1989).

Fry, Edward. *Cubism.* Trans. Griffin, Jonathan. London: Thames & Hudson, 1966.

Le Futurisme et les avant-gardes littéraires et artistiques au début du xxᵉ siècle, actes du colloque international. Nantes: Université de Nantes-Centre international des Langues, 2002.

The Futurist Painter Severini Exhibits his Latest Works. Pref. Gino Severini. London: Marlborough Gallery, 7 April–7 May 1913.

George, Waldemar. *Larionov.* Paris: Bibliothèque des arts, 1966.

Georges Braque. Saint-Paul: Fondation Maeght, 1980.

Georges Braque. Saint-Paul: Fondation Maeght, 1994.

Getsy, David J., (ed.). *Sculpture and the Pursuit of a Modern Ideal in Britain, c. 1880–1930.* Aldershot: Ashgate Press, 2004.

Gilot, Françoise and Lake Carlton. *Life with Picasso.* New York - Toronto - London: McGraw-Hill Book Company, 1964.

Gino Severini. Pref. Bernard Dorival. Paris: Musée national d'art moderne, July–October 1967.

Gino Severini. Florence: Palazzo Pitti, 25 June–25 September 1983 (Milan: Electa, 1983).

Gleizes, Albert. *Souvenirs. Le cubisme 1908–1914.* Ampuis: Association des Amis d'Albert Gleizes, 1997.

Gleizes, Albert Gleizes, and Metzinger Jean. *Du "cubisme".* [Paris: Eugène Figuière, 1912]. Saint-Vincent-sur-Jabron/Sisteron: Présence, 1980.

Godoli, Ezio (ed.). *Il Dizionario del futurismo.* Florence: Vallecchi, 2001, 2 vol.

Golding, John. *Cubism: A History and an Analysis 1907–1914.* London: Faber and Faber, 1959, rev. 1988.

Gur'ânova, Nina. *Ol'ga Rozanova i rannij russkij avangard* [Olga Rozanova and the First Russian Avant-Garde]. Moscow: Gileâ, 2002.

Guro, Elena, lebnikov Velimir, Kručënyh Alexeï, and Matûšin Mihajl. *Troe* [The Three], St Petersburg: Žuravl', 1913.

Green, Christopher. *Léger and the Avant-Garde.* New Haven (CT)/London: Yale University Press, 1976.

Green, Christopher (ed.). *Roger Fry's Vision of Art.* London: Merrell Holberton Publishers/Courtauld Art Gallery, 1999.

Gruetzner Robins, Anna. *Modern Art in Britain 1910–1914.* London: Merrell Holberton Publishers/Barbican Art Gallery, 1997.

Hanson, Anne Coffin, (ed.). *Severini futurista: 1912–1917.* New Haven (CT): Yale University Art Gallery, 18 October 1995–7 January 1996 (New Haven (CT): Yale University Press, 1995).

Harrison, Charles, and Wood Paul (eds.). *Art in Theory, 1900–1990.* Oxford: Blackwell, 1992.

Haskell, Barbara (ed.). *Joseph Stella.* New York: Whitney Museum of American Art, 22 April–9 October 1994.

Howlett, Jana, and Mengham Rod (eds.). *The Violent Muse: Violence and the Artistic Imagination in Europe, 1910–1939.* Manchester: University Press, 1994.

Hulten, Pontus (ed.). *Futurismo e Futurismi.* Exh. cat. Palazzo Grassi, Venice, 1986. Milan: Bompiani 1986.

Humphreys, Richard, John Alexander, and Robinson, Peter. *Pound's Artists: Ezra Pound and the Visual Arts in London, Paris and Italy.* London: Tate Gallery, 1985.

Imoda, Enrico. *Fotografie di fantasmi*. Milan/Turin/Rome: Fratelli Bocca Editori, 1912.

Italia Nova. Une aventure de l'art italien, 1900–1950.
Paris, Galerie nationales du Grand Palais, 5 April–3 July 2006
(Paris: Réunion des musées nationaux / Skira, 2006).

Jacob, Max. *Art poétique* [1922]. Paris: L'Élocoquent, 1987.

Jacques Villon. Rouen: musée des Beaux-Arts, 14 June–21 September 1975; Paris: Grand Palais, 11 October–15 December 1975 (Paris: Réunion des musées nationaux, 1975).

Janacek, Gerald. *The Look of Russian Literature. Avant-Garde. Visual Experiments 1900–1930*. Princeton (NJ): Princeton University Press, 1984.

Jannini, Pasquale A., Lista Giovanni, and Orlandi Cerenza G. (eds.). *La fortuna del futurismo in Francia*. Rome: Bulzoni, 1979.

Jumeau-Lafond, Jean-David. *Les Peintres de l'âme. Le symbolisme idéaliste en France*. Antwerp: Pandora, 1999.

Kahn, Gustave. *L'Esthétique de la rue*. Paris: Eugène Fasquelle, 1901.

Kahnweiler, Daniel-Henry. *Der Weg zum Kubismus*. Munich: Delphin Verlag, 1920.
— *Juan Gris, sa vie, son œuvre, ses écrits*. Paris: Gallimard, reissued 1946.

Kazimir Malevich. Barcelona: Fundació Caixa Catalunya, 21 March–25 June 2006.

Khardjiev Nikolaï, and Trenin Vladimir, *La Culture poétique de Maïakovski*. Trans. Gérard Conio. Lausanne: L'Âge d'homme, 1982.

Khlebnikov, Velimir. *Zanguezi et autres poèmes*. Trans. Jean-Claude Lanne. Paris: Flammarion, 1996.
— *Tvoreniá*. M. Polâkov (ed.). Moscow: Sovetskij Pisatel', 1986.

Khlebnikov, Velimir, Kruchonykh Alexei, and Matiushin Mikhail. *Pobeda nad solncem. Opera*. [Victory over the Sun; St Petersburg, 1913]. Trans. in French J.-C. and V. Marcadé, as *La Victoire sur le soleil. Un opéra*. Postf. J.-C. Marcadé. Lausanne: L'Âge d'homme, 1976.

Kliun, Ivan. *Moj put' v iskusstve* [My Way in Art]. Moscow: RA, 1999.

Kovalenko, Georgij. *Aleksandra Ekster*. Moscow: Galart, 1993.
— *Aleksandra Ekster – Cvetovye ritmy* [Coloured Rhythms]. St Petersburg: Palace, 2001.
— *Russkij kubo-futurizm* [Russian Cubofuturism]. St Petersburg (reprinted): Dmitry Bulanin, 2002.

Kovtun, Evgeni, and Povelikhina Alla. *L'Enseigne peinte en Russie et les peintres de l'avant-garde*. Leningrad: Aurora Art Editions, 1991.

Kozloff, Max. *Cubism-Futurism*. New York: Charterhouse, 1973.

Kručœnyh [Kruchenykh], Aleksej, and Zina V. *Porosâta* [The Piglets]. St Petersburg: 1913.
— *Utinoe gnezdyško… durnyh slov* [The Little Duck's Nest… Bad Language]. St Petersburg: 1913.

Kupka, František. *La Création dans les arts plastiques* [1923]. Paris: Cercle d'art, 1989.

Laffitte, Sophie. *Alexandre Blok : une étude*. Paris: Seghers, 1958.

Lanne, Jean-Claude. *Vélimir Khlebnikov, poète futurien*. Paris: IES, 1983, 2 vol.

Larionov, Mihajl. *Lučism* [Rayonism]. Moscow: Münster, 1913.

Larionov, Mihajl, and Parkin Varsanofij. *Oslinnyj hvost' i mišen'* [The Donkey's Tail and The Target]. Moscow: Münster, 1913.

Larionov, Mihajl (ed.). *Mišen'* [The Target]. Moscow: 24 March–7 April 1913.

Laugier, Claude, and Richet, Michèle. *Œuvres de Fernand Léger au Musée national d'art moderne (1881–1955)*. Paris: Centre Pompidou, 1981.

Laurvik, John Nilsen. *Is it Art? Post-Impressionism – Futurism – Cubism*. New York: The International Press, 1913.

Leal, Brigitte (ed.). *Collection Art moderne*. Paris: Centre Pompidou, 2006.

Lebel Robert. *Sur Marcel Duchamp*. Paris/London: Trianon, 1959; facsimile of the 1st edition plus a book of unpublished letters by Marcel Duchamp. Paris: Centre Pompidou/Mazzota, 1996.

Léger, Fernand. *Fonctions de la peinture* [Paris, Gonthier, 1965]. Paris: Gallimard, 1997.

Le Noci, Guido. *Fernand Léger, sa vie, son œuvre, son rêve*. Milan: Apollinaire, 1971.

Longhi, Roberto. *La Scultura futurista di Boccioni*. Florence: Libreria della Voce, 1914.

Lewis, Percy Wyndham. *Blasting and Bombardiering* [1937]. London: Calder & Boyars, 1967.

Lista, Giovanni. *Futurisme. Manifestes, proclamations, documents*. Lausanne: L'Âge d'homme, 1973.
— *Marinetti et le futurisme. Études, documents, iconographie*. Lausanne: L'Âge d'homme, 1977.
— *Futurismo e fotografia*. Milan: Multhipla, 1979.
— *Giacomo Balla futuriste*. Lausanne: L'Âge d'homme, 1984.
— *La Scène futuriste*. Paris: CNRS, 1989.
— *F.T. Marinetti. L'anarchiste du futurisme. Biographie*. Paris: Nouvelles Éditions Séguier, 1995.
— *Le Futurisme. Création et avant-garde*. Paris: L'Amateur, 2001.
— *Dada libertin et libertaire*. Paris: L'Insolite, 2006.
— *Loïe Fuller, danseuse de la Belle Époque*. Paris: Stock/Somogy, 1994; 2nd edition revised and enlarged. Paris: Hermann, 2007.
— (ed.). *Cinema e fotografie futurista*. Museo di arte moderna e contemporanea di Trento e Rovereto, 18 May–15 July 2001 (Milan/Paris: Skira, 2001).

Lista, Giovanni, Lemoine Serge, and Nakov Andrei. *Les Avant-gardes*. Paris: Hazan, 1991.

Livchits, Bénédikt. *L'Archer à un œil et demi*. Eds. Sébald, E., and Marcadé V. and J.-C. Lausanne: L'Âge d'homme, 1971.

Lucini, Gian Pietro. *Marinetti, Futurismo, Futuristi*. Compilation of writings selected by Mario Artioli. Bologna: Massimiliano Boni Editore, 1975.

Mach, Ernst. *Analisi delle sensazioni*. Milan/Turin/Rome: Fratelli Bocca Editori, 1903.

The Machine as Seen by the End of the Mechanical Age. New York: The Museum of Modern Art, 1968.

Malevich, Kasimir. *Essays on Art 1915–1933*. Trans. Andersen, Troels, New York: George Wittenborn, 1971.
— *Écrits I. De Cézanne au suprématisme, Écrits II. Le Miroir suprématiste, Écrits III. Les Arts de la représentation, Écrits IV. La Lumière et la Couleur*. Ed. J.-C. Marcadé. Lausanne: L'Âge d'homme, 1974–1994.
— *Kazimir Malevič, Sobranie sočinenij v pâti tomah*, vol. 3. Moscow: Gileâ, 2000.

Marcadé, Bernard. *Marcel Duchamp*. Paris: Flammarion, 2007.

Marcadé, Jean-Claude. *Les Avant-gardes littéraires au XXe siècle*. Budapest: Akademiai Kiado, 1984.
— *Le Futurisme russe. 1907–1917 : Aux sources de l'art du XXe siècle*. Paris: Dessain & Tolra, 1989.
— *Malévitch*. Paris: Casterman/Nouvelles Éditions françaises, 1990.
— *L'Avant-garde russe, 1907–1927*. Paris: Flammarion, 1995.
— *De Russie et d'ailleurs. Feux croisés sur l'histoire. Pour Marc Ferro*. Paris: IES, 1995.

Marcadé, Jean-Claude (ed.). *Présence de F.T. Marinetti*. Proceedings of the UNESCO international conference held 15–17 June 1976. Lausanne: L'Âge d'homme, 1982.

Marinetti, Filippo Tommaso. *D'Annunzio intime*. Milan: Verde e Azzurro Editions, 1903.
— *La Conquête des étoiles, poème épique* [Paris, La Plume, 1902]. Paris: Sansot, 1904.
— *Destruction, poèmes lyriques*. Paris: Vanier-Messein, 1904.
— *La Momie sanglante*. Milan: Verde e Azzurro Editions, 1904.
— *Le Roi Bombance, tragédie satirique en 4 actes, en prose*. Paris: Mercure de France, 1905.
— *Les Dieux s'en vont. D'Annunzio reste*. Paris: Sansot, 1908.
— *La Ville charnelle*. Paris: Sansot, 1908.
— *Poupées électriques, drame avec une préface sur le futurisme*. Paris: Sansot, 1909.
— *Enquête internationale sur le vers libre*. Milan: Edizioni futuriste di Poesia, 1909.
— *Mafarka le futuriste, roman africain*. Paris: Sansot, 1910 [1909].
— *Le Futurisme*. Paris [Sansot, 1911]. Lausanne: L'Âge d'homme, 1980.
— *Monoplan du pape, roman politique en vers libre*. Paris: Sansot, 1912.
— *La Bataille de Tripoli (26 Octobre 1911), vécue et chantée par F.T. Marinetti*. Milan: Edizioni futuriste di Poesia, 1912.
— *I Poeti futuristi*. Milan: Edizioni futuriste di Poesia, 1912 (collective anthology).
— *La Grande Milano tradizionale e futurista. Una sensibilità italiana nata in Egitto* [1913]. Milan: Mondadori, 1969.
— *Zang Tumb Tumb: Adrianopoli Ottobre 1912, parole in libertà*. Milan: Edizioni futuriste di Poesia, 1914.
— *Guerra sola igiene del mondo*. Milan: Edizioni futuriste di Poesia, 1915

Maritain, Jacques, "Gino Severini". *Brefs écrits sur l'art*. Paris: Mercure de France, 1999.

Markov, Vladimir. *Russian Futurism: A History*. London: MacGibbon & Kee Ltd, 1968.

Martin, Marianne W. *Futurist Art and Theory 1909–1915*. Oxford: Clarendon Press, 1968.

Martin, Sylvie. *Futurisme*. Cologne: Taschen, 2005.

Mattioli Rossi, Laura (ed.). *Boccioni's Materia: A Futurist Masterpiece and the Avant-Garde in Milan and Paris*. New York: The Solomon R. Guggenheim Foundation, 2004.

Medardo Rosso: Le origini della scultura contemporanea. Museo di Arte Moderna e Contemporanea di Trento e Rovereto, 28 May–22 August 2004, (Milan: Skira, 2004).

A Memorial Exhibition of the Work of Henri Gaudier-Brzeska. Pref. Ezra Pound. London: The Leicester Galleries, May 1918.

Metropolis. La città nell'immaginario delle avanguardie, 1910–1920. Turin: Galleria civica d'Arte moderna e contemporanea, 4 February–4 June 2006 (Turin: Fondazione Torino Musei, 2006).

Metzinger, Jean. *Le Cubisme était né. Souvenirs*. Chambéry: Présence, 1972.

Michel, Walter, and Fox C.J. (ed.). *Wyndham Lewis on Art: Collected Writings 1913–1956*. London: Thames & Hudson, 1969.

Michelini, Gaia. *Nietzsche nell'Italia di D'Annunzio*. Palermo: Salvatore F. Flaccovio, 1978.

Milner, John. *Kazimir Malevich and the Art of Geometry*. New Haven (CT)/London: Yale University Press, 1996.

Morasso, Mario. *L'Imperialismo artistico*. Milan/Turin/Rome: Fratelli Bocca Editori, 1903.
— *La Nuova Arma: La macchina*. Milan/Turin/Rome: Fratelli Bocca Editori, 1904.
— *La Vita moderna nell'arte*. Milan/Turin/Rome: Fratelli Bocca Editori, 1904.

Natalie de Gontcharowa et Michel Larionow. Pref. Guillaume Apollinaire. Paris: galerie Paul Guillaume, 17–30 June 1914.

Natalie de Gontcharowa et Michel Larionow. Paris: Musée national d'art moderne, 21 June–18 September 1995; Martigny: Fondation Pierre Gianadda, 10 November 1995–21 January 1996; Milan: Fondazione Antonio Mazzotta, 24 February–26 May 1996 (Paris: Centre Pompidou).

Nevinson, Christopher R. W. *Paint and Prejudice.* London: Methuen, 1937.

O'Keeffe, Paul. *Some Sort of Genius: A Life of Wyndham Lewis.* London: Jonathan Cape, 2000.

Olivier, Fernande. *Picasso et ses amis.* Paris: Librairie Stock, 1933.

Pach, Walter. *Raymond Duchamp-Villon sculpteur 1876–1918.* Paris: Jacques Povolozky, 1924.

Panizza, Mario. *Il Positivismo filosofico e il positivismo scientifico: Lettere ad Hermann Helmholtz.* Florence: Bencini, 1871.

Les Peintres futuristes italiens., Pref. Umberto Boccioni et al. Paris: galerie Bernheim-Jeune, 5–24 February 1912; London: The Sackville Gallery, March 1912 *(Exhibitions of Works by the Italian Futurist Painters)*; Berlin: Der Sturm gallery, 12 April–15 May 1912 *(Zweite Austellung. Futuristen)*; Brussels: Galerie Georges Giroux, 20 May–5 June 1912.

Peters Corbett, David. *The Modernity of English Art 1914–1930.* Manchester: Manchester University Press, 1997.

Peters Corbett, David, Holt Ysanne, and Russell Fiona (eds.). *The Geographies of Englishness: Landscape and the National Past 1880–1940.* New Haven (CT)/London: Yale University Press, 2002.

Picabia, Francis. *Écrits.* Paris: Pierre Belfond, 1975.

Picasso, Pablo. *Propos sur l'art.* Marie-Laure Bernadac, and Androula Michael (eds.). Paris: Gallimard, 1998.

Picon, Gaëtan. *La Naissance de l'art moderne.* Geneva: Skira, 1974.

Pierre, Arnauld. *Francis Picabia. La peinture sans aura.* Paris: Gallimard, 2002.

Poggi, Cristina. *In Defiance of Painting: Cubism, Futurism and the Invention of Collage.* New Haven – London: Yale Univ Press, 1992.

Poincaré, Henri. *La Science et l'hypothèse* [1902]. Paris: Flammarion, 1968.

Pound, Ezra. *Henri Gaudier-Brzeska.* Auch: Tristram, 1992.

Previati, Gaetano. *I Principi scientifici del divisionismo: La tecnica della pittura.* Milan/Turin/Rome: Fratelli Bocca Editori, 1906.

Robert Delaunay, Marie Laurencin, Pref. Maurice Princet. Paris: Galerie Barbazanges, 28 February–13 March 1912.

Robert Delaunay, 1906–1914. De l'impressionnisme à l'abstraction. Paris: Musée national d'art moderne, 3 June–16 August 1999 (Paris: Centre Pompidou, 1999).

Roche-Pézard, Fanette. *L'Aventure futuriste : 1909–1916.* Rome: École française de Rome, 1983.

Romains, Jules. *La Vie unanime.* Créteil: L'Abbaye, 1908.

Rose, William Kent (ed.). *The Letters of Wyndham Lewis.* London: Methuen, 1963.

Rowell, Margit, and Wye Deborah (eds.). *The Russian Avant-Garde Book. 1910–1934.* New York: The Museum of Modern Art, 2002.

La Russie à l'avant-garde. 1900–1935. Brussels, Palais des Beaux-Arts, 5 October 2005–22 January 2006 (Fonds Mercator-Europalia, 2005).

Saint-Point, Valentine de. "Théâtre de la femme", *Montjoie !* (Paris), 1st year, no. 7 (issue devoted to the Crisis in French Theatre).

Sartini Blum, Cinzia. *The Other Modernism: F.T. Marinetti's Futurist Fiction of Power.* Berkeley/Los Angeles/London: University of California Press, 1996.

Salmon, André. *La Jeune Peinture française.* Paris: Société des Trente, Albert Messein, 1912.
— *Souvenirs sans fin* [1956]. Paris: Gallimard, 2004.

Salon de la Section d'or. Paris: Galerie La Boëtie, 10–30 October 1912.

Sarabânov, Dmitry. *Istoriâ russkogo iskusstva konca 19-na ala 20 veka* [History of Russian Art from the End of the 19th to the Beginning of the 20th Century]. Moscow: AST Press Galart, 1993.

Sculptures de Duchamp-Villon, 1876–1918. Pref. André Salmon. Paris: Galerie Pierre, 1931.

Second Post-Impressionist Exhibition. Pref. Roger Fry. London: Grafton Galleries, 5 October–31 December 1912.

Il Secondo Ottocento italiano: Le postiche del vero. Milan: Palazzo Reale, 26 May–11 September 1988 (Milan: Mazzotta, 1988).

La Section d'or. Paris: galerie La Boëtie, 3–16 March 1920.

La Section d'or, 1925, 1920, 1912. Musées de Châteauroux, 21 September–3 December 2000; Montpellier: musée Fabre, 15 December 2000–18 March 2001 (Paris: Cercle d'art, 2000).

Ševčenko Alexandre [Chevchenko]. *Principy kubizma i drugih sovremennyh tečenij v živopisi vseh vremen' i narodov* [The Principles of Cubism and other Contemporary Tendencies in Painting of all Times and of all Peoples]. Moscow: 1913.

Severini : œuvres futuristes et cubistes. Paris: galerie Berggruen, 1956.

Severini, Gino. *La Vita di un pittore* [1946]. Milan: Edizioni di Comunità, 1965.
— *Écrits sur l'art.* Pref. Serge Fauchereau. Paris: Cercle d'art, 1987.

Sidoti, Antoine. *Genèse et dossier d'une polémique. La Prose du Transsibérien et de la petite Jehanne de France, novembre-décembre 1912–juin 1914.* Paris: Lettres modernes, 1987.

Un siècle de sculpture anglaise. Paris: Galeries nationales du Jeu de Paume, 6 June–15 September 1996 (Paris: Réunion des Musées nationaux, 1996).

Signac, Paul. *D'Eugène Delacroix au néo-impressionnisme* [Éd. de *La Revue blanche,* 1899]. Françoise Cachin (ed.). Paris: Hermann, 1978.

Silver, Kenneth. *Esprit de Corps: The Art of the Parisian Avant-Garde and the First World War, 1914–1925.* London: Thames & Hudson, 1989.

A Slap in the Face! Futurists in Russia. London: Estorick Collection, 28 March–10 July 2007.

Soffici, Ardengo. *Il caso Medardo Rosso; preceduto da L'Impressionismo e la pittura italiana.* Florence: B. Seeber Editori, 1909.
— *Cubismo e Oltre.* Florence: Ed. Libreria della Voce, 1913.
— *Cubismo e Futurismo.* Florence: Ed. Libreria della Voce, 1914.

Sola, Agnès. *Le Futurisme russe. Pratique révolutionnaire et discours politique.* Typescript of her PhD thesis, Université Paris III-Sorbonne nouvelle, 1982.

Sorel, Georges. *Lo Sciopero generale e la violenza.* Rome: Edizioni Industria e Lavoro, 1906.
— *Réflexions sur la violence.* Paris: Librairie de "Pages libres", 1908.

Souriau, Paul. *La Beauté rationnelle.* Paris: Félix Alcan, 1904.

Spate, Virginia. *Orphism: The Evolution of Non-Figurative Painting in Paris 1901–1914.* Oxford: Clarendon Press, 1979.

Stefani, Manuela Angela. *Nietzsche in Italia, rassegna bibliografica, 1893–1970.* Assisi-Rome: Carucci, 1975.

Les Synchromistes. Morgan Russell et S. Macdonald-Wright. Paris: Galerie Bernheim-Jeune & Cie, 27 October–8 November 1913.

Tallarico, Luigi (ed.). *Boccioni cento anni.* Rome: Volpe Editore, 1982.

Tisdall, Caroline, and Bozzolla, Angelo. *Futurism.* London, Thames & Hudson, 1977.

Tsvetaeva, Marina. *Nathalie Gontcharova, sa vie, son œuvre* [1929]. Trans. Véronique Lossky. Paris: Clémence Hiver, 1990.

Umansky, Konstantin. *Neue Kunst in Russland 1914–1919.* Potsdam/Munich: Kiepenheuer/Goltz, 1920.

Ungersma Halperin, Joan. *Félix Fénéon. Art et anarchie dans le Paris fin de siècle.* Paris: Gallimard, 1991.

Vaccari, Walter. *Vita e tumulti di Marinetti.* Milan: Omnia Editrice, 1959.

Vakar, I.A., and Tat'âna N. Mihienko (eds.). *Malevič o sebe. Sovremenniki o Maleviče* [Malevich on Himself. Contemporaries on Malevich]. Moscow: RA, 2004, 2 vol.

Vers des temps nouveaux. Kupka, œuvres graphiques 1894–1912. Paris: musée d'Orsay, 25 June–6 October 2002 (Paris: Réunion des Musées nationaux, 2002).

Vorticism Exhibition. London: Doré Galleries, June–July 1915.

Xe Exposition d'État : Création sans objet et suprématisme. Pref. Liubov Popova. Moscow: May 1919.

Wees, William C. *Vorticism and the English Avant-Garde.* Toronto: University of Toronto Press, 1972.

Wells, Herbert Georges. *The Time Machine: An Invention.* London: Heinemann, 1895.

Wilson, Andrew (ed.). *ICSAC Cahier 8/9: Vorticism.* December 1988.

Wyndham Lewis. Manchester: City Art Gallery, 1 October–15 November 1980.

Zanovello Russolo, Annamaria. *Russolo l'uomo l'artista.* Milan: Cyril Corticello, 1958.

CATALOGUES RAISONNÉS AND STANDARD REFERENCES

Balla
Lista, Giovanni. *Balla*. Modena: Edizioni Galleria Fonte d'Abisso, 1982.

Boccioni
Calvesi, Maurizio, and Coen, Ester. *Boccioni. L'opera completa*. Milan: Electa, 1983.

Bomberg
Cork, Richard. *David Bomberg*. New Haven (CT)/London: Yale University Press, 1987.
— *David Bomberg*. Exh. cat. (London, Tate Gallery, 17 Feb.–8 May 1988), London: Tate Publishing, 1988.

Braque
Laude, Jean. *Catalogue de l'oeuvre de Georges Braque: Cubisme 1907–1914*, Paris: Maeght, 1982.

Rubin, William. *Picasso and Braque: Pioneering Cubism*. Exh. cat. (New York, The Museum of Modern Art, 24 Sept. 1989–16 Jan. 1990), New York: The Museum of Modern Art, 1989.

Carrà
Bigongiari, Piero and Carrà, Massimo. *L'Opera completa di Carrà dal futurismo alla metafisica e al realismo mitico 1910–1930*. Milan: Rizzoli, 1970.

Del Marle
d'Orgeval, Domitille. *Félix del Marle*. Exh. cat. (Grenoble, Musée de Grenoble, 17 June–3 Sept. 2000), Paris: Réunion des Musées Nationaux, 2000.

Robert Delaunay
Robert Delaunay : 1906-1914 de l'impressionnisme à l'abstraction. Exh. cat. (Paris, Centre Pompidou, Paris, 3 June–16 Aug. 1999), Paris: Centre Pompidou, 1999.

Sonia Delaunay
Robert & Sonia Delaunay. Exh. cat. (Paris, Musée d'Art Moderne de la Ville de Paris, 14 May–8 Sept. 1985), Paris: Musées / SAMAM, 1985.

Duchamp
Schwarz, Arturo, *The Complete Works of Marcel Duchamp*, New York: Delano Greenidge Editions, rev. and expanded ed. 1997.

Duchamp-Villon
Duchamp-Villon: Collections du Centre Georges Pompidou, Musée national d'Art moderne et du Musée des Beaux-arts de Rouen, exh. cat. (Paris, Centre Pompidou, 20 Feb.–24 May 1999), Paris: Réunion des Musées Nationaux, 1999.

Epstein
Silber Evelyn. *The Sculpture of Epstein with a Complete Catalogue*. Oxford: Phaidon Press, 1986.

Silber, Evelyn, and Friedman Terry, (eds.). *Jacob Epstein: Sculpture and Drawings*. Leeds City Art Galleries. London: Whitechapel Art Gallery, 1987.

Exter
Chauvelin, Jean (ed.). *Alexandra Exter*. Chevilly-Larue: Max Milo Éditions, 2003.

Gaudier-Brzeska
Silber, Evelyn. *Gaudier-Brzeska: Life and Art: with a Catalogue Raisonné of the Sculpture*, London: Thames & Hudson, 1996

Gleizes
Robbins, Daniel, Georgel, Pierre and Varichon, Anne. *Albert Gleizes: catalogue raisonné*. Paris: Somogy Éditions d'art, Fondation Albert Gleizes, 1998

Goncharova
Natalia Goncharova: the Russian Years. Exh. cat. (St. Petersburg, State Russian Museum, 25 Apr.–15 July 2002), Palace Editions, 2002.

Nathalie Gontcharova: Michel Larionov. Exh. cat. (Parigi, Centre Pompidou, , 21 June–18 Sept. 1995), Paris : Éditions du Centre Pompidou, 1995.

Kupka
Leal, Brigitte, Brullé, Pierre, and Malsch Friedemann. *František Kupka: la collection du Centre Georges Pompidou, Musée national d'Art moderne*. Exh. cat. (Paris, Centre Pompidou, 28 Mar.–9 June 2003), Éditions du Centre Pompidou, Paris 2003.

František Kupka, 1871-1957, ou l'invention d'une abstraction. Exh. cat. (Paris, Musée d'Art Moderne de la Ville de Paris, 22 Nov. 1989–25 Feb. 1990), Musée d'Art Moderne de la Ville de Paris, Paris 1990.

Larionov
Parton, Anthony. *Mikhail Larionov: and the Russian Avant-garde*. London: Thames & Hudson, 1993.

Léger
Bauquier, Georges. *Fernand Léger: Catalogue raisonné de l'œuvre peint, 1903–1919*. Vol. 1. Paris: Adrien Maeght, 1990.

Lewis
Edwards, Paul. *Wyndham Lewis: Painter and Writer*. New Haven and London: Yale University Press for Paul Mellon Centre for Studies in British Art, 2000.

Macdonald-Wright
South, Will (ed.). *Color, Myth, and Music: Stanton Macdonald-Wright and Synchromism*, Raleigh: North Carolina Museum of Art, 2001.

Malevich
Troels, Andersen. *Malevich. Catalogue raisonné of the Berlin Exhibition 1927*. Amsterdam: Stedelijk Museum, 1970.

Nakov, Andrei. *Kazimir Malewicz. Catalogue raisonné*. Paris: Adam Biro, 2002.

Nevinson
Walsh, Michael J. K. *Nevinson C. R. W.: This Cult of Violence*, New Haven and London: Yale University Press for the Paul Mellon Centre for Studies in British Art, 2002.

Picabia
Borràs, Maria Lluïsa, *Picabia*, London: Thames & Hudson, 1985.

Camfield, William A., *Francis Picabia: his Art, Life and Times*, Princeton, N.J.: Guildford; Surrey: Princeton University Press, 1979.

Picasso
Daix, Pierre. *Picasso: the Cubist years, 1907–1916. A Catalogue Raisonné of Paintings and Related Works*. London: Thames & Hudson, 1979.

Popova
Dabrowski,i Magdalena. *Liubov Popova*. Exh. cat. (New York, Museum of Modern Art, 13 Feb.–23 Apr. 1991), New York: Abrams 1991.

Russolo
Tagliapietra, Franco and Gasparotto, Anna. *Luigi Russolo: vita e opere di un futurista Luigi Russolo: Life and Work of a Futurist*. Exh. cat. (Museo di Arte Moderna e Contemporanea di Trento e Rovereto, 27 May–17 Sept. 2006 / London, Estorick Collection, 4 Oct.–17 Dec. 2006), Milan: Skira, 2006.

Severini
Fonti, Daniela. *Gino Severini, catalogo ragionato*. Milan: Mondadori/Daverio, 1988.

Soffici
Cavallo, Luigi. *Soffici, immagini e documenti (1879–1964)*. Firenze: Vallecchi Editore, 1986.

Stella
Zilczer, Judith. *Joseph Stella*. Exh. cat. (Washington, Hirshhorn Museum and Sculpture Garden Collection, 12 May–17 July 1983).

Wadsworth
Black, Jonathan. *Edward Wadsworth. Form, Feeling and Calculation: the Complete Painting and Drawings*, London: Philip Wilson Publishers, 2005.

INDEX OF NAMES

PHOTO CREDITS

Printed and bound in January 2009 by Conti Tipocolor, Florence
Printed in Italy